CONTENTS

ILLUSTRATIONS

NO CAPTION NEEDED

NO CAPTION NEEDED

ICONIC PHOTOGRAPHS, PUBLIC CULTURE,
AND LIBERAL DEMOCRACY

ROBERT HARIMAN AND JOHN LOUIS LUCAITES

THE UNIVERSITY OF CHICAGO PRESS

Chicago and London

The University of Chicago Press, Chicago 60637
The University of Chicago Press, Ltd., London
© 2007 by The University of Chicago
All rights reserved. Published 2007.
Paperback edition 2011
Printed in the United States of America

20 19 18 17 16 15 14 13 12 11 3 4 5 6 7

ISBN-13: 978-0-226-31606-2 (cloth)
ISBN-13: 978-0-226-31612-3 (paper)
ISBN-10: 0-226-31606-8 (cloth)
ISBN-10: 0-226-31612-2 (paper)

Library of Congress Cataloging-in-Publication Data

Hariman, Robert.
No caption needed : iconic photographs, public culture, and liberal democracy /
Robert Hariman and John Louis Lucaites.
p. cm.
Includes index.
ISBN-13: 978-0-226-31606-2 (cloth : alk. paper)
ISBN-10: 0-226-31606-8 (cloth : alk. paper) 1. Popular culture—United States—
History. 2. Political culture—United States—History. 3. Photographs—Political
aspects—United States—History. 4. Visual communication—Political aspects—
United States—History. 5. Rhetoric—Political aspects—United States—History.
6. Mass media—Political aspects—United States—History. 7. Democracy—United
States—History. 8. United States—Politics and government—1945–1989. 9. United
States—Politics and government—1989-. 10. Photojournalism—United States—
20th century. I. Lucaites, John Louis. II. Title.
E169.12.H369 2007
306.0973—dc22

2006026049

ACKNOWLEDGMENTS

Where to begin? At the beginning, of course. But where is that? Was it when the two authors, knowing only vaguely of one another, had a chance meeting at a conference? Or was it prior to that, when friends, advisors, mentors, and events somehow led each of us to see how politics, culture, and history came together in, of all things, rhetoric? Or was it later when a third colleague invited Hariman to write an essay for a volume on public memory, and he, not having the time to do it alone, suggested that perhaps he could add something to an essay already in draft form by Lucaites? After all, how long could it take to finish work already half-done? Years later, we know that if anything was saved, it wasn't time. Good thing, too, as the longer story is one more example of how scholarship is deeply and rightly social.

We have been friends now for eighteen years, and we want to acknowledge that. The work that led to this book began, officially, eleven years ago in a coffee shop in Evanston, Illinois. In the intervening years, it has matched the ebb and flow of our lives. Thanks to e-mail and cell phones, the project somehow moved forward while teaching classes, writing articles, serving on committees, editing manuscripts, and otherwise doing our jobs, and also while running errands, cooking meals, attending kids' sporting events, taking vacations, nursing bad backs, mourning the passing of friends and colleagues, and on and on. Too often in the humanities we think of the production of

knowledge as a solitary affair. This is an impoverished model of scholarship that ignores our many relationships as writers, teachers, and colleagues. This book would have come out earlier if it had been written by either one of us alone, but it would not be what it is had it not emerged out of the rich experience of coauthorship and the unexpected pleasures of friendship.

The social bonds of scholarship also extend across a wide network of colleagues and students. Acknowledging that is a daunting task, and we don't take it lightly, although we are sure that we cannot recall all of the debts we have accrued. Readers of portions of the manuscript include Carole Blair, Stephen Browne, Karlyn Kohrs Campbell, Gregory Clark, Celeste Condit, William Doty, Bonnie Dow, Peter Ehrenhaus, Theresa Enos, Cara Finnegan, Oscar Giner, Carol Greenhouse, Stephen Hartnett, Jeffrey Isaac, Barbara Koziak, David Holloway, Bill Lewis, Jim McDaniel, Nancy Miller, James Naremore, Julianne Newton, Lawrence Prelli, Art Sanders, Jon Simons, John Sloop, Ted Striphas, Keith Topper, Jeffrey Wasserstrom, and Barbie Zelizer, as well as the anonymous reviewers for several journals and the University of Chicago Press. All were generous with their time and comments.

Equally generous were those who took it upon themselves to send us examples of image appropriation; some are displayed in the book, others are cited in the notes, and all of them provided both evidence and support. Thanks, thus, to Courtney Bailey, Jeff Bennett, Barbara Biesecker, Nathan Carroll, Maurice Charland, Robert Clift, James Cherney, Darrel Enck-Wanzer, Suzanne Enck-Wanzer, Jim Farrell, Kathleen Farrell, Cara Finnegan, Traci Gibboney, Bruce Gronbeck, Theresa Hines, Joan Hawkins, Dixon Hollis, Melanie Loehwing, Jamie MacLeod, Matt McGarrity, Leila Monaghan, Charles Morris, Stephen Olbrys, Phaedra Pezzullo, Susan Ross, Dan Schowalter, Wang Shen, Hall Smeltzer, Robert Terrill, Julie Thompson, Rebecca Townsend, Jasmine Trice, Mike Tumolo, Isaac West, and David Worthington. Images and much else were tracked down by three research assistants, Kendra Laffe, Julie Heineman, and Tim Barouch, who deserve much more than they were paid.

Three universities provided timely and generous financial support at key points in the development of the project. At Indiana University, we were supported by the Department of Communication and Culture, the College of Arts and Sciences, and the College Arts and Humanities Institute. Special acknowledgement is due to department chairs Robert Ivie and Gregory Waller. At Northwestern University, support was provided by the Department of Communication Studies and the School of Communication, with special thanks to Department Chair Peter Miller and Dean Barbara O'Keefe. Support also was provided by the Center for the Humanities and the Office of the Provost at Drake University.

We also appreciate that permission has been granted to draw on prior publication of some of the material in this book. This earlier work includes the following: "Dissent and Emotional Management in a Liberal-Democratic Society: The Kent State Iconic Photograph," *Rhetoric Society Quarterly* 31 (2001): 5–31, courtesy of the Rhetoric Society of America; "Performing Civic Identity: The Iconic Photograph of the Flag Raising on Iwo Jima," *Quarterly Journal of Speech* 88 (2002): 363–92, and "Public Identity and Collective Memory: The Image of 'Accidental Napalm,'" *Critical Studies in Media Communication* 20 (2003): 33–65, courtesy of the Taylor & Francis Group (http://www .tandf.co.uk/); "Ritualizing Modernity's Gamble: The Iconic Photographs of the Explosions of the *Hindenburg* and the *Challenger*," *Visual Communication Quarterly* (winter–spring 2004): 4–17, courtesy of Lawrence Erlbaum Associates; "Liberal Representation and Global Order: The Iconic Photograph from Tiananmen Square," *Rhetorics of Display*, edited by Lawrence J. Prelli (University of South Carolina Press, 2006), 121–38, courtesy of the University of South Carolina Press.

Douglas Mitchell and Tim McGovern at the press have supplied their usual, one-of-a-kind editorial support and encouragement. Maia Rigas has been everything we would hope for in a copyeditor—and more. We also want to thank the many students, lecture audiences, neighbors, friends, and strangers we met along the way who have expressed such enthusiasm for the project. Whatever the merit of our arguments, your response to the icons assures us that we have touched on something valued in American public life today.

Finally, we must thank our families, not least for the many, many times something was interrupted by a phone call from one of us. Ginny, Stephen, and Katie, and Jane, David, and Katie, this book is dedicated to you.

1

INTRODUCTION

The gaunt woman, her face lined with care, stares past the camera while three children cling to her amidst the Great Depression. A soldier catches a nurse in a powerful embrace on VJ Day in Times Square as onlookers smile approvingly. A naked Vietnamese girl runs in terror from the napalm attack engulfing the road behind her. Plumes of smoke streak outward in silent array as the *Challenger* explodes in the blue air over Florida. A solitary Chinese man stands calmly before the barrel of a tank at Tiananmen Square.

These images and a few others like them are the icons of U.S. public culture. Like any religious icon, they work in several registers of ritual and response. They are easily recognized by many people of varied backgrounds. They are objects of veneration and other complex emotional responses. They are reproduced widely and placed prominently in both public and private settings, and they are used to orient the individual within a context of collective identity, obligation, and power. They come to represent large swaths of historical experience, and they acquire their own histories of appropriation and commentary. Whatever the circumstances of their dissemination, however, they always seem to stand above the welter of news, debates, decisions, and investigations. They have more than documentary value, for they bear witness to something that exceeds words. Objects of contemplation bearing

the aura of history, or humanity, or possibility, they are sacred images for a secular society.

Or not. Perhaps they are important precisely because they are accessible, undemanding images suited to mass-mediated collective memory. Visual commonplaces, these familiar images operate like the stock figures in memorial statuary, ceremonial oratory, and other representational practices that have been used to construct a community's sense of the past. From ancient ode to Renaissance pietà to still photograph, available technologies of public representation situate life in the present within a formal composition and enduring context of meaning safely secured from change. Such images provide a more or less idealized sense of who we are and what we ought to be, and they allow anyone to have a sense of personal affiliation with large-scale events. A key factor may be that these images are experienced within the ordinary routines of everyday life: browsing through the magazines in the dentist's office or looking at a neighbor's coffee-table book on the history of the twentieth century. Perhaps, as Time Warner might say, these images are snapshots from the American family album.

And that may be the problem. Popular images disseminated, promoted, and repeatedly reproduced by large-scale corporations and seamlessly sutured into the material practices of ordinary life—whether documenting victory or disaster, surely these images exemplify ideology at work. Look at them critically, and it is all there: the production of truth by a technological apparatus of surveillance; the gaze of social authority and its objectification of the other; fragmentary representations of events that reinforce dominant, totalizing narratives; artfully manufactured sentiments ranging from patriotism to grief used to justify state action; the reproduction of exploitative conceptions of race, class, and gender as if they were the natural order of things, as real and unremarkable and unchangeable as what you see in the background of any photo: that wall, a bookcase, the shelf of books, nothing out of the ordinary. Photojournalism might be the perfect ideological practice: while it seems to present objects as they are in the world, it places those objects within a system of social relationships and constitutes the viewer as a subject within that system.[1] These relationships—including the relationship between media producer and audience—are arbitrary, asymmetrical relations of power, yet they are made to appear natural as they are articulated through the unexceptionable signs of the real world.[2]

But there may be more to the story. The images standing out above the billions of other images scattered through media space cannot be exempt from the laws of power, but they may be reflecting other forms of social, political, and artistic consciousness as well. Perhaps they are works of art, more spe-

cifically, of a public art grounded in the experiences and aspirations of a democratic society and oriented toward the problems and rewards of ordinary life. Democracy is lodged in the middle realm of human experience. It thrives in middle classes, produces middlebrow sensibilities, gets by on mediocre education, and lives by the law of averages. Yet, for all that, democratic societies produce popular artworks in music, film, television, and other media capable of reflective examination of the social world. Photojournalism is a characteristically democratic art, and the iconic photo is its signature work. Although icons are limited aesthetically while also oriented toward basic topics of public concern, they are doing more than reproducing a structure of power. From an intermediate position within the social order, the icon provides a reflexive awareness of social forms and state actions that can lead to individual decisions and collective movements on behalf of democratic ideals. Indeed, it is the artistic excellence of the icon—its transformation of the banal and the disruptive alike into moments of visual eloquence—that reproduces an idealism essential for democratic continuity.

Or, if that is too grand, perhaps they are conversation pieces for a vernacular public sphere. Or they could be prominent examples of how visual media hollow out the public sphere from within, replacing the systematic thinking and rational deliberation of print cultures with a miasma of fragmentary information and sensory appeals leaving little distinction between news and advertising, public affairs and private consumption. Or they could exemplify the pastiche composition and ahistorical organization of a postmodern culture; or the circulation of dead emotions in a postemotional society; or the primitive artistry of a postliterate society . . .

Or they could be nothing significant at all: grainy pictures on disposable newsprint, old *Life* magazine images left to the flea market of history, perhaps lingering in memory for a while like old song titles, but no more than that. And what do they have to do with politics anyway? They are merely pictures, not laws or armies, votes or money, institutions or peoples. Representations rather than actions, they seem to justify the political scientist's disregard for the epiphenomena of language, symbolism, and other ornaments of material power. Even political theory has kept its distance from visual representation, perhaps from an aversion to political spectacle learned from the experience with Nazism, or from a more deep-seated preoccupation with the ideas and arguments structuring political thought. Without propositional meaning or syntactical structure, evoking strong emotional responses among ignorant viewers, used by sophisticated persuaders to manipulate mass audiences, iconic photographs would seem to confirm the long-standing suspicion of visual display in Western philosophy.

3

A popular art in public media having marginal status as a mode of thought or action: where have we heard that before? The alternating disregard of and paranoia about visual practices in the public media have telling similarities with the conventional denigration of the art of rhetoric. Both are said to be too grounded in popular opinion, too emotional, insufficiently knowledgeable, artistically muddled, wrongly motivated, ethically corrosive, and politically dangerous. All these claims can be true in the particular case, of course, and to a certain extent more generally, but they also carry a host of assumptions that can wreak havoc with any serious attempt to maintain a vital relationship between theory and practice in the human sciences. The problems begin to emerge if one draws the conclusion that follows most directly from the critique: public discourse should be based on elite judgment, emotionally muted, limited to available knowledge, aesthetically rarified, conducted by those with preapproved intentions, dedicated to moral instruction, and incapable of changing the established regime. We won't rehearse the full defense of rhetoric here, but it should be obvious that the conventional academic attitude towards public discourse generally, and public visual practices in particular, relies on or quickly leads to a more general and more troubling endorsement of political ideas that are either unworkable or undemocratic.[3]

Frankly, the authors of this volume enjoy some political spectacles, we think the media should communicate emotions, we take aesthetics seriously, we are suspicious of both criticism of excess and praise for objectivity, we are sympathetic to the conventional feelings, popular tastes, and mixed media of democratic societies, and we don't believe that politics can be reduced either to rationality or power. Stated otherwise, we are dedicated to the critical study of public discourse and public arts on the assumption that they are crucial to the success of democracy. We draw on the historical study of rhetoric as it is both a practical art and a theory of public address. Traditionally, that study was oriented toward the preparation of political elites and professional advocates for strategic maneuver in public performance and deliberation; it was used to realize specific intentions in the formation of policy, determination of legal judgments, and commentary on public affairs. In contemporary study, the emphasis has shifted from the individual's pursuit of advantage to the collective construction of identity, community, and power. Public discourse is understood to channel social energies through structures of representation that can be labeled rhetorical, ideological, aesthetic, political, and more. Public texts are complex mediations of experience. In every case the focus is on how the material practice enables and constrains actors and audiences alike as they try to acquire knowledge, apply values, and otherwise do

4

the work of making agreements and building consent. The pursuit of advantage is still open to individuals within specific locales, while at the same time processes of domination and resistance, and of negotiation and change, play out across a wide range of media.

These and other inclinations lead us to the study of visual rhetoric. But we are hardly alone: the study of various practices of visual representation is booming, so much so that it seems similar in scope to the "linguistic turn" that expanded across the human sciences in the twentieth century.[4] It is becoming evident that Western culture has always been more dependent on visual materials than had been thought,[5] that modern science and medicine have been driven by development of increasingly sophisticated modes of imaging,[6] that cities and nations have been organized visually,[7] that racial, ethnic, sexual, and artistic identities have been shaped by photography and other visual practices,[8] that social reform and human rights advocacy have been advanced by photojournalism and other visual arts,[9] that social theory itself has been mediated by various forms of observation,[10] and so forth and so on. Closer to home, everyone is increasingly aware that we now are awash in images. From the commercial insignia displayed on every available surface to the visual carnival of the World Wide Web, there is little reason to doubt that social actors are more and more likely to be thinking, feeling, and acting on the basis of what they have seen rather than only heard or read. Of course, these modalities are not so neatly separated in practice, so there is good reason to move beyond the question of which mode is dominant and consider more complicated relationships between communication technology and culture.

Iconic photographs provide an accessible and centrally positioned set of images for exploring how political action (and inaction) can be constituted and controlled through visual media. They are the images that you see again and again in the historical tableaus of the visual media: whether on the cover of the pictorial history of the twentieth century, as the final, lingering shot of the montage advertising a World War II retrospective, or on the Web page memorializing popular protests of the 1960s. These images don't stop there, however, for they also are picked up by political cartoonists and by political demonstrators; they are used in commercial advertising and reproduced on T-shirts and all manner of promotional materials including academic book covers; they are displayed in museums and referred to in written history, fiction, and poetry; they are copied into drawings, silk screens, tattoos, and other media of vernacular art; they are parodied in magazines, newspapers, video, and on Web pages; and they are analyzed in scholarly studies of photography, photojournalism, political representation, and related topics.

Iconic photographs are not the only images that occur in these venues, of course, but they are the images that occur repeatedly and in all of them.

They are a small set—fifteen, twenty, maybe thirty at the most across a span of generations.[11] They in no way comprise the long list of influential photos, but they are the photos that stand out from all the others over time. Anyone can begin to get a sense of this class of images by following one of our own, obviously anecdotal techniques for tapping into public memory. Whenever we would be asked about our work—for example, by the strangers next to us on airplanes—we would mention the iconic photos, defined roughly as "famous pictures from the news media" and then ask our interlocutors to list those that came to mind. We soon learned what would be the typical response: three or four of the set would be listed immediately, usually with some comment about the powerful impact one or more had on that person or on society. Other images would be mentioned only occasionally, and often in a more speculative tone. Variations within the set had obvious explanations such as generational differences. Similar responses were produced by students in our classes, lecture audiences, and others whom we quizzed. What is just as important, we believe, was the tone of response, which would be something like, "Oh, that's fascinating, I'd love to see that book." This is not the response we get if we say that we study "the history of public discourse." When we mentioned the icons, however, people's interest would come alive. They loved some of them, shuddered at others, were curious about a few of them, and admired them all. They also seemed to use them—whether to mark time, orient themselves toward the political community, or think about and judge the historical event or period.

It became obvious that people don't know a great many circumstantial details regarding any iconic photograph such as its date, specific location, names of the participants, original medium of representation, photographer, and so forth.[12] Nor do you, unless you can identify February 1, 1968, or point quickly to Kent State on a map or say whether the Tiananmen Square image (which is not in Tiananmen Square) was originally a video screen grab or a still photograph. Likewise, although the "beauty" of the images often was remarked upon, there was no attention to the professional values of photographic art: no one cared whether the images were in black and white or color, or about their resolution, or the photographer's artistic models and style. These images were obviously highly specific objects of memory and admiration, yet also somehow abstract representations whose value was far more symbolic than referential, and more a public art form than objects for connoisseurship.

The task of this book is to demonstrate how these photographs fulfill sev-

eral important functions in U.S. public life. We examine only U.S. domestic media, as that is what we know. It remains to be seen whether and how iconic photos operate in other national and transnational media environments. We also have tried to work with photos that were clearly important within U.S. public culture rather than in respect to specific subcultures. For example, many devoted baseball fans will be familiar with several of the most revered images from the history of baseball, including "the swing" taken by Joe DiMaggio, "the slide" by Jackie Robinson, and Babe Ruth's farewell as he leaned on his bat while looking up at the stands. Each photo is sold as a commemorative object, referenced in verbal remembrance, and often reproduced more widely. They could be called icons within the subculture and they are salient without, but they don't do the same work for public life as they do for baseball.

A more difficult case is that of Holocaust images, which we think are in a class by themselves.[13] Their extraordinary historical circumstances, moral weight, and traumatic impact, as well as their specific relationship with Jewish identity, all combine to create a visual history that is, though still representative of modern journalism and public culture, virtually unique. Some of these images are not iconic yet still significantly salient; one thinks of the stacked corpses. Some, such as "a child at gunpoint," may be iconic within specific subcultures and also circulate more widely with less intensity.[14] Others are iconic and more: that is, a study of them as icons would miss important elements of their historical value and moral force. Thus, the Holocaust images are of enormous importance to modern self-understanding and moral reflection, and, therefore, essential components of public life and a key demonstration of the ethical, political, and rhetorical importance of photojournalism. Yet they also are not neatly coordinate with the genre of iconic photographs, nor should either set of images stand in for the other. We have not discussed Holocaust images for these reasons and one more, which is that Barbie Zelizer and others have already provided superb studies of their history, contemporary appropriations, and profound challenge to habits of representation.[15]

The photos we have selected not only are widely recognized but also are thought to have had distinctive influence on public opinion. Why else, one might wonder, would heated debate persist about the Vietnam images, and why would the Chinese government ban the image of the man standing before the tanks in Tiananmen Square? In fact, claims regarding influence are notoriously difficult to prove. Nonetheless, the contrary claim—that salient public practices have no effect—is even less credible. Although one need not attend to the rhetorical dimension of a text or image to account for

important elements of its meaning, there would be little motivation to conduct such studies if all believed that the practice in question was incapable of influence.[16] Like all public address, the icons make some beliefs and actions more intelligible, probable, and appealing, and others less so. Critical analysis attempts to explicate this dimension of meaning on the assumption that others can then assess more carefully how much actual force each image had in respect to specific audiences. The issue will always remain a matter of debate, and we believe it is a debate that should be happening continually.[17] Healthy democracies are those where citizens are accustomed to arguing thoughtfully about how they are influenced.

David Perlmutter and others have rightly challenged the myth that iconic images *dominate* public opinion. They argue that polls don't support claims that specific images had immediate influence on public opinion, and that opinion formation by individuals is not a simple response to images but rather depends on individual predispositions and values.[18] We agree, but we also believe that influence goes well beyond what can be measured by polling, and that a focus on individual response can be misleading when predispositions and values are widely shared. The larger problem is that determinations of influence seem trapped between two, very different modes of proof. On the one hand, there are many testimonials about how images from snapshots to icons have had decisive impact on individual viewers. "That's when I . . ." fell in love, decided to enlist, knew whom to vote for, or otherwise made up one's mind. On the other hand, the collective impact of specific images (and reports, for that matter) is easily lost in the general questions and generic results of public opinion polling.

The problem with assessing influence also lies with having too narrow a conception of what is being influenced. If a position on a specific question of governmental policy is the question—should the United States withdraw from Vietnam? from Iraq?—then the photo of a civilian being traumatized may not directly affect the outcome so much as reinforce already established beliefs. Although such questions of policy are touch points of public life, they also are relatively isolated elements in a rich tapestry of beliefs, attitudes, interests, values, customs, and commitments that constitute the atmosphere in which civil society breathes. That atmosphere—that culture—provides the conditions of intelligibility and appeal for many, many decisions, large and small.

Our approach is to focus on how each image operates as a distinctive element of U.S. public culture. As part of that, each image presents a pattern of motivation that can make some responses more likely than others. The "Migrant Mother" offers a plea on behalf of the New Deal, the execution of a

bound prisoner argues against the Vietnam War (to the dismay of the photographer), and so forth. There is much more to the rhetorical power of the icon, however. We believe we can identify five additional vectors of influence that seem important for photojournalism and particularly for iconic photographs: reproducing ideology, communicating social knowledge, shaping collective memory, modeling citizenship, and providing figural resources for communicative action. As we hope to show along the way, the influence that does occur comes from complex relationships between formal characteristics of the image, its circulation across a range of media, and varied appropriations by diverse actors, all within a rich intertext of images, speeches, commentary, and other texts.

By ideology, we mean a set of beliefs that presents a social order as if it were a natural order, that presents asymmetrical relationships as if they were mutually beneficial, and that makes authority appear self-evident. Whether claiming that God made woman out of man, or that anyone can become president of the United States, one is articulating an ideology. The same is true whether one is arguing for market deregulation or universal health care. As Louis Althusser has argued, ideology articulates an imaginary relationship between people and their material conditions, but not one that is simply a false account of the real.[19] What is important in this view is to recognize how the dominant codes articulate dominant social relationships and that the distinctive ideological effect is the formation of subjective identity consistent with that social structure. Roland Barthes's account of "myth" or what has come to be called the "third order of signification" fills out this picture. The ideological code produces a way of talking about the world but one that is necessarily "impoverished" in order to sustain its own contradictions. Images, although they always exceed the code, also, because of their combination of transparency, reproduction, and syntactical impoverishment, operate as highly effective means for *relaying* the code and thereby both extending and reinforcing the ideological function.[20] Thus, the iconic image's combination of mainstream recognition, wide circulation, and emotional impact is a proven formula for reproducing a society's social order.

Because an image both exceeds any code and remains relatively inarticulate, it can become a site not only for the ideological relay but also for depicting the dynamic negotiations that are the rich, embodied play of societal power relations in everyday life. Images of people cannot avoid presenting them as they are naturally and socially: male and female, men and women, and more or less masculine or feminine. Nor does it stop there, as the image also can show all the other variations of gendered display that then are used to negotiate the social structure. So it is that the ideological function is al-

9

ways present in the iconic image but not always salient. Because the "same" image can already contain within it both dominant and resistant responses to social authority, there need not be just one effect. More important, there is much more than the ideological relay occurring when photojournalism does succeed at constituting an *intermediate* zone between hegemony and resistance, that is, when it creates a public culture. In that middle realm other forms of rhetorical effectivity come into their own: social knowledge becomes more than dominant-subordinate relationships, collective memory serves more than elite interests, citizenship becomes a distinctive form of social identity, and the resources for communicative action can be more than just the master's tools.

The most complicated relationship between the photographic image and public opinion occurs because images communicate social knowledge. Classical theories of rhetoric established that persuasive discourse works when it can efficiently tap into the tacit knowledge held by the audience as they are members of a society. The text must activate deep structures of belief that guide social interaction and civic judgment and then apply them to the particular case.[21] Such knowledge is both relative and powerful. Thus, depending on the social context, the claim that someone is wealthy can mean that he need not steal while in office (as could have been the assumption in classical Athens), or that she is not likely to understand the plight of the common people (as might be assumed in a working-class bar in the United States). Photographs are an ideal medium for activating tacit social knowledge precisely because they are a mute record of social performance. One can see in a glance what is not being said yet is a vital basis for identification and judgment. With some photos, one can see the social substrate in respect to highly particular circumstances, say, the politician running for office. With the iconic image, social knowledge is fused with a paradigmatic scene, say, of poverty or war. Strategic use of the photo, whether by the press or through subsequent appropriation by political advocates, is possible only because of the social knowledge being communicated.

As we hope to show, this dimension of the iconic photo can quickly exceed strategic maneuver. Iconic photographs influence public opinion because, like all photojournalistic images, they are storehouses of the classifications, economies, wisdom, and gestural artistry that make up social interaction. Icons draw on this knowledge to create a web of social connections that lead to and from the historical event and provide multiple paths for both identification and criticism. Moreover, because they are distinctively public images, they recast social knowledge with regard to the distinctive concerns and roles of public life. Ultimately, we shall argue that this fusion of social

knowledge and public identity in the widely circulated visual image nurtures the "stranger sociability," to use Michael Warner's term, that is a key form of liberal-democratic civil society.[22]

Communicating social knowledge establishes a context within which specific vectors of influence can develop. One such vector is the negotiation of collective memory. Although most photojournalism, like most journalism, is highly oriented toward the present, the iconic photographs assume special significance in respect to the past. Iconic images rise above many other images and the vast background of print journalism to shape understanding of specific events and periods, both at the time of their original publication and subsequently. They clearly provide direct confirmation of verbal news reports, but this news value accounts for very little of their appeal. No one doubted that America was in a depression before they saw the "Migrant Mother," or that the war was over when they saw the "Times Square Kiss" in *Life* the week after VJ day. What the icons do is to document much larger and more powerful social facts—poverty's erosion of the soul, war's repression of happiness—and they present those conditions within the interaction rituals of everyday life. Thus, icons are capable of situating understanding within a particular scene and a specific moral context. The Great Depression becomes the "Migrant Mother," and the "Times Square Kiss" becomes a return to normalcy. Historical events and political decisions become personalized, and personal understanding is always embedded, normative, and capable of determining subsequent action. This capacity for influence increases over time, as the images remain in the public eye while almost all of the other documentation of the period disappears into institutional archives. And the more collective memory is constructed through the visual media, the more likely it is that the iconic photos will be used to mark, frame, and otherwise set the tone for later generations' understanding of public life in the twentieth century.

This use of images for orienting the self within civic life leads directly to another vector of rhetorical effectivity. Here we refer to the icon's articulation of a model for civic life. Icons can define relationships between civic actors. As Louis Kaplan has observed, "in the modern period—the period when both the nation-state and the medium of photography have been instituted and have flourished—photographic images have externalized and realized how we imagine community."[23] Photography, and in particular photojournalism, has done this in great part by showing images of people acting together. In these images, citizens see one another in common circumstances (working, waiting in line, celebrating, demonstrating, shopping) and in the many different locales, subcultures, and preoccupations of a large, pluralistic society.

In short, images in the public media display the public to itself. They also put the state and other institutions on display and valorize some behaviors over others. Thus, the icons offer performative guides for public judgment and action, although not on behalf of a single political idea. The Kent State photograph legitimates dissent expressed through public demonstrations of emotion. The *Challenger* explosion situates the public as spectators looking up to a technocratic elite. Different images offer different models of citizenship. Some models are displayed in the picture—most notably the citizen-soldiers raising the U.S. flag atop Iwo Jima. Others are projections evoked by the picture—as when the "Migrant Mother" positions the audience as providers for basic needs. Some reinscribe conventional forms—as with "John-John" Kennedy saluting the passing caisson of his assassinated father—while others operate by confronting the status quo—as when a teenager dons a Che Guevera T-shirt. All of them will highlight some roles and relationships and therefore make others less vital or intelligible or legitimate. In every case, the iconic image interpolates a form of citizenship that can be imitated. We believe this is a major reason why any particular photo acquires iconic status while others that are more newsworthy or horrific or elegant or original do not.

This capacity to provide performative models for citizenship is underscored by another dimension of influence. The combination of the icon's visual eloquence and its wide circulation provides figural resources for subsequent communicative action. As the image is known for being known, it becomes a technique for visual persuasion. Easily referenced and, due to the proliferation of digital technologies, easily reproduced and altered, the iconic image offers a means to tap into the power of circulation and the rich intertext of iconic allusiveness for rhetorical effect. For example, the Iwo Jima flag raising has been used as a rhetorical device by political advocates, editorial cartoonists, commercial advertisers, and the *New York Times* on topics ranging from POW policies to baseball to fashion to nostalgia. We believe that the combination of being a "small" device—as opposed to video or film—yet having wide recognition provides a relatively democratic resource for persuasion on specific issues. Each of our studies of individual icons provides examples of this underappreciated dimension of public advocacy. As digital technologies continue to drastically reduce the costs of communicating with images, iconic appropriation becomes the leading edge of a public culture that can be shaped by vernacular visual artistry.

Even though iconic images usually are recognized as such immediately, and even if they are capable of doing the heavy lifting required to change public opinion and motivate action on behalf of a public interest, their meaning and effects are likely to be established slowly, shift with changes in context

and use, and be fully evident only in a history of official, commercial, and vernacular appropriations. As the iconic photos operate across these several dimensions of public communication, they may reveal pervasive features of American public life. Our study advances two arguments in this regard: first, iconic photographs demonstrate how photojournalism underwrites democratic polity; second, successive iconic images across the twentieth century reveal a shift within public culture from more democratic to more liberal norms of political identity.

To underwrite polity, a communicative practice will provide something that guarantees the political effectiveness of public actors or institutions: the cultural capital, as it were, that can be drawn on to maintain continuity when specific initiatives or institutions are challenged or falter. We believe that photojournalism provides resources for thought and feeling that are necessary for constituting people as citizens and motivating identification with and participation in specific forms of collective life. Underwriting is something that typically operates in a general manner—providing resources in respect to categorical conditions rather than in respect to individual circumstances—yet ultimately it is not used unless applied in respect to specific events.[24] The photographs found in print media function in both dimensions: providing generic forms of assurance regarding the existence, nature, and legitimacy of the public world and the public media, and also specific validation and infusions of meaning for public action when events are chaotic, dangerous, or disturbing.

This claim runs against the grain of theories of the public sphere and public deliberation, which assume that visual practices necessarily disrupt a society's ability to make sound judgments in the public interest.[25] That view, however, overlooks the role and persistence of visual materials and discourses of spectatorship in the formation and development of democratic societies and of the public sphere itself.[26] Indeed, Danielle Allen has asked whether "democratic citizens" might "have a special need for symbols and the world of fantasy precisely because their real political world does not and cannot give them the autonomy, freedom, and sovereignty it promises."[27] Even though the development of modern public culture did occur primarily through the print media of newspapers, magazines, books, journals, reports, and other forms of documentation, it also has been dependent (especially in the United States) on oral and visual practices rich in symbolism and ranging from public oratory to torchlight parades and Wild West shows. The print media are the source of the leading theory of public culture formation, however, and there is little doubt that they are the primary vehicles for legitimation of any political actor or institution.[28] Yet it is precisely because of the

print media's virtues of disembodied assertion, systematic organization of ideas, and dispassionate tone that other media become necessary, since such virtues often are insufficient to motivate collective action.[29] Photojournalism underwrites liberal-democratic polity by providing resources for thought and feeling that are not registered in the norms of literate rationality that constitute the discourse of political legitimacy in Western societies. Instead of seeing visual practices as threats to practical reasoning or as ornamental devices that may be a necessary concession to holding the attention of a mass audience, we believe they can provide crucial social, emotional, and mnemonic materials for political identity and action.[30]

But what is "political identity," particularly in a liberal-democratic, pluralistic, multicultural society experiencing global expansion? Our second general claim about American public culture grows out of this question. One of the dilemmas at the heart of modern polity is how to negotiate the trade-off between individual autonomy and collective governance, that is, between liberalism and democracy. These separate though linked principles are central to the political system and are grounded in foundational documents, asserting, for example, that the government is instituted to "secure" (not grant) the individual's "unalienable rights" and declaring that "We the people" (collectively) constitute the sole authority for governing.

Democracy and liberalism are political ideas that have become deeply intertwined in the development of Western civil society, and the terms each necessarily cover a range of meanings. They cannot be parsed easily, but each has to be summarized if we are to recognize how the term "liberal-democratic" reflects not only a historical achievement but also a continuing tension within public life today. The democratic ideal is encapsulated by the statement that government should be of, by, and for the people. A democratic government is legitimate only if it is based on periodic and fair elections open to all adult citizens; it is responsible only if it maintains equality before the law and acts on behalf of the general welfare; it is sustainable only if it remains attentive to public opinion and respects minority interests. More generally, "democratic," as in the phrase, "a democratic society," can refer to enactment of egalitarian norms throughout civic life. Thus, social goods such as education, health care, and respect, as well as common obligations such as obeying the laws, voting, and polite behavior, should not be distributed according to social status. More generally yet, "democratic" can refer to a sense of collective solidarity, as when a "democratic revolution" occurs prior to the establishment of representative government, or when one appeals to "the people" as they are defined by fellow feeling that reflects shared sacrifice and collective desire for the common good.

Democracy's complications come largely from two, well-known sources: on the one hand, failure to realize the ideal because of undue influence of elites; on the other hand, distortion through majority rule on behalf of social homogeneity. Liberalism, however, is a more complicated term reflecting major transformations in modern political history. Self-identified liberals range from Milton Friedman to Molly Ivins, and liberalism can include everything from the New Deal to comprehensive deregulation. Today, "neoliberals" are dedicated to dismantling the legacy of the "liberal" welfare state, while the American public consistently registers support for liberal (i.e., relatively progressive) policies while voting against "liberal" (i.e., Democratic Party) politicians. Liberal political theory has been criticized by Marxists, progressives, civic republicans, communitarians, and conservatives, and subject to vigorous debate internally as well. It seems that just about everyone and no one is a liberal, and that whatever is there, there is much not to like.

The reason for this apparent confusion is that liberalism "is the political theory of modernity. Its postulates are the most distinctive features of modern life."[31] These features include fundamental protections for private property and individual liberty, governments that are both strong and self-limiting, and societies that are both free and competitive. The first principle of modern liberalism is that individual autonomy is the supreme good. As John Gray states, liberalism "is individualist, in that it asserts the moral primacy of the individual against any collectivity."[32] This principle holds whether one is a libertarian demanding no regulation of private life or a progressive insisting on full protection of human rights. Our use of "liberal" in this book is centered on this commitment to individual autonomy. That commitment leads in turn to a second principle that society should allow optimal realization of individual liberty. That principle can justify both the pursuit of profit in free markets and the prohibition of prayer in public schools. Where democratic practice would be likely to fuse social and political goods, liberalism would presume that social practices, from economic activity to religion to family life to virtually any form of the individual pursuit of happiness, should be free from political regulation, at least until proven that they destroy the autonomy of others. These commitments to individual liberty and a free civil society often are accompanied by more general presumptions on behalf of rationality, neutrality, and universality. Whether advocating free markets or corporate transparency, the assumption is that the liberal policy is grounded in reason rather than custom or other collective preferences. Thus, social organization is best defined by neutral application of laws and other rules that should be buffered from prejudice, emotional responses, or circumstantial

considerations. Finally, liberal policies, whether market economies or declarations of human rights, apply universally. Their worth comes from their relationship to the moral autonomy of the human person, not from suitability to specific, historically contingent conditions.

In ordinary experience, the tension between liberal and democratic ideals is experienced as a murky gray area of guilt and freedom between self-interest and the common good. This tension comes to a head in the definition of citizenship. Citizenship, encompassing the rights and duties of membership in a political community, often is thought of as a juridical concept having little presence in everyday life. We believe it is a significant though usually latent constituent of identity in any modern society, and one that is essential to the deep structure of the public news media. One sign of its importance is its complexity. Recent study has identified several fault lines within the concept; drawing on fairly consistent accounts of U.S. political history, scholars have identified tensions between liberal and civic republican, liberal and democratic, and egalitarian and inegalitarian principles.[33] As Rogers Smith has documented, this last tension is due to a pervasive tendency for citizenship to be determined in practice by social ascription, that is, by attributions of social membership according to race, gender, class, religion, and other categories. In addition, all versions of citizenship acquire a different inflection in scholarly study depending on whether one is defining citizenship as a managed subjectivity and therefore a form of domination, or as a form of political affiliation and therefore a means for the exercise of democratic sovereignty. This book, although mindful of the ascriptive dimension of citizenship and the ideological constitution of subjectivity, is oriented toward the manner in which *public* identity is created as a potentially vital form of political affiliation. The modern conception of the public, by definition, is a distinct type of social interaction that is not identical with any social ascription. Likewise, although any discourse can be a means of domination, our focus on the relationship between citizenship and photojournalism emphasizes how political agency can be taken up through many diverse acts in the coproduction of political meaning. Our sense of public address is similar to Smith's idea of "multiple traditions," whereby "American political actors have always promoted civic ideologies that blend liberal, democratic republican, and inegalitarian ascriptive elements in various combinations designed to be politically popular."[34] We are interested in photojournalism in part because we believe that public images provide a distinctively effective means for both displaying and negotiating the various combinations making up political identity.

To say this, however, requires that one recast citizenship as more than a

legal property. Indeed it is many things at once, including an institutional framework, a regulative ideal guiding the news media, one discourse among others in the polyglot media environment, and more than one kind of embodied subjectivity. This last register of meaning is particularly important for understanding the role of photojournalism within the print media. Whatever its limitations, the photographic image is unmatched at revealing at a glance what Allen has called the "deep rules" that prescribe interactions in public places.[35] And photographs not only expose but also model social behavior, not least the behaviors that constitute citizenship as an embodied identity. Thus, they provide a civic education, for better or worse. This education displays specific habits of deference or assertiveness, self-interest or altruism, and other dispositions as well. Because photojournalism consists of images of people one does not know personally, it creates its own deep rule of citizenship: the habit of being benignly attentive toward strangers.

Liberal-democratic citizenship is of necessity ambiguously defined, loosely enforced, relatively abstract and, therefore, a questionable basis for collective action. Indeed, in the modern era, which is defined in part by large, heterogeneous states maintained through technologies of mass communication, citizenship might depend on modes of representation that can enact the relationship of the abstract individual to the impersonal state. So it is that public audiences acquire an appetite for models of how to be "good citizens," and the mass media are more than happy to supply them. The typical Fourth of July picture of a child eating an ice cream cone in front of a U.S. flag is just such an image, as is the image of three firefighters looking up at the flag they have raised at ground zero in New York City. If citizenship is to be an actual mode of participation rather than a merely legal construct, then it has to be articulated in a manner that encourages emotional identification with other civic actors.[36] In its journalistic form, the photographic image represents and validates the complex identification vital to an embodied citizenship. Accordingly, an iconic photograph can continue to shape public understanding and action long after the event has passed or the crisis has been resolved pragmatically.

Such images can have a profound relationship with liberal-democratic polity because photography itself is a characteristic art of the modern era. On the one hand, photography has been hailed since its inception as a democratic medium. It was widely accessible (requiring relatively little skill to produce and little money to acquire photos); it was quickly and thereafter an object of popular interest; it was largely devoted to depicting ordinary people and everyday life; and it was used as a means of persuasion by progressive advocates.[37] On the other hand, photography has become natural-

ized as snapshot photography, which consists largely of portraits of those in one's "small circle" of individual associations.[38] Used to adorn the home and individual workspaces, snapshots are a matter of personal reference having no explicit political significance. The snapshot frames, fragments, and reduces reality to the scale of private life. As this way of seeing has become the dominant rhetoric within the advertising that drives economic activity, photography has become the primary medium of the private sphere.

Photojournalism is defined by this intersection of liberal and democratic sensibilities. By its location in the public media and its focus on public events, photojournalism is a premier visual practice for articulating democratic life; because of its conventional (and somewhat unavoidable) focus on individuals in tightly framed scenes on the scale of a family photo album, it reproduces a preoccupation with personal experience and the self-interested pursuit of happiness. The point is not to determine which bias is the deeper one in the medium itself—as if there existed such a thing as the medium itself—but rather to recognize that any particular image can direct public response one way or the other while still drawing on the (composite) natural attitude people have toward photographs in a public medium.

To put it baldly, we believe that photojournalism is an important technology of liberal-democratic citizenship.[39] From this perspective, one can consider how any particular photo equips the viewer to act as a citizen, or expand one's conception of citizenship, or otherwise redefine one's relationship to the political community. And one also can ask whether an image might foreclose on some possibilities for action, restrict civic membership, or otherwise limit identification with others. To take a page from Richard Chalfen's study of snapshot photography, the public is a "camera culture" sustained by the photographic practice of photojournalism.[40] Thus, iconic images are premier examples of how the visual practice is used to communicate public culture, socialize viewers into that culture, and equip them to deal knowledgeably and reflexively with social change while maintaining characteristic habits of interaction. And by looking at a series of images over time, one can ask whether there have been shifts in the tacit dimension of a public culture—whether some activities become more or less assured, and whether some possibilities are more or less available to the imagination. As we examined more than a half century of iconic photographs, paying particular attention to how they address a public audience, we observed a significant shift in political disposition. This shift is not from positive to negative images, or from patriotism to protest, or from consensus to fragmentation, although each of these differences also can be observed. The more fundamental shift is

from liberal democracy to democratic liberalism—from a liberal-*democratic* polity to one that is *liberal*-democratic.

This tension has been a theme of U.S. social commentary since Tocqueville.[41] The relationship has largely been a good one, but today there may be greater cause for concern. As Benjamin Barber has remarked, "Liberal democracy has been one of the sturdiest political systems in the history of the modern West. As the dominant modern form of democracy, it has informed and guided several of the most successful and enduring governments the world has known."[42] The problem is that "[l]iberal democracy has been based on premises about human nature, knowledge, and politics that are genuinely liberal but that are not intrinsically democratic. Its conception of the individual and of individual interest undermines the democratic practices upon which both individuals and their interests depend."[43] In a similar vein, Paul Kahn has observed that "[f]or liberals, the very idea of a liberal community is problematic. . . . The liberal subject is universal; he or she is not defined by membership in a particular community."[44] With liberalism becoming ever more ascendant, in great part because this historical development of democratic societies has occurred in tandem with the growth of consumer capitalism, the possibility increases for additional fracturing between these two tectonic plates of modern political identity.[45]

Although we have more to say about this tension throughout the book, the immediate point is both descriptive and normative: the icons of U.S. public culture increasingly underwrite liberalism more than they do democracy, and we believe this imbalance threatens progressive social and economic policies and ultimately democracy itself. Because the iconic photo has been distinctively shaped by the tension within liberal-democratic polity, and because it may have been one means for managing that tension, it provides a significant measure of a cultural shift that is occurring throughout U.S. society and may be the leading edge of globalization on U.S. terms.

We don't expect to have the last word on any of these general claims, and surely our case is limited by focusing exclusively on a single genre of representation. We do hope to develop a cohesive account of the rhetorical techniques at work in iconic photography, but that is best achieved through attention to the specific features of the individual pictures. We treat each icon as a moment of visual eloquence and, therefore, as a mediation of important questions of public life, questions that acquire a distinctive inflection with each photo. No chapter provides a full account of any of the common features of the genre. Likewise, sometimes we pay more attention to the immediate context of publication and sometimes more to subsequent appropria-

tions of the photos, as each image lends itself to seeing one facet or another of a complex visual practice.

Like any photograph, our arguments in each case will elicit different reactions from different readers. What is most important is that scholars and citizens alike become more engaged, thoughtful, and creative when arguing about the images that are part and parcel of public culture. Surely that will involve moving beyond the limitations of our work, and it may lead to a considered deflation of the status of iconic images. All we ask is that the reader consider our interpretations and the images themselves as attempts to contribute to a culture of art and argument that can sustain and improve a democratic society.

To that end, some readers may want to refer to or question our interpretive method, which we set out in chapter 2. We begin with a definition of the iconic photograph as an artifact of public culture and then identify five dimensions of cultural meaning that coalesce in the iconic image. The significance of these factors can be developed in specific cases by charting the relationship between the aesthetic design of each image and its history of appropriation across official, commercial, and vernacular media for persuasive effect. As various publicists, artists, and advocates draw on key features of the original image, one can see not only the strong patterns of identification within the image but also how public culture is being extended and negotiated through image circulation. The image proves to be aesthetically powerful yet politically elastic, and circulation includes not merely mechanical reproduction but also artistic improvisation and complex forms of viewer response. The significance of our approach can be highlighted by contrast with the iconoclasm characterizing the dominant theoretical frameworks for understanding modern media: public sphere theory and ideology critique. Each theory depends on a deep-seated suspicion of the relationship between imagery and power that, ironically, leads to misrecognition of common resources for political action on behalf of the common good. As we will show, the study of visual culture can be part of a third way to understand and nurture public life.

The subsequent chapters might be imagined as a history of moments. Beacons of collective memory, each iconic photograph was taken in a sliver of a second. This book examines nine moments that cover a span of over sixty-five years of public culture. The images may warrant a continuous narrative, but that is not our emphasis. They are single shots, and it is important to keep in mind that much was never pictured and already has been forgotten. We read them as a slide show that can reveal something about the changes occurring in U.S. society during that time.

Chapter 3 looks at the "Migrant Mother" and the "Times Square Kiss," two icons of the "greatest generation" that endured the Great Depression and won World War II. Now awash in nostalgia for a lost solidarity, the public media inadvertently reveal how the emotional experience of that time (and any time) was one of both acute anxiety and idealized reconstructions. The two icons chart a course from wasteland to romantic renewal, and they sanction the modern state's movement into private life and then its withdrawal on behalf of a new form of normalcy. They reveal how public representation can refract class through gender and align an egalitarian ethos with traditional social roles. These photos' rhetorical power also comes from channeling emotional tensions and social energies through norms of civic decorum. In addition, both photos exemplify the distinctive sense of agency created by the photographic icon: through the use of a rhetorical figure we call the "individuated aggregate," individuals are used to depict collective experience in a manner that fulfills both the need for collective action and the primacy of individual autonomy in a liberal-democratic society.[46]

Chapter 4 focuses on the image of the flag raising on Iwo Jima. Unquestionably the most popular image of World War II, this icon continues to be used both to celebrate the ideal of the citizen-soldier and to fault subsequent generations for their lack of virtue. Although those who venerate it may assume the image is unambiguous, its aesthetic design and subsequent appropriations reveal significant complications. Layered transcriptions of egalitarian, nationalist, and civic republican appeals both reinforce and constrain one another to create a strong but open-ended emotional response. Thus, the icon reveals that positive images of virtue can appeal to a democratic public only by perpetuating the very conditions of difference and change that they are supposed to overcome. As the appropriations make especially clear, the icon's aesthetic excellence can instill public memory with a sense of decline, while the image itself can become a rhetorical vehicle for articulating a range of attitudes from civic piety to cynicism. These characteristics acquire renewed emphasis and additional inflection with the emergence of a new icon: the image of three firefighters raising a flag at ground zero in New York City reprises both the Iwo Jima image and its history of appropriation.

The allusion to Iwo Jima at ground zero is one of many attempts to erase the decisive generational break that shaped the last third of the twentieth century. As the Vietnam War became the war at home, public opinion focused on the relationship between citizenship and dissent. Some commentators claimed that rational debate was no longer possible; we believe it was no longer sufficient to resolve the public controversy. The photo of a girl crying out over the murdered student at Kent State University became a prominent

image not only of student protest but also of the possible breakdown of civic order. Whatever its effect on the continuation of the war, it both raised the stakes and brought powerful emotional undercurrents of public life to the surface. Chapter 5 examines how the photograph provided a new model of political identity in which citizenship is an emotional construct and emotional display is a mode of dissent. By revealing how emotions are constructed through visual images in the public media, the iconic photo demonstrates how photojournalism communicates essential resources for democratic deliberation. Icons may be one means for resolving conflicts that are highly polarized and unlikely to be resolved through ordinary politics, and grief may be an important form of democratic solidarity. This latent public sphere may be especially important in a liberal society where emotional experiences may provide otherwise unnoticed continuity between public and private life.

Chapter 6 gives additional inflection to these changes. The passage from victory culture to Vietnam syndrome is captured at a glance by comparing the Iwo Jima icon with the photograph of a Vietnamese girl running from a "friendly" napalm attack. This image, like the several other icons from the period, exposed the criminal conduct and systematic deception that were the foundations of U.S. prosecution of the war. The photograph also reveals important features of iconic representation, including a capacity for representing moral contradiction and trauma by reproducing repetitive behavior in a single moment of time. Trauma involves fragmentation, and the napalm photo becomes a masterpiece in part because of how it provides aesthetic resources for registering and responding to war's terrible splintering of reality. The photo serves another purpose as well, however, for it advances a liberal sensibility suited to a polity that already has become a loose aggregate of individuals. Thus, in our fragmentary narrative, the napalm photo represents the point at which the balance in the public culture shifts from appeals for democratic solidarity to a discourse of liberal individualism.

The photo discussed in chapter 7 of the lone Chinese man standing before a tank at Tiananmen Square brings the tensions between liberalism and popular democracy to a single point of resolution in a characteristic scene and political scenario for the articulation of a global public culture by the Western media. It also may provide the best demonstration of how aesthetic designs have political consequences. The picture's distant point of view, layout on a grid of universal signs, contrast between the unencumbered individual and the mechanized state, and related features have the same result as other high modernist projects: the photo provides a radical simplification of social life, constructs a homogenous form of citizenship, articulates a disciplined public sphere, and projects a liberal future. The viewer who sympathizes

with the man in the photo is being schooled in "seeing like a state," while a record of a popular democratic revolt becomes a devaluation of democratic publics and globalization is envisioned to be unfolding as a liberal, modernist project. At this point the iconic photograph's influence is demonstrated ironically: because it so thoroughly underwrites liberalism while subordinating emotional display to modernist design, it leaves the public culture with diminished resources for democratic action.

These basic questions about modern civilization acquire additional meaning in chapter 8. Airships adapted from military use and symbols of the transcendental power of modern technology, the midair explosions of the *Hindenburg* and the *Challenger* had similar effects on public consciousness. Only a very, very few people would ever have ridden in either vehicle, yet in each case the images of fiery death captured the profound anxieties wrought by living in a machine age. Thus, the iconic images of disaster became ritual performances mediating the individual's lack of control over the potentially catastrophic technologies necessary for modern life. Each image and their different trajectories through media space also provide distinctive inflections to the aesthetic mediation of these anxieties. Whereas the *Hindenburg* image became a cautionary tale of technological hubris, the *Challenger* icon was used to justify indifference to risk and continued acceptance of modernity's gamble. In a conjunction of impersonal image and mythic narrative, public mourning became organized around a virtual pyre that can sanction continued sacrifice.

A fragmentary history can stop any time, and we might as well stop here for another reason as well: because of the expansion of digital media, photojournalism is experiencing significant changes, and the same may be true for liberal democracy. Photojournalism's vehicle of print journalism continues to decline, current icons already are being remediated across the World Wide Web, and viewers increasingly assume that any image might have been altered or fabricated by anyone with a computer.[47] Our study may be more historical than we would like. As the era of print photojournalism comes to an end, we may find that a particular formulation of liberal democracy is dying along with it, perhaps because of the demise of the public art. Print photojournalism was one way of representing the social world, and liberal democracy was one way of organizing society. Each may have leaned on the other more than had been thought. As a corollary, it may be that the iconic photos are performing a transitional function at this time.[48] They may be provoking or fueling an attitudinal negotiation within Western publics between nostalgia and cynicism, or they may be carrying some of the older resources—including perhaps the tension between democratic and liberal identities—into

the visual archive that will be the infrastructure of collective memory and civic advocacy in the next phase of modern social organization.

Or not. Perhaps they will fade into oblivion—just like that woman in the electric chair, or the bodies scattered on the ground at Gettysburg—and perhaps it will be a good thing, too. We take up these and related questions about photojournalism and public culture in the concluding chapter of this volume. Our own work with the icons has brought us to be more skeptical than we were at first regarding their value for grassroots political consciousness, while the digital revolution presents technologies for more heterogeneous and plastic and widely available constructions of the imagetext. As we hope to demonstrate nonetheless, the iconic photograph still provides an important object for critical reflection on the nature, limitations, and value of visual rhetoric, public culture, and the democratic project.

2

PUBLIC CULTURE, ICONS, AND ICONOCLASTS

Think of a statue in a town square. Whether an officer on a horse or a pioneer looking westward, it probably was erected many generations ago. It certainly is overlooked today, left to pigeons and distracted children on school trips. Yet it was commissioned by a democratic assembly, crafted with artistic skill, and placed in an explicitly public place. It was praised by some and probably faulted by others for its more or less successful embodiment of civic ideals. It served to create an image of the model citizen in order to define a public space and, with that, a democratic polity. It was a work of public art.

Public arts are prominent modes of display and sure to become things not noticed. Statues, parks, posters, graffiti, and other work large and small soon blend into the background of ordinary perception. Each art communicates distinctively, yet all suffer the same fate. Nor is the problem their visual nature, as platform oratory, popular song, and the many forms of public writing from biography to editorial commentary to pulp fiction are caught in the undertow of history. Or so it is in a modern society where market-driven, high-technology, mass media production drives constant change. Yet even as such artworks fade from explicit view, every effort to communicate with the

public creates something beyond itself. Art constitutes culture, and public arts constitute a public culture.

We believe that photojournalism is a public art and that the iconic photograph is a leading artifact of public culture. Some definitions may be in order. By "culture," we refer to the manner in which speech, writing, the arts, architecture, entertainment, fashion, and other forms of representation or performance cohere to structure perception, thought, emotion, and conduct. More to the point, a culture is a distinctively coherent set of social practices. Thus, one can speak of Balinese culture, Midwestern culture, sports culture, and so forth. These fields of articulation are relatively autonomous, internally complex, and typically learned through habituation. Culture can be isolated as a set of symbols, for it always operates through communication, just as it can be tied to a calculus of interests, for it always develops within specific social relations. Each approach alone is too reductive, however, to account well for how culture equips people to do the social, political, and ethical work required to live together.[1]

Our focus on *public* culture isolates those texts, images, discourses, and arts that have developed historically through use of modern communicative media to define the relationship between the citizen and the state. Public culture includes oratory, posters, print journalism, literary and other artistic works, documentary films, and other media as they are used to define audiences as citizens, uphold norms of political representation and institutional transparency, and promote the general welfare.[2] Obviously, our focus on the public character of any medium can appear arbitrary, for at least two reasons. The first is that media in liberal democracies are never purely public but rather reflect the richness of modern societies. Second, definitions of the public may appear to be tautological, for, as Michael Warner has argued, the public exists largely by virtue of being addressed as a public.[3] That said, terms such as "public speech," "public opinion," "public interest," and the like articulate a zone of intelligibility wherein specific forms of discourse, interaction, and responsibility are recognized and capable of becoming authoritative.

Public culture is a virtual reality that begins when one awakens to the radio alarm weather report and continues as one reads the morning newspaper, moves through public spaces, scans billboards and TV screens, talks about public matters, and forms judgments regarding any of the subjects found in those media.[4] This ongoing listening, reading, viewing, and talking with others constitutes subjects as citizens within the places and practices of ordinary life, while the circulation of discourse and the media sustained by that circulation constitute norms for discursive performance and insti-

tutional accountability that provide the constraint on state power theorized as the "public sphere." That abstraction, however, does not adequately represent how public life involves a distinctive form of subjectivity, which in turn is precisely what is constituted through the mix of media conventions, artistic improvisation, and audience response that is known as culture.[5] The manifold media and messages of the public sphere cohere not by virtue of their content alone, which is always shifting, but because of shared properties of design, addressivity, and circulation. We have argued elsewhere that public address depends on aesthetic designs that have political effects.[6] Here we assume that public artistry works intertextually to create a distinctive culture that underwrites political relationships. Photojournalism is a patently artistic form of public address, and the zenith of photojournalistic achievement is the iconic photograph.

But what is an icon? Any definition is restrictive; the issue is why particular restrictions are selected. "Icon" obviously is applied to a wide range of images ranging from smiley buttons to the crucifix, which in turn articulate varied yet overlapping cultures. No theory we know of can account adequately for the generation, circulation, and uses of the full range of visual icons.[7] We are oriented more toward public culture than popular culture, more toward mainstream appeal than subcultural meaning, and more toward the intersection of official and vernacular usage than to one realm at the expense of the other.[8] Our study is focused on a class of photographic images that occur initially in the public news media and then circulate there and more widely to become familiar markers of a distinctively public subjectivity. "Icon" is a familiar term among photojournalists and commentators on the public media.[9] Our use of the term is consistent with theirs. To make that common usage both explicit and more focused, we define photojournalistic icons as those *photographic images appearing in print, electronic, or digital media that are widely recognized and remembered, are understood to be representations of historically significant events, activate strong emotional identification or response, and are reproduced across a range of media, genres, or topics.* A few images meet these criteria. Others meet some but not all of them. The Pulitzer Prize image of James Meredith writhing from shotgun wounds on Highway 51 isn't widely recognized; the publicity shot of Marilyn Monroe's legs bared by an updraft isn't easily associated with any historical event; the image of Douglas MacArthur wading ashore in the Philippines doesn't grab most people; many, many outstanding photographs of significant events simply do not circulate widely.

No definition of a genre can be advanced today without a series of qualifications. We have learned the hard way that when talking appreciatively about

icons, it is very easy for many in the academic audience to conclude we have a naïve understanding of representation. So, for example, we should emphasize that we are not claiming that our definition has universal application. To state the obvious, images are open to a wide range of interpretive responses that in turn reflect prior interpellations of class, race, gender, and other social classifications determining individual subjectivity. Likewise, the study of iconic images makes it very clear that "What they 'mean' . . . is not necessarily fixed or stable over time."[10] The reproductions of iconic images need not reflect a broad consensus or fixed meanings, nor does extent of circulation prove influence. Our analysis of each image is not done to enhance its status, nor do we believe that other images—and other conceptions of polity— should be shelved in deference to the few that have achieved mainstream prominence. In particular, we are not valorizing icons in order to minimize the use of less popular images for dissent or for creating alternative communities.[11] Nor are we assuming that there is no longer need for continuing critique of conventional media practices. Such work is well underway, and we add our two cents' worth where we can, but we are more interested in the specific task of understanding how any iconic image produced and disseminated through photojournalism defines what it means to be a citizen, to live in a modern polity, to possess equal rights, to have collective obligations, and similar determinations of public identity. These would be the icons of liberal-democratic public culture.

VIEWING THE ICON

To develop a more fine-grained understanding of the role of iconic photographs in U.S. public culture, it is necessary to examine specific images according to an interpretive method. The great deal of sophisticated work in cultural studies, semiotics, and other disciplines in the past few decades now stands as a veritable hardware store of critical tools, and we know where that can lead. It is tempting to buy tools you don't need while working with materials that are largely prefabricated. No wonder the results so often look the same. As much as we will rely on previous work, we believe that our ambition of identifying important relationships between iconic images and public culture requires that at times we work across the grain of prevailing themes in social theory and visual studies. As we hope to demonstrate, in order to critically assess public culture on its own terms one cannot be content with analysis in terms of social categories of race, class, gender, or ethnic identity, nor should one rely on standard critiques of the media spectacle and the power of visual technologies to counterfeit reality and fuel illusion.[12] Such

accounts offer both accurate depictions of mechanisms of social control and a persistent misrecognition of public communication.

Our approach tries to work with regard to both the characteristic features and limitations of public culture as these are evident in the artistic genre of the iconic photograph. Most generally, this project follows from earlier work on the conjunction of aesthetic perception and political meaning in persuasive appeals.[13] In order to account for the rhetorical power of the iconic images, we develop five assumptions about their appeal, which we will set out below. These assumptions guide the analysis of each photograph through, first, a close reading of the patterns of visual display and audience identification in the image itself, and then by tracing a history of official, vernacular, and commercial appropriations.[14] By marking the photograph's distinctive forms of appeal and following how they are reproduced, highlighted, altered, or parodied in varied contexts, we can offer one account of their role in public culture.

Our axioms for interpretative analysis can be set out as a single statement: the iconic photograph is an aesthetically familiar form of civic performance coordinating an array of semiotic transcriptions that project an emotional scenario to manage a basic contradiction or recurrent crisis. These five elements of visual rhetoric encompass but are not exactly identical with the social conventions, symbolic mode, internal operations, audience response, and political effect of the image. Any of them may apply to all photojournalism, and they will coalesce in many an image, but they are found in particularly strong association in the icon. As with all eloquence, iconic appeal provides a qualitatively significant concentration of artistic resources that are otherwise much more broadly distributed. Thus, once described, none of these emphases should appear alien to public culture. Each bears some elaboration, and some more than others.

Aesthetic Familiarity

Photojournalism, like any public art, cannot invoke the artistic license of the modern fine arts to be wildly transgressive. Artistic achievement in a public art is defined by rising above ordinary expectations but not to repudiate them. Thus, our first assumption is that iconic photos must be structured by familiar patterns of artistic design. They draw on generic conventions from the middlebrow arts such as landscape or portrait painting, and they do not feature the sharp contrasts, double images, or other techniques of avant-garde photographic art. They also draw on other, similarly limited repertories of design and response: popular iconography (mother and child, a soldier saluting), representational realism (everything to scale, nothing uncanny),

journalistic conventions (balanced composition, a sense of decorum), visual grammars learned from film (establishing shots), advertising (image before text), and so forth.

This artistic conventionality extends beyond the visual dimension of the photographic image. The icons draw on the professional mythology of the news media, not least that journalism is the first draft of history and that photographs get us close to the action. By being placed amidst print journalism, the icons also can work in conjunction with other discourses of polity such as speeches, declarations, official reports, judicial opinions, and editorial commentary. The "Migrant Mother" is meaningful in part because of its tacit relationship to the most quoted line from Franklin D. Roosevelt's first inaugural address, "the only thing we have to fear is fear itself." The *Challenger* explosion became captioned by Ronald Reagan's speech to the nation that evening—a speech that was strong on sentimentality and civil religion. Likewise, the icons reflect the topical orientations and social knowledge taken for granted in political argument. They draw on stock images and ideas of war and peace, poverty and the distribution of wealth, civic duty and personal desire, and other unavoidable concerns of collective life, and they stay within the realm of everyday experience and common sense. You don't have to know a thing about either art or political philosophy to appreciate why a sailor would kiss a nurse. In sum, iconic photographs acquire rhetorical potential by representing events according to the conventions of those visual arts and persuasive practices familiar to a public audience. The iconic image is a moment of visual eloquence, but it never is obtained through artistic experimentation. It is an aesthetic achievement made out of thoroughly conventional materials.

Civic Performance

The familiar, popular designs used in photojournalism, political speech, advertising, and the like are found everywhere. The icon's appeal must include some value added to the conventional forms. To capture the aesthetic engagement that we believe is central to its appeal, we make a second assumption that the iconic photograph functions as a mode of civic performance.[15] As this claim stakes out the most distinctive features of our (rhetorical) perspective on iconic photography, it requires more discussion than the others.

Some devotees of the performative arts will object to our approach. Photographs are static; performances are dynamic. Photographs are infinitely reproducible and portable and mundane; performances are unique events in specific situations having special status. Photographs are known to be copies; performances create a sense of presence. Photographs count on a

naive realism; performances require a heightened awareness of artistry. Although photography can record performances and people do perform for the camera, these exceptions prove the rule, for they are pale substitutes for what actually happens in a theater or concert hall. We believe these arguments are good as far as they go, but that's not very far. They each depend on a false comparison, as photographs capture single events and some performances are reproduced thousands of times. Their basic function is to protect the sanctity of a fine arts experience—and its institutions—which is not at issue when one is discussing photojournalism. If one begins with the problems of understanding how photographs captivate audiences, however, the door swings wide open. Photographs can operate performatively, and performance theory provides a rich vocabulary for their interpretation.

Our sense of photographic performance may not apply to every photographic practice, but it is evident in widespread features of the medium, in strong conventions of photojournalism, and particularly in the iconic photographs, which we see as command performances in the public media.[16] Photography is grounded in phenomenological devices crucial to establishing the performative experience. Framing, for example, whether by the theatrical stage or the rectangular boundaries of any photo, marks the work as a special selection of reality that acquires greater intensity than the flow of experience before and after it. As they are framed, photos become marked as special acts of display. This aesthetic status heightens awareness of the stylistic features of any subject—and especially of the distinctive gesture—while it also carries expectations for "communicative competence" in both the production and reception of the work.[17] These expectations emphasize how the photo is situated and reflexive. The photograph always is of a specific place and time, while it occupies highly programmatic settings in the public media; for example, we typically see flags and fireworks on the Fourth of July, front page and above the fold. These settings allow a second-order, reflexive consciousness that comes from foregrounding social actors, other signifying practices such as gesture and fashion, and at times the communicative role of the photograph itself. Thus, as Barthes remarked, the photograph becomes "a kind of primitive theatre."[18]

The strongest affinity between performance and photography also lays to rest a persistent reservation about the medium. Photography is a mechanical art, twice over: it operates through a mechanism, and its images can be and typically are reproduced many times without loss. Because the photograph is an impersonal record of a prior reality, and because the image becomes more impersonal and more distant through reproduction and dissemination, photography seems condemned to a necessary banality. But it is this absolute de-

pendence on mechanical reproduction that provides photography with its deepest connection to live performance. The linkage is that performance is "restored" or "twice-behaved" behavior.[19] Performance is never for the first time, in several senses: it assumes competencies established through habituation or drill; it typically follows composition and rehearsal; even if unplanned, emergent, or improvisational, it reworks long-established repetitions of various forms of display; it imitates only those activities that already are occurring repeatedly in the society; and it is coproduced or completed by an audience that already is familiar with the conventions or the work.[20] Photography is grounded in all of these conditions, and it provides an additional form of repetition as well, which occurs through the reproduction and dissemination of specific images. All people are social actors, and photography recreates recognizable moments of social performance.

This duplication of social reality also provides photography with an epistemology. As Bert States summarizes, behavior that doesn't have the "unremarkable twice-behavedness in daily life" can't be restored artistically or wouldn't be worth restoring "even if you could find an example of it, because no one would know what it was."[21] This remark points to both the typified character of social interaction and the tradition of phenomenological social theory that has attempted to understand that dimension of social reality.[22] Performance and the knowledge disseminated, examined, or gained through performance occurs only in respect to what has already become commonly apprehensible to a community. The repeatedness of any photograph is itself an iconic representation of the object to be seen within its frame: that object is not a unique conjunction of materials, but a typical, recurring feature of one's environment. Thus, the photograph is capable of providing deep knowledge of social reality, both in its specific manifestations and as it is itself an unending process of repetition.

This display of the recurrent character of social life points to another sense in which photojournalism is performative. It is positioned within literate societies and their verbal media as a performative ritual.[23] Images are always in the same places, whether it is in a newspaper, coffee table book, or public relations advertisement, and they often are showing the things one expects to see there, whether it is a space shuttle launch, mountain vista, or vaguely ethnic workers smiling on the job. The typical next step in our account would be to identify the standard functions of ritual behavior, but there is a slightly different point to be made. Performance in nonliterate societies often attempts to provide some revelation of the sacred.[24] Stated otherwise, it illuminates what is unsayable, whatever is larger and more powerful than what can be contained in a culture's system of representation. By anal-

ogy, we would suggest that photojournalism, when it is operating as a form of ritual performance in a literate society, acquires the capability to reveal or suggest what is unsayable or at least not being said or seen *in print*.

To summarize, like other performances, iconic photographs are aesthetically marked, situated, reflexive examples of "restored behavior" presented to an audience.[25] Through phenomenological devices such as framing, the iconic image highlights the deeply repetitive features of social life, a condition reinforced further by the mechanical reproduction of the photograph itself. As with other modes of civic performance, the iconic photograph doesn't just draw on social knowledge enthymematically but refashions social forms to structure understanding, motivate action, and organize collective memory. These modes of imitation become particularly visible, yet also destabilized, as the photograph acquires a history of subsequent appropriation and commentary.

The civic performance is also an act having political consequences. Any political regime, no matter how arbitrary and brutal, is grounded in society and articulated through culture. The more representative, noncoercive, or sophisticated the regime, the more comprehensive, productive, and reciprocal those relationships will be. In short, the successful polity must be validated by cultural representations that reflect its embodiment of a common life. Likewise, this requirement of repeated performance of the society itself (and not just of the regime) provides continual opportunities for both error and dissent. Professional politicians are well aware of this fact, which is why specific images are continually being used (or avoided) to advance partisan interests. Whether posing next to a scenic vista in the American West or staging a statue toppling in Iraq, the image is composed to persuade. This intentional use is the least of it, however. As with all other social reality, political actors and institutions are legitimated when they appear in social space. The same applies to media audiences. People come to exist and be valued when they are seen by others, and especially when they can see themselves being seen. We see ourselves constantly in social mirrors: the eyes and reactions of others. We check on ourselves in manufactured mirrors, which are instruments of the social gaze. And we look for images of ourselves in the public media, which become the mirror of collective identity. We cannot see our actual, individual selves there—even those who are represented regularly see not themselves but their roles or performances—but we do see ourselves as we are citizens, consumers, imperialists, dissenters, Americans, Canadians, moderns, members of the "family of man" (*sic*), and so forth. Political identity grows out of the social practices of particular peoples in specific places as they become known to themselves in the communicative media that articu-

late a culture. Visual icons are particularly well suited to communicate this social knowledge that is the foundation for political affiliation. The performative embodiment of social codes in the public media provides a community with both models for civic action and a sense of collective agency.

Semiotic Transcriptions

More than one thing is being presented in any performance, however, and there has to be both a sense of coherence if it is to be meaningful and a sense of movement if it is to create aesthetic pleasure and rhetorical power. In addition, to have popular appeal a work must be open to multiple and often inconsistent perspectives. At this point an objection often arises, because single images have only rudimentary equivalents of the verbal syntactical structures that distribute information serially and articulate relationships of sequence, cause, concession, and so forth.[26] The observation, now widespread, is also misleading. Although it operates without a complex verbal syntax, an image will have to contain social coding if it is to have any meaning—at the least, it has to be coded as a photograph rather than an element of the natural world. Furthermore, it always is situated within an intertextual field of discourses and other images. A rich visual image in a public space cannot avoid being multiply coded, and these several codes must cohere in a manner that provides a sense of dynamic, dramatic movement toward some whole that can encompass the parts.

Accordingly, the iconic photo presents a set of "transcriptions." The term comes from Umberto Eco, whose example points both to the larger operation of shifting between visual and verbal semiotics and the specific shifts in meaning that occur as a reader is cued by specific narratives or interpretive terms to different patterns in and extending beyond the composition.[27] We use it to feature the artistic, social, and political codes that are used to provide multiple representations of an event and of each other. Such codes articulate romance, tragedy, gender, class, nationalism, technocracy, and many other forms of collective organization. Each code is available for audience identification, while the iconic image also coordinates them in a manner that provides aesthetic management of the tensions within the frame. Through dense yet instantaneous articulation of the codes defining a historical event, the image can represent complexity and appeal to a large audience.

We believe that iconic images become so because they have strong economies of transcription: that is, such images coordinate "beautifully" a number of different patterns of identification, each of which would suffice to direct audience response, and which together provide a public audience with

sufficient means for contending with potentially unmanageable events. Because the camera records the décor of everyday life, the photographic image becomes capable of directing the attention across a field of cultural norms, artistic genres, political styles, ideographs, social types, interaction rituals, poses, gestures, and other signs as they intersect in any event. The iconic image fuses these codes together as an image of collective experience, such that they then provide resources for interpreting historical processes and defining one's relationship to others.

Emotional Scenarios

Contrary to the conventional understanding of images as dead things, they work by activating vital repertoires of social behavior. One observes social interaction depicted within the frame, those people are put into a social relationship with the viewer, that relationship is embedded in interaction between media source and audience, each of these interactions occur in conjunction with the other images and agents in the media environment, and all this is apprehended through the social awareness of the viewer and the interactions of the breakfast table, coffee shop, classroom, or other settings in which media content is discussed.

This pervasive sociality triggers another dimension of performance that is important enough to stand as our third axiom: iconic photographs provide the viewing public with powerful evocations of emotional experience. Performances traffic in bodies, and they evoke emotional responses precisely because they place the expressive body in a social space. The photograph is such a space, and the iconic image constructs a scenario in which specific emotional responses to an event become a powerful basis for understanding and action. They can do so because they mime the social processes though which emotions are created in the first place.

David Hume observed that we feel more through the public exposure to others' emotions than through an interior circuit of sensations, and contemporary scholarship on the social construction of the emotions provides strong confirmation of this fact.[28] The photograph's focus on bodily expression not only displays emotions but also places the viewer in an affective relationship with the people in the picture. These emotional signs and responses operate reliably and powerfully because they are already presented within the society's conventions of display, as anyone recognizes when viewing theater from another culture. More technically, the image activates available structures of feeling within the audience, keys the emotional dimension of an event, and bonds audience, artistic practice, representational object, and

social context affectively. Thus, photography operates not just as a record of things seen but also as a way of seeing that is attentive to what is aesthetically distinctive, socially characteristic, and emotionally evocative.

Iconic photographs concentrate and direct emotions. They are described as being especially emotional images, and by their public character they channel affective response to animate roles and relationships. The images provide dramatic enactment of specific positionings, postures, and gestures that communicate emotional reactions instantly, and they both display and create interactions that become circuits for emotional exchange. This emotional resonance then can be relayed across media, genres, and topics through the icon's circulation. (Indeed, the full appreciation of iconic affect might lead to a better understanding of how public emotionality is inherently a distributed phenomenon.) The emotions captured in the iconic image acquire additional significance because they become political emotions. Some images activate emotional responses such as civic pride or outrage that are overtly political, while others communicate feelings of pleasure or pain that become complexly political as they are folded into historical tableaus.

Thus, iconic images are civic performances combining semiotic complexity and emotional connection. We believe that this emotionality is a source not only of their appeal but also of their value. Democratic publics need emotional resources that have to be communicated through the public media. That, and not the masses' childish yearning for enchantment, is why the public media include images and why some images are not only moving but eloquent. There is another reason as well. Iconic images are emotional because they are born in conflict or confusion. Thus, we turn to the last and crucial function of the iconic image, which is that it encompasses a basic contradiction or recurrent crisis within the society, a deep problem that will already be coded into the picture.

Contradictions and Crises

Any polity (like any complex system) encompasses foundational contradictions. Rights may be equally distributed but sacrifices are not; free and equal individuals become winners and losers in free markets; private interests often clash with the public interest. Any conflict can become a crisis of legitimacy; more accurately, such crises emerge when events reveal how the political structure inhibits fulfillment of the social contract. There are at least three sources of contradiction that always are present in a political system. First, because political power comes from combining diverse groups or interests, the political coalition always can fracture (say, when the leader dies, when strong subordinate leaders arise, when demands are not met, or

when class conflict surfaces). Second, as Isaiah Berlin has argued convincingly, the normal condition of politics is that some goods are mutually contradictory. So, for example, one cannot optimize both liberty and security at the same time.[29] Third, because representation is always "broken," that is, always incapable of reproducing the social totality, any political discourse or image necessarily fails to meet all needs while it cannot avoid signifying biases, exclusions, and denials.[30] Furthermore, such conflicts are inevitably emotional as they stab us, calling up powerful feelings, and yet they are not easily localized, put in their place, or otherwise controlled precisely because they are structural problems.

These conditions provide the motivational ground for a great deal of mass mediated phenomena, "media events" not least among them. As Daniel Dayan and Elihu Katz have documented, such events include the disruption of social time, the fusing of public and private sensibilities, the heightening of intensity, feelings of solidarity and empathy, and other effects as well. Such effects also apply to the iconic photo, and there is no doubt that they can abet reinscription of dominant social relations. Yet they also can culminate in "that alternative model of social life in which the usual down-to-earth, 'indicative' approach to social reality gives way to a *subjunctive* *and utopian openness to alternative possibilities.*"[31] In addition, through subsequent circulation and appropriation the iconic image also aids continued revisiting and revisioning of the "original" event to negotiate basic questions of legitimacy as they complicate a coherent sense of past, present, and future. Thus, the visual icon becomes an aesthetic resource for performative mediation of conflicts. There is no definitive resolution, however. Because all societies, and particularly democratic societies, are grounded in conflict, there is continual need for performances that can manage conflict. The stage is set for iconic circulation.

NOT SO MECHANICAL REPRODUCTION

Copying, imitating, satirizing, and other forms of appropriation are a crucial sign of iconicity, and more so than we realized at first. Like most viewers of and commentators on iconic images, we initially assumed that there was indeed an aura to the image that in turn was the result of its distinctive beauty or some similar quality of the image itself. That response need not be denied and ought not be ridiculed, but it is also a distorted because partial view shaped more by the history of the visual arts than the conditions of modern image production. This focus on the image has to be matched with equally attentive study of its history of appropriation. The same "mechanical

reproduction" that destroys the aura of the fine art work can at the same time create an aura for lesser images.[32] The cheap reproduction and wide circulation of images characteristic of photography are in fact the conditions of possibility for iconic appeal. Nor are these effects solely due to differences between the technologies of earlier visual arts and the modern media. The widespread appropriation of common images is an important element of democratic public culture.

Linda Zerilli's case study of a nonphotographic icon, the Statue of Liberty, provides a useful account of the deep connection between image appropriation and political identity. Following Hannah Arendt's analysis of the problem of establishing democratic legitimacy, Zerilli argues that symbols such as the statue are necessary sites for both stabilizing and contesting the meaning of American democracy. Developing this argument requires a corresponding appreciation of intersubjective meaning. "Indeed, the question of referential meaning, the 'what' of signification, cannot account for the broadest historical shifts in the statue's meaning."[33] Or, we would add, in the meaning of any icon. Zerilli's study of the statue's composition and history of appropriations offers a nuanced and forceful demonstration of how iconic images are central to the democratic imagination and an example of how the study of visual imagery can be a vehicle for political theory. For our purposes, the key claim is that "American democracy is kept alive by translation, augmentation, refoundings—in a word, by the copy that is not One."[34] As our examples will show, the iconic photograph plays an important role in U.S. public life because it is a copy that is not One. The icon is a widely shared image that also is not only open to varied interpretations but also regularly used as a means for directly engaging, contesting, and celebrating the meaning of U.S. democracy.

Stated otherwise, appropriations are a key feature of iconic circulation precisely because the images are being used to do the work of democratic legitimation. They are used by citizens to negotiate the self-understanding of a democratic society amidst historical change and to work out public opinion and personal attitudes about specific political actors, policies, and practices. So it is that media technologies and political cultures—photojournalism and liberal democracy, for example—can develop in patterns of mutual reinforcement and dependency. That also is why the study of image appropriation can lead to both cheap knockoffs and high-stakes questions of collective identity. Zerilli believes that the sale of many cheap reproductions to ordinary people is testament to the "imbrication of commodity culture and liberal nationalism . . . As Anne McClintock writes, 'a crucial political principle took shape: the idea of democracy as the voyeuristic consumption and com-

modity spectacle.'"[35] Yes, but critique also may reflect a rush to judgment. When looking at the array of Statue of Liberty knockoffs—dozens of which are displayed in the PBS documentary film on the statue—one also should be able to see other qualities.[36] We see vitality, egalitarian accessibility, and what Anne Norton claims is the "peculiar virtue" of liberal democracy: its magnanimity.[37] We also see in the continual variation of the "same" image a comic attitude toward popular invention that lacks a name but is the opposite of pretentiousness.

Thus, the meaning and rhetorical power of the photographic icon is created within two poles: an aura of transcendent representation and repeated refashioning in the vaudeville show of democratic public culture. The histories of the individual icons reveal how this is a productive tension that generates symbolic resources for both social cohesion and political dissent. They also reveal that copying can be far more than an instrument of social conformity, political domination, and cultural mediocrity. The circulation of the iconic images moves them across varied and downright strange contexts, and before audiences who are quite capable of seeing both continuity and incongruity. The varied appropriations demonstrate that common images are used to model normative behavior but also for satiric mimicry to challenge those norms, strategic improvisation to change them, and other forms of artistic invention for purposes both serious and silly.

Whatever the result, it is sure to upset those who have set themselves up as the guardians of propriety. So it is that the critical study of iconic images cannot be content to account for their appeal and the role they play in public culture. Any account of the icon's rhetorical power has to be set against prevailing habits of iconoclasm.

ICONOCLASTS AND PUBLIC CULTURE

It is not easy for the literate observer to inhabit a world of images. A hermeneutics of suspicion runs from Plato to contemporary moralists such as Susan Sontag and Neil Postman, and it includes the comprehensive critique of surveillance in continental thought, the strong emphasis on literacy in public sphere theory, the assumption of social control in ideology critique, and a general inattention in Anglo-American political theory to popular media.[38] Such discourses all exhibit a strong logocentrism, which Barbara Stafford defines as "that cultural bias, convinced of the superiority of writing or propositional language, that devalues sensory, affective, and kinetic forms of communication precisely because they often baffle verbal resolution."[39] Indeed, Stafford believes that "[t]o produce a new world of perspicu-

ous and informed observers (not just literate readers) will . . . require a paradigm shift of Copernican proportions."[40]

That may be, but we also caution that the idea of an epochal shift itself depends on a binary opposition between print and visual cultures that is belied by photojournalism. Although one can easily subordinate the photos themselves to the printed text that dominates the newspaper—and there is no doubt that the print media depend on an ideology of the printed text—the history of journalism suggests a different story. The news media expanded their range of publications and their circulation in tandem with increased incorporation of illustrations and photographs, expanded further by adopting the technologies of radio, film, video, and digital media, and now include thriving businesses in the sale of images via books, posters, tote bags, and similar retail items. In addition, photography and photojournalism have from the start had an explicit, albeit complicated, relationship with both democracy and social reform movements. In short, there is a "reading public" that already has extensive experience "reading" images and texts together.

Few of these readers are social theorists, however. From an academic perspective, it is unlikely that a visual practice could ever be equal or superior to discursive media for enacting public reason or democratic deliberation, or that the constitution of identity through the continual reproduction of conventional images could be emancipatory. Indeed, this skepticism imbues the two most important theoretical perspectives on the relationship between discourse and society: the theory of the public sphere and ideology critique. Nor is it entirely misplaced: the visually dominant media spectacle can be a politics of representation by which the sovereign displays power before the masses who are constituted as subjects rather than as citizens. State accountability, reasoned judgment, and democratic influence are all displaced. Likewise, the belief that a photograph is a clear window on reality is itself an example of the natural attitude of ideology, and photographic images may be the ideal medium for naturalizing a repressive structure of signs. In place of critically reflective public consciousness, millions of banal, anonymous images daily reproduce normative conceptions of gender, race, class, and other restrictive forms of social identity.

This, then, is the theoretical burden of proof: demonstrating how iconic photographs can operate as a legitimate form of public address—that is, one that constitutes viewers as citizens capable of intelligent deliberation and political agency—while also remaining aware of its capacity for refeudalization and ideological control. We believe that proof should turn on the analysis of specific cases, but more should be said here, for we also believe that the study of photojournalism—and of all forms of public address—provides one

means for attending to unfinished business in the study of democratic societies. Public sphere theory and ideology critique have their own problems, not to mention well-known frictions when placed side by side, and some of these difficulties are the result of their shared aversion to visual representation. Some of the unique characteristics of public media, public discourse, public opinion, and public identity will always appear distorted or remain invisible to the iconoclast, while attention to visual practices in the public realm can extend the range of social theory.

Although Jürgen Habermas's account of the rise and fall of an ideal public culture has many critics, few have challenged his assumption that deliberative rationality is subverted by visual display. For Habermas, the verdict is clear: when the public assumed its specific form, "it was the bourgeois reading public . . . rooted in the world of letters," and the subsequent disintegration of that culture was accomplished in part through the rise of the electronic mass media and its displacement of public debate by political spectacles.[41] Yet, even Habermas's theory does not privilege print alone, for it relies on the circulation of arguments between printed media and the oral conversation of coffee shops, salons, and similar gathering places for enacting critical reason. Thus, print culture becomes a play of deliberative "voices," which supply a metaphysics of presence for the disembodied medium and the public sphere alike.[42] This circular remediation is believed to follow a common propositional syntax, but the door has nonetheless been opened to much more as well.

The public sphere is an imaginary community of extended conversations among people who are most of the time actually writing and reading, or broadcasting and listening, or performing and watching, or otherwise using communicative media without conversing in the same place and time. All media need virtual embodiment and interaction if they are to create a sense of shared experience and secure the continued attention of the audience. Why else have the TV anchor read the news? Why was the "death of the author" so traumatic? Each medium has its characteristic techniques of embodiment, and the nature, extent, and quality of public culture may depend as much on circulation through a range of media as on the properties of any one medium. Stated otherwise, the ideal public sphere is deformed by an ideology of print; any purely literate public would be stillborn.

Print has long been supplemented by illustrations, speaking tours, plays, and even newsboys and photographs of newsboys, confirming that "all media are mixed media."[43] This is the reason that "readers" can move back and forth between text to image so seamlessly. A vital public culture will of necessity be constituted by several media, each supplying access, artistic re-

sources, and lines of response not so readily available to the others. This is not a book about television, so we don't have to rehearse the anxieties about that medium displacing print media. We do challenge, however, the presumption that visual media categorically degrade public rationality. We also note that the focus on TV and more recently on digital media has in each case obscured the enormous extent and influence of the more humble practice of photojournalism. U.S. public culture was what it was during the second half of the twentieth century because visual images, as much or more than conversation, were the definitive supplement to print journalism and the most significant means for virtual embodiment of public identity. We believe that photojournalism was a decisive visual practice then and that it continues to be so, and that public culture is the better for it.

This argument is more than a brief for the virtues of pluralism. The key consideration follows from the question of how public identity is constituted. Publics never exist in any one place for the simple reason that they exist only as a virtual reality. As Michael Warner has put the matter, the public is a discursively organized body of strangers constituted solely by the acts of being addressed and paying attention, and nothing else.[44] The public news media, for example, broadcast daily to no one in particular while obsessively measuring audience size and public opinion as the leading measures of responsiveness. Between these acts of broadcasting and signs of attention, the public is constituted. This public is an abstraction that is assumed to have actual political force, which it does acquire if enough people act as if that is so.[45] This public can only acquire self-awareness and historical agency if individual auditors "see themselves" in the collective representations that are the materials of public culture. Visual practices in the public media play an important role at precisely this point. The daily stream of photojournalistic images, while merely supplemental to the task of reporting the news, defines the public through an act of common spectatorship. When the event shown is itself a part of national life, the public seems to see itself, and to see itself in terms of a particular conception of civic identity.

No one basis for identification can dominate, however, or the public devolves into a specific social group that necessarily excludes others and therefore would no longer be a public. As Habermas notes, "The public sphere of civil society stood or fell with the principle of universal access. A public sphere from which specific groups could be excluded was less than merely incomplete; it was not a public sphere at all."[46] Thus, by overlaying Habermas's and Warner's definitions of the public, one can see an unavoidable "kink" in the constitution of public culture. If specific embodiment becomes completely dominant (e.g., the white male property owner), the public ceases to

exist, having been displaced by a specific social group. If the impersonal and rationalized forms and categories of public discourse (e.g., news for citizens) predominate, then the public also ceases to exist, having no motivational basis for uptake and action. Thus, publics need media that can articulate the impersonal categories of public identity through the embodied features of social identity, without each canceling out the other. If the social classification dominates, then "the public" is merely an ideological device on behalf of a social group; if the socially neutral protocols dominate, public reason has no agency for challenging other forms of authority. Concepts such as "citizenship," emotions such as civic pride, acts such as public advocacy, and practices such as critical reflection can only be taken up by others if they also provide some basis for identification, some grounding in the positive content of lived experience.[47] The abstract forms of civic life have to be filled in with vernacular signs of social membership.

To take a specific example, the Iwo Jima icon is celebrated for its egalitarian ethos, yet it also appears to be a picture of white men.[48] The picture could imply that only such men were qualified for citizenship or contributing to the war effort, although that would hardly fit with its use by the government to maintain public support for the war. The rhetorical problem is that affirmation of the principle of equality is necessary for both legitimacy and social cohesion in a democratic society, but that principle has no motivational power without social embodiment, which always will be limited to some and exclude others. This dilemma persists in subsequent appropriations of the image that have substituted women and people of color for the soldiers. Thus, both the legitimacy and the power of the public sphere are at stake in any specific articulation of public address, although some forms of public address may prove better suited than others to negotiate this contradiction in modern representation. One could expect, moreover, that such forms would be perceived as both more likely to provide context than argument, and to be means of distortion and manipulation rather than rational deliberation. So it is with visual images, particularly those in close daily association with the preeminent mode of public representation: the news coverage of print journalism. The widely disseminated visual image provides the public audience with a sense of shared experience that anchors the necessarily impersonal character of public discourse in the motivational ground of social life.

The strategic value of Habermas's grounding of the public in reading is thus apparent, as the positive content of *who* is reading *what* remains tacit. Picture viewing is another form of tacit experience that can be used to connect people: all *seem* to see the same thing, yet the full meaning of the image

remains unarticulated. Most important, visual images also are particularly well suited to constituting the stranger relationality that is endemic to the distinctive norms of public address.[49] The public must include strangers, for it "addresses people who are identified primarily through their participation in discourse and who therefore cannot be known in advance."[50] Basic principles of the Habermasian public sphere—public use of reason, the bracketing of status, topical openness, and in-principle inclusiveness—have a fundamental orientation toward interaction with strangers. One need not follow any of these norms to interact with, persuade, be persuaded, and otherwise live amiably among those one knows; families, for example, typically require these norms to be checked at the door. If photojournalistic images can maintain a vital relationship among strangers, they will provide an essential resource for constituting a mass media audience as a public.

The images of photojournalism are at once essentially impersonal texts circulating among strangers and a performative embodiment of the social content essential for attentive uptake of public discourse. The individuals in the picture are always strangers—even if identifiable as individuals, they are there not as members of one's small circle of association but rather as social actors enacting categories of social performance. Some images acquire unusually high degrees of public response amidst continued circulation. These striking images succeed not from any unconventionality in their content or composition but rather from an exceptional ability to constitute and negotiate public consciousness. By filling in the impersonal form of that consciousness with corresponding signs of social experience, they provide an affective anchor for political ideas. Through their circulation, they provide a basis for the reproduction of and critical reflection on public culture. Through their aesthetic appeal and plasticity, they provide the public audience with an emotionally complex, performative mediation of basic contradictions. By examining iconic photographs as a genre of public address, one can reassess the role of visual practices in the public media and discern specific problems, anxieties, and attitudes that define public culture in particular historical moments.

This is not to deny the extent to which visual practices are subject to ideological control. There are two levels of identity formation that need to be distinguished, however, for they reflect distinctive concerns. First, any conception of a public culture is dependent on a specific intersection of class structure and communication technologies. The prevailing conception of the public circumscribing our project is that of the bourgeois public sphere created in the print media. Because of this alignment of class and medium, challenging the hegemony of print journalism can complicate middle-

class norms of propriety that in turn affect conceptions of citizenship. For the most part, however, the critique of the public sphere has not seriously troubled its reinscription of class.[51] Our position on this question is ambivalent: on the one hand, we find the (bourgeois) public to be one of the great achievements of modernity; on the other hand, the norms of print culture are increasingly inadequate criteria for managing the dynamic, pluralistic practices that characterize the contemporary media environment and democratic participation in the twenty-first century.

For the most part, the battles that have been fought about the concept of the public have been pitched at another level. Taking our cue from Rogers Smith, we can call this the level of ascriptive identity.[52] Any public discourse will be constrained by actual asymmetries of power operative in any historical period (patriarchy not least among them).[53] If there is to be a vital and progressive public culture, even according to the most narrowly drawn Enlightenment ideals, it will have to include awareness of how its ideals are always partially contradicted by actual practices of articulation. This second dimension of ideological articulation has been the target of all of the liberation movements defining the past half century of political conflict in liberal democracies, movements that are challenging and expanding conceptions of citizenship, social justice, and political community. In every case, what initially was seen as a threat to public reason proved to be an argument for a better society. What has not been recognized adequately is that the problem cannot be purged from public address, for it lodges precisely in the kink between public and social identification. Publics by their nature require joint articulations of impersonal forms of identity (or they are not publics) and embodied forms of sociality (or they will not be effective).[54] They must foster social identification without localizing social identity. This is precisely where the opportunity for ideological manipulation arises. Audiences can always become habituated to specific representations and thereby manipulated on behalf of specific interests as they otherwise are trying to interact as publics. Likewise, by becoming articulated through the public media, the ideological formation acquires a range of influence and legitimacy that would be more costly or more contested were it to be done through private channels.

The ambiguous potentiality of photojournalism is particularly evident with those images that become iconic. On the one hand, these images are moments of visual eloquence that acquire exceptional importance within public life. They are believed to provide definitive representations of political crises and motivate public action on behalf of democratic values. On the other hand, they are created and kept in circulation by media elites, they are used in conjunction with the grand narratives of official history, they repro-

duce traditional social roles, and they present all this as the transparent depiction of reality.[55] What may seem to be a standoff is in fact a dynamic process; as a result, we believe that timing may be a crucial and often overlooked factor. If, over a specific period of time in which crucial decisions are at issue, photojournalism provides images that bring the pertinent social knowledge, collective memory, emotional range, civic models, and other resources for democratic action to bear on the political establishment, then the visual practice will be functioning primarily as a public art. If the images are not providing the public audience what it needs in a given time on a given topic, then it is likely that the images are primarily operating to reproduce structures of selective advantage. Stated otherwise, every iconic image is transversed by ideological patterns, but in some photos they act like the vehicle of a metaphor, that is, as a relatively neutral means for carrying other tacit resources needed for the system's successful operation as a democracy. In other cases the ascriptive patterning will be dominant, suppressing precisely those resources needed for authentic democratic participation.

We are not concluding merely that the individual always has a degree of freedom within a social structure. Icons do operate ideologically, and our work is in part a study of the ideology of liberalism. It is important to recognize, however, that no theoretical reduction of the image to an ideological code can be presumed to "speak truth to power." There are at least two reasons for this claim. The first follows from Michel Foucault's demonstration of how truth is an effect of power: as a result, the theoretical reduction itself is a violent remaking of the image on behalf of a discursive regime.[56] This is not to say that truth is not important in public affairs or in journalism—it is vitally important to both—or that images cannot be truthful. It is to say that some accounts of visual culture produce social theory at the expense of what the images are actually doing. Ideology critique often operates through paired reductions that erase the distinctively visual properties of the image. Thus, one reads from image to text to sign system, and from instantiation to ideological code to social structure. As Victor Burgin states, at "the very moment of their being perceived, objects are *placed* within an intelligible system of relationships. . . . They take their position, that is to say, within an *ideology*."[57] Photography, it seems, is no exception. "Photographs are *texts* inscribed in terms of what we may call 'photographic discourse.'"[58] Any documentary capability must defer to the system of signs structuring comprehension.[59] By the time one is through, the image's nature as indexical report, material artifact, experiential object, aesthetic design, or rhetorical act disappears. There is a corresponding constriction of any capacity in image or audience for variable meaning or political negotiation. All recal-

citrance to the structural explanation has been removed or shunted into a dialectic of hegemony and resistance. Needless to say, this pattern of explanation can be self-validating, not least because it overlooks those features of the visual practice that might work aslant the structures of domination. Ironically, these reductions also miss other, less recognized, and thoroughly structural elements of visual meaning such as the society's "distribution of the sensible."[60] For our purposes, the more immediate problem is explicating how photojournalism creates a public culture that lies somewhere between hegemony and resistance, and doing so in respect to the distinctive features of each image.

There also is the larger problem identified by Peter Sloterdijk that modernity has entered into a terminal phase of "enlightened self-consciousness" whereby all forms of power have been unmasked with no change in behavior.[61] Irony is too widely dispersed throughout modern consciousness, subjectivity too fragmented, the administration of power too cynical, and critique too disposed to reification for unmasking to be other than a reproduction of the world it would change. So it is, for example, that scholars such as Hanno Hardt can conclude that "mass communication continues to represent the economic and political authority of the dominant order, from where it creates the realities of self and society and dispenses its myths for the masses as prescribed by the routines of the spectacle."[62] We should not be surprised, and we are not surprised or particularly worried when reading such an indictment, as it is neutralized at the moment of reception. Nor is the audience the problem, as the response is shaped by the thoroughly conventional text, not least the iconophobia that is carried by "spectacle." That reference to visual enchantment is the final blow of the hammer. Hardt is striking only air, however, as his readers already are accustomed to living responsibly within the world being exposed. There is no need to choose between truth and spectacle or between "the masses" and those who order a latte. A better approach might be to consider how a critical language can reproduce the system it would change and, second, that the stronger case for change might come from becoming more engaged with those visual practices that do appeal to one's fellow citizens.

We are trying to identify how public images operate as intermediate forms of symbolic action between the level of individual choice and structural determination. The image appears in the public media, acquires iconic status, and influences collective action and memory because it can mediate the social, political, and cultural contradictions in which a particular people find themselves to a degree that allows them to address common problems. This mediation is always contingent, provisional, and incomplete, and it al-

ways comes at a cost—usually the cost of reproducing other inequities and deferring other problems. To look back and only see the costs is not simply one-sided, it is to overlook a mediating process by which the society functions and changes. As Warner advises, the critic must not miss "the tension inherent in the form" of public address, which "goes well beyond any strategy of domination."[63] The significant entailment is that the ideological implications of specific texts or images are necessary but not sufficient for understanding how public address fulfills the interrelated functions of constructing public identity and motivating political behavior.

Iconic photographs provide the public audience with "equipment for living" as a public.[64] They provide important resources for political action that do not fit neatly within either the idealized norms of public reason or the mechanisms of political domination. So it is that one needs the "multileveled analysis" that is "always demanded of public texts."[65] Critical study must grant the iconoclasts their due, but there is much more to be done. We hope to show how iconic images contribute to the coproduction of political meaning that occurs throughout a modern, liberal-democratic society. More to the point, by looking carefully at the leading photographs in U.S. public life, perhaps the reader can see what potential liberal democracy has for nurturing social justice and the common good.

3

THE BORDERS OF THE GENRE

Had you been strolling through Best Buy in the summer of 2001, you might have seen a display of Samsonite Worldproof camera bags. Behind one of the racks for the bags there was a grainy reproduction of a gaunt woman holding one child while two others clutch her as they turn away from the camera. Later known as the "Migrant Mother," she stares wearily, anxiously into the grim poverty of America's Great Depression. Behind the second rack another image depicted a brash sailor clutching a graceful nurse in a passionate embrace as they celebrate VJ Day. Dubbed the "Times Square Kiss," the image captures the joyful return of a world where uniforms, rationing, and dying will all fall away.

The display announced that the bags were "Dedicated to the World's Photojournalists." And for good reason:

> To the photojournalist, life is a series of split seconds. The path of history changes in the flash of an expression, an assassin's bullet, a goal scored in overtime. Once captured, the most powerful of these images become icons that define an era and add immeasurable meaning to our lives. We honor photojour-

nalists worldwide and their perseverance in the face of arrest, imprisonment, and even death.

One might question whether scoring a goal is the equivalent of an assassination or how history could be redirected by a change of expression, but only if you are on the outside of the culture of popular media and retail consumption. It is the camera that records change of expression; personalities, politics, and sports are standard categories of visual news coverage; and retail decision making is nothing if it is not trafficking in images that can become tokens of personal identification. Nor should it be surprising that the intrepid photojournalists are nowhere to be seen. In an age of mechanical reproduction, artists and audiences alike are articulated primarily as experiential anchors for the images themselves, which acquire a cultural currency largely independent of the circumstances of either their production or their reception. And so it is that the display tells us of the "immeasurable meaning" of these images, a magnitude of response too great to be specified. The retailer is banking on the excessive value, mystery, and desire of commodity fetishism, while offering a world of meaning that remains mute.

Samsonite is there to help, however, and so one might read the text accompanying the photo stationed behind the first of the two bags on display:

Photo by Dorothea Lange. Migrant Mother. 1936. Lange was arguably the greatest photojournalist of the Thirties. Her shots of poverty-stricken migrants came to symbolize the great depression.

Then, the next bag:

Photo by Victor Jorgensen, Kissing Strangers, 1945. Jorgensen covered the War as part of Edward Steichen's elite corps. His shot in Times Square during the celebration of Japan's surrender came to symbolize the nation's embrace of peacetime.

Great pictures, no doubt about it, but not from events that in any way threatened the photographers with "arrest, imprisonment, and even death." And who is Victor Jorgensen? Wasn't the famous photograph of the "Times Square Kiss" taken by Alfred Eisenstaedt? It was, but that photo is owned by Time-Life and available only for a hefty fee. The shot by Navy photographer Jorgensen was taken from a different angle at the same time, and since then it has lived a shadow existence as the public domain stand-in for the image made famous by *Life* magazine. This sleight of hand is emblematic of the paradoxical nature of the visual icon: what is assumed to be a single, transparent image is in fact something closer to an afterimage. There usually are

multiple versions of the "original" involving small alterations in angle or distance, and there always are variant crops and differences in the size of the reproductions, which also are shown both in black and white and in color and given multiple captions in diverse media. Yet, despite a thousand variations introduced through the reproduction and circulation of these images, they remain fixed as if they were a single moment of visual truth, so much so that all the circumstances of their production and initial presentation become merely items for captioning, unstable and ultimately dispensable.

The iconic images are the dominant signs in this example, capable of both generating the accompanying narrative and canceling its contradictions and distortions. They are chosen for reproduction because they are iconic, and their placement there continues the process of circulation through which they acquire their distinctive status. Nor is the captioning entirely specious: the descriptions are on target regarding both the definition of the genre and the meaning of the specific images. Much remains to be said, however, and one can start by asking why these two images might be paired together. Poverty is one thing and jubilant celebration another. A woman burdened with responsibility and want might be the consequence of two strangers coupling during a wild party, but she is not the obvious companion to such a scene. Although one typically would purchase only one camera bag—perhaps even to carry a camera—it seems odd that anyone would choose that grim portrait of want unless it is already evocative of a larger understanding of the iconic image. The consumer is purchasing a camera bag and an image and something more: perhaps a collective memory of, say, an "American Century," perhaps also personal association with the power of documentary photography.

The somewhat incidental pairing of the two iconic images on the retailer's rack is richly evocative in a way that goes beyond the ironies noted above: by examining these two images in conjunction with one another, one can identify the borders of the genre. If the Samsonite ad seems a cheapening of the images, it is only because they meet high standards of formal composition. In each photo (figs. 1 and 6 below) one can observe classical symmetries, sharp contrasts of light and shadow, and powerful vectors of compression or expansion—witness the tension in the lines of the mother's face and the vibrant movement up the street into the space and light of Times Square. In each we also see the evocation of powerful symbolic forms: Madonna and Child in the stable, as well as the deep humanism of Renaissance portraiture; the romantic swoon ritualized in classical ballet, ballroom dancing, and Hollywood film, as well as the exciting social turbulence and semiotic excess of the carnival. These artistic allusions work in concert with the

norms of photojournalism: we see collective events depicted via representative individuals, a carefully controlled disclosure of private relationships within a public medium, social actors offered for view rather than directly confronting the viewer, and no evident artistic manipulation of the image, which then appears as a transparent window on reality. Each photograph also draws on the dominant ideological structures of its time: women are acted upon, rather than acting; relations of class are masked by portraits of individuals; race is effaced as the world worth saving appears to be a white world. The images also provide a visual incarnation of the most powerful tensions of the historical period: the terrible and devastating struggles with poverty and war, the contradictions between capitalism and community and between collective security and individual happiness. The two photographs also seem to complement one another to frame a mythic narrative: despair is transformed into hope; individual vulnerability is replaced by bonding and celebration; natural scarcity and emotional desolation are displaced by soaring spirits that break through public inhibitions. That's not a bad story, nor is it far from a good script for a blockbuster movie.

These two images also trace a national narrative of the odyssey from Great Depression to victory culture and so of the "American Century" in all its glory. Each has become a significant signpost in collective memory—for example, when a huge reproduction of the "Migrant Mother" stands as the only visual image of the depression in a century timeline displayed in the foyer of the Museum of Westward Expansion in St. Louis, Missouri.[1] Each may be capable of activating the narrative as a whole—as when the Eisenstaedt print is the cover image for the *Life* retrospective, *The Way We Were: Decades of the Twentieth Century*.[2] Their power surely comes in part from the extent to which each depicts crucial phases of this story in a single image, and they share other similarities, as we shall see. Yet these common features acquire additional power and inflection from the differences between the two images. The two photographs present negative and positive images of the common people, a feeling of anxiety and one of celebration, an appeal for action and a model for imitation, a resource for dissent and one for affirmation, and other alternatives for invention and inference as well. The triumphal story they now tell together may serve as one of the borders of the genre, one of the constraints that iconic representation has to observe or at least negotiate artfully. The aesthetic alternatives they embody fill out the genre's outline more fully. These alternatives, as well as their varied political functions, are the means by which the iconic image can represent and be used to manage the tensions of liberal-democratic public culture. Consider each photograph in its turn.

"MIGRANT MOTHER"

Dorothea Lange's "Migrant Mother" (fig. 1) was photographed in February 1936 in a pea pickers' camp in Nipomo, California, while on assignment as a photographer for the Resettlement Administration (RA), which soon would become the better-known Farm Security Administration (FSA).[3] As Lange told the story years later, the decision to stop at the pea picker's camp was fortuitous. She was driving home after a month in the field when she happened upon a sign identifying the camp. She tried to ignore the sign and drive on, but after twenty miles she was compelled to return to the camp, "following instinct, not reason."[4] She shot six photographs of the woman and members of her family in a very short period of time, starting at a distance and working her way closer and closer after the fashion of a portrait photographer.[5] Her photos first appeared in the San Francisco News on March 10, 1936, as part of a story demanding relief for the starving pea pickers.[6] The feature was a success: relief was organized, and there is no record of death by starvation. This story of the photo's origin and impact is, of course, a bit too good. Every icon acquires a standard narrative and often others as well. The standard narrative includes a myth of origin, a tale of public uptake or impact, and a quest for the actual people in the picture to provide closure for the larger social drama captured by the image.[7] In this case, the photo's origin is due to serendipity, not routine or craft. There is no mention of Lange's government subsidy nor of the fact that the photo was retouched to remove the woman's thumb in the lower right corner.[8] Most tellingly, it slides over the fact that the iconic photo was not actually shown in the San Francisco News until the day following the original story.[9] The photo acquires significance as Lange becomes a poetic vehicle for the operation of historical forces; by mobilizing public opinion, the photographer provides the impetus to collective action. "The star illustration of moving somebody to do something is 'Migrant Mother.'"[10]

As was the custom among RA/FSA photographers who were trying to adhere to scientific method, her notes record no names but they do feature socioeconomic categories such as "destitute pea pickers" and "mother of seven children."[11] The picture itself needs no such help to draw on the prior decades of documentary photography. Direct exposure of ordinary, anonymous, working-class people engaged in the basic tasks of everyday life amidst degraded circumstances was the template of the social reform photography established by Lewis Hine and others in the early part of the twentieth century.[12] The connection between photographic documentary and collective action was a well-established line of response, available as long as the photog-

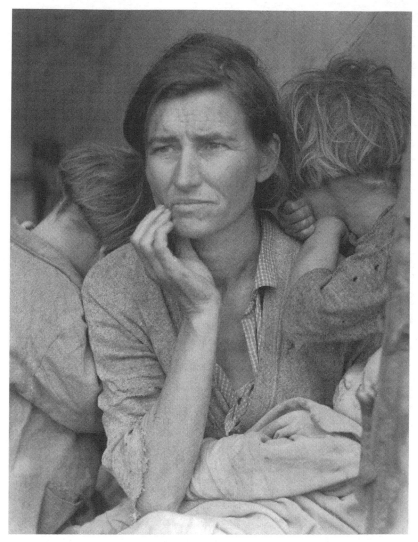

FIGURE 1. "Migrant Mother," 1936 (Dorothea Lange, photographer). Library of Congress FSA/OWI Collection.

rapher did not include the signs of other genres such as the focus on dramatic events of ordinary photojournalism or the obvious manipulation of art photography.[13] Many other photos also met this standard, however, while the "Migrant Mother" quickly achieved critical acclaim as a model of documentary photography, becoming the preeminent photo among the hundreds of thousands of images being produced by RA/FSA photographers and used to pro-

mote New Deal policies.[14] Roy Stryker, the head of the RA/FSA photography section, dubbed Lange's photo the symbol for the whole project: "She has all the suffering of mankind in her but all of the perseverance too. A restraint and a strange courage. You can see anything you want to in her. She is immortal."[15] According to a manager at the Library of Congress, where the image remains one of the most requested items in the photography collection, "It's the most striking image we have; it hits the heart. . . . an American icon."[16]

Taken within the context of the Great Depression, it is not difficult to see how the photograph captures simultaneously a sense of individual worth and class victimage. The close portraiture creates a moment of personal anxiety as this specific woman, without name, silently harbors her fears for her children, while the dirty, ragged clothes and bleak setting signify the hard work and limited prospects of the laboring classes. The disposition of her body— and above all, the involuntary gesture of her right arm reaching up to touch her chin—communicates related tensions. We see both physical strength and palpable worry: a hand capable of productive labor and an absent-minded motion that implies the futility of any action in such impoverished circumstances. The remainder of the composition communicates both a reflexive defensiveness, as the bodies of the two standing children are turned inward and away from the photographer (as if from an impending blow), and a sense of inescapable vulnerability, for her body and head are tilted slightly forward to allow each of the three children the comfort they need, her shirt is unbuttoned, and the sleeping baby is in a partially exposed position.

These features of the photograph are cues for emotional responses that the composition manages with great economy. At its most obvious, "Migrant Mother" communicates the pervasive and paralyzing fear that was widely acknowledged to be a defining characteristic of the depression and experienced by many Americans irrespective of income. Thus, the photograph embodies a limit condition for democracy identified by Franklin Delano Roosevelt in his first inaugural address: "[T]he only thing we have to fear is fear itself—nameless, unreasoning, unjustified terror."[17] Roosevelt could not embody that emotion without bringing the country down with him, but perhaps this correspondence accounts in part for each being the most memorable text and image from the era. The shift from his oratory to her visual image has other consequences as well. Embodiment provides a dual function emotionally: it both represents and localizes feelings that can literally know no bounds. By depicting what was known to be a generalized anxiety within the specific form of a woman's body, that emotion is both made real and constrained by conventional attributions of gender.

Of course, the "Migrant Mother" is also overwhelmingly a photograph

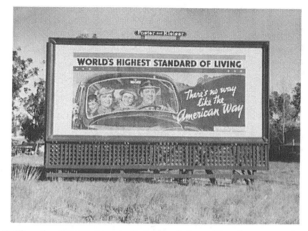

FIGURE 2. "Billboard on U.S. Highway 99 in California," 1937 (Dorothea Lange, photographer). Library of Congress FSA/OWI Collection.

about class, and one that evokes not just sympathy but compassion, an impulse to help that crosses social boundaries. The powerful depiction of class difference becomes most obvious when the photograph is contrasted with other visual images that dotted the symbolic environment at the time, such as the National Association of Manufacturers (NAM) ad campaign. One especially prominent billboard in the NAM campaign featured the image of a middle-class family—including a smiling mom, self-assured dad, and rosy-cheeked cherubs in their Sunday-best clothing—out for a leisurely drive in the family car. The visual image is framed between two captions announcing "World's Highest Standard of Living" and "There's No Way Like the American Way" (fig. 2).[18] NAM was not known for enthusiastic support of the New Deal, and it is clear that visual images figured prominently in the competition for public opinion. The more memorable images would have to be more than straightforward depictions of one condition or another, however, and more than just idealized or realistic.

Class difference is a touchy subject in American political culture, and its presence is often carefully veiled.[19] In "Migrant Mother" class is framed and subordinated in its allusion to religious imagery and its articulation of gender and family relations. The religious allusion may seem obvious, for the photograph follows the template of the Madonna and Child that has been reproduced thousands of times in Western painting, Roman Catholic artifacts for both church and home, and folk art.[20] The primary relationship within the composition is between the mother and the serene baby lying beside her exposed breast, while the other children double as the cherubs or other

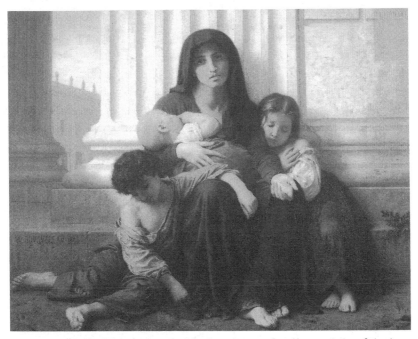

FIGURE 3. William Adolphe Bougeureau, *Charity*, 1865. Reproduced by permission of Birmingham Museum and Art Gallery.

heavenly figures that typically surround the Madonna.[21] The center-margin relationship establishes the mother as the featured symbol in the composition, while the surrounding figures fill out its theme.[22] Their poses, with eyes averted, give the scene its deep Christian pathos. Their dirty clothes are evocative of the stable in Bethlehem, while their averted eyes make it clear that all is not right in this scene. Instead of heavenly majesty, the transcription from sacred to secular art features vulnerability.

Rather than merely another instance of reproduction, it is more accurate to see the Lange image as a transitional moment in public art. The "Migrant Mother" provides two parallel transcriptions of the Madonna and Child: the image moves from painting to photography, and the Mother of Christ becomes an anonymous woman of the working class. These shifts demonstrate how iconic appeal can be carried over from religious art to increasingly secular, bourgeois representation, and from fine arts institutions to public media. Indeed, there is another, intermediate predecessor that, as far as we know, has not been noted before: William Adolphe Bougeureau's painting, *Charity* (1865; fig. 3).[23] The painting recasts the portrait of the Madonna and Child as a poor woman with a baby and two other ragged children; her face

appears tired and anxious, she is staring blankly into the distance, and the children are asleep or looking away from the viewer. We do not know whether Lange was aware of Bougeureau's portrait, which had been long consigned to oblivion by the modernist artists and writers that she admired. The comparison does remind one that iconic photographs can exemplify what had been characteristic of the Salon painters, the combination of technical realism and moral sentimentality.

As Wendy Kozol has documented, the use of impoverished women with children to represent poverty had been established as a convention of reformist photography by the 1930s.[24] Lange's photograph evokes this "iconography of liberal reform" by the association of the children with their mother in a world of want while leaving the male provider, who had been "rendered ineffectual by the Depression," out of the picture.[25] The analogy with the image of the Madonna strengthens the call to the absent father, whose obligation to care for this woman and her children assumes Biblical proportions (and the structure of patriarchal responsibility and control). The photograph follows the conventional lines of gender by associating paralyzing fear with feminine passivity and keeping maternal concern separate from economic resources. The mother gathers her children to her, protecting them with her body, yet she is unable to provide for their needs. She cannot act, but she (and her children) provide the most important call for action. More to the point, the question posed by the photo is, Who will be the father? The actual father is neither present nor mentioned. The captioning never says something like, "A migrant mother awaits the return of her husband." As with the Madonna, a substitution has occurred. Another provider is called to step into the husband's place.

Any iconic photo structures relationships between those in the picture and the public audience; indeed, that rhetorical relationship is the most important appeal in the composition and the primary reason that the images can function as templates for public life. In the case of the "Migrant Mother," the photograph interpellates the viewer in the position of the absent father. The viewer, though out of the picture, has the capacity for action identified with the paternal role. This position outside the image also doubles as a place of public identity, for the viewer is always being defined as part of a public audience by the photograph's placement in the public media, while the public itself never can be seen directly. Thus, the public is cast in the traditional role of family provider, while the viewer becomes capable of potentially great power as part of a collective response. The mother's dread and distress call forth the patriarchal duty to provide the food, shelter, and work that is needed to sustain the family, while the scale of the response can far exceed individual action. In fact, the picture already has rendered individual action secondary

to an organized collective response (a response such as Roosevelt had called for to combat the terror "which paralyzes needed efforts to convert retreat into advance"). Ironically, the "Migrant Mother" creates the greatest sense of deprivation in respect to one thing that the woman had: a husband who could provide for her. Yet by becoming the definitive representation of the Great Depression, the era is defined visually as Roosevelt proclaimed: a psychological condition and a failure of state action rather than a "failure of substance."[26]

One measure of the shift of responsibility from individual to collective action is that the woman's husband is rarely if ever identified, and he remains a cipher throughout later narratives about the photograph and the woman and children in the frame.[27] This marginal identity is marked in a poem dedicated to the photograph: "During bitter years, when fear and anger broke / Men without work or property to shadows."[28] The shadow father continues the Biblical allegory as well: just as Joseph is not the real father in the Christ myth, so the migrant mother's husband is displaced by the higher power of the public (and its agency of the state). And like Joseph, he is kept offstage, mentioned only to fulfill the same role of providing social legitimacy for the woman and her children. By keeping the literal father offstage, actual economic relations are also subordinated to a dispensation of grace from a higher source of power that either has or acquires transcendental status. And just as identification with the religious icon makes the viewer an agent for continuing God's work in the world, so does the secular icon make the public response of the viewer an impetus to state action.

By representing a common fear that transcends class and gender and by defining the viewer as one who can marshal collective resources to combat fear localized by class, gender, and family relations, "Migrant Mother" allows one to acknowledge paralyzing fear at the same time that it activates an impulse to do something about it. This formal design reveals an implicit movement from the aestheticization of poverty to a rhetorical engagement with the audience, from a compelling portrait to compelling action by the audience on behalf of the subject depicted. For those who initially encountered this photograph in the 1930s, the "Migrant Mother" captured a profound, generalized sense of vulnerability while simultaneously providing a localized means for breaking its spell. With the passage of time and for subsequent generations, the relationship between vulnerability and the need to act has been reversed somewhat, providing a localized sense of fear (by situating the subject of the photograph within a specific time, place, and class), and a generalized sense of action (by casting the viewing public, in whatever incarnation it might appear, in the position of acting on behalf of those in such circumstances). In short, the photograph compresses into a single

image a rationale for the social welfare state. This rationale is not programmatic, of course, but emotional: the photograph works primarily to activate and manage feelings of both vulnerability and obligation that are endemic to our liberal-democratic culture.

The iconic power of Lange's "Migrant Mother" is manifest in its continual and frequent reproduction since the 1930s as a symbolic representation of America's communal faith in its capacity to confront and overcome despair and devastation. It is a visual commonplace that retains the aura of its original even as it is reproduced and divorced from its immediate cause and adapted to different circumstances.[29] More than just a representation of our past, it collapses past and present to create a structure of feeling. As Michael Denning notes, "its power lies largely in its iconic, non-narrative stasis, its sense of presence and being. The title seems an oxymoron, as if migrant and mother were contradictory; indeed, there is little sense of migration or movement in the photograph."[30] A fundamental property of still photography reinforces the idea that the image represents a condition rather than a moment in an unfolding story. The corresponding idea that completes the image dramatically is that any response to and change in that condition must come from outside the frame. Any subsequent narrative should be a story of how the condition was alleviated, not just for that woman, but for all those mired in poverty.

John Szarkowski once remarked that "one could do very interesting research about all of the ways that the Migrant Mother has been used; all of the ways that it has been doctored, painted over, made to look Spanish and Russian; and all the things it has been used to prove."[31] The photo's legacy seems to have several, closely related articulations. The most obvious is its role as dominant image in collective memory of the Great Depression. This role is largely institutional: it is the issue of the school books, museum displays, postage stamps, didactic Web pages, and other media for organizing a national narrative for a popular audience.[32] That story is buttressed by the second-order account of the photograph's iconic status, as when the Art in America curricular package for teachers says "*Migrant Mother*, a portrayal of a homeless working family, is an *ICON of the Great Depression*."[33] Steady circulation of the photo and a recounting of its origin, nobility, effect, and stature not only keeps the image before the public but also maintains a structure of democratic representation. The relationships between the people in need, the people as a public, and the people as a state are mediated by the public practice of photojournalism, which in turn assists as it records the course of the nation through the vicissitudes of history.

Whether it is due more to the continued circulation of the photo or the

implicit promise it offers about the political function of photojournalism, the icon seems to have become a template for images of want. In the 1970s, the image was appropriated by a Black Panther artist who rendered the photograph as a drawing that racialized the mother and her children, making them African American. The drawing emphasized race, an issue typically repressed in U.S. collective memory of the Great Depression, but the caption drew attention to the relationship between race and economic oppression, a problem that remained for African Americans after the initial successes of the civil rights movement began to fade into the background: "Poverty is a crime and our people are the victims."[34] The drawing thus conjured the structure of feeling that underscored the original photograph's characterization of unwarranted victimage, albeit with regard to a different audience.[35] This variation on the image extends across a range of ethnic groups and topics, as is evident from a Google search for "Migrant Mother." The search turns up not only the original photo but also images of poor women with children who are struggling with poverty, addiction, and forced migration. The mothers range from Hispanic to Asian, sometimes their children are nursing (on the left breast, as the child in the iconic photo had done earlier) and sometimes they are just being held (as in the icon). The template also may be at work in a *Time* cover that places a woman carrying her child at the front of a migration of civilians during the war in Kosovo.[36] The relationship between an icon and a stock image may be hard to pin down, but as the captioning suggests, the lineage is there. It also may be reinforced by the circulation of a lesser known image taken during the same year (1936) of a nursing mother looking upward anxiously amidst a crowd in Estremadura, Spain.[37] The single image of the iconic photograph both draws on older visual patterns and produces a logic of substitution and reinforcement, yet without losing its charismatic power.

In the late 1970s and early 1980s the photograph was featured once again in a way that underscored its ideological significance, this time as a point of articulation between American liberal democracy and late capitalism. In 1978 the unnamed women in the photograph was identified in an Associated Press (AP) story published initially in the *Los Angeles Times* and then syndicated across the nation. She was Florence Thompson, a "75 year old Modesto woman."[38] The story, entitled "'Can't Get a Penny': Famed Photo's Subject Feels She's Exploited," featured the original photograph, the cover of Roy Stryker's edited volume *In This Proud Land: America 1935–1943*, and a picture of the now aging Thompson sitting in her trailer home adorned in glasses and what appears to be a polyester leisure suit. The story is not subtle in its contrast between the unnamed woman in the photograph and Thompson herself. The woman in the photograph is contemplative, apparently concerned

about her children and family; Thompson is bitter, angry, alienated not so much by her past as a migrant worker but by the commodification of her image that completely divorced the woman in the photograph from the living Thompson. As she states in the story: "I didn't get anything out of it. I wish she hadn't taken my picture. . . . She didn't ask my name. She said she wouldn't sell the pictures. She said she'd send me a copy. She never did." Admitting some pride in being the subject of a famous photograph, she concluded, "But what good's it doing me?"[39]

Here, of course, we see what happens when the living, named subject of the photograph speaks back in a way that undermines the structure of feeling that the photograph has conventionally evoked. In the original photograph the viewer is invited to identify with and act upon the victimage and despair of an anonymous migrant mother as a duty of family and community. Had Florence Thompson later expressed gratitude or marveled at how far the country had progressed or even hoped aloud that no one should have to go through such want and worry again, her voice would have echoed the photograph's alignment of generalized sympathy and state action to alleviate the symptoms rather than the causes of inequity. When she speaks back and demands compensation, the aura of the original—or at least the presumed authenticity of the original structure of feeling—is destroyed, and underneath is revealed a harsh (and corrupting) world of alienated labor and commercial exploitation. The expectation created by the iconic image is that one should feel concern and commitment, a willingness to help those worthy of public support; instead, the AP article portrays greed and ingratitude.[40]

This article is particularly troubling because it cuts in two directions. On the one hand, it questions the motives of Lange and those who subsequently have profited financially and otherwise from the photograph. On the other hand, it indicts Thompson, also characterized in the article as a "full-blooded Cherokee Indian," who fails to understand her place in "America's" collective memory, and who is made to appear willing to trade it all in for a few pieces of silver. In either case, the self-interested pursuit of gain at others' expense contradicts the iconic bonding of individual need and collective action within an ethos of democratic community. If this exposé were to stick to the photograph it would make it difficult to preserve the significance of the image in U.S. public culture.[41] The closing line of the article is poignantly ironic in this regard. Contrary to Thompson's effort to exercise her property right to stop publication of the photo, "lawyers advised her it was not possible." It is not so much a question of what is possible, however, but rather of what is appropriate. Once framed by the iconic image of the "Migrant Mother," Florence Thompson's liberalism is unseemly.

The story, however, does not end here. Five years later Thompson, now a victim of cancer, suffered a stroke that rendered her speechless. Once again the "Migrant Mother" appeared. This time, however, Thompson could not say the wrong thing, and she returned to her original subject position as a voiceless victim of a "paralyzing fear" with which all could identify. Her grown children, now voiced, explained that their mother lived on Social Security and that she had no medical insurance; she was a victim of circumstances. They thus pleaded for funds to help cover her medical costs. Over a period of several weeks she received $30,000 in contributions.[42] Florence Thompson died shortly thereafter, but not before experiencing the impact of her own disembodied iconicity on U.S. public culture.

The story continues to circulate but not as the full story. It has been neatly edited to feature only the shift from poverty then to prosperity now, a change illustrated by a picture of mom with her three daughters from the photo, who now are beaming, healthy adults (fig. 4).[43] "Florence and her family came

FIGURE 4. Florence Thompson and her daughters, Modesto, CA, 1979 (Bill Ganzel, photographer), http://ganzelgroup.com. Reproduced by permission of Bill Ganzel.

through the Depression and worked their way into the middle class," we are told. What more does one need to know? Dad is still absent—not in the picture, and never mentioned—and perhaps that erasure schools the viewer not to ask too many questions. Yet despite the journey to Happyville, the second photo still contains a haunting echo of the original. Thompson does not look happy. Indeed, she looks beaten, with downcast eyes and a sagging body that is tilting sideways as if she might fall. More tellingly, her hands again speak volumes. The right hand is, after all those years, still touching her cheek in a gesture of self-consciousness or anxiety. The left hand, which in the original had been removed in the darkroom, now is holding on to her daughter's arm as if for emotional support. Whereas her daughters look directly at the viewer with snapshot smiles, Thompson still is being offered for view.[44] She remains passive, dependent on others for help, intimately tied to her family but an object rather than agent of public opinion. The narrative explains away this possible dissonance by saying that she felt more at home in the trailer than in the suburban tract house her children had provided her. Still a migrant, Thompson remains trapped in her past, unable to participate fully in the new culture of consumption. Her daughters have no such handicaps, however, and in any case the contradiction between individual self-assertion and collective identity has been artfully erased. Although Thompson and each of her three daughters in the picture now are named, she can never achieve full individuality, while their individual lives stand as narrative fulfillment of and substitute for the political program that undergirded their lives and came to be symbolized by her image.

The photo's circulation as an icon also generates additional uses. As with any icon, it has been altered for comic effect, although less so than some.[45] Frankly, there is little to exploit in that regard, and perhaps it is significant that the most widely available instances treat gender ironically.[46] Some might conclude that use of the photograph in the 1996 Clinton campaign film "A Place Called America" was close to parody. The film's organizational scheme is that of paging through a family photo album. The "Migrant Mother" appears and goes quickly by, as if one is looking at a shot of distant relatives or another family from the neighborhood. Too strong a connection would have made little sense during the roaring 1990s, but the almost subliminal presence at once situated the Clinton presidency within the tradition (and accomplishments) of the New Deal, while it constituted a visual (and perhaps only a visual) commitment to the continuation of the Democratic party's program of social welfare. It is worth noting also that the image appeared amidst shots of military action. What otherwise would be an incongruous

association provides a leveling of the hierarchy of national service. If anti-poverty programs are as important as the army, then perhaps there was less reason to fault Clinton for his lack of a military record.[47]

And the beat goes on. For a particularly weird example of how the icon of poverty can be used to promote prosperity, we note the January 1997 advertisement for an Arts and Entertainment Network show, "California and the Dream Seekers." As a blonde woman drives a 1950s red convertible down Rodeo Drive, we see amidst the palm trees three sepia-tinged photos: one of a few guys using old movie cameras, one of a gold prospector and his mule, and the "Migrant Mother." Perhaps she is just there to provide gender balance, but the brush with irony seems not to have bothered the ad writers. The accompanying text claims that "here [in California] they could escape their past and invent a new life," and apparently we are to assume that the migrant mother made it, just as did the gold diggers before her, as did the early Hollywood cinema, which now provides the overwhelming validation of the story being told. It's a good thing to chase dreams, at least if you do so in California.[48] (This use of the photograph reminds us of the remark that the film *Gandhi* was a hit in Hollywood because its subject embodied their deepest commitments: he was thin and tan.) Marked by sepia tones as events thoroughly interned in the past—there are apparently no starving pea pickers today—the good life now is the individual pursuit of happiness, a life lived without collective obligations toward others.

Despite these examples of how the iconic image can be simultaneously relied on and diminished in use, the "Migrant Mother" still can be used for powerful statements on behalf of democracy's promise of social and economic justice. The January 3, 2005, cover of the *Nation* is a case in point (fig. 5).[49] The feature story is titled "Down and Out in Discount America." The mother's dress has been colorized blue and the woman is wearing a Wal-Mart jacket to which a nametag has been added. The designer's description of his work reveals a clear sense of political artistry:

> I think the inspiration is obvious: Wal-Mart is, in many ways, just a new Dust-bowl for the workers in it, as it inspires a steady downward spiral of both shoppers and workers. Socially regressive institutions and circumstances still abound; it's just that this one has better parking.
>
> Using the well-known Depression-era symbol of people (and women especially) going as far down as they can go seemed like an [sic] simple way to say that. Putting her in a Wal-Mart jacket shows the reason why it's happening.
>
> And everyone who sees it gets it right away.[50]

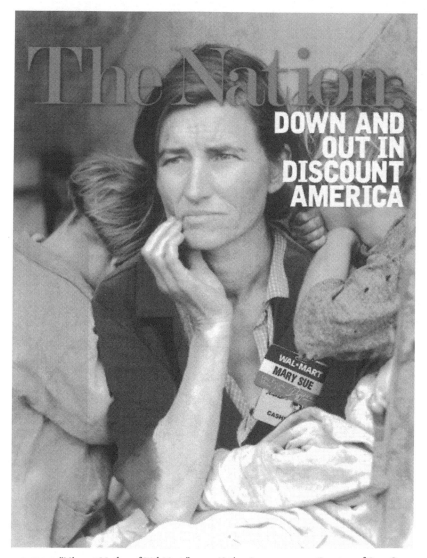

FIGURE 5. "Migrant Mother of Wal-Mart," cover, *Nation*, January 3, 2005. Courtesy of Gene Case and Stephen Kling, designers, Avenging Angels, New York.

The "Migrant Mother" is a single, vivid image, and also a complex representation that draws together the reformist tradition of documentary photography, the pictorial conventions of religious iconography, and the interpellation of the public audience in the place of an absent father. Subsequent appropriations reflect varied structural and strategic interests, while

they work with and reinforce the defining features of the composition.[51] The image provides a powerful pattern of definition that then can be transposed to other times, social locales, and issues. It articulates a familiar yet complex structure of representation, emotional response, and collective action. It provides a stock resource for both advocacy on behalf of the dispossessed and affirmation of the society capable of meeting those needs. Thus, it outlines a set of conventions for public appeal that can in turn go through successive transpositions, yet it does so without cost to the aura of the original.

The icon's power comes no more from its plasticity than it does from having a fixed meaning. Instead, the iconic photograph outlines a set of civic relationships in respect to fundamental tensions within liberal-democratic society. This is a society that has to honor both the common good and the individual pursuit of happiness, both the public representation of social reality and the mystification of economic relationships, both sacred images of the common people and a process of commodification. The "Migrant Mother" is only our first and perhaps least complicated example, but identifying the photograph's several transcriptions and its range of appropriations already begins to trace the borders of the genre. That outline becomes clearer when we turn to the next image in our visual archive of collective memory.

"TIMES SQUARE KISS"

Alfred Eisenstaedt's "Times Square Kiss" (fig. 6) would appear to tell a different story from that of the "Migrant Mother," and so it does in part. Eisenstaedt, often dubbed the "father of photojournalism," had been one of the original four photographers hired by *Life* magazine at its inception in 1936.[52] In August 1945 he was on assignment for *Life* in Manhattan, and when the victory over Japan was finally announced on August 14th, Eisenstaedt took to the streets to record the festivities later described in an article dubbed "Victory Celebrations":

> It was as if joy had been rationed and saved up for the three years, eight months and seven days since Sunday, Dec. 7, 1941. The tensions of war exploded into an orgy of frenzy and fun. Clock-around celebrations in the cities went on to a cacophony of church chimes, air-raid sirens, honking horns, blaring bands, singing, shrieking and shouting. Telephone books were torn into confetti and streets were strewn with tons of paper. Servicemen kissed and were kissed, ripped shreds from their uniforms and gave them out as souvenirs. For the most part it was all good natured letting off steam. But in San Francisco, teeming with sailors on shore leave, the steam exploded. Store windows on Market

Street were smashed and display goods looted. By the end of the third day of the blowout, authorities had to order sailors back to their bases and warn civilians off the streets.[53]

Accompanying this article were fourteen photographs titled "The Men of War Kiss From Coast to Coast." The only full-page photograph, and the one that was to become an icon for the end of the war and the return to normalcy—and, as we shall see, much more—is the one now known as the "Times Square Kiss."

As with the "Migrant Mother," it is not difficult to see why Eisenstaedt's picture would be an attractive repository for collective memory. The two kissers depicted in the photograph are shot in middle distance. Class is obscured by their uniforms, and gender is placed in the foreground. The act of kissing communicates joyfulness while implying even greater emotional release to come. Spectators are present within the picture bearing witness to the event. The couple is doubly posed: against a tableau of a vital public space and as a passionate moment of romantic coupling. Indeed, they form the point of a V (like the "V-for-Victory") that stretches out beyond them through the spectators (male on his side, female on hers) into the larger crowd.[54] They are the focal point of the photograph, which channels the powerful energies of the collective celebration into the emotional intensities of the two bodies embracing. This synesthesia of public and private life is reflected further in their placement and gestures: the distance of the couple from the camera and the focus on their bodies rather than their faces (which are almost completely turned from the camera to each other) makes them relatively impersonal. Likewise, despite their obvious passion they each stop short of intimacy: he is kissing her intensely and she is bent far over in his powerful grasp, arching up to him willingly while appearing to return the kiss, yet he is awkwardly holding back his left hand, which could be holding her head or breast, and she keeps her left arm well back, although she could have grabbed his head, back, or butt. They enact, without any explicit sense of irony, both the sexuality that is a primary obsession of private life and the decorum that is the necessary discipline of public life.

This last point bears special comment. Of the fourteen photographs contained in the "Victory Celebrations" layout, at least six clearly display men and women kissing in public. The remaining photographs depict mob scenes of one sort or another that teeter between "good natured letting off steam" and uncontrolled violence. That tension is teased out in the narrative that frames the layout:

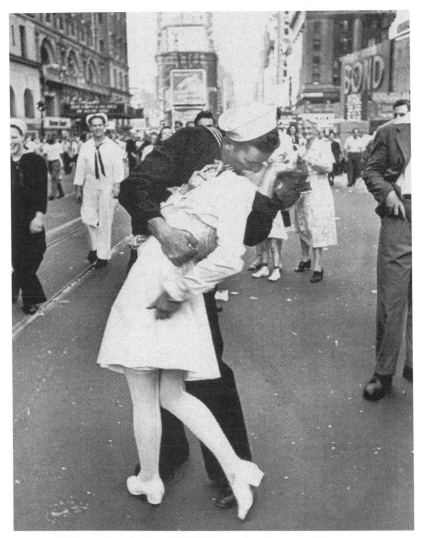

FIGURE 6. "Times Square Kiss," 1945 (Alfred Eisenstaedt, photographer). Getty Images.

News photographers had long trained servicemen to assume ardent poses for the camera but there was little posing in last week's coast-to-coast frenzy of kissing. From city block to city block the purpose was the same, but the techniques varied. They ran the osculating gamut from mob-assault upon a single man or woman, to indiscriminate chain-kissing. Some servicemen just made it a practice to buss everyone in skirts that happened along, regardless of age, looks or inclination.[55]

Although one might question the claim that there was no posing going on, the narrative of natural, unrestrained sexuality was clearly coordinated with the earlier narrative of uncontrolled violence and was visually manifest in the total layout of photographs.

With the sole exception of the "Times Square Kiss," all of the other "kissing" pictures depict more lascivious or transgressive acts, and in doing so they place the tenuous balance between liberty and order at risk. In one photograph the woman's legs are spread, ready to wrap themselves around a sailor's waist, his right hand groping the back of her thigh as he pulls her dress up to reveal more than would have been modest in 1945. In another photograph a sailor cradles a woman in his arms. The caption identifies him as a "longing, determined sailor [who] grabs a willing light-o'-love and hoists her into position." In perhaps the most telling of such photographs, a woman is held in the air in a prone position by several soldiers sitting on the top of a jeep. The woman has her back to the man directly beneath her who is reaching around and kissing her. The caption reads: "On Hollywood Boulevard in Los Angeles carousing servicemen neck atop the hood of a careening jeep. The city rocked with joy as impromptu pedestrian parades and motor cavalcades whirled along, hindered only by hurled whiskey bottles, amorous drunks and collisions." What makes this last photograph so important is not just that it contains within its narrative an explicit articulation of unrestrained sexuality and mob violence; in addition, it is literally the suture between the first half of the layout that features the celebrants—the American people—as an undifferentiated mob, characterized in one caption as showing "no respect for history," and the second half of the layout that features the kissers. Only the "Times Square Kiss," the last photograph in the series, resists the narrative and its articulation, depicting a more contained return to social order in a full-page photographic layout.

This tension between liberty and order, as well as between repression and release, becomes more evident when the "Times Square Kiss" is compared to an earlier Eisenstaedt image of a man kissing a woman as he is about to depart for the war. Entitled "Soldier's Farewell," this *Life* cover photo for the April 19, 1943, issue is a study in interdiction (fig. 7). The air must be chilly, as both figures are wearing topcoats, while he also is wearing an officer's hat and scarf as well as holding a raincoat over his arm. As with his uniform, her blouse and hair suggest that they may be somewhat affluent, and they are in any case dressed up for the occasion. And what an occasion: the background consists of a large, impersonal building, along with a single stranger looking on soberly, all in soft focus. The couple's contrasting sharp focus puts them into an intimate space, yet it also accentuates the folds produced by

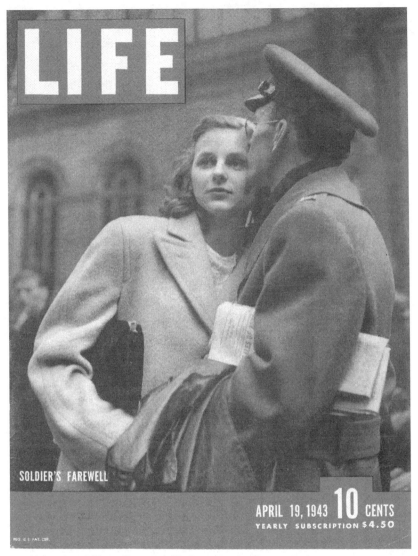

FIGURE 7. Cover, *Life*, April 19, 1943 (Alfred Eisenstaedt, photographer). Getty Images.

the bulkiness of their clothing. That clothing and much else stands between them, as their actions make clear. He is giving her a chaste peck on the side of her forehead, as one might kiss a child. His right arm may be around her waist, but we don't see it. We see the other arm held back, having to support the raincoat while holding a newspaper to his side. The paper's authority in the foreground of the picture matches the building's backdrop: a dominant

regime of impersonal spaces and print media denominate policies, deployments, and obligations that take little regard of the individual soldier, much less those he loves. She matches his stance and his reserve: her right arm clutches her purse to her side, her averted face stares pensively into a distant space that must stand for an unknown future. She leans slightly toward him to offer her head for the kiss she does not return, but both are upright, self-contained, already armored against the likelihood of irreparable loss. His thin wire-rim spectacles, which suggest both paternal reserve and vulnerability, are in no danger of being knocked off here.

Perhaps in the next moment they looked each other in the eye and came together in a rush of desperate passion, but it would be no part of the public record of this typical scene and the social types they represent (soldier and civilian, man and woman, lovers accepting their public duty). During war, Eros is under wraps, and individuals have to contain their emotions as a protection against greater pain later. Together for a last moment, they are already separated, restrained by self-protective mechanisms that may prove futile as the machinery of war pulls them still farther apart. The image captures the pathos of private life during a time of collective obligation. It functioned as both a realistic portrait of the emotional complexity many couples experienced and as a model for conduct of public life generally. There should be little wonder that the end of the war would unleash pent-up passions, or that an image would have to be found that could reverse the war's hierarchy of values.

The "Times Square Kiss" provides that reversal. The sailor and nurse probably come from lower or lower middle-class backgrounds (given their respective rank and occupation), but that is not certain. What is certain is that they participate in the egalitarianism of the war effort, which is represented by their uniforms. And this common bond is the source of the picture's drama. The sailor's exuberance is due to the fact that he has just been released from the probability of one day of being killed or wounded. The nurse has taken to the streets because she, too, wants to live without fear, separation, pain, and death. What is perhaps most significant is that the picture is from the "home front," and that it is a picture of a heterosexual kiss. One would expect the end of the war to be most meaningful to those most likely to die the next day, not to a sailor in New York City (surely one of the best details in the war). One could imagine pictures of relief, of comradely play, or of former enemies joining hands, among others, and many such photographs did appear. But only the "Times Square Kiss" foregrounds the tension between the war effort and the normal practices of everyday life. As a poster sold in bookstores and casual decorating shops captions the image, the couple is "Kiss-

ing the War Goodbye."[56] The war becomes enforced separation of the sexes, uniformed inhibition and repression of the yearnings of private life, subordination of Eros to Thanatos; the end of the war is signified by the release of long-suppressed passions.

This motif has had continued appeal long after the end of the war. A photograph from 1945 of a couple kissing in the street might not seem to have much of a chance in today's libertine popular culture, but nonetheless it snagged first place in a list of the "top 100 of Britain's biggest turn-ons."[57] An illustrated advertisement in *Modern Bride* based on the scene spells it out: "A Hero's Welcome: They Celebrated Victory by Surrendering to Love."[58] A twenty-six-foot-tall statue of the couple is, not surprisingly, even less subtle: the title is "Unconditional Surrender."[59] The tone of these displays is neither joyful nor lascivious, but comic: the iconic image encourages the smile bestowed on young love, which places the viewer in a regenerating world of merely temporary social divisions.[60] Indeed, the smile is modeled for the audience by the spectators in the picture who, unlike the spectators in some of the earlier photographs in the kissing layout, appear to be oblivious to the camera and focused on the drama unfolding before their eyes. In sharing their enjoyment of the scene, we are reassured that the demands of citizenship ultimately lead to individual happiness.

Life magazine maintains that "Times Square Kiss" is one of its three most famous photographs, and it would be hard to dispute that claim.[61] As with the relationship between "Migrant Mother" and the Great Depression, it is virtually impossible to encounter popular cultural renditions of World War II, and most especially the end of the war, without seeing this photograph. It is a staple of textbook treatments of the war at home, and it reappears regularly in newspapers and magazines on the anniversary of VJ Day as a civic performance that helps viewers to relive the moment.[62] Most important, it stands as a visual monument to an expansive collective memory of the war's purpose, which becomes the preservation of not only an abstract freedom threatened by the forces of totalitarianism, but also everyone's right to a "normal" life.

Such is the theme of many of the appropriations of this image. Or rather, by tracing a series of appropriations, we can see how the image maintains both collective memory and an ongoing process of commodifying the past. There are a number of straightforward reproductions of the image that draw on its iconic status as a historical marker. It was chosen as the central image for commemorative stamps issued on the fiftieth anniversary of World War II.[63] The image stands not only for the war but also perhaps for history itself when it is one of the four History Channel "Pictures from the Past" jigsaw puzzles, and the one used at the Web site to advertise the set.[64] A similar ex-

ample is provided by an ad for the History Book of the Month Club, in which the image is placed beside the mailing label and underneath the pitch of "Three books for four dollars." The claim that there is "No obligation to buy more" sits right above the closely cropped couple, perhaps drawing on the image's celebration of individual liberty from obligation, and the idea of giving in to the impulse to indulge oneself. A second ad line—"Get free access to the Oxford English dictionary online"—is placed just below the nurse's arched back, giving a rather direct meaning to free access.[65] A book club's use of visual imagery to sell history will not be without its ironies.

The kiss image can function so well for advertising because it is not only a marker of a historical event but also a model for imitation. So it seemed to JCPenney when they used the image to advertise the Hunt Club line of clothing (fig. 8).[66] As a man and woman embrace in the classic pose, the relation of past to present is marked by the obvious pastiche of the composition, for the couple have been interposed into the original Navy photographer's shot, and they and their Hunt Club outfits are in color while the rest of the picture is in black and white. Other changes also are worth noting: each of them wears a conspicuous wedding ring, and they aren't actually kissing—instead of the full-mouthed clench of the 1945 picture, the couple have their mouths closed with his lips placed above hers. This appropriation draws on the original scene's erotic power, yet it counters with near-complete domestication of the primal image. Sex now is unambiguously clothed in marriage and retail consumption, and social inhibitions apparently are back in style as well. Other elements of the ad remain consistent with the central image in the picture—for example, the earth tones, boxy designs, and functionality of the clothing replicate the working-class egalitarianism of the original uniforms much more than they do the aristocratic aspirations of the Hunt Club label.[67] The clothes themselves, the fusion of desire and decorum in the iconic photograph, and the JCPenney demographic all cohere: the ad banks on an audience that is already well acquainted with managing a tension between desire and economic self-restraint.

The ad also may draw on an implicit nostalgia that is more evident in other uses of the image. A New York Life Insurance Company television ad attempts to tap that emotional aura by recreating the Times Square celebration, now with ticker tape, music, and flags, as something like a New Year's Eve dance.[68] The couple are back in uniform, although with a bit more flair, and they embrace passionately, although in a more balanced stance that might reflect newer ideas of gender equity. The association with the product is left unstated, but its logic seems clear: the couple's (and every young couple's) life course that is prophesized by this image deserves the protec-

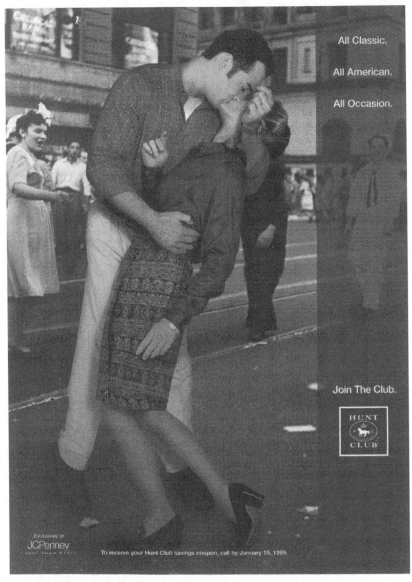

FIGURE 8. JCPenney Hunt Club advertisement, 1998.

tion that life insurance can provide. A private insurance company might also be drawing on the image's implication that the government will now be withdrawing from its prior comprehensive involvement in private life; thus, the celebration also warns against a withdrawal of government provisioning and a return to life in the marketplace. Perhaps it is no coincidence that the

FIGURE 9. "A Sentimental Journey: America in the '40s," Reader's Digest Video.

ad appeared during a period when the future of Social Security was a matter of public debate.

This positioning of the image as the beginning of a collective experience of a privatized social order is evident in its presence on the cover of the Reader's Digest home video "America in the '40s: A Sentimental Journey, 1945–49" (fig. 9). The kiss appears on the left of the cover, the point of origin for two parallel, left-to-right tracks of development. On the top, the couple becomes the all-American middle-class family of dad, mom, buddy, and sis looking at their new suburban tract house. Beneath them but in larger proportions are Bugs Bunny and radio comedian Fred Allen, signifying the new order of popular entertainment accompanying the renewal of private life. The kiss is thus elaborated visually into a new age made out of the two modes of reproduction featured in that iconic image: heterosexual love and the mass media. This fusion of consuming passion with the pleasures of consumption is accented further by Bugs and Allen, representative figures of popular culture who can double as phallic symbols while also keeping the tone clearly light—so light that talk of symbols seems a duller nonsense than the chuckles of popular entertainment and family fun.

The past can only do so much, however, and for the full transformation implicit in this collage one has to look to the Universal Studios store in the renovated Times Square of the twenty-first century. There they are, the couple eternally caught in their embrace in Times Square, although now the sailor is Bugs and the nurse an anonymous doe (fig. 10). At this point, it appears the commodification is complete. The couple stand in the doorway like greeters at a church, albeit greeters who have succumbed to their desires as they model the rapture that apparently is to be found by purchasing the movie paraphernalia inside. They also suture past to present and Times Square's historic status as a public space to its current makeover as virtual monument to the marketplace. Even so, the image has to model desire within a logic of restraint, a tension evident in the two most obvious alterations in the pose (beyond the fact that they are cartoon rabbits): the kiss has become more chaste, but look at his hands, which clearly mean business.

There is another factor as well. As Lauren Berlant and Michael Warner have remarked, "National heterosexuality is the mechanism by which a core national culture can be imagined as a sanitized space of sentimental feeling and immaculate behavior, a space of pure citizenship."[69] The kiss icon exemplifies this mechanism in action: a man kissing a woman in the nation's most famous town square to celebrate military victory is a perfect case of heteronormative citizenship. Many subsequent reproductions of the photo extend that cultural ideal across time and social space. But precisely because

FIGURE 10. Universal Studios Store, Times Square, New York (Robert Clift, photographer). Courtesy of Robert Clift.

the image enacts "national heterosexuality" so directly, it can become an effective means for challenging and changing that ideal and, with that, a basic template of citizenship.

Perhaps the most famous appropriation of the kiss is the *New Yorker* cover illustration of two *men* in uniformed embrace (fig. 11).[70] As before, the particular inflection comes from both reproduction of the iconic template within a different context and from variation on the composition itself. Whereas advertisers shift the scene (and implied action) from civic to commercial activity, here the shift is from one civic issue to another: from war and demobilization to the question of whether gays should be allowed to exercise their civil rights. Those rights would include being allowed to serve openly in the military—one of the most basic dimensions of citizenship—but the cover isn't specifically defined in terms of any question of policy.[71] It seems more likely that the appropriation is so striking because it directly challenges the very idea of citizenship being aligned with and therefore limited by sexual orientation.

This challenge is presented via a strategic masterstroke that simultaneously reproduces the social transgression at the heart of the gay rights debate and normalizes it. By showing what is otherwise unsaid in public debate— that some men in uniform kiss each other passionately—the cover creates

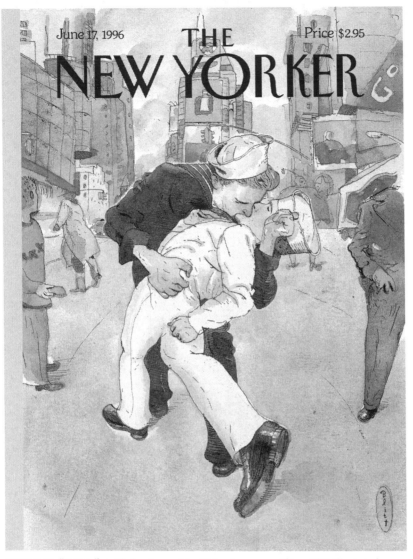

FIGURE 11. "Two Sailors Kissing," cover, *New Yorker,* June 17, 1996 (Barry Blitt, illustrator). Courtesy of *The New Yorker* / Condé Nast Publications.

a sense of scandal, but by showing how supposedly "deviant" behavior fits seamlessly into the public model of heterosexual normality, the image presents multiple challenges to conventional beliefs. The image is at once both strange and familiar, a scandal and what one should expect from sailors given a new lease on life, a breach of decorum and a model of how civic obligation

and the individual pursuit of happiness can cohere seamlessly in an open society.[72] Yet it is not a simple assertion but rather a sophisticated illustration of the tensions in the public debate—not least the tension between eros and heteronormative conventions—and of the complexities of social change.[73] Note the other element of the picture that has been altered: the spectators, instead of looking on and smiling, are averting their faces. The illustration highlights both a significant change in sexual mores and continuing discrepancies in social acceptance. Gay sailors can be model sailors, especially if allowed the same rights to self-expression that are granted to other sailors, but the public audience lags behind. This gap is mediated by the magazine itself and its artful use of the materials of public culture.

The *New Yorker* cover is in turn part of a larger process of imitation that reflects continuing struggle over embodied citizenship, as well as the permeable boundaries of popular culture and private life. The cover itself may be the inspiration of a photograph by Guzman of two gay men kissing: now the one on the left is a soldier while the nurse's uniform has been replaced by a white T-shirt.[74] The image would seem to be posed, but one can't be sure. The kiss photo surely receives visual allusion on the cover of a brochure titled *LGBT Marriage and Family* that features the Statue of Liberty kissing a bent back, blindfolded Justice.[75] Two gendered, nineteenth-century icons of civic republican representation become refitted as symbols of a Queer Nation through the mediation of a twentieth-century iconic photograph.

Other players keep the conventional model of citizenship alive and embodied. These instances often include combinations of vernacular and official activity, as with the stock photographs of sailors kissing their lovers on returning from sea. That kiss is a civic ritual of Navy life celebrating the return from military to civilian space, akin to the shift underway on VJ Day. Sometimes the iconic allusion is made explicit, as when the *Baltimore Sun* remarked about a photograph labeled "Warm Welcome, Norfolk," that "this photograph works on many levels and is reminiscent of Alfred Eisenstaedt's 1940s Times Square homecoming pictures."[76] Any such allusion to the icon is not a form of advocacy but rather a comic counterpart to the background seriousness of war, business, and other social regimes. Reenactment becomes one element of a vernacular rhetoric, an appropriation of cultural forms in the practice of everyday life.[77] It should not be surprising that savvy comics then pick up the theme. The writers of the animated television show *The Simpsons* are the comics most attuned to visual icons, and their appropriation of the "Times Square Kiss" is indicative of their sophistication. The show purports to show private life as it really is, including the manner in which ordinary people step into the forms of popular culture, often with mixed results

at best. Bart's social sophistication is certainly nothing to brag about, but he can play one role with aplomb: at the close of an episode in which he has organized the neighborhood kids to work together to defeat an outsider who had been bullying them, he grabs Lisa for the classic kiss.[78] He is wearing a sailor hat, while the other kids cheer in unison. Once again, collective action culminates in a celebration of romantic coupling. But, of course, Bart is kissing his sister and so merely playacting. (We hope he is playacting. He, too, is walking the line between civility and transgression that is an essential tension within the icon itself and a source of its rhetorical power in subsequent appropriations.) The episode then reveals that someone took a picture of the embrace and posted it on a community bulletin board. Thus, the show foregrounds the use of photography and mass-mediated dissemination that produced the template that was being imitated. As Bart's imitation of a photo becomes a photo to be imitated, the genre of iconic photography emerges out of the intersection of media practices and everyday life, while those two realms each become more caught up in the other.

The relationship between civic imitation and playacting continues to be a feature of this iconic photo. This comic afterglow is one of the characteristics of its subsequent narrative of discovery. One of the central features of the "Times Square Kiss" is that we cannot see the faces of the two kissers and thus lack the ability to identify them as specific individuals. They could be almost anyone who was of their age and stature alive at the time. And that, of course, is part of the picture's special allure, for what is important is not the individuality of the kissers but who and what they can represent. Even so, in August 1980, *Life* published an article in which it identified Edith Shain as the nurse, accompanied by a contemporary photograph of her, once again taken by Eisenstaedt, and announced a call for the "real" sailor to come forward. Over ten sailors identified themselves as the kissing sailor, and two additional women claimed to be the nurse. *Life* has posted many of the replies on its Web site.[79] In almost every instance the would-be kissers focus on some physical feature that allegedly is theirs alone but in each instance is too general to prove anything conclusive: "a 32-inch waist," a hairline that "comes to a point at the temple," "a bulging vein," a slightly misplaced military insignia, "my usual left-handed kissing clutch." What is most interesting about these accounts is their playfulness. There often is a verbal "wink" that signals the potential inadequacy in their evidence, but at the same time acknowledges the fun in playing the game.

This experience of make-believe obviously depends on the picture's ability to evoke emotional memory. One respondent, Jack Russell, noted, "It suddenly hit me that our ship wouldn't be going to Japan and that the whole

terrible thing was ending." He then recalls that "[I] immediately began to manifest a high affect. I started grabbing girls like everyone else was doing and started kissing." James Kearney recalled that although he stood five foot eight inches tall in 1945 (and thus too short to be the sailor in the photograph) he was definitely the sailor in the picture because "that day I felt ten feet tall." When Wallace Fowler admitted to his wife that he was the kisser she pointed out that the kisser seemed to be taller than his own five foot, seven inches. "I perished the thought," reports Fowler, but the "blissful memory lingered," so much so that he finally hit upon an explanation for the apparent discrepancy, "I realized that the angle of the camera could give a taller impression." And so on. It is also important to recognize, however, that these accounts feature not only the emotional connection between the end of the war and the return to normalcy, but also restrained celebration and domesticated remembrance. To our knowledge, no one has come forward to identify themselves as the kissers in any of the other photographs published in *Life* that day. Indeed, it is almost as if the men who did come forward were seeking to perform the photograph all over again, perhaps because it reminds them not only of how they felt but also of how they were supposed to feel.

This perhaps endearing stretch for emotional reenactment became carnivalized when a temporary statue was unveiled in Times Square for the "first annual VJ Day 'Kiss-In'" in August 2004, and then again in 2005 for the sixtieth anniversary of VJ Day.[80] The events were sponsored by the Times Square District Management Association. The statue looked like a large porcelain figurine, aesthetically connecting the event with the "collectables" subculture, while nurse Edith Shain also became a fixture at the site and provided a reenactment of the famous clinch with one of the contenders for the identity of the sailor.[81] For several days the site became a festive scene as thousands of people kissed, cheered, donned sailor caps, mugged for cameras, and otherwise somewhat spontaneously recreated the original mix of private and public celebration (fig. 12).[82] Plenty of photos were taken, a Web site created, and press coverage followed the event, often to display a wide range of lifestyles. This carnivalesque copying of the iconic image may be the perfect blend of nostalgia and irony for a liberal-democratic public, most of whom were born well after the end of World War II.[83]

More important, these festive reenactments may be advancing a progressive redefinition of public culture. In the 1945 image, the public space is defined by traditional, exclusively heterosexual gender roles, with boys on one side and girls on the other, male domination of the acquiescent female, and so forth. The *New Yorker* cover provides a reversal, as the two men kissing represent a homosexual counterpublic that challenges its own exclusion

FIGURE 12. "VJ Day Is Replayed" (Mario Tama, photographer). Getty Images.

while receiving perhaps grudging acceptance or some other combination of tolerance and denial that is mimed by the averted faces of the few others on the street. In the twenty-first-century carnival, however, one sees all the old binaries neutralized by a parody reproduced in the public space. Instead of majority and minority status, one sees equal display and carefree association among straight and gay, young and old, lovers and strangers; even image (the statue) and reality (Edith) are put side by side, showing each to be a copy of the other. The gathering is tied together not by a common cause but rather an "universal" emotion and the stylistic flourishes of wearing sailor hats while striking variations of the iconic pose.

Coverage of the festival also reactivated the narrative about the figures in the picture, in this case the "mystery" of the sailor's identity.[84] It seems that people—and the press—will go to great lengths to supplement the iconic photo with a narrative of the people in the picture. News stories reported that "a team of award winning scientists from the Mitsubishi Electric Research Lab (MERL) in Cambridge, MA, using leading-edge 3-D face scanning technology is helping to solve a 60 year-old mystery." Not many photos become sixty-year-old mysteries, of course, or merit MERL's time, which will not come cheap. "This in combination with expert photographic analysis is providing compelling evidence that points to George Mendonsa, a native of Newport, Rhode Island, as the Kissing Sailor in the famous 1945 *Life* magazine photograph that captured the elation and relief of the nation after four

83

years of loss and sacrifice in WWII."[85] Of course, we also learn that the analysis is not 100 percent reliable.[86] The point of the story is not likely to be a quest for truth. Whatever the technology of reconstruction, the iconic image is being updated for an audience that wants both the original emotion and something else.[87] The icon presents anonymous figures enacting stock characters embodying a democratic structure of feeling, which then in turn is recast within a liberal framework emphasizing individual identity and personalized reactions.

To later generations in a prosperous society, the "Times Square Kiss" might have more emotional resonance than the "Migrant Mother." Sex is more appealing than despair, of course, and depression harder to imagine than war, but the important difference is that the "Times Square Kiss" identifies a moment in our collective memory that has become easier to romanticize as part of America's destiny as "leader of the free world."[88] The Great Depression, by contrast, has always resisted such a romanticizing impulse. The cultural value of most wars is generally open to interpretation, but in U.S. cultural remembrance World War II was a necessity. It came to our shores without invitation, and all we had to do was to curb our individualism, mobilize as a people, fight the good fight, and then return to the world of ordinary, everyday life the way it had been prior to the attack upon Pearl Harbor. The conventional narrative carries a reassuring myth that made it easier to suppress the gnawing pain that attended the loss of those who never returned. For subsequent generations who had no direct contact with the war, however, this story has become a utopian remembrance of a time in the past to which we might return from the present as we seek to deal with the conflicts and disappointments of our more complex social order. And in that context, the photograph is dehistoricized as the difference between the military (collective) and private (individual) lives of the kissers is effaced, collapsed into the simple, happy times of a unified victory culture.[89]

This adaptation of the photograph's emotional appeal is manifest most clearly in an episode of a popular television show broadcast in 1990. *The Wonder Years* was a coming-of-age tale situated between the turbulent period from 1968 to 1974. The series is narrated retrospectively and at some distance from the original events through the eyes of Kevin Arnold, a twelve-year-old about to enter the seventh grade when the series begins. The series was thus quite explicitly about the problem of remembrance, and within that context it privileged an emotionally tinged, nostalgic view of childhood and family. In the third season an episode titled "Daddy's Girl" began with a lengthy full-screen shot of the "Times Square Kiss."[90] In the introductory voice-over,

the adult Kevin Arnold talks about happier times and a simpler way of life where everyone seemed to understand what their place was in the world. The photograph clearly provides the interpretive frame and emotional tone for the episode that will follow.

The story is simple, familiar, and engaging. Kevin's sister Karen, a rebellious and free-spirited hippie, is about to turn seventeen. Her relationship with her father, Jack Arnold, is strained by the fact that his little girl is growing up and about to leave home. More to the point, Karen rejects the moral codes by which Jack has defined his life, including, in her opinion, his unreflective and oppressive commitments to country, capitalism, and bourgeois family values. (Jack served his country as a U.S. Marine during the Korean War, and while he doesn't actively support the Vietnam War he doesn't oppose it either; he is a moderately successful but generally unfulfilled middle manager who does the bidding for corporate America and can only dream of the day when he will not have to punch a clock or dance to someone else's tune; he takes full responsibility as provider for his family and is outraged when his wife considers getting a job.) As is fitting with Karen's unconventional approach to traditional roles and expectations, she announces that she doesn't want a party and she doesn't want any presents. Jack can't accept this request and sets about to find Karen an appropriate birthday present, while her mother plans a modest party "just for the family."

As the episode unfolds Jack takes Kevin and his brother Wayne to a department store to search for presents. Commercial trinkets of one sort or another beckon, but Jack can't find what he is looking for and returns home without a gift, obviously distressed by his inability to give his daughter either what she wants (her freedom) or what he thinks she needs the most (a moral anchor). As the episode moves to a close, the family gathers in their living room for a brief celebration of cake and presents despite Karen's continuing protestations. When it looks as if all of the presents have been given out, Jack hands over a package which contains his Marine "kit bag." He worries that she doesn't like it, but she smiles, remembering a time when she still enjoyed being "Daddy's girl" and announces that she loves it. While exploring the bag she finds Jack's dog tags and asks "these too?" "Those are mine," he says somewhat shyly, as he reaches out to take them back, breaking the spell of identification that, for a slight moment, had brought them together as father and daughter. Not everything can be transferred across genders or generations, but something once lost has been found. As the episode ends, Karen hugs her father, calling him "Daddy" and telling him that she loves him. As she leaves with her friends, Jack wistfully remembers in his mind's eye the

8 mm family home movies of the two of them during a simpler, happier time when she truly was "Daddy's girl," a time when she looked up to him and he could still shelter her from the world into which she was about to venture.[91]

The episode drips with nostalgia, but what makes it important for our purposes are the ways in which its dramatic resolution reverberates with the emotional complexity of the Eisenstaedt photograph shown at the beginning. As we have already observed, the photograph marks out the conceptual boundaries and competing tensions of public and private life, and it enacts a careful balancing act to maintain their equipoise. Passion is not effaced, but restrained within the twin economies of conventional gender relations and military decorum. The sailor is active, the nurse is passive. While he is described in the caption as "uninhibited," he nevertheless carefully observes a modicum of discipline and propriety, as does she. The Woodstock generation, which Karen Arnold represents, called these conventions into question in a way that put the stability of the moral order represented by the "Times Square Kiss" at grave risk. Jack, we must recall, was a veteran of the Korean War, not World War II, and for him a return to the time portrayed in the Eisenstaedt photograph constituted a dehistoricized, romanticized articulation of the relationship between public and private life. And the nexus of that articulation would have been the intersection between the demands of military order and the expectations of conventional gender roles. When Jack finds himself constrained to negotiate his relationship with Karen at the risk of losing her altogether, he invites her to partake of his conventions and moral traditions in a nonthreatening way. He offers her a piece of his life of civic obligation to do with as she chooses, while he releases her to pursue her own, individual happiness. That she accepts it, and in so doing reciprocates by authorizing his conventional role as her "Daddy," suggests the possibility of rapprochement. But it also suggests that the ideology of gender relations within which they are operating functions as a much more powerful rhetoric of control than either of them is capable of admitting. The writers of the episode had no trouble with these conventions, however. The "Times Square Kiss" is hardly a photograph that automatically reaffirms the values of sacrifice and discipline, values that are supreme during wartime but exactly what were being thrown aside that day in Times Square. Once the sexuality of the icon has been neutralized by the incest taboo (as in *The Simpsons*), its corresponding emphasis on social order becomes all the more evident.

If the photograph and the show work well together, there won't be much difference between Jack's successful adaptation to social change and the audience's construction of collective memory. Consider how the changes troubling Jack all resulted from the return to private life promised by the

Eisenstaedt photograph. Demobilization had begun decades of unrivaled economic growth that in turn gave new meaning to life, liberty, and the pursuit of happiness. Ultimately, the baby boom, rising affluence, and social mobility culminated in the carnival of the 1960s. Thus, the TV show functions as the photograph did within its original context: it demonstrates that there can be a precarious yet adequate middle ground between social change and social restraint. Notice that the show not only used the photograph to frame interpretation but also reproduced many of its means of identification: spontaneous yet restrained intimacy between a man and a woman, passionate yearnings for personal happiness tangled up with norms of social responsibility and decorum, personal connectedness reviving amidst social tumult, resumption of traditional gender roles on behalf of liberalization, and a happy ending to an anxious period of conflict. The episode thus renews the photograph's promise: despite all the changes, the (culture) war is over, and there will be a return to the normal preoccupations of private life, where families not only form and grow but also regenerate.

PHOTOJOURNALISTIC ICONS AND LIBERAL DEMOCRACY

In many respects, Dorothea Lange's "Migrant Mother" and Alfred Eisenstaedt's "Times Square Kiss" are very different photographs. Their important differences are easily accentuated when we imagine how we might place the figures from either photograph into the scene of the other. The harsh ironies that result from this experiment reflect the profound relationship of each to the specific national trauma of its time, as well as the fact that each operates as a direct, nonironic appeal for audience engagement with its subject. And yet, for all their differences, each image follows a common and powerful logic of viewer response that characterizes liberal-democratic public culture.

The shared commonalities include several features that are symptomatic of many iconic photographs. These include their formal elegance, strong realism, focus on vernacular practices, foregrounding of powerful emotions, and alignment of historical process, individual agency, and collective purpose. Thus it is that we can see how both "Migrant Mother" and "Times Square Kiss" each concentrate energy in the center of the composition; how they portray grinding poverty as a mother cares for her children and impetuous behavior while walking in the street; how they depict fear and jubilation; and how they lead us to the conclusion that the depression hurt people by preventing them from providing for themselves what should then be provided by the government, and how the end of the war released people from

collective obligations to act on their own behalf to achieve domestic happiness.

We want to suggest one additional distinction that highlights the rhetorical significance of the visual memory these photographs produce. As our analysis has already suggested in a variety of ways, both the "Migrant Mother" and the "Times Square Kiss" provide a model for negotiating the tension between individuality and collectivity. Recall the importance of gesture in each photograph. Note in particular the manner in which the subjects' arms articulated deep tensions between capability and vulnerability and between intimacy and impersonality. In like manner, we believe that the entire composition of each photograph activates the tension between individual worth and collective identity, a tension that is exacerbated during collective crises such as depression and war. The distinctive problem for a liberal-democratic society in such crises is that any political response has to be oriented toward large-scale measures designed to meet needs defined in the aggregate, while still maintaining ideological commitment to the primacy of the individual. The problem of poverty will not be solved by helping only the migrant mother, nor will the solution be likely to gain support if it cannot be assented to by citizens habituated to see themselves as individuals first and last. Stated otherwise, public support for state action on behalf of groups of people often depends on representations of individuated suffering, just as public celebration of state action culminates in representations of individuated benefit, although in every case the public sentiment has to be directed beyond individualism.

Both "Migrant Mother" and "Times Square Kiss" follow this pattern of representation. Indeed, we believe that their staying power across cultural time and space comes precisely from their embodiment of a particular conception of human being that we call the *individuated aggregate*.[92] This is contrary to the tendency of democracies to aggregate individual actions such as votes; instead, the impetus for action comes from acting as if an aggregate were an individual. The problem of poverty may seem intractable, but certainly we can help this woman. The process of demobilization is sure to be frustrating, but there is no doubt this sailor and nurse have the right attitude. They are neither individuals nor abstractions, neither everywoman and everyman nor specific persons with names and stories, neither unique characters nor a literary type. Such photographs leave most of personal life undisclosed, while they are as close as a photographer can get to collective behavior. They are the result of the refraction of common life through the lens of photojournalism: a new construct of human being based on an ideal

equipoise of the tension within our political culture between personal sovereignty and public authority.

The linguistic form of the individuated aggregate is metonymy: a reduction of a more general construct (such as "class") to a specific embodiment (such as an individual migrant worker). Such compositions have to be simultaneously personal and impersonal. They must suggest intensities of private life, but they cannot be so thoroughly personalized that they inhibit generalization. They depend on a thorough-going realism, but they motivate action in response to the general condition being represented rather than to the specific event of the picture. This combination of individual impulse and social abstraction comes through an emotional response. Compassion, anger, joy, and all the rest of our emotions are activated by particulars yet are potentially boundless. Therefore, they provide precisely the means both for personal identification with the specific individual being represented and for assuming a broad field of action on the basis of that identification.

Furthermore, the individual aggregate always implies a specific direction for collective action. The relationship between the viewer and the photograph becomes a model for the relationship between the public and the condition being depicted. In the case of the "Migrant Mother" and the "Times Square Kiss," we can see a forward and backward movement along the same path. The first photograph justifies state action to step in and support people when the organic institutions of the market and the family are failing. The second photograph justifies relaxing or eliminating state regulations such as military drafts, rationing, and other wartime measures. In each case, of course, we see the ideological reproduction of the late-modern capitalist society, but our focus here is less concerned with ideological critique than it is with the means of persuasion. Response to an individual need not involve public assent or political institutions, and response to a social condition might not get public support, but an individuated aggregate evokes the necessary combination of individual sympathy and collective agency.

Thus, the two icons articulate a visual convention for managing powerful tensions between individual liberty and collective obligation. As they continue to be reproduced, these icons provide subsequent generations with a particular structure of feeling that helps to cushion public apprehension of poverty and war, both past and present, while it also provides a template for representing subjects worthy of public support or deference.[93] In a world increasingly dominated by collective enterprises, the continual reproduction of such iconic photographs (and the adherence to their elements of composition and logic of response through the conventions of photojournalism)

maintains the form of individual agency while habituating the public to institutional management of collective behavior. These conventions then become standard means of persuasion; indeed, they illustrate how people must be portrayed to be deemed worthy of redemption from practices of destruction accompanying the social order.

The iconic photograph can be assumed to be the most salient example of common forms of photographic illustration and of print journalism in general. The individuated aggregate is a case in point: photojournalism produces many, many images of representative individuals, and description of an individual's experience is the standard lead-in for any feature news story. The two modes of representation work together seamlessly in this regard: a story on zoning regulations, day care, or any other issue will begin with an account of a named individual's difficulties and will be accompanied by a photo of that person in the relevant environment. Although the appeal of the iconic image certainly grows out of (and reinforces) this convention within the public media, it also exceeds it to create additional rhetorical power. The difference is that the figure of the individuated aggregate fuses individual and collective reference to create a symbol; the iconic representation becomes the event itself.

This transformation is evident from three shifts in representation: from personalized to anonymous individuals, from verbal to visual modality, and from subordination to magnification. The iconic images are anonymous (or, if not, they involve individuals who do not need to be named). This anonymity can have specific implications in respect to the historical setting of the photograph (as we argue in chapter 4 with regard to the flag raising on Iwo Jima), it articulates the stranger identity that is an essential characteristic of public judgment (as we argue in chapter 6 with regard to the image of "Accidental Napalm"), and it always shifts the emphasis from individual experience to social types, characteristic responses, and collective obligations. This shift does double duty because the iconic photograph also reverses the hierarchy of verbal and visual media. Instead of providing an illustration for the verbal report, the image is dominant, and any accompanying verbal text is merely a caption or reduced to the function of captioning. More important, visual immediacy then displaces the discursive organization of the news. In the typical report, the featured individual is obviously an example, and dispensable as such: if his or her situation improved or proved to be otherwise than reported, the report as a whole would still stand because it was about a question of policy pertaining to a class of events. Likewise, the story itself invariably moves from the individual case (and its immediate rhetorical function of grabbing the attention of the reader) to a more systematic

account that is focused on the arrangement of statistical data, expert testimony, and political interpretations, all according to norms of reasoned argument and balanced coverage. (The story may return to the individual case or to similar cases, but for the obviously subordinate purposes of maintaining interest and giving the report an aesthetically coherent conclusion.) With the iconic photograph, however, all that either doesn't happen or is pulled inside the image itself, which then provides a suitably comprehensive account of the event entirely through the visual composition.

The verbal and visual accounts cannot be directly mapped onto each other, however, and one difference is that the iconic image produces a shift in magnitude. Instead of subordinating image to text (and visual hermeneutics to discursive organization), the iconic image looms large. The single figure becomes the event, the era, and a pattern of civic perception and public response. Instead of the long chains of discourse that constitute public debate, the image becomes the means for incorporating public opinion into a civic performance. Poverty, fairness, and government intervention become a poor woman staring anxiously into space. War, mobilization, sacrifice, luck, and a return to normalcy become a couple embracing on a city street. The image displaces much else that happened, while it also communicates essential features of public identity in a "language" that features the expansiveness of strong emotional response.

Thus, the icon can appear to be a popular example of a common convention in contemporary journalism, but one also can see the many conventional instances of photojournalism as a daily echoing of a master trope of liberal-democratic representation that is fully realized only in the iconic image. The individuated aggregate exemplifies the magnitude appropriate to collective identity while maintaining a basis for individualized identification suitable to a liberal-democratic society. So it is that iconic photographs can function both as *aides-mémoire* in collective memory and as a means for filling out and making real our own sense of personal identity. As we experience how it was supposed to feel, we come to live within that structure of feeling. We become individuated aggregates ourselves.

One can always point out that it did not feel that way then, and that feelings today are as varied as the viewers, and that even those caught up in the image do not stay there long, and that both individual self-interest and mass uniformity continue to be powerful forces amplified by the media. Such claims are true enough but explain very little. The real issue in this debate is whether one will accept that iconic images are artificial memories and emotional prostheses, or assert that such technologies harm the individual and the polity. Seemingly transparent reproductions of the real that are in

fact twice buffered by time and idealization, icons do pull the viewer into an imaginary world. But people need imaginary worlds, the best of which are called art. Human beings are not fully equipped to apprehend the world directly: we are incomplete, cognitively and morally deficient, and much in need of technological support.[94] Fortunately, we are capable of creating art, media, and machines to compensate for what is missing. Politics and photojournalism are both arts that can extend an essential but imperfect capacity for connecting with and caring for others. To be able to do so, they have to be capable of being misleading and misused. Thus, skepticism is an important guard against error, but there also is good reason to understand what the skeptic cannot see.

Our iconic memories are intensified depictions of the past and rich resources for living in the present; they help us to withstand the shocks of living amidst the competing tensions of freedom and necessity, self-consciousness and social determination, liberal personality and democratic polity. They provide models for action and assurances that we need not lose what we value most. Ultimately, they function as evidence of things unseen, referring not just to what has past but to what always is outside of our given frame of perception. Whether such images will serve the ends of mystification and idolatry or movement towards a better life they cannot themselves represent, remains to be seen.

4

PERFORMING CIVIC IDENTITY

FLAG RAISINGS AT IWO JIMA AND GROUND ZERO

The photograph was taken by AP photographer Joe Rosenthal on February 23, 1945, and appeared prominently two days later on the front page of Sunday newspapers across the country; shortly thereafter it was reproduced in virtually every local newspaper and weekly news magazine.[1] The first news editor in Guam to see the photograph remarked, "Here's one for all time!"[2] The *New York Times* quoted an editor who dubbed it "the most beautiful [picture] of the war."[3] The following week *Time* magazine reported, "Henceforth, Iwo would be a place name in U.S. history to rank with Valley Forge, Gettysburg, and Tarawa. Few in this generation would ever forget . . . the sculptured picture of Old Glory rising atop Mt. Suribachi."[4]

Public reception was immediate and resounding. Newspapers were inundated with requests for reprints as families began to hang it on their living room and dining room walls. The *Times-Union* of Rochester, New York, compared it with Leonardo da Vinci's *The Last Supper.*[5] On March 12 the *New York Times* published a letter dated February 28 that proclaimed, "On the front page of the *Times* of Feb. 25 is a picture which should make a magnificent war memorial. . . . Reproduced in bronze, this actual scene should make good art and a fitting tribute to American men and American valor."[6] The point

was not lost in Washington, D.C., as several members of Congress quickly urged passage of a bill that would fund the building of a monument based on the image. The permanent monument was not unveiled until 1954, but by mid-March Congress had appropriated the Rosenthal image as the symbol for the Seventh War Loan Drive; at the same time the photograph became the subject of a public campaign to have the U.S. Post Office issue a special "Iwo Jima" stamp. More than 3,500,000 posters bearing an artist's rendition of the photograph were produced for the bond drive, as well as nearly 15,000 large billboards and over 175,000 cards to be placed on the sides of streetcars and buses; the postage stamp sold over three million copies on the first day and 137 million copies before going out of print in 1948.[7] The original photograph was awarded the Pulitzer Prize, the only time the award was given by acclamation in the same year the prize photo was taken.[8]

Photographs from the war were numerous, of course, but none evoked such an immediate, positive reaction, and only a few have even come close to withstanding the test of time. By most accounts the photographic print of the flag raising has been reproduced more than any other photograph— ever—and the image itself has been placed on inspirational posters, commemorative plates, woodcuttings, key chains, cigarette lighters, matchbook covers, beer steins, lunch boxes, hats, T-shirts, calendars, comic books, credit cards, cacheted envelopes, trading cards, postcards, and human skin.[9] In celebration of the fiftieth anniversary of the World War II, it was featured as *the* symbol of the war throughout the mass media on books, videos, and numerous Web sites. References to it have become common in public argument while it continues to be featured in popular appeals to patriotism and as a vehicle for ironic commentary in editorial cartoons.[10]

It is obvious that the Iwo Jima icon is beloved by many people, especially by many of those who experienced World War II. They celebrate the image because they see it as a beautiful monument to democratic sacrifice and "national unity of purpose."[11] Much later, it became easy for others to see the image as a model for unreflective respect for authority, habitual conformity, and other excessively majoritarian and exclusionary attitudes. Neither view is out of line with either the design or the use of the image. If one has gazed up at the memorial statue after walking among the graves at Arlington National Cemetery, it is hard not to honor the war dead. If one has been told to "Love it or leave it" by a fool in a flag T-shirt, it is hard not to disdain patriotic symbolism. The question, however, is not which response is more legitimate, but rather how the iconic image mediates the experience of citizenship across the political spectrum. We shall argue that the composition of the image, its varied appropriations, and its continuing circulation in the

public media reveal a complex process in which democratic citizenship is continually renegotiated through artistic variation on what has become a conventional model of civic identity.

Instead of a simple message of patriotic allegiance, the iconic photograph of the Iwo Jima flag raising provides a coordinated visual transcription of three powerful discourses in American political history: egalitarianism, nationalism, and civic republicanism. The successive overlay of these codes in a single image, along with additional dynamics of visual appeal, foster strong emotional identification with the image as well as a history of referential slippage and strategic maneuver. The varied appropriations of the image across successive generations demonstrate how liberal-democratic public life is continually redefined in respect to an array of attitudes ranging from civic piety to cynicism. This ongoing negotiation occurs in part because public culture is produced though both imitation and improvisation. The need for iconic images is demonstrated further by the use of the Iwo Jima image after the attacks of September 11, 2001, and by its reprise in the image of three firefighters raising a flag at ground zero in New York City.

TRANSCRIPTIONS OF CIVIC PIETY

They are on a high barren place (fig. 13). No trees, only the twenty-foot pole. No other mountains, only a blank visual field of featureless lowlands and overcast sky. The immediate foreground is a low tangle of shattered wood, rock, and metal debris, the underbrush of war's devastation. The photograph's blasted, empty terrain allows the figural composition to project powerfully into the mind's eye. It also presents an idealized model of the modern battlefield. The island is as featureless as the sea, while the Marines are the only soldiers left on the field, struggling against impersonal forces rather than against other men.[12] There are no civilians, no houses or other buildings, not even enemy fortifications; no society is evident except for the one being erected. This barren stage cues the photograph's conjunction of aesthetic design and political representation. War provides the backdrop for a moment of national celebration, and the battlefield becomes a world to be made in our image.

The Marines fit perfectly into the scene. They may be the ideal work group: the leader directing the task while laboring no less than the others; those directly behind him in perfect concert with him, attentive and disciplined, while those in the rear are still straining to add any last effort that might be needed. The visual analogies evoked by the image are to similar forms of manual labor: a community barn raising or putting one's shoulder to the

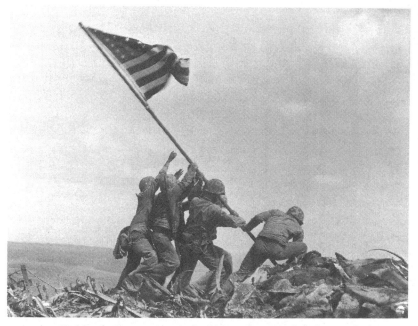

FIGURE 13. "Raising the Flag on Mount Suribachi," 1945 (Joe Rosenthal, photographer). AP/Wide World Photos.

wheel.[13] There is a palpable harmony to the bodies as they strain together in the athleticism of physical work. Although the poses shift from being bent close to the ground to bearing a load to lifting upwards, one can draw a horizontal line across their belt lines, their knees all move together as if marching in step, all their physical energy flows along their common line of sight to the single point of impact in the earth.[14] The figure planting the pole could be a Renaissance sculpture as the dynamic energies of the human form are concentrated in the exquisite muscularity of his body. He also concentrates the energies of those poised behind him as their forward movement is channeled down the pole and through his legs, back, and arms into the earth. We see the sure coordination of bodies with each other and with an instrument dedicated to their task.[15]

The icon's transcendental status is secured by a particular illusion of transparency because the actors are not behaving as if they are self-consciously affirming a cause. Even though the Marines are engaged in an act of display, there is no hint that anyone is performing for the camera.[16] The significance of this absence is evident from comparison with the follow-up photograph, which, according to the common sense of snapshot photography, should be

FIGURE 14. "Marines Pose in front of the Flag They Just Raised on Mount Suribachi," 1945 (Joe Rosenthal, photographer). AP/Wide World Photos.

the preferred picture. There we see a larger, somewhat more varied group of men facing the camera; they are smiling and cheering before the flag, whose size is evident now that it is fully unfurled (fig. 14).[17] This picture, of course, is powerless, a thoroughly conventional picture of men obviously acting on cue. By contrast, the power of the iconic image comes in large measure from the unselfconsciousness of those in the picture. The combination of historical setting, visual transparency, and selfless action creates a truth effect: it seems that this is the image through which the meaning of the war can be seen.[18]

The appeal of the Iwo Jima image typically is summarized by reference to three features of the photo: the men are anonymous while working together; the flag raising symbolizes the nation's sacrifice and victory in World War II; the photo as a whole has the aesthetic quality of sculpture. These comments identify three codes of American public culture that are in fact beautifully coordinated in this iconic image: egalitarianism, nationalism, and civic republicanism. These are not the only motifs at work in the image, but they are crucial principles of appeal. Because of their joint articulation, each has a slightly different inflection than might be expected. By identifying each

briefly in turn, one can begin to account for the icon's compositional rich-ness, a richness that proves to be a creative resource for a wide range of ap-propriations.

As Paul Fussell notes, "The photograph is not about facial expressions but about body expressions, suggesting, in a way bourgeois faces can never do, powerful and simple communal purpose."[19] Fussell's observation captures a conventional relationship between depictions of the working class, the ac-ceptance of anonymity, and political community. Hal Buell sees the same thing: "Six Americans, all for one, working together in victory and valor."[20] In other words, the photograph depicts the U.S. war effort as essentially egalitarian. The Marines are wearing identical uniforms, in field dress, with no brass or other indication of rank. They become ordinary men in common labor for a common goal. The pants and field jackets cling to the men's bod-ies from long use, and the dark tones suggest the sweat of honest labor. Thus, the composition also has the affective resonance of genre painting. The men in the picture are immersed in the deep rhythms of their labor while bathed in an aura they cannot see. The full implication of this portrait of the working class is that they are equal to the task *because* they are equal alongside each other, just as they are prepared to labor on for the military without regard for their personal safety until all are equal in death. This visual icon of the idea of political equality fuses the lesser sacrifice required in any egalitar-ian society—setting aside received rank, privilege, or other advantages for the common good—with the ultimate sacrifice of giving one's life for one's comrades and the nation. That the military is a hierarchical organization is irrelevant, an awareness displaced by other hierarchies in the picture: the subordination of the men to the flag rising above them, and their superior position to the invisible Japanese positioned below.

The egalitarian ethos of the photograph receives its most vivid enactment through the Marines' physical entrainment. Coordinated, ritualized bodily interaction such as marching or applauding, entrainment ties groups to-gether. The entrainment in the flag raising provides a performative embodi-ment of collective discipline; the iconic image becomes a relay between the Marines' military training and a civilian population mobilized for war. Thus, equality is given a specific inflection: rather than an absence of hierarchy, it becomes an unconscious equivalency in action. Equality also shifts from an abstract property of citizenship to something that is realized in concert with others, while working together, toward a common goal. Equality becomes something that one can see in action; acting together as in a war effort be-comes the means for securing equality.

Because it is more myth than reality, any strong egalitarian appeal can

both motivate and jeopardize social discipline. The egalitarian ideal soon draws attention to actual conditions within the society; while calling for common effort it also implicitly condemns any denial of equality. Frustrations experienced by workers, women, and people of color were in fact barely contained by the war or were being fueled by the economic mobilization, tensions already strong enough to require management across the spectrum of commercial and government propaganda.[21] The ideological dilemma was that strong images of egalitarian effort were needed to mobilize the home front, but these carried unsettling implications about established social organization. The flag-raising photograph seems to have neutralized any radically egalitarian implications. That damping may come from its particular depiction of equality, which features only men, an idealized embodiment of working-class routine, and military service. We believe the stronger constraint comes from placing the egalitarian norm within two larger patterns of motivation: the rhetorical appeal to nationalism and a civic republican political style.

As one of the men in the picture remarked much later, "You think of that pipe. If it was being put in the ground for any other reasons . . . Just because there was a flag on it, that made the difference."[22] Without the flag, the Marines are merely completing another of an endless series of instrumental tasks on behalf of unstated objectives that can range from winning the war to keeping the men busy. With the flag, all the actions of the campaign from strategic planning to the awful work of hand-to-hand combat are folded into the symbol of national unity. The flag makes labor into purposeful action, it makes the work group the embodiment of the nation, and it makes the tableau a model for imitation. The nation, in turn, becomes the fitting object of coordinated action. These attributions were evident in the captions for the photograph that referred to the flag as "Old Glory" and placed the battle for Iwo Jima in line with other great battles from the Revolutionary War forward. These first verbal anchors placed World War II within a historical tableau that framed the common purpose of this war, as with all U.S. wars since the country's inception, as nation building.[23]

It is hardly news to note that the Iwo Jima image evokes nationalism, but there may not have been sufficient recognition of how it exemplifies nationalism as a rhetorical phenomenon.[24] The quintessential collectivity of modern politics, the nation is an "imaginary community" in that its members can never be assembled in a single time and place, and its legitimacy can come only from diverse peoples acting as if they share a common substance.[25] Stated otherwise, the nation is first and foremost an abstraction. If it is to become more than an abstraction, that is, if it is to become a complex network

of institutions and customs, people have to be motivated to act collectively and to make individual sacrifices on its behalf. Symbols obviously provide that motivation, but only if the symbols themselves are deployed to make a vital connection between the actual experience of social life and the more distant and abstract collectivity.[26]

The iconic appeal of this image stems in part from its ability to articulate an abstract conception of national identity through figural composition.[27] More technically, the composition provides the visual equivalent of the verbal trope of metonymy, which conveys "some incorporeal or intangible state in terms of the corporeal or tangible."[28] This is more than a formal equivalence, as it overlaps with the fundamental requirement of political representation that the state has to be grounded in social life presented through cultural media. Only when the flag is situated within the context of specific social types or signs of vernacular life can it resonate as a performance of the sociality that is the ground of politics and the motivational basis for allegiance and sacrifice.[29] The Iwo Jima image is more than another instance of nationalism because it so effectively grounds abstract national identity in embodied social performance. Although the flag is in fact the object defining the Marines' action, their presence also is defining the flag. Thus, this iconic image creates a double movement up and down the pole, giving the abstract nation living embodiment while giving collective labor the transcendental status of nation building.

This relationship between the Marines and the flag is extended performatively through an additional transformation that overrides the conventional segmentation between military action and civilian spectatorship. While the Marines represent the nation-state's monopoly on force, the behavior modeled is not a specifically military action. They are raising a flag, and custodians raise flags. Although in uniform and on a battlefield, their dramatic action is a ritual act of citizenship. Thus, the tableau can be easily extended metaphorically to represent the national public as a whole. Witness the poster for the Seventh War Loan Drive, which captioned an illustration of the image with the words "Now All Together." The public can be hailed as fellow soldiers because model soldiers are already performing as fellow citizens.

Thus, the photograph not only relays the discourse of nationalism but also provides a figural enactment of national identity that emphasizes coordinated effort by ordinary people. This definition is reinforced by a number of smaller motifs creating the tonality of the image. The flag is underscored by signs of aspiration: arms pointing, lingering upward along a rising trajectory from earth to sky.[30] The picture is brushed with touches of the natural sublime, from the craggy mountaintop to a sky of alternating dark and light

clouds, and even the wind is flowing in the right direction. This fusion of nature and culture in a heroic uplifting gives the image a sense of destiny. Although the scene of desolation and the figures' battle dress imply that there is much work yet to be done, it will be done by a nation that has tapped into transcendental power.

Yet even conceptions of the transcendental have specific cultural inflections. This image is thought to be timeless because it conforms to a conception of political action that emphasizes how politics is constrained by history and oriented toward maintaining a community across time. The image also implies that community is maintained by remembering heroes in order to develop citizens capable of private sacrifice for the public good. In other words, the picture appears beautiful because it represents a traditional sense of virtue that conforms to the political style of civic republicanism:

> The aesthetic sense of the republican style includes an appreciation of form and function taken from public arts such as architecture and commemorative statuary. This aesthetic favors figural representation of the civic culture and artistic definition of its public space. . . . This artistry typically displays political leaders and audiences who have figured in the history of the republic, it represents civic virtues and accounts for political achievement and the common good in terms of those virtues, and it follows habits of representation that feature the whole, clothed body and standard typifications of gender.[31]

This description applies point for point to the picture, particularly as one adjusts for a martial republicanism typical of wartime. Soldiers are substituted for politicians while representing the audience on the home front through their clothes, labor, and subordination to the symbol of national unity. They epitomize common purpose and exemplify a range of virtues found in both military and civic action. Finally, the entire set of values is presented through and reinforced by conventional notions of masculinity. The inflection is telling; although war provides the mythic setting for depicting men as aggressive, physically powerful, and fully realized in conquest, these men fulfill a more domestic version of masculine identity.[32] They are working rather than fighting, and they do not see themselves as heroes. The many descriptions of the photo mirror these appeals: its beauty is synonymous with its depiction of virtue, and that virtue is deeply encoded within the conventional hierarchy and habits for organizing civic life.

This civic republican style of political representation is further articulated through monumental and quotidian appeals. "The monumental figure is the one that is supposed to extend across the entire public space and through historical time," and the quotidian example is a matter of detail "on a small

scale in order to manage a specific situation."[33] One reason the photo of the flag raising is so powerful is that it operates in both registers. The image has a monumental outline—a group of men dwarfed by the standard they are raising against a huge sky and distant horizon—and sculptural qualities—the massed figures are as if cut from stone, powerful yet immobile.[34] No doubt these features and their corresponding sense of "timelessness," not just the patriotic message so familiar to the wartime audience, made for such strong extension into posters, war bond drives, and a memorial statue. Monumental appeal is self-limiting, however. Public statuary typically becomes an allegory of civic republicanism itself: although still visible to subsequent generations, it is unseen or unappreciated because it becomes overly familiar and set too far above the private concerns of the individuals passing by in their day-to-day routines. The iconic photograph counters this tendency through the inadvertent reproduction of the details of everyday life, such as the swatch of undershirt on one Marine's arm or the creases in another's jacket. This sense of photographic detail can undercut the values being evoked by the monumental dimensions of the icon, but here it complements that dimension. The vernacular features of the photograph provide an additional basis for identification with the figures, one that is less heroic because it is more ordinary and so a compelling reassurance that the event is personally meaningful.[35]

These two dimensions of the republican aesthetic merge into a common telos: the heroic scale and collective victory, signified by a flag rising above the battlefield, and the common life, signified by the uniforms and coordinated actions of the Marines laboring beneath the standard, converge in the republican ideal of consensus. Within the republican orbit, collective action requires prior and renewed commitments to the common good, commitments that are evident from setting aside personal differences and material interests. These qualities are easily identified with the action in the picture in both its monumental outline and everyday detail. Here, as rarely observed in public or private life, we see the features of everyday labor coordinated through an action taken to communicate national purpose across a great space.

This stylistic accomplishment also helps to account for the photograph's subsequent use. The photograph can appear to be a timeless image of national values in part because the action depicted bridges the divide between war and civil society. Set on a battlefield, a flag raising reproduces an action seen more often at civic ceremonies. More important, the republican style valorizes public arts precisely because they "are understood not so much as accounts of what happened, but as designs for imitation while preparing for

events to come."[36] If it had merely been read as a sign of success on Iwo Jima, the photograph's future would have been brief. It succeeded, however, because it so beautifully filled the need for civic representation, that is, because it was an example of republican artistry transposed into the public medium of the age. A painting or sculpture would have been consigned immediately to the back rooms of a military museum, but this was an achievement of civic artistry within the public space created by the newspapers, news magazines, government posters, and other mass media. Within that space, the photo could function as a model for imitation, not in respect to future battlefields, but to the entire field of civic action. The republican style valorizes arts that can focus attention on public values and a civic community's need for continued service, which includes the performance of selfless action before other members of the community.

The icon's suitability for modeling citizenship is exemplified in an advertising brochure for the George Eastman House, a museum in Rochester, New York. The brochure displays a photograph (fig. 15) of a boy looking up raptly at a framed copy of the flag raising on the museum wall. The scene is tightly cropped so that the boy seems alone with the icon, and his stance makes him seem as if he were standing at attention. The picture is, of course, "cute": the rhetoric of military honor is performed by a small, rumpled child; he is so caught up in observing that he is unaware of being observed; instead of being what he desires to be, a soldier engaged in heroic action, he is a civilian immobilized by spectatorship. The full implication is that the child, awkward yet unfettered by self-awareness, reveals an essential feature of adult life. That feature in this case is identification with a work of public art portraying noble civic action. In case you might doubt that photography was an art, the image on display is an icon framed and labeled in museum display. In case you might miss the point of the brochure, the caption invites the viewer to "Get in the picture." By running along the vertical border, the caption visually as well as verbally reinforces the boy's act of identification, which is signified even more directly by the top of his head crossing the picture frame to overlap with the bottom of the iconic image.

The brochure is an exercise in civic education, albeit one that portrays the public as a child. It also is one that extends the designs in the iconic image. Although still male, now more obviously white, and less ambiguous regarding class, the use of the child is an egalitarian trope, the image orients the model citizen toward acts of service and sacrifice on behalf of the nation, and the foregrounding of public art to communicate virtue across the generations is thoroughly civic republican. Likewise, the range of imitation is extended from military to civilian action, while a lack of self-consciousness is

FIGURE 15. George Eastman House membership brochure, 2002.

again presented as an important part of democratic identity. But, of course, that is not the whole story. The appropriation is not for a war bond drive but rather to sell subscriptions to the George Eastman House. The advertisement is built up out of reproductions, insinuations, and associations: the ad is a photo of a copy of a widely reproduced image; the Associated Press image is presented as if it were property of the Eastman House and museum-quality artwork rather than a news photo; the boy reproduces the act of awed spectatorship establishing the iconic aura, which is fused with visiting the museum. Thus, identification with the iconic photo is shifted from sacrifice on behalf of one's country to consumption on behalf of supporting the museum, an institution of civil society. This second-order identification is cued

verbally by placing "Membership" just below the boy's feet. Through membership, you can "Get in the picture" to have as much pleasure as this boy experiences when gazing at the icon. Not having subscribed, we can't say. It is enough here to note that the ad is a good example of the complex transferences and alterations in meaning that occur when iconic photographs are appropriated as means of persuasion. As we shall see, the many appropriations of the Iwo Jima image demonstrate that iconic photographs are not only depictions of civic performance but occasions for continual improvisation on behalf of diverse motives and attitudes.

ICONIC PERFORMANCE

As has been widely recognized, following its initial production and dissemination in 1945 the photograph immediately became the undisputed icon for the nation's collective victory in World War II, and shortly thereafter it became the leading example of the "uncommon valor" and "common virtue" that defined the "greatest generation" as it faced the Cold War.[37] As Karal Ann Marling and John Wetenhall summarize, "In the first quiet years of peace, in fact, Rosenthal's photo became the definitive, collective memory of war: its classical sculptural calm; the absence of bloodshed; the triumphant lift of the Stars and Stripes all suited the national temper."[38]

The representational meaning of the iconic photograph, however, has not remained stable or unified. If nothing else, it is obvious that some referential slippage has occurred with the movement from one generation to the next. So, for example, visitors to the Ted Williams [Baseball] Museum in Hernando, Florida, before it relocated in 2006, would have found a large photograph of the Iwo Jima Memorial prominently displayed in one of the main rooms amid an array of photographs of Williams as a fighter pilot and as a star outfielder for the Boston Red Sox.[39] One might assume that Williams provided air support during the battle for the island. In fact, Williams flew only training missions during World War II and did not enter combat until the Korean War. The photographs recast history as myth while joining U.S. militarism and major league sports as a common culture. The intertextuality also works in the other direction: associating the image of the flag raising with Williams, a widely recognized athlete in a culture that valorizes sports celebrities, weakens the anonymity so important to the egalitarian appeal of the photograph. Roland Barthes's account of the rhetoric of the image applies directly: the connotations of victory culture and celebrity culture (that is, of political and social triumphalism) are naturalized by being fused with the denotative reference of the photograph; this ideological structure induces

viewers to glorify elites and maintain a collective fantasy of virtual association; and the reproduction of the image extends this regime across the realm of representation while bonding spectators on those terms.

One can go further down the road to reification, as when the image was invoked in a Supreme Court decision over flag burning in *Texas* v. *Johnson* (1989), and shortly thereafter when President George H. W. Bush announced his support for a flag desecration amendment to the Constitution while standing against the background of the Marine Corps Memorial.[40] As the flag itself becomes the focus of attention, the sacrifice and teamwork of the men hoisting it fades into the background, while a working-class norm of respect is yoked to loyalty to the state. One might think that this flag fetish and its jingoistic patriotism is a baseline value of the image, but appropriations of the icon reflect other commitments just as well. Examples include clear statements of dissent against the U.S. war machine (with a flower substituted for the flag or with a peace symbol emblazoned on the flag), or more oblique performances of alternative perspectives (replacing the flag and pole with a stone monolith).[41] They veer further still, including an advertisement for a brand name of blue jeans in which teenagers raise the flag that now bears the product name in place of the stars; the action to be imitated has shifted drastically from sacrifice for the common good to individual accumulation in a consumer society.[42] More ordinary examples include a T-shirt that shows a bunch of guys raising a fishing pole, displacing war and its civic virtues with leisure and a joke. Others are just plain silly—or perhaps sophisticated commentaries on civic piety, dissent, and commerce alike—as when the Marines are joined by Pillsbury Doughboys (note the pun) and the slogan "Bring the Doughboys Home."[43]

This cornucopia of visual inventiveness leads some commentators to bemoan the fact that the image appears to have lost its original aura. John Hartley, pointing to its usage by other nations such as Japan and Croatia, concludes that the image "has demonstrably lost all referential status: no longer a photo of these men in this place on this occasion, it is also no longer a mythologized image of abstract values like 'America,' 'victory,' or 'war.' It is just an image of itself, and refers only to our familiarity with it. It makes no truth claims, no propositional statements. It's not even propaganda, being well past the stage where it could be claimed as the exclusive semiotic property of any 'we' community."[44]

Hartley makes an important point about meaning exceeding reference, but in doing so he moves from one extreme to the other. As one examines the full range of circulation and appropriation for the Iwo Jima image, it becomes clear that a comprehensive account of its role in the articulation of

public culture requires seeing more than an evacuated signifier and less than a single rhetoric of the image that reinscribes a national mythology. As one examines the use people make of the image, it becomes clear that its connotative power is modulated, whether to be amplified or redirected, to negotiate relationships regarding the state, history, political conflicts, social conflicts, generational changes, culture wars, the culture of consumption, and more. Marling and Wetenhall note that the process was well underway by the time of the 1954 unveiling of the Arlington memorial, "To the meaning of a patriotic icon, facts, photographs, and the eyewitness testimony of the photographer himself were all but irrelevant. The symbol had taken on an independent life of its own."[45] Over the years, there emerged "a broad spectrum of meanings discovered in the flag raising."[46] What is important to recognize is that this variability in meaning increases the value of the image; we shall argue that it makes it well suited for the coproduction of democratic public culture.[47]

The slippage in referential meaning began immediately. The initial skepticism at Time-Life about whether the photograph was staged proved to be literally mistaken but culturally prophetic. The legend of its inauthenticity has persisted, perhaps as a futile attempt to restore a sense of referentiality belied by the circulation of photographic images. The bond drive quickly made it an image of American military action in any theater, and for many spectators the Arlington memorial stands not for the Marines but for all the war dead. Despite persistent promotion by the Marine Corps, subsequent commemorative use does the same. For example, the sole image on the exterior wall of the D-Day Museum in New Orleans (fig. 16) is a large blowup of the Iwo Jima flag raising. The photograph is superimposed on the image of a large black rock that could be Mount Suribachi, and the flagpole is extended into a metal pole holding a cloth flag. The icon represents the entire war effort, while the extension from military to civic virtue and from museum past to the present day is modeled by the extension of the image to the real flag.

Other, less institutional iterations of the icon follow the pattern. The photograph has clearly become one of, perhaps *the*, framing device for World War II.[48] In 1995, for example, the History Channel produced and marketed a five-volume video collection titled *World War II: The War Chronicles*. The Iwo Jima photograph is superimposed over a map of Europe and then displayed across the spine of all five videos.[49] The composition artfully melds action in the Pacific theater with the war in Europe, but the photograph is dominant as the action figure against a more abstract background. Other products follow suit. Commemorative calendars of the war use the flag raising as the sole image on the cover.[50] A compact disc (CD) titled *The Words and Music of*

FIGURE 16. Mural of the Flag Raising, D-Day Museum, New Orleans, LA (Barbara Biesecker, photographer). Courtesy of Barbara Biesecker.

World War II has only one image on the cover, despite the fact that the photograph signifies without either words or music. A British publisher places the iconic image on the cover of a book devoted to the war in Europe, where Allied efforts apparently consisted largely of British operations.[51] The History Book Club periodically features the photograph in its advertisements as an image of World War II, often without any verbal reference to Iwo Jima. The image graces the cover of *Unexplained Mysteries of World War II*, although there is little mystery in the battle for the island.[52]

Commercial use of the icon has spread it across a remarkable range of social settings. Sample appropriations include the Iwo Jima Motel, movies and movie posters, toys, war and science fiction comics, book covers across the political spectrum as well as an American government text, personal checks, a Book of the Month Club ad, a virtual postcard, funk and hip-hop CD covers, condoms, and more.[53] Full exploitation of the symbolic value of the image may be revealed best when it is also being diverted metaphorically to other ideologies and interests. Religious use is instructive, if at times mystifying. The Web page of a campus ministry included the image to visually caption its Looking Ahead column, adding "Something Special! There is something special going on August 24! Stay tuned to find out exactly what

strange and exciting things will be going on at this very special 1st Service."[54] More explicit association is made at a Lutherans for Life Web site, where the icon is the sole image with "Battles for Life" written across it and "No greater love has a man than to lay down his life for another" above it.[55] The text begins:

> My dad served in the U.S. Navy during World War II. In the years following that war, I remember him putting on his uniform to attend the Naval Reserve meetings. I was always proud of him. The significance of the accomplishments of our armed forces was a real part of my childhood.
>
> When public television aired the films, *Victory at Sea* and *Battle of The Bulge*, I was pleased that my son wanted to watch the episodes. As my son had the opportunity to learn about the tremendous sacrifice our men and women made in defeating the forces of the Third Reich, I had opportunity to remember the role my dad had played.

Perhaps one can be forgiven for thinking that the Marines were raising the flag against the Third Reich. Of course, the author will have known the difference, just as he knew that the icon easily stood for the war as a whole and for sacrifice for the common good. The shift from Iwo Jima to the war to Christian sacrifice expands the shift from referential to symbolic meaning, while also equipping the author for further topical extension of the image:

> Jesus said that no one has any greater love than the one who lays down his life for another. We may not be called upon to die for others, but we are called to commit ourselves to protecting the preborn, the infirm, and the elderly. Perhaps this is our way of laying down our lives for others in what has been called the "culture war."

What is most interesting rhetorically is not merely the reorientation of the symbol "pragmatically" from epideictic celebration to deliberative advocacy, but also its use as the leading image of a collective memory that is obviously anchored not in direct experience but rather in watching documentary and fictional films.[56] The transmission of civic virtue across three generations is accomplished not by continued military service but rather by a visual practice.

A generational lineage of cinematic propaganda can seem heavy-handed, but commercial appropriations can be much more canny. An Allstate Insurance ad at the time of the 2002 Winter Olympic Games provides a highly inventive appropriation that demonstrates how iconic imagery can function as an ideological relay while also transforming the values that are being cele-

FIGURE 17. Allstate Insurance advertisement, 2002.

brated (fig. 17). The flagpole and flag have become a hockey stick (reminiscent of the stunning U.S. victory in ice hockey over the Soviet team during the Cold War), and the Marines have been replaced by the bare, strong arms of anonymous athletes. As the allusion to past military and Olympic victories portends future success, the caption says "The Right Hands Make All the Difference."[57] Hands reaching upward in continued effort and aspiration were a minor yet distinctive element of the iconic design that is artfully replicated here, while the caption extends the image into the commercial present of the insurance company's well-known slogan, "You're in good hands with Allstate." As the ad traverses historical time from World War II to the Cold War to the present, the referent for the image shifts from military action to athletic training to financial protection. These transpositions are modeled by the image itself, which is a complete fabrication involving no part of the original image except carefully selected elements of design such as the stars and stripes, the line of the pole, the entrained bodies, and the sense of movement captured within a still medium. While the background reproduces the tonality of the photograph's horizon, national identity is melded with sport, masculinity is highlighted, and nationalism is reduced to the red, white, and blue motif of fashion design. The formal allusions and alterations in emphasis all serve a seamless suturing of the discourses of war, sports, and commerce—and on behalf of commerce.

To account for the full range of appropriations and to fully understand the rhetorical potential of the icon, one has to shift from a focus on representation to civic performance. The image can drift from the referential and intentional moorings supplied by the original context of publication, though they also can be reinstated, but in any case that relationship between image and historical event is secondary to modeling civic interaction in the present. The various appropriations may authorize everything from patriotic sacrifice to going fishing. More typical images—say, of fishing—can depict different activities, but not authorize them, or they can authorize civic identity—say, by showing a soldier saluting a flag—but not depict the texture of vernacular life. The difference has considerable significance for understanding public culture. Our shift in critical stance is on behalf of a specific argument about the nature of mass-mediated cohesion in liberal democracies. The iconic image can foster social connectedness, political identity, and cultural continuity not because it has a fixed meaning apprehended by all spectators, but because it seems to provide that meaning while allowing more situated identification that includes artistic reworking on behalf of a wide range of attitudes.

The performative dimension of the Iwo Jima image was activated immediately through the bond drive—an explicit appeal to the public audience that also was organized around rallies and other events that featured audience participation. The icon was not only the central image in that drive but also the template for statues and live reenactments.[58] Of course, Hollywood wasted no time in cashing in with two productions (*The Sands of Iwo Jima* and *The Outsider*), and now another (*Flags of Our Fathers*) is finished and released.[59] Subsequent restagings have included a made-for-TV movie (*The American*), a History Channel/A&E Television Network documentary (*Heroes of Iwo Jima*), and a ballet (*Uncommon Valor*) by Houston choreographer Timothy Levine. The icon also is regularly reenacted at parades, reunions, and other civic events as well as at a festival of living art in Orange County, California. These reenactments of the image are all explicitly performative: they involve staging for an audience, imitation guided by attention to design, and emotional response. The response, like the reenactment itself, is not limited to the values supposedly evident in the original. Some reenactments are very serious, of course, including both Boy Scout troops solemnly posed with scoutmasters, and 70s era protesters lifting a peace flag. Images of *Star Wars* storm troopers, campers on a hilltop, and fraternity boys wrestling with a keg of beer move in the other direction. The same holds for digital reenactments. A Web album of the Beeville, Texas, Fourth of July celebration has as its titular image the

juxtaposition of the Marines with a small boy planting a flag.[60] Beeville does not suffer from a lack of flags, but the photomontage most clearly signifies the town's civic republican commitment to passing civic virtue from past to future generations. For comic relief, one can turn to another Web album that placed the iconic image alongside a photo of a rugby lineout. The pairing included the caption, "I'm no Joe Rosenthal, but sometimes the composition of a lineout takes on truly artistic qualities."[61] The visual analogy reflects a way of seeing according to conventional figures shared by a democratic public. Thus, the image works some of the time as a relay to tie disparate settings and different media together on behalf of the state, but also on behalf of a shared culture that is not so easily defined. How else are we to explain a culinary review of Craig's, An American Bistro in West Palm Beach, Florida, that characterized the house specialty pot roast in these terms: "With a sprig of rosemary rising from its crest, it resembled Iwo Jima's Mt. Suribachi when the American flag was raised there during World War II."[62]

Vernacular reenactments make the transition from explicitly civic events such as a bond rally to the performance of everyday life. By tracking Iwo Jima paraphernalia such as figurines, commemorative plates, paperweights, plaques, wall hangings, ball caps, key chains, beer steins, and T-shirts it becomes evident that there is a steady demand for opportunities to take the icon into small-scale, everyday settings.[63] Michael Billig identifies nationalism's dependence on banal repetition of the flag, but one can go further to consider how that banality also is a resource for negotiating one's relationship to the imaginary community.[64] Whether used as personal adornment or placed within a familiar scene, the image becomes a part of the play. On the surface, this commercial trade can appear to be no more than patriotic kitsch: the supposed object of reverence is miniaturized and placed, without hint of irony, on clothing, dishes, and other everyday items, or reworked in cheap materials by not-too-skilled artists, or used for obvious promotion of this or that business (Penworthy Bear, the Drudge Report, motivational posters, T-shirt sales, and of course the Marine Corps). Dismissal of the trade in the icon on these terms would miss key elements of the performative reworking of the photographic medium. The iconic appropriations provide the means for embodiment of an otherwise transcendent symbol. The seeming contradiction in "red-state" fashion where the flag is both sacralized and placed on halter tops, jean jackets, truck windows, and who knows what else, is no problem within the context of performance. (In addition, we should note that there is little distinction in actual practice between image content and the materiality of the photographic object.[65]) The abstract symbol is being grounded in lived experience, while that experience is being bonded

(through the visual relay) to a sense of collective identity that includes the nation and also more local, regional, or cultural groups. This supplement to other forms of citizenship is thoroughly aesthetic—a matter of fashion, not voting or any other duty or sacrifice or commitment—and it is important. It is still kitsch, but kitsch should be seen as a democratic art.

This embodiment can involve intense identification—say, with the Marine Corps, which is the reason for at least one of the snapshots on the Web that show the image tattooed on someone's back. It also can be part of a much more limited association within a complex personality—after all, who is defined solely by their key chain? Likewise, it can be more or less subtle. A colorized print that says "Historic MOMENT" spells out the iconicity as if for the culturally illiterate, while other works place it amidst tableaus and texts that serve as carefully designed personal statements addressed to others assumed to share a common history. The common denominator of these various forms of embodiment, whether corporeal, cosmetic, or virtual, is that they project group identification. The difference between representation of the nation and its performative reassertion can be slim at times, but often there is a difference precisely because another group is emphasized in the foreground. Note that the examples above include the Boy Scouts of America, the peace movement, *Star Wars* fans, an amateur rugby club, the Marine Corps, and other groups as well. Indeed, a fair amount of the kitsch should be read as an affirmation of working-class identity (including corresponding conventions of political belief and display). Like performance itself, group membership is explicitly a matter of coproduction between actors and audiences. The reproduction of the iconic image surely is an economical way of activating basic conditions of performance and group affiliation.

We want to stress, however, that because this group identification is being mediated by the public art of photojournalism, it acquires a distinctively democratic character. As Benedict Anderson has remarked, "communities are to be distinguished, not by their falsity/genuineness, but by the style in which they are imagined."[66] Anderson stresses the importance of print media in the development of the nation-state and thereby provides a crucial and yet underdeveloped linkage between nationalism and the modern democratic public. What remains to be fully understood is how public visual arts provide crucial stylistic inflections that strengthen, extend, and also supplement the ongoing articulation of political allegiance. James Bradley captures the power and peculiarity of the flag image in this regard when he notes that "[t]he photograph had become a receptacle for America's emotions; it stood for everything good that Americans wanted it to stand for."[67] The flag raising stands for "everything good," and it may allow the audience to feel good

about everything American, but that feeling lacks a specific anchor. Unlike many photographs, the figures in the iconic photograph provide no facial cues as to how to feel. Instead, the emotional response is evoked behaviorally and obliquely through the relation of the group to the flag above them and by their gestures of commitment to the task. Stated otherwise, a civic performance that culminates in the abstract form of the flag leaves a key basis for identification undefined. Iconic photographs are objects of powerful emotional identification but never limited to one emotion. Moreover, they have to be more open to a range of individuated responses than they appear to be if they are to equip people to negotiate the persistent tension within liberal democracy between individual autonomy and collective responsibility.

The image of the flag raising provides one example of an open and expansive public emotionality. Whether summarized as "patriotism" or "victory" or "honor," the image constructs an emotional relationship characterized by a specific public object and a relatively undefined private affective response. Its articulation may be especially unproblematic within a visual medium; in any case, the emotional openness corresponds to the semantic emptiness of the ritual performance, and both reflect the characteristic coproduction of a democratic culture: the identity of the collectivity has to be reaffirmed by an audience whose interests usually are individuated, plural, heterogeneous, conflicted, unconscious, or unspecified. The most important fact of this coproduction is not the particular content held in common but that "uptake" occurs across a range of demographic or partisan preferences.[68] Obviously, the positive image and its expansive emotionality provide one means for the ongoing reproduction of this basic sense of democratic assent.

If the nation is a cultural artifact created through public arts, then the design and circulation of the iconic photograph of the Iwo Jima flag raising provide stylistic inflection that encourages both egalitarian collective identity and an emotional responsiveness not tied to any one definition of the state. The utility of this iconic image for democratic public culture becomes further evident as it circulates through a variety of media and all manner of material objects. The flag raising proves to be both exceptional and banal, a transcendental image and a material object, an incarnation of the imagined community and a means of personal expression, a civic ritual and a prop within the performance of everyday life. Whereas most images, like most texts, fit more into one category or another of meaning production—public or private, formal or informal, among others—the icon can encompass the full range of public address and response.

The coproduction of collective experience also requires negotiation of an attitude. Following Kenneth Burke, we define attitudes as incipient actions.[69]

Both politics and performance traffic in attitudes. The appropriations of the Iwo Jima icon reveal that it provides a means for reaffirming, contesting, and negotiating individual attitudes toward collective experience. These attitudes range from piety to cynicism, and they may well be one of the fundamental dimensions of public life.

FROM CIVIC PIETY TO PUBLIC CYNICISM

One photograph has been celebrated among all others of World War II not because it was the best representation of the nature of war or because it provides the strongest statement of national beliefs or power, but because it enacted the best performance of deep norms of our public culture. It was a work of civic art having the qualities of public sculpture and the features of a common life. Most important, perhaps, through the successive transcriptions from egalitarianism to nationalism to civic republicanism, the photograph directs civic action into channels of cooperation that need not have radical implications for social change. To be an icon, however, the image has to retain a sense of autonomy from either popular taste or elite interests; that autonomy comes in part from the aesthetic quality and cultural richness of the image.

We believe that the photo continues to be a force in public discourse because it is a performance of civic action that seems to be "above" the many social conflicts that emerged, first in the postwar period; then with the cultural revolution of the Vietnam era; then again with the end of the Cold War; and following the events of September 11, 2001, with the advent of a new cold war that recreates a national security state defined against a transnational phenomenon. The historical details defining the photo do not direct its application. This war, that era, it doesn't matter. What does matter is that the photo has become the single most powerful image of democratic solidarity in our culture. It has set the standard for collective action: there they are, "the greatest generation," individuals working together, rising as one to unexpected obligation, and mutely, without question or hint of cynicism.[70] They remain individuals who will go their separate ways in private life, but when duty calls, they respond without personal regard and with the unconscious coordination that comes from a good-faith acceptance of the disciplines of large-scale institutions. And they do so humbly; the defense of liberty is guaranteed by workers who take pride not in themselves but in getting the job done.

History actually falls short, but the rhetorical problem is more interesting: the formal perfection of the photograph becomes a burden as it con-

demns subsequent generations to a narrative of decline and fragmentation. The high degree of aesthetic cohesiveness makes its model of citizenship too distant, particularly when such civic piety is transposed to a democratic culture whose dissension and partisanship are no longer kept in check by war and older, more stringent norms of social conformity. It is no accident that this is a characteristic anxiety of civic republicanism. The image of willing subordination to the higher good of the nation has an unconscious coherence that can rarely be realized and is not often seen in the give-and-take of ordinary life. The ability of the image to move easily across contexts, from military to civilian life, and from one generation to those following it, also makes it a vehicle for the republican pathos of liberty's defenders having to watch their sacrifice squandered by those who enjoy its benefits.

Thus, a paradox emerges, at least for any society, such as a modern democracy, that is experiencing continual social change. The more literally a later generation reproduces the actual conduct of a prior generation, including the beliefs, norms, and structures of feeling that make that conduct meaningful, the more out of step it will be in its own time; conversely, the more it develops without regard for the dominant model of citizenship, the less virtuous it will seem. The more idealized or "timeless" the model, the more difficult its application in each successive generation. Ultimately, the most positive images available to a community would become a catalog of all it cannot do. We know from experience, however, that the process of representation somehow avoids this end state. Images of virtue never reach a state of complete alienation, but they also never escape some combination of ideal form and partial application. They always can be used to sell lesser goods and to represent a falling short of what should be. To put the point bluntly, in a working democracy civic piety *always* is accompanied by its denigration. This dialectic acquires additional inflection in a liberal-democratic society in which the primary tension is between individualism and collectivity, a unitary collective obligation and varied individual responses. Likewise, the central problem of civic republicanism is not doing battle with an external threat, but rather failing to communicate virtue effectively from one generation to the next. Democratic action requires collective challenges—a state to be founded, a communal crisis to be averted, a war to be fought—and when such moments fail to appear, it becomes difficult for subsequent generations to respond "appropriately" to an image like the flag raising.

The Iwo Jima icon demonstrates the back and forth movement of this dialectic of democratic public address. On the one hand, the idealized image continues to be offered as a basis for imitation, though often through strange juxtapositions; on the other hand, it becomes a commonplace for denigrat-

ing everything from selfishness to faux patriotism, but does so by appealing to supposedly absent values. These oscillations suggest that public culture is composed not only of laws and opinions, or beliefs and emotions, or interests and identities, but also of a range of attitudes toward the nation, the government, distinctive social groups, specific policies, and other recurrent features of the news. Icons may be distinctively suited to conveying attitudes: think of the reverence evoked by a religious symbol or the optimism of a smiley button. And as each of these examples suggests, the iconic image also can be turned against its characteristic attitude, even to suggest that the real basis of the original response is a sham.

The most important consideration here is not that meaning can be manipulated, but that people accept and modify dominant symbols in order to negotiate their relationship to their collective environment. Decisive action actually is rather rare in stable societies and everyday life, but all of life is in fact defined by one's potential for action. One does whatever one does within a context of what one could or could not do, and one's sense of security, agency, and worth depends in great part not just on what one does but on one's sense of what could happen or might happen. Thus, although actions are relatively rare, attitudes are constantly in play. More important yet, they are a crucial element in democratic continuity. One votes every several years, but both voter interest and electoral accountability depend on the pretense that the public and their representatives are continually making decisions in respect to each other.

If public life becomes a trafficking in attitudes, some are likely to have more currency than others. A polity characterized by extreme contempt all around is not likely to thrive; the same can be said of one characterized by constant veneration. By tracking the varied appropriations of the Iwo Jima icon, we can suggest that American public culture is defined in part by a range of attitudes than runs from civic piety to public cynicism. These attitudes will be in play across the entire media space, and many locales, subcultures, and individuals will be characterized by one or another attitude being predominant. Generations also are described accordingly by many a pundit. One might expect the Iwo Jima icon to be nothing more than a symbol of civic piety, but it is in fact used to give eloquent expression of the full range of attitudes. This use of the icon across the attitudinal spectrum is an important demonstration of how the iconic image can be a resource for democratic advocacy and identity.

The use of the icon to evoke civic piety continues unabated, although not uninflected. Various examples beyond what was noted above suggest both partisan and more complicated repositionings of the image. It is fre-

FIGURE 18. Waveland Cafe, Des Moines, Iowa, 2001 (Robert Hariman, photographer).

quently referred to on Web sites that emphasize "American Patriotism" and is used to teach children about "valor" and "veterans," as in *A Is for America: An American Alphabet*.[71] Grassfire.org, a conservative political action group, has planted the icon as a lawn sign distributed nationwide. The sign pairs the iconic image with the slogan "Support Our Troops." It was distributed by at least one county Republican organization during the last presidential election, and a thousand plus were posted across from Cindy Sheehan's protest against the war in Iraq at the Bush ranch in Crawford, Texas.

A more complex example of grassroots patriotism comes from a neighborhood eatery in Des Moines, Iowa, known for good food and great waitresses who take no backtalk from anyone. After the bombings of 9/11, the café put the Iwo image on its window along with the caption, "God Bless the USA," and a talk balloon that says "Keep it flying!" (fig. 18). The interesting inflection is that the Marines now are waitresses, who also are smiling or waving as they plant the flag. The old image has been refigured in a new world where women are the center of the action and where even during a crisis irreverence is the order of the day. The reproduction creates an intermediate place between "love it or leave it" piety and liberal aversion to showing the flag. This middle ground also is suggested by the composite temporality of the

composition: as the World War II image has been pulled forward, the waitresses have gone a bit retro by wearing dresses and aprons that never are seen inside the place. The image is undoubtedly patriotic, yet also consistent with the independent women, their irreverent style, and the blues guitar blaring out of the kitchen.

Much of the time, of course, the icon is used as a straightforward or heavy-handed assertion of patriotism, often to quell dissent. Within that, one should be sensitive to more local inflections, as the image is being used not only to discipline others but also to define the persuader, ground the abstract concepts and relationships of national life in social experience, and maintain a received sense of public culture. It even can be a means for "updating" conservatism, as on the cover of *America: A Patriotic Primer*, a children's book by Lynne Cheney. Ms. Cheney is not known as an advocate of multiculturalism, yet the cover features five boys and girls of varied hues planting the flag in a field of grass and flowers.[72] Visually, at least, we are all multiculturalists now.

For many of those coming after the greatest generation, however, the image has taken on a second life more akin to a haunting. Those more accustomed to the Vietnam syndrome than to a victory culture can see the image as at once a source of guilt and betrayal. Katherine Kinney observes that "Iwo Jima haunts the Vietnam War literature," and the key trope of that troubled legacy is "the flag raising."[73] Or, to those oriented more toward upward mobility than to "raising the standard," the icon can become a sign of the impossibility of civic virtue today. For example, the flag raising is parodied in an episode of *The Simpsons* in which Bart becomes a member of a boy band.[74] As part of a video, Bart and his band members, dressed in military camouflage, parachute onto a beachhead and proceed to plant the flag in the exact pose of the original with the camera focused on their legs and backs. In the next scene we discover that they had parachuted into a beach party; what appeared originally to be a flag pole turns out to be a tetherball pole; and rather than training for civic leadership, Bart and his friends play with three bikini-clad women. The ideal of masculinity central to the original image is given comic exaggeration, while the main point is that heroic virtue is now a fantasy. Bart is no more likely to become a war hero than he is going to live in the MTV-imagined community of beaches and babes.

One finds this strong use of contrast in numerous editorial cartoons that comment on public policy or public culture. In every case, the master trope is irony. A common technique is to alter the flag. In one such cartoon the standard is being raised in Kosovo, but the flag has been inverted so that it is upside down.[75] In another, the flag has been converted into a dollar bill that

is burning, the look on the face of George Washington is one of exasperation, while the Marine Corps Memorial is relabeled "The Drug War Memorial."[76] A related variant is to substitute some token of policy or social convention for the flagpole. As Janis Edwards and Carol Winkler have documented, examples include replacing the pole with an enormous gas pump, a female soldier whose dress is being lifted up, and a baseball bat.[77] The argument is straightforward in every case: instead of allowing our soldiers to die for oil profits, we should rein in our excessive consumption. Past soldiers would not have abused women in the military and present soldiers should not do so either. Society should be mindful of past sacrifices made to secure present freedoms, not glorify sacrifice bunts.

Other examples work in much the same manner. One substitution that occurs periodically is to replace the flag or flagpole with the McDonald's arches. The artist implies that another, far worse substitution has occurred. Instead of laboring on behalf of the nation, the soldiers now serve a private corporation. Instead of sacrifice for the common good, they lift up a consumer society. The relative age of the two icons implies that the movement has been from past to present, and so that a society in which people worked together on behalf of the common good has become a society in which people stream through fast food lines while going their separate ways. The full implication is one of betrayal: surely men did not die for this? But, of course, they did: the democratic victory also was on behalf of the individual's right to engage in free enterprise. Something is awry, however, for the relationship between democracy and liberalism is clearly oppositional in this image. The image appeals to a nostalgic yearning for a virtuous past that is used to highlight how the present is cheap, crass, and otherwise corrupted and corrupting.

The substitution of various objects for the flagpole or flag is so common that it has become a visual cliché. The "original" photomontage may have been an antiwar poster that replaced the flagpole with a flower. Recent substitutions include an oil derrick, pipeline, gas pump, flag announcing "free speech" (with the reporters raising the pole), the speedometer on the "war machine" (with the Bush administration pushing up the needle), a television antenna, cigarette, bong, dollar bill, bar code, smiley face (for a supposed Canadian monument), and crucifix (following on the release of Mel Gibson's *The Passion of the Christ*). Many of these strengthen the irony through allusion to key elements of the original composition. In a particularly telling example from the year 2000, four flags are in the picture, each held by one of the four presidential or vice-presidential candidates in the 2000 campaign;

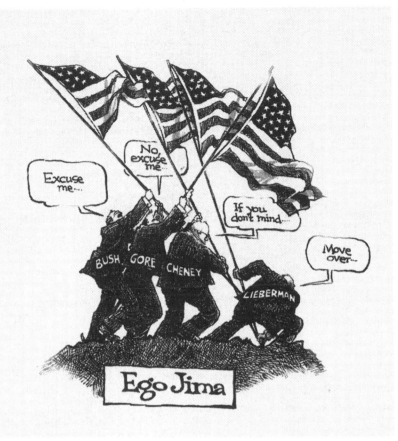

FIGURE 19. "Ego Jima," editorial cartoon, 2000 (Steven Benson, cartoonist). Reproduced by permission of Steve Benson and Creators Syndicate, Inc.

the candidates are clearly at cross purposes while the inscription reads "Ego Jima" (fig. 19).[78] The cartoonist has neatly reproduced the iconic template in some particulars, such as the hilltop, flag, and postures of the men, while also making the difference between then and now all too apparent. Instead of one flag, four; instead of working together, partisan jostling; instead of self-less dedication to a common cause, egotism putting them at cross purposes. The addition of speech underscores the point being made visually: the faux civility cues us to the equally false attachment to the flags they carry. The political candidates' commitment to the nation, like their relationship to the democratic process of the electoral campaign, is but the costume in which they compete for individual advancement. The figural irony carries a civic

FIGURE 20. Still shot of Homer Simpson, *The Simpsons*, season 11, "Selma's Choice," 1993.

republican judgment: the nation is ill served by leaders who are more focused on themselves than on the people they are to serve. The fact that one of the four candidates is now president may add a prophetic touch to the cartoon. In a more recent version, a soldier, firefighter, and FEMA worker are behind President Bush as he plants a No Parking sign in New Orleans following hurricane Katrina; instead of selfless dedication to the recovery effort, he looks up at a TV crew and asks, "How do I look?"[79]

The contrast between past and present is made most clearly in another episode of *The Simpsons*. Homer Simpson, the paragon of unfettered desire, is bequeathed a collection of potato chips molded in the form of celebrities "such as Otto Von Bismarck and Jay Leno." When he comes across a potato chip in the form of the flag being planted on Mount Suribachi (fig. 20), he immediately acknowledges its cultural significance by uttering, "Uh-oh!" Then, after contemplating it for no more than two seconds, he succumbs to temptation, pops it in his mouth, and eats it.[80] Instead of the individual sacrificing himself to the community, we have the communal icon being sacrificed to the most banal of individual desires, the impulse to eat junk food. The image, which began as a sacred emblem of the nation's greatest collective achievement and a model of civic identity, is profaned in potato paste as a symbol of the nation's love affair with commercial consumption and an unbridled and

fragmented individualism. Political history has become popular culture, the selfless, heroic citizen has become the acquisitive and consumptive individual; liberal democracy has been reduced to liberalism.[81]

An ironic stance and civic piety might seem to be worlds apart. They certainly are so when comparing individuals such as the Marine who tattoos the totemic image on his back with the computer geek who runs it through Photoshop to create something scandalous for somethingawful.com. In the ironic remaking of the image, however, the effect depends on the original narrative of civic piety; indeed, it yearns for it. When an editorial cartoon substitutes an image of Lynndie England—the U.S. soldier featured in the Abu Ghraib photographs of military personnel abusing Iraqi prisoners—for the lead marine raising the pole, the point is not that we should be bemused at how times have changed.[82] The visual irony condemns behavior that fails to live up to the ideals embodied in the original, ideals that also would entail more virtuous public policy, more selfless public figures, more commitment by leaders and public alike to the common good, and so forth. Even so, irony and the liberal, media-savvy society it represents don't sit well with more conservative visions of social order. One result is a reworking of major symbols as objects for nostalgia.

For those in relatively sophisticated locales, irony can make direct imitation of models of civic piety more difficult. Few will place the Iwo Jima icon on the back window of their BMW. In place of seemingly direct imitation, one compensatory reaction that results is nostalgia. Following the fiftieth anniversary of World War II in particular, nostalgic reproductions of the image were rampant, and the image acquired special significance as the generation that fought the war was passing away. The association of the image with the "Greatest Generation" is evident from a cartoon by Brian Duffy (fig. 21). The Marines now stand for the entire generation, military and civilian, male and female. There they are, on the beachhead of heaven, still behaving even in death as exemplars of civic virtue. Perhaps the most poignant instance of such nostalgia in recent years has been the publication of James Bradley's *Flags of Our Fathers*, which spent more than forty-five weeks on the *New York Times* bestseller list in 2000–1.[83] Bradley details the story of the six flag raisers (one of whom was his father, Navy corpsman John Bradley) in a narrative that careens back and forth between realism and sentimentality, and finally settles on a nostalgic paternalism where "boys of common virtue" become men in combat and then fathers in small towns: "It's as simple as that."[84]

So simple, in fact, that it can be commodified. At the appropriately named Web store "Future Memories," the five-hundred-piece History Channel jigsaw puzzle of the flag raising refers to "one of the most inspiring acts of

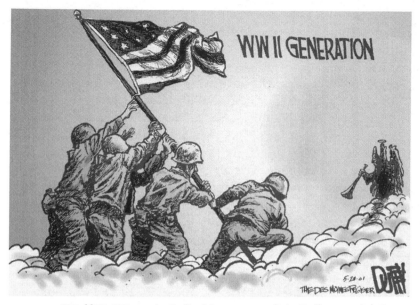

FIGURE 21. "World War II Generation," editorial cartoon, 2001 (Brian Duffy, cartoonist). Courtesy of Brian Duffy.

patriotism ever recorded on film." The internment of the act within the past tense and photographic medium already places it in the preserve of reverie. A business report on the puzzle maker's success claims that, when designing a puzzle, "The image has to have longevity, nostalgia or recognition."[85] The Iwo Jima image, of course, has all three, which can explain why it is a feature at nostalgia stores, where it is available also as a poster, stick-on tattoo, postcard, GI Joe doll, and more. The patriotism is always there, of course, but also set in the past as an object for memory. The image is the same, but the attitude contrasts with both the strident patriotism and more vital, mixed media of many a personal Web site and political action organization engaged in debate on contemporary issues.

Just as piety creates a backlash of ironic contrasts, so does nostalgia provoke a corresponding cynicism. The cynic cuts deeper, though never so much as to be wholly free of the old order. A cynical attitude denies that reform is possible, which also makes persuasion futile. This last implication is hard to take, however, which can lead to a back-door sentimentality. The tension between nostalgia and cynicism is highlighted in a pre–9/11 2001 *New York Times* article by Rick Marin titled "Raising a Flag For Generation W.W.II" and accompanied by a 9″ × 9″ artist's rendition of the flag raising image with disproportionately large photographs of the heads of actors Tom Hanks and

Ben Affleck, TV news anchor Tom Brokaw, and President George W. Bush. Each head faces the viewer and is adorned with a World War II army helmet.[86] Marin identifies the four men in the picture as members of a "not-so-great generation" living in "cushy times" who have helped to fuel an "immense national neurosis" focused on pining for the virtues associated with World War II. Against the excessive pursuit of pleasure today, the veterans are extolled as "a truly inspiring generation because they were so pure in their belief and willing to lay down their lives at the drop of a hat. It seemed like they put their country before themselves." Yet Marin makes clear that those purchasing nostalgia today have no real comprehension of or desire for the lack of self-consciousness embodied in the behavior of the "greatest generation." The artist's rendition is telling here in its difference from the original photograph: the faces of the flag raisers are not only easily recognizable, but they dwarf everything in the picture, including the flag. They are portrayed as individuals, not members of a team working towards a collective goal, and each has achieved success as a result of his exploitation of public sentiments. The image remains recognizable as the iconic photograph, but its meaning has been turned on its head. Marin underscores the point with his own cynicism, "Mr. Brokaw quotes [FDR's] exhortation: 'This generation of Americans has a rendezvous with destiny.' Americans of a comparable age now have a rendezvous with their dot.com destiny, but that's it."[87]

For all his cynicism, Marin is guilty of his own version of nostalgia: as he vilifies the "not so great generation" for its overt romanticizing of World War II as a sort of "extreme sport," he continues to yearn for what he takes to be the "truly" great generation that was "clear-eyed," "unsentimental," and unselfconscious. The closing words of the article are telling in this regard: "What's admirable about the men and women of the greatest generation is that they didn't think they were." The illustration captures this sentiment perfectly with its alterations in magnitude: oversized heads of ego-driven individuals intrude into a world in which individuals did not loom so large.

With this example, the use of the icon comes full circle, returning to its original transcriptions of egalitarianism, nationalism, and civic republicanism. In order to articulate harsh criticism of contemporary society, artist and editorialist alike recall a time when civic actors were equals—proportionate to each other—and dedicated to the common good—proportionate to the standard. As such, they were fitting models for subsequent imitation. The linkage between these ideals and photojournalism also is highlighted, perhaps inadvertently: the loss of visible virtues is coordinated with the change from the seemingly transparent photo to the obviously crafted illustration and the new "dot.com" media. Likewise, the vision of a greatest generation

also depends on a certain naiveté regarding the public media: because the flag raisers weren't posing for competitive display or aware of being recorded, their performance of civic virtue was assumed to be authentic. Because the medium was thought to be a transparent mode of representation, they were assumed to be as they looked. Thus, the image itself can be used to anchor those ideals in public discourse and particularly in the print media.

Of course, this combination of public naiveté and artistic excellence is a recipe for both manipulation and cynicism, and the possibility of the former provides a continuing rationale for articulating the latter. What else can one say when the image is used by the Illinois Lottery to promote their Veterans Cash game? The ad rewards both pious and cynical attitudes, with the tension perhaps to be resolved by placing a bet. Furthermore, as the icon is reproduced and disseminated widely over time, it becomes easier to code it cynically. Thus, the original transcriptions in turn motivate an attitudinal trajectory that may be deeply embedded in liberal-democratic public address. This range of attitudes runs from civic piety to irony to nostalgia to cynicism. These stages are represented in the Iwo Jima appropriation by the war bond drive, the editorial cartoons faulting later military policy, many of the commemorative reproductions, and digital alterations of the photo to condemn contemporary individualism.

Perhaps it is more accurate to say that the dominant tension is between piety and irony, with nostalgia and cynicism as derivative formulations. Expressions of piety and irony often involve strong cultural differences yet share a deep commitment to a democracy that can be true to its ideals in terms of the ordinary citizen's experience in the present. Nostalgia and cynicism are both reactions against a degraded present, and they each are hard to sustain when actually engaged in collective decision making. Drawing on Burke again, we can describe the attitudes further by noting that piety and irony are "frames of acceptance," while their derivatives are often "frames of rejection."[88] Each attitude provides a basic sense of the political community and of one's sense of political agency. On the one hand, one might support elected authority or be wary of the abuse of power (including the rhetorical power to deploy iconic images), but in either case one is politically engaged. On the other hand, one might memorialize civic virtue or sneer at civic commitment, but in either case there is a fundamental alienation from the actually existing political culture. In any case, the iconic image is being used frequently to express all of these attitudes. Thus, there is good reason to claim that it is not always relaying the same meaning, yet it is a common resource for constituting and negotiating public culture.

It also is important to recognize that times and tropes change. Nostalgia waxes and wanes, as does everything else. Although individuals may have fixed attitudes, the attitudes themselves can be more or less useful as situations vary. We have described irony as a mode of civic engagement, but it rightly has been criticized for often being used to rationalize selfishness. Nostalgia can be used to unite generations and motivate civic renewal, as more than one small town has learned. What is needed in any case are relatively constant symbolic resources for articulating and negotiating collective action. Iconic images cannot do that alone, but they may provide important precursors for more deliberative work.

Whatever the attitude being expressed by or attributed to the Iwo Jima icon, the image may also provide a litmus test of where one stands in respect to the deep tension within liberal democracy. Generally, the Iwo Jima image usually is used to reinforce a more democratic than liberal vision of polity and often to criticize liberalism. This holds true whether the appropriation is conservative or progressive, nostalgic or ironic or both. But this is not the end of the story. Just as the icon continues to circulate, so new appropriations continue to emerge in public discourse. For example, at FreeRepublic .com, "A Conservative News Forum," a satirical rant aligns the Clinton administration with the now famous photograph of a federal agent dressed in riot gear and holding a machine gun in the face of the terrified refugee child Elián González. The author of the posting, taking on the persona of the federal agent, notes: "But most of all, I am proud that from here on out, the photo of me staring down the very face of evil [Elián González] will replace trite, worn-out scenes like the flag being planted on Iwo Jima. Now we truly have an icon more glorious than all others, which will represent just exactly what America stands for in the Year of our President 2000!"[89] The text gives the newer picture a public voice that recognizes a competition among the photos for iconic status. This speaker is savvy in other ways as well, assuming not only social knowledge regarding the circulation of the image of the flag raising but also that the Iwo Jima photo was *the* model of the good war (i.e., the good use of force) and that it was the most "glorious" icon of them all. The flag raising still is being used to articulate cynicism that is activated in part through contrast with a nostalgic past, but it also takes a curious turn as the general thrust of the argument is on behalf of libertarian paranoia.

To summarize, the Iwo Jima flag raising demonstrates how iconic photographs have strong qualities of artistic performance, a series of transcriptions that carry deep resources for public identification, a rhetorical richness, open emotionality, and attitudinal range that facilitates civic life, and

sufficient circulation to ensure continual slippage, reactivation, and reflexivity. Whether it inspires civic duty or condemns personal egotism, whether on behalf of solidarity or *ressentiment,* or whatever turn it may be given in the continuing articulation of visual rhetoric, the iconic photograph continues to be a vital resource for U.S. public culture.

"AN ECHO OF IWO JIMA"

On September 11, 2001, terrorists hijacked commercial airliners and used them as guided missiles to attack two architectural icons of U.S. hegemony: the World Trade Center in Manhattan and the Pentagon in Washington, D.C. In the blink of an eye on live television and then over and over again, the nation watched as thousands of lives were destroyed. The national media response was comprehensive, including everything from special editions of newspapers and news magazines to new stories quickly added to entertainment magazines such as *Country Weekly* and to campus newsletters like the *IU Homepage.*[90] The coverage also may have been a high-water mark for photojournalism, as this profoundly visual event was immediately converted via digital technologies to thousands of color photos disseminated through the print media and their Web sites. This visual coverage repeatedly joined images of the destruction with depictions of the emotional reactions of ordinary people. As their shock, fear, grief, and despair was communicated through the mass media, and while government leaders were struggling to craft organizational and rhetorical strategies for state action, a direct and comprehensive emotional response to the event was modeled visually for a national audience.

This visual representation of the event soon developed a narrative logic for reconstituting the public audience as a unified nation whose civic virtue guaranteed triumph over the disaster. Images of rescue workers, still-standing buildings, blood drives, and the Statue of Liberty were all part of the mix, and by the end of the week a nationwide flag mania was underway.[91] Flag images dominated front pages and every section of the print media, flags were distributed in every available medium from newspaper inserts to decals, the Pledge of Allegiance was reintroduced into schools and civic rituals, and, of course, more than one retailer got into the act. The shift in emphasis emotionally was notable: fear and anger had not disappeared, but rather than accentuate resignation and despair, they were transformed into repeated performances of civic pride.

The many thousands of pictures taken of the 9/11 attacks and their aftermath included hundreds of outstanding photographs, and although the

thousands of flag images often were predictable, they also included many striking images of patriotism and resolve. If an icon was to emerge, it would not be for lack of competition or a need for additional coverage. It is all the more remarkable, then, that one image quickly became elevated above the others as the iconic representation of the event. We are referring to the image of three firefighters raising the U.S. flag amid the rubble that hours before had been the World Trade Center. Within days it was transformed from a single representation of a news event into a historic marker for the disaster and an interpretive frame for national response.

A number of different images (from several angles) of this event circulated through the media, but the one that quickly took pride of place was shot by Thomas E. Franklin of the *Record*, a Bergen County, New Jersey, daily newspaper and appeared on the front page on September 12, 2001 (fig. 22).[92] It was picked up and displayed on the front page of newspapers across the nation, as well as by network and cable television stations.[93] It began to appear on numerous Web sites and became the opening image of a PowerPoint presentation titled "Still Flying" that circulated internationally as an e-mail attachment. It was used by *Newsweek* as the cover for its special report titled *After the Terror*, by *Time* as the cover for its special report *Time for Kids*, by *Life* as the cover for its annual *Life: The Year in Pictures*, by Britannica as the cover for its 2001 *Year in Review*, and by *People Weekly* as the centerpiece of the cover for its annual double issue dedicated to "The 25 Most Intriguing People of 2001." It also appeared in numerous video montages shown on national television, including many that were displayed prominently during Sunday afternoon football coverage on the Fox Network, CBS, and ESPN, as well as during ABC's Monday evening NFL game of the week.[94] The image was reenacted at both baseball's 2001 World Series and football's 2002 Super Bowl and at local Fourth of July celebrations across the nation. Additionally, there was an immediate call to establish a memorial park at ground zero in Manhattan that would include a statute of the firefighters raising the flag, and there were so many requests for copies of the photograph that the *Record* initially set up a special Web site for distributing free electronic copies, as well as 8.5" × 11" prints and larger posters for a small donation to a disaster relief fund.[95] By December 13, the New Jersey Media Group reported that the fund had surpassed $1,000,000, largely through sales of the firefighter photo.[96] Subsequently that Web site has been devoted to outlining the criteria and procedures for acquiring permission to use the photograph on anything from book covers to coffee mugs, T-shirts, and much more. It also has been displayed as a special commemorative button, a framed collectible, a bumper sticker, and decal (all available at eBay.com), and it has been featured as a

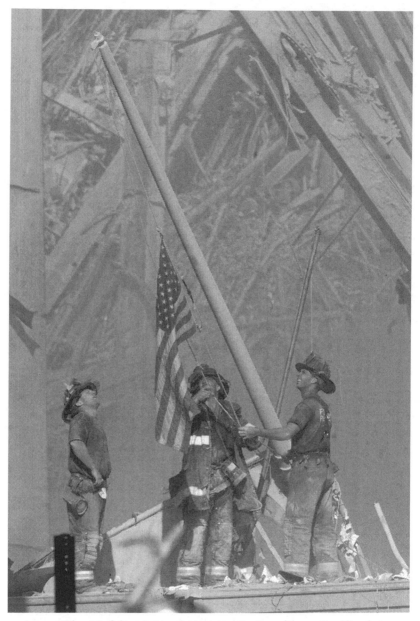

FIGURE 22. "Three Firefighters Raising the American Flag," 2001 (Thomas Franklin, photographer). Copyright 2001 *The Record* (Bergen County, NJ).

colorized silver dollar and a gold-plated Christmas ornament.[97] It was made into a three-dimensional display at Madame Taussaud's Wax Museum, painted on the wall of a Louisiana prison, and emblazoned on motorcycles, snowboards, and various collectible items like ashtrays and model train sets.

Soon the image itself was a story. *USA Today* reported that "the photograph has gone around the world from Ground Zero to Afghanistan. It has been tattooed on a man's arm, carved on a pumpkin and painted on a barn near Middletown, NY. It has appeared on magazine covers and slipcovers, quilts and campaign buttons. A woman in Stillwell, KS, hand glued 20,000 colored beads to create a mosaic of it. People in Arlington, TX, are making a stained-glass window of it."[98] Early in 2002 the photograph began to earn numerous awards—fourteen in all—including the AP Managing Editor's Photograph of the Year and the National Press Photographers Association's Attack on America Feature photograph of the year.[99] On March 11, 2002, the six-month anniversary of the 9/11 attack, President Bush held a special ceremony in the Oval Office of the White House where he was joined by the three firefighters and revealed a 45¢ stamp that reproduced the image of the photograph.[100]

What we find noteworthy is that this is the first instance of an iconic photograph being created out of the template of a predecessor. The point is made most clearly by the ways in which the two photographs have been juxtaposed across the field of public representation. *People* magazine captioned one version of the photograph as "an echo of Iwo Jima."[101] Tim Russert referred to it on NBC's *Meet the Press* as "Our New Iwo Jima," thus underscoring the connection between *then* and *now*, a linkage made even more pronounced on numerous Web sites that seamlessly juxtaposed the new image with its predecessor.[102] This correspondence was evident to others as well, including the photographer: "As soon as I shot it, I realized the similarity to the famous image of Marines raising the flag at Iwo Jima."[103] The *New York Post* saw it the same way and enlisted James Bradley Jr. to spell out the analogy, which he did, from the "spontaneous" origin of each photo to the egalitarian virtues and related "sentiments" held in common by the soldiers and firefighters.[104] This association continues in both visual production of and commentary on the image. Perhaps the most rhetorically transparent example is a History Channel spot entitled "A History of Courage." The composition mixes written text from the Declaration of Independence, oral remarks by Presidents John F. Kennedy, Lyndon B. Johnson, Franklin D. Roosevelt, and George W. Bush, a split-screen image of soldiers marching (above) and firefighters walking (below), and a series of flag images—at first in the background but culminating in moving pictures of the original Iwo Jima flag raising that segue

into the new icon.[105] The Iwo Jima image is captioned by Bush's voice, and the last image with a written text, "The History of the Spirit of America."

This doubling of the original image into the second is supported by two other developments in the public discourse generated by the attack: the prevalence of the Iwo Jima image in other visual rhetoric in the aftermath of the disaster, and revision of the previous discourse regarding "the greatest generation." No less than nine editorial cartoons using the Iwo Jima image appeared in newspapers and on the wire services within one week of 9/11.[106] In each cartoon we get the identical, full integration of the two scenes, such that the flag raising imitates the figural composition of the original photograph of the Marines on Iwo Jima planting the flag, but this image is then transplanted to the rubble of the World Trade Center with firefighters, policemen, and other rescue workers prominently substituted for U.S. Marines. These illustrations in turn are buttressed by unmarked use of the Iwo Jima image in photomontages and by verbal references to the icon that appeared across a range of print and digital media.[107]

These verbal references led directly to the many editorials, letters, and other commentary that appeared to praise contemporary rescue workers, generational cohorts, and citizens generally for their embodiment of the older virtues or their willingness to make the equivalent sacrifices.[108] For example, "I have been struck by the picture that many of you have seen in the papers of the firefighters raising the flag in NY. It brings to mind the raising of the flag on Iwo Jima during WWII. History repeats itself in many ways. Let us follow the guidance of that greatest generation as they fought and defeated evil. I am confident our generation will display the same courage and strength as they did."[109] The common message was made especially clear in a cartoon strip that has police "spontaneously" recreate the original flag raising, albeit this time in front of an approving public audience.[110] Police now are like soldiers then, the war on terrorism now is like war between nations then, and—note the addition to the composition—the public now is like the public then.

As the visual and verbal allusions make clear, the analogy emphasizes precisely those features of the original that distinguish it as a moment of visual eloquence. The firefighters are both featured in the commentary yet consistently and emphatically denominated by their anonymity and working-class norms of hard physical labor, self-sacrifice, and loyalty. The assertion of an identical response now as then reassures the civic republican anxiety about virtue being reproduced across the generations, while the photo repeatedly is captioned to emphasize consensus and the moral purpose of the republic. Captioning also underscores the nationalism of the image: the text

on the *Newsweek* cover photo reads, "After the Terror God Bless America." This nationalism is directed by the image, in which all three firefighters are looking up to the flag, yet the photo's prominence amid all the other flag photos—many of which show the flag itself to better advantage—derives from the way that the composition grounds the flag in a material embodiment of the civic virtues it represents.

There are additional connections as well. In each instance the photograph was taken within an event still unfolding amid great loss, and it acquires predictive power while redefining the event in terms of a still-unrealized victory.[111] Both photos are of incidental acts of display, and their news value is limited, yet each has become the definitive image for commemorating the event and motivating civic action. The pole cuts across the frame on the same diagonal in both compositions, while the flag itself is moved upward by coordinated effort. The flag raising is situated in a scene of barren devastation; there is no direct sign of the absent enemy who nevertheless remained a threat, whether lurking in caves on Iwo or in Afghanistan. Against this tableau of destruction and absence are anonymous, uniformed figures working together selflessly and without regard for their personal safety. Notice, too, that in each instance the particular tools of their profession—guns, fire hoses, flashlights—are either missing or deemphasized, muted by shadows and / or complementary colors. The central action of each photograph is forward looking as it visually collapses past and present into a promised future that is to be created by all citizens working together. These are not pictures of "war," however much the precipitating events and surrounding discourse might suggest otherwise, but of the reconstitution of civic virtues manifested within intersecting transcriptions of egalitarianism, nationalism, and civic republicanism.

There are a few differences within the visual field created by the two icons that also are notable, not least because they reflect changes in the public culture. The changes involve, first, a softening of the ideological categories that dominated the original photo's reception, and, second, a somewhat more liberal articulation of democratic solidarity. In the new icon and all of the cartoons using the older image, the figures are not soldiers per se but rather public service workers who adopt some but not all the elements of military organization. Thus, the shift from military to civilian articulation of a shared commitment has already happened within the image itself. This potential difference is pushed further in two of the cartoonists' transpositions of the Iwo Jima image into the disaster scene, as those illustrations include women among the figures raising the flag.[112] Contemporary egalitarianism still is represented primarily by images of the working class, but the composite im-

plication is that the United States of America is a pluralistic society in which solidarity includes expanded recognition of equal contributions and equal rights of other citizens, while civic action is directed through a range of predominately civilian activities.

Here too, however, we must acknowledge that the multiple transcriptions of liberal democracy within the image open it to a range of interpretations that oscillate between secular piety, irony, nostalgia, and cynicism. So, for example, even as cartoonists' revisions of the photograph to include women were met with the silence of consent, an effort to incorporate a racial element into a memorial statue of the image unleashed a firestorm of criticism. The ensuing debate achieved a sort of stasis between those demanding a memorial that was "historically accurate" and those demanding one that acknowledged the "multicultural diversity" of those who contributed to the common effort of response to the attack. In the end there was no easy accommodation, and the decision to build a memorial statue was tabled.[113]

These domestic alterations lead to the second variation on the Iwo Jima template. Notice that in the new icon we can see the faces of the three firefighters raising the flag. Although, vide the *New York Post*, their voluntary anonymity is an important piece in the mythic construction of the icon as a legitimate heir of the original, the newer image provides an additional means for putting a human face on the tragedy that buried thousands in a mass grave, and not incidentally, it depicts individual reactions to the event.[114] As opposed to being melded together into a single, massed effort needed to complete their task, the three firefighters are standing apart from one another. Indeed, like the audience for the photograph, they are united primarily by an act of coordinated seeing. And as that vision is focused on the rise of the flag, so does the nation provide an abstract basis for unity among individuals who otherwise remain distinct from one another in their separate standpoints.

We wonder if this inflection resonates with another strain of public discourse that has been actively promoted since 9/11, which is the appeal to fulfill one's civic duty by continuing previous levels of retail consumption.[115] If, as in the new icon, civic actors are still separate individuals, then perhaps individual gratification can coincide with civic duty. Liberal individuals acting independently in a free market are not a model for democratic action on behalf of the common good, and buying for one's self-gratification is a far cry from buying war bonds (and so depleting one's short-term discretionary income), but perhaps one can believe that individual shopping sprees and continued accumulation of consumer goods could reverse the economic losses from the attack. Although the predominance of the two flag raisings

in the visual commemoration of the disaster clearly is an important element in the resurgence of democratic solidarity that has dominated media coverage and public response in the period following 9/11, both the appropriations of the older image and the inflections in the new one suggest that liberalism has become more pervasive within the public culture than was evident in the photograph from 1945.

Yet even that is not the end of the story. In no time the appeal for patriotic retail consumption had become an object of satire, including two cartoons that used the Iwo Jima template. In the first of these, the soldiers labor to erect a tower of boxes labeled "printer," "microwave," and—at the top—"big screen TV."[116] In the second, the flag remains, but the soldiers have been replaced with a horde of shoppers bedecked with shopping bags.[117] Once again, the iconic image has been appropriated to fault the present for its falling away from the civic virtues of the past; once again, the difference is between self-sacrifice on behalf of a common good and the individual pursuit of privatized self-gratification. Even amid a comprehensive resurgence of nationalism, and one that included pervasive use of the Iwo Jima icon to revoke the discourse of generational decline and celebrate a reemergence of civic virtue, the iconic image also was used to provide ironic commentary on the president's evocation of national character.[118]

The point of all this is perhaps a simple one but worth emphasizing nonetheless. Photojournalistic icons operate as powerful resources within a public culture not because of their fixed meaning but rather because they artistically coordinate available structures of identification within a performative space open to continued and varied articulation. If these images are important elements of public identity, then scholars will have to readjust some of their conceptions of how identity is constituted. Both traditional conceptions of persuasive appeal and modern methods of ideology critique are needed to explicate the icon, while neither approach alone will capture how collective identity is negotiated aesthetically. Likewise, explanations of specific symbols such as the flag or specific ideological formations such as nationalism will need to recognize that specific images and their appropriation, which are endemic to public discourse, are means not only for transmission but also of inflection and critique.

This chapter identifies some of the complexities involved in the use and representation of such an image. When the Iwo Jima photograph first appeared in 1945, it was fundamentally an expression of secular piety for a social order compelled by circumstances to underscore the collective responsibilities of liberal democracy. In the wake of the social turmoil associated with the Vietnam War, however, and following the end of the Cold War,

the accent within U.S. public culture shifted from democracy and the *public* demands of collectivity to liberalism and the *private* needs of the individual. With that shift, reproductions and appropriations of the Marines raising the flag became the performative marker of a cultural tension that slowly had worked its way to the surface, signaling alternating attitudes of nostalgia (for an ideal past that never was) and cynicism (about an ideal future that seemingly never could be). The bombing of the World Trade Center and the Pentagon changed that, creating a crisis that once more shifted the accent in the direction of democratic solidarity. This renewed emphasis has been the result of many forms of public communication, but it seems undeniable that visual images have played an important role.

Public identity is negotiated in an event-driven process of performance and response, a process epitomized by its most prominent visual artifact, the iconic photograph. What appear to be distinctive images of historical events prove to be markers of a common yet complex way of seeing and acting toward others. Icons such as the flag raisings on Iwo Jima and at ground zero are used to affirm patriotic citizenship, criticize prevailing cultural beliefs and practices, and authorize and negotiate the diverse particularities of identity and affiliation in a liberal-democratic society. Whether objects of veneration or disparagement, they exemplify the importance of photojournalism in U.S. public culture.

5

DISSENT AND EMOTIONAL MANAGEMENT

KENT STATE

In bourgeois societies, emotional life is organized in part by a distinction between private experience and public restraint. The emotions themselves are understood to originate deep within the individual, their expression is one of the characteristics of private life, and sharing them is one of the surest marks of intimacy. When public life appears emotional, it is assumed to be imperiled: either the political official is exhibiting a loss of the self-control essential for responsible administration of the state, or the public audience is succumbing to those irrational impulses that can lead to demonstrations, riots, and the breakdown of social order. Political behavior, including not least of all political speech, is believed to require a governing rationality that subordinates emotional reaction to the deliberate, analytical assessment of interests and constraints, means and ends, and other objective features of the political environment.[1] Note, for example, Henry Kissinger's succinct reprimand of the students protesting the U.S. invasion of Cambodia: "They were, in my view, as wrong as they were passionate . . . Emotion was not a policy."[2]

This prejudice is reinforced throughout academic and public commentary. Criticisms of mass-mediated emotion are legion, with the fault being placed by turns on specific persuaders for manipulating mass audiences, on the public for being so susceptible to manipulation, and on the media for not exercising more self-restraint. Public affect is praised only when it is safely contained in nonpolitical venues such as sporting events or in decorous spectacles such as state funerals; otherwise, it is likely to be regarded with suspicion or condemned outright. Public figures are praised for their gravitas and ridiculed if they are too expressive.

This suppression of emotional display operates with equal or greater force in political theory. Whether discussing foundational concepts, political institutions, or international relations, the conventional wisdom is that such matters can be understood without emotional engagement.[3] Perhaps scholars need such working assumptions, and one must acknowledge that rationality is a difficult enough achievement as it is. As Barbara Koziak has argued, however, scholarly study on these terms can lead to serious failures in explanation while being complicit with political discourses that do not articulate sufficient means for achieving the promise of a democratic society.[4] One might add that indifference and lack of fellow feeling by leaders and voters alike may be a greater danger than surplus emotion in a modern polity, and that the greatest crimes typically are the issue of leaders who are at once too calculating and emotionally stunted. Nonetheless, understanding public discourse remains limited by a pervasive modernism.

This general suspicion or suppression of emotional display creates opportunities for both persuasive power and theoretical reflection. Because modern civic order is based on muted affect, emotional display can become a mode of dissent. Likewise, dissent is understood to be primarily an emotional phenomenon, something more likely to be signified by mute acts of display such as marching or flag burning than by verbal eloquence and printed documents. As these examples may also suggest, there can be a secondary alignment of affect and dissent with visual media. Some of the more conventional formulations include reporting political criticism whenever it is expressed visually, making such displays the center of protest coverage, limiting coverage of free-speech issues to debates about visual display, and faulting television for distracting or inflaming the public. This alignment of public dissent, excessive affect, and visual media is not writ in stone, but it has become a conventional discourse within and about the public media.

Because these conventions predominate, it is easy not to see the extent to which the media—including the print media—are awash in emotion, and even easier to misunderstand and undervalue the role of the emotions

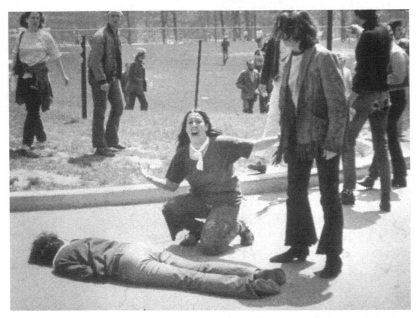

FIGURE 23. "Kent State University Massacre," 1970 (John Filo, photographer). John Filo/Hulton Archive/Getty Images.

in public life. We believe that emotions are crucial elements of democratic deliberation, judgment, and action. Full appreciation of their value requires moving beyond the assumptions that they are private experiences, subject to manipulation, and excessive. These assumptions are not false, of course, but only half true, and they obstruct understanding of how emotions comprise a language for collective life. To see how that is so, one must look to where emotions are richly articulated in the public media, identify how they are shaped by conventional assumptions and alignments, and consider how they also might be functioning rhetorically in ways that exceed those constraints.

If there is to be a test case for coming to terms with the public display of emotion in U.S. public culture, it should be the picture of a young woman screaming in pain, incomprehension, and outrage at those who have shot the Kent State University student lying dead on the pavement before her (fig. 23).[5] The shooting occurred on May 4, 1970, several days after President Richard Nixon had announced that the United States was invading Cambodia. Nixon's expansion of the war violated Cambodia's neutrality as well as his promise to the American people not to expand the war. Hundreds of campuses exploded in protest, some institutions were shut down, and the ROTC

building at Kent State went up in flames. It could easily appear that American society was spinning out of control.[6] Just after noon on Monday, soldiers of the Ohio National Guard opened fire on the Kent State campus, killing four and wounding nine.[7] The student photographer covering the scene saw the girl kneeling beside the body and letting out "a God-awful scream"; the photo went out on the AP wire that day and "quickly became an icon, that special kind of picture that somehow sums up a greater series of events," one that was "symbolic of the war fought on American streets."[8]

It is not enough to say that the photo sums up or symbolizes a historical moment, however. Because it has achieved iconic status, it will be schooling public audiences. Because it is a photograph that aligns powerful emotions with dissent, it provides a lesson in how citizenship can be experienced and articulated emotionally. Because its emotional register features the painful emotions characteristic of grief, it will have a special potential for shaping public memory.[9] As we shall see, however, identifying the visual eloquence of the photograph does not eliminate the problems endemic to reconciling emotional display and collective life. Perhaps the easy binary opposition with reason is set aside, but in its place we discover ineradicable ambivalences that insure that civic relationships are never settled. As we shall see, these problems include the need to feel like (not just as) an individual while still connecting with other people, and to engage with powerful emotions while still maintaining civic order. In the public culture of the United States, democratic dissent must reproduce liberal individualism to appear emotionally authentic, and for that reason and others as well dissent is both empowered and constrained by its visual expression. Emotional images may be crucial to deliberation on behalf of a just community, but they can be so only if deployed within conventions of public address that operate as an impersonal regime of emotional management. The study of iconic photographs can explicate these conventions, which in turn provide the backdrop for understanding the emotional richness and rhetorical power of the particular image.

THE CRY OF PROTEST

Although all iconic photos (and many others as well) evoke strong emotional reactions, the Kent State image is virtually unique in its depiction of raw feeling.[10] The composition of the picture focuses directly on the distraught girl in the center of the frame, and there on the expression of anguish created by her face and outstretched arms. Her scream seems to be ripping out of her heart, spontaneous, uninhibited, and unanswerable—almost as if she had

been the one shot. This feeling is powerful not only because of its expressiveness but also because it matches the political situation represented by the photograph. The girl's anguish registers not only personal affect, but the profound social rupture that has occurred. The U.S. government is not supposed to shoot its citizens for walking in public, or for gathering in free assembly, or for speaking and demonstrating against the actions of the government. Political conflict at home is not supposed to be a war, and by shooting thirteen students the Ohio National Guard had seriously wounded American society's basic sense of legitimacy. By crying out across the dead body as if to say, "How could you?" the girl fuses an overwhelming feeling with a fundamental belief. The result is "emotional," but one could also say that it is a concise representation of a complex and unusual event.[11]

This representation draws on and reproduces a fund of social knowledge. This knowledge has a specific structure that corresponds to key features of visual representation: it is both literal and typified, both manifest and latent, and both abstract and affective. Although the icon's legitimacy derives in part from the belief that a photograph is a direct, unaltered record of what actually happened in a unique event, its literal circumstances and corresponding news value are relatively unimportant.[12] Few of those who have seen the photo could identify the date it was taken, and almost everyone assumes that the screaming girl was a student.[13] As Michael Griffin has remarked, "The 'great pictures' . . . are seldom analyzed as informational illustrations of specific events and locations. Rather, they are celebrated on a more abstract plane as broader symbols of national valor, human courage, inconceivable inhumanity, or senseless loss. It is precisely their nonspecificity that makes them timeless."[14] To achieve this general effect, the iconic picture must rely on the viewer's recognition of typical settings such as the scene of a university campus and routine activities such as marching, milling around in a public space, and so forth. These typical actions can be related to a set of types. Through manifest gestures such as kneeling, opening one's arms outward, and crying out, a single figure can become the basis for a series of typified actions: the soldier kneeling beside a fallen comrade, a woman grieving aloud, a citizen calling down authority caught in criminal behavior, a supplicant begging for mercy, a victim giving oneself up to persecution. Whether resonant with classical tragedy, religious myth, or personal experience, such allusions can each bear a deep current of feeling.

This image of emotional expression is typical in another sense as well: like much emotional display, it is gendered.[15] Not only is it considered more appropriate and more natural for a woman to cry in response to distress or loss, but women also are the standard vehicle for representing emotional response

in public, for example, in response to an entertainer or public speaker.[16] The cry has stereotypically been more legitimate as a public act when coming from a woman, who becomes the sign of both domestic order and its collapse.[17] This structural intensification of the photo's explicit emotionalism acquires additional reinforcement from the alignment of masculinity and war. Note how the girl is positioned between two male bodies: one on the ground before her, and the other in bell-bottomed jeans standing beside her. One has been shot, while the other stands, seemingly unmoved (in comparison to the girl breaking down in grief beside him), looking as if for those who are shooting. Like the other figures in the picture's background (all but one of whom are male), he seems more a part of the scene than someone capable of responding to it emotionally. Like the other men behind him, his stance matches that of the National Guardsmen standing outside the frame: alert, calculative, focused on the enemy. Thus, he mirrors the political standoff between the Guard and the demonstrators—two groups of soldiers, one uniformed and one irregular (just as in Vietnam). These interlocking differences in gesture and gender then give a specific inflection to the girl's emotional outburst. Just as she is kneeling, she is breaking the political standoff by crying out (as mothers cry out for peace). As often is the case, a specific articulation of progressive politics relies on a relatively conservative set of social conventions, perhaps because they provide the surest connection to emotional identification.

This social mediation of the image directs the viewer to be critical of military action at home and, by extension, abroad, while it construes the antiwar movement as a paramilitary action that also should be stopped. Thus, the image's emotionality has a totalizing force: it calls for peace, but peace that would end both war and demonstrations. While articulate dissent at the time could involve sophisticated discussions of geopolitical policy and domestic politics, this image decries a breakdown of social order that neither side in the political conflict is likely to understand as each will use it for its own purposes, committed more to the fight than to what is at stake. The stage is set, then, for constituting a public response to the political standoff. A girl is positioned between two male bodies, one dead and the other unmoved. They are signs of the problem—citizens are killing each other, and escalation is likely—while she is incapacitated by her sorrow and fear. All she can do is cry out. The key to the political scenario being displayed is this: to whom can she cry?

Any text will hail an audience, but one source of a photograph's power is that its lines of interpellation can be a direct imitation of face-to-face interaction.[18] The Kent State image constitutes a public response by placing

the viewer within a precisely articulated relationship to a powerful, complex emotion. The girl's cry is a direct demand for accountability and compensatory action—a terrible wrong must be acknowledged and made right—but it is not stated directly to the viewer. Her body faces an area to the side of and behind the camera, and that vector is reinforced by the diagonal across the picture frame and by the line formed by the massed figures to her left. These literal vectors denominate an abstract space, one in which we suppose there are the Guardsmen who represent the state. She addresses the state: "How could you do this?" The picture, however, addresses the viewer. Her emotional outburst is not at us, and the picture offers it to us for reflection. We, the public audience, are at the end of a secondary vector formed by the stance and line of sight of the male figure to her right and the line running from the open space in the center of the picture between the two clumps of figures through the pole directly behind the girl and so through the girl directly to the lens of the camera.[19] These two vectors constitute an identity for the viewers of the photo: we are hailed as standing separate from, yet beside the state that is being denounced for criminal behavior. The girl is screaming at those beside us while being offered directly to us for our judgment or action. Thus, the photo's combination of emotional display and visual interpellation creates a strong sense of moral crisis, a point at which the audience must decide where it stands. Obviously, that choice is weighted, and the differences have specifically emotional components. If we align with the state, we are exposed to the full force of her blast. If we step toward her, we are drawn into an empathic relationship with a person in pain and also into a scene of political action and indeterminacy corresponding to the open space behind her. Furthermore, we already are indirectly responsible as bystanders to the criminal action, yet we are denied the easy option of simply stepping into the roles cast in the picture as they are all either part of the problem (the men) or not sustainable forms of political action at all (the screaming).

Any AP coverage of a political demonstration is likely to constitute its audience as citizens and citizenship as a property of democratic life that is grounded in the public media. The Kent State photo is no exception. Indeed, the photo is a picture of key elements of civic life: strangers congregate in an open space before public buildings, their clothes exhibit an egalitarian ethos while there is nothing to suggest that they will limit themselves to one subject or another, and their behavior indicates that they have the freedom from work or other obligations that allows discussion and collective action.[20] More ominously, but equally important, the acts of assembly and discussion evident in the picture are countered by the act of violence that originated outside the picture frame to silence one of the crowd and disperse the others.

The picture becomes a simulacrum of the public sphere, where free discussion among citizens and public accountability are the only legitimate means for countering state coercion.[21] More to the point, that public will only acquire political effectivity if it can hold the state accountable to public opinion. And so the picture articulates two additional choices that together create a particular structure for subsequent political action: will the public keep up the demand for accountability and change, and will the state respond adequately to that demand? If the answer to both questions is yes, then the joint structure is relegitimated and, by extension, other potential actors such as more radical demonstrators are presumed to be unnecessary.

This entire structure of articulation is presented solely through a visual image that is centered on an inarticulate cry. In one sense, the lack of text is an advantage, as it makes the basic structure of citizenship the key feature of the interpellation, rather than any topical claim about the war, the university, or society. To be a citizen is to act as a member of the public by developing those opinions that will hold the state accountable for its actions in respect to the public interest. No other ideas need apply. There is another implication as well, however. For the dominant elements of the visual presentation also give that structure a profoundly emotional inflection. In short, the photo reconstitutes citizenship as an emotional act.

As a legal construct citizenship is a formal designation of political membership and rights that is conferred by the state and held by individuals. For citizenship to be something that is practiced, valued, and defended, however, it must also be emotional—that is, something that can be experienced as an embodied way of reacting to the world. As Barbara Koziak has argued, the political emotion will be more than simple affect: it will be a complex scenario that provides sufficient resources for participation in a particular kind of polity.[22] For citizenship to function emotionally, it requires representation as a scenario of political action. By reading the iconic photo as a political scenario, we can discern how citizenship, like most emotional meaning in our society, is socially constructed as the property of individual agents.

These attributes of citizenship are built into the design of the Kent State photograph. The arrangement of the figures provides the first key, as the girl is positioned as the only node of expression within a dynamic swirl of activity. Indeed, the picture's emotional power comes in part from its strong compression of emotional display. Her intense expressiveness is heightened by contrast with those around her, none of whom are acting in a manner that would draw notice on any city street. And she appears to be on a street (it actually is a driveway): a strong border is formed within the picture by the curb that cuts across the horizontal frame, marking the open field in the

background and pavement in the foreground.²³ That pavement is another sign of a public space where citizens are to be protected rather than shot, and where individuals are expected to restrain their personal reactions rather than emote loudly. Thus, her scream is amplified by both the other figures' spectatorship and the pavement itself. This contrast is cemented by the dead body before her. The citizen who has been illegally deprived of his rights is also the body that can no longer speak. She becomes that body's voice, a ventriloquism that also transfers that body's lost citizenship to her outcry while making her capable of channeling everything else that is latent in the scene. Her scream is more than the expression of individual grief or a sign of personal injury, for it carries the social energies swirling around her while venting the deep betrayal that occurs when a citizen is killed by their own government. Although an individual actor, her place in the composition gives her collective agency, a cry of the people.

Just as emotions are construed as the outward expression of internal forces, the photo creates its own emotional power by situating an outcry within a compositional structure that compresses as it channels what is not otherwise being expressed in the scene. And just as emotions are thought to be individuated, so is a protest that applies to the entire polity expressed by an unknown individual. This reproduction of conventional assumptions about emotional life within the compositional structure of the picture provides the basis for redefining citizenship as an emotional practice that requires individual expression of social energies and collective values. Citizenship is transferable from one body to the other, not by legal entitlement or any contractual relationship, but through acts of empathy, affectional identification, and emotional expression on behalf of the other. Because the citizenship that one holds is something that the state can take away by force, then it also must be something that has to be practiced if it is to be retained, both for oneself and in trust with others. The girl becomes a civic model because she is capable of spontaneous, profound, authentic grief and rage on behalf of a fellow citizen.

This emotional display must be contained, however, because the public culture is also an achievement of rationality, self-control, and impersonal structures. The girl is the only one venting her feelings, and the picture would be very different (and not iconic) if everyone in the scene were doing so. Note how her emotional display is counterbalanced at every turn by norms of decorousness, not least the conventions for muting war photography. The body is not mangled, no wound shows, the face is averted, the blood drained away; it is a body "at rest." Likewise, the uniform pavement, the restrained or arrested behavior of all those around the victim, and the fact that the girl is

kneeling rather than in an upright and more belligerent stance suggest that her outcry is occurring within an established order of public representation.[24] The rhetorical power derives from its local transgression of this order, but not to the extent that it could stand for an alternative model of public speech.

This relationship between emotional display and public order receives an additional twist within the photo. There is one other woman in the scene, in the upper left corner. By her presence, the picture becomes perfectly balanced: a figure in each upper corner is equidistant from the girl, forming a triangle that starts with her and extends backward to outline the scene. The woman also is perfectly balanced: shoulders back, purse hung expertly by her side, a jacket tied neatly around her waist, an unbroken stride; she could be stepping out of a clothing ad or a college admissions brochure. She certainly doesn't seem to be affected by the events dramatically unfolding around her. Instead, she looks at the men to her left—not at the girl screaming or the dead body—and her gaze seems disinterested, perhaps analytical. Between these two female figures there is the strongest contrast in the picture. One is upright and walking, the other kneeling as if knocked down; one composed, the other falling apart; one unemotional, one venting agony; one a detached spectator, the other vividly engaged in the event.[25] They represent two extremes of political response, while all the other figures are milling around in a middle ground of intermediate degrees of participation. The question that arises is whether the overall design of the image makes any one of these figures more appealing than the others. The answer comes not from a grammar of visual design but rather from the nature of emotional identification. Instead of making one or another figure the basis for identification, the emotional structure of the event is constructed out of their relationships to one another, and those relationships then double as a range of choices for the public audience constituted by the scene. One's response to the shooting can range from acute protest to disinterested continuation of one's private life, while the feeling that one has from the picture itself is neither pain nor indifference, but a complex sense of both alarmed engagement and the need for continuity.

To summarize this additional complication of the photograph's overall structure, the image both evokes and constrains an emotional form of citizenship. On the one hand, the picture says that this is a time for emotional reaction, a strong reaction that may stop you in your tracks, disrupt your composure and those around you, a reaction that is by its very nature transgressive and a form of political dissent. This emotional response to a pub-

lic event is warranted by a series of breaches in public order that threaten every citizen: first by the demonstrators and now by the power of the state. Citizenship itself has to be exercised if it is to be secure, and that exercise will take the form of an emotional demand that the state stop waging war against its own people. On the other hand, the demand must occur within a context of self-restraint; one breakdown in public order cannot be repaired by another. Dissent is to be a strong but localized response, a direct call for accountability in respect to the specific events that triggered the emotional reaction. At the very moment that the public is to see itself overcome by the justified emotion of outrage, it also is to stand to the side of itself, capable of calculating and monitoring its actions in respect to conceptions of order and purpose. Either option alone would damage the long-term viability of a liberal-democratic society, which depends on both identification with others and individual autonomy.[26] By placing them together within an aesthetically unified composition, the iconic photograph transforms a record of a specific event into a structure for political identity.

Thus, the iconic image of emotional distress doesn't merely "appeal to our emotions," nor does it "inflame" or "manipulate" the viewing public. Such claims may sound simplistic today, but they were being applied with sledgehammer subtlety at the time. For example, an editorial in the *Cleveland Plain Dealer* lambasted the electronic media coverage of Kent State by repeatedly invoking a strict opposition between emotion and reason. The editorial writer claimed that nothing had "so distorted the reason and objectivity of television and radio news teams as did the deplorable incident on the Kent State campus. Never has one side of a story been so graphically illustrated, while the other has been so completely ignored or discounted. . . . It was a case of emotion winning the day and reason be damned." Moreover, this bias harmed the community, "for in a time of highly charged feelings the last thing needed is additional fuel." The local TV reporter "never quite managed to get her emotions under control." NBC news anchor David Brinkley, "who has never mastered the fine art of concealing emotion," was a "disgrace." The "cheapest moment" came when the media interviewed a father of one of the slain students: "The man, understandably near hysteria, made a number of irrational charges against the government and the condition the country was in, labeling it a totalitarian state." By contrast, we are told, the media should not crusade on behalf of "what it knows not," while it should have exonerated the Guardsmen who were merely providing the protection needed against "radical types."[27] The editorial is a perfect example of ideological distortion, slavish deference to authority, and faulty reasoning. More interesting, per-

haps, is its unintended consequence: by explicitly labeling official authority as rational even when it is out of control and murdering innocent citizens, it legitimates emotional display as a mode of dissent.[28]

The Kent State icon doesn't manipulate the public. The photograph does engage the viewer emotionally, but primarily by activation of a dramatic scenario in which specific forms of identification and participation become meaningful. In particular, the central concepts in this scenario—the concepts of democratic citizenship and dissent—are constituted as modes of emotional life, and they acquire specific powers and constraints accordingly. Although still firmly contained within norms of bourgeois society, these emotional resources are essential for sustaining liberal-democratic polity, not least against the authoritarianism exemplified in the *Plain Dealer* editorial. Because the photo embedded this complex emotional pattern into a record of unwarranted violence by the state, it has become an icon of dissent whose rhetorical power reaches well beyond questions of policy to influence not only the collective memory of an era but also future possibilities for civic action. To understand that trajectory, however, we need to focus on the photograph's most difficult appeal: its transcription of dissent as a moment of overpowering grief.

PUBLIC MOURNING AND POLITICAL IMAGINATION

Grief can appear to be an almost pure form of hypocrisy. Which is more greatly mourned, the dead person's loss of life or our loss of their company, support, and love? How do we deal with death but by both crying and laughing, and by both facing our mortality and fussing about the most trivial details of social life. Why the aesthetic excesses, whether for paid mourners in some societies, or in the United States for lavish caskets that will be sealed in concrete, buried underground, and never seen again? These are examples of the affected display that runs through the word "hypocrisy" straight back to its Greek root, the word for acting on stage. Although such complications and lack of economy are respectfully overlooked (and wisely so) in respect to private mourning, they are all that much harder to take when seen in displays of public grief, particularly when one has no prior attachment to the celebrity, public official, or accident victim whose funeral is splashed across the media today.

If one is to understand public emotionality, however, it is impossible to avoid demonstrations of public grieving. We believe that the Kent State photo has become iconic in part because of how it doubles as not only a statement of protest but also a public display of direct, spontaneous grief for the murdered

body on the ground. Such grieving is invariably messy and easily disparaged, yet it also may be an important means for articulating both solidarity and the need for renewal within the civic community. Even more important, perhaps, the commemorative impulse that also follows from public grief may help the political culture function as a community of memory.[29] Most important, the display of public grief may be necessary to maintain justice as a political ideal. We hope to demonstrate how the iconic photo is capable of these virtues, but not because it transcends conventional aesthetic and political norms defining public culture. Public grief, like any form of public emotionality, will always be conventional and thus also a thoroughly ambivalent agency of political reform. This more complex articulation becomes evident by examining further how the Kent State photo channels socially or politically disruptive emotions through conventions of decorousness, and then by considering how its performance of grief can be a model for embodied citizenship.

The photo relies on one of photojournalism's strongest conventions, which is to present a clean image of death. The significance of this dimension of the iconic shot is evident by comparison with two other photos taken on the same day. There are no photographs of Jeffrey Miller being hit and perhaps jerking, spinning, or crumpling to the ground, but there is another photograph of his inert body and a thick stream of blood flowing from his head across the pavement.[30] Also taken by the same photographer from the reverse angle of the iconic shot, this rarely seen image documents the violence of the killing. It also shows the two people attending to him, and their quiet laying on of hands offers performative evidence that the boy has been killed. In the iconic shot, both of these features are missing or hidden by the position of the body or bleached out by the angle of the sunlight. Most important, perhaps, the body with its face averted carries no record of pain. Even if Jeffrey Miller was killed instantly, the story of May 4 is one of great pain—from the thirteen who were killed, maimed, or wounded, to their family, friends, and other loved ones, and to the many who grieved over the violence and the damage to the body politic. Because the bloody image was taken by the same photographer who snapped the iconic image, we assume that it had the same opportunity for distribution; it obviously has a different effect, and one that has been relegated to the archive.

The second comparison case had full benefit of national distribution, for it was a *Life* magazine cover photo of another victim of the shootings (fig. 24).[31] It may seem surprising that this cover photo did not become iconic.[32] There is testimony to its powerful emotional impact, and it is the more direct representation of the pain experienced by those who were shot.[33] Prostrate, his chest heaving and head arching backward, the young man seems caught

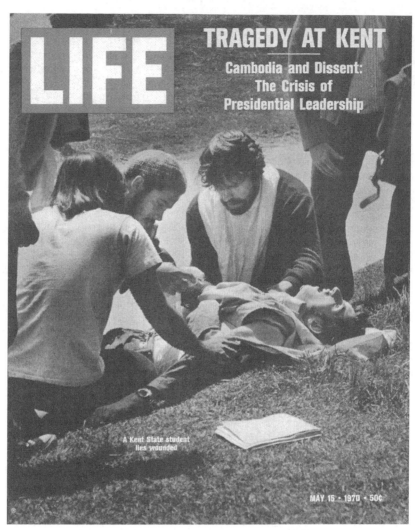

FIGURE 24. Cover, *Life*, May 15, 1970 (Howard Ruffner, photographer). Getty Images.

between pain and shock as he struggles to hold on to reality and not slip away, to live and not die. Surely this is a moving depiction of the pathos of that terrible day, but that is not enough and perhaps also too much for iconic appeal. The iconic photo, by contrast, is grounded not in the pain of those who were shot but rather in the pain that might be experienced by anyone else. It is primarily a representation of the public and primarily about public judgment or action, with its ostensible subject being subordinated to that end. Moreover, since it is reproducing the public culture, it has to respect the norms

of decorousness defining that culture. This becomes complicated when the photo also is articulating that culture emotionally, and even more so when the emotions communicated are emotions of dissent. Thus, a compensatory balance has to be established: both the transgression being depicted and the transgressive act of dissent have to be balanced by some sense of more basic order. As we noted above, this is evident in showing the murdered boy from the angle that minimizes the damage to his body. This convention is part of a general tendency in twentieth-century American culture toward a modern, "cool" emotionality, and of course, it is by placing the girl's strenuous cry between the wholly unexpressive body on the ground and the minimally expressive bodies also in the scene that establishes the dramatic power of the photo.[34] By wrapping the corpse in a shroud of decorum, the girl's transgressive emotionality is both amplified and balanced.

There is another contrast with the *Life* cover that applies here as well. In that composition, the body in pain is in equipoise with those attending to it through a tight center-margin design: one wounded student gasping in pain grabs our attention, but so do the attentive, serious students focused intently on tending to his wound. In this image, his pain is muted because balanced by their care. In the iconic shot, however, her pain is exploding upwards above a dead body powerless to do anything. Balance comes from the scene as a whole articulating the outlines of a public space that includes the viewer, while the picture shifts viewer attention from the damage to the dead body and terrible pathos of the dying to the experience of vicarious pain in a bystander.

This focus on the grief experienced by those physically, socially, or politically close to the victim in turn shifts the social context from one of either aid or retaliation to emotional management. Those around the dying may lose control of their emotions, and they are allowed to do so, but those around the grieving have a different obligation, which is to help the bereft regain their emotional stability. Thus, the emotional dimension of the iconic photo correlates with its political stance of legitimating topical dissent within a larger commitment to political moderation. The cry of anguish and the social fact of dissent must be acknowledged, but they are to have a limited continuity. The fundamental emphasis is not on the past event—which may in part account for the lack of public interest in the judicial aftermath that included at least one miscarriage of justice.[35] The emphasis is on the mutual readjustment of the community to heal the wounds of loss and grief and reconstruct a viable social order.

The reorientation toward a status quo in the emotional narrative implied by the iconic photo is evident indirectly from its use as a commonplace in radical advocacy. In the 1970 upheaval, it was used immediately in campus

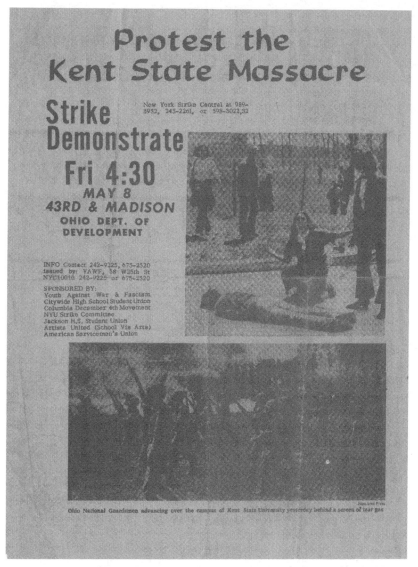

FIGURE 25. "Protest the Kent State Massacre," poster, 1970. Courtesy of New York University Archives.

newspapers and antiwar flyers announcing additional protests. Some are still around and available occasionally for purchase at flea markets and on eBay. The one we have selected is typical (fig. 25). Despite calling for the intentionally disruptive actions of a strike and demonstration, the poster ties those actions directly to the news media and other signs of legitimate citizenship.

The flyer consists largely of the call to action, the iconic photograph paired with a now forgotten photograph of the troops deploying across the campus, and a list of sponsoring organizations. The grainy production values of cheap and fast grassroots advocacy enhance the gritty documentary value of the photographs while evoking a public world of breaking news about citizen action to curb state power. The photographs provide a visual enactment of the cause for protest as they display a murdered student and (perhaps) the soldiers who killed him. The images also provide two alternatives for citizen action: the murderous conduct of the National Guard or public demonstrations like those at Kent State. The viewer clearly is to react against the one photo and identify with the other. Although it can be at most only three days after the iconic photograph was published, it needs no caption, while the other image is captioned and rather prosaically at that. The icon already stands by itself and is used as a powerful depiction of both the government's crime and appropriate citizen response.

Sometimes this iconic photograph has received additional enhancement, as with a record cover from 1970 that colorizes the picture and a contemporary Web site that crops the photo to a close-up shot of the girl's face.[36] The first change supplies a more sensory orientation to the photo, while the second amplifies her emotional distress. The best example of radicalizing the photo is its use in a poster (fig. 26) that is categorized variously as representing Kent State, the antiwar movement, or dissent.[37] By smearing "AVENGE" in red paint across the black and white icon, the poster makes its point eloquently: this is a picture of a murder by the state, justice is not to be found, and the only fitting recourse is radical, violent action in return. The red graffiti lettering adds several layers of transgression that, by direct implication, are not there in the picture itself. Red in this context is the color of blood and revolution. Graffiti is an act of violence to property, and the lettering on the poster treats the icon as public property in need of revolutionary graffiti. It also is an act of aesthetic violence: overwriting a visual image with verbal text, placing one artistic medium across another, covering the sharp pictorial realism of the photograph with a smear of paint, messing up the formal elegance of the photo. This violence is itself controlled, of course: note how the letters follow the diagonal from lower left to upper right, perfectly in line with the figures that ascend from prone to kneeling to standing. The poster is an act of desecration but also an artistically savvy example of visual rhetoric. It is unquestionably radical, however, particularly because of how it reframes the iconic image underneath the letters. The bold act of defacing the image to call for revenge assumes that the image itself does not direct that action. It has to be defaced, dehumanized, taken out of its context of grief, empathy, and

FIGURE 26. "Avenge," poster, 1970. Department of Special Collections and Archives, Kent State University. Courtesy of Kent State Archives.

emotional management, and redirected away from its complex emotional response of expressing dissent while reaffirming public order. Stated otherwise, the photo has to be altered aesthetically to call for violence because as it is it condemns violence—not just state violence but violent reaction to the state as well. Not surprisingly, the protestor who would have defaced the photo is, like the National Guardsman, outside the pictorial frame.

Thus, the icon's appropriations provide a larger register of its basic designs as it both legitimates and constrains dissent. Perhaps an iconic image is understandably ambivalent since it is used to reconstitute a public during a period of crisis or perennial conflict. Unlike both the *Life* cover and the "Avenge" poster, the iconic photo begs the question of what one ought to do; or, perhaps we should say it is left as an open question. Rather than modeling or calling for a specific action (e.g., caring for those who have been harmed or avenging them), the iconic photo models and evokes a powerful emotional bond between citizens that supposedly will motivate right action while leaving it undefined.

This lack of definition allows the photo to become a site for negotiating citizenship in subsequent generations. This civic function is most evident in a poster that was part of a commemoration twenty years after the killings (fig. 27).[38] The poster features the iconic image but with two significant

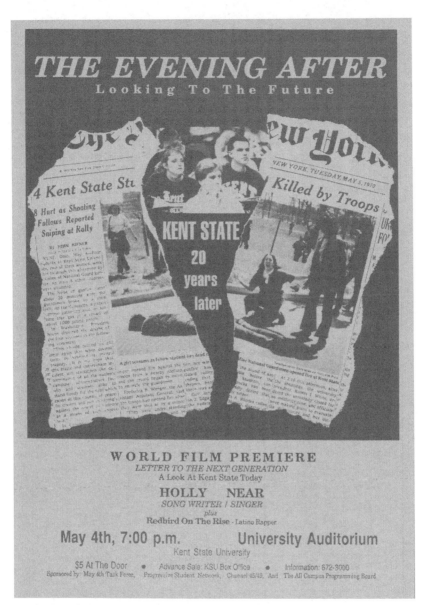

FIGURE 27. "The Evening After," poster, 1990. Department of Special Collections and Archives, Kent State University. Courtesy of May Fourth Task Force.

changes: It includes the surrounding newsprint from when it appeared on the front page of the *New York Times*, and it has been torn in two so that an image of contemporary Kent State students could be inserted. They are also the audience for the event, of course, and their representation shows them to be quite different than their counterparts in 1970. They are sitting in rows in a classroom, silent, with short hair, giving whoever is at the front of the room their full attention. According to the poster, it is now "The Evening After" (following a very long day, it seems), and this event is "Looking to the Future." Though still a progressive event, the poster's image fulfills the more conservative implications of the iconic photo: the photo has now been put into the past—that's the effect of returning it to that day's newspaper, dated May 4, 1970—and the contemporary student body, which has been inserted into the place of the public audience being hailed by the photo, is looking not backwards but into the future. They also are larger than the figures in the photo, which has been recessed back into the poster's aesthetic space. The poster's design still captures the original feel of the iconic photo by tearing it in half and actually breaking the dead body, yet this energy is funneled upwards into the staid image of the students. Just as the photo's desecration in the "Avenge" poster reproduced the icon's sense of social rupture and transferred the energy it creates to radical action, this progressive but not radical poster transfers that energy into the image of a young yet orderly public that is still preparing itself for responsible citizenship while awaiting its time to act, a time that will come only in the future.

Thus, while drawing on the icon's emotional power, including the power released by social rupture and signified by both emotional display and aesthetic transgression, there also is a strong tendency to reproduce its balancing norms of decorum. The icon is a complex representation of both rupture and continuity, transgression and order, emotional expression and management, dissent and moderation. The important point to be made here is that this ambivalence is inseparable from its influence. Stated otherwise, such tensions are continually being negotiated in public discourse and particularly through photojournalism, and calls for rationality are of little help in determining what is happening or how public opinion should be formed. The iconic photo will provide publics with the emotional resources that are crucial for understanding and responding effectively to complex political situations, but those resources include both forms of affective display and modes of restraint. As emotions cool, the icon can be used to reactivate them and so to keep alive the capacity for empathic communion with other citizens and for dissent against the state and its instruments of abstraction and rationalization. This is essential if citizenship is to be a lived, embodied

practice. Yet the same image can also school citizens in norms of decorum that will work more to the advantage of the status quo than to any attempt at broadening solidarity or opposing state action. And those norms also are essential for citizenship.

As both radical and more civil appropriations reveal, the Kent State image seems to be tilted more toward emotional management than one would think at first glance. It is an image of an act of and occasion for public grieving, but the eruptive, potentially irrational expression of grief also is contained with norms of public order. There is a deeper sense, however, in which the iconic display of the pain over the loss of another's life proves to be vital for the political imagination and so for a substantive idea of justice.[39] This emotional resonance, as well as its dialectic of death and reanimation, also is grounded in the design of the photo and revealed through yet another artistically accomplished appropriation.

The pretext for this next use of the iconic photo is the parking lot memorial constructed at Kent State. The story of that memorial typifies much of the aftermath of the May 4 tragedy. Persistent agitation by the local progressive community finally overcame the institution's unseemly recalcitrance to honor the dead and accept its place in history, leading to a compromise that might be an insult to the victims were it not so banal.[40] In response to the perceived "desecration" produced by "parked cars, oil slicks and massive indifference," stubby stone markers were erected in the lot.[41] These knee-high, abstract pylons look vaguely utilitarian, as though they could be used to extinguish a cigarette or park a shopping cart. Even so, the intention in placing vertical markers on an otherwise horizontal and wholly instrumental surface would seem to be to keep the lot from reverting to completely ahistorical use; at that point, the university would have effectively paved over collective memory. The memorial's strategy is brilliantly extended in a digital image (fig. 28) that superimposes the iconic photo on one set of the markers.[42]

This calling up of the image, as if out of a grave beneath the stone markers, reproduces what may be the most elemental design in the photograph, which is its transference of the pain of the murdered body to the still living girl. Indeed, it is crucial that she has *not* been shot; because of the lack of physical harm (to her), her cry of pain can perfectly symbolize the social rupture that has occurred. Everyone milling about in the scene is witness to a shooting, but only her expression of pain can communicate the unmaking of a world. This ventriloquism, by which she can speak for the dead, tells us what they have experienced and how they would howl in protest were they still writhing in pain on the ground. And because pain has no object and no

FIGURE 28. Prentice Lot Memorial Dedication, September 8, 1999, Monument, photo collage (Mike Pacifico, artist). Courtesy of Mike Pacifico.

limit, it is the ideal vehicle for dissemination: she speaks for all the dead—and so it does not matter that Jeffrey Miller may have felt very little pain or none at all—and she speaks for the wounded and for those wounded in spirit because they lost loved ones and for all those sickened by the Kent State violence.

She also speaks for the monument. The superimposition of the image both reveals and compensates for the aesthetic and civic weaknesses in the memorial sculpture. The struggle over collective memory that produced the multiple levels of the site was only minimally evident from the site itself, but this conflict is highlighted in the digital image. Likewise, the actual participants in the historical conflict, who also had been abstracted, are identified by the other images of soldiers, student protestors, and antiwar posters that have been added around the iconic image. The words "TRUTH DEMANDS JUSTICE" that also are superimposed from a protest banner provide continuity between the original antiwar movement and the subsequent protests to bring the National Guardsmen and other state actors to court. There is little doubt that small abstract poles set amidst a parking lot present a sorry representation of public culture, but the digitally enhanced image restores the people, the controversies, the civic ideals, and the emotions that are crucial for public life.

Both photograph and commemorative pylon are mute, of course, but it is clear that the photographic image is being used to give voice to a site that is inexcusably silent. That is why the image of her crying out has to be at the center of the composition. Nor is the silent image of a cry so paradoxical: "the open mouth with no sound reaching anything . . . coincides with the way in which pain engulfs the one in pain but remains unsensed by anyone else."[43]

The silent cry may be the most accurate representation of a cry of pain, while it doubles as a metaphor for how society does not hear, feel, or remember conflict, suffering, and the knowledge gained from suffering. The silent cry evokes a past that should be present for all rather than just for those who still are hurting. Just as the photograph restores the bodies that have been erased from public memory by the abstract design of the memorial, so does the body crying out restore the voice that has been silenced. And it is precisely because the cry is a cry of pain that the image can speak so eloquently: her crying out on behalf of the dead accomplishes a reanimation of the world that is essential if a damaged, war-torn society is to achieve justice.

As Elaine Scarry has suggested, the animation of inert material is at the heart of the creative process by which human beings make tools, forge civilizations, and generate art and culture.[44] This creative world making is revealed through her study of the world-destroying operations of torture and war, and by that comparison she discerns fundamental analogies between pain and the imagination. The iconic photo from Kent State demonstrates this deep connection: the girl's cry of pain, by temporarily reanimating the dead body, awakens her audience to possibilities for judgment and action that go beyond circumstantial understanding of the event and procedural resolution of the conflict. As one gazes at the photo, it becomes harder to say, "How unfortunate, he wasn't even a protester," or to passively observe the rationalization of the crime in university and civic investigations, slow-moving lawsuits, and private settlements. The icon not only testifies to a social rupture, it also tears open the institutional narratives for rationalizing the event to close the breach. In place of that reflex, the widening circles of pain radiating from her cry make possible to the imagination distant conflicts bursting into the settled arrangements of private life, unnecessary sacrifices for corrupt institutions and a criminal foreign policy, civic warfare and a society in flames. But that is not all. The image also makes possible ideas of a comprehensive public dissent, of political movements to not only stop the war but also create a more just society, of a democratic society attentive to human need and accountable to history.

Whether one imagines the one alternative or another, the expression of empathy for the dead is a sure metaphor for civic solidarity.[45] In fact, empathy is precisely the point at which the seeming hypocrisy of grief is revealed to be something else. While seemingly mourning our own loss, we actually are affirming the deeply social nature of our being in the world. The dead is shown to be the other self. Because this other self is found within a scene of political conflict, it receives an additional inflection: by grieving for a stranger cut down in public, the mourner affirms an elemental sense of

civic friendship. The fellow citizen is the other self of one's own public life. Without that deep solidarity, an emotional kinship that can only be taken up rather than bestowed by birth, there is no public life.[46] If it is not taken up, if we already are seeing public mourning from the standpoint of radical individualism, then we are left as isolated selves having no fellow feeling, we are inanimate to one another. Or, a bit more familiarly, we see how the other's grief is hypocritical.[47]

Thus, the public cry of pain, one that fuses emotional display with political dissent, is not just a condemnation of authority but also an act of world making. By reanimating the dead body, the girl activates and expands public imagination, an act replicated years later when her picture is used to reanimate a public memorial of the event. The visual artifact can conjure up the dead who would populate a community of memory, and it can call us to ideals that have yet to be adequately realized. This reanimation is possible in all media, but the visual image of a cry of pain seems to have a particularly strong impact, perhaps because it models the gap between pain and empathy, perhaps because it is used to mediate the gaps between lived experience and print media and between past and present in collective memory. Like the addition of her image to the abstract markers at the memorial site, the visual icon reanimates the world by giving body and even voice to the abstractions that also are essential constituents of political consciousness. Dissent, citizenship, the state, the public, order, and justice, these and other forms of political action are all caught in a continual alteration between the animate and the inanimate—between ideals and institutions that can be either vital and inert, creative or reified, nurturing or deadening. If an iconic image can reanimate a controversy, the past, or the idea of dissent, then it has helped democracy realize its promise.

PUBLIC EMOTION, LIBERAL INDIVIDUALISM, AND DEMOCRACY

As we have noted above, there is a conventional wisdom shared by pundits and many academics regarding the process of public opinion formation. This mentality maintains a strong distinction between reason and emotion, is alternately indifferent to and critical of both rhetorical and visual practices, and grounds civic education in literacy and print media. We have to admit that one doesn't have to watch a great deal of TV to see their point. A critic of these assumptions may be inclined to temporize, suggesting that emotions have their place, that they need only to be fenced in by a vigilant press, or that they can be neatly "commensurable" with public reason.[48] We believe that the study of iconic photographs reveals the need for an understanding of public

culture that is not only more nuanced than the prevailing ideas but that ultimately recognizes a different "language" of public life.

This reformulation begins by emphasizing how public reason has to be underwritten by public emotion, particularly if the public is to have the rhetorical effectivity that is crucial to its value and continued existence.[49] If public opinion cannot counter state power, and if public media cannot constitute an intermediate realm of civic participation between the state and private corporations, then why take the public seriously? Just as important, if citizenship is to be an embodied identity, an actual mode of participation in decision making rather than merely a regulative ideal, then it has to be articulated in a manner that encourages emotional identification with other civic actors. Likewise, the public media, rather than being a mode of restraint on emotionally charged action, need to employ those modes of representation such as photojournalism that can provide adequate and at times eloquent depictions of emotional complexity.

A second consideration is that one must acknowledge that an emotional public culture is not so much less reasonable as it is more unruly. Indeed, this may be why the opposition between reason and emotion can seem so intuitive; despite its variance from experience, it registers a phenomenological distinction between economy and excess that is a visible, persistent feature of social organization. This is the distinction, for example, between the bounded definitions of agreed-upon rules and the boundless articulations of both pain and the emotionally charged political imagination. Whatever it is called and whether rational or not in the particular case, this tension in public address is not to be avoided indefinitely. As the iconic photo demonstrates, public images can bring people to experience emotions that can tear them up, and although public emotionality always will be clothed in norms of decorum, it will have to remain dangerous if it is to be capable of overcoming what may be the greatest danger for public life: indifference towards others.

These considerations are examples of how a strong theory of public culture has to be more than a restatement of the ideal of public deliberation. By starting with a photo that evokes a strong association between visual imagery, emotion, and dissent, we can ask how a vibrant democratic public culture (i.e., one in which dissent is effective) is an emotional culture, how particular images communicate or constrain particular emotions, how particular emotions and emotional constraints alike might contribute to democracy, and how disruptive emotions can be crucial for democratic citizenship. We also have suggested that it is necessary to step aside from modernist assumptions about emotion in order to understand the emotional power of the iconic photo and of photojournalism more generally; likewise, analysis

of the iconic performance of a powerful emotion can illuminate something about the nature of emotions that is occluded by modernist assumptions. The visual icon demonstrates that although reason and emotion may not be neatly commensurable, the tension between them need not be a significant tension in public life. Instead, an analysis of how emotions are constructed in contemporary public address suggests that the key question for civic life today is how committed a society will be to either liberal individualism or democratic association. We also can see how liberalism is perpetuated by presenting emotions as if they were individual properties.

Fortunately, the work done on the social construction of emotions provides a useful vocabulary for getting beyond the common sense of liberalism. The first step that is needed is to set aside the conventional psychology that defines emotions as individual subjective states.[50] Instead of this conventional wisdom, the emotions can be described as shared (intersubjective) moods created by performance of appropriate gestures in a social space.[51] From this perspective, emotions are group properties, triggered by events or performances, established through communication, involving complex social forms, and producing social cohesion and persuasion. In order to accomplish these social functions, emotions "must be objectified in concrete symbols" that are found in public arenas and rituals.[52] Such emotions are culturally relative, which has several important corollaries: given emotions can be more or less available within any one society; available emotions will be intricately woven into the material fabric of a society; they will be used to cue and negotiate social relations from the basic social structure to speaker-audience interactions; and these contingent resources determine the quality of life for any given community. Emotions flood language and all other symbolic media in a society, yet they also can limit the capacity of the individual and the community to realize some goods.[53]

The iconic photo at Kent State illustrates these and additional features of emotional life that will escape notice from the conventional perspective on emotion. Rather than expressing or evoking individual affect, the photo provides the elements for constructing (and experiencing) a shared mood that is used to represent and direct action toward a complex event. The emotional character of the photo comes from its structure of display, one having an affective register that uses situational cues to activate culturally defined, socially organized norms for emotional meaning.[54] That structure includes an individual's cry as its central voice, but it also brings in other voices, some both censorious and relegitimating, and so the photo becomes a sophisticated political discourse that recreates the meaning of an event by locating it within a social space. This social location obviously provides a wide and deep

basis for public understanding and response, while at the time it created the means for emotional transformation of a longstanding political standoff that had been wasting lives and resources amidst general quiescence. A rhetorical moment was indeed emotional but only because emotions are rhetorical, and the persuasive breakthrough achieved by the photo was an example of a polity being brought to its senses by its capacity for feeling.[55]

This achievement is confounded, however, by a dilemma of emotional presentation in U.S. public culture. Although emotions are socially constructed, this society constructs them as properties of individual experience. Thus, the public media are in a mildly paradoxical condition of creating shared moods without going against the grain of the folk psychology of individualism. Depictions of public emotionality have to be made consistent with a conventional categorization of emotions as private, individual feelings. This is not difficult to do, as the Kent State photo demonstrates by focusing its display of affect on an individual figure whose subjective intensity is contrasted with the indifferent actions of the strangers who make up the social scene around her. As we noted in chapter 3, iconic photos rely on this construction of an individuated aggregate, which is the use of an individual figure to depict a condition requiring collective action. The individual has to be foregrounded to merit attention and establish identification in a liberal society, but she also has to be stylized enough so that the response to the social problem in question is a collective response regarding the appropriate class of people rather than personalized response to that specific individual. The Kent State photo provides an additional dimension to this mode of appeal by construing it according to that society's model of emotional meaning. In other words, there is an analogy between the social construction of emotions as if they were individual attributes and the self-understanding of a liberal-democratic society as if it were a collection of sovereign individuals. Both the emotions and polity are localized within the figure of the individual person who has both legal rights and an essentially private life. Any attempt to appeal to public feeling, and particularly to activate a manifestly democratic response such as dissent on behalf of a public interest, will have to work against but also with these interlocked cultural and political beliefs.

We believe the Kent State photo is successful in part because it masters this rhetorical problem. This resolution is not a fixed effect, however. As we noted in chapters 1 and 2, iconic photos acquire a semiofficial history that usually emphasizes a narrative of liberal individualism. This denial of the icon's social character works by personalizing the photograph; the first step is to identify by name the girl, Mary Ann Vecchio, and the photographer, John Filo.[56] The history of the photo's influence then becomes a story of individual

lives transformed by a single moment of media coverage and of a subsequent meeting that becomes a none-too-subtle narrative of closure for the event.[57] Our favorite example is Emerson College gushing about the meeting at its twenty-fifth anniversary conference:

> This conference marked the historic first time meeting of Mary Ann Vecchio Gillum, the fourteen-year-old girl pictured in the now famous photograph taken at Kent State, and the man who took that Pulitzer Prize winning picture, John Filo. The photograph, which has become an emblem of an era that will forever be a part of the American psyche, shows an anguished Vecchio kneeling over the body of Jeffrey Miller who had been shot moments earlier by Ohio National Guardsmen.
>
> The historic meeting was a success for both Vecchio, currently working as a cashier at a Las Vegas casino, and Filo, a deputy photo editor at *Newsweek* magazine, as well as Emerson College. News of their meeting and of the conference at Emerson appeared in such newspapers as the *New York Times*, the *Boston Globe*, the *Baltimore Sun* and the *Boston Herald*, and the Associated Press photograph of the first meeting ran in newspapers throughout the world. "It was finally time for us to meet," said an understandably nervous Vecchio. Upon meeting Vecchio for the first time Filo said, "I always worried about this person. . . . I am so happy that she is now happy."[58]

All that is missing is a smiley button. The visual representation of an appalling crisis in American political history becomes retold as a story of individuals making nice. Note also how the continuity between past and present is supplied by featuring Vecchio's emotional condition: the anguished girl is now calmer but still "nervous," and emotional performances are still gendered. (She is nervous, he reports on his emotions.) To complete the transformation of a disturbing history of public conflict into a present and future state of private happiness, the story also substitutes both a new picture and new emotions for the anguish radiating from the iconic image: in a snapshot that originally appeared on the Emerson College memorial Web site, Mary and John hold hands as if on a prom date while an accompanying note says "Love one another" (fig. 29), and in another the two are described as having "happier times today" while posed in a manner eerily similar to a snapshot of a couple comfortably settled into married life.[59]

Because public feeling is an important element of democratic polity, this privatizing of emotion can have antidemocratic consequences. The liberal transformation of public dissent into private coupling, along with its advice to "be happy," narrows the range of emotions to be experienced. In this case, only nice emotions are recognized and even they are curtailed; neither rage

FIGURE 29. "Mary Ann Vecchio Meets John Filo," Emerson College, April 23, 1995, (photographer unknown). May 4 Collection, box 109, Department of Special Collections and Archives, Kent State University. Courtesy of Kent State Archives.

nor love of country are included, for example. The projection of private life into the public realm displaces public emotionality and democratic solidarity alike. This is the dominant tendency in the entertainment media's celebrity culture and the surest mark of its influence on political rhetoric, and it is clear that not even the iconic photo can resist such a makeover.

By contrast, a more powerful public emotionality has greater range, not only because negative emotions are important resources for dissent (they are in private life as well), but also because the more open display actually has a different phenomenological structure. Rather than matching one emotion to another for direct empathy or imitation (being "nervous" or "happy," especially if one believes that happy families are all alike), the public emotion operates enthymematically: it provides a scenario that then is filled in affectively by the audience according to the varied experiences of their private lives.

To get a sense of this process, we might ask what emotion is being represented by the girl's cry in the iconic photo. Note that we have not used a single label, but have referred to it as anguish, grief, outrage, etc. Nor has the lack of specificity mattered.[60] We believe that there is no single term that describes her powerful blast of feeling, much less the emotional complexity of the photo as a whole. It may be that there are no English words corresponding to that specific emotion, but we believe that is not the problem.[61] The Kent State photo exemplifies the general characteristic of public emotionality that we identified in chapter 4 and that we shall develop further here: emotional displays in a democratic society are necessarily open or incomplete. What may be grief to you may be outrage to me, and we need not settle the disagree-

ment as long as the public text coordinates both responses along the same vectors of identification and action. The appeal to a public audience has to be enthymematic not just in respect to a fund of social knowledge but also in respect to a range of emotions. It has to allow for members of the audience to supply an emotional subtext to the message on the basis of different standpoints, experiences, personalities, and bodily dispositions.[62]

This openness is not quite the same as inarticulateness, however, especially when visual media are employed. Both the girl's cry and the overall structuring of the scene constitute a performance of emotional response to a political crisis that allows for a range of feelings to be organized and focused, but one would never say the girl is joyful or the scene is a dance around the Maypole. The openness is partially limited by the actual circumstances of the event, while it also acquires additional definition according to the several functions it serves. These functions include its representation of a complex social scene, channeling of multiple identifications, and capacity for nonpartisan affiliation. The photo does not survey the events at Kent State as a whole; there are a number of pictures of the confrontation, and no one of them tells the story. Instead, it is an arrangement of figures in social space that can map and activate available structures of feeling in the society. Whether the feeling of campus life, comradeship in a social movement, the rupture of the social contract, or a parent's love and fear for their absent child, the photo provides a visual form on which such meanings can be placed and applied to understand and react to the event. This schematic character of the photo may account in part for its persistence in collective memory and its capacity to act as a rhetorical commonplace in discussion of the antiwar movement.[63]

The schematic and typified character of this emotional tableau is reinforced by a curious omission in most reproductions and all commentary on the photograph. Much of the time, the girl's shirt seems to be a uniformly dark color.[64] The amount of darkening varies, but slight differences in tonality are not likely to be noticed in public media reproduction. There is a difference, however, in what one can see. In the lighter images, one can discern lettering across the front of the girl's shirt. That would hardly be surprising on a college campus, but she is not a student and the shirt does not say "Kent State" or "Ohio State" or "Harvard." If you look carefully you can see that it says "SLAVE." This was not a typical statement of either protest or countercultural identity in 1970, not in Haight-Ashbury and certainly not in Ohio. It is at best idiosyncratic, perhaps esoteric (a shortened form of "wage slave"?), and it could be kinky. In any case, the lettering sets her apart from her role in the political drama. Instead of much more broadly categorical ascriptions of a young woman, student, citizen, or even demonstrator, the label on her shirt

would suggest a narrower and potentially perverse basis for identification. But that doesn't happen, often because darkened reproduction of the image obliterates the confounding sign. Likewise, despite the delayed response of creating a narrative about the persons in the iconic photo, this facet of Mary Ann's identity has remained unremarked upon. For good reason, we would add. The emotional power of the photograph runs through its strong typification of civic actors.

This dependence on social types for emotional power is evident in a parody that appeared in the *Onion* during the 2006 NCAA national basketball tournament: "Kent State Basketball Team Massacred by Ohio National Guard in Repeat of Classic 1970 Matchup."[65] It seems that the Kent State players were overwhelmed by the Guard's "superior offensive firepower," while the article scored a double-double on the play of war metaphors in sports culture: "'It was an absolute bloodbath,' said Kent State head coach Jim Christian, who said he was 'still in shock' from the on-court massacre. 'We certainly weren't ready for what happened out there . . . one minute we were getting ready to square off, and the next they were just taking shot after shot . . . they just killed us out there tonight.'" There was one photograph with the story: Mary Ann Vecchio, now dressed as a Kent State cheerleader with a pompom in each outstretched hand, screaming over a fallen basketball player. The iconic template is assumed to be so obvious that the article never refers to the image, which has no caption. What also goes without saying is that the comic effect is created by the transposition from demonstrator to cheerleader, two stock figures of emotional display that imply very different conceptions of social order. Likewise, the article concludes by having a fan replicate the icon's form of address. "'I was only a kid when that happened [referring to the massacre of 1970],' noted local fan Lori Klaus, 'but I still knew that performance was a national disgrace . . . I guess now I'm part of history, too. . . . Why,' Klaus asked those around her. 'Why did this happen?'" As before, a young woman asks the public to demand explanation for a killing. The parody neatly reproduces essential elements of the iconic image, though now in a context that is silly. By doing so, it also highlights the contrast between the anguish of real murder and the artificially heightened emotions of the NCAA tournament. By making Vecchio a cheerleader, the *Onion* asks its audience to reflect on the political triviality of campus life today.

To conclude, if dissent is important to the wisdom and sustainability of democratic polity, then it is essential that public discourse is capable of emotional depth and power. We believe that visual practices have long been important yet undervalued constituents of democratic culture precisely because they are media for emotional representation that lead to performative

identification. That identification can contribute to rational deliberation, which can go awry without it. Iconic photos are special cases that reveal general tendencies in our public media and the culture they constitute. Through analysis of the Kent State icon, we hope to have demonstrated how a modern democratic society has developed both dissent and citizenship as emotional constructs. We also have suggested how public emotionality is less a matter of triggering or expressing affect than one might think, for it is a complex social composition defined by internal tensions between decorum and transgression, public display and private indifference, collective identity and individual autonomy, conventional forms and open interpretations, and other dynamics as well. The iconic photo is not just a condensation of more prevalent tendencies, however, for it can become a powerful schema of public memory because it alone is able to overlay the photographic record with a model of polity to manage a recurrent crisis in democratic social order.

We hope this analysis can illustrate and perhaps advance claims made about both the social construction of emotions and the relationship between emotions and political regimes. The Kent State photo seems to be a perfect example of what Koziak calls a "governing scenario of political emotion . . . These scenarios are the vivid images through which we recall quickly, and even unconsciously, what it means to be emotional or to observe an emotional event."[66] As they are explicitly political, these scenarios can reveal "how political regimes work, how they generate loyalty, how they create images of the relationship between citizens, how they manage what goods we expect from political community, and what we are willing to give to community and other individuals."[67] This may be a tall order, but its accomplishment certainly will depend on close analysis of the aesthetic designs and rhetorical functions that produce the appeal and influence of the iconic image within public culture.

In addition, if the Kent State icon is a reliable guide, we can qualify Koziak's commitment to the "integrative" emotions that would bind people together into mutually supportive civic relationships. Ronald de Sousa makes an eloquent case for valuing a wide range of emotions rather than limiting consideration to "a privileged class of ethically relevant emotions."[68] He doesn't want to abandon all sense of ethical discrimination, however, and neither do we. Thus, "ambivalence" becomes an inevitable attitude for the theorist and one recommended to the community, and attention remains focused on the criteria for inclusion or exclusion. One should add that this dilemma is continually being negotiated in public discourse (albeit often indirectly or in vernacular idioms) and that successful strategies there might reveal more general features of how emotions are and ought to be vital resources for the

conduct of life. Eugene Garver, for example, argues that the emotions connect reasoning to principles and perceptions necessary for achievement of the good life.[69] If these resources seem a bit too fixed in advance, we also should recall Scarry's insight into the deep connection between pain and the political imagination. The community needs not only integrative emotions but also those that can disrupt settled arrangements and make vivid the need for change because they know no bounds. Perhaps it is only by experiencing the limitless pain of betrayal that one can imagine justice and trust as uncompromised ideals.

At this point, it also is important to reintroduce suspicion of the electronic media, particularly Stjepan Mestrovic's claim that modern society now is "postemotional," a condition created and maintained in part by "the recycling of dead emotions from the past."[70] Both pain and the imagination are frightening and so often avoided. The continual reproduction of the iconic image, along with the likelihood that its emotional power diminishes over time, suggests that it could become a display of chloroformed passion, a specimen from an earlier, more vital era. This effect would be enhanced by both overexposure and the loss of context that comes from relegating the rest of the visual record to the archive. It is not a sure thing, however, and Mestrovic's analysis depends on precisely the modernist assumptions that we are challenging.

The complex yet open character of public emotional performance suggests that civic bonds are established not only by specific emotions—or virtues—such as compassion or friendship, but also by a more comprehensive flow of love, fear, laughter, hurt, wariness, grief, desire, and the many other feelings that flood language and all other social interaction. This stream of affect, and its corresponding disruptiveness or at least looseness of social and aesthetic control, may be an important feature of modern democratic life, and perhaps crucial in a liberal-democratic polity where vital yet temporary connections between public affairs and private life have to be continually reestablished if the civic community is to function.

Yet even this claim leads to another irony. To return once more to the Kent State photo and its reliance on gendered conventions of emotional display, we can ask whether the representation of democracy as an emotional practice can reinforce an authoritarian alternative. If the Kent State photo reconstitutes the U.S. public in opposition to excessive state power, it does so by feminizing that public. As Robert Ivie has argued, there is a persistent tendency in American politics to characterize democracy as fragile, vulnerable, always in need of protection by leaders and policies that necessarily are more "realistic," less "sentimental," and often more violent than would seem con-

sistent with democratic ideals.[71] This patriarchal conception of leadership is especially strong in foreign affairs, where it operates as a strategy for continually deferring democratic movements around the globe. The Kent State demonstration was one moment in a national protest against a foreign policy based on the assumption that democracy could not be established without military force, and controversy over the shooting of the students included a strong backlash of editorials and letters claiming that civil order must be restored at all costs to protect American liberty.[72] It is not enough, then, to keep the iconic photo before us as we remember Kent State, the protest against the war, or the Vietnam era. The image displays powerful emotions to generate rhetorical power on behalf of dissent, public accountability, and a vital form of citizenship. Yet it also coexists with discourses that restrict its power or turn that power against the public interest. An image of democratic dissent can become a sign of democracy's vulnerability and inadequate political agency. To counter this reaction, there is need for scholarly argument, prudent advocacy, and reasoned dissent. And for rage.

6

TRAUMA AND PUBLIC MEMORY

ACCIDENTAL NAPALM

Perhaps there should be no surprise that public discussion of the Vietnam War continues to haunt American politics. Despite President George H. W. Bush's declaration in 1991 that "we've kicked the Vietnam syndrome once and for all," the 2004 presidential campaign between Senator John Kerry and President George W. Bush took place as guerilla warfare against the U.S. occupation of Iraq was becoming increasingly violent, widespread, and effective.[1] While pundits debated the validity of comparing Vietnam and the second Persian Gulf War, Vietnam veterans campaigned for both candidates, Daniel Ellsberg wrote on behalf of leaking government documents to the press, troop morale declined, and the electorate polarized amidst claims that dissent was unpatriotic. Indeed, there is reason to believe that the war never ended, for a fairly direct line can be drawn from the bitter disputes about Vietnam to those neoconservative policymakers who seized the opportunity to get it right this time.[2]

The Vietnam War's reprise occurred in media behavior as well. Just as photojournalism had played an important role in defining the Vietnam War and motivating dissent, so were images of the war in Iraq becoming focal points of controversy and defining moments for public response.

The images are engraved onto the memory, pictures that become powerful summations of the nation acting in extremis—going to war.

Conjure them up: the battleship *Arizona* exploding at Pearl Harbor, Marines raising the U.S. flag at Iwo Jima, the naked Vietnamese girl running from a napalm attack, the South Vietnamese official shooting a man in the head on a Saigon street.

A deluge of images of the war in Iraq compete for that iconic status: an American soldier carrying a wounded Iraqi enemy, a statue of Saddam Hussein tumbling down, a triumphant President Bush in a fighter pilot's uniform, a despondent Hussein undergoing a dental exam, burned bodies hanging from a bridge in Fallujah, rows of flag-draped coffins in a military transport plane, a hooded Iraqi prisoner standing on a stool, his body apparently wired for electricity.

Which pictures attain that status will depend on how the nation chooses to remember this war—as an altruistic attempt to liberate an oppressed people, a well-meaning but misguided incursion into a complicated culture, or a blatant abuse of American power.[3]

We can almost see the winnowing shed of media history at work. One must question the mechanism, however, for it is unlikely that the nation first selects a story and then supplies the pictures. The images themselves and the uses made of them will influence the collective scriptwriter. Indeed, the inability to lay Vietnam to rest, despite the short-term attention span and near-total historical amnesia of the U.S. media, may be due in part to the fact that collective memory of that war was defined by images that are themselves traumatic.

Because those images are also thought to have been influential, they are being called on again as public debate flares up in response to the more recent war's images of U.S. criminality: the photographs of American soldiers terrorizing prisoners in Abu Ghraib prison.

Governments tried to claim—as usual—that this exposure of their actions was "irresponsible," but without the photos the torture and killing that had been documented for a year would never have been available to us: the precondition to our being able to stop it. In the same way, the anti-Vietnam War movement gave us the tragic photo of the little girl burning from US napalm referred to now as a turning point in ending that war.[4]

They are contested for the same reason, as when another commentator suggests that the Abu Ghraib photos are "just evidence" rather than "icons," that is, no reason to question more than the behavior of those few indi-

viduals committing the crimes.[5] While the administration launched its media campaign to contain the damage done by the torture photos and to return to a narrative of spreading democracy, commentary on the Web repeatedly turned to the images from the earlier war in order to comprehend the new photos of Americans abroad.[6]

For obvious reasons, there is more agreement about which of the Vietnam images are iconic than there is regarding those from Iraq. "The defining image of the Vietnam War was the naked little girl running down the road crying, her clothes burned off by napalm. The defining image of the Iraq war will probably be Private Lynndie England in a corridor in Abu Ghraib prison, holding a leash attached to a naked Iraqi man lying on the floor."[7] To make it from "probably" to "the defining image" can take time. It does not require unanimity, however, for other Vietnam icons have received similar labels. What matters is why any icon continues to define the past, how it is evoked in contemporary public debate, and what its continuing history of appropriation reveals about public culture. The image of a naked little girl running down a road reveals that the comparisons with Vietnam are neither misplaced nor driven by events alone. That little girl will not go away, despite many attempts at forgetting.

She is running down a road toward the camera in Vietnam (fig. 30), screaming from the napalm burns on her back and arm. Other Vietnamese children are moving in front of and behind her, and one boy's face is a mask of terror, but the naked girl is the focal point of the picture. Stripped of her clothes, her arms held out from her sides, she looks almost as if she has been flayed alive. Behind her walk soldiers, somewhat casually. Behind them, the roiling dark smoke from the napalm drop consumes the background of the scene.

The photo was taken by AP photographer Nick Ut on June 8, 1972, released after an editorial debate about whether to print a photo involving nudity, and published all over the world the next day.[8] It then appeared in *Newsweek* and *Life* and subsequently received the Pulitzer Prize.[9] Today it is regarded as "a defining photographic icon; it remains a symbol of the horror of war in general, and of the war in Vietnam in particular."[10] Amid many other exceptional photographs and a long stream of video coverage, the photo has come to be regarded as one of the most famous photographs of the Vietnam War and among the most widely recognized images in U.S. photojournalism.[11]

The photograph's iconic stature is believed to reflect its influence on public attitudes toward the war, an influence achieved by confronting U.S. citizens with the immorality of their actions.[12] These claims are true enough, but they don't explain much. As early as 1967, Robert Kennedy could assume

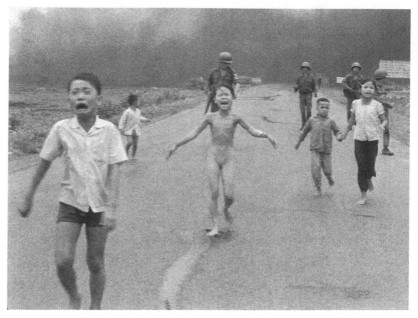

FIGURE 30. "Accidental Napalm," 1972 (Nick Ut, photographer). AP/Wide World Photos.

people knew what he was talking about when he said, on the floor of the U.S. Senate, that "it is our chemicals that scorch the children and our bombs that level the villages."[13] By 1972 there had been many, many press reports and a number of striking photos that would suffice as evidence for any claim that the United States was fighting an immoral war. Indeed, by 1972 the public had seen burned skin hanging in shreds from Vietnamese babies, a bound Vietnamese prisoner of war being shot in cold blood, the slaughtered bodies of My Lai, and similar pictures of the horror of war.[14] The iconic photograph could not have been effective solely because of its news value, nor does it appear to be especially horrific. In addition, the captioning and other information about the causes of the event and its aftermath would seem to limit its documentary value. The story is one of "Accidental Napalm," as the photo was captioned in some reports;[15] the strike was by South Vietnamese forces, not U.S. troops; the girl was immediately tended to and taken to a hospital. As an indictment, there isn't much that would stand out after cross-examination. And why would a still image come to dominate collective memory of what is now called the first television war, a war the public experienced via kinetic images of firefights, strafing runs, and helicopters landing in swirls of dust and action?[16]

An image of suffering can be highly persuasive, but not because of either the realism ascribed to the photo or its relationship to a single set of moral precepts.[17] A structure of public moral response has to be constructed, it has to be one that is adapted to the deep problems in the public culture at the time, and it has to be consistent with the strengths and weakness of the medium of articulation. This iconic photo was capable of activating public conscience at the time because it provided an embodied transcription of important features of moral life, including pain, fragmentation, modal relationships among strangers, betrayal, and trauma. These moral circumstances are strengthened by photographic performance, particularly as they reinforce one another, and their embodiment in a single image demonstrates how photojournalism can do important work within public discourse, work that may not be done as well in verbal texts adhering to the norms of discursive rationality.

The iconic photograph of an injured girl running from a napalm attack provides a complex construction of viewer response that was suited to the conditions of representation in the Vietnam era, while it also embodies conventions of liberal individualism such as personal autonomy and human rights that have become increasingly dominant within U.S. public culture since then. This ongoing mediation of public life can be explicated both by examining how the photograph's artistry shapes moral judgment and by tracking subsequent narrative reconstructions and visual appropriations of the image in the public media. In what follows, we show how this photograph managed a rhetorical culture of moral and aesthetic fragmentation to construct public judgment of the war, and how it embodies a continuing tension within public memory between a liberal-individualist narrative of denial and compensation and a mode of democratic dissent that involves both historical accountability and continuing trauma. This tension reflects and reproduces essential features of the public itself, a social relationship that, because it has to be among strangers, is ever in need of images.

CIVILIANS IN PAIN

The little girl is naked, running right toward you, looking right at you, crying out. The burns themselves are not visible, and it is her pain—more precisely, her communicating the pain she feels—that is the central feature of the picture. Pain is the primary fact of her experience, just as she is the central figure in the composition.[18] As she runs away from the cause of her burns she also projects the pain toward the viewer. This direct address defines her

relationship to the viewer: she faces the lens, which activates the demanding reciprocity of direct, face-to-face interaction, and she is aligned with the frontal angle of the viewer's perspective, which "says, as it were: 'what you see here is part of our world, something we are involved with.'"[19] The photograph projects her pain into our world.

This confrontation of the viewer cuts deeper still. Her pain is amplified by the boy in front of her, whose face resembles Edvard Munch's famous painting *The Scream*. That pain, like all great pain, breaks up the social world's pattern of assurances. Just as she has stripped off her clothes to escape the burning napalm, she tears the conventions of social life, a disruption signaled by the photo's violation of the news media's norms of propriety. Public representation is always constituted by norms of decorum; without them, the public itself no longer exists. Yet war by its nature is a violation of civility, normalcy, civic order. Thus, a visual record of war will have to negotiate an internal tension between propriety and transgression.[20] So it is that lesser forms of transgression can play an important role in the representation of war. The nonprurient nudity of the napalm photo doesn't just slip past the censor's rule, for the seeming transgression of her nakedness reveals another, deeper form of concealment. The image shows what is hidden by what is being said in print—the damaged bodies behind the U.S. military's daily "body counts," "free fire zones," and other euphemisms. The photo violates one set of norms in order to activate another; propriety is set aside for a moral purpose.

Girls should not be shown stripped bare in public; civilians should not be bombed. Likewise, U.S. soldiers (and many viewers mistakenly assume the soldiers are U.S. troops) are supposed to be handing out candy to the children in occupied lands, and the United States is supposed to be fighting just wars for noble causes. Just as the photograph violates one form of propriety to represent a greater form of misconduct, that breach of public decorum also disrupts larger frameworks for the moral justification of violence. Like the explosion still reverberating in the background, the photograph ruptures established narratives of justified military action, moral constraint, and national purpose.[21] It is a picture that shouldn't be shown of an event that shouldn't have happened, and it projects a leveling of social structure and chaotic dispersion of social energies. The picture creates a searing eventfulness that breaks away from any official narrative justifying the war.

The photograph appeared during a period when the public was recognizing that their government was waging war without purpose, without legitimacy, and without end. The illusion of strategic control had been shattered by the 1968 Tet offensive, all pretence of consensus had been killed in the 1970

shootings at Kent State, and by 1972 even those prolonging the war were relying on a rhetoric of disengagement. To those living amidst the public controversy about the war, it seemed as if the war made no sense and U.S. society was coming apart at the seams.

This sense of fragmentation was amplified by the media practices defining the Vietnam War. Day after day the public saw a jumble of scenes—bombings, firefights, helicopter evacuations, patrols moving out, villages being searched, troops wading across rivers—that could seemingly be rearranged in any order. If there was any organizational principle to this flow of images, it was that of collage: a seemingly shapeless accumulation of images that contained moments of strong association, irony, or unexpected allure, but that lacked any governing idea. This continual stream of images reflecting a war without clear battle lines dovetailed perfectly with the government's lack of either a plausible rationale or coherent strategy.[22] In addition, the reproduction of the details of everyday décor and ordinary behavior underscored the general substitution of scene for purpose. Try as the proponents of the war in Vietnam might to resurrect the idea of a theater of war with clear battle lines and victories, all on behalf of a justifiable political objective, such ideas were at odds not only with the nature of that war but also, and perhaps more important for their persuasive objectives, with the visual media that were shaping public knowledge of the war.

In short, what was a sorry truth about the war became a dominant feature of its coverage. The daily visual record of activities was likely to make the war seem to have no purpose. Although this media environment was primarily televisual, it reinforced the most significant effect that photography can have on the understanding of war. As Alan Trachtenberg has observed of Civil War photography, the "portrayal of war as an event in real space and time," rather than "the mythic or fictional time of a theater," was accompanied "by a loss of clarity about both the overall form of battles and the unfolding war as such and the political meaning of events."[23] In other words, the photographic medium is inherently paratactic: because photographic images operate meaningfully without a connecting syntax, these images denote only fragments of any coordinated action.[24] They give specific events a singular significance, but they leave larger articulations of purpose outside the frame.

The accidental napalm photograph is a model fragment. Featuring anonymous figures in a featureless scene that could be occurring anywhere in Vietnam, lacking any strategic orientation or collective symbol, confounding any official rhetoric of the war's purpose or U.S. commitment to the Vietnamese people, devoid of any element of heroism, and clearly recording an unintended consequence, it would not seem to qualify as an event at all. But

it does qualify, because the photo's fragmentation carries with it a shift in the basic definition of an event: an event is no longer an action that comes at a dramatic moment in a sequence of purposive actions; instead, it is an experiential moment having heightened intensity independent of any larger plot.

The photo's embodiment of an aesthetic of fragmentation not only captured the character of a purposeless war, it also provided a means for resolving the moral predicament the war presented to the American public. How can any idea of right conduct be established within a condition of political and representational incoherence? It is within this context that the girl's nakedness acquires additional meaning. As Michael Walzer observes, even hardened soldiers are averse to killing an enemy who is out of uniform.[25] Simple vulnerability, particularly as it is symbolized by nakedness, puts us in an elemental moral situation. More to the point, nakedness in war foregrounds the moral relationships that still bind strangers to one another. The uniformed soldier has an identity; the naked body has been stripped of conventional patterns of recognition, deference, and dismissal. Like the parable of the Good Samaritan, which featured a naked man discovered along a road, the girl's naked vulnerability is a call to obligation, and as in the parable, one that has occurred unexpectedly. In the words of John Caputo, "Obligation happens."[26] Obligation can appear out of nowhere, without regard to one's social position, directly encumbering one in ways that are decidedly inconvenient and, worse, that may disrupt deep assumptions regarding how one's life is patterned and what the future should hold. Thus, the photo abruptly calls the viewer to a moral awareness that cannot be limited to roles, contracts, or laws; neither is it buffered by distance. A fragmented world is still a world of moral demands, only now they may be most pressing when least expected, and the demand itself can shatter conventional wisdom.

By activating this deep register of moral response, the photograph counteracts the conventional political realism that places war and international relations generally outside the moral circumference of domestic politics.[27] This field of moral action also is constructed through a number of departures from the conventions of war photography. It features civilians rather than soldiers, those acted upon rather than those acting, people harmed by our actions rather than by the enemy, a failure to protect rather than protection extended, unintended consequences rather than strategic action, war's continuing hurtfulness rather than an aftermath of dead bodies in repose. Above all, it shifts attention from the national subject to the distant consequences of state action. For a sense of contrast, place this image of war against the soldiers raising the flag on Iwo Jima. In place of identification with a heroic

version of the dominant subject, the napalm photograph encourages identification with alien victimage. This difference carries with it a corresponding shift from a logic of imitation to a logic of compensatory action.

Because the girl in the photo is anonymous, the response to the photo has to be to the class she represents rather than merely to that specific person, and so the compensatory action also becomes generalized. It concerns a class of people who can only be helped by people acting collectively. Because this sense of unexpected collective obligation conformed to the growing unease about the war within the American public at the time—and as the moral and financial costs of the war were continuing to accumulate—the picture could become a rallying point for opposition to the war. Despite anyone's best intentions or prior indifference, the public audience now was obligated to counteract the violence of their own state. Public action would consist not of emulating other citizens but of doing something else to help a stranger.

This identification with the stranger has both a modern face and the structure of classical tragedy. The girl's nakedness provides a performative embodiment of the modern conception of universal humanity. She could be a poster child for the Universal Declaration of Human Rights, and as an adult she both has served as a goodwill ambassador for the United Nations and founded an international organization to aid children harmed by war. The dramatic charge of the photo comes from its evocation of pity and terror: we see a pathetic sight, the child crying in pain, and as we enter into her experience we feel both pity for her and the looming sense of terror that lies behind her injuries. The terror that tragedy evokes comes not from the physical injury itself but from the social breakdown behind it, which is why Aristotle noted that the most effective tragedies involved harms done off stage and within the family.[28] The picture reproduces this design: First, despite its patently visual nature, the napalm attack is already over and the girl's burns are not visible—most are on her back, and the photograph's low resolution minimizes the others. (Aristotle's dictum also helps to explain why more gruesome pictures of children burned by napalm failed to become iconic.) Second, she is a child, a member of a family, and familial relationships are either modeled (between the children) or broken (between parents and children, as the biological parents are absent and the other adults are indifferent soldiers). The pity for the child is compounded by this sense of social breakdown; again, the horror of war is the destruction of social order and of meaning itself. Her pain activates the terror of tragedy, which comes from the realization that humans can be abandoned to a world no longer capable of sympathy, a world of beasts and gods, of destructive powers and impersonal forces, of pain without end.

This tragic structure is filled out by the relationships between the children and the soldiers. The crucial fact is that the soldiers are walking along slowly, oblivious to the horror surrounding them, almost nonchalantly, as if this were an everyday experience. Their attitude of business as usual contrasts vividly with the girl's sudden, unexpected, excessive experience of pain and terror. The message is clear: what seems, from looking at the girl, to be a rare experience sure to evoke a compassionate response, is in fact, as evidenced by the soldiers, something that happens again and again, so much so that the adults involved (whether soldiers there or civilians in the United States) can become indifferent, morally diminished, capable of routinely doing awful things to other people. Precisely because the photo is operating as a mode of performance, its formal implication is that what is shown is repeated behavior.[29] The photo that will be reproduced many times is itself not the record of a unique set of circumstances but rather a dramatic depiction of those features of the war that are recurring over and over again past the point of caring. As the girl screams and other human beings walk along devoid of sympathy, the photo depicts a world of pain that reverberates off of the hard surfaces of moral indifference. This is why knowledge of the circumstantial events (such as the girl receiving treatment immediately) rightly provides no qualification to the moral force of the photograph. The knowledge that would matter would be a demonstration that this was a rare use of napalm, or that U.S. forces and their Vietnamese allies almost never harmed civilians in the war zone. But, of course, by 1972 the truth of the brutality of the war had breached the surface of national consciousness.

This aspect of the photograph is highlighted in a drawing by Jon Haddock titled "Children Fleeing" (fig. 31). The work is one in his Screenshots series, which recreates photographic or filmic images as drawings from "an isometric perspective, in the style of a computer game.[30] Each of the Screenshots places the viewer above the action; that shift in perspective, along with the flat surfaces and toy-soldier modeling, makes one aware of the combination of virtual involvement and emotional buffering characteristic of video game technologies. In a few of the shots, however, Haddock introduces additional distortion of the original image. By moving the viewer to the back of the scene, Haddock makes the soldiers the center of the photograph and perhaps the cause of the children's terror. The soldier's nonchalant attitude is even more apparent, and, since there now is no sign of the napalm, it is as if the children are fleeing from the soldiers. It is the soldiers and not any "accident" that is the leading edge of the war's disruption of domestic life.

Thus, the iconic photograph is not about informing the public; rather, it offers a performance of social relationships that provide a basis for moral

FIGURE 31. Jon Haddock, *Children Fleeing*, Isometric Screenshots Series, 2000. Courtesy of Jon Haddock.

comprehension of and response to what is already known.[31] These modal relationships in turn can exemplify morally significant actions such as self-sacrifice or betrayal. The full significance of the photo's depiction of these relationships becomes clear when one recognizes how it also reflects the dilemma of democratic accountability in modern war. On the one hand, the citizen-soldier is both agent and representative of the public; on the other hand, the public has authority for but no direct control over their troops. When those troops are projecting power far away yet reported on daily in the national media, the situation gets even worse. It is easy for the public to find itself guilty for actions it did not sanction, and for soldiers to be blamed for events no one anticipated. Soldiers and civilians alike can feel betrayed.

The napalm photo features two betrayals. Whether American or Vietnamese, the soldiers are agents of the United States who are supposed to be protecting the girl, yet they appear content merely to herd her and the other children down the road. The soldiers are not helping, they even seem to be treating the children like prisoners of war (for guns are still drawn), and they are indifferent to the suffering before them.[32] A little girl seems to appeal directly to the public for help, yet it can do nothing while its representatives in the picture add insult to injury. As the girl is betrayed by the institutional

181

figures who are supposed to protect her, so is the public betrayed by the same institution.[33]

Although the activity within the frame directs action, the fact that this is a photograph—a "static" image—means that time has been stopped. The picture holds its experience of terror and uncompleted action for all time, while having the activity within the frame eternally repeat itself (for that is what it is, performatively restored repetitive behavior). This mythic sense of eternal recurrence as well as its "vertigo of time defeated" corresponds perfectly to the phenomenological structure of trauma: one simultaneously feels stopped in time while constantly repeating the actions within that isolated moment.[34] The normal flow of time has been fragmented into shards of isolated events, while the traumatized subject remains trapped in the continually recurring scene, unable to break out of the ever-recurring pain. Although this phenomenological state is commonly thought to result from exposure to carnage, Jonathan Shay has pointed out how the deeper cause is a sense of betrayal.[35] Likewise, an iconic photo that is said to capture the horror of war is not gruesome, but it does freeze the spectator in a tableau of moral failure. Betrayal short-circuits the power of institutional narratives to sublimate disturbing incidents, and the photograph perpetuates this sense of being caught in time, helpless before the event itself, unable to move on. This sense of powerlessness extends to control of the memory itself, as the image circulates through the media, recurring again and again unbidden.

Thus, the photograph came to provide symbolic representation of the U.S. public's experience of the Vietnam War. Somehow, it seems, the United States got caught in a situation not of its own making, a morally incoherent situation in which terrible things were done to other people, things the public still can't face and can never set right. Against processes of denial, the photograph provides at least an image of this condition: having already done the wrong thing, wanting to do the right thing, yet frozen, incapable of acting in that place at all. Nor will history oblige by allowing the nation to start over or restore a sense of innocence. The basic conditions of modern U.S. warfare are all there: imperial action in a distant, third world country far from the public's direct control; massive, technologically intensive firepower being used to spare soldiers' lives at enormous rates of "collateral damage"; mass media coverage sure to expose guilt while apparently providing no means for action. The moral danger of this world is captured tonally in the picture's composition of light and darkness: as the dark smoke blots out the sky and while the girl bathed in light has in fact been seared with liquid fire, the elements of the sublime are present but out of order, gone demonic. Light hurts, darkness towers over all, awe is induced by destruction, terror is not

sublimated to a transcendent order. The photo depicts a "troglodyte world" where moral norms have been either inverted as children are being targeted or abandoned as soldiers walk through the scene not caring.[36] The image calls a public to moral awareness, but its rhetorical power is traumatic.

THE LIBERAL ANTIDOTE

The photograph's activation of the structure of trauma is evident as well in its subsequent history of interpretation. According to Shay, the crucial step towards healing from a traumatic experience is to construct a narrative of one's life that can contextualize the traumatic moment.[37] The narrative does more than soothe, for it addresses trauma's crucial characteristic of being bracketed from any sense of temporal continuity. The traumatic moment is stopped in time, and narrative gets time moving again so that the moment may eventually recede, dissipate, or become complicated by other elements of larger stories.

This photo has produced several narratives.[38] The most frequently told of these is the story of the relationship between the girl, Kim Phuc, and the photographer, Nick Ut.[39] Both of Vietnamese ethnicity, they became lifelong friends. "Nick Ut visits Kim Phuc and her family often in Toronto. 'Kim and I are almost like family, she calls me "uncle" and I talk with her almost every week,' he said."[40] The story functions as a convenient displacement of responsibilities while breaking out of the traumatic moment. Her Canadian citizenship provides an easy surrogacy that neither involves the U.S. public directly nor leaves them completely out of the story. Likewise, the family now stands in for all other relationships, from friendship to the uncomfortable fact that he once recorded her suffering. As he becomes a surrogate uncle in her new home, public trauma is displaced by the generosity of private life. Most important, within this context she can be safely transformed from an anonymous girl into an individual person. She has a name, and the story is now *her* story, a unique personal history that may or may not be publicized. Where once the photographer created her as a public image, now he validates her as an individual person.

A recent variant of this story is Denise Chong's *The Girl in the Picture*, which chronicles Kim's personal odyssey of recovery while trying to free herself from the publicity generated by the photo. "She felt as though the journalistic hounds would make her into a victim all over again. 'The action of those two women [both journalists, one with a camera] on the sidewalk,' she lamented to Toan, 'was like a bomb falling out of the sky.'"[41] Note how this narrative replays the performance of the iconic photograph: allied tech-

nology continues to harm an innocent Vietnamese civilian, while the public again is drawn into an act of inflicting pain it did not authorize, an act that can only be redeemed through empathic identification with her suffering. The traumatic "scars [that] war leaves on all of us" are then ameliorated by a narrative of her life after the war.[42]

Another, rather peculiar story is that of the Rev. John Plummer, who confessed to be the officer who had ordered the air strike that burned the girl. Plummer staged an elaborate and improbable reunion with the girl (now a woman), resulting in a second picture titled "The Meeting at the Wall," this one of the two of them smiling cheek to cheek as if at a honeymoon resort in the Poconos.[43] It turned out, however, that Plummer had not ordered the air strike.[44] What is most interesting about this revelation is that, although there was much discussion of the misrepresentation, the response of many commentators was charitable.[45] The lack of scandal, especially among veterans, about a veteran's phony confession of guilt is remarkable, but it can be explained. On the one hand, the assumption of excessive guilt is a characteristic of the post-traumatic stress disorder suffered by some veterans and an understandable attempt to overcome their paradoxical sense of being criminals in a morally incoherent world. On the other hand, both veterans and the public needed such a story of reconciliation.

This relationship between trauma and a rhetoric of healing that can displace concerns about justice is most evident in the picture of Kim with her infant child (fig. 32) taken by photographer Joe McNally in 1995.[46] This picture may also be an attempt at something like a visual sequel to the iconic photo, and one that supplies a Hollywood ending for the story. The continuities and discontinuities between this photo and the icon establish the key differences in effect. Her nakedness is still there, but it has been carefully controlled by changes in posture and camera angle to maintain the modesty expected of a grown woman and a tranquil public culture. Her injury is still there, of course, but now the effects of the war are to be dealt with on an individual basis, and those who created them are no longer in the picture, no longer capable of being interrogated or condemned.

Perhaps the soldiers have been replaced by the scars on her skin. The display of the scars also reveals the relationship between the physical and symbolic dimensions of the two images. In the iconic photo, her physical wounds were not visible; they were communicated by her expression and the other child's cry of terror. Thus, the physical harm that was the most basic consequence and moral fault of American military actions was depicted indirectly. In the sequel, the physical harm is revealed, but given its relationship to the other features of the picture, it acquires a different significance. Now

FIGURE 32. "Kim Phuc and Child," 1995 (Joe McNally, photographer). Reproduced by permission of TimePix.

the wounds are superficial, for they appear to have no effect on the woman's internal health.[47] Inside, she is capable of bearing a "normal," healthy baby. And what a baby it is: unblemished, its new, smooth skin a striking contrast to her mature scars. Now the physical damage to Kim is merely the background for a tableau of regeneration. Although she is not doing that well in one sense, for she is still scarred, she obviously has achieved one of the great milestones of personal happiness by giving birth to a healthy child. While

185

the past is still present, it is inert, no more than ugly tissue that has no power to prevent a new beginning and personal happiness. In the United States, history lasts only one generation.

The sunny optimism of this story of war's aftermath is validated by the rest of the composition. Her beatific expression and the figural enactment of Madonna and child portraiture suggest a serenity in which traumatic memory or persistent conflict has no place.[48] Likewise, in place of the dark smoke from the napalm blast, the background of this photo is a darkened blank wall. This gentle décor and her carefully draped clothing invoke the conventions of retail studio photography, which in turn anchor her happiness within a familiar scene of private life: the framed portrait that is displayed proudly by the child's grandparents.

All of these changes occur within a thoroughly traditional transcription of gender roles. The muted sexuality of her late girlhood has been channeled into the conventional role of motherhood. Men clearly maintain their monopoly on violence, while a woman embodies the virtues of nurturing; Vietnam and peace itself remain feminized while war and the American military establishment retain their masculine identity.[49] The scene defines private life as a place centered on women and children, where mothers are devoted to and fulfilled by caring for their families.

The shift from public to private virtues has been encoded by taking a second photograph for public dissemination in a manner similar to taking a photograph for distribution within one's family. The substitution of photos provides a double compensation: Kim has been given a beautiful child to replace her own damaged childhood, and the second image is given to the public in recompense for its past discomfort. The baby also replaces the other children in the original scene—those running down the road and those who didn't make it. The war is over, and children who could be running in terror for their small, vulnerable lives are now sleeping quietly in their mothers' arms. Moreover, where the earlier children were Kim's siblings and so the sign of collective identity, this child is her child, her most dear possession and a sign of the proprietary relationships essential to liberalism. The transformation is complete: from past trauma to present joy, and from the terrors of collective history to the quiet individualism of private life.

Thus, this sequel to the iconic photo inculcates a way of seeing the original image and the history to which it bears witness. A record of immoral state action has become a history of private lives. Questions of collective responsibility—and of justice—have been displaced by questions of individual healing. The wisdom that recognizes the likelihood of war's eternal recurrence

has been displaced by a narrative of personal happiness and of a new, unblemished, innocent generation. As Nick Ut commented, when being "reunited" with Kim Phuc at the exhibition of the McNally photo at the West Los Angeles Museum of Tolerance, "Vietnam was a great tragedy, but she is lucky. I am very happy for her."[50]

What is important to note here is that the reinscription of the iconic photograph by the second image is neither unique nor inappropriate. It invokes a therapeutic discourse that has become a symptomatic and powerful form of social control in liberal-democratic, capitalist societies.[51] Two dimensions of that discourse are directly relevant to the case at hand. First, as Peter Ehrenhaus observes, the therapeutic motif "voyeuristically dwells on intimacy and poignancy while never violating the illusion of privacy."[52] And second, as the emphasis shifts attention from public to private trauma, it invokes a context of "individual or family responsibility" that contains dissent directed towards the social and political order.[53] In the second photograph, then, Kim Phuc's "private" recovery and maternity substitute for the napalm girl's "public" cry of pain; the effect is to foreclose on acts of dissent that would question state accountability.

This narrative containment of the original image is not a wholly unwarranted imposition, for that image draws upon conceptions of personal autonomy and human rights that are foundational in a liberal-individualist society, it features a wounded individual crying out for help, and it produces a traumatic effect. The second photo's visual reinterpretation of the war is achieved not by distorting the iconic photo but rather by extending designs in the original that were essential for its moral significance and rhetorical appeal. In short, as the second photograph reworks artistic elements of the iconic image, it enhances an ideological transcription that was already available within the scene. Indeed, the "second" inflection helps to define the original image, as when the icon is celebrated in an exhibition because it is "a symbol that has helped lead toward reconciliation."[54]

So it is that this iconic photo can be both unusually striking and unavoidably ambivalent. On the one hand, a partial record of a supposedly incidental moment became a defining event of the war, one capable of negating the moral certainty and aesthetic unity of the U.S. culture that had coalesced during World War II. On the other hand, the photograph is not only a transgression but also the enactment of another model of political identity always available within U.S. public life and ascendant amidst the prosperity and contradictions of the postwar era. Rather than simply tear down one set of ideals, it also advances the habits of another way of life.

The McNally photograph provides a transcription of the public culture by recoding a public controversy about the justification of war as a story of innocent individuals ambushed by history. It recodes years of deadly violence against a people as a story of how one individual has been wounded. It recodes questions of justice as a rhetoric of healing. By the time that "Kim's Story is one of forgiveness—of the personal and public healing of wounds from this century's longest, most divisive war," it has become a story in which personal experience cannot just represent but also displace public relationships.[55] This is a fundamental dilemma of liberalism: by making the individual's experience the primary source of meaning, internal transformations can suffice for action in the world. In addition, the more the physical wound persists as a metonym for all the damage done by the war, the less concern there need be regarding larger forms of responsibility. Physical wounds need only medical care and time to heal; some political traumas can only be resolved by confronting questions of justice and restitution. The photograph of a wounded girl does operate as a "primitive theater," but one that can leave the audience capable only of going their separate ways.[56]

In this liberal sensibility, actions are meaningful because they are symptomatic of internal conditions rather than because they adhere to proven models of character. The individual's experience is the primary locus of meaning, and conflict resolution may be as much psychological as political. The individual's autonomy and human rights supersede any political identity, and obligations are encountered along the road rather than due to any sense of tradition or collective enterprise. Collective action is essentially moral and humanitarian rather than defined by national interests, but it also is ad hoc, not directed by long-term objectives and analysis. The fundamental tension in political life is between the individual and society, and once the individual is protected other political possibilities are likely to be deferred to the more immediate engagements of private life. And when private life is synonymous with national healing, public life becomes a dead zone, a place, as we shall see, that is inhabited by ghosts and where images become specters of reanimation.

DISSENT AND THE HAUNTING OF PUBLIC CULTURE

Barthes asks, "Mad or tame? Photography can be one or the other."[57] The photograph "Accidental Napalm" is repeatedly tamed: by the banality of its circulation, by personalizing the girl in the picture, by drawing out a liberal narrative of healing, by the segue into the celebrity photo of Kim's regeneration, and more. But it also remains mad: an indelible image of terror

FIGURE 33. *"Veritatis* Vietnam," photo collage, 2000 (Edward M. Chilton, artist). Courtesy of Edward M. Chilton.

that obsessively repeats itself, that keeps the public audience interned in the real time of fatality rather than fantasies of renewal, staring at screams that cannot be heard and haunted by ghosts that will not speak. This madness is something that need not be far from the anger fueling political dissent, and although grounded in the image, it does not happen by itself; rather, like taming, it is something that results from continued use of the image.[58]

As images become disseminated they also become resources for public argument, particularly as advocates themselves are skilled in using visual materials. A strong example of artistic accomplishment in grassroots public discourse was provided on a Web page titled *Veritatis* Vietnam, designed by Ed Chilton, a Vietnam veteran still critical of the war.[59] Chilton digitally superimposed the napalm photograph over the U.S. flag and the face of Cardinal Spellman, archbishop of New York, who had aggressively promoted the war in Vietnam until his death in 1967 (fig. 33). The explicit intention is to excoriate Spellman for his support of the war. Although the verbal text following the image may seem too much of a harangue, the visual collage is hard to get out of one's mind. It achieves this effect by reproducing key features of the original photograph's rhetorical power, but now though a seemingly supernatural projection of that image into both past and present. Indeed, time is nightmarishly scrambled, as the girl from 1972 challenges the cardinal who died in 1967, while they are placed together on the Web decades later. The composition is haunting, and for good reason: the girl is now a ghost, a fragment of the past that will not be assimilated into the amnesia of the present.

Once again, the photograph breaks into official representations of U.S. institutional legitimacy. Once again, it is aesthetically and morally disruptive: it should not be inserted into the image of the flag, just as the naked, terrified girl should not have been on everyone's breakfast table, and it tells the audience that things that should not happen did happen. In the composite image, the photograph's role in a struggle over the meaning of the war is heightened: by intruding into images of the flag and the two crosses on the cardinal's shoulders, the scene becomes a battle between the icons themselves. The war is brought home, as actions over there are shown in direct clash with symbols of legitimacy here, and dominant institutions are confronted with their complicity in the war's destruction of innocent children.

As before, the napalm image is a fragmentary scene, one obviously located in the specific historical event of the war, yet not enfolded into any sense of a progressive historical narrative or sound military strategy. Indeed, the children's screams of terror tear apart the official narratives of American political and moral superiority. This attack on institutional authority is strengthened by the image of Cardinal Spellman. His position at the front of the composition parallels the position of the soldiers in the rear as they are roughly equidistant from the children. His crosses are placed as if they were military insignia (cardinal or general, did it matter?), and his expression can be read as either implicitly predatory (the large round head, raised eyebrows, and intently focused eyes are owl-like) or morally hardened (the facial mask is uniformly controlled and blank while his mouth is pursed as if to make a dismissive remark). Once again, the public sees its representatives—now those who promoted the war along with the soldiers who fought it—acting as if they were habituated to the suffering they imposed on others.

The fact that it is *once again* is no accident. As before, the image captures the trauma victim's sense of being stuck in time. In direct contrast to the narratives of compensation and healing used in the mainstream media to neutralize the iconic photograph's sense of guilt, this image reinserts the past into the present to immobilize those attempting to move beyond past conflicts and historical responsibility. The superimposition of images does not just compare the past with the present, it fuses them: the image of terror and guilt now is always within the flag, an ineradicable part of the United States' legacy. Likewise, the flag and institutional religion are exposed as covering devices, symbols and discourses (such as the cardinal's public speeches on the war) that are used to suppress moral truth and public guilt. Like the icon within it, the composition evokes a psychology of eternal recurrence and denial. Although this structure of feeling can be dismissed as yet another example of Vietnam syndrome, it also is another instance of the tragic dimen-

sion of war's pathos—why will more continue to be sacrificed? Because the knowledge gained of suffering will be lost or denied to those who remain.

All Chilton wants to do is blast Cardinal Spellman, and he does a pretty good job of that. His most important accomplishment, however, is restoring the iconic photograph to its rightful place in public discourse. As any icon floats through media space across subsequent generations, and particularly as it gets rewritten into liberal narratives of individual healing, it can lose too much of the political history and emotional intensity that are essential for participation in democratic debate. By placing the icon against the symbols of the flag and the cross, this appropriation restores the conflict, hypocrisy, complicity, confusion, and intensity that fuels debate about the war. Above all, it restores a sense of public life. The girl is no longer a single individual, and the question is not whether she is happy today. Once again it is a picture of the victims of military action and those who marshaled their destruction, of the public's lack of control over a war fought in its name, and of the questionable moral legitimacy of U.S. institutions. By restoring the public context that in turn allows the iconic photo to challenge authority, the composite image demonstrates that perhaps not everything is lost after all.

This call to public conscience is evident in another remediation of the photo, this time by transposing the girl into an illustration that accompanies a *Boston Globe* review of a book on the Vietnam veterans' movement. The review is titled "Soldiers of Misfortune," and the visual composition (fig. 34) is a stunning depiction of the multiple layers of suffering that characterized the Vietnam War.[60]

The girl is running forward, her arms stretched out, as she always is running, but now she is passing through a sprinkler on a suburban lawn. She still is screaming, but now she is wearing a bright polka-dot bikini. Behind her smoke still billows upward, although now it comes from the chimney of a suburban house, over which a military helicopter hovers against a pastel blue sky. Beside the girl, a veteran sits in a wheelchair. It is as if he had been parked there to watch her, but his dark glasses, blank face, and slack limbs suggest some awful combination of social isolation and internal preoccupation. He and the girl form the two rear points of a triangle; at the third point equidistant between them and at the front of the picture is a child's plastic ball. It is red, white, and blue.

We doubt anyone could draw a more disturbing image of the war at home, one that better confronts the liberal-individualist narrative with democratic responsibility, or one that so vividly captures the traumatic sense of continued suffering and unresolved guilt evoked by the original photograph. The girl's magical appearance in the most characteristic contemporary U.S. set-

FIGURE 34. "Suburban Napalm," illustration, 2001 (Jeffrey DeCoster, illustrator). Courtesy of Jeffrey DeCoster.

ting is profoundly unsettling. She won't go away, she has even turned up here. But that is only half of it: her transposition into the suburban scene doesn't just bring the war home, it erases the ethnic difference undergirding the moral indifference to Vietnamese suffering. As with any strong appropriation, the later image amplifies key features of the original design. In this case, by (re)clothing the girl the illustrator has completed the work begun by her originally being naked. While the first image made her less Vietnamese because universally human, this image takes the next step by placing her in the United States' most familiar sense of humanity: our own culture. To spell it out even further, it becomes even easier to recognize that it was wrong to inflict pain on girls in Vietnam, because it would be just like bombing the kids playing in one's own backyard. Perhaps this act of imagination is made easier as immigrant Vietnamese have become ever more assimilated into U.S. public culture, but the illustration makes it clear enough: she could have been one of ours.

If left there, the picture would have been a dated and heavy-handed condemnation of Vietnam veterans. The juxtaposition of the disabled veteran changes all that. Someone incapable of walking is not going to harm civilians now, and even if he did before he has paid for it. The picture's balanced positioning of the two representative figures makes it clear that both were harmed by the war, both scarred for life. They both are victims, but that victimage is no longer the liberal pathos of individuated harm and therapeutic recovery. Instead, the picture restores the iconic photograph's depiction of types—Vietnamese civilians, not Kim Phuc—and it positions the seemingly different figures—young, female, Vietnamese civilian; adult, male, U.S. soldier—in equivalent categories of continued trauma. It is the visual equivalent of President Clinton's verbal evocation of two nations united by "shared suffering."⁶¹

The two figures share another similarity. The girl's emergence in the suburban scene many years after the end of the war is supernatural—a haunting of the American imagination. This return might be indicative of society's continued traumatization by the war, or it might symbolize the failure to confront historical responsibility, but it is a haunting nonetheless. The veteran has a similar nature, for he is a ghostly figure, so transparent that you can see the outline of a tricycle behind him showing through his body. The difference between them is that she is vivid and active while he barely has strength of presence, much less a capacity to act. The contrast could be (and probably is) an argument that the public has been more fixated on one set of victims than another for which it has equal or greater responsibility. But it seems more complicated than that. She shouldn't be there but is there; he should be there but is disappearing. Neither one belongs in the scene, because both are aesthetic disruptions of the Happyville template that provides the background for the picture. The key to understanding their mutual estrangement is the two small details of the smoke and the ball. The smoke is the thick, oily product of bombing taken from the original napalm drop, but now it is coming from the furnace of the house. (That the heat is on in the summer appears to be artistic license.) The dirty pollution of war is also the byproduct of U.S. affluence, because both imperial power and domestic tranquility are fueled by the same dark processes. The moral buffering produced by the United States' distance and wealth and the dirty truth that we waste lives needlessly are shown to be deeply linked and largely hidden. The picture exposes eloquently the complicity between the good life at home and criminal behavior elsewhere in the world.

But who then is responsible? The ball provides part of the answer. Both a perfect prop within the scene and a reference to the nation-state, it is po-

sitioned to mediate the relationship between the two figures. Together the three form a closed, harmonious form. But the red, white, and blue ball is not "Old Glory." Instead, it signifies an ersatz patriotism, the broad dissemination of national symbols that characterizes mainstream popular culture. There is only the barest trace of any sense of collective responsibility, while the object typifies the easy activities of kids' games and backyard leisure, or at most the fireworks on the Fourth of July. This reduction of political identity and collective responsibility to a small, soft plastic toy is what is necessary to represent its place within the suburban scene. It is there, but ironically so and easily kicked aside.

This projection of responsibility to the front of the pictorial frame follows directly from the composition of the iconic photo. Both victims are still in need of help, and both are not likely to be helped by what little sense of collective responsibility is available in the contemporary U.S. scene. As before, the picture hails the viewer. As before, the viewer is positioned aside from the state that is the agency of harm (it has harmed the girl, brought the soldiers to harm, and is not caring adequately for those soldiers today). As before, the picture can be a sweeping denunciation of moral indifference, although now the accusation is given an additional, sharper edge: the problem is not a runaway state or uninformed public, but a nation lulled to irresponsibility by its pursuit of domestic happiness. This irresponsibility includes not listening to the Vietnamese civilians and U.S. soldiers who have had direct experience of the war but who have been silenced subsequently. As before, the picture fragments consensus through embarrassing depictions of suffering; by placing that suffering within a context of unthinking routine it both identifies a collective responsibility and locks the experience of guilt into a haunting, eternal recurrence of traumatic memory.

THE ICON, THE STRANGER, AND AMERICAN COLLECTIVE MEMORY

The multiple transcriptions and deep ambivalences of visual eloquence allow skilled advocates a rich repertoire for appealing to a public audience. Iconic photographs are calls to civic action, sites of controversy, vehicles for ideological control, and sources of rhetorical invention. Although the appropriation of such icons have to be consistent with the original photograph's basic designs, and although they typically extend its strongest tendencies, they are also a source of new and at times remarkably sophisticated appeals. Most important, perhaps, they can articulate patterns of moral intelligence that run deeper than pragmatic deliberation about matters of policy and that disrupt conventional discourses of institutional legitimacy.

That is not the end of the story, however. Vietnam veteran William Adams has remarked, "What 'really' happened is now so thoroughly mixed up in my mind with what has been said about what happened that the pure experience is no longer there. . . . The Vietnam War is no longer a definite event so much as it is a collective and mobile script in which we continue to scrawl, erase, rewrite our conflicting and changing view of ourselves."[62] The situation is even more fluid for the public audience that never experienced the war directly. Amidst a "torrent" of books, movies, articles, memorials, Web sites, and more, U.S. public life continues to be defined by its conduct and loss of the war in Vietnam.[63] Explanations for this lack of closure range from the critique of the mass media's overexposure of the war to the war's "resistance to standard narratives of technology, masculinity, and U.S. nationalism."[64] We believe that iconic photographs emerge and acquire considerable influence because of their capacity for dealing with the dual problems of overexposure and ideological rupture.

The Vietnam War has the distinction of being a rich lode of iconic photographs. Four in particular receive the widest circulation: the burning monk, the execution of a bound prisoner of war, the napalm girl, and the girl screaming over the dead student at Kent State.[65] By explicating several relationships within this set of images, additional functions of the napalm photograph, its genre, and photojournalism generally can be highlighted. As Marita Sturken has noted, the common features of this set of images include their depictions of horror, their challenge to ideological narratives, and the fact that they have acquired far greater currency than any video images of the war, which included identical footage of two of the events (the execution and the napalm attack). Sturken's account of this last difference is telling: the photographs highlight facial expressions, connote a sufficient sense of the past, circulate more easily, and are "emblems of rupture" demanding narration; in addition, the filmed events are actually more chaotic or horrific.[66]

These observations are accurate, although also at odds with the general assessment that the iconic image is the best representation of the horror of war. Our reading of the napalm photograph suggests how that idea needs to be refined. This iconic image of the Vietnam era becomes the telling representation because of its fragmentary character. It represents not so much physical harm as the loss of meaning, the futility of representation itself in a condition of social breakdown "when words lose their meaning."[67] A visual medium is the better vehicle for representing this slippage or incapacity. The image implies that another medium (words) has already proved incapable of full representation of the war, and because the image can show but not tell, it automatically represents both the event and the gap between the event and

any pattern of interpretation. The still image performs this dual sense of representation and absence most effectively: It frames the event for close, careful examination, while also providing nothing outside the frame and interrupting any sense of continuity. The result is not blankness, however, but an "optical unconscious"[68] that can supply both exact knowledge of the morally decisive moment and the "lacerating emphasis" of fatality as it incorporates past and future alike in the eternal present of the image.[69] As we have also noted, this epistemological condition is deeply resonant with the psychological structure of trauma.

There is a three-way relationship between loss of meaning, traumatic injury, and moral response that characterizes the deep lack of resolution regarding the Vietnam War and that also is a key feature of the iconic photographs. The photos are indeed less horrific than they could be; they show little physical damage, while pictures taken seconds later in every case show more blood or burned flesh. The performative key is not physical damage, however, but the expression or conspicuous absence of an expression of pain. This distinction between physical gore and pain is crucial, for several reasons. Bodily disruption does not automatically call for a moral response as it always is subject to interpretation (think of surgery). Pain, however, by its very nature cuts through and destroys patterns of meaningfulness, while its expression is evidence of an internal world—the world within the body that Elaine Scarry defines as the "interior content of war"—and so a basis for connection with others without regard to external circumstances.[70] Moral response requires not evidence of harm, but a sympathetic connection that is most directly evoked by pain. For the same reason, justifications of violence always have to minimize the pain it produces.

The four icons of the Vietnam War exemplify the dialectic between displays of pain and indifference to pain. The napalm and Kent State photos are the most powerful registers of moral outrage precisely because they are performances of the pain experienced by an innocent victim of U.S. military action. "The image of the burned girl made Americans see the pain the war inflicted," and it also used that pain to bond the girl and the public emotionally.[71] As we demonstrated in the previous chapter, the girl at Kent State acts as a ventriloquist for the murdered body on the pavement in front of her while also directly venting the pain experienced sympathetically and, therefore, modeling sympathetic response to the dead and wounded as the appropriate form of citizenship in respect to that event. Each performance also is gendered, as a girl crying represents the "victimized, feminized" country of Vietnam and the peace movement at home.[72]

The logic of conventional gender typing also structures the other two

icons, each of which is notable for its repression of emotion. The expression of the man being shot is sometimes described as a searing expression, but not often; it could double as an expression one might see when someone gets bad news. What is most significant is the executioner's lack of emotion. The photo's moral punch comes from its documentation of how the state can kill with such complete lack of regard for the pain it is causing. As with the laconic soldiers in the napalm photo, the officer's businesslike manner is a cue to the fact that this situation is routine, something that those in the picture see every day. The lack of empathy becomes the sign of immoral conduct, a sign that can't be erased by circumstantial knowledge about the soldiers involved.[73] The burning monk follows a similar logic that operates in the reverse direction. The salient fact in the photo is that someone's resolve to resist the government could be so great that he would not only commit self-immolation but be able to do so without showing pain. The monk's discipline while literally under fire defies the Saigon government, which cannot conquer the body even as it burns. Male suppression of pain thus becomes the vector for projecting a power that can be used either to extend or resist state control, while female expression of pain becomes the vehicle for public response to state abuse of power—a response that, unlike the male acts, can be imitated by anyone who is looking at the picture.

One conclusion to be drawn at this point is that the iconic images from the Vietnam War—along with the subsequent images of Kim Phuc that are used to put the war to rest—also create a fragmented (re)gendering of the public sphere. The public is feminized in a manner that has both positive and negative consequences. On one hand, set against a masculine monopoly on violence and state action that is increasingly irrational, the feminized public reinstates the essential features of the classical model. In addition, this gendering corrects for various faults in that model, not least its inattention to emotion, norms of reciprocity and care, divisions between public and private life, and the need for openness in actual practice. On the other hand, such gendering hardens a number of dangerous alignments among power, violence, and masculinity, and against discourse, deliberation, and social reciprocity.[74] Worse yet, as women only cry out and scream while remaining helpless, public speech becomes hysterical and without agency, and as their meaning is transferred to the visual medium that is featuring a woman's body, the public becomes subject to the male gaze while being reduced to the politics of spectacle. Such logics produce both more war and further constriction of public culture.

These transcriptions of gender are as important as they are obvious, but they are not the only means by which iconic photos can embody essential

features of the public sphere. Michael Warner has identified, among others, two features of public culture that are especially pertinent to the case at hand: "The public is a social space created by the reflexive circulation of discourse," and it is a "relation among strangers."[75] The still photo acquires greater mnemonic capacity due to its ease of wide and continuous circulation. Even in digital environments, video clips are more time- and skill-intensive whereas still photos circulate easily and also can be reproduced across posters, editorial cartoons, book covers, T-shirts, and an astonishing range of other items. As the public is constituted in the dissemination and circulation of texts that compete for attentiveness and verbal "uptake" by audiences, the images that circulate best have a natural tendency to become the carriers of public consciousness.[76] The iconic images then stand out further because their conjunction of aesthetic form and political function allows for a reflexive representation not only of the particular event but also of the conditions of public representation most crucial to understanding the event. No one text or image can do this, but those that can capture the tensions within the discursive field will be more likely to become the markers of the field.

Because a public is always, by definition, a group whose membership cannot be known in advance, public discourse is addressed to strangers. As Warner claims, a public "might be said to be stranger-relationality in a pure form, because other ways of organizing strangers—nations, religions, races, guilds, etc.—have manifest positive content." Perhaps most important, "We've become capable of recognizing ourselves as strangers even when we know each other."[77] If the public audience is to be capable of response and action, however, those within it cannot be operating in a realm of pure relationality, not least because there is no such language available. The discourses of public address must be inflected, embodied, and otherwise provide real bases for identification through aesthetic performance, and they have to do this in a manner that also maintains the reflexive openness of public identity. Warner's own language seems to be a description of the iconic photograph:

> The development of forms that mediate the intimate theater of stranger relationality must surely be one of the most significant dimensions of modern history, though the story of this transformation in the meaning for strangers has been told only in fragments. It is hard to imagine such abstract modes of being as rights-bearing personhood, species being, and sexuality, for example, without forms that give concrete shape to the interactivity of those who have no idea with whom they interact.[78]

The iconic photograph is one such form for mediating stranger relationality. A relationship that is hard to imagine is in need of images, and the iconic

image acquires public appeal and normative power as it provides embodied depictions of important abstractions operative within the public discourse of a historical period. In addition, the photograph becomes a condensation of public consciousness to the extent that, while it provides figural embodiment of abstractions, it also keeps the lines of response and action directed through relationships among strangers rather than specific individuals or groups. Thus, the photo of the napalmed little girl provides figural embodiment of the concepts of political innocence, human rights, third world vulnerability and victimage, mechanized destructiveness, criminal state action, and moral callousness. As it does so, it also puts the girl in the place of the stranger within the public. Her relationship with the viewer is an embodied case of stranger relationality. Set amidst characteristic features of public life (e.g., civil infrastructure, state action, press coverage) and appealing directly to the public audience (e.g., created through circulation, contrasted to the family and state in the picture, identified by no ethnic or other localized identity, not known in advance) the girl and the audience alike are anonymous, essentially strangers to each other.

Because the girl is distinguished by her pain, her strongest positive content is the internal content of the war; because the war also is conducted among strangers, it becomes a perverse form of stranger relationality. Because the girl's pain is presented directly to the viewer, she embodies the stranger we can recognize within ourselves, and so her world and ours are drawn together into a single public realm. As Warner notes, the stranger of modern public life is not exotic or inherently disturbing; we would add that it is different from the Other that is articulated through every form of social exclusion (i.e., all forms of nonpublic identity).[79] The girl's appeal for help would be subverted by her being perceived as one of the Other, a small, marginal figure within a minor, distant, marginalized group. Her moral force comes from being perceived as a stranger in pain, which not only activates the transcription of Biblically directed compassion, but also makes her someone who is included among the public and so has the right to hold the state accountable.

The iconic photograph's fragmentary framing of the girl's combination of naked expressiveness and personal anonymity also keys subsequent narratives about "the girl in the picture." As Kim Phuc becomes clothed, and then partially, modestly unclothed to reveal her scars while holding her baby, she becomes a symbol for the restoration of domestic tranquility. As she forgives those who bombed her, she becomes a model of political reconciliation and also a means for forgetting the obligations of political history. As she becomes a celebrity promoting universal human rights, she personalizes the

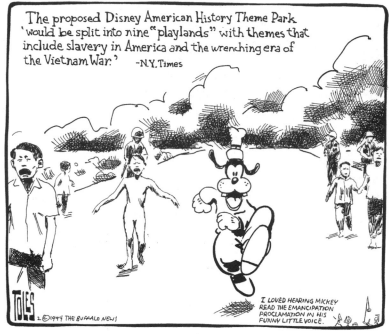

FIGURE 35. "Disney Napalm," editorial cartoon, 1994 (Tom Toles, cartoonist). By permission of *The Buffalo News.*

stranger identity that is an essential element of moral judgment in public discourse.

The other Vietnam photos offer similar mediations of public life, just as they also are subject to a range of appropriations that comprise a continuing negotiation of American public culture. H. Bruce Franklin's study of how the execution photo was reworked in popular films and comics to become a conservative symbol provides the most dramatic example of how icons figure prominently in the continuing struggle over the meaning of the Vietnam War, but all four of the images are at issue.[80] The napalm girl's reappearances within the public media provide a varied range of examples; such appropriations are inevitable in public discourse due to a corollary of stranger relationality: the condition of topical openness.[81] Thus, the napalm icon has been taken beyond the Vietnam War to condemn other forms of betrayal or injustice. In a cartoon protesting the Disney theme park that would have been located near the Manassas battlefield, Goofy is running down the road beside the crying girl (fig. 35).[82] There may not be a better satire on the relationship of the corporate entertainment industry to history. The Disney park would

Report Says Nike Workers in Vietnam Paid Starvation Wages and
Suffer Corporal Punishment and Forced Running Inflicted by Managers

FIGURE 36. "Just Do It!" editorial cartoon, 1997 (Jeff Danziger, cartoonist). Courtesy of Jeff
Danziger.

be like a napalm drop on the community of memory, and it would cheapen
any sense of either justice or honor. In a more recent cartoon protesting Nike
labor practices, the girl reappears, wraith-like, as a poster on the wall of a
factory in Vietnam (fig. 36).[83] As Vietnamese girls (or women) work at the as-
sembly line, the cry of pain speaks for them, its anguish amplified further by
the Nike slogan at the top of the poster: Just Do It. Their only choice is to keep
working at "starvation wages," while U.S. mechanization operated by Viet-
namese proxies continues to harm the Vietnamese people. The photo can
operate as a rhetorical figure within the picture and as a linking device that
activates historical memory and obligation to motivate public intervention.
The device works because the cartoonist has drawn on essential features of
the icon in order to recreate its original effect of activating moral judgment
within a supposedly amoral scene (war then and the free-market economy
now). The transfer of moral response is possible because Vietnam continues
to be feminized while the girl has been restored to her original anonymity
and pain. These devices combine to constitute a public culture known to
itself by the continued circulation of iconic images.

The photo's prominent place in public memory of the Vietnam War is
likely to persist. It is reproduced frequently in volumes on famous and note-
worthy photographs.[84] The image continues to join private recollection and
public memory of the Vietnam War as it appears in fiction, poetry, and other

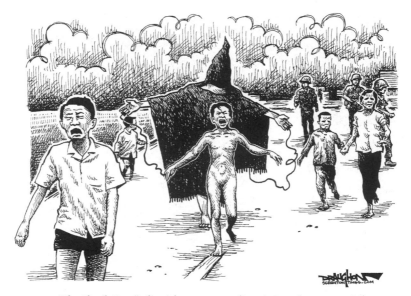

FIGURE 37. "Abu Ghraib Nam," editorial cartoon, 2004 (Dennis Draughon, cartoonist). Copyright 2004 courtesy of *The Scranton Times*.

arts.[85] As the examples from the U.S. occupation of Iraq suggest, other appropriations keep the antiwar message alive by using the icon to protest foreign policy by placing it in the context of Vietnam.[86] A particularly startling juxtaposition is achieved in an editorial cartoon that has the hooded figure from Abu Ghraib behind Kim Phuc (fig. 37).[87] At the least, the older iconic image is used to heighten the emotional and moral content of its successor. Her nakedness reveals the vulnerability of his shrouded body, her scream voices the agony within his hooded silence, her violated innocence represents his torture. As the tableau draws on virtually every element of the napalm icon's repertoire, the moral message is linked to the even more troubling implications of a traumatic history. Once again, war crimes are occurring because of U.S. policy; once again, the public is trapped in a space between pain and indifference; once again, the war will not go away. This haunting, sickening, traumatic relationship between past and present is underscored by the parallelism between the girl's arms and the arms of the hooded figure. Worse yet, there is room on the road for more figures to be added as Americans continue to repeat history rather than learn from it.

The napalm icon also has been used as ammunition in the struggle over the control of political images. When the photo of a Palestinian father and son cowering in the midst of a gunfight was rising to iconic status in the Arab

media, an Israeli newspaper paired that image with the napalm icon in order to foreground the newer photo's "excessive" emotional impact.[88] The photo's rhetorical power is also acknowledged by the backhanded tributes of visual parody: images at somethingawful.com place the girl in a polka dot dress, surrounded by runners at a finish line, playing hopscotch, replaced by beverage containers (a particularly subtle allusion), and so forth. Alterations in a higher register include a number of important appropriations of the napalm image by contemporary artists.[89] Artistic reproductions of the photo includes Jon Haddock's "Children Fleeing" (fig. 31), previously discussed; Jerry Kearns, "Madonna and Child" (1986), which superimposes the girl on Andy Warhol's print of Marilyn Monroe;[90] Juan Sanchez, "It Is Beautiful to Love the World with Eyes Not Born" (1987), which places the girl among children in Nicaragua;[91] Vik Muniz, "Memory Rendering of Tram Bang," which replicates the photo as an afterimage;[92] Judy Chicago's "Im/Balance of Power" (1991), which mixes media "to represent the terrible imbalance of priorities in the world's treatment of children";[93] Peter Kuper's "Bombs Away" (1991), which places a man on the road under a rain of missiles that are shaped as clothed girls;[94] Manit Sriwanichpoom's recreation of the image with contemporaries wearing designer clothes in "This Bloodless War" (1997);[95] Tony Scherman's painting of roses titled "A Kim Phuc V" (Gia Huynh, 2000);[96] Jean-Luc Verna's photograph of a bald, tattooed, naked man running towards the camera and screaming, titled "Nick Ut, Kim Phuch Phan Thi, Sud-Vietnam, 8, 2001";[97] and a particularly disturbing painting by Eric White entitled " 'Nam!' 1949 an RKO Pictures Release" (1999) that replaces Kim with a nude Bette Davis while turning the other children into clothed, anxious Americans who could have been photographed by Diane Arbus.[98]

These patently artistic uses of the image both demonstrate and extend its rhetorical power while also perhaps suggesting that more ordinary reproductions of the image are likely to be taken for granted over time. As the napalm girl and other Vietnam icons reappear within the emerging photomontage of the U.S. occupation of Iraq, their presence testifies to both how public commentary relies on iconic memory and how particular icons can recover the evocative power dissipated through more conventional circuits of appropriation. The images return and recover their "original" meaning and force in part because of the shape and coverage of current events and also because they contain important resources for understanding and advocacy. To be put to work, however, they have to have remained in circulation. That circulation follows patterns that transcend events and reveal additional dimensions of public culture.

As appropriations of the napalm photo accumulate, and as the photo

slides back and forth along a continuum from public anonymity to personal celebrity, the interpersonal field of stranger relationality acquires a sense of presence. This field is filled out comprehensively by all photojournalism—that is, by its continual reproduction of images of strangers as if they were residents of a common world. The napalm photo also reveals how it is developed and defined by extreme cases of itself: celebrities and ghosts. Both are exceptional forms of individual presence, simultaneously familiar and strange, and known through their circulation. No reader of this chapter is likely to have ever met Kim Phuc in person, much less spent any time with her, but most will have known who she is. Like any icon, the celebrity is created by dissemination and evidence of a broad field of attention. So it is that celebrity developed in conjunction with the ascendancy of the mass media, and the category has been a commonplace in photojournalism at least since *Life* magazine in the 1940s.[99] The celebrity is the widely recognized stranger, that is, a stranger whose image is in wide circulation. More to the point, celebrity is a compensatory mechanism within the media to mask its strangeness. The celebrity image dresses the impersonal process of circulation in signs of personal expressiveness. Thus, the redefinition of the napalm girl as Kim Phuc accomplishes a powerful shift in public consciousness. The direct engagement with the stranger on the road is attenuated into a much more familiar world of everyday sociality where one lives among specific individuals who have more or less intimate relationships with one another.

The circulation of images doesn't stop there, however. Despite the many iterations of Kim Phuc and her message of forgiveness, her past life as the napalm girl won't go away. That image of trauma continues to appear, ghost-like, in tableaus of the American flag, suburban lawns, economic expansion, and so forth. A ghost is an afterimage, a specter that should disappear but refuses to go away, and whose very presence troubles the modern present and its logic of linear time. Photojournalism disseminates images, mechanically reproducing them by the millions and spreading them without control over their destination or use. Dissemination always has been accompanied by mythologies of haunting, including photography's early association with spirit worlds, and death remains a preoccupation in photography theory.[100] Ghosts are, like signs, bodies without material agency, and reanimation is itself a metaphor for the circulation and uptake constituting public culture. The ghost also embodies stranger relationality, an unbidden presence that functions as a witness to other relationships and that makes the familiar strange. More significantly, ghosts are a reminder of unfinished business. Thus, the ghost of the napalm girl triggers another strong shift in public consciousness: the familiar social world becomes unsettled, the ghostly figure pre-

sents a call for justice and redress, and time begins flowing backward. This powerful undertow can pull one into a world of signs, swirling images, and the eternal recurrence of traumatic memory, but it can also provide an escape from the amnesia of the present.[101] A sense of strangeness is necessary for reflection on the limits of one's moral awareness, not least as that is produced by the mass media, and it also may be necessary for deliberation.

The celebrity is one extreme of the field of stranger relationality, and its covering device; the ghost is the other extreme, and perhaps an essential means for reanimating public consciousness amidst reified forms of social reality. Both the celebrity and the ghost exemplify essential features of the modern stranger: they are within but not fully of the social group, they are in intermediate positions between the viewer and larger sources of power, they are related to the viewer abstractly rather than through more organic ties, and they are at once both far and near.[102] This last characteristic is especially important, as it is perfectly coordinate with the phenomenology of photographic experience: the content of the photograph is always both far and near, whether a distant scene brought into one's reading space, or a loved one placed within an impersonal medium of paper and ink. This may be why emotional response is so crucial to whether a photograph is appealing. The emotional identification temporarily overcomes any sense of artificiality or awkwardness that comes from seeing the image as an image. Likewise, in a world lived among strangers, emotional resonance becomes an important measure of connection. So it is that both incarnations of the napalm girl succeed, as the celebrity Kim Phuc and the traumatized little girl on the road each activate strong emotional responses. The narrative of traumatic experience haunting the imagination becomes a part of the articulation of other icons as well, and often as part of a liberal narrative of healing. More generally, the iconic image marks out a particular kind of public culture. In this culture, a strong form of stranger relationality underwrites heightened moral awareness, rational-critical deliberation about state action, and continued accountability. Even so, historical events are constituted as moments of emotional intensity rather than as decisive actions, and there may remain a permanent lack of connection between moral sentiment and any specific model of action. Neither ghosts nor celebrities do much other than circulate and watch the rest of the world. That, of course, is essentially what publics do, but they are valued because of the belief in a sense of agency. The test of that belief may lie in how the public image can influence political cognition and collective memory.

A common feature of deliberation and memory is a sense of time. We will close by considering how the iconic photo can delay or stop time. The

traumatic structure of the napalm photo freezes an action that is happening quickly and could be quickly forgotten. This strong temporal delay is the visual equivalent of the extended duration of verbal deliberation, and it is a contribution to restoring meaningfulness. In addition, extended attention to the image in the present can activate a stronger connection between past and future, and one that is directed by the image and not just by larger narratives: One can see the past moment still recorded in the photograph beheld in the present, while the image projects a future that also has been fulfilled in time before the present and may be still unfolding. The iconic photo can operate in a postliterate society as a democratic moment, one that slows down the public audience to ponder both what has been lost in the rush of visual images and what is still unrealized in what has been seen. As Paul Virilio and Sylvère Lotringer have observed, "Democracy, consultation, the basis of politics, requires time," while the fundamental dynamic of modern society is the *acceleration* of all modes of exchange.[103] This acceleration is driven by the combination of technological development and logistical mobilization that occurred as the economy was oriented toward a permanent condition of military preparedness. It has produced a war culture that permeates modern life while weakening democratic practices. Visual media are highly complicit in this process of social reorganization. The cinema is Virilio and Lotringer's primary example, although video and digital technologies have become the primary media and employ stronger techniques for both fragmenting and accelerating representation.[104]

In respect to the mediation of public life, we might say that the problem is not the presence of a political spectacle but rather the kinetic quality of that spectacle. Amidst this torrent of sights and sounds, the iconic photograph can induce a consciousness that is almost a form of slow motion. As Paul Lester has remarked of iconic images, "Interestingly, moving films shown to television audiences were made at the same time . . . but it is the powerful stillness of the frozen, decisive moment that lives in the consciousness of all who have seen the photographs. The pictures are testaments to the power and the sanctity of the still, visual image."[105] This is a common sentiment in the print media, but it should not be seen as mere special pleading.[106] "The electronic image flickers and is gone. Not so with the frozen moment. It remains. It can haunt. It can hurt and hurt again. It can also leave an indelible message about the betterment of society, the end of war, the elimination of hunger, the alleviation of human misery."[107]

If a still photo can slow down the viewer, it might nurture a more reflective, more deliberative mentality. That deliberative moment is not a pure space, however, but one already inflected by the photo's embodiment of pub-

lic discourse and its performance of public identity as stranger relationality. Photojournalism provides such resources on a daily basis that is necessary for maintaining public life, while the iconic photo then becomes a condensation of events and public culture alike that has the artistic richness necessary for continued circulation. The icon is a *lieu de mémoire*: a site where collective memory crystallizes once organic sociality has been swept away amidst the "acceleration of history" produced by modern civilization. Pierre Nora's description of this form of memory can double as an account of the iconic photo: "Simple and ambiguous, natural and artificial, at once immediately available in concrete sensual experience and susceptible to the most abstract elaboration," iconic photographs operate in a dialectic of loss and recovery, official codification and vernacular disruption, verbal context and visual immediacy.[108] "In this sense the *lieu de mémoire* is double: a site of excess closed upon itself, concentrated in its own name, but also forever open to the full range of its possible significations."[109] The photo of the napalm girl is not a figure of nostalgia amidst modernity's inevitable sense of alienation, however, but rather a symbolic form suited to the stranger relationality that constitutes, extends, and empowers public life. Thus, it provides the means through which moral capability can be retained by a public that has no common place, social structure, or agency.[110] Both as a singular composition and as a figure in circulation, the icon provides a rhetorical structure for remembering and judging what otherwise would be consigned to the past.

The image of the little girl running from her pain became a moment when the Vietnam War crystallized in U.S. public consciousness. The photo not only represented the moral error at the heart of the U.S. war effort, but also embodied a process of cultural fragmentation that was accelerated by the war and its coverage. The features of that composition then became a template for remaking the public world through its continued circulation in the public media. Or worlds: The audience can choose one world where resilient individuals get on with their lives, where history has the inert presence of a scar, and moral response to others culminates in personal reconciliation. Or the audience can choose another world in which the past haunts the present as a traumatic memory, one that continues to demand public accountability for those who would betray the public by harming fellow strangers exposed to the relentless operations of imperial power. So it is that a liberal-democratic public will work out its capacity for thought and action in a discursive field where striking images can shape both moral judgment and collective memory.

7

LIBERAL REPRESENTATION
AND GLOBAL ORDER

TIANANMEN SQUARE

For most people, knowledge of foreign affairs depends almost completely on mass media coverage of distant places and opaque cultures. On any other topic such as crime, welfare, taxes, or education, media reports of government policy are likely to overlap with ordinary experience. That experience might be as simple as leaving one's car unlocked without incident, standing in a checkout line as food stamps are cashed, balancing a checkbook, or paying a textbook fee. By contrast, representations of world politics are comprehensively mediated and largely incapable of being tested directly. Photojournalism becomes especially influential in this context, for it records features of the world that seem to be apprehensible at a glance. The newsprint may report a swirl of competing statements, while what can be seen becomes the equivalent of a reality check. This is the point, therefore, where the relationship between photojournalism, public opinion, and ideology is strongest. Iconic photographs can shape public understanding of foreign affairs by framing historic events according to familiar cultural assumptions that can double as means for ideological control. The iconic photo featured in this

chapter demonstrates how a fundamental tension within modern societies is at the heart of the historical transformation known as "globalization."

The liberal-democratic societies were the big winners in the competition for economic and political power in the twentieth century.[1] Currently, they are the societies that exercise the greatest influence over development of the emerging global order of advanced, large-scale, corporate economic networks supported by state-of-the-art technologies in communications, transportation, data management, and so forth. They also are case studies in the contradiction between liberal self-assertion and democratic norms: for example, when corporations benefiting from the manifold legal and civil advantages of the democratic nation-state ship their jobs overseas and shelter profits offshore, they are advancing their own interests at the public expense. This tension can peak in respect to China, a society experiencing both liberalization and democratic reforms while under an authoritarian government that oversees the biggest underdeveloped market in the world. Finding the right balance between liberal and democratic practices, and doing so in respect to Chinese traditions, may be the key to successful modernization and the achievement of a "Chinese Century." Such considerations are not likely to be part of the external pressures of globalization, however. There is little doubt that liberalization is in the interest of those already dominant outside of China, but democratization is a more open question. The incorporation of Chinese citizens into a global order of individual rights and open markets is one thing, while continued national determination through popular movements may be another.

The popular protest in China's Tiananmen Square provides a near-perfect case study in the tension between a democratic spectacle and liberal conventions of representation. We shall argue that the iconic photo from the protest in Tiananmen Square subordinates Chinese democratic self-determination to a liberal vision of global order. This imbalance occurs through the photo's aesthetic conventions, which displace democratic forms of political display and activate a cultural modernism that reinforces individualism and apolitical social organization. Thus, the photo can be a progressive celebration of human rights while also limiting the political imagination regarding alternative and perhaps better versions of a global society.

ICONIC HISTORY

The drama in Tiananmen Square began as a series of demonstrations memorializing the reformer Hu Yaobang in mid-April, 1989.[2] By organizing around the Monument to the People's Heroes in the square, the demonstrators de-

fined themselves as the heirs of the demonstration of May 4, 1919, that had inaugurated the political movements defining modern China. After a series of clashes with the police, on April 21 students began a continuous occupation of the square. Over the following weeks the protest mushroomed into a prolonged confrontation between students and urban workers on the one side and the Chinese government on the other. Events soon exceeded the abilities of the leaders on either side: government officials refused to meet with student leaders, a *People's Daily* editorial condemned the students in language reminiscent of a previous persecution, demonstrators participated in hunger strikes, and by May 29 one million people were marching and milling about in the square in violation of a government order to disperse.

During the next few days the crowds melted away, leaving a much smaller cohort still camped in the square, but the escalation toward violence continued. Increased deployment of troops was met by organized resistance throughout the city, often by workers and other citizens. An advance of several thousand soldiers into the square on the morning of June 3 followed the past month's pattern of confrontation, standoff, and military retreat. Then, the deluge: in the evening, new troops launched a sustained, violent assault to clear the streets and the square. Tanks crashed through barricades as automatic weapons were fired into the crowds and at the fleeing demonstrators. Hundreds were killed—some mashed by tanks or other heavy vehicles—while many others were wounded. Sporadic violence continued for several days, but the public protest was broken, and in the following weeks thousands of demonstrators or other dissidents were imprisoned, some to be executed.

The first icon of the demonstration was a thirty-seven-foot tall statue crafted by art students and modeled on the Statue of Liberty (fig. 38). Labeled the Goddess of Democracy (a revealing shift in nomenclature) by the demonstrators and positioned facing the government's giant portrait of Mao, various photos and live coverage of the statue were featured prominently and for obvious reasons in the U.S. media.[3] The statue would be a fitting representation of the event, but for reasons that may not be obvious: seemingly a direct insertion of Western ideals into Chinese public culture, it was in fact intentionally altered to reflect a process of appropriation.[4] Although seemingly a universal symbol of liberty, it became festooned with flags, banners, flowers, and other signs that defined the monument within a cultural milieu largely illegible to the Western audience. Ironically, the statue also continued a civic republican tradition of figural representation that has become antique in the West. The Goddess still is included in some montages commemorating the event, but its status as a marker of democratic ideals has largely been displaced.[5]

FIGURE 38. "Goddess of Democracy," 1989 (photographer unknown).

The dominant image today is of a man standing before a row of tanks. Because the scene was recorded in several photographs and two video clips, initial coverage and reproductions include a number of variations on this image reflecting, among other things, small changes in the man's stance from one second to the next. Three photographs of the event have dominated circulation. The first, by Jeffrey Widener (AP), is a middle distance shot of four tanks that includes a lamppost in the foreground and a city bus in the upper part of the frame.[6] The second, by Charles Cole (UPI), is more of a close-up that fills the frame fully across the diagonal with three tanks and the front bumper of the fourth.[7] The third (fig. 39), by Stuart Franklin (Magnum), is a long-distance shot that includes more of the street and the city bus (though it often is cropped out of the picture in publication).[8] In addition, each photo has been cropped in various ways and had its color tones altered in reproduction. Initially, the Widener photograph was most frequently printed in U.S. newspapers, an effect, we assume, of its availability on the AP wire. The Cole image appeared in *Newsweek* and may have appeared more often outside the United States because of its UPI distribution. *Time* magazine used the Franklin photograph on its June 19, 1989, cover, along with a two-page blowup of the picture on the inside of the magazine, and subsequently it has been used most often in appropriations that mark the anniversary of the event or serve as parodies. We suspect that the wide circulation of the Franklin image has at least something to do with the fact that Time-Life has dubbed it the picture

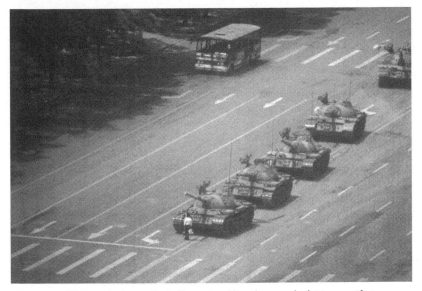

FIGURE 39. "Tiananmen Square," 1989 (Stuart Franklin, photographer). Magnum Photos.

of choice and reproduced it countless times in its numerous histories and retrospectives on photography and the twentieth century.

We focus on the Franklin image in our analysis primarily because its design features locate it at the midpoint between the Widener and Cole images. The man is facing the tank in a resolutely balanced stance and holding items in both hands in Cole and Franklin, but not in Widener. He is directly in front of the tank in Cole and Franklin but set back several paces in Widener, and the crosswalk and directional vectors are evident in Widener and Franklin but not in Cole. There are four tanks in Widener and Franklin, but not in Cole. There is a bare foreground and a bus in the background in Cole and Franklin but not in Widener. Thus, the Franklin photograph is one that shares the most—and most important—elements found in any two of the three images. We also hope to show that where it is at the extreme end of a range, as with the long depth of field, it is the strongest articulation of designs central to all three. Even so, the important issue is *not* which of the three images is most iconic. All three images continue to circulate, they are used interchangeably with one another to reference the same event, and nobody seems to care enough about the differences to comment on them.

The several photographs all show the same scene: An anonymous figure in black pants and a white shirt faces standard battle tanks in the generic camouflage used by every modern army.[9] He has positioned himself in front

of the lead tank to stop its forward movement. The tank has stopped but its commander remains within; it could lurch forward to crush the man, yet there is no indication of any movement on either side. To Western observers, it is the premier image of the dramatic events in Tiananmen Square. "There is only one streetscene in China worth remembering in Western eyes. . . . this streetscene was transformed into iconography. . . . The man and the tank would live on beyond the few tense moments of the encounter to become a permanent and universal symbol."[10]

Nor should that be surprising, for the image had the benefit of a media blitz. As David Perlmutter has documented, video and still images of the man before the tank dominated newscasts, newspaper and newsmagazine coverage, and public commentary (including a speech by President George H. W. Bush).[11] The photograph appeared as early as June 5 on the front page of the *Los Angeles Times,* which reprinted it in the same space the next day; on June 6 it appeared on the front pages of newspapers across the country, including the *New York Times,* and when it didn't appear on the front page it appeared on the inside, usually paired with a sidebar article emphasizing the "Measure of Defiance."[12] Some papers, such as the *Times,* also reprinted stills from video broadcast on *ABC Evening News.* The image subsequently was featured in *Time, Newsweek,* and *U.S. News and World Report.*[13] Indeed, it quickly became the framing device for both journalistic and political representation of the Tiananmen protest.

In subsequent years, the image has dominated visual histories, particularly those produced in the public media, and has become a stock image at Web sites and on posters in English, Chinese, and French advocating dissent.[14] According to Perlmutter, "The image of the man blocking the tanks has become the supericon of Tiananmen," and, according to Richard Gordon, it is "one of the defining iconic images of the 20th century, like a monument in a vast public square created by television."[15] This ascension culminated in the unknown man's selection by *Time* as one of the twenty most influential "leaders and revolutionaries" of the twentieth century.[16] He was, of course, neither a leader nor a revolutionary, and Perlmutter's argument seems inescapable: the iconic status of the photo was a product of the Western media elite.

This photographic icon also has displaced the Monument to the People's Heroes that was the point of origin for the protest in Tiananmen Square. As Wu Hung has stated, the demonstrations and massacre combined to redeem the memorial site as "a living monument that wove people's recollections of their struggle and death into a whole. Surrounding it a new public emerged."[17] The difference between the two monuments, one stone and the other photographic, is a difference not only between Chinese and Western understand-

ing of the events in Tiananmen Square, but also between the national articulation of Chinese public culture and a global public sphere constituted by the Western media.[18] As the image of the man and the tank achieved iconic status it has acquired the ability to structure collective memory, advance an ideology, and organize or disable resources for political action. As we shall see, the photo of the man and the tank constitutes liberalism as the dominant mentality for an emerging global order.

Before taking another step, however, we should acknowledge that our interpretation confounds a virtual experience important to progressive politics. As a sharp reviewer noted, "I still want to see the anonymous man as a hero, in whom I can invest all my desires to oppose authority, and your reading tries to rob me of that pleasure."[19] So it does, but not to deny that use of the photo. The man is standing up to authority—literally, courageously, remarkably so. The photograph is an inspiring performance of democratic dissent. It is not a photo with a single message, however. Widespread appeal depends on the articulation of multiple and often contradictory meanings in a deceptively simple manner, while iconic images achieve that status because their formal simplicity carries a complex array of codes that together equip the viewer to negotiate deep contradictions in public culture. The obvious tension in the Tiananmen icon between the individual citizen and state authority is really there, and it also is the dramatic vehicle for managing other tensions between relatively liberal or democratic conceptions of citizenship, between realist and idealist conceptions of political power, between national and global definitions of civil society, and more. This complexity, and with it, the dominant ideological orientation of the photo, can only be revealed by explicating a series of transcriptions. These intertwined codes begin in the compositional design but can be traced outward along lines of appropriation into possible habits of reception. Reception occurs in the world in which one lives, and so the photograph ultimately becomes a parable for understanding the world around it. One can still stand up to state power—or at least admire those who do—but understanding the iconic photo requires that one also face up to one's own mythology. After all, the man is still standing there only in the photo.

SEEING LIKE A STATE

Tiananmen Square has been central to the rise of modern China and the scene of violent suppressions of democratic speech. Since we know that both the man and the tanks are Chinese, and that they are facing each other in Tiananmen Square following weeks of popular demonstrations on behalf of

democratization and other governmental reforms, the photograph becomes a record of that historical event and by extension of a process of political transformation underway in China and throughout the world.[20]

This political drama provides the most obvious context for the photograph. The man confronting the row of tanks is a picture of contrasts: the lone civilian versus the army; the vulnerable human body versus mechanized armor; "human hope and courage challenging the remorseless machinery of state power."[21] These dramatic differences lead directly to the predominant appropriation of the photo as a critique of authoritarian regimes and a celebration of liberal-democratic values. The image's reprise of a dramatic conflict between freedom and oppression is only one in a series of transcriptions, however. Although situated at the center of the composition, it does not comprise the only order of perception activated by the composition as a whole.

The key to our analysis of this image is to see that the dramatic standoff is positioned within a modernist perspective toward pictorial space. This larger aesthetic frame unfolds from the vantage of the photographer, who is above and at some distance from the scene. From this vantage, one looks down on the scene from a safe place that is not included within it; the tank commander has no knowledge of the camera.[22] The tanks are still impersonal, but so is the scene as a whole. The viewer is disconnected from the scene, positioned as a distant spectator who can neither be harmed by nor affect the action unfolding below. The viewer of the picture acquires the neutral, "objective" stance of the camera.[23] As James C. Scott has demonstrated, whenever we view unfolding events with an objective detachment afforded by a purportedly neutral point of view, we are "seeing like a state." By contrast with the swirl of people and banners around the Goddess of Democracy in the Square, this scene is highly *legible* to the Western viewer. "Legibility implies a viewer whose place is central and whose vision is synoptic. . . . This privileged vantage point is typical of all institutional settings where command and control of complex human activities is paramount."[24] The authoritarian state that is positioned within the picture is subordinated to the individual standing freely before it, but both of these alternatives are subordinated to the modernist scheme of representation that dominated governmental and most other institutional practices in both capitalist and socialist regimes in the late-twentieth century.

Thus, it is not surprising that the photograph depicts an event unfolding in an open, almost completely deserted public space. The field on which the man and tank are positioned is a model of the abstraction characterizing modernist design: it is a flat, uniform, concrete surface of a city street, de-

signed for modern transportation technologies such as the bus visible at the upper border of some versions of the photograph. It is devoid of any place to sit, congregate, or talk, and its dimensions are not to "human scale," that is, for personal transactions, but rather built to accommodate the flow of vehicular traffic. The traffic pattern is evident from the only symbols on the surface: straight, parallel lines in white or yellow and white directional vectors that are either straight or at right angles. There is no ornamentation, and there are no words. Take out the representational figures in the center, and you have a modernist painting in the tradition of Piet Mondrian.

Of course, the photograph combines abstraction and figural representation; as it does so, it activates additional codes of modern political order. The photographic angle makes the man's act of political protest an exercise in disciplinary power: a constitution of the subject through controlled use of the body within a zone of surveillance.[25] Historically, the liberal public sphere was largely oblivious to the disciplinary society emerging at the same time in the same networks, and disciplinary power often operates without direct confrontation with the agencies of public opinion. (So it is that theorists of each formation can largely talk past one another.) In this photo, there is a clear overlay of the two orders as neatly sutured transcriptions: a silent body in public view generates the authority of public opinion in opposition to the state's use of force, while disciplinary technologies of urban design and visual representation frame the scene as if it were being viewed from an observational tower. The full extension of this logic is that the global media become a panoptic technology: not there but there, not visible in the local scene but keeping it under observation.

This elite perspective also characterizes the realist style of political representation, which has been the dominant means for rationalizing power in international relations. By withdrawing emotionally from the swirl of events to assume a topographical perspective, the prince—or political analyst—sees the historical event as a tableau determined by "an abstract world of forces (functionally equivalent, socially barren entities like military units or nation-states or transnational corporations)."[26] This perspective is defined as much or more by what it excludes as by what it features. The banners, costumes, and swirl of bodies creating a carnival atmosphere in the square, the songs, parades, and other forms of public emotionality, the pamphlets, speeches, and constant din of talk all are replaced by an empty, regimented space marked by force flow vectors and dominated by the organized deployment of uniform, interchangeable military machines. The one visible human being in the scene also conforms perfectly to dictates of this style, for he is a model of self-control. "One survives in this world through strategic calculation of

others' capacity to act and through rational control of oneself."[27] Standing erect, poised, overcoming the natural impulse to flee from danger, acutely gauging the will of the unseen tank commander opposing him, the man's bold act of heroism also is an incarnation of realism's rational actor. His immobile, balanced stance and the clean lines of his modern, black-and-white attire provide aesthetic confirmation of this attitude.[28] More to the point, this rational self-control by the individual, which in turn is part of a larger mentality of viewing political reality in respect solely to calculations of self-interest and power, constrains identification with the Chinese reform movement. Rather than being pulled inside the mass demonstrations for popular democracy, this realist transcription of the event highlights individual calculation of risk and rational self-control while viewing political reality in terms of abstract projections of power.

Additional elements of the photo reinforce this realist mentality. Any photograph is silent, but this one is a portrait of political action without speech. (Actually, a crowd of onlookers was shouting throughout the scene, but that was not recorded by the photograph.) Tanks are not exactly built for negotiation, while they perfectly embody the essential definition of the modern state—its monopoly on force. The man is silent, using his body rather than his voice in a gesture that converts vocal protest to nonviolent resistance, a recognizable form of political action capable of balancing material coercion—for a moment. The scene's composition provides an allegory for the profound imbalance within the realist view of the world between force and morality. Moral, social, or cultural constraint on force is always precarious, held in place by the good will that is a sure casualty in violent or prolonged conflict. The man stops the tanks, and his symbolic power (e.g., his capacity to represent national identity, citizenship, civic rights, or the value of the individual person) temporarily, precariously, is capable of balancing the coercive power that was moving toward him. These symbolic values are represented through an absence: the empty space at his back that at once corresponds to the real, material tanks on the other side and predicts the inevitability of his giving way to their advance. The composition itself is predictive, as the tanks already have advanced across most of the pictorial field along the lines and vectors on the street indicating the forward direction of the traffic. As those lines correspond to the right-to-left diagonal line across the picture frame, they connote movement from their starting point toward their destination behind the man (and behind and to the side of the viewer, who may not be targeted but is being outflanked). The message seems clear: in this confrontation, force will prevail.

This conclusion is the more plausible because the only figure shown is

male. One man stands against a mechanized army unit, the epitome of masculine power. This ideological grammar provides an additional basis for realist projections, as ideas of pluralism, cooperation between different social groups, and dialogue become less evident in a monotonic system, and conventional norms of rationality, emotional control, and hierarchical command are reinforced. It also may underscore the extent to which the photograph portrays the Chinese government as a threat rather than an actual perpetrator of violence. Tanks such as those stopping here had been churning through the square to destroy whoever had not left fast enough, and other pictures of the aftermath of that violence depict government-induced disorder while eliciting identification with the pain and relative innocence of the victims. The iconic photo, however, remains a gestural dance of masculine display. Within this gendered space, as in realism itself, there is far more attention paid to threats than to actual violence (which often proves embarrassing, if only because it reveals hidden complexities in motive and response). And this focus on *potential* violence gives a particular shape to the event. On the one hand, it is the preferred modality of state power: more efficient, less accountable, less capable of unintended consequences such as martyrdom, more transferable across the entire state apparatus of procedures and officials. On the other hand, it increases and inflects the man's representative power. It becomes easier to see him as a figure of revolution rather than of gradual change, a precursor to dramatic reversal of the picture's vectors rather than an endogenous transformation of a complex system. In short, a world of masculine display is a world of force fields and threats, of pushing and backing down rather than negotiating, and of imposition and resistance rather than mutual change. A photograph celebrating democratic revolution reproduces the act of seeing like a state, a perspective that supports hardliners on each side of the Chinese conflict while overlooking less legible, more encultured forms of democratic reform.

The realist transcription is not sovereign, however, in part due to the visual syntax of the photograph. The tanks are moving through the pictorial frame along the upper-right to lower-left diagonal, that is, from the new to the old and from the ideal to the real.[29] The tank has crossed the midline, moving into the past and perhaps taking the nation-state with it. The man stands short of the midline but his line of sight orients the viewer on the vector extending into the new and the ideal; he is a figure of unrealized potential. Thus, the photo is a literal depiction of realism and a prophetic representation of liberalism. According to that allegory, arbitrary authority cannot stand against the innate human desire for freedom and the rule of law. The tank's hesitation portends the eventual triumph of liberalism and

individual self-determination. The man's vulnerability keeps the door open to the continued need for force, however, particularly when both liberalism and realism contrast themselves to mass movements, power vacuums, and other harbingers of anarchy. Individual freedom and a world of forces, self-determination and rational calculation, an authoritarian present and a liberal future—these potentially difficult conjunctions are smoothed over by their aesthetic coordination within the conventions of modernism.[30] What remains is not contradiction but rather a complex representation that can mediate differences between two Western discourses of political order and account for immediate events while projecting long-term transformation. Force prevails in the photo, but it will not prevail over time, the time of modernization.

Any representation is a partial record of its object, but modernist representation is based on especially severe reductions in information. Whether for the purpose of artistic autonomy or rational administration, the approach is the same: surface variation, local knowledge, provisional arrangements, mixed categories, and social complexity are all subordinated to processes of reduction and abstraction, and when geared toward production, to processes of standardization and regimentation.[31] With few exceptions, the orientation is toward the universal rather than the parochial, the geometric rather than the organic, the functional rather than what is customary, an "international style" in architectural design and bureaucratic practices rather than attention to cultural differences and vernacular politics.[32] And, as Scott remarks, "The carriers of high modernism tended to see rational order in remarkably visual aesthetic terms. For them, an efficient, rationally organized city, village, or farm was a city that *looked* regimented and orderly in a geometrical sense."[33] This way of seeing allows the agent to identify economies in resource use that serve specific interests, and especially the interest of administrative control.

The extent of representational reduction achieved by the tank photo is evident only in respect to its context as that is defined by other accounts and especially other photos and video clips of the events in the square.[34] Although the photograph cannot be faulted merely for not being a picture of something else—it is a record of what was in fact in place before the lens of the camera—its subsequent stature in collective memory gives its aesthetic principles additional significance. It may be that the high modernism of the picture gives it particular leverage as a means of remembrance; it is, after all, already somewhat abstract and schematic, and its grid pattern regimentation of the visual field is formally consistent with its figural content of a man exercising great self-discipline before a military column.[35] The tonality of the

photo further reinforces this schematic orientation. Both scientific representation and the abstract coding used by sociocultural elites are optimized by black-and-white values, while the naturalistic coding familiar to everyone is optimized with moderate color tones.[36] The photo typically is presented in print and electronic media in these mixed tones or in black and white, while the most widely available poster also is in black and white.

The major variation is a poster that adds a brilliant red background and golden text in Chinese ideograms and in English to praise the man's courage (fig. 40).[37] This exception confirms the rule: the picture is given a sensory orientation that creates emotional identification through aesthetic norms defining Chinese political culture. Note also the change in point of view. Now the viewer is positioned on the street behind and below the man, while the tank barrel looms above. Although the man now is larger, as befits his foregrounding as a symbol of civic virtue, the point of view makes the tank more dangerous to both the man and the viewer.[38] The viewer now is in the position of those bystanders not in the iconic photo, a position of direct participation in the historical event and of personal endangerment. By contrast, the steep vertical downward angle of the iconic photo places "the social world at the feet of the viewer, so to speak; knowledge is power."[39] Thus, the iconic image aligns muted sensation with the visual angle of disengaged observation. In the poster's reworking of that image, the viewer becomes a virtual participant in the demonstration and can experience the fear that makes courage necessary. And while the poster retains the modern dress and anonymity of the citizen before the tank, it fuses that basis for transnational identification with the national language and political traditions of Chinese culture.

This comparison underscores how the panoptic point of view and related design features of this iconic image actually produce a distorted view of the political action on the street. Note what is lost when attention is turned from the historical event of the demonstration to the tableau of the man before the tank. From a day when one million people were congregating in the square, this photograph shows only a single person. Instead of a crowd milling about amorphously amidst tents, kites, flowers, food vendors, impromptu stages, and cultural icons, an individual is standing still in a perfectly balanced posture in an empty public space. Instead of posters, wall signs, banners, and flags, there are the abstract vectors of traffic control. Instead of noise, sirens, and the smells of food, garbage, and urine, there is silence and a general anesthesia of sensory engagement. Instead of parades and a constant flow of motorbikes, ambulances, trucks, and other vehicles, there are tanks stopped in a broad but deserted street. Instead of displays of public emotionalism, there

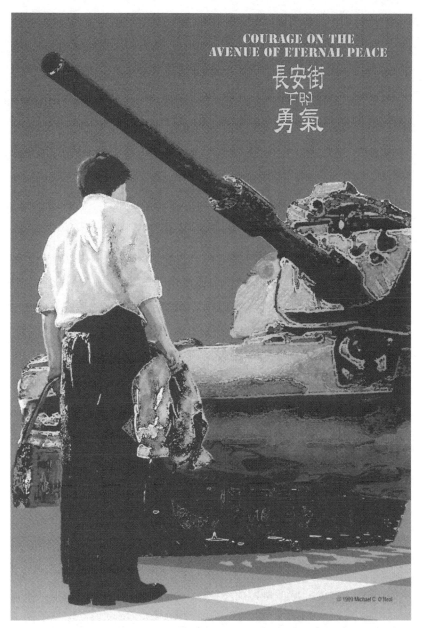

FIGURE 40. "Courage on the Avenue of Eternal Peace,"1999, poster (Michael C. O'Neal, artist). Courtesy of Michael C. O'Neal.

is an act of calculated immobility. And, as already noted, instead of violence there is merely the threat of violence.

It is crucial to remember that these differences in representation are not merely matters of taste; they are endorsements of different modes of political agency. Jeffrey Wasserstrom's observation on student protests in Shanghai puts the point clearly: "What made these protests so powerful was their efficacy as *symbolic performances* that questioned, subverted, and ultimately undermined official rituals and spectacles. Lacking economic clout and generally shunning violence, students had to rely primarily upon their ability to move an audience. This they did through the use of oratory, song, gestures, and other forms of symbolic actions. In short, they made all the techniques actors use in aesthetic forms of drama serve the purposes of the *political theater* of the street."[40] The symbolic resources for political performance are some of the most basic forms of democratic knowledge, and their suppression in the realm of representation then underwrites other political modalities such as money or guns.

We must also acknowledge, however, that this reduction occurs primarily over time as one image displaces others. It was not the immediate effect of the photograph. The contrast with the events surrounding the scene depicted was at the time experienced as a continuous and mutually validating flow of events. The extensive reduction accomplished within the pictorial frame occurred amidst a welter of information that was already known and a sense of historical change that was being experienced and celebrated. Although this iconic image encourages a loss of information and alteration of political agency within public memory, it also will carry traces of the original context that are fundamental to its dynamic ambivalence regarding democratic and liberal ideals. Thus, the condensation within the iconic image is experienced as an intensification of experience, and it works to organize that experience.

The intensification of experience occurs by concentrating the energies generated by an event into specific, concrete images. There is no focus to a crowd, but our attention naturally zeros in on a lone figure in a square. Likewise, the government, heretofore represented only through long shots of buildings, now becomes visible in the condensation symbol of the battle tank. In a corresponding reversal, the public becomes known largely by its absence—an empty street, emptied because people have been fleeing from danger. In their place stands only the man, the individuated aggregate capable of both representing collective experience and eliciting identification from an audience habituated to individualism. The impulse to focus on the individual in liberal representation is underscored by the fact that there are

a number of photos of groups of Chinese citizens stopping army vehicles—
these successful acts of resistance had been occurring for several days—but
there is only one photo of an individual acting by himself, yet that is the one
that became iconic.[41]

This reduction of a month-long mass demonstration before government
buildings to a single moment in which a lone individual stands up to a tank
condenses the entire conflict into an image of exquisite drama; information
is lost, but in its place is the potential for a celebration of political liberty.
This potential should not be underestimated. A compensatory shift from the
material reality of power to a celebration of the possibility of future freedoms
may be one way in which the photo continues to underwrite democratic pol-
ity. Democracy may always require an unreasonable amount of hope of the
sort found in idealistic performances of individual dissent, and liberal de-
mocracy may require a strong association of political expression with indi-
vidual self-assertion. This figure of dissent need not stand in a modernist
space, however.

The photo alters experience not merely by suppressing facts but rather
through the construction of a political scenario.[42] Through reduction of the
Chinese demonstration to this iconic moment, the photograph transforms
the event from an episode in Chinese national history into a parable about
the future global order. This transformation flows out of what is left after
the reduction: in place of the pluralism evident in the square, there remains
only an iconography of modernism. In place of calls for public accountabil-
ity and democratic participation in governance, there is a symbol of personal
liberty and individual rights. Instead of a massed public confronting an en-
claved leadership, there is the categorical difference between the individual
and the state. In this scenario, political action occurs within a modernist
terrain in which state power and calculations of risk still predominate. The
fundamental historical question is whether Western liberalism will achieve
global hegemony, and the key to this drama is to give individuals the lever-
age that comes from voluntary participation and coverage by the Western
media. Change is achieved through the actions of ordinary people acting as
individual entrepreneurs, and it goes without saying that change will occur
gradually while still-muscular totalitarian regimes grind slowly to a halt and
ponder how to redirect their large, awkward machinery.

To summarize thus far, the iconic photo of the man standing before
the tank is a paradigmatic case of modernist simplification. Through a se-
ries of reductions and intensifications of the political conflict erupting in
Tiananmen Square, the photo restructures that conflict on the terms most
legible and reassuring within a Western narrative of the continued expan-

sion of modern technologies, open markets, and liberal ideals throughout the world. The universal validity of those scientific, economic, and political principles is implied by their depiction within the modernist "international style" of representation and by their extension without modification across the globe. These processes are evident in a photo that carries only the most muted sign of Chinese identity—the star on the army tank—while being constituted throughout by characteristic signs and figures of modernism. In this narrative, the state contracts to its most elemental functions while economic activity and a corresponding individualism expand without limit except as they are channeled by modern technologies of production, transportation, and communication.[43] The image could be taken—and has been taken—anywhere in the world.

The photo's simplification of the Chinese conflict can have such comprehensive implications because it reproduces one of the fundamental achievements of modernization. As Scott observes, the development of the modern state required a comprehensive standardization of names, measures, jurisdictions, currencies, languages, and other signifying practices previously under local control. In every case, standardization was accomplished through simplification and in conjunction with "that other revolutionary political simplification of the modern era: the concept of a uniform, homogeneous citizenship." Taking France as his leading example, Scott argues that "in place of a welter of incommensurable small communities, familiar to their inhabitants but mystifying to outsiders, there would rise a single national society perfectly legible from the center. The proponents of this vision well understood that what was at stake was not merely administrative convenience but also the transformation of a people. . . . The abstract grid of equal citizenship would create a new reality: The French citizen."[44]

A similar transformation is created on the grid of that Beijing street. In place of the welter of signs, most of them unreadable to those outside of China, and a dense, mass gathering that cannot be taken in as a whole, there is a transparent, perfectly legible depiction of a modern individual standing in an empty, uniform public space before a generic symbol of routinized state power. The photo has in a stroke transformed Chinese political identity into the "uniform, homogeneous citizenship" of the modern era. This is a layered transformation: it converts one (or more) forms of Chinese citizenship into another; it seamlessly integrates Chinese citizenship into a universal order of human rights (such that this citizenship, like any state currency, is convertible with any other); it elevates all civic identity into this universal form that now applies primarily to the global order rather than to any specific nation.[45] What once was the basis for the transformation of France from

a premodern collage of local prerogatives into the uniform jurisdiction of a modern state, now becomes the basis for transforming national identities into the uniform economy of rights in a global order. And just as the earlier change in Europe was accomplished through the standardization of names, languages, and measures, so does the global order work through a standardization of signs. This common emphasis on matters of representation does not extend to continued administrative centralization, however. The center of the global order is the lens of the camera.

THE LIBERAL FUTURE

Modernism has always been about the future. Despite the differences between, say, Italian futurists and the German Bauhaus, a common denominator was elite management of mass societies through the technologies and production values of the machine age. The perceived opposition was a democratic irrationality. As Le Corbusier, the representative figure of modern design declared, "It is a question of building which is at the root of the social unrest of today; Architecture or Revolution. . . . Revolution can be avoided."[46]

This rationalizing of historical change always depended on the capacity to transport the design principles of modernism across cultural borders. An international style should be the same style and the infrastructure of a modern civilization should be based on the same technologies and engineering whether one is in New York, São Paulo, or Tehran. People have a vexing habit of preferring their own way of life, however, and so the modernist project encounters continual frustrations. It is just at this point, the problem of extending modernism, that modern visual media play a decisive role. As Scott remarks, "One response to this frustration is a retreat to the realm of appearances and miniatures—to model cities and Potemkin villages, as it were. . . . The effect of this retreat is to create a small, relatively self-contained, utopian space where high-modernist aspirations might more nearly be realized."[47] Scott defines the definitive cases as the theme park and museum, and the expansion and likely effects of these media in first world societies is well documented. But there is another, much cheaper and more portable example of a "small, relatively self-contained, utopian space": the photograph. Here the aesthetic effect of miniaturization is perfectly realized and completely normative.[48] When the photo's composition is itself a model of modernist design, its predictive potency becomes enormous: "Just as the architectural drawing, the model, and the map are ways of dealing with a larger reality that is not easily grasped or manageable in its entirety, the miniaturization of high-modernist development offers a visually complete example of what the

future looks like."⁴⁹ When a democratic revolution is compressed into a man and a tank seen at a distance—miniature figures that could be toys—and that surface is a plane surface marked as a grid—as if it were a game board— then a complex, partially illegible historical process has been represented as a model of the modern world's characteristic social order. Once again, the future is a modern future, achieved by modern technologies projecting the continued extension in space and time of universal values, values that are known to be universal because legible, transportable, and rational.

This use of the photographic icon to define the future is evident in other media portrayals of the Tiananmen Square protest. The documentary film *The Gate of Heavenly Peace* is a fitting example due to both its overall excellence and its use of the tank photo as a framing shot.⁵⁰ The narrative begins with action shots of the carnage and casualties along with interviewees reacting to the attack by the army, follows with video footage of the man's encounter with the tank, then with similar tape from a state "news" voice-over that emphasizes the tank commander's restraint, and then again a bit later with the original clip to frame the rest of the film.⁵¹ As the story develops, three basic political alternatives emerge: the authoritarian state, the popular democracy movement, and a doctrine of individual self-realization. The state is represented by its army and by officials who divide into two, mutually limiting camps of hardliners and reformers. The popular movement of students, workers, and intellectuals likewise splits into two contradictory camps of pragmatic pluralists and neo-authoritarian demagogues. The third alternative of liberalism cannot be paralyzed by division because it already is completely dispersed into an unknown number of individual lives. These individuals include most prominently an articulate pop singer who celebrates self-expression and the mother of a murdered boy who emphasizes the importance of taking small steps individually to achieve reform.

By the end of the film, the state has lost all legitimacy and popular democracy has failed. The swirling montage of the opening shots of the demonstrators fade into memory, while the thrice-performed iconic standoff between the individual and the state remains the elemental political scenario awaiting resolution. The film ends with pictures of the boy who was killed while observing the demonstration. Like the man before the tank, he was not a demonstrator, just someone caught up in the event. More poignantly yet, he was only a boy, a figure of potential unencumbered by the responsibilities of adult life.⁵² His mother says, "Should we simply wait for another chance to start a Democracy Movement like 1989? Would that save China? I don't think so. The only way to change our situation is for each one of us to make a personal effort. Every small action counts." The narrator concurs: "When

people abandon hope for a perfect future and faith in great leaders, they are returned to the common dilemmas of humanity. And there—in personal responsibility, in civility, in making sacred the duties of ordinary life—a path may be found."[53] Popular democracy has been transcribed into the "utopian" political theory that was the standard categorization of Communism by the West during the Cold War. Genuine, justifiable political emotion has been depicted as unrealistic desire, and public grief over the loss of both lives and freedom has been reduced to the experience of a single person's private mourning.[54] Liberalism is the practical alternative—the only alternative for a real world. Ironically, one utopian project has been criticized by means of another: the use of visual imagery to imagine that another messy "cultural revolution" in Chinese democratization can be avoided through management by modern technologies and incorporation into the global economy. The last shot of the film is not of a demonstration, nor of the million people protesting in the square, nor of their leaders speaking before them. It is the picture, as from the family photo album, of the boy's face.

The film and the iconic photo articulate a common narrative of the ascent of liberalism in a global context. Each sublimates an interrupted democratic movement into the projection of a liberal future. This projection also is evident from how the iconic photo often is placed in a story and in its relationship to other photos from the crackdown. *China: From the Long March to Tiananmen Square* provides one illustration.[55] The front cover of the book gives the Goddess of Democracy pride of place. The history culminates in images of the massacre, followed by a last chapter entitled "Aftermath" that ends in the image of the tank. The back cover is a single image that serves as an additional articulation of the iconic photo: another tank is parked on an overpass, beneath which a young, heterosexual couple sits on a bicycle, already on their way to starting a happy private life by quietly slipping unnoticed and unaccompanied by others beneath the gaze of the state. As in the iconic image, the quiet revolution that is prophesized is set within a modernist composition of geometric lines and empty spaces. A similar sequence occurs on the Web page Tiananmen Square 1989: images of various acts of public protest are followed by the carnage, then the tank, and finally the couple under the bridge. The sequence reduces and transforms a history of democratic dissent into the individual pursuit of happiness.[56]

Our point is not that the complexity expected of a China expert is missing from public documentary media, but rather that another culture's articulation of democratic self-assertion has been reconstituted according to the aesthetic and political conventions of the Western audience. These images fulfill Anne Norton's observation that "liberalism has become the common

sense of the American people, a set of principles unconsciously adhered to, a set of conventions so deeply held that they appear (when they appear at all) to be no more than common sense."[57] Instead of a possible "second center" for the emergence of a global culture, we see another version of ourselves. Instead of a more hybrid modernity, we see the familiar patterns of modernization. Instead of a deep yearning for democracy, we see an open space for individual self-assertion.

The modernist image is itself a complex design that is open to varied uses, however. The modern simplifications of uniform measures and uniform rights were both liberatory and the infrastructure of a comprehensive extension of disciplinary power. Likewise, modernist representation can articulate individual rights while it subordinates those forms of cultural identity that don't fit into its scheme of legibility. The universal constitution of Chinese citizenship reassures the Western audience that the global society will develop on familiar terms, yet it certainly is a progressive development for those dissidents who are in exile, and there is no question that China needs more liberty, not less. Rather than decide between choices that are not mutually exclusive, it is more useful to consider how this iconic photo organizes all political ideas within the projection of a social order.

As a complex articulation of modern life, liberalism has developed in conjunction with the rise of the bourgeois public sphere. Liberal individual, public forum, rational deliberation, self-assertion, and enlightened pursuit of happiness all fit together as a coherent pattern of motivation: the actor, scene, agency, act, and purpose comprising the modern ideal of political action.[58] The iconic photo from Beijing, like other icons, provides performative enactment of key features of the public sphere. Unlike the others, in this image the public has a minimalist definition. The scene is a large, urban street, an open field for the movement of strangers. It is a public space in the sense that it is created and maintained by the state for the operation of civil society. Notice, for example, the bus, the standard vehicle of public transportation, that appears in some versions of the photograph. The state thus operates domestically as a neutral infrastructure for the movement of people, goods, and services. That infrastructure includes public spaces through which strangers can move without being impeded by any obligation to interact with one another. This is not a public space in a stronger sense signified by Tiananmen Square, however, which, like village commons throughout China, was designated as the place where the people would recognize one another as a people, celebrate the common enterprise or deliberate about the distribution of common resources, and call citizens to civic duties while holding leaders accountable to civic obligations.[59] It is, instead, the abstract

space of modernist urban design, intended to allow the society to function with maximum efficiency.

On this neutral field there are the figures of the man and the tank(s). The man is anonymous, and he is dressed as any man in a modern city might be dressed at some time during the week. He is devoid of personal identity and social position in just the way that all are subject to the traffic laws. The public realm will operate like the public streets, a zone of regulations through which people move without notice to conduct their private business. None of this is a source of nobility, of course. That comes from his opposition with the tank. He is denominated by this difference: the opposite of the impersonal state machinery following orders must be the private individual exercising his personal liberty. The full articulation of this opposition fills out the model of the public sphere: civil society is opposed to the state; the surest check on abuses of state power is the public accountability that comes from the revelation of state actions in the public media; the individual, who cannot resist state violence, can be protected if there is an intermediate realm of public opinion that has the capacity to influence state action and be influenced by individuals.[60]

So far, so good, but there is a significant deviation from the classical model as well. The significant shift comes from a feature the man shares with the tank opposite him: just as that tank (unlike others that day) is only a form of potential violence, so is the man a symbol of the potential for democratic culture. Essential elements of public life are in place but the public sphere is largely empty, only a potential space for development. The photo gives us a model of the public sphere as it has been projected onto the developing world. This is a world the U.S. audience knows largely through photojournalism and according to the assumption that Catherine Lutz and Jane Collins have identified succinctly: "Their present is our past" and our present is their future.[61] As this assumption is inflected by modernist aesthetics, the public sphere within China will emerge only as China becomes the leading edge of an expanding global public culture having uniform citizenship and technologies of communication. There is one worldwide network of public media, one universal definition of human rights, and only one version of modernity. The photo is of a transitional scene into a new world order; it is a picture of the future.

Neither government official nor demonstrator, the man is unmarked politically. He still signifies, of course, but now by the jacket and bag he holds in his hands. These items appear functional and altogether ordinary, characterizing him as someone who meets his own needs and defines himself through the acquisition and use of consumer goods.[62] These humble items articulate

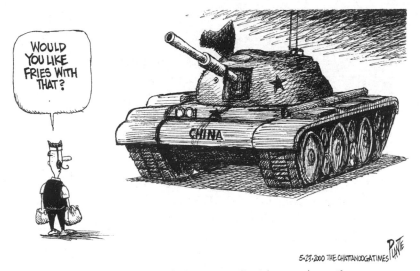

FIGURE 41. "Would You Like Fries with That?" 2000, editorial cartoon (Bruce Plante, cartoonist). Reproduced by permission of Bruce Plante / The Chattanooga Times Free Press.

both dimensions of contemporary liberalism: the ordinary person's pursuit of happiness in a world of personal liberty and free choice, and the economic interest in freeing all activity from any restrictions on market behavior. The Chinese are not likely to buy U.S. tanks, but they could be buying American jackets, drinks, CDs, life insurance, and mass media programming, so the corporate interest in market expansion is perfectly fused with the self-interest of the Chinese consumer. Likewise, the man's subsequent retreat into private life may be the loss for the realm of civic participation, but he will continue to shop.

This shift from the political to the economic sense of liberalism is perfectly captured in two subsequent appropriations of the photo by editorial cartoonists. In the first drawing (fig. 41), the man becomes a franchise food clerk who asks the tank, "Would you like fries with that?"[63] In the second (fig. 42), a protestor at the World Trade Organization meeting in Seattle confronts the tank dressed in a turtle costume, which now has a driver popping out of the hatch to speak. The driver is wearing a business suit labeled "US," and he says, "We believe that entry into the WTO will push China towards democratic reform."[64] These successive reversals lay out the logic of globalization with brilliant clarity. In the first cartoon, the heroic citizen becomes a hapless little guy trying to do his job. (Note also the nice touches of replacing the bag and jacket with sacks of food and the addition of a headset. Those small, handheld items in the photo are large enough to be recognized as signs of

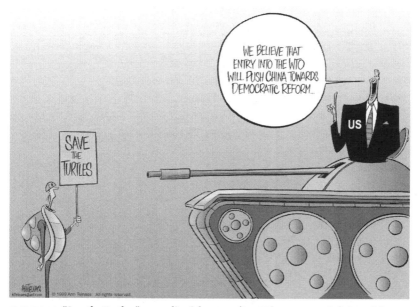

FIGURE 42. "Save the Turtles," 1999, editorial cartoon (Ann Telnaes, cartoonist). Copyright 1999 Ann Telnaes. Reprint permission granted by Ann Telnaes in conjunction with the Cartoonist Group. All rights reserved.

consumption, and communications technologies are always part of the new global order.) He speaks, but only to mouth a programmed catchphrase, while democratic dissent has become an appeal by American corporations for the China market and the global future is one in which all are free to sell and consume American popular culture. The full political implications are brought out by the irony in the second cartoon. An even more hapless figure stands before the tank—wearing a turtle suit is not going to save anyone—and now the United States is the oppressive regime willing to use force to silence dissent on behalf of order. In case we might miss the point, the speaker's demeanor makes it clear that economic liberalization is an end unto itself that includes no commitment to "democratic reform" in China or Seattle or anywhere else. Democracy is no more secure in the global order run by the major economic powers and their police agencies, the nation-states, than it was in Tiananmen Square.[65] The parodic depiction of this difficult-to-visualize political problem is possible because of the complexity of the iconic photo that supplies the rhetorical commonplace for the cartoon's public statement. The historical association with democratic dissent, the deep structure of modern liberal assumptions, and the subordination of the one to the other shape audience response in both the original photo and its appropriations.

Thus, the photo articulates the bourgeois public sphere, particularly its foundational principle of the individual standing in opposition to the state and in need of the leverage provided by public media. Yet this model is deformed by its modernist projection. In China, according to the photo, the development of this intermediate realm of public discourse, participation, and accountability is possible yet currently unrealized. But it will happen largely through the operation of Western media and economic activity. As it happens, it will continue to rely on a disciplinary infrastructure useful for the management of large populations, an infrastructure that relies on modernist designs and visual technologies to control bodies, traffic, and state actions alike. At the center of this procedural grid is placed the liberal individual: unencumbered except as he chooses to be so, essentially anonymous, confronting the state only to tell it to stay out of private life.[66] Other forms of civic identity remain possible, but they are at odds with both large-scale management and the individual's pursuit of happiness in private life. As the cartoons suggest, in this new world order democratic dissent looks ridiculous.

CITIZENS AND CONSUMERS

The photo's reproduction of the aesthetic conventions of global modernism leaves only empty space and a sovereign individual as the means for democratic polity. The question then becomes, what will be most likely to be valued in such a world? As Geremie Barmé argues, "Comrades have become consumers without necessarily also developing into citizens."[67] The global economy requires that individuals be consumers, and the question of democratization is merely whether it is necessary for that outcome. The image of a lone individual stopping a tank in its tracks contrasts liberal values and those of the totalitarian state, but it also deflects awareness that democratic norms can be at the mercy of market forces. The image is iconic in part because it so concisely embodies both the public interest and individual autonomy, but it does not suggest that they need be valued equally.

All is not lost, however. The pathos of the editorial cartoons depends on the photo's iconic status as the marker of a democratic revolution. If the revolution failed, at least the photograph preserves one beautiful moment of heroic dissent. If the dissent failed on the ground—neither the tanks nor the government crackdown were stopped—it nonetheless endures as a long running civic performance in U.S. public culture. The Tiananmen icon is neither democratic nor liberal but rather both at once. The question is not whether one orientation is the more fundamental to the rhetorical power of the image. We are arguing that *both* patterns of definition are there, and that

the high modernist coding of liberal ideology in the pictorial design is far more powerful than most would assume. The more interesting question is how the image can be put to potentially contrasting uses.

This tension is evident in the Tiananmen icon's history of appropriation. Although one should be wary of categorizing such a wide range of artistry, several examples should suggest how appropriation of the iconic photo has traveled from Cold War democratization to liberal consumerism within a global economy. The best example of its "original" use may be *Time* magazine's coverage of May/June 1989. *Time* devoted four consecutive cover stories to the events in the square, culminating in the June 19 cover that featured the tank photo. The photo is reproduced as a two-page spread to introduce the feature story, while additional coverage includes vivid images of the conflict. The story begins as a caption to the iconic photo:

> One man against an army. The power of the people versus the power of the gun. There he stood, implausibly resolute in his thin white shirt, an unknown Chinese man facing down a lumbering column of tanks. For a moment that will be long remembered, the lone man defined the struggle of China's citizens. "Why are you here?" he shouted at the silent steel hulk. "You have done nothing but create misery. My city is in chaos because of you."
>
> The brief encounter between the man and the tank captured an epochal event in the lives of 1.1 billion Chinese. The state clanking with menace, swiveling right and left with uncertainty, is halted in its tracks because the people got in its way, and because it got in theirs.[68]

The textual emphasis clearly is on a democratic revolution against the Communist state. The man stands for the Chinese people, who are citizens acting collectively, and the state is silent while he is given the power of speech. This description continues the story, developed across the month of feature coverage, that Communism was being transformed from within.[69] The cover puts the tank above the headline, "Revolt against Communism: China, Poland, USSR" (the last three words separated by stars). Within, "Defiance rocks the Communist world. China resists while Moscow and Warsaw struggle to reform."[70] At the top of the feature story, directly above the lead tank, the single word "Communism" (in red) signals this historical context, while the text within notes that "it was a well-established truism of the 20th century that a Communist regime is a military regime in disguise. The disguise came off in Hungary in 1956, in Czechoslovakia in 1968, in Poland in 1981—and in China last week."[71] The tank icon may have been favored by the prominence of tank photos in the visual history of twentieth-century Europe; it certainly filled out this Cold War narrative better than any other

photo in the *Time* montage.[72] If a man will stand up to a tank, and the tank will stop, then we clearly are nearing the end of the historical trajectory of the totalitarian state. Likewise, even as the magazine reports on the Chinese government's obliteration of public dissent, the iconic photo provides the final, definitive representation of the event as a moment of successful democratic self-determination.

Time has since changed its tune. The commemoration of the man before the tank today as one of the twentieth century's "leaders and revolutionaries" is artfully consistent with the early coverage, but the story has become one of values and aspirations that can be realized without political action, in part due to the power of the image in a global communication environment. "The man who stood before a column of tanks near Tiananmen Square— June 5, 1989—may have impressed his image on the global memory more vividly, more intimately than even Sun Yat-sen did. Almost certainly he was seen in his moment of self-transcendence by more people than ever laid eyes on Winston Churchill, Albert Einstein and James Joyce combined."[73] Self-transcendence and service as "an Unknown Soldier in the struggle for human rights" are good things, but they are not the same thing as a successful democracy. Indeed, "nine years after the June 4 incident, moreover, it's unclear how much the agitators for democracy actually achieved," while *Time* pins its hopes on the "technology" of fax machines, television, and the Internet that can allow the Chinese "to claim and disseminate an economic freedom they could not get politically." Thus, the "unknown Chinese man" who represented "the power of the people" in the initial coverage of the event has been separated from other failed demonstrators and rehabilitated as a stateless, universalized "Unknown Soldier of a new Republic of the Image," wherever that is. The commemoration largely acquiesces to the regime's refusal to accept democratic reform, while it emphasizes the icon's embodiment of liberal ideals.

Others have taken up where *Time* began, while the general direction seems to be down the same road. The photo is the lead image for a number of Web sites protesting Chinese authoritarianism, and on posters bearing slogans on behalf of democratization and people's movements.[74] When China lobbied to host the Olympics, editorial cartoonists drew on the tank icon frequently. The visual similarity between Olympic rings and tank tread assemblies was put to good use, and was possible because the icon had already made the battle tank a premier symbol of the Chinese government. In one of Patrick Chappatte's cartoons, the man appears somewhat older and perhaps more westernized in his features as he stands before the Olympic-ringed tank that looms large over him.[75] Time has passed and the Chinese regime may be

"I would rather die on my feet than live on my knees."

FIGURE 43. "Intel's Inside," cartoon, n.d. (Ken Hamidi, cartoonist). Courtesy of Ken Hamidi.

adept at using the Olympics to cover over history, but it still will be bad news for the little guy. This simple message is enhanced by the artist's improvisations, which supply darker tones while shifting perspective to place the viewer closer to the man and below the tank. In a more recent cartoon, Chappatte has the tank squashing a lone demonstrator whose hand is still visible from underneath its treads as he drops a sign that says "Tibet."[76] Again, the artistic inflection is telling: because the direction of the tank is reversed so that it is driving from the given into the space of the new, the authoritarian state—and not the demonstrator's ideals—dominates history. As with *Time*'s coverage in 1989, the icon is a template of democratic revolution, but now on behalf of a movement whose prospects are increasingly bleak.[77] Other cartoonists have used equally sophisticated designs. Don Wright fuses the iconic shot with a less well-known image of demonstrators lying smashed amid wrecked bicycles, placing them before a panel of Olympic judges.[78] The smiling judges hold up cards that each say "10" as they look down on the broken figure who is labeled "Human Rights." Behind him looms the tank, and the judging table says "2008 Olympics," where, we are to conclude, violent suppression of human rights will be an Olympic event.

These emphases carry through other uses of the icon, particularly as it is taken farther afield. *Time* magazine's reconstruction of the photo seems to draw on a deep correspondence between globalization, communications technology, and human rights, although not everyone is so optimistic about the relationship between the three. A vernacular cartoon (fig. 43) clearly questions the idea of unified progress. The tank, now without the markings of the nation-state and labeled "Intel's Inside," comes from a Web site dedicated to confronting Intel's "predatory" employment practices.[79] In this image the

FIGURE 44. "Google under the Gun," 2006, illustration (David Wheeler, illustrator). Reproduced by permission of David Wheeler.

tank is about to roll over the man, who would rather "die on my feet than live on my knees," while the tank's flag bans e-mail, marking the digital medium as a valuable but endangered mode of democratic communication. The multinational corporation thus assumes the power and tyrannical disposition of the nation-state, while the monopoly on force becomes a monopoly on modern technology.[80] This remake of the iconic image transfers the idea and ideals of democratic revolution from the public to the private sector. Consistent with Habermas's concept of "refeudalization," the cartoon argues that the commercial corporation can become a tyranny within liberal civil society.[81] Intel controls ordinary people by suppressing their rights to free speech and free association; such rights can be restored only by creating transparency and democratic processes within the corporation. This is a tough sell in the United States, which may be why the advocate draws on the iconic image. Whatever the image does for the cause, the appropriation highlights its relevance for engaging the issues of a global society developed by Western institutions and technologies and dominated by multinational corporations.

The story came full circle when *Time* reported on Google's decision to impose Chinese government censorship on its Web searches in China. The title "Google Under the Gun" was illustrated by a drawing (fig. 44) of the iconic standoff, this time with the man sitting at a computer terminal placed inside the barrel of the tank.[82] The illustration probably was prompted by the fact that the leading example of the censorship as it was reported in the United States was a comparison of Google Images searches in each country for "Tiananmen Square." As the *New York Times* demonstrated, screens in China

showed conventional tourist photographs, while "the first five results on Google Images in the United States show the solitary protestor in the path of a tank column during the 1989 crackdown."[83] *Time*'s illustration of the story may be a perfect synthesis of its earlier and later stories, and so of the democratic and liberal inflections of the image. The artistic license largely was used to enhance the earlier coding. These changes include coloring the tank red, moving the star to the front of the machine, elongating the barrel, putting it aggressively into the personal space of the man, and changing the point of view to bring the viewer closer to the man's experience of the tank's power. The tank is linked by the color red to the flags and building by which the state defines the square, while the man is linked to the space itself by the brown tints used to color his chair, shirt, skin, and the ground under and around the tank. Red becomes the color of the Chinese state, and if brown can be a color of the common people, then the man becomes the figural embodiment of a more democratic definition of the public square.

The illustration is not only democratic, however, as the scene also represents *Time*'s later substitution of digital technologies for democratic politics as the means of change. The man is no longer standing in a public square but sitting in the private space defined by keyboard, screen, and mouse. He is not standing up to the tank but staring into a virtual environment of icons and other images that happen to be encased anachronistically in the tank's mechanical apparatus. The liberal individual who should be free to move unhindered through a global communications medium is being intruded upon by an overbearing state. The government, like its tank, should provide for collective security, not intrude into the private sphere and restrict personal liberties. Free access to information is the key factor in *Time*'s vision of a global civil society, which will work by aggregating individual preferences in a "new Republic of the Image." Once again, a prior democratic moment becomes the background for a liberal future that is as capable of displacing the progressive ideal as fulfilling it.

The Tiananmen Square icon's other appropriations are further evidence of its range. These include the $8,000 question on "Who Wants to Be a Millionaire," a "Daily Show" spoof of such contests, a Michael Jackson World Tour poster, an ad campaign by the Partnership for a Drug Free America, a T-shirt, and the 2004 Super Bowl. Some of these suggest a general drift from historical reference to more vague yet immediate bases for identification. How else could the image be the first one up for the American Moments group of posters at AllPosters.com?[84] A Chinese citizen taking a stand in China without any connection with or support from the United States becomes the incarnation of something American.

The 2004 Super Bowl video lead-in to the halftime show, produced by MTV, is a fine example of the dual articulation and general tendency in appropriations of the Tiananmen icon. The clip has a series of individuals urging that the viewers "choose to" fight, vote, speak out, and otherwise get involved. The tank image flashes briefly between Muhammad Ali saying "Choose to fight" and someone else saying "Choose to vote"; thus, in the blink of an eye it mediates a transition from realist force to liberal rule of law. Prior to the icon but not immediately so someone says "Choose to take a stand." The video ends with a young woman onstage in the stadium shouting, "Houston, choose to party!"[85] The shift from videotape of historical icons to live performance in real time completes the displacement of speaking out and voting by partying. Politics is reduced to the personal enjoyment of commercial consumption.

MTV can misuse anything, of course, but more explicit parodies suggest that the halftime show was not completely out of line. Two Web-based video-cartoons called "Tiananmen Square Man" are illustrative. In the first cartoon, the man puts down a boom box and starts break dancing in front of the tank. In the second cartoon, a man and boy are playing baseball as the tanks pull up, while captions allude to *America's Funniest Home Videos*, a TV show and visual genre devoted to private life. The boy then lines a pitch into the midsection of the man in front of the tank, who collapses. (Oops! He can stop a tank, but not a carom out of the private sphere.) The parody takes the liberalism in the photo to absurd extensions, but not to activities out of line with the individual pursuit of happiness. Vernacular alterations of the photo at other satirical Web sites push the point: the icon carries both an affirmation of democratic values and an embodiment of personal liberty that, when realized, quickly leads people away from solidarity.[86] An artist's concluding note inadvertently contains a further irony regarding the photo's frame of reference: "Relax I'm just having some fun; if you're going to complain you better be more active in the political arena than me (and I'm a member of Amnesty International, Red Cross and Greenpeace, seriously.)"[87] Any conflict between individualism and political commitment? Not when your politics consist of membership in three international organizations.

On the other hand, we also need to be open to the possibility that this appropriation and others can be forms of *metis*, the tactical adjustment to dominant forces celebrated by theorists of resistance such as Scott and Michel de Certeau.[88] As Dutton argues, this possibility for tactical redirection of the image also qualifies the critique of its commodification.[89] Perhaps one can see both in an episode of *The Simpsons* where Marge stops a tank in direct allusion to the icon.[90] Due to *The Simpsons*' consistent portrayal of how American

FIGURE 45. Chick-fil-A advertisement, 2004. Advertising image used by permission from
Chick-fil-A, Inc., and The Richards Group.

society encourages selfishness and greed, recourse to the Tiananmen Square
icon is one way to keep the democratic ideal alive.[91] Even that, however, de-
pends on a well-developed sense of parody.

The range of appropriations suggest, first, that the power of this iconic
image comes from its being a performance of both democratic virtue and
liberal autonomy; second, that it can be "tilted" one way or the other through
both reproduction and reception; and third, that the historical trajectory
is toward the liberal inflection. These claims can be illustrated by our con-
cluding example, a television advertisement that moves through master-
ful, mildly parodic imitation of the iconic image to achieve what may be an
all-too-accurate articulation of liberal-democratic identity. Since 1995, the
Chick-fil-A corporation has been running a clever ad campaign that features
cows trying to persuade the public to limit its consumption of hamburgers.
Unable to speak, the cows still can hold up signs that say "Eat Mor Chikin" and
otherwise try to influence those streaming through fast-food restaurants.
But everyone knows that those cows are facing a tough battle as McDonald's
alone consumes almost one billion pounds of U.S. beef each year.[92] Perhaps
the cows need a heroic example; if so, he (she, actually) appeared during the
telecast of the 2002 Chick-fil-A Peach Bowl: a single cow stands before a bull-
dozer to stop it from leveling an area where a burger shack is to be built.
A sign says, "Coming Soon: Circus Burger" and pitches a thirty-two-ounce
burger. The cow moves back and forth to counter the bulldozer's attempts to
get around it—imitating the video clip of the original confrontation—and
then, in case there's any doubt about the allusion, the last shot (fig. 45) has
four bulldozers lined up, with the cow and tanks on the left-to-right diago-
nal and seen from above right center in the exact position and perspective as

in the iconic photo.[93] The ad closes with a shot of graffiti that says "Eat Mor Chikin."[94] Like oppressed peoples everywhere, cows have to retake the public square.

A lot is going on here. The ad presumes that the iconic shot has become part of a widely shared cultural literacy; Peach Bowl ads are not cheap, so few risks will be taken regarding audience comprehension. There apparently also is no risk of a breach of decorum whereby the appropriation would impugn the audience's emotional bond with the original image and provoke a patriotic backlash if taken too lightly. And the ad's light touch is remarkable. It enacts a sure sense of parody, but not to diminish the original. Instead, the shift from seriousness to silliness elevates the other side of the comparison, making the cow's cause a matter worthy of public support. In fact, there is nothing in the scene that suggests any reason for eating chicken rather than beef. Instead, the imitation of the Tiananmen Square standoff imports a political scenario that in turn redefines all involved in fast-food consumption. The burger chains are now in the position of the Chinese government, an aging, rigidly conventional regime seeking only to maintain mass conformity to maintain power. The anonymous cow represents everyone's interest in breaking corporate control of a consumer society. Willing to challenge entrenched power, Chick-fil-A restaurants provide the gateway to a new future of expanded choices. While one is chuckling along with the ad, eating chicken becomes an act of democratic empowerment.

Of course, this is nuts. Shifting one's preferences from one fast-food chain to another is not going to revitalize American democracy. The ad's sophistication speaks volumes about liberal-democratic identity construction, however. Key features of public dissent are recreated within a comic frame that allows one to enjoy them without actually becoming in any way committed to political action. Instead, identification occurs entirely with regard to a topography of private life: the viewer makes choices about small-scale consumer consumption—where to drive through tonight?—that supposedly are choices between social conformity or individual self-expression. Cows cannot speak and consumers are not likely to speak out, but the comic imitation of a silent act of public protest makes consumption appear to be a public act. The democratic mythos of representing the will of the people to challenge authoritarian power becomes a vehicle for motivating completely individuated acts within private life.

The ad, like all the appropriations, draws on both the drama of the lone individual facing the tank and on the tension between the liberal and democratic implications of his action. The first motif sets the play, and the second accounts for its relevance. The shift from democratic representation to

individual liberty in visual appropriations and verbal interpretations of the iconic image can occur so seamlessly, without risk of objection, because both elements of liberal-democratic political culture are embodied in the same composition. The logic of the Chick-fil-A homage is clear, however. For all its wit, the fact remains that the audience is brought to identify with a cow. The bulldozers are not going to be stopped, in part because the cow is never going to speak. The allure of graffiti—the voice of the people!—aside, the sole representative of dissent in the ad is speechless and inevitably so. Resistance for someone who identifies with that position can only consist of standing up to machines sure to destroy them, or—and here's the shift—through acts of consumption that are imagined to be countercultural but are actually just a transfer of disposable income from one cash register to another. The ad really is amusing, but laughter in popular culture can mask a deep fatalism about individual powerlessness. The Chick-fil-A/Tiananmen Square ad both taps and manages this condition. How else could we smile along when the brutal suppression of a popular movement is remembered as an argument to eat at a fast-food franchise?

Of course, the ad is not the problem, and the Tiananmen Square icon is justifiably iconic. As the ad makes quite clear, however, iconic images exist because they are far more than literal representations of current events. The ad can draw on the iconic template because it already has become established as a parable deeply appropriate to liberal-democratic public culture. A single individual dared to stop a tank, and the tank stopped, revealing the profound legitimacy of individual action, which was at once representative of the will of the people and an assertion of inalienable human rights. This individual appears to the Western audience as a universal figure: he is defined by a modernist aesthetic, which in turn confers an undifferentiated citizenship, and anyone can identify with the heroism of his act because he was doing it alone, anonymously, as a private individual on his way home from work. The simplified and disciplined public culture that is projected aesthetically has normative implications: it is supposed to be both the destiny of Chinese democratization and the model for any public culture in the emerging global society of transnational economic and communications networks.[95]

We shouldn't romanticize indigenous development—Chinese democracy could not only be less liberal but also less democratic than one would wish—but it does hold out the possibility of a richer global civil society. Stated otherwise, a decidedly democratic global society would produce a heteronomous modernity, while a global liberalism is more likely to produce the homogenous social order of late-modern design.[96] The iconic image from Tiananmen Square obscures the idea that there might be alternative forms of modern-

ization and that a global society could develop according to a different logic than expansion of and assimilation into Western liberal-democratic culture. Thus, the risk is the same whether relying on the iconic photo or the liberal civil society it implies: despite the richness that is there, the result is a loss of information.[97] So it is that modernist representation can obstruct solving the problems modern civilization is likely to face.[98] The man stopping the tank can be a model of democratic dissent or an example of liberal hegemony, symbol of a new world order and a masking of its true cost.

As Norton has remarked, "Representation is not merely a form of governance, it is also the means we use to create ourselves in a new world order."[99] This iconic photo is one means for creating a global public culture that is a *liberal*-democratic culture. For most viewers of the photo, this will be a culture in which freedom is experienced primarily through retail consumption. As citizens develop into consumers, they can forget what it means to be citizens. To remember that, they can look to the iconic photo from Tiananmen Square, but they will need other images as well. The choice between the individual and the authoritarian state is an easy one, but either way you get the empty street.

8

RITUALIZING MODERNITY'S GAMBLE

THE *HINDENBURG* AND *CHALLENGER* EXPLOSIONS

Leopards break into the temple and drink to the dregs what is in the sacrificial pitchers; this is repeated over and over again; finally it can be calculated in advance, and it becomes a part of the ceremony.

Franz Kafka, "Leopards in the Temple"[1]

Any society develops technologies that increase control over nature and thereby create new dependencies and more complex networks of contingency and chance. Modern societies achieve astonishing technological development, including the ability to fly, and a corresponding awareness of how easily the individual can be subject to forces beyond one's control. Likewise, the increasingly rational organization of large sectors of society carries with it greater awareness of the role of chance in determining individual outcomes; a market society pretends that this condition is a virtue. This paradoxical condition has to be managed, and it provides opportunities for manipulation.

Thus, one of the distinctive characteristics of modern life is the paradoxical relationship between progress and risk, or control and catastrophe. We label this condition "modernity's gamble." We find it most significantly in the fact that advanced societies devour nonrenewable resources at a rate that will be suicidal—unless it fuels development of technologies that can eliminate dependency on those resources. The gamble also is evident when technological benefits for individuals are magnified millions of times over by the scale, organization, mass production, and democratization of modern societies to endanger humanity. Here the overuse of automobiles and antibiotics are primary examples. A third variant can be found in the arguments about normal accidents and system effects, where intensive development and dependence on technology allows greater freedom and mobility while also creating individual loss of control and increased probability of catastrophes.[2] Airplane crashes are the most vivid reminder of this bet gone bad.

Modernity's gamble, then, is the wager that the long-term dangers of a technology-intensive society will be avoided by continued progress. As with any wager, it is driven not only by calculations of probability but also by an unrelenting desire to beat the odds. Modernity's gamble thus assumes a leap of faith that must be negotiated in agreeing to the particular terms of the wager. Without the technology of air transportation, one could never fly to Boston—or die by falling from 30,000 feet. The gain in technical capability is matched by a loss of control over one's life, and as modern civilization develops we increasingly find ourselves having to place bets that cannot be avoided and to gamble on the reliability of increasingly complex systems.

This combination of dependency and uncertainty is a sure recipe for anxiety. There should be little surprise then, that throughout the twentieth century mass publics have been fascinated with images of technological disaster, for such images reveal the risk that otherwise is hidden beneath the smooth surfaces of modern design.[3] Disasters also provide spontaneous occasions for creating the public audience, drawn like moths to the flame yet protected by the virtual experience provided by the mass media.[4] The publicizing of such images can both dramatize a deep tension of modern life and provide the occasion for mediating and resolving that tension through civic performance.[5] Two such images exemplify how this use of photojournalistic representation has developed over time: the explosion of the *Hindenburg* dirigible in 1937 and the explosion of the *Challenger* space shuttle almost fifty years later in 1986.

Both cases might be dismissed as no more than examples of media hysteria. The loss of life was low compared to more common disasters, and very

few people were ever likely to fly on either craft. The public response seems to reflect the excessive influence of widely disseminated visual images rather than assessment of comparative loss or probable risk over time. So, let's be reasonable:

Engineers hate risk. They try to eliminate it whenever they can. This is under-
standable, given that when an engineer makes one little mistake, the media will
treat it like it's a big deal or something. Examples of bad press for engineers:

- *Hindenburg*
- Space Shuttle *Challenger*
- SPANet ©
- *Hubble* space telescope
- *Apollo 13*
- *Titanic*
- Ford Pinto
- Corvair.[6]

The tongue-in-cheek tone speaks volumes about the anxieties involved. There obviously is more at stake than "bad press for engineers." The likeli-hood of mistakes on the job at one end of a technological process can produce catastrophic results at the other. On one side, you have engineers who have both the technical capacity to produce marvelous machines and the unend-ing task of reducing yet never eliminating risk. On the other side, you have a public that not only observes the spectacular disasters that result from small errors, but also is subject to similar risks while living within range of nu-clear power plants, driving cheap cars on suspect highways, relying on ATM machines and other information transfer networks, and consuming an ever greater range of products that contain altered genes. What is so much "bad press" on one side is on the other side the inescapable gamble of life in a tech-nological society. Where engineers express irritation with a jumpy public, those driving their Neons while believing their money really is secure in the bank are relying on an illusion of control over their lives and property. And the media are playing both sides of the street: holding the engineers account-able but only when there's a good story, and informing the public but never connecting the dots to reveal a pattern of fatality. The result is a combina-tion of spectacular images and a process of routinization. It is telling that the list above is headed by the two disasters that have produced iconic pho-tographs. By tracing the trajectory of those images through the media, it becomes clear that they both reveal and manage a profound tension within modern society.

HINDENBURG

The first balloon capable of transporting humans was launched by the Mont-golfier Brothers in France in the eighteenth century; by the early part of the twentieth century the use of dirigibles for both military purposes and commercial travel was fairly common, especially in Europe. Even so, the *Hindenburg* was recognized as a technological marvel. A magnificent flying machine, it was nearly as large as the ill-fated *Titanic* and could traverse the Atlantic Ocean in a mere three and one-half days.[7] Its arrival at Lakehurst, New Jersey, on May 6, 1937, was much anticipated, with an army of journal-ists and radio broadcasters—including twenty-two photographers—wait-ing all day for a flight that arrived eleven hours late. Its explosion, killing thirty-five passengers, was clearly a significant event, easily warranting the major front-page coverage that it received by the *New York Times* (fig. 46) and most national newspapers on the following day. It must be noted, however, that this was *not* the first time that the explosion of a dirigible employed for passenger travel had received such front-page coverage. Seven years earlier, on October 5, 1930, the *Times* had given above-the-fold, front-page coverage to the death of forty-six passengers in the explosion of Britain's *R-101*, at that time the largest dirigible in the world.[8] The key difference between the explo-sion of the *R-101* and the *Hindenburg* was that the crash with the greater death toll was represented visually only by a file photo of the craft hovering in the air, while the *Hindenburg* was caught photographically at the moment of its explosion.

There were numerous photographs of the explosion of the *Hindenburg*, and several of them remain in circulation. The *New York Times* printed a full page of photographs of the disaster, the wreckage, and some of the survivors on May 7, as well as several others the following day; other newspapers provided more extensive photographic coverage, including several rather gruesome images of burn victims, while newsreels were distributed across the country within days.[9] Many of these images were truly spectacular, not least the one on the front page of the *New York Times* on May 7, but only one image was to become iconic.[10] That was one of the three photographs taken by Sam Shere for the International News Service and distributed by the newly established Associated Press Photo Service. It never appeared in the *New York Times*, but it did appear on the front page of the *Washington Post* and in other newspa-pers; within a week it had full-page coverage in *Life* magazine and graced the front pages of newspapers in France and Germany.[11] More to the point, it has come to be reproduced more and more prominently than any other image of the event.[12] As with other iconic photos, these reproductions range across a

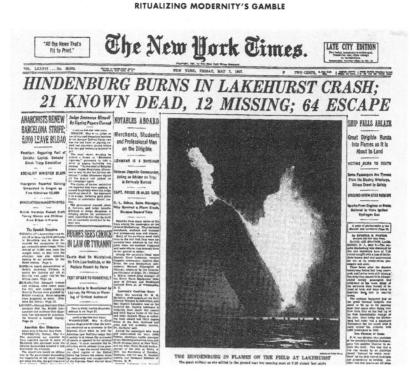

FIGURE 46. Front page, *New York Times*, May 7, 1936.

wide span of media, including books, magazines, record album covers, posters, postage stamps, and Web sites. In addition, the Shere photograph is almost exclusively the one singled out for use in visual satire.[13] Thus, although all of the *Hindenburg* photographs contribute to the photojournalistic record of the event and several have stayed in public circulation, the preeminence of Shere's photograph suggests that it has special aesthetic and symbolic appeal. It also may be the richest in informational content, with the exception of one significant detail. Unlike one other image printed in a number of newspapers and magazines at the time and occasionally reproduced today, it does not show the Nazi swastika adorning the tail.[14] This erasure is consistent with the narrative of the event that emerged at the time to mute the nationalist tensions between Nazi Germany and the United States.[15] The *Hindenburg* is memorialized not as a sign of the gathering storm but rather as a symbol of universalized, technocratic modernity.

All photographs are performative, but they need not be staged. The *Hindenburg* icon (fig. 47) couldn't have been staged—not then, anyway—and yet it is perfectly composed. An enormous explosion erupts upwards, yet the front half of the airship still hangs in the air, its smooth skin undisturbed

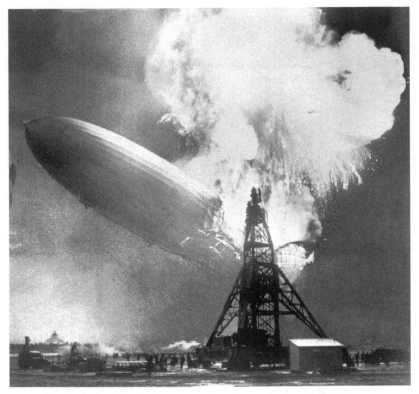

FIGURE 47. "Explosion of the *Hindenburg*," 1936 (Sam Shere, photographer). MPTV.

by the inferno consuming the rear of the craft. This towering ball of fire is itself both a shattering, ripping outwards, a big bang seemingly coming out of nowhere, and yet also proleptically suggestive of a mushroom cloud as it unfolds upwards in a pattern of symmetrical, circular expansion. The fireball erupts from just off center of the picture, and everything else connects at or radiates from that point. The airship extends far out along the diagonal into the empty space of the left side of the photograph, while that line is extended down into the right corner by the strut of the mooring tower. Likewise, the explosion rising up along the vertical axis is extended downwards by the main frame of the tower, as if that structure were grounding an electrical storm arcing across the sky. The relatively dense configuration of tower and frame building in the lower right corner is the counterweight for the long extension of the airship like an empty seesaw plank into the air. That sense of elevation and vulnerability is heightened by the light, empty space in the lower left quadrant below the ship. The light-dark alteration provides

additional balancing within the frame: light background below the diagonal is balanced by dark background above it; the ambient light in the lower left is balanced by the light of the explosion in the upper right; the darkest corner, the lower right, has within it a light surface (the roof of the building), while the darkness of the upper left has a corresponding film of light leaking around the nose of the ship. The craft itself is a mirror image of the dominant pattern, with its underside swathed in darkness while its upper surface is brilliantly illuminated by the blast. As a small counterpoint, the smoke billowing along the right top of the frame is matched by the steam extending along the ground on the lower left. Thus, we have a beautifully balanced representation of an unplanned, uncontrolled explosion.

This image of dynamic forces caught in a static frame is emblematic of early modernist aesthetics while it also prompts a viewing strategy that was anathema to the late modernism that prevailed later in the twentieth century. That strategy is to see how the image activates important elements of an allegorical tableau.[16] Look at the photograph again: the set could be from Fritz Lang's 1927 film *Metropolis*. Giant structures of the machine age tower over an industrial landscape. The skeletal architecture of the mooring tower foregrounds its construction out of steel girders. The airship is perfectly streamlined yet thoroughly mechanical rather than organic, as one can see the evenly straight, geometrical lines of its aluminum frame along the length of the craft. There are people visible in some reproductions of the photo, but they are Lilliputian figures, uniformly dark, featureless, and tiny; and there are a number of them, not individuals but an anonymous group scurrying along the ground beneath the great structures and forces towering above them and capable of collapsing upon them indiscriminately.[17] This difference in magnitude—enormous machines and antlike humans—shows that the technoscape is not built to human scale. The pathos of this scene was captured in the live radio broadcast, when a distraught Herb Morrison keened, "oh, the humanity and all the passengers." The industrial civilization itself dominates, determining where resources are expended, how the landscape is organized, who is sacrificed. The great ship and its mooring tower create a hierarchy of values, putting the technological domination of nature above human interaction, while that hierarchy is in turn topped by the power of nature itself, the enormous and wholly impersonal forces that at once exceed and are harnessed by technology. This hierarchy stipulates a chain of deference from human societies to their impersonal machines to the deadly forces they contain. This iron dependency is represented further by the other structures that project upwards in the distant background, including another steel tower that suggests a continual extension of the scene beyond the hori-

zon. Towers of steel, seemingly infernal steam rising from a continuous industrial plant, and the dark, grainy hues of the photograph as a whole place the event within the common scene of twentieth-century allegory: an industrialized, rationalized dystopia.

This double coding of the image reverberates outward from the explosion in the center of the photograph. There is a sudden, catastrophic eruption of natural forces out of the smooth, functional shell of the airship. The instantaneous equipoise of the undisturbed front of the craft and the firestorm in the rear captures perfectly the dialectic of modern technology, whereby murderous forces of nature are temporarily controlled for human use. This principle is not scientific but dramatic. As Kenneth Burke restates the idea of dramatic unity, "the scene is a fit 'container' for the act, expressing in fixed properties the same quality that the action expresses in terms of development."[18] In the same manner, the machine is the fit container for the forces within it, and the eruption of those forces breaks not only the machine but a larger sense of intelligibility. One might imagine running a filmstrip back and forth: as the explosion flows back into the craft, not only the machine but the order of the machine age is restored. Nature is controlled, contained, so much so that its destructiveness is nowhere to be seen. The ship floats serenely, majestically, the idol of technological prowess that had been seen in file photos and advertisements. Then the explosion rips outward again, rupturing both the ship and the illusion of control.

The image is both a reminder of this tension within modern civilization and a reassurance that the tension itself can be contained. The beautiful symmetries of the composition are a model of order. The proportionality of machines and explosive forces also is perfectly balanced. The drama itself is largely one of great forces, natural and technological, with the people visible within the scene being little people and the people about to die not visible at all. The rupture and revelation and anxiety that are there are also stopped in time, caught for reflection but virtual as well, not an immediate threat to those viewing the image. And as one views, one is swept up out of simple anxiety or criticism into the grandeur of the forces swirling upward. The scene ultimately is one of the encounter between little people and great forces, and the result is likely to be an attitude of deference.

Even so, it must be said that nothing can wash away the dark tones and roiling energies of the photograph. Its reconstruction of the world being ripped apart is never complete, and the allegorical implication always remains that this world is fundamentally dangerous. There is little sense that the society itself will collapse but rather that its continuation will not be one of steady ascent toward enlightenment. To restore that idea, one needs a dif-

ferent picture. As it happens, the shape of things to come is foreshadowed by the other large structure in the *Hindenburg* photo. The mooring tower still stands. As it stands, it provides another proleptic reference: the structure used to dock one type of airship looks like the outline of another that will replace it. One wonders if the architect read the science fiction of the day. With its large, swept back wings, the tower outlines the frame of a rocket standing as if ready to launch. Like other allegories that link past and future, the *Hindenburg* icon anticipates another disaster when another airship would explode not far above those looking up in awe, first at the ship itself and then at the forces ripping it apart.

CHALLENGER

"It happened," notes *Time* magazine's cover story of February 10, 1986. "In one fiery instant, the nation's complacent attitude toward manned space flight had evaporated at the incredible sight in the skies over Cape Canaveral. Americans had soared into space fifty-five times over twenty-five years, and their safe return came to be taken for granted. An age when most anyone, given a few months' training, could go along for a safe ride seemed imminent."[19] Modernity's gamble is relentless, the odds ultimately always in favor of the house; the anxieties that attend it can be repressed for a time, and especially in the face of a good run, but eventually the wager comes due and the bet goes bad. As Charles Perrow notes, "The space missions illustrate that even where the talent and funds are ample, and errors are likely to be displayed before a huge television audience, system accidents cannot be avoided."[20]

What makes the explosion of the space shuttle *Challenger* particularly significant is that it was being viewed on television by millions of schoolchildren sitting in anticipation of seeing the first civilian, a schoolteacher, being propelled into space. It was a national spectacle to foster democratic identification with the space program as the symbol of technological progress. And when the explosion occurred, *Time*'s Lance Morrow noted, "the moment was irrevocable. Over and over, the bright extinction played on the television screen, almost ghoulishly repeated until it had sunk into the collective memory. And there it will abide, abetted by the weird metaphysics of videotape, which permits the endless repetition of a brute finality."[21] Morrow's characterization is on the mark regarding the networks' repetition ad nauseam of the videotaped explosion, but what he couldn't take account of is how quickly those images would be replaced in public memory by photographic representation.

There are many still images of the disaster, often taken from the video-tape itself; when viewed in succession, they provide a moment-by-moment record of the entire trajectory. First the engines ignite on the launch stand, pushing enormous clouds of fire and vapor along the flat Florida coastline. Then the shuttle assembly lifts off and climbs slowly upward, its exhaust becoming ever more streamlined as the machine becomes more distant. Then there are the successive stages of the explosion, beginning with several that are pure blast outward, all fire and force. As the trajectory continues, one image shows the back end of the shuttle still protruding from a ball of fire while two contrails are starting to develop in twin arcs in front of the explosion. The next image shows just the trace of the shuttle along with some fire still protruding from an enveloping white cloud while the contrails continue to extend forward. Then the cloud expands, with the fire within turning to gauzy orange as the contrails elongate. The shot used most often by NASA follows, with the cloud all white but for a partial shade of pink and the contrails now turning back on themselves, losing force. After this come images of ever increasing dispersion, until finally there are only thin streaks trailing downward.

The iconic image of the *Challenger* explosion occurs along the top of this visual trajectory, when one sees the oval cloud with the two forward tendrils. There is no one iconic photograph, however, but rather an interchangeable set of the minutely differentiated stages of the cloud's expansion. The set begins with the rear of the machine still visible and ends with complete envelopment and exhaustion of the upward movement. All of these images are less decisive than those of either the shuttle assembly ripping apart or the debris falling into further disarray. Thus, the iconic image is actually something like an afterimage, and one that records the explosion as a terrible and yet still self-contained event. And, as with the *Hindenburg*, the iconic image captures fundamental tensions in perfect equipoise. The icon both records and conceals the explosion; there is both the blast and a symmetrical form still on upward trajectory; risk remains tied to promise. We see both a disaster and a beautiful image that continues to inspire the awe that was to have been evoked by the successful launch.

Note also that none of the several iconic shots are captioned to emphasize any difference among the set. They all are presented as if each one is the icon, the original, transparent photograph. Multiple images clearly are not being used to break iconicity, and they all draw on that symbolic power. That power is reinforced by their distribution. For the representative iconic photograph, we have selected the widely reproduced NASA image that probably has been seen more than any other record of the explosion (fig. 48).[22]

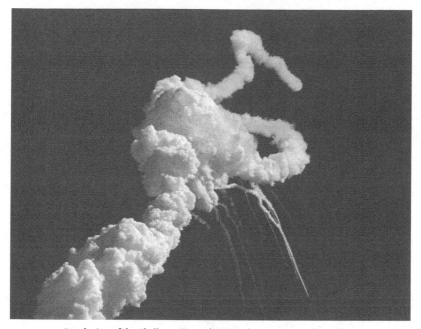

FIGURE 48. "Explosion of the *Challenger*," 1986 (NASA, photographer unknown). Courtesy of NASA.

The disaster occurred at 46,000 feet, but one would never know it from the picture. The thick cumulus surface of the vapor trail rises in sharp detail against the perfectly clear blue sky. Caught tightly in the pictorial frame, with nothing else in sight, one sees an abstract form against a uniform field of empty space. The composition itself hangs there as if on a museum wall: a work of abstract art without reference to anything but the aesthetic medium and with no context but the process of perception. The closeness of the image is consistent with this sense of intensity, for it poses no direct threat to the viewer. Although the photograph depicts a massive explosion of rocket fuel, the image is frozen, and the exploding materials are clearly arcing away from the position of the viewer, following a trajectory that will fall away towards the horizon. Thus, the photograph brings one close to the blast, to a position one could never actually occupy, while also carrying the destruction away, buffering the viewer from the dispersion of the explosion.

These features suggest that the *Challenger* icon is an aesthetic simplification of the *Hindenburg* photograph. In place of an airship exploding into a massive fireball, one sees a relatively abstract image that sublimates emotional response. The explosion is foregrounded as before but now defined

in terms of time rather than space: one sees the trail of the launch preceding the blast, the blast, and the beginning of the dispersion of the now shattered craft—a minutely linear succession of events that nonetheless have no other identifiable location, no reference point to establish a reliable sense of scale. There are no buildings or human figures. Its reference point comes, rather, from the vector of the image, which rises on the left-to-right diagonal from the space of the given to the space of the new, and from the real to the ideal.[23]

This visual vector has perfect correspondence with the myth of the space program, a utopian narrative that lifts humanity from earth to the stars, and from our present world of constraints to a future where our ideals of enlightenment are realized.[24] The image communicates both the general trajectory and the specific failure: the first by the strong arc up along the lower-left to upper-right diagonal, and the second through the tendrils from the explosion that are just beginning to fall back to earth. Thus, the design of the image ensures that the event depicted is read teleologically. Space program and iconic image alike will be defined in terms of an idealized world in which all genders, races, and nationalities are unified in a common ascent via the technocratic achievements that are the upper reach of modern civilization. NASA's previously successful appropriation of this mythic narrative was stamped on the image by Reagan's eulogy on national TV following the disaster. Dying in midflight, successful flight, the space program itself, and the destiny it promises became fused in the single statement that the astronauts "'slipped the surly bonds of earth' to 'touch the face of God.'" The iconic scene became transcendental, an abstract space of ascension spanning all earthly distinctions and leading ultimately to heaven. Against this background, the individual is not dwarfed but ennobled, even sacralized, and the terror at the heart of the sublime is progressively muted.

This containment of the full force of the explosion is encouraged by the image and the medium alike. The enormous power of a fully loaded, liquid fuel tank exploding is in fact miniaturized. Even though the camera brings one relatively close to the action, the size and force of the blast remain much smaller than they would seem if they had happened at ground level.[25] In addition, the bodies and the machines are wholly absent from the image, nor is the blast itself directly visible. Together crew, machine, and blast lie within the white vapor cloud; the warm, soft, faintly colored substance looks somewhat like a *Life* magazine image of a live egg yolk within its gauzy white solution. This force, like all mythic forces, could well be both destructive and creative, and it seems to be more a form of potentiality than of expended power. Thus, the blast that ruptured the container of the rocket tank is nonetheless contained aesthetically by its display as a small, symmetrical image.

Such inferences may seem excessive to some, but there are few limits on the spectator's interpretation of the bright, clean, abstract forms that are devoid of representation of any body or object whatsoever on the uniform, unmarked blue canvas. Set within the context of the space program, the image's resistance to allegorical interpretation disappears. There references to both classical and modern myths abound, while the attempt to recuperate the technocratic ideal never ceases.[26] It should not be surprising that the iconic image provides both a representation of natural forces violently rupturing the technology that would harness them, and a secondary recontainment of those forces to motivate continued acquiescence to the normativity of the technological order. To see how it might work otherwise, one has to look no further than the videotape of the launch and explosion. There—and contrary to some other iconic photos that have identical video footage—the moving picture is far more shocking than the still photograph. The shuttle is seen riding the tank and booster rockets steadily upward, and then BANG! it is shattered, destroyed, gone. You see what is destroyed, and you see it destroyed, and this happens so fast and violently that it feels like one is being hit in the gut. The rest of the film then chronicles the dispersion of the wreckage, and the slow descent of the increasingly distant vapor trails toward earth becomes almost elegiac.[27] One hurts, and can begin to mourn, and then the tape is over. By contrast, the photograph remains ever before us, still at a single moment in time, showing what is thought to be an explosion but is in fact its aftermath, with the actual craft barely a memory.

The *Challenger* explosion may be a cautionary tale—although it wasn't for NASA—but its deeper resonance is with modernity's gamble. The image is both disruptive and reassuring, and that ambivalence mirrors the anxiety of living in the machine age. Flight can only be achieved by containing natural forces until they can both fuel engines and produce disasters. So it is that we need to be continually reassured that those forces are under control, while events will continue to challenge this illusion. The abstract image of the *Challenger* explosion would become iconic in part because it mediated this tension so well, providing both acknowledgement of disaster and recontainment of disruptive fears natural to a society that does not respect natural constraints.

TRAJECTORIES OF RITUAL PERFORMANCE

Visions of the future in modern societies are inseparable from ideas of technological development. In the United States, this has been so since the early national period, when the Whigs used technology as a way of framing the

good life for citizens rooted in mutual prosperity and social connected-ness.[28] Progress, machines that promise prosperity, and an easier and more comfortable life are now the substance of the American Dream.

So it is that pictures of machines have been an important medium for vi-sualizing the future, and machines that could fly have epitomized modern technology freeing humanity from natural constraints. In the twentieth cen-tury, pulp fiction led the way. Science fiction book covers featured airships as icons of technological utopias, starting with dirigibles floating above high-tech cities. For a while, actual dirigibles could be used, and eventually images of commercial airliners cruised throughout media space.[29] The space shuttle took such ritual performances to new heights, while Web and magazine cov-erage of the space program is still dominated by images of the shuttle and the space station floating serenely in a gentle equilibrium, perfectly controlled yet weightless. That weightlessness symbolizes freedom from natural con-straint, which is what the high-tech society promises. Should such an image be ruptured by a violent explosion . . .

One of the most remarked upon characteristics of disaster coverage is the contrast between the single, dramatic, irrevocable moment of the disaster and the continual reproduction of its image. The explosion seems to activate a perpetual motion machine within the electronic media. Commentators and ordinary observers alike report how the disaster images are played over and over and over again. Although the reactions to that "mechanical repro-duction" (in Benjamin's terms) of the "tragedy" (as it is typically described) occasionally are censorious, more often they express a more modern emo-tion that is something between puzzlement and nausea.[30] Instead of pity and terror, we witness displacement. One technology is interrupted, but another immediately clatters to life to fill the gap in perception. What begins as fatal-ity acquires an artificial life in the public media.

Thus, disaster coverage becomes a performance of public culture that is at once spectacular and somewhat eerie. The coverage of the failed machine acquires strong similarities with prior media promotion of the technology. Where once the launch dazzled, now the explosion does. Where repetitive exposure of successful operations had produced inattention, now sustained coverage pulls the failure into the background where it becomes routinized as a normal accident. It also is true that disaster coverage brings additional pressure to bear on the organization: increased scrutiny, calls for public ac-countability, questions about relative value of the investment, and similar demands are all part of the glare of media coverage. At some point, however, the trajectory toward routinization becomes a resource that organizations have learned to exploit.[31] Through continuous iteration and strategic inflec-

tion the coverage comes to resemble the low-level hum of power lines. Risk has been normalized again, and so the stage is set for another disaster.

This is the general tendency, but not the specific visual history. In charting the histories of the *Hindenburg* and *Challenger* images, distinctions emerge. Some of these differences represent nothing more than circumstantial differences in time and social space, and some demonstrate that media technologies also are subject to chance and accident. Yet there are other variations that suggest that the two icons represent separate trajectories through collective memory and different attitudes toward modernity. These trajectories often run in parallel, but where they diverge they reveal hidden choices regarding modernity's gamble—and different wagers.

HINDENBURG: WHISTLING PAST THE GRAVEYARD

The *Hindenburg* story begins as a case study in the now somewhat antique idea that the mass media have direct, specific, "hypodermic" effects. The explosion was the occasion for the first live coverage of a disaster, first color photojournalism, and first transatlantic radio broadcast. The images were widely disseminated for several days through newspapers, magazine coverage, and newsreels, captivating millions. The coverage produced large public gatherings, international communiqués, and quickly gave new meaning to the proper name "Hindenburg." Most important, it prompted public scrutiny and comprehensive fear that killed commercial dirigible travel. In the course of a few weeks, zeppelins went from being a celebrity technology to a relic of the past.[32] Through contrast with previous, file-photo coverage of other (and greater) disasters, it becomes clear that photojournalism had a direct and decisive effect on public opinion.

The traces are there still, but the proliferation of *Hindenburg* images across a range of media suggests that the force of the original photo is largely spent. This is not to deny the capacity of the image to stop and hold the reader for a moment or even to create a sensation of terrible rupture and vulnerability, but the range of reproductions shows that the image has become, by turns, a rhetorical commonplace, a curio, and a cautionary note. In every case, one sees a process of routinization: the image becomes a persistent item within collective memory but also something that has receded into the background of concerns. After all, it is in the past.

The most obvious use of the *Hindenburg* icon is as a rhetorical commonplace used to mark modern disasters. Of course, one effect of the photo is that the *Hindenburg* remains a well-known disaster, unlike the many other calamities involving railroads, bridges, and other more common technologies.

While other, though not less fatal, events are forgotten, one can read about the *Hindenburg* in children's book series such as American Disasters, Great Disasters, and Cornerstones of Freedom, and there are several *Hindenburg* memorials, including the museum at Lakehurst, New Jersey and a number of Web sites (not least in France, perhaps as one trace of that original radio broadcast), as well as trade books and a movie.[33] Its salience goes further, however, for it is typically used as the single or dominant image for the genre of disaster coverage: examples include the cover image for the 2000 calendar of "Disasters of the Twentieth Century," the cover of several children's books, and a number of Web sites.[34] This use of the *Hindenburg* explosion to mark disasters as a class of events also accounts for its association with the *Titanic* and with 9/11.[35]

The photo also has come to represent (and probably motivate interest in) the technology and history of the dirigible. The cover of John Toland's *The Great Dirigibles: Their Triumphs and Disasters* is exhibit A, and it has been followed by a number of Web pages.[36] Perhaps for similar reasons, the *Hindenburg* photo is featured in sites about the Speed Graphic camera used at the time, the radio broadcast of the disaster, and histories of photojournalism, of live coverage, of disaster coverage, of influential photos, and so forth.[37]

At some point these increasingly familiar references take a turn not seen with the other icons, which is that the image becomes something like a curio to be handled, passed around, and used for polite conversation. For example, on the Gibson Guitar company's special Tribute to the Twentieth Century Guitar, which has a panorama of illustrations to provide a visual history of each decade, the iconic image is surrounded by comedian W. C. Fields, psychiatrist Sigmund Freud, comedians Laurel and Hardy, and baseball player Babe Ruth.[38] (One can imagine pointing and saying, "Oh, look, the *Hindenburg*," and moving on to the next image.) When it appears on a stamp (issued by Maldives), it is part of the Mysteries of the Universe set.[39] Puzzlement about the cause of the explosion has received renewed life recently, including a *National Geographic* video that uses the iconic image on its cover.[40] When it is the featured image for a jigsaw puzzle, the company emphasizes the "mystery" that can only be solved by "combing literal clues with visual clues."[41] And, of all the uses of hydrogen, isn't it a bit odd to see the *Hindenburg* explosion illustrating that element on the periodic table?[42] Other examples of emotionally truncated use include a 1999 Ray Tracing photo-illustration competition winner, as well as occasional spoofs in photo manipulation.[43] Add to these an early computer game, record/CD covers (for Led Zeppelin and Predominance), T-shirts, a variety of iris, a professional wrestling advertisement, and

the usual visual jokes by the Tourist of Death and Ribman, and it seems that the general effect is one of limited affect.[44]

This routinization of the photo's power is only a general tendency, and it is managing a sense of terror that can be reactivated by skillful appropriation of the image. The domestication of the image to mark (and historicize) a class of events or enhance a hobbyist's collection is one example of how cultural representation is used to smooth over modernity's gamble. This complacency, of course, increases the likelihood of another disaster, and so the icon can once again rupture collective denial. Thus, when *Wired* put the image on its cover to feature "The Fall of the Music Industry," the caption above the photo said "Rip. Mix. Burn." with the last word in red and the flames colorized.[45] The analogy is point-for-point perfect, implying that a large industry based on a soon to be antique technology is complacent regarding its impending disaster. It also is ironic, however, as the magazine has little sympathy for those caught, like the wealthy passengers on the *Hindenburg*, in the impending collapse.

Thus, the parodies one expects of an iconic image acquire a specific twist in this case. Against the dulling of the image, they either emphasize its explosiveness or foreground the process of routinization. The *Onion* captures the explosiveness (and perhaps its loss of value) outrageously: "AWESOME Nation Wowed by Tremendous *Hindenburg* Explosion; Gay Ball of Flame Warms Hearts Chilled by Depression."[46] An illustration on the Web substitutes a giant penis for the airship, perhaps inadvertently replacing one curio with another, and marking both the explosiveness of male sexuality and the difference in scale between machines and human bodies.[47] The Tourist of Death and Ribman perform minor criticisms of routinization by marking the explosion's distance from the audience (such that the tourist standing in the foreground can dwarf the machine) and the inhuman scale of the scene (where the Ribman is an invisible speck).[48] Other *Hindenburg* spoofs include an animated cartoon that endlessly replays the dirigible's rapid collapse against a large, cheery, bright green background. What may have been a unique event acquires perpetual iteration through the digital medium, continuing endlessly until the viewer becomes bored.

All disasters evoke jokes that are symptomatic of the anxieties they manage. The most widely disseminated appropriation of the *Hindenburg* icon is also the most revealing joke. On a poster (fig. 49) sold in college bookstores and elsewhere, the closely cropped iconic photo is captioned with the enormous letters "SHIT!"[49] The print heightens the light-dark contrasts within the photo, while against the darkened background the strong white letters pick up the bright hues of the horizontal horizon and the vertical explosion.

FIGURE 49. "Shit!" poster, n.d.

The poster perfectly captures both the terrible nature of the explosion and its subsequent routinization. On the one hand, there is a disaster, a terrible conflagration, people burning to death; on the other hand, the sharp pang of astonished irritation one feels when hitting one's thumb with a hammer. The poster also doubles as a cautionary note, for we really ought to attend to the little things that can avoid large explosions, but that, too, is part of the acquiescence or lack of choice that is being touched by the joke. After all, in the machine age catastrophic effects can come from small causes: a loose O-ring, a piece of foam, or the human error accompanied by someone saying "Shit." And when caught at the moment the world unravels, what else can one say? In the immortal words of the *Challenger* pilot: "Uh-oh."

The poster captures fundamental paradoxes of an industrial civilization: we can travel to the moon and be crushed to a pulp if someone falls asleep at the wheel; we mourn the human life lost in a disaster and have no choice but to continue to take similar risks; we pretend that the human costs of technological progress are incidental effects of occasional accidents, when in fact they are routine and inevitable features of the system. The famous "caption" for the photo, radio announcer Herb Morrison's anguished cry, ". . . oh, the humanity," marks both the individual lives lost and the loss of humanity itself: the loss of a world built to human scale, the tragic predicament of humanity in a world of machines. And who wants to admit to that? The joke is on us, and so we need a joke. The "SHIT!" poster is a good joke but can only go so far, leaving the audience in a nicely balanced moment of irony that assuages anxiety while revealing its source.

The jokes about the *Hindenburg* are managing a pervasive, systemic, and generally repressed sense of fear, while they (paradoxically) have to work against a process of routinization to which they themselves contribute. More than humor is needed if the iconic image is to be restored to its original capacity for pity, terror, and reflection, or if one is to do something with its allegorical potential for a dystopian critique of modernization. Sometimes encountering the icon itself will do, particularly if one comes across a large print of it unexpectedly. Beyond that, there are at least two works of art that draw on the icon to awaken the viewer to a larger sense of public feeling or critical consciousness.

The first of these (fig. 50) is a strange, almost shocking painting of a woman holding the blazing, broken dirigible titled *Pieta with Hindenburg*.[50] The acrylic paints and artistic techniques are straight out of the fantasy worlds of contemporary popular illustration: the Madonna is draped in vaguely Wagnerian robes that may include a breastplate, and she is sitting in a stone cellar that also winds behind her into a seemingly cosmic passage. These allusions

FIGURE 50. Bruce Duncan, *Pieta with Hindenburg*, 1999. Courtesy of Bruce Duncan, http://www
.calweb.com/~hatter.

are but context for the central, almost vulgar image, which is of the large,
red, throbbing form in her lap. It could be phallic (think of the earlier illus-
tration of the *Hindenburg* cock), but that is too simple, and it is much more
like an entire organism, raw and alive with pain while yet broken and dying.
Evoking the root meanings of the term *pietà*, pity in the Italian and piety in
the Latin, the painting is a portrait of compassion. One must ask, however,
what is the object of the compassion? By drawing on the traditional form and
making the machine so palpably organic, the work fuses two contradictory
tendencies: she mourns the burning body and so the humanity burning in
a fire of their own making, and she mourns the machine itself, a beautiful,

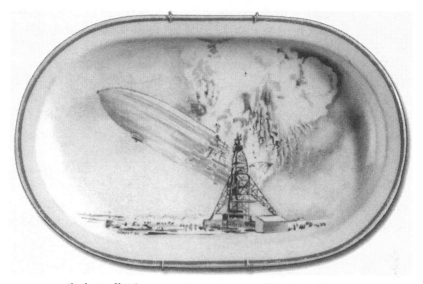

FIGURE 51. Charles Krafft, Disasterware™, 1992. Courtesy of Charles Krafft.

almost living thing, a life form of the machine age that, like the age itself, is doomed to catastrophe. Even "the humanity" of the original event now appears to be but one side of a convenient dialectic: the machine age depends on the illusion that machines are fundamentally different from their makers. Disasters are at once bewailed because of the loss of life (and not of the machines that are replaceable) while usually being attributed to "human error," as if the machine itself was not already an extension of human intelligence and aspirations. Despite the popular conventions, the grief cuts deeply, restoring a depth of feeling and a pity that realizes there really is no distinction, that human beings will not be able to stay clear of their machines as they go down in flames. Despite its use of a popular aesthetic, there is nothing modern here: humanity always loses and the best we can hope for is compassion.

This painting fuses traditional form and vernacular techniques to restore a strong, unsettling feeling to the historical memory triggered by the iconic photograph but often lost in its subsequent routinization. A second artwork (fig. 51) goes in the other direction to overemphasize the detachment and sentimentality that displaces modern catastrophe over time.[51] The work is part of a series titled Disasterware: "Using all the traditional materials of Dutch Delft painting, Charles Krafft brings the art solidly into the twentieth century with the creation of art works that reflect our modern realities. Floods, fires, murders, Nazi atrocities and artisic (sic) angst rise up from these plates rather than quaint windmills and skaters dressed in ancient costumes."[52] In

a nutshell, the series joins "the Delft tradition . . . with non-traditional subjects reflecting the uncertainties of life." Of course Krafft doesn't move the "art" one bit, as there is little danger of seeing heartland kitchens displaying decorative plates of catastrophes. What Krafft does is to offer a satiric counterpoint to a process of denial. The Delft appeal to faux tradition and its images of a serene simple life where decorative plates will never be shattered are themselves marketable precisely because they serve as an antidote to the "modern realities" of the world outside the home. By bringing the catastrophic image inside that frame, the domestic defense becomes as fragile as porcelain.

The double shift in medium and context prompts reflection on how images function as ritual performances in ordinary life. Could we someday come to the point where these terrible things would be completely normalized? Could we be there already, although not yet via this particular medium? Could any terrible event become enveloped in a practice of domestication, and has the anguish—"the humanity"—of the *Hindenburg* disaster become mere sentiment as the image circulates year after year? Ultimately, of course, the answers are all the same. Decorative plates are both precious yet affordable, and they soon become barely noticed fixtures in the background of daily life. Atrocities, disasters, all terrible things receive special notice, but as long as the costs are kept reasonably low they recede into the background. The memory is there as an old photograph in the drawer—still poignant when taken out, but faded like the seemingly antique world it depicts. It testifies to deep feelings, but they remain circumscribed by things that are themselves no longer familiar or useful. The image remains a complex portrait of modern mortality, yet one likely to become no more than a conversation piece on a rainy night.

CHALLENGER: DEATH, TAXES, AND IMAGE CONTROL

With the *Challenger* photograph the story becomes more complicated. Although any icon remains available for varied appropriations, the *Challenger* image has become deeply embedded within the public relations campaigns that have dominated public perception of the space program. And while most icons both break free of captioning and pull other images into their orbit, the *Challenger* icon has been almost completely neutralized by speeches, journalism, science center simulations, and other discourses as they are coordinated to maintain public support for NASA. With a budget of fifteen billion dollars per year at stake, the results should not be surprising. Even so, the *Challenger* icon is well suited to this service, and it provides a strong example

of how public anxiety is mediated by the display and intertextual containment of photographic images.

Despite the many analogies between the two airships, right down to the *Challenger* being destroyed by exploding hydrogen, the two disasters happened in two different media environments. Rather than an event that happened to be covered by the press, the *Challenger* launch was a media event. The media were being expertly and quite willingly used by NASA to boost public interest in the shuttle program, and the shuttle's mission had become an exercise in public relations. After a national competition, NASA had added a schoolteacher to the crew and then helpfully provided lesson plans to build excitement for the launch, which was broadcast live to assembled schoolchildren across the country. Now that the decisions made by the launch managers that morning have been scrutinized, it is plausible that they were under pressure not to cancel the show. Whatever the reason for the launch, the shuttle then exploded during live television coverage, and the tape was played over and over throughout the day. Teachers cried, students were led in silence back to their classrooms, and the president rescheduled his State of the Union Address to deliver a nationally televised eulogy instead.

As Michael Rogin has documented, Reagan had a peculiar genius for being attuned to and living in the visual media.[53] His highly effective speech provided both the striking phrase to caption the visual coverage and the mythic narrative to neutralize any potentially traumatic effect. It also provided the template for subsequent routinization of the disaster. Reagan begins with his stock-in-trade equation of the nation with family life, as "Nancy and I are pained to the core by the tragedy" while "[w]e mourn their loss as a nation together."[54] He emphasizes the uniqueness of the crash, setting it at a higher order of tragedy than the three astronauts who had died earlier but not "in flight." He then celebrates the crew who "did their jobs brilliantly" and bonds emotionally with their families while noting the astronauts' desire to "explore the universe and discover its truths." Having personalized both the nation and the space program, Reagan shifts to a more impersonal observation that "we've grown used to wonders in this century." Against this habituation to technological progress, NASA has continued to "dazzle" us while exemplifying the pioneer spirit. Returning to the context of family life, Reagan addresses the schoolchildren of the nation and explains the importance of "exploration and discovery." He assures the children that the nation will continue to follow its astronauts into the future, and begins his concluding remarks with a personal testimony to his own "faith in and respect for" the space program and American freedom. He states an absolute commitment to continuing the program and offers his sympathy to the space program per-

sonnel. The last two paragraphs evoke "the great explorer Sir Francis Drake," and the now-famous conclusion: "We will never forget them, nor the last time we saw them, this morning, as they prepared for the journey and waved goodbye and 'slipped the surly bonds of earth' to 'touch the face of God.'"

The speech is both an effective public eulogy and a testament to the anxieties it had to manage. These are evident from the initial insistence on the uniqueness of the disaster. This might seem a small difference to the dead, but it does obscure the fact that the same organization and many of the same technologies were involved in both the midair explosion and an earlier immolation on the launch pad. The praise of the crew is also a bit odd: how is it that one can perform "brilliantly" in the first seventy-three seconds of launch? This overstatement leads to the most labored section of the speech, which is the discussion of routinization. Routine acceptance of technologies because they are safe and therefore uneventful should be an *accomplishment* of modern civilization, but it is a two-edged sword for NASA. Astronauts waving for the camera while orbiting safely look like old news. Ironically, disasters provide occasions for reactivating public identification. By urging us to be dazzled once more, Reagan smoothly incorporates the disaster coverage into the normal operation of the space program. The crew is relabeled as "pioneers," which acknowledges risk while projecting them into a vast natural landscape awaiting exploration and promising adventure.[55]

This myth of modern exploration is the centerpiece of his words for the schoolchildren. It is revealing that there is no discernable change in syntax or diction at that point in the speech. Reagan can easily segue back to the general audience by avowing his "faith in and respect for" the space program, a statement that fuses transcendent and technocratic authority while modeling childlike deference to the state rather than rational assessment and democratic deliberation. The basis for identification remains clear as he promises that there will be "more teachers in space." The only shift in composition appears when Reagan goes up a tick while addressing the NASA personnel, thus registering their cognitive superiority to the public audience. Then it's back to the public with the statement that "There's a coincidence today," the anniversary of the death of Francis Drake. Back in a world of coincidence and wonder, the conclusion continues the infantilization at work throughout the speech: the last two paragraphs could double as a child's bedtime story and good night prayer.[56]

It is difficult to separate the appeals adopted for maintaining the space program and those characteristic of Reagan's oratory, but there is little need to do so. Indeed, the space program rhetoric—particularly as it plays out visually—might be seen as a continuation of Reagan's rhetorical success, and

criticism of Reagan's rhetoric cuts to the core of NASA public relations. Lauren Berlant puts it harshly when she says, "Mass national pain turns into banality, a crumbling archive of dead signs and tired plots," but she hits the mark when adding that "Paradoxically, once they become banal, they are at their most powerful: no longer inciting big feelings and deep rages, these claims about the world seem hardwired into what is taken for granted in collective national life."[57] By placing public issues in the context of family life, sentimentalizing and personalizing public identity, and defining the future as the continuation of a mythic past, Reagan's speech and the images it captioned became a representational idiom of "abstracted forms and spaces of intimate privacy" that relegitimated an inherently risky and very costly government program.[58]

Whatever the reach of Reagan's oratory, the space program had particular need of his appeals. The rhetorical problem and its solution coexist in the reference to Francis Drake. Like all the great explorers of his time, Drake may well have embodied the quest for knowledge and the spirit of the modern age, but he and his peers also went to sea to get rich. There is no comparable utility to the shuttle program. As many commentators have pointed out, NASA has created the space station and the shuttle as reciprocating ends for each other with no outside payoff. And, of course, successive shuttle missions don't go further into space but instead consist of successive iterations of a near-earth orbit where the greatest danger is avoiding floating debris from other launches.[59] Because NASA cannot appeal to the actual utility of its program, it becomes completely dependent on a structure of belief that is inherently mythic. Note, for another example, Reagan's words from his eulogy at the space center in Houston:

> We think back to the pioneers of an earlier century, and the sturdy souls who took their families and their belongings and set out into the frontier of the American West. Often, they met with terrible hardship. Along the Oregon Trail you can still see the grave markers of those who fell on the way. But grief only steeled them to the journey ahead.
>
> Today, the frontier is space and the boundaries of human knowledge. Sometimes, when we reach for the stars, we fall short. But we must pick ourselves up again and press on despite the pain. Our nation is indeed fortunate that we can still draw on immense reservoirs of courage, character and fortitude—that we are still blessed with heroes like those of the space shuttle *Challenger*.[60]

In place of any rational calculation of utility and risk, we have a narrative of the American West, just as instead of the near-earth orbit, we have "seven star voyagers." The space program is itself a form of performance, and the

story being performed is modernity's mythic narrative of continuous tech-nological progress to acquire knowledge, realize freedom, and achieve the control over nature essential for happiness. Even so, the gamble underlies it all, for "the story of all human progress is one of struggle against all odds." Against those odds, one had better be "fortunate."

This myth is pervasive and often merely a backdrop to more ordinary ac-tivity; note that Internet browsers have been named Navigator, Explorer, and Safari with visual imagery to match. In NASA's case, however, the mythic ap-peal is paramount, and it continues to be accomplished through the combi-nation of visual and verbal techniques evident in Reagan's captioning of the *Challenger* images. Recall the concluding words from the January 28 speech, when Reagan spoke of the crew as they "waved goodbye and 'slipped the surly bonds of earth' to 'touch the face of God.'" This text is already a com-posite of visual memory and verbal abstraction, and it achieves a reframing of the disaster through a double substitution: First, the image of the astro-nauts "waving" before they enter the shuttle is substituted for the image of the explosion; second, the abstraction of immortality is substituted for the fact of destruction. This series of transpositions across the imagetext directs the audience to look back before the time they actually saw the shuttle ex-plode (the iconic image), to the personalized image of the astronauts walk-ing to the shuttle (as if a snapshot from a family gathering or local sporting event), which then is described as if it were in the same moment of time as the launch and explosion. One could not literally see them as individual per-sonalities in the shuttle as it launched, so one is directed to see them as they were before the launch, which then becomes transposed into the abstraction of a wonderful immortality, which can be symbolized by the abstract form of the iconic image.

This abstraction of pain and sentimentalizing of public response was re-peated continuously in the coverage of the disaster (and its successor event, the loss of the *Columbia*). It extends far beyond that through commemora-tive coverage, monuments, museum exhibits, children's books, elementary education lesson plans, Time-Life publications, Web sites, and more. Much of this is guided by NASA's lavish expenditures on public relations, but one need not look for direct control. The coverage of the disaster in children's literature is particularly instructive. Children were singled out as a primary audience for the launch and addressed directly in the president's speech to the nation. Childhood's vulnerability demands that adults reduce the event's traumatic effect, while there clearly is an interest in insuring that an entire generation is not scared off of capital-intensive technologies.[61]

A review of several accounts of the disaster written especially for school-

children reveals that this is a not unsophisticated genre. Adjusted for age level, the accounts typically provide a high degree of information content, an analytically sound narrative, and careful synopsis of major issues and findings in public debate. They are less "chatty" than many a journalist's report in the adult media and often more acute than many of the news stories appearing at the several "anniversaries" of the disaster. Even so, like children themselves, they can be all too candid mirrors of the adult world.

Despite their often surprisingly deliberative reportage, the books nonetheless follow a common path that leads to the same conclusion. First, the author emphasizes the uniqueness of the disaster while reiterating that it occurred against a backdrop of routine and reliable technological progress; second, the disaster is explained as the unfortunate intrusion of political influence into the technocratic process; and finally the future is defined in terms of sacrifice on behalf of mythic greatness that can overcome continuous risk. *Challenger: America's Space Tragedy* by Michael D. Cole is typical: the prior immolation of three astronauts is erased, and the first chapter of this book on the shuttle program takes its title from the NASA announcement at the time: "A Major Malfunction."[62] Yes, one might call it that, and doing so reincorporates the loss into a larger, generally well-functioning technological process. Cole then reports that "the cause of the explosion was discovered in the weeks and months that followed. It became clear that the tragedy could have been avoided. The explosion of the *Challenger* should never have happened." The critique of NASA management follows, albeit with a sleight of hand whereby "some administrators at NASA were under political pressure to speed up the shuttle's launch schedule."[63] (What is not said is that the "political pressure" came from other administrators at NASA.) Less deliberative and more Reaganesque appeals are developed through the accompanying visual imagery, which includes, in order, a group shot of the crew with a model of the spacecraft and an American flag, the logo for the Teacher in Space program, a four-shot sequence (two of liftoff, a rarely seen and "messy" shot of the explosion geysering upward, and the iconic image), and a snapshot portrait of Christa McAuliffe in sports shirt standing before an American flag. The sequence is from a group shot to a more personalized photo, and within that from literal representation of the initially successful launch to a relatively serene view of the "major malfunction." These images identify the space program with the nation in a context of "abstracted forms and spaces of intimate privacy." The visually supported narrative then locks into place: The disaster was an unique, avoidable, and correctable event; the large, complex technological enterprise is sound; the major source of error is in the institution (not the technology) and its susceptibility to politics; pub-

lic response should be channeled through identification with the celebrity individual who "always took pride in the space program." The conclusion follows: "The courage and dedication of McAuliffe and the *Challenger* crew would not be forgotten. Neither would their sacrifice. That sacrifice would begin the long journey toward a better space program and a brighter future for America in space."[64] Or, in Reagan's words: "The future doesn't belong to the fainthearted; it belongs to the brave. The *Challenger* crew was pulling us into the future, and we'll continue to follow them."[65]

This narrative is pervasive. The details can vary while following a formulaic beginning, middle, and end. The story begins by frankly acknowledging the "accident," while at the same time using a combination of explosion and file photos to frame the event. In Gregory Vogt's *The Space Shuttle*, for example, we find a portrait of the astronauts and the iconic image of the explosion.[66] This combination of sentiment and abstraction is followed by an attempt to finesse the problem of modernity's gamble. The technocratic context is activated by detailed description of the many improvements made following review of the disaster; indeed, "safety modifications could be made to prevent it from happening again." Wisely, however, a caveat is added. "Even with the modifications to the space shuttle, space flight is still not 100 percent safe, and it never will be. There will always be risks. It is the job of a large team of safety review experts as well as everyone involved, from shuttle crew members to the technicians who assemble the nuts and bolts, to do the best they can to minimize risk."[67] Timothy Levi Biel continues the pattern in *The Challenger*. The text returns to discussion of a technical solution to the O-ring problem and is accompanied by sidebars on "A Safer Shuttle" and "Future Shuttle Missions," the latter placed above a file photo of a shuttle floating beside the space station. This substitution of images is followed by additional claims regarding reform: "Until it has proven 100 percent reliable over several years, only trained, professional astronauts will fly on shuttle missions. There will be no more teachers in space or politicians in space for many years to come." Perhaps it is revealing that the return to normalcy will take both "several years" and "many years."[68]

Once future continuity of the program has been projected forward to minimize risk, the story can turn to the happy event of the next shuttle launch. Now free of political intrusion, "this was the most experienced crew NASA had ever put together for manned space flight." As the launch approached, the "mission management team reviewed engineers' analyses" while spectators "looked on anxiously" as they recalled the "ghastly, orange fireball and cloud of white smoke." Not to fear, "*Discovery* [note the name] was on its way and the United States was back in space." *Discovery*'s launch had eclipsed the

iconic memory of the *Challenger* explosion, and the accompanying narrative reaffirmed a binary division of technocratic control and democratic spectatorship. It was a mission to be judged as a performance and one that would be successful if it squelched public skepticism about the space program. The flight "helped to heal some deep wounds. For the moment . . . most Americans were glad to be back in space. To the five astronauts aboard the shuttle, there was no question that this was the right decision." It only remains for them to play out their roles as pioneers. And so they do. There were "no politicians, and no other civilians on board," but note the frontier inflection in the voice of the highly trained professional: "As one of them said to Mission Control shortly after the *Discovery* entered its orbit, 'We sure appreciate you all gettin' us up into orbit, where we should be.'"[69]

So it is that the books for kids, from school textbooks to paperbacks, begin by rather frankly acknowledging modernity's gamble but then wish it away with a rhetoric of technocracy and frontier mythology.[70] The risks are there, and some will sacrifice their lives for progress, but then the risks recede, problems are attributed to nontechnocratic entities such as politics, the press, and eventually the culture of managers who overrule engineers, and the nation's vision is lifted again to the frontier of outer space. This narrative is underwritten by a conventional array of images that again and again couple the iconic shots of the explosion with portraits of the crew and especially of its one nonspecialist, Christa McAuliffe. Thus, both within the narrative, within the photo array, and between the two modes of representation, there occur sophisticated alterations of abstraction and personalization that together produce a docile public response.

Strategies of displacement are equally evident in the adult press. Press coverage of the disaster eventually revealed the house odds and raised serious questions about whether to gamble with people's lives.[71] The technocratic mind quickly geared up in response: "*Challenger* did not 'explode' in the common sense of the word; it was set aflame by a leak in the seals of a right booster rocket."[72] The bureaucratic response is less subtle: "There was no pressure to get this particular launch up. . . . We have always maintained that flight safety is our top priority."[73] When that lie was exposed, the strategy shifted to claiming that what had once been denied has now been corrected. In the words of the Cape Canaveral bureau chief:

> Shuttle *Atlantis* headed back to its Kennedy Space Center (KSC) assembly building Friday, a clear sign that NASA is walking the walk—and not just talking the talk—when it comes to the agency's "safety-first" mantra.
>
> Fifteen years after the ill-fated *Challenger* flight, a dangerous rocket booster

problem prompted senior shuttle managers this week to delay the planned launch Friday of *Atlantis* rather than risk a $2 billion spaceship, a $1.4 billion science lab and the lives of five astronauts.

Independent aerospace safety experts, meanwhile, are applauding the three-week postponement—a delay that comes amid an intense agency push to ramp up NASA's $60 billion *International Space Station* construction project.[74]

The irony of subsequent events is painful enough, and worse, the clues are there from the start: the five lives are at the wrong end of a declension of values, and the praise is highlighted by the fact that the agency is once again putting the shuttle program under "intense" pressure. The story is supported by file photos of the shuttle booster assembly, its payload, and the crew to supply a visual restoration of the organization after the *Challenger* disaster. The standard clearly is one of sheer performance, as if launching on time would ordinarily be worth the risk of losing five lives and $3.4 billion. More revealing yet is the sidebar that accompanies the story: a Hewlett-Packard ad that displays a rocket engine blasting off while offering a chance to enter their lottery for a trip to "Mission SPACE at Epcot." Come on, take a chance. The prizes are ten trips for "families of four."[75] One wager is substituted for another, the gamble is neutralized by placing it within a context of family life and harmless simulation, while adults are reduced to children as all enjoy Disney's version of a "learning center."

The full irony became evident during the next shuttle explosion:

In Concord, though, they remembered McAuliffe. The tragedy seemed to carry a special significance at the Christa McAuliffe Planetarium, where one popular exhibit is a shuttle flight simulator that carries the name *Columbia*.

The small planetarium celebrates space exploration, and it lays a special claim to the pioneering spirit that it also noted in McAuliffe's epitaph.

NASA programming, beamed in by satellite, airs continuously on a television at the planetarium. Recently, the station had been buzzing with the news that another teacher would be sent to space.[76]

Why shouldn't another teacher join the crew, when thousands of schoolchildren have been riding safely in *Columbia*? Anything else would be a betrayal of their pioneer spirit.[77] So it is that there now are *Challenger* learning centers in fifty states, Canada, and the United Kingdom.[78]

This entombment of the disaster in the visual stream of NASA programming and its mythic narrative of exploring the stars is not limited to the Christa McAuliffe Planetarium. *Life* magazine has been a strong supporter of the space program (including fifty-five cover stories), and its story on the

educational centers continues the association of national policy with family life. As Wendy Kozol has documented, this is a crucial characteristic of *Life*'s rhetoric; it is evident from early features on the astronauts' wives to the preoccupation with Christa McAuliffe.[79] Note the sequence of images for a story on McAuliffe: Christa in training, the iconic shot, the astronauts waving as they head for the shuttle, Christa in a plaid dress jumping in a classroom as she holds the model of shuttle, a child in a learning center, three widows of the astronauts, McAuliffe's husband and their now grown children.[80] The iconic image is the smallest of the set, and quickly displaced by the shot referenced in Reagan's speech and then the snapshots of an anonymous child and astronaut family members. Another story at the *Life* Web site pushes the family motif visually by publishing "newly discovered photos" from the family album to celebrate McAuliffe's "pioneering spirit."[81] These and similar stories contain the hero's expressions of pluck and good cheer while reaffirming the narrative in which "America steps boldly back into space."[82]

The full realization of this narrative is achieved visually through the "last" substitution of a personal image for the iconic photo. The *Life* cover (fig. 52) of February 4, 1996, declared that "Christa's Dream Lives On." The cover text reads, "Ten years after our worst space disaster, family and friends remember the lost heroes of the shuttle CHALLENGER—and America dares to reach for the stars again."[83] While addressing readers as a nation, public affairs are mediated by the personal relationships of family life, and any debate is suppressed by a triumphalist reassertion of national policy. That policy of continuing the shuttle program is embodied in the image of a smiling, confident Christa McAuliffe striding confidently through space. McAuliffe becomes something between a ghost and an angel, something that "lives on" in media space.[84] Just in case the transcendental aura of the text—where a dream lives on as America reaches to the stars—is not clear, a shower of rose-colored stars descends from heaven, halolike, to anoint her. Against the blue-black, star-speckled space behind her, she looms large, a being of cosmic scale, like an angel standing at the gates of heaven. She is the dream, a great and good supernatural force leading the way across the heavens toward "our" destiny. She also is set above the viewer in the exact proportions of adult to child. We look up to her as small schoolchildren might look up to a beloved teacher. The visual form of address reproduces a specific relationship between NASA and the public, that of teacher and schoolchildren. She now truly is a teacher in space, and one with an aura of supernatural confidence, while the public is schooled in deference to those running the shuttle program.

This combination of transcendental narrative and the completely personalized image of the disaster reestablishes mass identification with a techno-

FIGURE 52. Cover, *Life*, February 1996 (Michael O'Brien, photographer). Getty Images.

cratic elite. It also is a winning combination for reanimating the technological imperative. The iconic photo registered the deep trauma of modernity's gamble, and although the circulation of that photo serves both to reiterate the disaster and assist its routinization, the photo alone remains a troubling erasure of human presence. Full restoration is not possible, but the public can be lulled back into quiescence by containing the iconic image within a narrative of mythic progress, and by adding and ultimately substituting other images that are more carefully composed representations of the attitudes and civic relationships articulated in that narrative. The mystification

of what are brutal odds regarding fatality likewise becomes fully articulated visually in an image of the ordinary person killed in the disaster reincarnated to a moment of personal happiness. Labeled as the sign of the future, the image erases the iconic rupture of modernity's narrative of progress. The future will be like the past, but not that past. It will be the past anterior to the disaster, a happy time projected forward again. This projection is itself a spectacle, and the viewing audience is once again looking up, as if to see another launch.

VISUALIZING RISK

One can imagine a teenage boy walking along the edge of a precipice. One misstep leads to death, something the overconfidence of youth can hardly imagine, and yet surely he is aware of the danger . . . And that's about all one can see, if one is to visualize risk. Risk assessment is a calculative art, and most of the time risk itself is a statistical reality, a matter of living with the odds. The disaster image is a picture of a bet gone wrong, to be sure, but it is no more representative of risk per se than is a picture of a car traveling smoothly along a freeway. The disaster image doesn't represent risk so much as it disrupts a willful amnesia about the possibility of death. The single image tears a narrative that operates daily in thousands of lives to contain the anxiety that is a rational response to driving at seventy miles per hour, taking medications one could never analyze, or being told by a large corporation that there is no threat of contamination. Thus, the spectacular image becomes a means for reflection on a condition of ordinary life.

The still photograph is particularly important at precisely this point, for the stopped-time depiction of the catastrophic scene interrupts the ideology of continuous time that is central to modernity itself.[85] As Mary Ann Doane states,

> Catastrophe is thus, through its association with industrialization and the advance of technology, ineluctably linked with the idea of Progress. The time of technological progress is always felt as linear and fundamentally irreversible— technological change is almost by definition an "advance," and it is extremely difficult to conceive of any movement backward, any regression. Hence, technological evolution is perceived as unflinching progress toward a total state of control over nature. . . . Catastrophic time stands still. Catastrophe signals the failure of the escalating technological desire to conquer nature.[86]

Thus, the disaster photo has a correspondence of form and content that is missing in the typical public relations file photo. The file photo's interrup-

tion of time is belied by the content of the picture, for a smoothly function-
ing machine is one that operates on schedule and evidences a continuous
path to technological development. The photo's interruption of temporal
movement becomes a minor property of the representational medium itself
that is easily corrected by the narrative of progress. In the disaster photo,
however, the form performs the content, and so the image acquires greater
rhetorical power to disrupt that narrative in a fundamental sense, that is, by
stopping the forward flow of time.

There may be another reason why the still photograph dominates disas-
ter coverage. Barbie Zelizer's analysis of "about-to-die" photographs estab-
lishes that photographs can work in a subjunctive mood, by which the still
image communicates a sense of contingency or possibility.[87] Thus, death can
be somewhat denied, delayed, softened, or even framed in terms of an ideal.
They might not be dead yet, the event might be turning out differently, or
perhaps it could have been different if things had been handled better. The
psychological buffering is an obvious feature of facing death, but it doesn't
encompass all of the performative work being done. Nor do these effects de-
pend only on the content of the about-to-die photo; any still photo of an un-
folding disaster, by its nature, turns necessity into a moment, however thin,
of contingency. That instant can be a moment of denial, or one in which one
catches one's breath to absorb an impending emotional blow, or a cue for
reflection.

Thus, there is good reason to read the iconic images of disaster as ritual
performances capable of mediating a basic dilemma in modern life, and
to consider how the different trajectories of the *Hindenburg* and *Challenger*
images through media space reflect larger changes in public culture. In the
former case, the image activated a strong sense of collective identity ("oh, the
humanity"), and it led to rejection of a technology because the public trust
could no longer be assured. Subsequently, however, the image has become
merely a cautionary note. The public reaction almost seems nostalgic, and
the *Hindenburg* moves ever closer to the *Titanic* as examples of how people
miscalculated in the past. By contrast, the *Challenger* image was born of a
media event gone awry. The carefully assembled public audience was trau-
matized, but the capital-intensive public relations program already at work
quickly contained the damage within a narrative that articulated the tech-
nology ever more powerfully to mythic conceptions of national identity and
technological progress. This shift in the relation between image and text
carried with it a change in the conception of the public. Instead of the col-
lective experiences evident in the *Hindenburg* photo itself, identified in radio
and newspaper coverage of the event and public memorial services, and re-

peated in movie theater newsreels across the country, the *Challenger* story became a narrative of individual heroes, families caring for one another, and a state tending to its citizens as if they were schoolchildren. Most important, whereas the *Hindenburg* image activated a tale of technological hubris and the potential for modern life to create a dystopian future, the *Challenger* icon was used to justify indifference to risk and continued acceptance of modernity's gamble. As Kafka predicted, the leopards became part of the ceremony.

That is not the end of the story, however. The differences between the photos should not obscure common characteristics of the visual mediation of modernity's gamble. To do so, one must take a step back and reconsider the role of disaster in modern life. The first observation is that it doesn't happen much. That is, amidst the incredible complexity of modern machines and technological systems, their complete ubiquity in everyday life, and the trillions of operations and interactions that occur every day, there are very, very few *disasters*. Traffic light switches alternate in steady sequences, drivers stop and go on cue, planes land, electricity flows, trucks roll along, and life goes on uneventfully. There is another side of the relative lack of disasters, however: accidents that inconvenience, damage property, and harm and kill people happen all the time. The light at Thirty-First and Grand is out today, about 85 percent of all flights arrive on schedule, another PC crashes somewhere every few seconds, a car crosses the median and hits another head-on. What also happens is that this uneven but continuous stream of breakdowns and mistakes become incorporated into organizational feedback and adjustment loops. A crew is sent out, the routing is adjusted, a patch is run, a guardrail is installed.

The result is a background consciousness that is alternately anecdotal and statistical—and thoroughly banal. We attend to details most of the time, play the odds unconsciously, and negotiate complexity without much thought. Accidents such as a fender bender are indeed disruptive and cause for considerable reflection (as well as denial and argument), but they are infrequent and localized. They can, however, lead some to ponder just how precarious life can be when in the hands of a stressed-out air traffic controller, an understaffed hospital, or a weak regulatory agency. And sooner or later everyone does come to that realization, as the combination of high self-interest and lack of personal control is a sure cause for systemic anxiety.

Against the background of banality, fatality arises from time to time. The dialectic of banality and fatality becomes a powerful drama of modern life, and one that can only be fully realized within the mass media. Conversely, the media, across all genres from news to horror movies, communicate a sense that danger lurks beneath the surface of a supposedly safe, controlled,

modern environment. Disaster coverage is a prime example of this symbolic form.[88] More important yet, disaster coverage reveals how much the media are involved in managing modernity's gamble. The disaster exists primarily through the media. Without coverage, the event itself is another localized accident, harmful to those directly involved but easily absorbed into the statistical calculations. Indeed, most disasters actually kill and injure relatively few people—both *Hindenburg* and *Challenger* are cases in point—and certainly so relative to the overall assessment of risk. This point is made periodically by those who also point out that in the same week as the latest disaster more people died nationwide in traffic accidents, from lung cancer, or due to some other systemically distributed danger. The article always goes to the bottom of the pond.

The disaster looms large only through the mass media coverage of the event. The steady stream of otherwise localized accidents—tanker truck spills, fires, small plane crashes, freeway pileups, and power outages, among other things—create and disseminate a consciousness of fatality that can in fact have little relationship to one's actual circumstances. One explanation, which certainly is true, is commercial: "If it bleeds, it leads," because gore and fear sell.[89] There is more going on, however. One function probably is that the coverage operates as the largest and the most democratic feedback loop in overall system maintenance. The coverage alerts a wide range of people to likely operational problems and, for some technologies, expands the pool of possible problem detectors and problem solvers. It also brings public pressure to bear on governments to exercise oversight and regulatory functions and on corporations to address the problem to retain customers. Any disaster generates a series of stories about the standard procedures and quality control in the specific industry or business on display: interstate trucking, ferry boat services, and many other practices are brought under public scrutiny from time to time. Of course, it also creates the conditions for these institutions to focus more on public relations campaigns than on operational solutions. Nonetheless, the mass media become a cybernetic system within the operation of modern society, a technology for monitoring the reliability of other technologies.

The media system is itself extremely leaky and otherwise flawed as well. Coverage is event-driven, episodic, and short-term. Any corporate executive knows the odds are good that one can wait out the bad news. Some industries escape scrutiny because others are producing less frequent but more visible accidents. Coverage can have unintended effects: a big oil spill not only generates coverage of other spills but also raises the size of what qualifies as a spill big enough to merit coverage. Likewise, the constant din of accident

reports on the local news can habituate the media audience to failure rates that could be avoided. One rightly gets nervous if one looks too closely at how the media system works. One also would be misled, for primary purposes of the system include not only news reporting but also emotional management. Disaster coverage may help a society monitor system performance but has to manage emotional adjustment to "normal" system operation. This is done by shifting from the technical to the symbolic mode of performance.

Media coverage of a disaster becomes a performance of modernity's gamble. Through ritual enactment of the danger lurking beneath the surface of modern life, fatality is confronted, fear that otherwise has to be suppressed is let loose, pity and terror are activated within a virtual experience and dramatic frame that can cushion one enough to allow readjustment rather than flight. The trauma is created as a mediated experience, and it is contained both within the immediate performance and through a series of sequels. This performative sequence involves shifts in coverage to mark it as an exceptional event. For example, extended coverage signifies heightened significance by interrupting the standard schedule and periodicity of media programming, and the same effect comes from more extensive use of visual images. The ritual also has to contain the terror, however; indeed, containment stands in the place of catharsis within modern public discourse. In the mass public as in the modern machine, dispersion is the absolute enemy, for energies that are released are gone forever. Thus, the coverage has to include both virtual enactment of the disaster and figures of containment. As the coverage extends over time it offers ever more effective reconstructions that can provide assurance and return the audience from disruption to routine. This renormalizing of the system involves shifts back to periodic coverage, standard text-image ratios, and consensual iteration of a dominant narrative. In some cases, it also involves memorial practices that reflect sophisticated and highly uniform techniques for multimedia orchestration of public quiescence. The astronauts memorial at the Kennedy Space Center Visitor Center provides a good example: as Carole Blair and Neil Michel have demonstrated, it is a near perfect application of Disney World social engineering.[90]

The iconic images provide another confirmation of this pattern in media coverage, and they also highlight both the value and the limitation of relying on visual imagery to mediate risk. It becomes clear that visualization is central to the mediated experience of disaster. Without the imagery, it is exceedingly difficult to break out of the background mentality of living amidst complex systems. That mentality has to be either personal or statistical— the event either affects me directly or it goes into the overall calculation of

the odds. The visual image is inherently disruptive and incipiently collective. It breaks the statistical mentality, and it imitates the sense of immediacy experienced by those within the event. Likewise, it ruptures the narratives of normalization that stream through the media to maintain support for the technocratic systems enveloping everyday life or appropriating public funds. In place of the long-term run, it places one right at the scene of something gone horribly wrong.

Without such virtual experience, important elements of both collective life and individual psychology remain unattended. Ultimately, the system fragments along lines of wealth and power that in time leave everyone helpless, including those within their well-fortified bunkers. Against this tendency, the widely disseminated visual image creates a sense of common experience as it also activates strong emotional reactions that in turn motivate interaction and attention to others. Most important, the image creates a wide radius of response that motivates action toward the center. Likewise, without localization of the gnawing anxiety that accompanies playing the odds, there is no way for the individual to regain a sense of control. Individuals need to be careful but not paralyzed by fear, and the visual image is always one that can both be recalled anywhere and set aside as a discrete event. It does not depend on narrative activation or require anxious questioning. As the image solidifies within memory, it keeps one aware of danger while also localizing fear.

To summarize, the modern disaster is a product of the mass media. It exists within a field of dissemination and processes of routinization, rupture, and recontainment that are endemic to a high-tech society. The disaster photo becomes a leading figure in a performative ritual though which the mass media audience is maintained as an audience, activated as a cybernetic system in a technology-intensive society, and involved in a symbolic drama that allows reflection on and renegotiation of a deep tension within that society. The iconic photo provides an intensive instance of this last function. The photo is perpetually disruptive: it always exposes the dirty secret of all modern engineering, which is that systems that are safe enough to be applied to large numbers of people are nonetheless sure to kill some who would not have died otherwise. Yet the photo is not a mere exposé, for it also reproduces the strategies of containment that make modern engineering the comprehensive structure of everyday life. This ambivalence in turn makes it a central figure in the subsequent struggle to control the meaning of the event. As a history of appropriations develops, it becomes possible to see successful maneuvers in public relations that are, of course, also lost opportunities for reflection.

We think that the iconic image provides an additional service as well. We have argued that iconic images underwrite liberal democracy. That may seem evident when the content of the photo is explicitly political, as with a flag raising. Surely, there is reason to question how a photo of a machine exploding could serve the same purpose. It seems to us that there are at least two significant considerations that apply across all appropriations and the full range of attitudes in play. Whether utopian or dystopian, the disaster icon has both symbolic and emotional value for democratic polity. The symbolic value is this: the disaster cuts to the core of technocratic authority. Technocracy is always an alternative to democratic decision making and one that is rarely in the wings any longer. Complex societies have to cede control to experts in many different contexts, and the appeal to expertise provides additional cover for usurping authority from city councils and school boards and from the U.S. Congress and the president. When technocratic regimes are functioning smoothly, there seems little need for public involvement. More to the point, society seems to have avoided one of democracy's greatest weaknesses, which is that it does not require expertise for decision making and at times does no more than pool ignorance. The problem, of course, is that without public accountability technocratic regimes will become ends in themselves and dangerous to others. If one is committed to democratic government, disaster coverage becomes a public good. If one believes that democracies provide additional protection against large-scale technological catastrophes, such coverage is essential.

There is a second contribution, which may be more important than the first. The disaster creates strong emotional uptake across the public media. This activation of emotion, in particular of the emotions of pity, compassion, and identification, is a crucial counterforce to both technocratic routinization and liberal autonomy. Whether a cry of "oh, the humanity" or a eulogy to a schoolteacher chosen for her ordinary qualities, the iconic image obviously provokes a form of fellow feeling. Although enormous efforts are then made to direct those emotions for strategic benefit, they are at least there, and they are means for binding people together as strangers, citizens, and human beings sharing a common vulnerability. In addition, it might be that this empathy can be transferred from the topical field of the disaster to more comprehensive political relationships. To underwrite liberal democracy, the icon has to provide social, emotional, and mnemonic materials that are less likely to be available in print media. It might be that in an increasingly liberalized society, any form of collective compassion is better than none. The task is not to mute disaster coverage or discredit the iconic image but rather to find ways to keep citizens oriented toward helping one another.

At this point, one also should reflect on the limitations of the iconic image, and so on the visual representation of disaster. Our concern follows from the idea of emotional transference. One should ask what else can be carried from disaster coverage to other realms of public discourse. As least in respect to the *Challenger* photo, the record suggests that disaster coverage can become an exercise in carefully orchestrated stupidity, especially when the public is spoon-fed arguments and appeals that would literally spell disaster if applied with equal gullibility in other matters. Of course, in other matters we often are close enough to the action to know better, but that doesn't hold when being asked to consent to large-scale technocratic enterprises such as space flight, missile defense, nuclear waste disposal, environmental regulation, agribusiness, and war. And it does seem that there has been some "mission creep," to borrow a phrase. Decision making in the United States does not suffer from an excess of pessimism, and the public seems to be all too comfortable with both vivid visual displays of disastrous events and their containment within narratives of progress. There would be cause for serious concern were other areas of government to follow this formula of equating national identity with complete disregard for rational assessment of costs, say, in regard to preemptive war and prolonged occupation of another country. As long as it is enough merely to be "aware of the risks," governmental projects will be well short of prudence.

EPILOGUE

The iconic photographs of the explosions of the *Hindenburg* and the *Challenger* space shuttle function as a visual dialectic, marking the tension between dystopian and utopian attitudes towards modernity's gamble. The *Hindenburg* photo offers a somewhat gothic image of a "brave new world" that invites a bleak and cautionary attitude towards the catastrophic risks of industrialization and technology. One might continue to pursue technological advances after seeing this image, but always with a sense that the dangers are very real and the need to consider at least the possibility that the risks might outweigh the gains. The photograph of the *Challenger*, by contrast, is an abstract, white, airy image more conducive to reaffirmation of a utopian future. Perhaps this is because space is the "final frontier" in a culture that has always seen a better, more inclusive democratic future on the frontier, part and parcel of its manifest destiny; or perhaps it is because the trajectory of the explosion is upward and outward. In any case, it is an image that has been used primarily to normalize the risk of modernity's gamble by transforming it into a simple cost-benefit equation. Yes, space shuttles will

explode and men and women will be sacrificed, but that's simply the price "we" pay for progress. And after all, the expression of uncontained energy as a roiling, while cloud cast against a tranquil, blue sky is beautiful beyond words, literally awe-inspiring (not awful), more like the "face of God" than a mess made by human hands.

The dominant articulations of the *Challenger* photograph have helped to sublimate the dystopian attitude towards modernity's gamble. Thus, the image has become emblematic of the routinization of technology in late-modern life, literally a ritualization of modernity's gamble that can be invoked generically in the face of any catastrophic disaster that might otherwise invite considerations of technological hubris. Notice, for example, its prominent use in media reports of the explosion of the *Columbia* space shuttle in February 2003. The destruction of the *Columbia* was doubly traumatic, for it not only was a return of the repressed (another shuttle disaster, and another image of a flying machine exploding while trying to land), but its visual representation consisted only of images of dispersion and fragmentation.[91] Such images were simply not up to the task of both representing the event and containing the anxieties and criticisms that had been let loose. But what we find, whether on television, in print media, or on the Web, are reproductions and representations of the *Challenger* photograph and of other *Challenger* commemorative images. A Knight-Ridder paper provides one example of this direct substitution (fig. 53), with the older photo being used to represent the more recent explosion.[92] Similarly, although *Time* magazine used the image of *Columbia*'s sparkling dispersion on its cover, on the inside the *Challenger* image is used twice, in each instance framing the event historically and conceptually as a normal part of modernity's gamble—and leaving no doubt that in the not too distant future, once we figure out "what went wrong," we will be back at it again.[93]

This substitution of the older iconic image for the immediate photographic record obviously flies in the face of assumptions about journalism's commitment to direct, transparent representation of current events. This commitment is not set aside lightly, but rather only when larger social forces are at work. The high stakes are evident when one considers both sides of the substitution: why the images of the *Columbia* disaster did not become iconic, and why the older icon was used in their place. The difference is not in news value or in photographic quality, but rather in what is revealed and what is contained. The *Columbia* images are all images of radical fragmentation. Whether one looks at the brilliant pebbles in the sky or the broken shards of the shuttle that were scattered across hundreds of square miles of terrain, one sees only complete dispersion from the comprehensively destructive

FIGURE 53. Photograph of *Challenger* explosion, *Grand Forks Herald*, February 2, 2003.

release of energy. These images are all of the aftermath of the explosion, leaving the viewer with only loss and traces of what had been whole. It's over, and there is no doubt that the gamble failed. By contrast, caught at the moment of explosion, the *Challenger*, like the *Hindenburg* before it, freezes the event at the dramatic moment when those energies are being released. The iconic image captures the essential tension between technological control and the forces straining for release. Whereas the radical fragmentation of the *Columbia* images demonstrates nature's relentless breaking down of human effort, the iconic images keep the audience at the moment when one can still look back and imagine an alternative outcome—the dirigible floating magnificently above the ground, and the spacecraft thrusting powerfully upward into orbit. And of these, the *Challenger* image is more reassuring still, as even in the moment of destruction the explosion is contained aesthetically while the plumes of smoke continue to arc heavenward. All of the available images report the news about the respective disasters, but only the iconic images provide the resources to manage the deep tensions within technological society. The icons mark the social contract that is at risk, and they provide symbolic materials that are more or less oriented toward reassurance of the public audience and reconstitution of the status quo.

In one sense there is no conclusion to this analysis. The shuttle program has had another launch, another scathing report on its continued failure to

minimize risk, and another grounding. Officially scheduled for discontinuance, the shuttle now is being relabeled as an obsolete 1970s technology, which allows easy transference of the NASA rhetoric to its next generation of vehicles.[94] The disaster icons continue to circulate, while institutional and media elites are becoming ever more adept at manipulating ritualized civic performances.[95] Even so, all is not well, and this sense of instability may itself be the product of photojournalism's powerful influence on public opinion and collective memory. As John Staudenheimer notes:

> The terror attacks of 9/11, the collapse of the Internet stock boom and now the shuttle explosion have undercut the technological bravado that helps drive scientific exploration of all sorts. There is this feeling of vulnerability right in the center of where Americans tend to feel most confident, our sophisticated technological systems. For Americans, it's almost like being homeless. It leads to an identity crisis.[96]

The shift from the accidental explosion of the shuttle to the intentional destruction of the Twin Towers may seem a stretch—although both involve aircraft turned into fireballs—but it also appears in vernacular representations such as the Web site Icarus. This site, which is dedicated to commemorating the *Challenger*, now includes a pop-up poem eulogizing 9/11; that event is framed by the *Challenger* story, beginning with the iconic photo and the title, "Under a Clear Blue Sky."[97] The Twin Towers are depicted as marvels of technology embodying their civilization, yet the description contains a sense of preordained death: "Twin towers of glass and steel. Each taller than the *Titanic* was long. Twin pillars of Hercules. Reaching to heaven itself." The poem and its subsequent use of the *Challenger* legend marks the inescapable vulnerability of living within modern society while also providing ritualized reassurance that dangerous forces can be controlled.

In the emerging digital age, photojournalism will continue to provide powerful resources for advocacy, for manipulation, and perhaps for critical reflection. Recent events in Iraq more than prove the point, as the spectacle of "shock and awe" promoted yet another gamble, this one in the political sphere, but surely related to the excessive consumption of potentially explosive fuels. If the "defining image" of that enterprise or any other is to emerge, it will be one that captures not just the drama of the event but a fundamental tension within the public audience.[98]

The important question is not whether a defining image will emerge but to what extent media coverage will maintain current habits of unnecessary sacrifice. There is no reason to object to improving the quality of human life, and modern technologies have been enormously successful in that regard.

But the gamble is there: carbon dioxide levels are rising, oil is being used up for all time, the human genome will be modified, and "creative destruction" because of capital-intensive, high-tech, top-down globalization on American terms will continue. These changes are difficult to visualize, as are the risks they bring with them. Even though the icons of disaster may be compromised by their formal designs and their histories of appropriation, they remain among the few representations of hubris available in a society that is willing to gamble on anything. The ritual performance may be a gamble as well: will the public see both its common vulnerability and the need for democratic accountability, or will they settle for the bright lights, cheap thrills, and other distractions that allow the house to control the action?

9

CONCLUSION

The tall, strong sailor grasps the pretty nurse in his arms. The force of his embrace has bent her backwards, and her body cleaves to his gracefully as she joins him in a deep kiss. Spectators on either side of them look on and smile approvingly. They all are happy: it is VJ Day in Times Square, and what could be more appropriate than a sailor kissing a nurse? What could be more beautiful than his dark uniform against her white uniform, and her white skin against his black skin?

It didn't happen, of course: The photograph you've seen shows a white couple. Somewhere a black sailor may have kissed a white nurse that day, but it was not displayed in the national media as a symbol of celebration. A photograph captures a tiny sliver of time and space yet can reveal in a flash the social order. Photojournalism shows what can be done in public, and it allows one to think that what is not shown cannot be done. Any photo can be an invitation to participate in a way of life and also a vivid reminder that others—you, perhaps—are not welcome, perhaps not even thought possible.

Imagine for a moment what American society would have had to be to produce the photo of a black sailor kissing a white nurse in Times Square. No

segregation in the military, no laws against interracial marriage, no lynchings, no separate school systems, no sundown towns, no assassinations . . . Perhaps we only need add, "And what a wonderful world it would be." The United States isn't there yet, and the continued reproduction of an iconic image of a white couple may be part of the problem. Yet that image has also become a means for progressive advocacy that acknowledges difference to challenge definitions of normalcy. When a *New Yorker* cover depicted two male sailors in the iconic pose, they still were both white, but the illustration had directly challenged another of the icon's exclusions. Alternate pictures depict alternate worlds.

Such variation can only be persuasive if the original model is widely recognized and valued. This book has examined some of the most powerful images in U.S. photojournalism in order to understand how they have reflected, constituted, and been used to maintain and to change liberal-democratic public culture. This is a story, of necessity, of dominant media and mainstream cultural discourses that project across all areas of modern life. It is an attempt to see how these images work on their own terms, as it were, and how these terms were used to manage whatever contradictions and other limitations they contained. For it is only by understanding how they worked—how they were formal compositions negotiating specific social and political problems—that talk of change can be effective. If content simply to condemn their shortcomings, both the visual practice and the social order will continue to be relatively unintelligible—a machine we don't like much but can't fix.

That said, we have been distressed that images of the civil rights struggle don't seem to make it into the top tier of iconic images. There are many important photographs of that struggle, including those of schoolchildren being attacked by water cannon and of police dogs straining to attack a defenseless black man.[1] Nonetheless, the reproduction of the photographic legacy is hazy, with more substitution among photos than with Vietnam, for example. And the uptake is not the same, either: more and more generic pictures are mentioned, and with much less emphatic reference, while the stream of appropriations is weak at best. The case of the women's movement is even more vague, with only generic pictures of women marching to represent enormous changes in gender roles and the actual conditions of citizenship. In the first case, photography was extremely important to the success of the movement, yet the visual record is somewhat compromised despite the obviously visual salience of racial conflict. In the second case, it is obvious that at least one social movement could mobilize public support without leaving a visual legacy. The environmental movement offers an intermediate

case, for it has been advanced by effective use of photojournalism to document environmental degradation, and by persistent use of images of natural splendor to represent its political program (e.g., on each cover of the Sierra Club magazine), while it also benefits from the semi-iconic ascendancy of Ansel Adams's photographs and the images of earth seen from space.

This final chapter will draw on our study of iconic images to discuss the relationship between photojournalism and liberal democracy. Images both intensify and occlude experience, and iconic images provoke powerful moments of identification while also casting deep shadows within public memory. By reflecting on the icon, one can begin to see how a democratic society frames itself to maintain a public culture amidst conditions of social fragmentation, and how it forgets what lies outside the frame. At some point democracy is a way of seeing, and democratic self-reflection will be incomplete until ordinary citizens are able to discuss whether their habitual technologies and habits for viewing the world are helping them to sustain themselves as a public. This is not to disregard the importance of institutions, laws, or any other element of government and civil society. It does emphasize that all of these, like the world itself, are experienced and managed only as they are known and valued, which in turn depends in part on what we see.

THE LIMITS OF ICONIC MEMORY

All memory is limited, of course, and no medium of representation can avoid exclusion. One must search for each medium's distinctive blind spot and ask how that is related to its distinctive capacity for insight as well as what the costs might be of relying too much on what is shown. The first limitation of iconic memory is that it is necessarily mainstream. The icon is that which can inspire widespread identification, even when it is a disturbing image or one that supports political dissent. As we have shown, iconic images are shaped by norms of decorum and reinscribe social roles. There always are equally articulate images available for communicating civic virtue or dissent, national resolve or the horror of war, achievement or hubris, continuity or change. The icon emerges from the welter of images because it evokes the vital center of mainstream public culture. Iconic images capture both the central contradiction and the deepest commonality defining a polity. One result is that the icon necessarily loses experiences, ideas, and values that are equally important to the sustainability of the polity but evident only at the margins. Whether transgressive or utopian, the marginal image—or, the image of the marginal experience—is off to the side in the virtual space of the national cathedral.

This centering of the icon is not merely a matter of aggregating opinions to represent a majority. Everyone knows that sacrifice is noble, war is hell, democracy demands individual courage, and rockets can explode. The iconic image goes beyond as it seems to reveal a transcendental quality in ordinary experience. The religious metaphor in the label "icon" works because of how, by staring into the image, one senses a higher power unfolding and is lifted up into awe, reaffirmed in one's relationship to that power, and moved to act accordingly. For this to happen, the image must be at once easily recognizable and resonant with comprehensive patterns of meaning. One has to be able to see a poor woman as the embodiment of a broken social contract, or the man in front of the tank as the embodiment of a Cold War confrontation between freedom and the Communist state. Without such connections, there is neither political cognition nor rhetorical power. One also has to be able to place oneself in relationship with those in the picture, which happens most reliably by recurring to known social roles and habitual forms of personal agency. Without these, there is little capacity for action. Political identity obviously is much more than a calculation of interests, and it is these more symbolic linkages that become the basis for sacrificing any and perhaps all individuality.

One should ask whether the quasi-religious aspect of the secular icon is an impediment to public culture. The problem includes not just excluding other images but also establishing a model for image production that values mystification, continual reproduction of the same, and acutely emotional response, and that above all reduces historical experience into a powerful condensation symbol. The quasi-religious figure carries an aesthetic that is in some ways counter to the mission of photojournalism. The valuable and wholly secular image would be one that foregrounds actual conditions, that provides continually articulating documentation of the variety of social practices, and that encourages critical reflection and public deliberation across a wide range of experience. Social reform documentary is the obvious example, but one can see everyday journalism, despite its highly conventional character, as meeting this standard on a daily basis. Rather than asking who will take the next iconic photograph or relying on icons to recall important events and stock issues, perhaps the better practice would be to feature more articulated coverage such as the photo-essay and more varied use of the archive to illustrate retrospective commentary. It seems to us, however, that photo-essays in print media are on the decline as a genre of public address— if not in numbers, then in significance. Meanwhile, remediation as a Web genre has compressed the form into a strict sequence of images that restricts rejuxtaposition by the viewer. Likewise, the use of iconic images seems to be

a staple of digital memory, with the irony that enormous archives are now available yet covered by a few images that acquire ever wider circulation. The irony may not be avoidable: public memory becomes organized around a very few quasi-religious images as the exponential increases in information availability overwhelm individual processing capacity. A few dominant images can reflect either a scarcity of images or the reverse: an overabundance that has to be ignored if one is to function at all.

Continual circulation of the iconic images may involve a misplaced religiosity in another sense as well: iconic memory could become too ritualistic. Note that we said "too" ritualistic: we believe that democratic polity depends on civic performances to maintain commitment to democratic ideals and engaged citizenship. Hence, civic rituals should not be disparaged in principle. Ritualism, however, can be the death of citizenship just as it can be the death of faith. Should public commemoration become fixated on too few images, memory calcifies around these few events while great swaths of experience are lost. Historians always will have access to other media, but the ordinary citizen living in media space is left with the equivalent of an aboriginal calendar. By limiting the record to icons marking major events, and by the formulaic use of the icons over time, tribal memory becomes reduced to oral narratives that increasingly follow the cues on the visual artifact. The same is happening in public memory. As periods become reduced to wars that are reduced to a few images, the cultural narratives (e.g., on the History Channel), become increasingly formulaic. Stated otherwise, the more iconic images function to anchor experience and relay cultural narratives, the more the past will be ritualized. Although civic rituals activate the past in order to animate political ideals in the present, they also limit citizenship to the narrow confines of the medium of cultural memory. This is why images have been important supplements to print media, and also why images themselves need to be supplemented. The more icons are used to define the past, the more other images, oral histories, print documents, sound recordings, and other media are needed to keep the past alive.

THE VISUAL PUBLIC SPHERE

In the early days of the 2003 U.S. invasion of Iraq, *48 Hours* ran a story titled "Defining the War" in which the narrator noted that "the search is on for the one great image that will define the battle of Iraq."[2] The story may reflect wishful thinking among professional journalists, as if iconic images could be expected to arrive on schedule. Since icons are thought to be essential representations of historically significant events, and since the invasion

was thought to be such an event, it was sure to produce an iconic photo. The logic is confused, but the conclusion is that if there were no photo, it could hardly be an event worth remembering. It is easy to lampoon this story, but that would be to make too much of what was a discussion among professionals about their art.[3] What is more interesting is the manner in which it came close to being true. As the invasion quickly turned into conquest and then occupation, press reports promoted a succession of photos as icons of the war: a soldier holding an Iraqi child, the toppling of the statue of Saddam Hussein in central Baghdad, coffins draped with American flags, and a helmeted, begrimed U.S. soldier with a cigarette hanging from his lips. Each quickly passed from the scene. Then, in the early summer of 2004, a number of photographs appeared that stunned the world: a female soldier pointing mockingly at nude male prisoners' genitalia and leading another nude prisoner around on a leash, and perhaps most distinctively, a prisoner draped in a black cowl standing on a box, his arms outstretched as if on a cross, while electrical wires snaked away from his limbs. It's too soon to say whether these images will become iconic, but they sure had a good start. (It may be that they already have achieved iconic status and circulation outside the United States.)

In any case, they demonstrated important features that iconic images share with photojournalism more generally. Although the photos certainly were news for many viewers, most of the key information had already been published in newspapers throughout the United States. One can look back and see that attentive readers could have known that the Red Cross, the U.S. military, Amnesty International, and other organizations had already documented and criticized treatment of prisoners in Abu Ghraib and elsewhere. Those reports identified specific forms of mistreatment that clearly constituted torture. Likewise, administration documents sanctioning those techniques had been criticized. On the other side, a number of pundits had gone on record endorsing torture in the war against terror, and a feature story in the *Atlantic Monthly* had commended specific cases of U.S. use of "interrogation."[4] Most citizens apparently were not doing their reading, and many still believed that their government had clean hands, that U.S. forces were engaged in disciplined combat against a few barbarian infiltrators, and so forth. The photographs, however, showed what had been said but not seen in print. They became a primitive theater of cruelty, a performance in the public space that revealed a shocking truth and called official lies into question. They galvanized a public audience, evoked strong emotional reactions, and quickly were disseminated further through editorial cartoons, Web sites, and other media. They also provoked intense debate and the release

of incriminating government documents.[5] They were followed by the typical backlash that advances partisan reactions under the guise of a critique of visual rhetoric: supposedly serious commentators intoned that the photos were only partial records of isolated events, that the images and the media more generally didn't show the good things that were happening, and that the result was an emotional overreaction that could unfairly bias considerations of policy.

This story reveals that public discourse functions in an intermediate zone between two modernist illusions: one, that history will produce its essential, transparent representation that can be evident to all in a glance; the other, that public judgment needs to be disciplined against inherently unrepresentative and irrational media. The Abu Ghraib photos were neither transparent nor irrational. They were subject to norms of decorousness (e.g., through blurring and cropping) that at times protected the administration, they were more representative than many wished to admit, and they pushed the United States back into a framework of critical reason that had been dismissed as the crabbing of "Old Europe." Their shock value may fade, but at the time they demonstrated the importance of visual representation to the public sphere.

Rather than fault such images for characteristics shared with all other public media, one should appreciate their value as texts. That value comes not so much from the photographs themselves but from their contrast with the habits of reading that governed the reception of the earlier reports on the abuse. In fact, we believe that the photos reoriented readers to apprehend what was always there in the written reports. The list of approved interrogation techniques makes for disturbing reading—once one is reading with compassion rather than scanning bureaucratically. For another example, the terrible effects of sleep deprivation cannot easily be shown, and the Abu Ghraib photographs did not claim to show such effects, yet descriptions and condemnations of sleep deprivation were one consequence of their publication. Strong images can activate strong reading.

The photographs also were rich in social, cultural, and political detail: American military fashions and Old West slapstick; those overweight, privately contracted torturers wearing thin rubber gloves as they arranged naked prisoners like kindling at a barbeque or a lynching; regular army personnel walking around the pile of prisoners in the prison corridor as if it happened routinely every day; these and other images like them made it clear that the individuals involved were the end result not just of a chain of command, but of deeply set legacies of American culture that could be by turns benign or evil. Apologists were correct that the torturers did not represent the intentions or the character of the American people, but the fanatics who

drove the planes into the World Trade Center did not represent the Arab peoples. In each case, however, one can see social facts, cultural tendencies, and a historically specific capacity for cruelty. One also can see the perverse side of a society through its inadvertent projection of itself upon the other. Think of that pathetic figure in the dark cowl, a body transcribed by his captors. The Ku Klux Klan hood is taken off the persecutor and placed on the body to be lynched.[6] Christians convert a Muslim into Christ and so make themselves into Roman soldiers, yet they see no irony and no evil. The torture of the cross is updated for modern times: no wooden beam is necessary when electrodes are attached to the abject body. In the space of the imperial prison, the Klan can breathe freely as they take off their medieval hoods, which were already a strange identification with their supposed oppressor, and yet still use them as a form of terror. The overlapping identities are right out of Jean Genet's play *The Balcony*, where officials played their sadomasochistic games in a brothel while the real revolution escalated outside.

The analogy with Genet's theater within a theater goes deeper still, for the photos were taken as part of the soldiers' home-brew pornography. Free play after hours within an off-limits, authoritarian enclave, captured by amateurs using democratically accessible digital imaging technologies, the photos were scenes in a primitive theater for the troops' enjoyment. Thus, just as the acts themselves were a sick parody of American power, the use of the technology of dissemination became a perverse form of reflection. Dissemination can't be controlled, however, and as the images migrated from private showings to Internet circulation their double perversity acquired new value. With the unintended audience, they revealed a pornography of violence at the heart of the occupation. Instead of invoking secret pleasures, they provoked deliberation over policy and calls for greater transparency in government operations. Amateurs inadvertently did the professional photographer's job. In addition, they demonstrated the value of emerging dynamics of image circulation. Although progressive journalism on the Web can be safely ignored by the print media, the images circulating there eventually have to be shown if those media are to hold on to their legitimacy and their audience. Few readers or TV viewers will search for alternative news stories, but photographs appeal to the voyeur in all of us while their suppression seems to be a blatant form of censorship of the real. As the images of Abu Ghraib circulated on the Internet and from there pulled readers to international news sources, the major U.S. papers had to follow suit. Other censored images, such as those of flag-draped coffins, have followed similar patterns of distribution that demonstrate the extent to which the major media ignore alternative sources of photojournalism at their peril. News media confirm, alter, and enhance

an old truth: public culture is a visual culture. It should not be surprising that the struggle over the meaning of the Iraq war is being waged in part as a competition between images.[7] Instead of supposing that the public sphere is only incidentally or unfortunately entangled with visual practices, images and their circulation are important means for the formation of public opinion and public agency.

The literate public sphere depended on a set of assumptions about literacy, literary culture, the benefits of reading, and how those practices coincided with the public use of reason. Similar assumptions need to be developed regarding the role of visual practices. The first step is to take a deep breath and calm down every time elite commentary has another hysterical reaction to a visual tour de force. As this book was being prepared, both conservative and liberal pundits were having seizures about Michael Moore's film *Fahrenheit 9/11*. The liberals were the most embarrassing; conservatives at least had the excuse of partisanship.[8] Thoughtful punditry may be too much to expect, but somewhere there needs to be a careful examination of elite bias on behalf of the medium of print and against visual media.

The shift in academic discussion from literacy to visual literacy was another demonstration of the persistence of modernist assumptions about radical differences between media. Debate became centered on the question of whether visual media contained a semiotic code wholly different from verbal texts. Promoters of visual culture and defenders of old school literacy could agree that images and texts were separate worlds, each locked into a grammar that could not be translated into the other medium. More sophisticated formulations have finessed the issue, but considerable energy still goes into either promoting or warning against visual media, rather than understanding how they are tangled together to create culture.[9]

The origin of rhetoric as a practice of reflection is instructive in this regard. From the first, the art provoked intense discussion regarding its cognitive, moral, and political effects.[10] Critics of this new medium were largely categorical and censorious and often eloquent, yet the art flourished and produced profound changes in Western culture. It is no coincidence that the art emerged during a period of decisive change in communication technology. Ostensibly an analysis of the art of public speaking, rhetoric emerged when writing was becoming an important medium of intellectual exchange.[11] The anatomy of oratorical techniques was the articulation neither of speech nor of writing alone but of their codevelopment in a particular historical moment. You might say that rhetoric was speaking as it came to be seen through the lens of writing. Not surprisingly, the techniques of spoken message construction proved to work equally well for the analysis of written speeches and

then for other genres of writing, while the art of persuasive speech spread across time and cultures via written transmission.

Today, one can do much the same with visual and textual sensibilities: instead of parsing them into zones of mutual incomprehensibility, the challenge is to see how they are already thoroughly enmeshed in one another while also prompting potentially salient differences in response in any particular case. W. J. T. Mitchell opened the door to this world where "The interaction of pictures and text is constitutive of representation as such: all media are mixed media, and all representations are heterogeneous; there are no 'purely' visual or verbal arts, though the impulse to purify media is one of the central utopian gestures of modernism."[12] Although it still makes sense to distinguish texts from images, it is important to consider how meaning depends on a process of translation through multiple codes, no one of which need be foundational. The burgeoning scholarship in visual culture demonstrates how rhetoric, semiotics, ideology critique, psychoanalysis, and other critical vocabularies can be used to unpack visual images that in turn can function as mirrors for refracting the many discourses around them.[13] In addition, attention has to be paid to how visual arts are remediated in varied combinations within new media.[14] The current transition from old to new media provides a metaphor for this conception of visual culture: Digital technologies make images and texts (and sounds) equally fungible.

Thus, the visual public sphere is not uniquely or primarily visual. One is seeing public address as it always has been articulated, but from beyond the horizon imposed by print technologies. Public culture is a vast intertext of mixed media. Each medium can be dominant at any one time, and each offers a perspective on the others capable of both blindness and insight. The culture itself can be only seen to the extent allowed by the medium that one is examining. Our focus on iconic photographs offers one take on public culture, but not the only one. By "close reading" of the images and tracking a range of appropriations, we have developed arguments that apply there but not only there. Rather than posit a uniquely visual dimension of public life, one that could not be translated into print media without loss, we have considered how a set of images do the complex work of public address and how the visual genre exemplifies properties of public life that might be overlooked when reading.

Understanding visual literacy does not require a new critical vocabulary, but it does lead to a richer conception of public opinion. In the visual public sphere, there need not be a harsh divide between critical reason and spectatorship; indeed, that divide, although it can exist in specific historical moments, is itself an ideological framework derived from the transition from

monarchial power to the bourgeois political order. Looking back one can assume that the use of spectacle is equivalent to the representation of the sovereign before the people, and conclude that spectacle and public use of reason are features of different worlds. If one looks around, however, much more is going on as well. The people are looking not just upwards, but at each other, at fine and popular arts, at entertainment and advertising, and more. These many forms of representation create not a common apparatus of manipulation but rather a curious blend of naiveté and sophistication. People become adept at recognizing a wide array of genres and appeals and at shifting unconsciously between semiotic codes; at the same time, most retain an assumption of transparency when immersed within their preferred medium. The fact that photojournalism is assumed to be transparent is one measure of its acceptance as a medium of public opinion. The fact that photojournalism represents so much of the ordinary world is one index of how far spectatorship has come from monarchial representation. We won't say it demonstrates that the people are sovereign, but its ubiquity in the public media and its democratic content provide formal enactment of that principle. Photojournalism often does serve establishment interests, but it doesn't do so by virtue of being spectacular.

Instead of contrasting reason and visual representation, we need to ask what reason is within a visual culture. The question imitates Benjamin's famous inversion within the debate about the relationship between photography and art: "Earlier much futile thought had been devoted to the question of whether photography is an art. The primary question—whether the very invention of photography had not transformed the entire nature of art—was not raised."[15] Our conclusions regarding iconic photographs cannot cover all of photojournalism, but we are positive that the entire medium is laden with complex negotiations of multiple social codes, political ideas, practical reasoning, and emotional intelligence. The public use of reason within a visual culture may retain many of the features of the Enlightenment ideal, including skeptical assessment of claims to know and logical argument addressed to a universal (i.e., socially neutral) audience.[16] Likewise, it cautions against the disruption of these processes by ignorance, prejudice, and other vices of thought. Nonetheless, reasoning acquires a distinctively interactive and transcriptive character represented in public sphere theory by the idealized, virtual image of conversation in a coffee shop. Visual reason has to coordinate interpretation of the texts in the public media with the photos there and also with the myriad of other images referred to or otherwise impinging on any verbal report. If the photographs merely illustrated the text, this would not be much of a change, and sometimes that will be all that is happening.

Once the image is seen without subordination within the print framework, however, a different order of cognition emerges. Image can displace text, image can caption text, text can caption image, a composite representation may emerge that then alters any image or text by itself, and so on. More important, reasoning now has to negotiate more directly with intuition, for intuitive reactions are activated, directed, and represented by the verbally mute image. In the terms of classical rhetoric, photojournalism operates as an enthymematic process by which the audience supplies social knowledge and shared values to complete a speaker's argument.[17] The same process also allows the audience to resist an argument as it is being advanced verbally. The categorization, abstraction, syntactical sophistication, and other characteristics of verbal media also can double as means for misrepresentation, as becomes painfully evident when observing how democratic governments maintain support while mismanaging social problems and waging unnecessary wars.[18]

Just as verbal reason emerges in part through attentiveness to distortion, visual reason carries its own set of caveats. Many of these follow directly from verbal rhetoric. For example, iconic photographs vary in part by being either more epideictic than deliberative or the reverse. The raising of Old Glory on Iwo Jima is a moment of praise for national character, while the napalm girl confronts a national policy. Each in turn has acquired a standing critique as the one is said to be exclusionary and idealized, and the other unrepresentative and manipulative. These may be seen as verbal standards, but they work seamlessly when applied to some images.

Visual reason may function as well not only by avoiding fallacies but by disrupting mistaken assumptions. One can't say for sure, but we believe the difficulty in sticking with the "clash of civilizations" thesis following 9/11 was that the photographs of New York were so deeply multicultural.[19] The polarization, abstraction, and false generalization of that thesis was contradicted by the images from a central scene of Western civilization; skepticism regarding the claims about the other side follows a fortiori. Images, because they are both richly articulated and verbally mute, can stop the unreflective train of thought. Of course, they also can reestablish hegemony. As the New York street scenes came to be replaced by official photo opportunities and local reaction shots in Midwestern newspapers, a more homogenized, simplistic, and polarized view of the world returned. At their best, however, images provide resources for checking arguments—that is, to stop them for study and for empirical validation. Reason then becomes doubly interactive: one has to move between verbal and visual modalities and consider both the norms of critical reason and the people in the photograph. One even at times

is brought to address one's arguments to that audience; not a universal audience of all reasonable people, but a historically specific audience capable of demanding an experientially accurate form of public reason.

This shift to visually situated meaning leads directly to the kink in public culture that results from social embodiment of impersonal categories, as we discussed earlier. One can work outwards from that problem to a more comprehensive phenomenology of the visual public sphere. We have suggested that Michael Warner's discussion of circulation, uptake, and stranger relationality provides key categories for that project.[20] Likewise, dialectical themes such as liberalism/democracy, consensus/dissent, good war/bad war, and progress/risk are persistently being reproduced and negotiated. These and similar properties of public culture are continually articulating through the stream of words, images, and sounds in the public media. By focusing primarily on any one of these modalities, a different understanding of public opinion can be developed. (The attempt to start with sound remains a uniquely demanding and promising challenge, and one that would echo the lost work of the rhetorician Gorgias.) The key initial difference in each case is determined by the relationship between the mode and the object of consciousness. In the visual public sphere, publics cohere through a common spectatorship, the image becomes the focal object of public thought, and public opinion forms by association.

The alignment of spectacle with the political subject rather than citizen is a strong one, and for good reason. Grounded in political history, it reoccurs every time the public gets drawn to a major media event such as the Super Bowl or the outbreak of a war. Even so, imagine a public where each citizen is turning away from the others. The closest equivalent is private reading, which is indeed crucial for bourgeois public culture but by itself insufficient for a robust conception of public opinion. Public opinion left to reading alone would have neither public character nor political influence. So it is that the public depends on representations of citizens conversing, convening, celebrating, and demonstrating. No one believes that the twelve citizens holding placards outside the county administrative building are a political force, but the nightly news coverage would ignore them at the risk of its own legitimacy.

Such representative moments are the least of it, however. Public spectatorship is exercised primarily through the experience of looking at images of a public world of actors, action, and events. Here the iconic image is illustrative. Condensed into a single image are representative actors, models for civic action, and definitions of history. More important, the images are performative: imitations of civic life that call for action on behalf of the community.

That action may do no more than promote continuity, and much photojournalism is unexceptional for that reason. It is richly coded, nonetheless. Even the sappy human interest shot is a call for sophisticated social attitudes: for example, maintaining rule of law while also recognizing human frailty, celebrating childhood while schooling adults in the tasks of nurturing development, laughing at esoteric advocacy while accepting eccentricity, maintaining civility while recognizing difference, and so forth. Spectatorship as it is exercised through photojournalism is deeply political. The play of partisanship and ideology are part of that, and these articulations can be completely determinative of response in particular cases, but they work at all because of the more basic political orientation of the visual practice itself. Any public is an imaginary community, and the imagination creates public identity when one can seem to see a world in common with others and be placed in meaningful, moral relation to that world by the act of seeing.

What is seen? Our approach has put great emphasis on the content of the individual photograph. We should caution against too much of this. Public spectatorship depends primarily on the continual production and circulation of images. One image repeated constantly is a totalitarian technique, and the proliferation of signs in postmodern cultures is rightly feared by defenders of authoritarian rule. Likewise, fetishistic celebration of single images by ordinary individuals, such as when the Iwo Jima flag raising is tattooed on a man's back, probably is more a measure of powerlessness than of a robust public culture. Democratic public culture now depends on a stream of images in the public media, just as before it depended on the reproduction of public spaces and statuary. (In the new South Africa, the Afrikaner statues have been left standing, while television programming is a rainbow of colors and accents. The statues have become inadvertent monuments to both inclusion and the obsolescence of their medium.) Thus, liberal-democratic spectatorship is not only imaginary but also defined by the variability of its objects. Despite the conventionality of the content of most images, the deeper convention is the continual production of the new. The act of public seeing is inherently modern and modernizing. The intelligence that results is in turn inherently flickering, variable, modulated, and ultimately composite. Even the icons become composite images: of the several versions of themselves, of the other photos surrounding the event, of the other images of the historical era, and so on. The single image still can loom large, and analysis of its overlapping patterns is crucial to understanding both what is there and what processes of composition are being activated to reweave larger complexes of meaning. Icons may emerge as a source of stabilization within the otherwise comprehensive disposability of images. Just as the welter of public discourse

becomes organized by focal terms such as "freedom," the continual succession of photographs becomes anchored by focal images.[21] Ironically, however, even the icon disappears, becoming a palimpsest of multiple images, the copies that are not One.

Such is the inevitable result of phenomenological study: the perpetual retreat of the object. This dialectic between the focal object of consciousness and its dissolution into the network of meaning should not be mystified. It is inevitable because of the social basis of all meaning. Photographs capture moments of social interaction while situating viewers in social relationships. Public reason emerges as a practice of looking at and thinking about these images, and as a considered negotiation of the relationships in question. Does one accept or reject the little girl running toward you, the soldiers walking behind her, the state they represent? How does one's identity as a parent now inflect one's identity as a citizen? How does the knowledge that officials and other citizens are seeing the same image affect one's relationship with them? All of these considerations both depend on and can alter political arguments, while they are not the same thing as deliberative rationality.

The visual public sphere activates public identity as a web of associations rather than as a structure of arguments. Arguments are not erased, but they have to work through social networks. The emotional salience of images is crucial here, for emotions represent, activate, and organize much of the content of social and political association. Those relationships include but are not limited to the discourses of public policy and the norms of deliberation. Any public has to form opinions that can be defended as rational, but the seeing public is one that has to do so in constant association with others. One sees who is being discussed, and the act of seeing them activates one's own sense of social awareness. Critical reason is intertwined with social reflection. Images become mirrors, arguments are set in a context of social knowledge, and conclusions have to fit with or motivate adjustment of one's own relationships with others.

PHOTOJOURNALISM AND LIBERAL DEMOCRACY

Walter Benjamin concluded "The Work of Art in the Age of Mechanical Reproduction" with the remark that "mankind, which in Homer's time was an object of contemplation for the Olympian gods, now is one for itself. Its self-alienation has reached such a degree that it can experience its own destruction as an aesthetic pleasure of the first order. This is the situation of politics which Fascism is rendering aesthetic. Communism responds by politicizing art."[22] Unfortunately, what was a brilliant insight at the time has also been

misleading subsequently. Benjamin is used to reproduce the conventional wisdom that liberal-democratic politics are inherently not aesthetic and that any intersection of political motives and aesthetic practice is inherently threatening to civil society. These ideas lead otherwise sophisticated people to misunderstand their own civic culture. It leads as well to ingrained habits of dismissal and inattention regarding public arts and the study of rhetoric, coupled with a continual posting of false alarms about this movie or that spectacle. Benjamin's warning should not be forgotten and it should be applied as a means for making the familiar strange. The coverage of the *Challenger* explosion may indeed exemplify a society that "can experience its own destruction as an aesthetic pleasure of the first order." That does not cast NASA or Ronald Reagan as fascists. The question is not what is to be gained by keeping Benjamin before us, but what is lost by being too comfortable with his conclusion.

What is lost is an important vantage for understanding liberal democracies. Instead of assuming that polity does not depend on aesthetic practices, one needs to see how both liberalism and democracy are inescapably and rightly tangled up in arts, artistry, and aesthetic norms. Photojournalism is one such practice, and iconic photographs comprise a gallery that can help one understand liberal-democratic public culture. It is interesting to note in this regard that the shift from press illustration to photojournalism may have heralded "the loss of the republican ethos of citizenship."[23] Whatever the problems in affixing any label to a period of political history, it certainly is fair to say that the public culture of the nineteenth century was more civic republican than liberal and that the reverse is true today. What has not been adequately understood is how each version of U.S. public culture has relied on specific forms of visual journalism.

By examining this relationship, one can see not only the nuances of this or that image but also how public life is a way of seeing. This optic has developed historically and so carries both older and more recent technological and political skills. It probably has to be learned, but it is learned so early that it seems completely natural. This public optic sees a world of historically specific figures, people who act in or are acted upon by history. It sees a world of strangers who need not be threatening. It sees a layered world, one of overlapping codes, from the simple adornment of ordinary people with patriotic regalia on the Fourth of July to the complex geopolitical transcriptions of a man standing before a tank at Tiananmen Square. It sees a world of emotional scenarios, where politics is articulated through both staged scenes of political friendship and the spontaneous laughter, tears, and outrage of citizens reacting to political decisions. As it sees through a liberal lens, it sees indi-

viduals who are always the measure of political legitimacy; as it sees through a democratic lens, it sees people united together in a common cause.

As it is a mode of *seeing*, public culture is defined by ongoing variation of objects and perspectives. Thus, the outline of civil society is reproduced through the practice of photojournalism. Over time one sees a myriad of separate things in a common frame that is neither private nor defined by the state. An intensively *public* orientation emerges out of a range of conventions that include displaying officials, representing ordinary people, and iconic representations of citizenship. Thus, photojournalism inculcates a way of seeing that recognizes and reproduces the constitutional relationships of the public sphere.

To understand this optic, there is need for another element of Benjamin's critique. The circulation of images is indeed a fundamental characteristic of modern civilization, as is the remediation of the form and contents of earlier media in their successor technologies. Circulation is the common denominator of the two most distinctive institutions of modern society: markets and publics. The circulation of images is one basis for the formation of contemporary publics. More to the point, it is because photojournalism is an art of "mechanical reproduction" that it is so well suited to public culture. Iconic photographs provide test cases for understanding circulation. Our study has identified how circulation extends well beyond the "broadcasting" that often is thought to be the essential feature of the public media. Each icon reveals particular instances of complex patterns of appropriation whereby images are taken from the mass media into many smaller circuits of private consumption, social display, retail distribution, subcultural articulation, political advocacy, and so forth, and back again into other public arts and media such as cartoons and books, and then again reproduced in major media retrospectives, celebrations, and other performances. Throughout this process the images are continually subject to alteration, repositioning, and other forms of translation that reflect varied social settings, alternative media technologies, and above all, an ongoing dialectic of the individual and the collective. Photojournalism continually reconnects the liberal individual and the democratic public.

We also have emphasized that this is not an inherently balanced process. It already is evident that the twenty-first century will be a study in whether liberalism will side ultimately with democracy or more authoritarian systems, and whether democratization will expand globally only to produce theocratic versions of fascism. These are not problems that can be solved by photojournalism, but it will play a part in what happens. If a vibrant, liberal-democratic public culture is to prevail in any nation or in a global civil soci-

303

ety, that accomplishment will depend in part on how public opinion is supported, negotiated, and guided by public arts. If liberal-democratic societies are to evolve into better versions of themselves, they will have to be able to see themselves doing so. Photojournalism will be one means by which public culture is refigured to address the challenges a society faces: how it is that the society can become more inclusive, more civil, more capable of nurturing good judgment and responsible government without having to abandon democratic citizenship.

Iconic photographs should be judged by this standard. As images circulate or drop out of sight, and as new images emerge, public identity and the quality of political judgment will be at issue. Every photograph suggests a world that extends far outside the pictorial frame. Any photo, and particularly those photos that are valued by a group, can reflect the conditions of possibility for those living in such a world. As images change, the public becomes refigured. The result might be more accessible or more thoughtful forms of citizenship, or it could indeed be the displacement of citizenship entirely.

We began this project with the assumption that photojournalism was a dying art soon to be replaced by new practices of representation in the digital media environment. Add to that our assumption that photojournalism underwrote liberal democracy, and the conclusion would be that one version of liberal democracy would also change and perhaps disappear as the new media environment became ubiquitous. There they would lie together in the archive: a public art and a historically specific form of democratic polity. That may still happen, but obviously the story is more complicated. The beginning of the twenty-first century has been a renaissance for photojournalism, one driven by events (principally 9/11) and, more significantly, by the addition of digital media. The proliferation of images might be merely a transitional phenomenon, and both the practice and the credibility of photojournalism have been altered by digitalization, but these have been good years for the art. News organizations are distributing more images to audiences who seem to be increasingly attuned to visual representation. The circulation of images on the World Wide Web can drive public response to events and mediate public debate at a radically accelerated pace. Image appropriation has become radically democratized and so a more common form of individual expression about public events and public address. Not surprisingly, the transformation carries forward the dialectic of liberalism and democracy. Democracy is alive and well—on your desktop computer.

The good news is that the dreaded political spectacle is broken up, fenced in, or otherwise democratically interdicted by digital media. Even if an icon

became the leading image of a propaganda campaign, it would at the same time be pulled through circuits of appropriation that quickly distort and criticize its intended effect. The bad news is that the economics of an information-intensive environment are likely to produce more reproductions of fewer images according to the same market logic that is evident across the rest of the capitalist economy.

The search for the next icon is more than a preoccupation of photographers hoping to make their name. The images to come present the public audience with an opportunity to reimagine itself. The public culture that coheres around the next set of iconic images can be a rich articulation of art and argument, or it can be a dumb show of good feelings unconnected to action. It can be an engaged encounter with the problems testing modern society, or it can be a staged performance of civic virtues unconnected to policy. Not least, it can draw upon and enhance the richness of the subcultures constituting a democratic polity, or it can represent the few at the expense of the many.

The iconic image is a representative case in the relationship between visual media and the democratic project. Yet, as the black sailor should remind us, no image and no interpretation can speak for all viewers, and much remains to be shown and said and done if public life is to be capable of real beauty. The best pictures have yet to be taken.

NOTES

CHAPTER ONE

1 John Tagg, "Evidence, Truth and Order: Photographic Records and the Growth of the State," in *The Burden of Representation: Essays on Photographies and Histories* (Amherst: University of Massachusetts Press, 1988), 63–64; John Hartley, "The Triumph of the Still," in *Popular Reality: Journalism, Modernity, and Popular Culture* (London: Arnold, 1996), 196–231.

2 Among professionals the photograph is presumed to be an artistically crafted yet transparent window on reality. The tension between "art" and "objectivity" as the dual goals of photojournalism is identified in the National Press Photographers Association Code of Ethics, available at http://www.nppa.org/professional_development/business_practices/ethics. See also Dona Schwartz, "Objective Representation: Photographs as Facts," in *Picturing the Past: Media, History, and Photography*, ed. Bonnie Brennen and Hanno Hardt (Urbana: University of Illinois Press, 1999), 158–81; and Julianne H. Newton, *The Burden of Visual Truth: The Role of Photojournalism in Mediating Reality* (Mahwah, NJ: Lawrence Erlbaum, 2001); cf. Brian Horton, *Associated Press Guide to Photojournalism*, 2nd ed. (New York: McGraw Hill, 2001).

3 We should acknowledge that the undemocratic alternatives are not irrational, and we leave discussion of their merits to political theory. The more fundamental question for our project is that of the relationship between critical reason and representation. This battle between "rhetoric" and "philosophy" is as old as the debates between Plato and the Sophists and is replayed in numerous settings today. See, for example,

Samuel Ijsseling, *Rhetoric and Philosophy in Conflict: An Historical Survey* (The Hague: Martinus Nijhoff, 1976).

4 W. J. T. Mitchell labeled this shift the "pictorial turn," in *Picture Theory: Essays on Verbal and Visual Representation* (Chicago: University of Chicago Press, 1994), 9–34. The study of visual culture and visual rhetoric(s) has become a veritable growth industry since the mid-1990s, with hundreds of books and many more journal articles, as well as new scholarly journals such as *Visual Communication*, the *Journal of Visual Culture*, and *Invisible Culture: An Electronic Journal for Visual Culture*, available at http://www.rochester.edu/in_visible_culture/ivchome.html, and numerous academic conferences. A comprehensive bibliography of such works would be impossible to reproduce here. Recent reviews of work in communication studies include Michael Griffin, "Camera as Witness, Image as Sign: The Study of Visual Communication in Communication Research," in *Communication Yearbook 24*, ed. William B. Gudykunst (Thousand Oaks, CA: Sage, 2001), 433–63; and Kevin G. Barnhurst, Michael Vari, and Igor Rodriguez, "Mapping Visual Studies in Communication," *Journal of Communication* 54 (2004): 616–44. Introductory texts include Nicholas Mirzoeff, *An Introduction to Visual Culture* (London: Routledge, 1999); Marita Sturken and Lisa Cartwright, *Practices of Looking: An Introduction to Visual Culture* (Oxford: Oxford University Press, 2001); James Elkins, *Visual Studies: A Skeptical Introduction* (New York: Routledge, 2003); and Tony Schirato and Jen Webb, *Understanding the Visual* (London: Sage, 2004). Useful readers include Jessica Evans and Stuart Hall, eds., *Visual Culture: The Reader* (Thousand Oaks, CA: Sage, 1999); Nicholas Mirzoeff, ed., *The Visual Culture Reader*, 2nd ed. (London: Routledge, 2002); Chris Jenks, ed., *Visual Culture* (New York: Routledge, 1995); and Norma Bryson, Michael Ann Holly, and Keith Moxey, eds., *Visual Culture: Images and Interpretations* (Hanover, NH: Wesleyan University Press, 1994). See also Fiona Carson and Claire Pajaczkowska, eds., *Feminist Visual Culture* (New York: Routledge, 2001); and Charles A. Hill and Marguerite Helmers, eds., *Defining Visual Rhetorics* (Mahwah, NJ: Lawrence Erlbaum, 2004).

5 See David Freedberg, *The Power of the Image: Studies in the History and Theory of Response* (Chicago: University of Chicago Press, 1989).

6 See Sander Gilman, *Picturing Health and Illness: Images of Identity and Difference* (Baltimore: Johns Hopkins University Press, 1995); Lisa Cartwright, *Screening the Body: Tracing Medicine's Visual Culture* (Minneapolis: University of Minnesota Press, 1995); Karen Newman, *Fetal Positions: Individualism, Science, and Vision* (Palo Alto, CA: Stanford University Press, 1996); *Picturing Knowledge: Historical and Philosophical Problems Concerning the Use of Art in Science*, ed. Brian S. Baigre (Toronto: University of Toronto Press, 1996).

7 Richard Sennett, *The Conscience of the Eye: The Design and Social Life of Cities* (New York: Alfred Knopf, 1990); Wendy Kozol, *Life's America* (Philadelphia: Temple University Press, 1994); John Dorst, *Looking West* (Philadelphia: University of Pennsylvania Press, 1999); Laura Wexler, *Tender Violence: Domestic Visions in an Age of U.S. Imperialism* (Chapel Hill: University of North Carolina Press, 2000); *National Imaginaries, American Identities: The Cultural Work of American Iconography*, ed. Larry J. Reynolds and Gordon Hutner (Princeton: Princeton University Press, 2000); and Gary M. Pfitzer, *Picturing the Past: Illustrated Histories of the American Imagination, 1840-1900* (Washington, DC: Smithsonian Institution Press, 2002). See also Walter Benjamin, *The Arcades Project*, trans. Howard Eiland and Kevin McLaughin (Cambridge: Belknap, 1999); and Susan

Buck-Morss, *The Dialectic of Seeing: Walter Benjamin and the Arcades Project* (Cambridge: MIT Press, 1990).

8 See Catherine A. Lutz and Jane L. Collins, *Reading National Geographic* (Chicago: University of Chicago Press, 1993); Nicholas Mirzoeff, ed., *Diaspora and Visual Culture: Representing Africans and Jews* (New York: Routledge, 2000); Shawn Michelle Smith, *American Archives: Gender, Race, and Class in Visual Culture* (Princeton: Princeton University Press, 1999), and *Photography on the Color Line: W. E. B. DuBois, Race, and Visual Culture* (Durham: Duke University Press, 2004); John Ibson, *Picturing Men: A Century of Male Relationships in Everyday American Photography* (Washington, DC: Smithsonian Institution Press, 2002); and Marianne Hirsch, *Family Frames: Photography, Narrative, and Postmemory* (Cambridge: Harvard University Press, 1997). For a discussion of the relationship between visual culture and identity inflected through the lens of psychoanalysis, see Victor Burgin, *In / Different Spaces: Place and Memory in Visual Culture* (Berkeley: University of California Press, 1997).

9 See Maren Stange, *Symbols of Ideal Life: Social Documentary Photography in America, 1890-1950* (New York: Cambridge University Press, 1989); Cara A. Finnegan, *Picturing Poverty: Print Culture and FSA Photographs* (Washington, DC: Smithsonian Institution Press, 2003); and Kevin DeLuca, *Image Politics: The New Rhetoric of Environmental Activism* (New York: Guilford, 1999).

10 It now would be myopic to study twentieth-century critical and social theory without engaging the role of the visual in consideration of questions of power, subjectivity, and spectatorship in the works of Roland Barthes, Michel Foucault, Luce Irigaray, and Jacques Lacan, among others. The major work is Martin Jay, *Downcast Eyes: The Denigration of Vision in Twentieth-Century French Thought* (Berkeley: University of California Press, 1993). For a brief survey, see Patrick Fuery and Kelli Fuery, *Visual Cultures and Critical Theory* (New York: Arnold, 2003). See also David Michael Levin, ed., *Sites of Vision: The Discursive Construction of Sight in the History of Philosophy* (Cambridge: MIT Press, 1997); and Gary Shapiro, *Archaeologies of Vision: Foucault and Nietzsche on Seeing and Saying* (Chicago: University of Chicago Press, 1993). The inherent connection between changing conceptions and practices of visual perception and the development of modernity is developed productively by Jonathon Crary, *Techniques of the Observer: On Vision and Modernity in the Nineteenth Century* (Cambridge: MIT Press, 1990) and *Suspension of Perception: Attention, Spectacle, and Modern Culture* (Cambridge: MIT Press, 1999). See also David Michael Levin, ed., *Modernity and the Hegemony of Vision* (Berkeley: University of California Press, 1993); and Dudley Andrew, ed., *The Image in Dispute: Art and Cinema in the Age of Photography* (Austin: University of Texas Press, 1997).

11 One could argue endlessly—and no doubt productively—about how many photographs fit within this set, but there should be little question that it is a relatively finite set of images. We have reviewed thousands of books, Web sites, museum shows, and related media regarding visual history and the history of photojournalism. Our selection, driven by the criteria we develop in chapter 2, is reinforced by the fact that these images are among those that are most consistently reproduced in such collections. So, for example, while some might occasionally reproduce other well-known images of the 1930s depression such as Arthur Rothstein's "Fleeing a Dust Storm" or Walker Evan's portraits of the Burroughs family, it is Dorothea Lange's "Migrant Mother" that is commonly reproduced as the visual marker of that era. And while photographs of the bombing at Pearl Harbor and of General

Eisenhower inspecting the troops prior to D-Day are frequently reproduced images from World War II, it is Joe Rosenthal's photograph of the flag raising on Iwo Jima that is reproduced consistently as the distinctive visual image of the war. Representative collections include Vicki Goldberg, *The Power of Photography: How Photographs Changed Our Lives* (New York: Abbeville Press, 1991); Marie-Monique Robin, *The Photos of the Century: 100 Historic Moments* (Hohenzollernring: Evergreen, 1999); *Photos That Changed the World: The 20th Century*, ed. Peter Stepan (Munich: Prestel, 2000); and numerous volumes produced by Time Life Inc., including *Eyewitness: 150 Years of Photojournalism*, ed. Richard Lacayo and George Russell (New York: Time Books, 1995); *The Way We Were: Decades of the Twentieth Century*, ed. Killian Jordan (New York: Time, 1999); *Life: 100 Photographs That Changed the World*, ed. Robert Sullivan (New York: Time, 2003); *Life: Great Pictures of the Twentieth Century . . . and the Stories behind Them*, collector's edition (October 1999); *Life: Our Century in Pictures*, ed. Richard B. Stolley (Boston: Bullfinch Press, 2000); and *Life: Our Century in Pictures for Young People*, ed. Richard B. Stolley (Boston: Little, Brown, 2000).

12 David Perlmutter documented the point through a questionnaire survey of 146 college students in a mass communication class in which he displayed a range of "famous images" only to discover that they overwhelmingly failed to identify the "source event" of the image, and when they could identify the reference event, "few could give . . . any detail about the exact context and circumstances of the picture's creation and provenance." This leads him to the erroneous conclusion that such images are of "dubious renown." The problem is rooted in his somewhat rudimentary conception of cultural literacy, which privileges a simple sense of historical knowledge (defined here in terms of facticity) to the exclusion of a more complex sense of cultural understanding. In a similar study Paul Messaris demonstrated that students fail the historical knowledge test *but* are capable of recognizing parodies based on such images. Of course, one cannot recognize a parody without a sense of the cultural symbolism and structure of feeling invoked by the image. As Michael Griffin has remarked, "The 'great pictures' . . . are seldom analyzed as informational illustrations of specific events and locations. Rather, they are celebrated on a more abstract plane as broader symbols of national valor, human courage, inconceivable inhumanity, or senseless loss. It is precisely their non-specificity that makes them timeless." So, for example, students may mistake Joe Rosenthal's photograph of the raising of the flag on Mount Suribachi as taking place in the Korean War, but typically they do not misunderstand the cultural meaning of the image as an icon of national sacrifice (even though they might inflect that meaning in either pious or cynical registers). See David Perlmutter, *Photojournalism and Foreign Policy: Icons of Outrage in International Crisis* (Westport, CT: Praeger, 1998), 9–11; Paul Messaris, *Visual Literacy: Image, Mind, and Reality* (Boulder: Westview, 1994), 176–80; Michael Griffin, "The Great War Photographs: Constructing Myths of History and Photojournalism," in *Picturing the Past: Media, History, and Photography*, 131. The testing of factual recognition continues, with similar results and limitations: e.g., Barbara Seels, Barbara Good, and Louis Berry, "Recognition and Interpretation of Historically Significant Photographs," *Journal of Visual Literacy* 19 (1999): 125–38. The study of twenty photographs included five of the icons in this book as well as a photograph of "Al Capone fishing"; it is not surprising that one fell out of the pile, and the definition of historical significance remains a tad unsettled.

13 Others might disagree, and, of course, the classification depends on one's definition. For classification using a broad definition of the photographic icon, see Cornelia Brink, "Secular Icons: Looking at Photographs from Nazi Concentration Camps," *History and Memory* 12 (2000): 135–50.

14 Richard Raskin, *A Child at Gunpoint: A Case Study in the Life of a Photo* (Langelandsgade: Aarhus University Press, 2004).

15 Barbie Zelizer, *Remembering to Forget: Holocaust Memory through the Camera's Eye* (Chicago: University of Chicago Press, 1998); and Barbie Zelizer, ed., *Visual Culture and the Holocaust* (New Brunswick, NJ: Rutgers University Press, 2001).

16 Barnhurst et al. ("Mapping Visual Studies") distinguish between rhetorical, semiotic, and pragmatic approaches to visual communication. While granting that the rhetorical has been most pervasive, the authors push for more work in the other areas.

17 For the argument that a single image can, through reproduction, dominate representation to an extent that distorts collective memory and maintains structures of oppression, see Barbie Zelizer, "When War Is Reduced to a Photograph," in Stuart Allan and Barbie Zelizer, eds., *Reporting War: Journalism in Wartime* (New York: Routledge, 2004), 115–135.

18 Perlmutter, *Photojournalism and Foreign Policy*; D. Domke, D. Perlmutter, and M. Spratt, "The Primes of Our Times? An Examination of the 'Power' of Visual Images," *Journalism* 3 (Aug. 2002): 131–59.

19 Louis Althusser, "Ideology and the Ideological State Apparatuses," in *Lenin and Philosophy and Other Essays*, trans. Ben Brewster (New York: Monthly Review Press, 1971).

20 The concept of the relay and its conjunction with ideology was first articulated by Roland Barthes, "The Rhetoric of the Image," in *Image, Music, Text*, trans. Stephen Heath (New York: Hill and Wang, 1977), 32–51. At that time, "relay" referred to the work done by linguistic texts (e.g., dialogue in a film) to provide continuity across a series of images. "Ideology" was each society's single, totalizing system of connotations carried by the linguistic signs. Photography's capacity for persuasion came from its fusion of connotations with literal denotation of the thing seen, thus naturalizing the cultural system. Subsequently, it became clear that images can relay meaning across texts and discourses and that societies can be defined by more than one ideology.

21 *The Oxford Encyclopedia of Rhetoric*, ed. Thomas O. Sloane (New York: Oxford University Press, 2001), s.v. "Enthymeme"; Cara A. Finnegan, "The Naturalistic Enthymeme and Visual Argument: Photographic Representation in the 'Skull Controversy,'" *Argumentation and Advocacy* 37 (2001): 133–49.

22 Michael Warner, *Publics and Counterpublics* (New York: Zone Books, 2002), 74–76.

23 Louis Kaplan, *American Exposures: Photography and Community in the Twentieth Century* (Minneapolis: University of Minnesota Press, 2005), xv.

24 "Underwriting" is a potentially problematic metaphor to use when talking about photographic influence in that it risks reducing the "visual" to the "verbal" and thus opens the door to the critique of logocentrism. The same caveat applies to our later use of the term "transcription" to account for the articulation of meaning within the iconic image. One alternative, of course, is a kind of primitive realism that essentializes the meaning of a photograph apart from its textual (and cultural) surround. With photojournalism, in particular, this latter position is the more problematic, for photojournalistic efforts are rarely disseminated or circulated apart from some form

of captioning. They are, in W. J. T. Mitchell's terms, "imagetexts," a neologism that underscores the "interaction of pictures and texts [that] is constitutive of representation as such." Mitchell, *Picture Theory*, quotations from 89 n.9, 5. See also Jefferson Hunter, *Image and Word: The Interaction of Twentieth-Century Photographs and Texts* (Cambridge: Harvard University Press, 1987). In all of these questions of verbal-visual interaction, we ask the reader to beware essentialism on either side. One indication of a photograph's iconicity is that it circulates widely and often without any caption, but those captions that are applied have to be taken into account when examining specific reproductions. Images generate texts that frame images, and the process can end there or become more complex. As we hope to show, iconic images are more complex: they are framed by yet exceed their captions, they often are not captioned but still activate cultural codes, they can both reinforce and challenge prevailing discourses, and so forth.

25 This argument is elaborated in chapter 2.

26 See, for example, Lester C. Olson, *Emblems of American Community in the Revolutionary Era: A Study in Rhetorical Iconology* (Washington, DC: Smithsonian Institution Press, 1991); and *Benjamin Franklin's Vision of American Community: A Study of Rhetorical Iconology* (Columbia: University of South Carolina Press, 2004); and John Hartley, *The Politics of Pictures: The Creation of the Public in the Age of Popular Media* (New York: Routledge, 1992). Jay Fliegelman also provides a strong demonstration of the importance of aesthetic sensibility to the founders' conception of politics in *Declaring Independence: Jefferson, Natural Language and the Culture of Performance* (Stanford: Stanford University Press, 1993). See David Hackett Fischer, *Liberty and Freedom: A Visual History of America's Founding Ideas* (New York: Oxford University Press, 2005). See also Patricia Anderson, *The Printed Image and the Transformation of Popular Culture, 1790–1860* (Oxford: Clarendon, 1991). For a good general history of the public media's use of photography, see Michael L. Carlebach, *The Origins of Photojournalism in America* (Washington, DC: Smithsonian Institution Press, 1992); and *American Photojournalism Comes of Age* (Washington, DC: Smithsonian Institution Press, 1997). The historical importance of "democratic arts" may have been forgotten in part because of the influence of Walter Benjamin's celebrated essay "The Work of Art in the Age of Mechanical Reproduction," which suggested that aesthetic influence in politics was a key element of fascism; *Illuminations: Essays and Reflections*, ed. Hannah Arendt, trans. Harry Zohn (New York: Schocken Books, 1969), 217–25. For the rare history of communication that gets inside the shifting relationship between word and image, see Mitchell Stephens, *The Rise of the Image and the Fall of the Word* (New York: Oxford, 1998).

27 Danielle S. Allen, *Talking to Strangers: Anxieties of Citizenship since Brown v. Board of Education* (Chicago: University of Chicago Press, 2004), 22. Allen's fine meditation on rhetoric and public life argues that the U.S. Constitution extends into a fabric of social practices that can be changed dramatically by citizen action involving sacrifice on behalf of greater civic trust, and that one of several "refoundings" of the nation was sparked by the photographs of Elizabeth Eckford walking the gauntlet of white segregationists in Little Rock, Arkansas, in 1957. "Habits of citizenship begin with how citizens imagine their political world" (4), and that imagination can be shaped powerfully by images.

28 As Michael Warner has argued, "print discourse was a cultural matrix in which the

definitions of 'individual,' 'print,' 'public,' and 'reason' were readjusted in a new set of ground rules for discourse. The politics of printed texts in republican America lay as much in the cultural meaning of their printedness as in their objectified nature or the content of their arguments." *The Letters of the Republic: Publication and the Public Sphere in Eighteenth-Century America* (Cambridge: Harvard University Press, 1990), xi. See also David Zaret, *Origins of Democratic Culture: Printing, Petitions, and the Public Sphere in Early-Modern England* (Princeton: Princeton University Press, 1999); Elizabeth L. Eisenstein, *The Printing Press as an Agent of Change*, 2 vols. (Cambridge: Cambridge University Press, 1980); Henri-Jean Martin, *The History and Power of Writing*, trans. Lydia G. Cochrane (Chicago: University of Chicago Press, 1995).

29 On the cognitive and social effects of writing/printing, see Jack Goody, *The Logic of Writing and the Organization of Society* (Cambridge: Cambridge University Press, 1986). Our claim focuses on the dominant characteristics and ideology of print news media and not on all reading practices or all literature. Writing, printing, and reading have motivated collective action, but saying so doesn't say much and can mislead. The print news media have worked within (and helped construct and maintain) an intertext of mixed media that included visual arts, architecture, oratory, theater, prose fiction, poetry, songs, conversation, and other forms of speech such as reading aloud. These media in turn have involved a range of interpretive practices—including subaltern and dissident reading practices. It remains likely, however, that the transition from reading to collective action is impeded by print and more likely to occur when other modalities, and principally public speech and images, are active.

30 Stated otherwise, we believe that visual media can be an important repository of democratic knowledge. For the larger argument that classical polity depended on such knowledge, which is oriented toward persuasion and denigrated in political theory, see Josiah Ober, *Political Dissent in Democratic Athens: Intellectual Critics of Popular Rule* (Princeton: Princeton University Press, 1998). Note that the crucial middle step in our theory is to grant that good judgment and effective participation about collective concerns by citizens require more than literate media can provide or provide effectively, that is, more information, more social knowledge, more alternative constructions of an event, more norms, identities, or other bases for action, among other things. Such resources can come from several places, including the much-celebrated face-to-face interaction in coffee shops; we believe that they can be embedded in visual practices as well. This claim receives indirect support from the work in cognitive neuroscience regarding the human brain's enormous capability for processing visual information. We also should note scholarly discussion of whether images can present arguments, for example, the special issues of *Argumentation and Advocacy* on this question (vol. 33, no. 1 and 2 [1996]) and subsequent articles in that journal. See also J. Anthony Blair, "The Rhetoric of Visual Arguments," in Hill and Helmers, *Defining Visual Rhetorics*, 41–61.

31 John Gray, *Liberalism*, 2nd ed. (Minneapolis: University of Minnesota Press, 1995), 78. Gray reprises Benjamin Barber: "Liberalism has been the political philosophy of modernity. It has celebrated modernity's victories—emancipation, science, tolerance, reason, pluralism, rights—and it has been diminished by modernity's vices—alienation, deracination, nihilism, meaninglessness, anomie." Barber, *Strong Democracy: Participatory Politics for a New Age* (Berkeley: University of California Press, 1984), 177.

32 Gray, *Liberalism*, 86.

33 The contemporary problem of citizenship in liberal-democratic society is treated in a number of places. Recent discussions include Toby Miller, *The Well-Tempered Self: Citizenship, Culture, and the Postmodern Project* (Baltimore: Johns Hopkins University Press, 1993); Ronald Beiner, ed., *Theorizing Citizenship* (Albany: State University of New York Press, 1995); Will Kymlicka, *Multicultural Citizenship* (Oxford: Clarendon Press, 1995); Lauren Berlant, *The Queen of America Goes to Washington City: Essays on Sex and Citizenship* (Durham: Duke University Press, 1997); Rogers M. Smith, *Civic Ideals: Conflicting Visions of Citizenship in U.S. History* (New Haven: Yale University Press, 1997); Michael Schudson, *The Good Citizen: A History of American Civic Life* (New York: Free Press, 1998); David M. Ricci, *Good Citizenship in America* (Cambridge: Cambridge University Press, 2004); and Allen, *Talking to Strangers*.

34 Smith, *Civic Ideals*, 6. Smith argues that the tension between liberal and democratic principles explains less than does that between "more consensual, egalitarian and more ascriptive, inegalitarian arrangements" (9). One can grant the point while still recognizing, as Smith does, that the liberal-democratic tension persists while each concept continues to operate as a powerful pattern of identification in political persuasion. Likewise, the several bases for identification will operate differently in different realms of civic action. Smith's historical focus on citizenship laws naturally foregrounds ascription, while our focus on contemporary photographic icons foregrounds a negotiation regarding an already egalitarian but more or less liberal mode of identification.

35 Allen, *Talking to Strangers*, 10.

36 See Barbara Koziak, *Retrieving Political Emotion: Thumos, Aristotle, and Politics* (University Park: Pennsylvania State University Press, 2000); George E. Marcus, *The Sentimental Citizen: Emotion in Democratic Politics* (University Park: Pennsylvania State University Press, 2002); and Mabel Berezin, "Emotions and Political Identity: Mobilizing Affection for the Polity" in *Passionate Politics: Emotions and Social Movements*, ed. Jeff Goodwin et al. (Chicago: University of Chicago Press, 2001), 83–98. More generally, see Peter N. Stearns and Jan Lewis, eds., *An Emotional History of the United States* (New York: New York University Press, 1998).

37 On the popularity of photography in the nineteenth century, see Mary Warner Marien, *Photography: A Cultural History* (New York: Harry Abrams, 2000) and in particular her discussion of the growing interest in stereographs, *cartes de visite*, and photographic societies and clubs (81–85). The appropriation of photography as a medium for progressive and reform politics emerged at the end of the nineteenth century with the publication of Jacob Riis's *How The Other Half Lives* (1890) and was subsequently advanced in Lewis Hines's work on the *Pittsburgh Survey* and the various efforts of the Farm Security Administration photographers under the directorship of Richard Stryker. See Stange, *Symbols of Ideal Life*; James Guimond, *American Photography and the American Dream* (Chapel Hill: University of North Carolina Press, 1991), 55–148; and Reginald Twigg, "The Performative Dimension of Surveillance: Jacob Riis' *How The Other Half Lives*," *Text and Performance Quarterly* 12 (1992): 305–28. But note too that such social reform efforts frequently came under critique as paternalistic, "liberal rhetoric(s)" that supplanted a truly progressive political activism. See James Agee and Walker Evans, *Let Us Now Praise Famous Men* (1939; Boston: Houghton Mifflin, 1969); more recently see Martha Rosler, "In, Around and

Afterthoughts (on Documentary Photography)," in Richard Bolton, ed., *The Contest of Meaning* (Cambridge: MIT Press, 1989), 303-43.

Attention must also be directed to the ways in which photography has functioned as a political art contributing to a cohesive democratic vision ranging from representations of "illustrious Americans" to majestic depictions of nature that serve to celebrate the broad vistas of a national consciousness, what we might call a "democratic sublime." See Alan Trachtenberg, *Reading American Photographs: Images as History; Mathew Brady to Walker Evans* (New York: Hill and Wang, 1989); and David Nye, *American Technological Sublime* (Cambridge: MIT Press, 1994).

38 On the origins and commercialization of photography as "snapshot" photography, see Pierre Bourdieu, *Photography: A Middle-brow Art*, trans. Shaun Whiteside (1965; Stanford: Stanford University Press, 1990); Richard Chalfen, *Snapshot Versions of Life* (Bowling Green: Bowling Green State University Popular Press, 1987); Robert B. Ray, "Snapshots: The Beginning of Photography," in *The Image in Dispute: Art and Cinema in the Age of Photography*, 293–308; and Nancy West, *Kodak and the Lens of Nostalgia* (Charlottesville: University of Virginia Press, 2000). On vernacular use of snapshots to manage the collective memory of family life, see Richard Chalfen, *Turning Leaves: The Photograph Collections of Two Japanese American Families* (Albuquerque: University of New Mexico Press, 1991). Each of these studies illustrates that private and public experience readily intermingles in visual practices. As Chalfen concludes in *Turning Leaves*, "it becomes increasingly important to recognize the existence of alternative voices and discourses, sometimes in nonverbal, pictorial forms. . . . our claim has been that pictorial representation, even in what some might call 'vernacular' forms, should be acknowledged as a legitimate and significant addition to the human repertoire of expressive means—as a way the ordinary people 'write' both history and culture" (218).

39 See Toby Miller, *Technologies of Truth: Cultural Citizenship and the Popular Media* (Minneapolis: University of Minnesota Press, 1998), esp. 3–36, 182–215.

40 Chalfen, *Turning Leaves*, pp. 207 ff.

41 Alexis de Tocqueville, *Democracy in America*, trans. George Lawrence (1848; Garden City, NY: Anchor Books, 1969), vol. 2, esp. 31–57, 277–315. We should add that both the alignment and the tension between liberalism and democracy are possible because of contradictions within each ideology. Stuart Hall provides a pertinent account of the tensions within liberalism in "Variants of Liberalism," in Stuart Hall and J. Donald, eds., *Politics and Ideology* (Minton Keynes: Open University, 1986).

42 Barber, *Strong Democracy*, 3.

43 Barber, *Strong Democracy*, 4

44 Paul W. Kahn, *Putting Liberalism in Its Place* (Princeton: Princeton University Press, 2005), 44. We should add that several scholars have challenged this claim that liberalism is a political tradition that uniformly devalues or neglects community. See Stephen Macedo, *Liberal Virtues: Citizenship, Virtue, and Community in Liberal Constitutionalism* (New York: Oxford University Press, 1990); and William Kymlicka, *Liberalism, Community, and Culture* (New York: Oxford University Press, 1991). While liberal theory may prove to be self-correcting and Kahn's claim may need to be reined in, we think he grasps a basic problem in the discursive enactment of liberalism.

45 On the ascendancy of liberalism as a cultural common sense rooted in everyday practice, see Anne Norton, *Republic of Signs: Liberal Theory and American Popular Culture*

(Chicago: University of Chicago Press, 1993); on the emergence of consumerism and its implications for liberal-democratic citizenship in the post–World War II era, see Lizabeth Cohen, *A Consumer's Republic: The Politics of Mass Consumption in Postwar America* (New York: Alfred Knopf, 2003).

46 John Louis Lucaites, "Visualizing 'the People': Individualism and Collectivism in *Let Us Now Praise Famous Men*," *Quarterly Journal of Speech* 83 (1997): 269–88.

47 "Fewer Read All About It," *Washington Post*, November 30, 2004: "U.S. newspapers have been losing readers for nearly two decades. Morning newspapers absorbed some of the readers of dying evening papers, but daily circulation as a percentage of total adult population is down dramatically." Additional data are available at the Newspaper Association of America, Readership at http://www.naa.org/artpage .cfm?AID=1468&SID=1113.

48 For what may be one sign of this transitional role, the Tiananmen tank icon is the only image on the frontispiece and page 1 of Paul Wombell, *Photovideo: Photography in the Age of the Computer* (London: Rivers Oram, 1991). Serious discussion of this issue should begin with David D. Perlmutter, "The Internet: Big Pictures and Interactors," in Larry Gross, John Stuart Katz, and Jay Ruby, eds., *Image Ethics in the Digital Age* (Minneapolis: University of Minnesota Press, 2003), 1–25.

CHAPTER TWO

1 For a helpful review of many of the debates regarding cultural analysis, see Sherry B. Ortner, "Theory in Anthropology since the Sixties," in *Culture, Power, History: A Reader in Contemporary Social Theory*, ed. Nicholas B. Dirks et al. (Princeton: Princeton University Press, 1994), 372–411. See also James Carey, *Communication as Culture: Essays on Media and Society* (Boston: Unwin Hyman, 1989); and Warren I. Susman, "Culture and Communications," *Culture as History: The Transformation of American Society in the Twentieth Century* (Washington, DC: Smithsonian Institution Press, 2003), 252–70. See also Mieke Bal, "Visual Essentialism and the Object of Visual Culture," *Journal of Visual Culture* 2 (2003): 5–32, which makes a case for "visual culture" as a negative articulation following the "death of culture." Thus, culture is recast as a heterogeneous, intermediate, performative, and conflicted zone that challenges the conventions of inquiry in any academic discipline. The study of specific cultures need not remain at this level of analysis, but it would do well to retain Bal's critique of essentialism.

2 Our conception of public culture resonates with Thomas Bender's interest in "the making of public culture." His goal is to provoke narrative synthesis of a wide range of scholarship on behalf of a more robust conception of political history. Public culture "embraces a wide range of manifestations of power in society—from the institutional power of the state through the more subtle power to assign meaning and significance to various cultural phenomena, including the power to establish categories of social analysis and understanding. The public culture of a society is a forum where power in its various forms, including meaning and aesthetics, is elaborated and made authoritative. Because of its contextual quality, [this] public is an inherently political collectivity, and this distinguishes it from mere social collectivities or cultural pastiches" (126). The analytical power of this notion speaks to one of the compelling problems of late modern society, for rather than "[to] assume

that all relevant groups are represented in public," it seeks to understand "why some groups and some values are so much—or so little—represented in the public realm" (135). Despite these and other shared assumptions and commitments, Bender's model also differs from our own, not least in his focus on the role of the intellectual and his inattention to visual practices. Where he would look to the historian to provide "the mirror in which society looks at itself" (122), we consider how such conceptions of political identity are crafted within the public art of photojournalism. See Thomas Bender, "Wholes and Parts: The Need for Synthesis in American History," *Journal of American History* 73 (1986): 120-136. See also Nell Irvin Painter, "Bias and Synthesis in History," *Journal of American History* 74 (1987): 109–12; Richard Wightman Fox, "Public Culture and the Problem of Synthesis," *Journal of American History* 74 (1987): 113–16; Roy Rosenzweig, "What Is the Matter with History?" *Journal of American History* 74 (1987): 117–22; and Thomas Bender, "Whole and Parts: Continuing the Conversation" *Journal of American History* 74 (1987): 123–30.

3 Michael Warner, *Publics and Counterpublics* (New York: Zone Books, 2002), 65–67.

4 It might be illustrative to compare "public culture" with the alternative English translations of Habermas's German term, *Öffenlichkeit*. Thomas Burger says the term "may be rendered variously as '(the) public,' 'public sphere,' or 'publicity'" (translator's note to Jürgen Habermas, *The Structural Transformation of the Public Sphere: An Inquiry into a Category of Bourgeois Society*, trans. Thomas Burger [Cambridge: MIT Press, 1989], xv). "The public" implies both a situated collective entity like an audience and an abstract collectivity like a nation. This is familiar American usage (viz. John Dewey, *The Public and Its Problems*) and a significant conjunction, and it lies close to our sense of things. Unfortunately, it also invites association with both stock conceptions of the mass media audience and exclusionary social practices, which are merely historical rather than necessary elements of public opinion formation. "Public sphere" implies a more abstract and yet more self-enclosed space, something like a financial market. More important from our perspective, the term has a strong aesthetic dimension: spheres are abstract, formally elegant, inherently rational, self-completing and self-regulating entities imagined to be freestanding in abstract space and seen from a macroscopic perspective. Interestingly, this is the most common usage in social theory today. We think it plays to modernist assumptions about social organization and social theory that inhibit a strong understanding of democratic practices, not least the practices of persuasion in the public media. "Publicity" is at once the more radical and most limited term. Because it emphasizes the common practices and social facts of public relations, it leaves one focused primarily on the technologies and one-way relationships of strategic dissemination and so less disposed to appreciate public life as good conversation writ large. It does, however, foreground the impersonal dimension of public communication that operates through dissemination, circulation, and indirect response, and so could encourage more attention to that dimension of public identity behind the mask of "conversation." On the tension between the "public sphere" and "publicity," see Dilip Parameshwar Gaonkar and Robert J. McCarthy, Jr., "Panopticisim and Publicity: Bentham's Quest for Transparency," *Public Culture* 14 (1994): 547–78. "Public culture," which we do not offer as a translation of the German term, supplies yet another sense of an internally coherent social field, one that we hope encourages an emphasis on mixed media, indirect influence, virtual subjectivities, and interpretive study. See also note 2 above.

317

5 We should add that our perspective minimizes the differences between production and reception in order to identify intermediate factors such as design. Of course, the two poles of the communicative relationship are not identical, and at times it is crucial to identify the gap and explicate the differences. Such work, however, is not our work, and it can interfere with understanding circulation, appropriation, and subsequent influences on media production. This is particularly so as the investigation focuses on everyday practices. Toby Miller and Alec McHoul put the matter succinctly: "This means, in effect, that if we look at everyday life closely enough, shifting our attention from content towards method and technique, we will begin to see that the *problem* of culture effectively disappears. We no longer have to conjecture about how production and reception (or generating and recognizing) are different entities. A culture is, in fact, where *we* recognize what *you* are doing because, for all of us, culturally, that is *how* we would do it. If there is a deep distinction between production and recognition, then there simply is not a culture." Indeed, the theoretical problem is itself an artifact of certain tendencies in social theory: "culture is only a 'problem' of connecting production ('generating') and consumption ('recognizing') when it is *speculatively* treated as a *spectacular* field in which cultural objects are always considered as *representing* something beyond them (such as gendered, economic, or racial 'patterns')." *Popular Culture and Everyday Life* (London: Sage, 1998), 179.

6 Robert Hariman, *Political Style: The Artistry of Power* (Chicago: University of Chicago Press, 1994).

7 Any attempt would have to surpass W. J. T. Mitchell's *Iconology: Image, Text, Ideology* (Chicago: University of Chicago Press, 1986) and *Picture Theory: Essays on Verbal and Visual Representation* (Chicago: University of Chicago Press, 1994), as well as the many suggestions provided by James Elkins throughout the numerous books that comprise his natural history of the visual world. See, e.g., James Elkins, *The Object Stares Back* (San Diego: Harcourt Brace, 1996); *The Domain of Images* (Ithaca: Cornell University Press, 1999), and *Pictures of the Body: Pain and Metamorphosis* (Stanford: Stanford University Press, 1999). Marita Sturken and Lisa Cartwright provide brief discussion of several pertinent issues in *Practices of Looking: An Introduction to Visual Culture* (Oxford: Oxford University Press, 2001), 36–42.

8 The battles over the definition of "popular" culture are not worth revisiting. Suffice it to say that the term has multiple meanings and that no definition of public culture should imply a hard distinction from "popular" media, arts, and the like. There clearly is need, however, for more focused analysis of various forms of public and popular culture. For review of some of the definitional issues, see Barbie Zelizer, "Popular Communication in the Contemporary Age," in *Communication Yearbook 24*, ed. William B. Gudykunst (Thousand Oaks, CA: Sage, 2001), 297–316.

9 Examples are legion, as any Google search will confirm. Vicki Goldberg, *The Power of Photography: How Photographs Changed Our Lives* (New York: Abbeville Press, 1991) (135–61), treats it as a genre. Professional speech is exemplified by Peter Howe, "So Many Photographs, So Few Icons," *Digital Journalist* (Nov. 1999), http://www .digitaljournalist.org/issue9910/howe.htm. Institutional use includes the Library of Congress: "Curators learned to make critical distinctions among the photographs, to identify qualities that made one picture more compelling than another and determine what constituted a truly iconic 9/11 image." Jeremy Adamson, "The Image as Witness: Collecting Visual Materials from the National Tragedy," *Library of Congress*

Information Bulletin (Sept. 2002), http://www.loc.gov/loc/lcib/0209/images.html. Academic use includes Perlmutter, *Photojournalism and Foreign Policy* (11–23); and Kevin Kawamoto, "Study Text [Part One]: "The History of Photojournalism," Photography & Trauma, unit 3, Dart Center for Journalism and Trauma site, http://www.dartcenter.org/resources/selfstudy/3_photojournalism/text_01.html: "When specific photographs become symbolic of a particular event, triggering the public's memory (and related feelings and emotions) about that period in time, we can refer to them as enduring historical icons." Often the images themselves are used in place of the term to make the same point about the role of photojournalism and icons alike as historical markers: "The surpassing power of pictures enables them to become the permanent markers of enormous events. The marines planting the flag at Iwo Jima, the South Vietnamese general shooting his captive at point-blank range, the young John F. Kennedy Jr. saluting his father's passing coffin: each is the universal symbol for a historical moment. You don't need to see them to see them." Daniel Okrent, "No Picture Tells the Truth. The Best Do Better Than That," *New York Times*, Jan. 9, 2005, http://www.nytimes.com/2005/01/09/weekinreview/09bott.html?ei=5070&en=7eeaf1253d0ab2ea&ex=1141534800&pagewanted=print&position=.

10 Miles Orvell, *American Photography* (New York: Oxford University Press, 2003), 213.

11 Allan Sekula, *Photography against the Grain: Essays and Photo Works, 1973–1983* (Halifax: Press of the Nova Scotia College of Art and Design, 1984); Kevin DeLuca, *Image Politics: The New Rhetoric of Environmental Activism* (New York: Guilford, 1999).

12 Although he evinces no interest in public culture, James Elkins argues that to develop visual studies on its own terms will require moving past the skepticism that pervades the current overreliance on theorists such as Barthes, Benjamin, and Foucault and use of concepts such as the gaze, the scopic regime, and the spectacle. Elkins, *Visual Studies: A Skeptical Introduction* (New York: Routledge, 2003), 94–102. The point is not to disregard these resources but to develop a program of inquiry that also can better identify the specific classes and instances of visual phenomena.

13 Hariman, *Political Style*.

14 The study of appropriations need not be limited to visual practices and may be essential for the study of public culture. For a history of improvisation in popular song, see Robert James Branham and Stephen J. Hartnett, *Sweet Freedom's Song: "My Country 'Tis of Thee" and Democracy in America* (New York: Oxford University Press, 2002). For the ridiculous counterpoint, we note the St. Joseph aspirin advertisement that begins, "Ask Not What Your Coronary Artery Can Do for You," in stirring reference to John F. Kennedy's inaugural address.

15 Our sense of performance is drawn primarily from work in anthropology. Richard Bauman summarizes this perspective in "Performance," *International Encyclopedia of Communications* (New York: Oxford University Press, 1989), 3: 262–66; see also *Verbal Art as Performance* (Prospect Heights, Ill.: Waveland Press, 1984). For discussions of basic problems facing performance theory, see Richard Bauman and Charles L. Briggs, "Poetics and Performance as Critical Perspectives on Language and Social Life," *Annual Review of Anthropology* 19 (1990): 59–88; Charles L. Briggs and Richard Bauman, "Genre, Intertextuality, and Social Power," *Journal of Linguistic Anthropology* 2 (1992): 131–72; and Charles L. Briggs, *Competence in Performance: The Creativity of Tradition in Mexicano Verbal Art* (Philadelphia: University of Pennsylvania Press, 1988), 1–24. Dwight Conquergood argues for extending performance theory to public dis-

course in "Rethinking Ethnography: Towards a Critical Cultural Politics," *Communication Monographs* 58 (1991): 179–94.

16 We would note, for example, that while the language of performance itself is not emphasized, photojournalists are trained to capture performative moments of the public culture. See, for example see Ken Kobré, *Photojournalism: The Professional Approach*, 5th ed. (Boston: Focal Press, 2004), perhaps the leading textbook used in training young photojournalists in both form and content.

17 See Erving Goffman, *Frame Analysis: An Essay on the Organization of Experience* (New York: Harper Colophon, 1974); Robert Entman, "Framing: Toward Clarification of a Fractured Paradigm," *Journal of Communication* 43 (1993): 51–58; William A. Gamson, "Media Discourse as a Framing Resource," in *The Psychology of Political Communication*, ed. A. N. Crigler (Ann Arbor: University of Michigan Press, 1996), 111–31.

18 Roland Barthes, *Camera Lucida: Reflections on Photography*, trans. Richard Howard (New York: Hill and Wang, 1981), 32.

19 The concept of "restored behavior" comes from Richard Schechner, *Between Theater and Anthropology* (Philadelphia: University of Pennsylvania Press, 1985), 35–116. For a superb discussion of the concept, see Bert O. States, "Performance as Metaphor," *Theatre Journal* 48 (1996): 1–26.

20 Although we do not use Judith Butler's work on the performance of gender, our understanding of photojournalism is directly consistent with her central argument that identity is performative in that it is produced through repeated iteration. Thus, the public itself, the role of citizenship, and individual subjectivity are created through the circulation of texts and images. "This is the moment in which discourse becomes productive in a fairly specific way. So what I'm trying to do is think about the performativity as *that aspect of discourse that has the capacity to produce what it names.* Then I take a further step, through the Derridean rewriting of Austin, and suggest that this production actually always happens through a certain kind of repetition and recitation." Peter Osborn and Lynne Segal, "Gender as Performance: An Interview with Judith Butler," *Radical Philosophy* 67 (summer 1994): 32–39. See also Judith Butler, *Gender Trouble: Feminism and the Subversion of Identity* (New York: Routledge, 1990) and *Bodies That Matter: On The Discursive Limtis of "Sex"* (New York: Routledge, 1993). We should add that our sense of performative action does not depend on enforcing Butler's distinction between performance and performativity. Civic performance includes both the reproduction of prior categories and rearticulation to contest or otherwise shift what is taken for granted. Sometimes that distinction is salient, and sometimes the line, say, between conventional and parodic iteration is not easily drawn.

21 States, "Performance as Metaphor," 20.

22 For a brief discussion of the relationship between this tradition and attention to social artistry within rhetorical studies, see Hariman, *Political Style*, 177–95.

23 Icons are not the only instance of ritual communication in the public media, but they are distinctive examples of how public communication provides specific forms of ritual performance in place of more primitive forms of ritual behavior. See Eric Rothenbuhler, *Ritual Communication: From Everyday Conversation to Mediated Ceremony* (Thousand Oaks: Sage, 1998); and Daniel Dayan and Elihu Katz, *Media Events: The Live Broadcasting of History* (Cambridge: Harvard University Press, 1994).

24 We are indebted to Oscar Giner for this observation.

25 Bauman, "Performance," 3: 262–66.

26 This is one sense of Roland Barthes's comment that the photograph is a "message without a code." "The Rhetoric of the Image," in *Image, Music, Text*, trans. Stephen Heath (New York: Hill and Wang, 1977), 272.

27 Umberto Eco, "Critique of the Image," in *Thinking Photography*, ed. Victor Burgin (London: Macmillan, 1992), 33. See also Barthes's definition of the image as an "architecture" of multiple codes reflecting varied forms of knowledge that may or may not be possessed by individual readers, whose interpretation will vary accordingly ("The Rhetoric of the Image," 32–51). This early and strong conception of the semiotic complexity of the image often has been lost in subsequent appropriation of Barthes's work.

28 David Hume, "Of the Love of Fame," book 2, section, XI, *A Treatise of Human Nature* [1888], ed. L. A. Selby-Bigge (Oxford: Clarendon, 1978), 316. For contemporary work on the social construction of emotions see Catherine Lutz and Lila Abu-Lughod, eds., *Language and the Politics of Emotion* (New York: Cambridge University Press, 1990); and Gillan Bendelow and Simon J. Williams, *Emotions in Social Life: Critical Themes and Contemporary Issues* (New York: Routledge, 1998).

29 See Isaiah Berlin, "The Originality of Machiavelli," in *Against the Current: Essays in the History of Ideas* (Middlesex: Penguin Books, 1982), 25–80.

30 F. R. Ankersmith, *Aesthetic Politics: Political Philosophy beyond Fact and Value* (Stanford: Stanford University Press, 1996), 21–63. See also Ernesto Laclau, "The Politics of Rhetoric," in *Material Events: Paul de Man and the Afterlife of Theory*, ed. Tom Cohen et al. (Minneapolis: University of Minnesota Press, 2001), 229–53.

31 Dayan and Katz, *Media Events*, 195, emphasis in the original. This claim builds on the idea that in some ritual performances "modeling is the key moment, not simply a prelude" (178).

32 Walter Benjamin, "The Work of Art in the Age of Mechanical Reproduction," *Illuminations: Essays and Reflections*, ed. Hannah Arendt, trans. Harry Zohn (New York: Schocken Books, 1969), 217–25.

33 Linda Zerilli, "Democracy and National Fantasy: Reflections on the Statue of Liberty," in *Cultural Studies and Political Theory*, ed. Jodi Dean (Ithaca, NY: Cornell University Press, 2000), 174. This claim receives repeated emphasis, mutatis mutandis, in the study of photography's historical and mnemonic significance. There is less agreement, for obvious reasons, regarding how images work nonreferentially. We believe it is important to emphasize that the iconic photograph does *not* reproduce the same meaning over time, particularly a meaning fixed at the time of first publication. As Barbie Zelizer has stated, "it is possible, even probable, that images function in memory precisely through contingency, when meaning settles not at the image's original point of display but over time in new contexts that are always altered, sometimes playful, and often contradictory." "The Voice of the Visual in Memory," in *Framing Public Memory*, ed. Kendall R. Phillips (Tuscaloosa: University of Alabama Press, 2004), 161–62. Although not completely open to interpretation, the icon is a node in a network of images, texts, optics, discourses, beliefs, and attitudes that is continually being negotiated and otherwise shifting over time. Some combination of formal qualities and deep resonance allows the image to be relatively stable and powerful, but that is a dynamic process.

34 Zerilli, "Democracy and National Fantasy," 186.

35 Zerilli, "Democracy and National Fantasy," 175.

36 *Statue of Liberty*, directed by Ken Burns, Public Broadcasting System, 1985.

37 Anne Norton, *Republic of Signs* (Chicago: University of Chicago Press, 1993), 174. We should add that this position is on one side of a very thin line. One can cross from liberal virtue to the vices of consumer capitalism in the blink of an eye. Our criticism of liberalism in this volume places us much closer to Zerilli than to Norton, but with two caveats. First, we don't think that the visual practices involved are antidemocratic. Second, it matters a great deal when one gets to the point of critique. With Norton, we believe that one shouldn't start immediately but rather consider how liberal practices might be more complex and at times more democratic than one would expect.

38 Such iconoclasm is deeply rooted in Western history, religion, and culture. The so-called "father" of the attack on mimesis is Plato, but it is equally present in the texts of the Judeo-Christian tradition from Saint Augustine to Jacques Ellul. See Martin Jay, *Downcast Eyes: The Denigration of Vision in Twentieth-Century French Thought* (Berkeley: University of California Press, 1993), 21–82; Plato, *The Republic*; Saint Augustine, *The Confessions*, chap. 35; and Jacques Ellul, *The Humiliation of the Word*, trans. Joyce Main Hanks (Grand Rapids: William B. Eerdman's, 1985). Not to leave the Marxists out, see also Guy Debord, *The Society of the Spectacle*, trans. Donald Nicholson-Smith (New York: Zone Books, 1995). The most highly regarded statement in the United States is Susan Sontag's *On Photography* (New York: Picador, 1977). Sontag's love/hate relationship with the medium produced a stunning stream of brilliant insights amidst a relentless jeremiad on behalf of a seemingly beleaguered order of art, writing, the real world, and "the very idea of normative taste" (141). Her arguments against photography, when they are not empirically wrong or self-contradictory, could be applied with equal force to the arts that she feels warrant their privileged places well up the cultural hierarchy. Such inconsistency is typical and rarely noted when critics are blasting visual media or any new media. In *Regarding the Pain of Others* (New York: Picador, 2003), Sontag provides partial correction of some of her earlier claims and offers photojournalism grudging acceptance. For a more middlebrow version of iconoclasm, see Neil Postman, *Amusing Ourselves to Death: Public Discourse in the Age of Show Business* (New York: Penguin Books, 1985), especially 8–9.

39 Barbara Maria Stafford, *Good Looking: Essays on the Virtue of Images* (Cambridge: MIT Press, 1996), 23. See also her *Visual Analogy: Consciousness as the Art of Connecting* (Cambridge: MIT Press, 1999); and Mitchell, *Picture Theory*.

40 Stafford, *Good Looking*, 23; Vicki Goldberg, *The Power of Photography: How Photographs Changed Our Lives* (New York: Abbeville Press, 1991).

41 Habermas, *Structural Transformation of the Public Sphere*, 85. See also Immanuel Kant, "What Is Enlightenment?" [1784] in *Kant's Political Writings*, ed. Hans Reiss, trans. H. B. Nisbet (Cambridge: Cambridge University Press, 1971), 85–92.

42 Jacques Derrida, *Of Grammatology*, trans. Gayatri Chakravorty Spivak (Baltimore: Johns Hopkins University Press, 1974).

43 "The interaction of pictures and text is constitutive of representation as such: All media are mixed media, and all representations are heterogeneous; there are not 'purely' visual or verbal arts, though the impulse to purify media is one of the central utopian gestures of modernism." Mitchell, *Picture Theory*, 5. The question, then, is

not the autonomy of the visual or the dominance of the system of signs, but how interpretation necessarily moves across different strata of representation each of which is incomplete yet partially closed off from the others. This correction applies not only to captions and other verbal materials that frame an image but to all of the codes of the social text as well. No one code controls all signs, and any sign can shift across multiple codes.

44 Michael Warner, *Publics and Counterpublics* (New York: Zone Books, 2002), 65–124.

45 Michael C. McGee, "In Search of 'the People': A Rhetorical Alternative," *Quarterly Journal of Speech* 61 (1975): 235–49.

46 Habermas, *Transformation of the Public Sphere*, 85.

47 Kenneth Burke, *A Rhetoric of Motives* (Berkeley: University of California Press, 1969). Thus, in Burke's terms, visual icons would operate as "titles" (86) that provide a "*summing up* of many motivational strands" (110) in complex patterns useful for communication and negotiation.

48 Few viewers know that the figure in the rear is Ira Hayes, a Native American of the Pima tribe.

49 Warner, *Publics and Counterpublics*, 74–76.

50 Warner, *Publics and Counterpublics*, 74.

51 For a critique of the concept of the public sphere that begins with the notion of "class," see Oskar Negt and Alexander Kluge, *Public Sphere and Experience: Toward an Analysis of the Bourgeois and Proletarian Public Sphere*, trans. Peter Labanyi et al. (1972; Minneapolis: University of Minnesota Press, 1993), esp. 54–95, 289–95. For an interesting example and extension of this critique, see Miriam Hansen, "Early Silent Cinema: Whose Public Sphere?" *New German Critique* 29 (1983): 147–84.

52 Rogers M. Smith, *Civic Ideals: Conflicting Visions of Citizenship in U.S. History* (New Haven: Yale University Press, 1997).

53 For feminist critiques of the public sphere as irremediably gendered and thus warranting consideration of a "counter public sphere," see Nancy Fraser, "Rethinking the Public Sphere: A Contribution to the Critique of Actually Existing Democracy," in *Habermas and the Public Sphere*, ed. Craig Calhoun (Cambridge: MIT Press, 1992), 109–43; Mary P. Ryan, "Gender and Public Access: Women's Politics in Nineteenth-Century America, "*Habermas and the Public Sphere*, 259–88; Rita Felski, *Beyond Feminist Aesthetics: Feminist Literature and Social Change* (Cambridge: Harvard University Press, 1989), esp. 154–84; Joan B. Landes, "The Public and Private Sphere: A Feminist Reconsideration," in *Feminists Read Habermas: Gendering the Subject of Discourse*, ed. Johanna Meehan (New York: Routledge, 1995), 91–116. For a good example of what such a (re)gendered counterpublic sphere might look like, see Phaedra C. Pezzullo, "Resisting 'National Breast Cancer Awareness Month': The Rhetoric of Counterpublics and Their Cultural Performances," *Quarterly Journal of Speech* 89 (2003): 345–65.

54 See Ernesto Laclau and Chantal Mouffe, *Hegemony and Social Strategy: Towards a Radical Democratic Politics* (London: Verso Press, 1985); and DeLuca, *Image Politics*.

55 Perlmutter, *Photojournalism and Foreign Policy*, xiii–xvii, 1–11.

56 Michel Foucault, "Truth and Power," in *Power/Knowledge: Selected Interviews and Other Writings, 1972–1977*, ed. and trans. Colin Gordon (New York: Pantheon Books, 1980), 109–34.

57 "Photographic Practice and Art Theory," in *Thinking Photography*, ed. Victor Burgin (London: Macmillan, 1992), 45–46.

58 Victor Burgin, "Looking at Photographs," in *Thinking Photography*, ed. Victor Burgin (London: Macmillan, 1992), 144.

59 As John Tagg claims, photographic realism is the outcome of an "elaborate constitutive process." "The Currency of the Photograph," in *Thinking Photography*, ed. Victor Burgin (London: Macmillan, 1992), 111. There is a related issue that needs to be discussed, for the character of ideology critique of visual images today depends on its relationship to semiotics. Our argument can be recast as a claim regarding overreliance on the Saussurian logic of binary differentiation. A more relevant basis for a semiotic theory of visual meaning comes from Charles Peirce, whose distinction between indexical, iconic, and symbolic signs provides a sharper discrimination of the complexity of the photographic image. The photograph is indexical because there is a causal relation between the image and the object it represents. It is iconic because it provides figural models and analogies. It is symbolic because it refers to other signifiers and patterns of interpretation. There can be slippage at each level, including the matter of faking indexical qualities, but that is no more disabling here than it is anywhere else. The important qualification is that no line of signification is primary: *there is no hierarchy* for the three orders of index, icon, and symbol. Any such claim could to be worked out only in respect to particular cases. In fact, Peirce's distinction does not provide much of a warrant for the discourse of photographic realism—and certainly not for those invocations of realism used to mask domination—but that is not really the issue here. What is at stake is determining the relative autonomy of the visual practice from linguistic predetermination, the degree of incommensurability between different orders of explanation, and what a class of images can reveal about the internal dynamics of representation. Iconic images as we define them encompass all three levels of interpretation, and the icons provide good test cases, not for mapping out a mechanical triad of semiotic orders, but for understanding how visual images provide modes of symbolic action beyond what can be reduced to either the reality behind the image or a structure of representation. See Charles Sanders Peirce, *Collected Papers* (Cambridge: Harvard University Press, 1931–1958), 2: 275.

60 Jay reviews pertinent distinctions between visual field and visual world and between vision and visuality in *Downcast Eyes*, 4–9. See also Jacques Rancière, *The Politics of Aesthetics: The Distribution of the Sensible*, trans. Gabriel Rockhill (New York: Continuum, 2004).

61 Peter Sloterdijk, *Critique of Cynical Reason*, trans. Michael Eldred (1983; Minneapolis: University of Minnesota Press, 1987).

62 Hanno Hardt, *Myths for the Masses: An Essay on Communication* (Oxford: Blackwell Publishing, 2004), 141.

63 Warner, *Publics and Counterpublics*, 77.

64 Kenneth Burke, "Literature as Equipment for Living," in *The Philosophy of Literary Form: Studies in Symbolic Action*, 3rd ed. (Berkeley: University of California Press, 1973), 293–304.

65 Warner, *Publics and Counterpublics*, 15.

CHAPTER THREE

1 Aram Mardirosian, designer, "Timeline, 1901–1976," Museum of Westward Expansion, St. Louis, Missouri, 1976.

2 *Life, Decades of the Twentieth Century: The Way We Were*, ed. Killian Jordan (Des Moines: Life Books, Time, Inc., 1999).

3 The history of the Farm Security Administration's photography project has been told in numerous places, and in most of these Lange's "Migrant Mother" is a prominent part of the story. See, e.g., Lawrence Levine, "The Historian and the Icon: Photography and the History of the American People in the 1930s and 1940s," and Alan Trachtenberg, "From Image to Story: Reading the File," in *Documenting America: 1935-1943*, ed. Carl Fleischhauer and Beverly W. Brannan (Berkeley: University of California Press, 1988), 15–42, 43–75; James Curtis, *Mind's Eye, Mind's Truth: FSA Photography Reconsidered* (Philadelphia: Temple University Press, 1989); and Cara Finnegan, *Picturing Poverty: Print Culture and FSA Photographs* (Washington, D.C.: Smithsonian Books, 2003), 101–2. For a slightly different take that emphasizes the possible role that "Migrant Mother" played in characterizing Lange as the "mother" of social reform documentary, see Andrea Fisher, *Let Us Now Praise Famous Women: Women Photographs for the U.S. Government, 1935-1944* (London: Pandora, 1987), 139–55. For an important study of the RA/FSA photography project that nevertheless fails to discuss the "Migrant Mother," see Maren Stange, *Symbols of Ideal Life: Social Documentary Photography in America: 1890-1950* (Cambridge: Cambridge University Press, 1989), 89–132.

4 Dorothea Lange, "The Assignment I'll Never Forget," *Popular Photography* 46 (Feb. 1960): 42–43, 81.

5 Five of the six images can be found on-line at the Library of Congress Web site at http://www.loc.gov/rr/print/list/128_migm.html. The sixth image was never delivered to the Library of Congress and is now in the possession of the Dorothea Lange Archive at the Oakland Museum. It is reproduced in Paul Taylor, "Migrant Mother: 1936," *American West* 3 (1970): 44. See also Lawrence W. Levine, "The History and the Icon: Photography and the History of the American People in the 1930s and 1940s," in *Documenting America*, 16–17. For a thorough review of the composition of the "Migrant Mother" photograph, see Curtis, *Mind's Eye*, 45–46. For a documentarian's point of view, see Robert Coles, *Doing Documentary Work* (New York: Oxford University Press, 1997), 101–6.

6 "Food Rushed to Starving Farm Colony," *San Francisco News*, March 10, 1936, 3.

7 Vicki Goldberg provides an excellent summary of the origin and history of the "Migrant Mother" in *The Power of Photography: How Photographs Changed Our Lives*, expanded and updated ed. (New York: Abbeville, 1991), 135–44. See also Judith Fryer Davidov, *Women's Camera Work: Self/Body/Other in American Culture* (Durham, NC: Duke University Press, 1998), 2–6, 234–40; and Rebecca Maksel, "Migrant Madonna," *Smithsonian* (March 2002): 21–22.

8 Curtis describes how Lange had the negative retouched so that it was not evident that the mother had reached out with her other hand to grasp the tent pole to support her infant. The result is that she appears less as someone committed to and capable of providing for her family, and far more as someone stricken with anxiety. Curtis, *Mind's Eye*, 67. For a copy of the image before it was retouched, see "Migrant Mother, Nipomo, California," Public Record / Candid Witness series, George Eastman House, Still Photograph Archive, record 73:0095:0001, available online at http://www.geh .org/taschen/htmlsrc10/m197300950001_ful.html.

9 "What Does the 'New Deal' Mean to This Mother and Her Child," *San Francisco News*, March 11, 1936, 3.

10 Paul Schuster Taylor, "Paul Schuster Taylor," in *Photography within the Humanities*, ed.
Eugenia Parry Janis and Wendy MacNeil (Danbury, NH: Addison House, 1977), 38.

11 Lange's original caption read: "9058 C, Destitute pea pickers in California. Mother
of seven children, age 32. February [*sic*] 1936" (reproduction no. - LC-USF34-9058-C;
Locations FSA OWI – J339168) but it is seldom used today, where it is universally
and almost exclusively identified as the "Migrant Mother" or "Migrant Madonna."
There is no exact record for when the photograph originally accrued the designation
"Migrant Mother," though most commentators emphasize that it occurred shortly
after its initial publication. Davidov notes that it was "firmly stamped *Migrant
Mother*" when it was included in the Museum of Modern Art's first photography
exhibit in 1941. See Davidov, *Women's Camera Work*, 4. The emphasis on "mother-
hood"—both in Lange's original caption and in the subsequent titling—is not
surprising as it was a common trope of social reform photography in general and of
the RA/FSA photographers in particular. Alan Trachtenberg discusses Lewis Hine's
"A Tenement Madonna," first published in *The Survey* (subsequently to be renamed
Survey Graphic) on July 8, 1911, in *Reading American Photographs: Images as History,
Mathew Brady to Walker Evans* (New York: Hill and Wang, 1989), 194–95. Davidov
(*Women's Camera Work*, 237–40) suggests that Lange was probably not influenced by
Hine's "Madonna," *nevertheless*, we might take note of the influence of its caption on
the subsequent naming of the "Migrant Mother," particularly when we recall that
one of the earliest publications of the Lange image was in conjunction with an article
written by Paul Taylor, "From the Ground Up," *Survey Graphic* 25 (Sept. 1936): 526–27,
529, 537. On the significance of the trope of "motherhood" in RA/FSA photography,
see Wendy Kozol, "Madonnas of the Fields: Photography, Gender, and the 1930s Farm
Relief," *Genders* 2 (1988): 1–23.

It is also important to note the variations in captioning in the many reproductions
of the photo in scholarly texts, museum exhibitions, and popular media. "Mother-
hood" is not always accented, and to the extent that Lange's captions are used at
all, they are parsed and moved around to supply more or less emphasis on specific
economic conditions. As Finnegan points out, in *Survey Graphic* the photograph was
captioned "Draggin-Around People," a phrase that migrants used to characterize
themselves and derives from a "southern expression used to describe people who have
no permanent place to live." *Picturing Poverty*, 101–2. On Lange's customary practices
for a photo shoot, see Karin Becker Ohrn, *Dorothea Lange and the Documentary Tradition*
(Baton Rouge: Louisiana State University Press, 1980), esp. 79–80. For various cap-
tions of the "Migrant Mother" image, see Therese Thau Heyman, Sandra S. Phillips,
and John Szarkowski, *Dorothea Lange: American Photographs* (San Francisco: Chronicle
Books, San Francisco Museum of Modern Art, 1994), plates 42 and 43; Beaumont
Newhall, *The History of Photography* (New York: Museum of Modern art, 1964), 143. On
the rhetorical function of captioning, see Roland Barthes, "Rhetoric of the Image,"
Image, Music, Text, trans. Stephen Heath (New York: Hill and Wang, 1977), 32–51.

12 Hine developed a style of documentary photography that resisted artifice while
portraying social injustice. According to Trachtenberg, "he wished to show work-
ing people in their environments in a more detached and objective manner. Social
photography was for him an educational process; a picture was a piece of evidence, a
record of social injustice, but also of individual human beings surviving with dignity
in intolerable conditions." See "Lewis W. Hine, Social Photography," in *Classic Essays*

on Photography, ed. Alan Trachtenberg (New Haven: Leete's Island Books, 1980), 109. See also Trachtenberg, *Reading American Photographs*, 164–230; James Guimond, *American Photography and the American Dream* (Chapel Hill: University of North Carolina Press, 1991), 55–98; and Michael L. Carlebach, *American Photojournalism Comes of Age* (Washington, DC: Smithsonian Institution Press, 1997), 128–35. For Hine's influence on FSA Historical Section director Roy Stryker, including the tensions between Hine and Stryker over how the photographs should be used, see Stange, *Symbols of Ideal Life*, 47–132. On the agenda for the RA/FSA, see Ann Melville, *Farm Security Administration, Historical Section: A Guide to Textual Records in the Library of Congress* (Washington, DC: Library of Congress, 1985), 11.

13 See Carlebach, *American Photojournalism Comes of Age*, 104–41.

14 The photograph was used by the RA/FSA at numerous sites and places. For example, it appeared as the main focus of a story in *Midweek Pictorial* on October 17, 1936, under the headline "Look in her Eyes!" The article emphasizes the problems of tenant farming, with a map of the United States charting the problem of tenancy literally overlapping both the story and the photograph. A reproduction of this page from the newspaper appears in Levine, "The Historian and the Icon," in *Documenting America*, 34, reproduced from the Written Records of the Farm Security Administration, Historical Section—Office of War Information, Overseas Picture Division, Washington Section Collection, in the Prints and Photographs Division, Library of Congress, which documents numerous other such usages. It was also published in *Survey Graphic* (1936) and in Archibald MacLeish's *Land of the Free* (1938), as well as in numerous traveling exhibits. See Goldberg, *Power of Photography*, 137–40. The political and ideological power of the photograph was underscored by its ready acceptance in the artistic community as a masterpiece in its own right. Curtis reports that a version of the photograph published in *Survey Graphic* led to *U.S. Camera* identifying it as one of the "most significant photographs of the year," and in 1941 it was hung in the Museum of Modern Art. See Curtis, *Mind's Eye*, 67. In the 1950s it was part of Edward Steichen's The Family of Man exhibit, located in a section on nursing mothers and children "that came to be called 'Tits and Tots.'" Eric Sandeen notes that it was "not given a prominent spot." See Davidov, *Women's Camera Work*, 12 n117; and Eric J. Sandeen, *Picturing an Exhibit: The Family of Man and 1950s America* (Albuquerque: University of New Mexico Press, 1995), 69.

15 Roy Stryker and Nancy Wood, *In This Proud Land: America, 1935–43 as Seen in the FSA Photographs* (Greenwich, CT: New York Graphic Society, 1973), 19. The "Migrant Mother" is the single photograph on the cover of the book. Stryker's sentiment is commonly echoed in other sources as well. So, for example, George Elliott notes "'Migrant Mother' is famous because key people, editors and so on, themselves finding it inexhaustibly rich, have urged the rest of the world to look at it. This picture, like a few others of hers, like a few others of a few other photographers, leads a life of its own." George P. Elliott, *Dorothea Lange* (New York: Museum of Modern Art, 1966), 7.

16 Quoted in Maksel, "Migrant Madonna," 22. The image is available for purchase from the Library of Congress for fifty dollars, but in 1998 a "vintage" print of the image sold at auction for $244,540. William M. Landes, "Copyright, Borrowed Images and Appropriation Art: An Economic Approach," University of Chicago Law School John M. Olin Program in Law and Economics Working Papers, 113 (2d ser.), http://www.law.uchicago.edu/Lawecon/workingpapers.html.

17 Franklin Delano Roosevelt, "First Inaugural Address" in *The Public Papers and Addresses of Franklin Delano Roosevelt, Volume 2, The Year of Crisis, 1933*, comp. Samuel I. Roseman (New York: Random House, 1938), 11.

18 Numerous RA/FSA photographers, including Lange, Margaret Bourke-White, Arthur Rothstein, Russell Lee, John Vachon, and others made a practice of exploiting the irony of these NAM billboards displayed amidst scenes of economic depression and class difference. A number of these photographs were published in *Life* magazine in the mid-to-late 1930s. See Guimond, *American Photography and the American Dream*, 112–17; John Walker, "Reflections on a Photograph by Margaret Bourke-White," *Creative Camera* 167 (1978): 148–49.

19 On the general lack of attention to class issues and awareness in American politics, see Mary R. Jackman and Robert Jackman, *Class Awareness in the United States* (Berkeley: University of California Press, 1983), 214. For an excellent study of how "class" is discursively cloaked in U.S. public discourse, see Martin J. Burke, *The Conundrum of Class: Public Discourse on the Social Order of America* (Chicago: University of Chicago Press, 1995).

20 Curtis reports that "Lange related her composition to a cherished icon of Western art: The Virgin Mary in humble surroundings. Indeed, the Migrant Mother is often called Migrant Madonna." See *Mind's Eye*, 55. Marita Sturken and Lisa Cartwright demonstrate how this template can be developed critically, in *Practices of Looking: An Introduction to Visual Culture* (New York: Oxford University Press, 2001), 36–42.

21 John Pultz, *The Body and the Lens: Photography 1839 to the Present* (New York: Harry N. Abrams, 1995), 93.

22 On the center-margin relationship, see Gunther Kress and Theo van Leeuwen, *Reading Images: The Grammar of Visual Design* (London: Routledge, 1996), 203–12.

23 Birmingham Museum and Art Gallery, Birmingham, England, http://www.bmag .org.uk/. A digital artwork based on the "Migrant Mother" provides stark contrast to the sentimentality of the nineteenth-century lineage. The digital work places the iconic image behind a black-lined grid that is partially crossed by a purple zigzagging line. "A scanned 1936 vintage gelatin silver print from The Sandor Family Collection, 'Migrant Mother' by Dorothea Lange, juxtaposed with a computer generated icon of the Dow Jones graph from the 1929 stock market crash; a sketch for 'The Equation of Terror' installation." Stephan.com and Ellen Sandor, (art)n Laboratory, http://stephan.com/artn/?p=26. She seems to be caged, imprisoned by the structural fatality of the economy, with her fear another indicator of its violence.

24 See Kozol, "Madonnas of the Fields," 11 n30. Allan Sekula identifies a similar image from 1911 of a woman with two children. The photograph by Lewis Hine, which was titled *A Madonna of the Tenements* as it appeared on the cover of *Survey*, probably helped establish the conventional imagery and its "purely spiritual elevation of the poor." Sekula criticizes this "symbolist" photography "in the service of liberalism" for burdening the oppressed with a "bogus Subjecthood" and passive victimage. Allan Sekula, "On the Invention of Photographic Meaning," in *Photography against the Grain: Essays and Photo Works, 1973-1983* (Halifax: Press of the Nova Scotia College of Art and Design, 1984), 3–21. Sekula's contrast aligns resistance to liberalism with holding the line against metaphoric extension of the image. That alignment makes the most sense where he is focusing on the history of photography, that is, against the attempt to elevate photography to a fine art. The fact remains that one discourse

of artistic purity is replaced with another of documentary witness to the truth. Subsequent expansion of the realm of image circulation complicates not only aesthetic and spiritual auras but also the modernist norms of reportage. All are humbled as circuits of reproduction and appropriation allow images to oscillate continually between metonymy and metaphor, information and affect, fact and imagination, and the other poles of photographic meaning that Sekula identifies.

25 Kozol, "Madonnas of the Fields," 15.

26 Roosevelt, "First Inaugural."

27 The father is totally absent in mainstream narratives of Florence Thompson—the woman in the image—and only begins to appear at all in stories told by the family itself, such as at the Web site "Migrant Mother: The Story as Told by Her Grandson," at http://www.migrantgrandson.com/. Even in the family's story, however, the father is marginalized. As Geoffrey Dunn reports in a retrospective on the family, "By all accounts, Jim Hill [Florence's second husband; her first had died of tuberculosis] was a nice guy from a respectable family who never could seem to get his act together. 'I loved my dad dearly,' Norman Rydlewski [the baby in the photograph] said, but he had little ambition. He was never able to hold down a job.' The burden of supporting the family, and of keeping it together, fell on Florence." See Geoffrey Dunn, "Photographic License," *Santa Maria Sun*, Feb. 8, 2002, at http://www.newtimes-slo.com/archives/cov_stories_2002/cov_01172002.html.

28 Helen Pinkerton, "On Dorothea Lange's Photograph 'Migrant Mother' (1936)," in *A Formal Feeling Comes: Poems in Form by Contemporary Women*, ed. Annie Finch (Brownesville, Oregon: Story Line Press, 1994), 188.

29 The richness of the image is not exhausted by our analysis, of course. Liz Wells and Derrick Price use it to demonstrate how an image can reward eight different interpretive strategies. "Thinking About Photography: Debates, Historically and Now," in *Photography: A Critical Introduction*, ed. Liz Wells, 2nd ed. (New York: Routledge, 2000), 35–45.

30 Michael Denning, *The Cultural Front* (London: Verso, 1996), 137–38. Denning adds, "Though recent critics have attempted to recover its hidden narrative by identifying the woman, Florence Thompson, and situating the photograph as part of a series of photographs Lange took of Thompson, the image resists history." We explicate this tension later in the chapter and with regard to other icons. For a more cynical reading, see Paula Rabinowitz, *They Must Be Represented: The Politics of Documentary* (London: Verso, 1994), 87–88.

31 "John Szarkowski," in Janis and MacNeil, *Photography within the Humanities*, 95. Szarkowski adds, "It's interesting because the picture is almost totally ambiguous."

32 Ohrn claims that "Migrant Mother" is "probably the most frequently published photograph in the history of the medium." Ohrn, *Dorothea Lange and the Documentary Tradition*, xiv, 250, n56. This is an overstatement, and a stronger case be made for Joe Rosenthal's iconic photograph of the Iwo Jima flag raising, but it is not far off the mark. The photograph is commonly featured in histories of photography such as the PBS special on American photography anthologized in Vicki Goldberg and Robert Silberman, *American Photography: A Century of Images* (San Francisco: Continuum Books, 1999), 92, 100; and it is on the cover of Miles Orvell, *American Photography* (New York: Oxford University Press, 2003) and identified inside as "a celebrated icon of the Depression" (114–15). Often the image appears without comment or only with

the briefest caption, signs of its general recognition. It is commonly circulated as a (and often *the*) primary visual marker of the Great Depression and appears regularly as an illustration in museum exhibits, history and social studies textbooks, and on Web sites. For example, it is the lone image on the home page of "Photographs of the Great Depression" at http://history1900s.about.com/library/photos/ blyindexdepression.htm and the New Deal Network's lesson plan for eighth through twelfth graders on "The Great Depression and the Arts" at http://newdeal.feri.org/ nchs/lesson02.htm. In 2000 the U.S. Postal Bureau issued it as one of fifteen postage stamps celebrating the 1930s. Interestingly, all of the other stamps in the set are captioned with purely referential designators (e.g., President Franklin Delano Roosevelt; Empire State Building; Jesse Owens, Six World Records; The Monopoly Game), whereas the "Migrant Mother" is identified by the didactic caption "America Survives the Depression." When questioned about this label, Horace Hinshaw of the U.S. Postal Service noted that "the stamp isn't honoring the people it depicts but rather the event: the Depression era." See Elizabeth Partridge, "Migrant Mother—Icon or Person?" at http://www.elizabethpartridge.com/icon_rs.html. The photograph is also readily available for purchase as a poster through commercial sellers such as History Through a Lens, where it also is the titular image for the series at http://www .creativeprocess.net/moreposters/history/hlens.html#migrantmother. Robert Silver has made a photomosaic of the image using thousands of images from the FSA collection at http://www.joecarey.com/images/scrapbook/mosaic_migrant_mother.jpg. Perhaps one of the most telling signs of its significance to collective memory is the way in which it has become the standard against which other photographs (and other cultures) are measured, as when Steven McCurry's photograph of the Afghan girl that appeared on the cover of *National Geographic* in 1985 is said to have "become the Migrant Mother of her generation." See Nathan Hogan, "Face of Asia: Steve McCurry Photographs," *Afterimage* (July–Aug. 2003) online at http://www.findarticles.com/p/ articles/mi_m2479/is_1_31/ai_113683513.

33 Art in America, Migrant Mother, http://www.artsmia.org/art_in_america/21_1.html. This URL is not longer active but is cached at Google.

34 The Black Panther artist was Malik, and her drawing titled "Poverty Is a Crime" appears on the back cover of the *Black Panther's Newsletter*, vol. 9, no. 8 (Dec. 7, 1972). Reprinted in Heyman, "Migrant Mother as Icon," 61; Goldberg, *The Power of Photography*, 141; Wells, *Photography: A Critical Introduction*, 145; Janis and MacNeil, *Photography within the Humanities*, 40; and Davidov, *Women's Camera Work*, 5.

35 Other examples include a 1939 lithograph by Diana Thorne, "Spanish Mother, the Terror of 1938," and a cover illustration for *Bohemia Venezolana* (May 10, 1964). These can be seen in Goldberg, *Power of Photography*, 140–41; and Janis and MacNeil, *Photography within the Humanities*, 40. See also Davidov, *Women's Camera Work*, 5.

For another variation on the use of the photograph to visualize a different mode of victimization, see the adaptation used by Mothers of Lost Children on its Web site home page at http://www.mothers-of-lost-children.com. The term "structure of feeling" comes from Raymond Williams, *The Long Revolution* (New York: Columbia University Press, 1983). Two interrelated ideas are involved. First, emotions acquire an internal differentiation and general coherence that reflects the patterns of experience that have developed over time in community interaction. Second, this patterning of affective response is articulated in an intermediate realm of cultural performance

that is not identical with either lived experience or institutional discourses. We are particularly interested in how such structures of feeling can cohere in and be transmitted through forms of public address. See James Arnt Aune, *Rhetoric and Marxism* (Boulder: Westview, 1994), esp. 98–101.

36 See "An Ethnic Albanian Woman Feeds Her Baby as She Walks into Macedonia Last Week," *Time*, April 12, 1999. Other variations online include "Migrant Mother Delivers Baby in Open" *Tribune* [online edition, Chandigarh, India], Jan. 9, 2002, at http://www.tribuneindia.com/2002/20020109/punjab.htm.

37 Chim (aka David Seymour), "Land Distribution Meeting, Estremadura, Spain, 1936," in *Chim: The Photographs of David Seymour* (New York: Little Brown, 1996). The image is available online at http://museum.icp.org/museum/collections/special//chim/chim2.html. This image, taken from a public meeting prior to the Spanish Civil War, is sometimes captioned as if taken during an air raid on the city, a republican stronghold.

38 Associated Press, *Los Angeles Times*, Nov. 18, 1978, 1, 12.

39 While the photograph may have not done Florence Thompson any economic good, it has apparently been of some benefit to her grandson, Robert Sprague, who presents "The Second Trail of Tears (The Migrant Mother Story)" for a fee. The presentation emphasizes "the true story . . . of [the]woman and her struggles in life. A woman that 'never' gave up hope for the future, who overcame whatever the world tossed in her path." One can also purchase "Migrant Mother T-Shirts" emblazoned with the caption "Second Trail of Tears" for $19.36, online at http://www.migrantgrandson.com/products.htm.

40 In this context, too, note how Thompson implies a critique of the authenticity of the image when she claims that Lange got it wrong in her field notes: "There's no way we sold our tires, because we didn't have any to sell," she told this writer. "The only ones we had were on the Hudson and we drove off in them. I don't believe Dorothea Lange was lying, I just think she had one story mixed up with another. Or she was borrowing to fill in what she didn't have." See Dunn, "The Heart of a Woman."

41 It is interesting to note the strong critique of Thompson that has emerged from photographers and critics alike, all calling attention in various ways to the "larger than life" meanings of such photographs as they become part of the common culture. This in itself is not such an odd position for artists and historians to take, but it does raise questions about the ways in which such discourse papers over ideological contradictions. See, e.g., Martha Rosler, "In, Around and Afterthoughts (on Documentary Photography)," in *The Contest of Meaning: Critical Histories of Photographs*, ed. Richard Bolton (Cambridge: MIT Press, 1989), 303–42.

42 The story is related in Curtis, *Mind's Eye*, 67. See *New York Times*, Aug. 24 and Sept. 17, 1983, and *Los Angeles Times*, Sept. 17, 1983.

43 The picture is from Bill Ganzel, *Dust Bowl Descent* (Lincoln: University of Nebraska Press, 1984), 31. See also Netonline, American Photography, "An Interview with the Migrant Mother," *http://net.unl.edu/artsFeat/ap_migrantmother.html* (the original photo is shown and the second described); Theresa Novak, "Most poor people don't stay that way," *A Portrait of Poverty in Oregon* at http://eesc.orst.edu/agcomwebfile/edmat/html/em/em8743/part3/mostpoor.html (both pictures are shown); "Migrant Madonna," *Smithsonian* (March 2002): 22.

44 On the visual syntax of "demand" and "offer," see Kress and van Leeuwen, *Reading Images*, 121–30.

45 An April Fool's spoof in *Popular Photography and Imaging* shows the risks involved in playing with the "Migrant Mother." The spoof consisted of giving the icon a "make-over" so that she could fit into contemporary magazine advertising; two other classic photos received equally outrageous treatment. The altered icon was a clever contrast of contemporary superficiality with documentary witness, but "hundreds" of readers, predictably, were highly offended. The spoof appeared in the April 2005 issue (40). Subsequent editorial commentary (". . . I can't believe you guys would stoop so low!") and a sampling of the letters are at http://www.popphoto.com/article .asp?section_id=5&article_id=1303.

46 Margaret Dawson takes photos of her Uncle Hugh in many guises, recreating famous works from photography's history, including Lange's "Migrant Mother." See Margaret Dawson, *The Men from Uncle* (Christchurch: Jonathan Smart Gallery, 1998) and online at http://www.photospace.co.nz/books/lange150x200.jpg. Kathy Grove airbrushes the "dirt and worry" as a critical comment on both the sentimentality of the original image and a critique of the conventional, visual representations of woman as an object of desire, online at http://academic.hws.edu/art/exhibitions/laughter/ l2h.html.

47 "A Place Called America," directed and produced by Linda Bloodworth-Thomason (Mozark Productions, 1996). The film was shown on national television during the Democratic National Convention.

48 This juxtaposition of images with seemingly very different moral tones may be emblematic of fantasy in a consumer society. For another example, see the Pictures link at the personal Web site John's Sphere, http://john.jrcorps.com/index.php?id =169. The Pictures section is "devoted to priceless art I find." Only two pictures are there: the "Migrant Mother" and a photo of a red "Ferrari Enzo, my dream car" posed against an Arctic landscape.

49 *Nation*, Jan. 3, 2005.

50 Stephen Kling, personal e-mail correspondence with authors, Dec. 20, 2004. Note how this description suggests something like a syntax for iconic appropriation. The image refers to a recurrent historical process and the alteration provides the explanatory clause.

51 Examples include striking allusions to the original, such as the black and white pencil drawing of it by J. D. Hillbury, "Excerpt from Photograph 'Migrant Mother, Nipomo California' by Dorothea Lange" available at the Gallery by the Cemetery, http://www.gallerybythecemetery.com/oldwoman.htm. See also Dixie Earl Bryant's poem "Keep Your Chin Up," which is accompanied by a version of the photograph that eliminates the background and incorporates a red, yellow, and green rainbow, online at http://www.wakandaswar.8m.com/chinup.htm. Other examples include the garden-variety conventions of ordinary public address. Thus the story of Lange's photo shoot becomes a morality tale on the theme of small initiatives making a difference to others, as in a sermon by Dr. Linda McCoy, "Look Where You Can Reach," Jan. 20, 2000, The Garden, St. Luke's United Methodist Church, http://www .the-garden.org/SA/02-20-00.htm.

52 For a biographical interview of Alfred Eisenstaedt, see John Loengard, *Life: Photographers and What They Saw* (Boston: Little, Brown, 1998), 12–31. For an online biographical sketch, see "Life Remembers Eisie: Over 50 Years of Putting Our Lives in Pictures," at http://www.life.com/Life/eisie/eisie.html. The *Digital Journalist* special issue on

Eisenstaedt, "The Photojournalist of the Century" (Dec. 1999), includes four photo galleries of his work; the Times Square Kiss is the titular image for the first gallery, which is entitled "Icons," http://www.digitaljournalist.org/issue9911/eisieintro.htm.

53 "Victory Celebrations," *Life*, Aug. 27, 1945, 21.

54 George H. Roeder, Jr., notes that civilians had been encouraged to see V's in everyday life as reminders of the war effort. "*U.S. Camera* and the British-American Ambulance Corps sponsored a contest in which they asked for photographs documenting that wherever the engaged eye looked it could find the "V" form used to predict Allied victory. The entries, which captured V's in the way a book opened and a tree branched, in the ornamentation of a cast-iron fence, and in many other familiar objects, encouraged viewers to seek out this symbol in their own daily visual experience." *The Censored War: American Visual Experience during World War Two* (New Haven: Yale University Press, 1993), 63.

55 "The Men of War Kiss from Coast to Coast," *Life*, Aug. 27, 1945, 26. Note also the observation that the convention of posing kisses was already well established. This is another reason why one should know better than to claim that the photo was posed. As with most iconic shots, however, this one also has been accused of being fabricated, most recently in a guest editorial printed in the *Wall Street Journal*. See George Byron Koch, "An Old Sailor Confesses," *Wall Street Journal*, Aug. 14, 1996, A12. A response by Life managing editor Daniel Okrent appears in a letter to the editor, Aug. 20, 1996, A11. See also Ian Katz, "Media Guardian: Kiss and Tell . . ." *Guardian*, Aug. 19, 1996, T15.

56 This poster is available at numerous Web sites. We found it at www.art.com.

57 "100 Sexiest Turn-ons. . . EVER!" handbag, http://www.handbag.com/galleries/gallery/Sex/rels_sexiest100/MemberID=1/.

58 "Lucky Girl," *Modern Bride*, Dec.–Jan. 2003, 60. In this appropriation the photograph is recast as an illustration that has been antiqued to create the impression that it is old and worn. The sailor has become a soldier (and a sergeant!), the nurse is arching upward with great yearning, their hands are further along, and passersby are nowhere to be seen, but the uniforms, blocking, and New York street scene (the Empire State Building appears in the hazy skyline) leave no doubt where the pose came from. Perhaps most interesting is that the kissers are no longer white, their skin vaguely tinted to suggest an African American ethnicity.

59 "Great Big Kiss," HeraldTribune.com, http://www.heraldtribune.com/apps/pbcs.dll/article?AID=/20051112/NEWS/51112001/-1/INDEPTH, Jan. 28, 2006. The work by J. Seward Johnson, Jr., was one of twenty-seven pieces at the Third Invitation Exhibition of Monumental Works of Art, Sarasota Bayfront Park, Sarasota, Florida.

60 For exposition of the relationship between the literary *mythoi* of romance and comedy, see Northrop Frye, *Anatomy of Criticism: Four Essays* (Princeton: Princeton University Press, 1957), 163–206.

61 Paul Arbor, syndication manager of Life Picture Sales reports that "[Times Square Kiss] is now one of the three most famous pictures published in *Life*." See Abigail Van Buren, "The Unknown Kisser of World War II," *Dallas Morning News*, May 25, 1994, 13C. Time, Inc., goes further in asserting that it is one of their "most valued commodities" (reported by Laura Giammarco, Time, Inc., in a phone conversation with the authors, Dec. 8, 1997). Time-Life, apparently not trusting collective memory to work by itself, continues to promote the image. In 2005, they announced "The Search for

the Perfect Kiss Contest" on the sixtieth anniversary of the photograph. "LIFE maga-zine's Times Square kiss—perhaps the most famous kiss of all time. This romantic embrace has inspired generations of Americans in love. LIFE and the Today Show are looking for the next iconic kiss. Could it be yours?" *Life*, Sept. 16, 2005, inside back cover and http://www.life.com/Life/perfectkiss/. The iconic image is juxtaposed with a twenty-something couple kissing in front of a European-looking cathedral, providing a complete displacement of the original time, place, and context. Liberal-ism becomes the dominant discourse as the image is twice privatized through *Life*'s proprietary claim regarding the photograph and by redefinition into an exclusively private life of romance and consumption. Nor does Time/Life want to see its valued commodities left behind by the digital revolution: so it is that the January 28 2005 *Life* magazine cover story on "The Cameraphone Revolution" had on the cover two copies of the Kiss image, one as a slightly blurry full-field background to the smaller but sharper image that was on the screen of the cameraphone held in the foreground of the picture.

62 "Reliving History: GI's . . . Massive Homecoming Continues," *USA Today*, Aug. 27, 2004. *Life Celebrates 1945: The Old Order Dies, A New America Is Born*, special collectors edition, 2001. "Japan Is Still Struggling for Words," *Independent*, Aug. 15, 1945, which uses the image to signal the end of the war and reports "the moment, captured by photographer Alfred Eisenstaedt . . . is now synonymous with the end of the Second World War." It was foregrounded in the Price of Freedom exhibition that opened at the Smithsonian Institution on November 11, 2004, and in same day overage by the *New York Times*.

63 The issue can be seen at Naval War College, V-J Sailor, http://www.nwc.navy.mil/museum/VJDaySailor/. All the stamps have been set back in time by being illustra-tions rather than photographs. Oddly, the series is "Famous Personalities Who Went to War." The other stamps in the set feature named individuals, yet the central image used to sell the set is that of the anonymous couple. Obviously, the figures in the photograph are considered to be as famous as if they were celebrities. Perhaps to compensate for the couple's anonymity, the few smiling people in the photograph have been replaced in the ad for the series by an exuberant throng in Times Square who appear to be looking up and cheering the kiss.

64 "The Kiss in Times Square Puzzle" is licensed by The History Channel and sold at numerous Web sites. A related example is a television ad on A&E for the History Channel: Set against a black and white video of crowds cheering and celebrating, in the middle of the screen—in color and apparently superimposed into the scene—a sailor and a woman kiss in the familiar pose. An intertitle follows in two stages: "In 1945 World War II ended. . . . And then the baby boom began" (viewed Oct. 6, 1998). Other examples include an e-card that can be sent from World War II History Info, http://www.WorldWar2History.info/e-cards/; the album cover for Charlie Haden's *Now Is the Hour* (Polygram Records, 1996); and reproductions on various and sundry products such as backpacks, pocketbooks, lunchboxes, and T-shirts.

65 "Time Square Kiss" has been used frequently by the History Book of the Month Club and in a more recent advertisement we find a full page, 5" × 7" version of the image tinted in blue with the words "The American Experience" inscribed across the arc of the woman's back.

66 Our copy of the ad comes from *Glamour*, vol. 96, no. 1 (Oct. 1998), 225.

67 This combination of giving an aristocratic inflection to lower middle-class market-
ing is evident in a more recent appropriation of the iconic image for a major retailer's
advertising. On November 4, 2002, Target ran a full-page ad in the *New York Times*
that featured the iconic template through a series of transpositions that also updated
it. The woman is still in a white uniformlike dress, but now she is in the dominant
position of giving out the kiss. The man, who now is the one leaning backwards, is
in a sailorlike uniform, except now it is Target red with white Target insignia on the
cuffs and scarf. The rest of the scene remains in black and white and reproduces other
features of the original background, but, again, with a difference. The sailor on the
left becomes a woman walking with exactly the same posture and smile on the right.
The women smiling approvingly on the left become a heterosexual couple with more
appraising gazes on the left. The classical lines of the building have been brought in
closer and whitened, making the scene, like the passerby's clothing, at once more
European and less identifiable by place. Across the entire ad, the sharp contrasts of
black and white photography have been bleached out into a uniform gray tint. The
implication must be that Target, though still inexpensive and egalitarian, was now
moving upscale and ready to be taken up by a more affluent and sophisticated con-
sumer who is free to enjoy a product line that reflects both good value and sassy taste.

68 Viewed Feb. 18, 1998.

69 Lauren Berlant and Michael Warner, "Sex in Public," *Critical Inquiry* 24 (1998): 547–66.

70 *New Yorker*, vol. 17, no. 16 (June 17, 1996). For another variant of the gay sailors kissing,
see the cover of Gary L. Lehring, *Officially Gay: The Political Construction of the U.S.
Military* (Philadelphia: Temple University Press, 2004).

71 As with many appropriations of iconic images, the connection with the accompany-
ing verbal text is oblique. There is a reference within the issue to whether Clinton
would sign a legislative act directed against gay marriage, but that's a minor remark
with no textual or graphic connection to the cover. The more likely precipitate is that
June is Gay Pride Month and the occasion for a parade down Fifth Avenue.

72 The management of strangeness and familiarity within both the public sphere
(the kiss takes place on the street) and within the popular media might also mark
this as an additional example of what Lucaites and McDaniel refer to as "carnival-
hegemony," a manifestation of the democratic aesthetic that operates at the point
of collision between sameness and difference. See John Louis Lucaites and James P.
McDaniel, "Telescopic Mourning / Warring in the Global Village: Decomposing
(Japanese) Authority Figures," *Communication and Critical/Cultural Studies* 1 (2004):
22–24.

73 For another variant that has something of an international resonance, see Cam
Cardow's editorial cartoon in the *Ottawa Citizen*, April 11, 2003. Published less than
two weeks after the beginning of the U.S.-led invasion of Iraq, we find a character
who might well be Saddam Hussein in the position of the sailor, kissing a U.S. soldier
in the position of the nurse, with the word "INCOMING!" being shouted in the back-
ground. On the same day Mike Ritter's cartoon in the *Tribune of Arizona* showed an
Iraqi citizen in a sailor's cap kissing the Statue of Liberty.

74 Guzman, "Love in the Streets (1993)," in Alice Harris, *The White T* (New York:
HarperStyle, 1996)

75 Mirko Ilis, 2004, brochure for the Massachusetts Lesbian and Gay Bar Association Family Law Section.

76 "Warm Welcome, Norfolk, VA, April 29," *Baltimore Sun*, Dec. 31, 2003, 5E.

77 On the relationship between "play" and culture, see Johan Huizinga, *Homo Ludens: A Study of the Play Element in Culture* (Boston: Beacon Press, 1950); Hans Georg-Gadamer, *Truth and Method* (New York: Continuum, 1975), 91–118; and Richard Schechner, *Performance Theory* (New York: Routledge, 1988), passim.

78 *The Simpsons*, "Bart the General," written by John Swartzwelder, directed by David Silverman, Feb. 4, 1990.

79 "Edith Shain Says She's the V-J Day Nurse," *Life* (Aug. 1980). This story is posted with "The Smack Seen Round the Round 1945," "Would-Be Kissers 1995," and "11 Sailors & 3 Nurses Say They're the True Smoochers" at Life, V-J Day Kiss: Fifty Years Later, http://www.life.com/Life/special/kiss01.html.

80 V-J Day in Times Square Sixtieth Anniversary, "A Call to Arms . . . and Lips!" http://www.timessquarenyc.org/about_us/events_vjday.html.

81 Edith has played her role in other carnivals, including the 2005 West Hollywood Gay Pride Parade. Photos can be seen at Paparazzi Time: Minor Celebrities and Major Oddities, http://apavliko.tripod.com/WEHOparade/index.album?i=10.

82 *New York Times*, Aug. 15, 2005, B3. Photo by Mario Tama/Getty Images. The photo accompanied the report by Andrea Elliott, "V-J Day Is Replayed, but the Lip-Lock's Tamer This Time." The photo then became the image for the story "Our Own V-J Day" in *Advocate*, www.advocate.com, Sept. 27, 2005.

83 One reason to believe that the scene evokes a vital public culture is that it already is contested. For example, during a segment of *The Daily Show with Jon Stewart*, commentator Lewis Black notes how "one of the most iconic image[s] of [the] era" has been "colorized" and [now] "creepified" by being made into a statue in Times Square. Indeed, not only do "Americans love a good war," but they take special pleasure in romanticizing WWII as the "feel good war of the century." Black closes by noting that "no Times Square tourist is going to pose to have a picture taken with this sculpture," displaying a figurine of Lynndie England of Abu Ghraib fame leaning forward and giving the thumbs up. "Back in Black," *The Daily Show With Jon Stewart*, Comedy Central, Aug. 18, 2005.

84 Diane C. Dado, "Sailor's Loose Lips Launch Long-Lasting Kiss Mystery," *Chicago Tribune*, Aug. 12, 2005, 23.

85 VJ Day Sailor, http://www.nwc.navy.mil/museum/VJDaySailor/. This later captioning of the iconic image is discussed further in subsequent chapters.

86 But don't tell that to George: "'When I hear someone else trying to get credit for it, my blood boils,' Mendonsa said. 'I want that identification.'" "Scan Suggests Ex-Sailor was WWII Smoocher," ABC News, http://abcnews.go.com/GMA/Technology/story?id=1036576.

87 Vernacular appropriation can include harsher forms of faux remembrance. One example is a poem that works off of both the icon and the disposition to put oneself into the picture:

> Streets teeming with girls and drunken fools
> like me. I never thought I'd see the sun
> sink into the stinking ocean. I've been

cutting mines—they were metal plums. (Scratched
my mark—thrown overboard and taught to swim.)
This is what reward? I grab a woman
being kissed by a woman and kiss her
more. In March I cradled a man's head in
my arm. I took it, held it up high
and plainly told the world to screw itself.

John Ball, "Self-Portrait as the Sailor in Eisenstaedt's 'Kiss,'" http://www.happyrobot
.net/words/tvmovierights.asp?r=5639.

88 Note Secretary of State Madeleine Albright's skillful use of the kiss icon (and other
visual allusions) to illustrate this narrative. "Graduations are unique among the
milestones of our lives, because they celebrate past accomplishments, while also
anticipating the future. That is true for each of the graduates today, and it is true for
the United States. During the past few years, we seem to have observed the 50th anni-
versary of everything. Through media and memory, we have again been witness to
paratroopers filling the skies over Normandy; the liberation of Buchenwald; a sailor's
kiss in Times Square; an Iron Curtain descending; and Jackie Robinson sliding
home." Harvard University commencement address, June 5, 1997, available at Gifts of
Speech, http://gos.sbc.edu/a/albright3.html.

89 The use of the photo to advertise a production of *Much Ado about Nothing* cashes in
on this structure of feeling. The play is "re-imagined in America at the end of WWII"
and scored with "big band sounds of the 1940's" [sic]. The iconic photo ensures that
the potential ticket buyer will know that "romance will be in the air." Northwestern
University Theatre & Interpretation Center brochure, 2004–2005 season.

90 *The Wonder Years*, "Daddy's Girl," episode no. 45, directed by Jim McBride, original
broadcast May 8, 1990.

91 Note also the consistency of this episode with larger tendencies in American col-
lective memory. As identified by John Bodnar, they include the shared experiences,
emotional bonds, and local scale of vernacular practices, and the institutional obliga-
tions, idealized abstractions, and national scale of official rhetorics. As Bodnar sum-
marizes, "political issues were not entirely about economic power, military agendas,
or class and status issues, but were also about the small-scale realm of personal
and communal anxieties and feelings or what George Lipsitz called the 'emotions
close to home.' . . . Regardless of the number of forums that existed or the complex-
ity of communication over the past, however, the dialogic activity examined here
almost always stressed the desirability of maintaining the social order and existing
structures, the need to avoid disorder or dramatic change, the dominance of citizen
duties over citizen rights, and the need to privilege national over local and personal
interests." *Remaking America: Public Memory, Commemoration, and Patriotism in the
Twentieth Century* (Princeton: Princeton University Press, 1992), 246; see also George
Lipsitz, *Time Passages: Collective Memory and American Popular Culture* (Minneapo-
lis: University of Minnesota Press, 1990), xiv. The episode's suturing of vernacular
and official rhetorics may have been helped by its assemblage of the visual media of
iconic photograph, home movie, and television.

92 John Louis Lucaites, "Visualizing 'the People': Individualism and Collectivism in
Let Us Now Praise Famous Men," *Quarterly Journal of Speech* 83 (1997): 269–88.

93 One might say that iconic photographs become leading examples of what Cara Finnegan identifies as "image vernaculars," that is, "the enthymematic modes of reasoning employed creatively in particular visual cultures" to articulate collective political identity and morality. An image vernacular consists of the conjunction of photography and particular habits of perception taken from other arts and discourses popular in a given historical period. Finnegan offers as one example photography's conjunction with portraiture and physiognomy in nineteenth-century America. Cara A. Finnegan, "Recognizing Lincoln: Image Vernaculars in Nineteenth-Century Visual Culture," *Rhetoric and Public Affairs* 8 (2005): 31–58.

94 Hans Blumenberg, "An Anthropological Approach to the Contemporary Significance of Rhetoric," in Kenneth Baynes et al., *After Philosophy: End or Transformation?* (Cambridge: MIT Press, 1987), 429–58.

CHAPTER FOUR

1 Karal Ann Marling and John Wetenhall, *Iwo Jima: Monuments, Memories, and the American Hero* (Cambridge: Harvard University Press, 1991), 72. For a representative sample of how it was initially presented in newspapers, see *New York Times*, Feb. 25, 1945, 1; *Los Angeles Times*, Feb. 25, 1945, 1; *Washington Post*, Feb. 25, 1945, 1; *St. Louis Post-Dispatch*, Feb. 25, 1945, 1; and *Chicago Tribune*, Feb. 25, 1945, 1: 10.

2 James Bradley (with Ron Powers), *Flags of Our Fathers* (New York: Bantam Books, 2000), 220.

3 "Photographer Gets Praise for War Job," *New York Times*, Feb. 25, 1945, 22.

4 "Arms, Character, Courage," *Time*, March 5, 1945, 15.

5 "Art from Life in Defiance of Death," *Times-Union*, Feb. 27, 1945, cited in Marling and Wetenhall, *Iwo Jima*, 77.

6 A. B. R. Shelley, letter to the editor, *New York Times*, March 12, 1945, 18.

7 For the role that the photograph played in the Seventh Bond Drive, see Marling and Wettenhall, *Iwo Jima*, 102–21, and Bradley, *Flags of Our Fathers*, 281–95. On the issuance of the postage stamp, see Marling and Wettenhall, *Iwo Jima*, 92–94, and Sol Glass, *United States Postage Stamps: 1945–1952* (West Somerville, MA: Bureau Issues Assoc., n.d.), 18.

8 Hal Buell, *Moments: The Pulitzer Prize-Winning Photographs—A Visual Chronicle of Our Time* (New York: Black Dog and Leventhal, 1999), 21–23. The "prize value" of the icon is demonstrated by being the only image shown with a report on a ranking of the top stories in American journalism, even though other images were ranked higher. The caption says, "A panel of experts voted Joe Rosenthal's photo of Marines of the 28th Regiment of the Fifth Division raising the American flag atop Mt. Suribachi, Iwo Jima, as one of the top 100 works of American journalism in the 20th century." Richard Pyle, "Panel Votes on Best American Journalism," *Augusta Chronicle* (posted March 3, 1999), http://www.augustachronicle.com/stories/030399/fea_124-6154 .shtml.

9 Joe Rosenthal with W. C. Heinz, "Picture That Will Live Forever," *Collier's*, Feb. 18, 1955, 62; Harold Evans, *Pictures on a Page: Photojournalism, Graphics, and Picture Editing* (London: Heinemann, 1978), 147 (caption); Vicki Goldberg, *The Power of Photography: How Photographs Changed Our Lives* (New York: Abbeville Press, 1991), 143.

10 The examples here are almost too numerous to list. The photograph appeared promi-

nently in President Bill Clinton's 1996 campaign film shown on national television during the Democratic National Convention: *A Place Called America*, directed and produced by Linda Bloodworth-Thomason (Mozark Productions, 1996). Elite textual references include Madeline Albright, Secretary of State, Condon-Falknor Distinguished Lecture, University of Washington School of Law, Seattle, WA, Oct. 29, 1998, and Chief Justice William Rehnquist, dissenting, *Texas v. Johnson* 109 S. Ct. 2550 (1989). For its use in editorial cartoons, see Janis K. Edwards and Carol L. Winkler, "Representative Form and the Visual Ideograph: The Iwo Jima Image in Editorial Cartoons," *Quarterly Journal of Speech* 83 (1997): 269–89.

11 Marling and Wetenhall, *Iwo Jima*, 8.

12 Marines will bristle at being called "soldiers," which groups them with the Army. We often use the generic term throughout this chapter as that better represents how many people see the photo and how it is used outside of the Marine Corps.

13 George H. Roeder, Jr., *The Censored War: American Visual Experience during World War Two* (New Haven: Yale University Press, 1983), 80.

14 Paul Fussell, "Images of Anonymity: World War II in Black and White," *Harper's*, Sept. 1979, 77.

15 This body-object articulation is also a disciplinary technique that has numerous instantiations in civilian life. Although amidst the lack of ceremony characteristic of the battlefield, the Marines' coordinated action still provides a "rhetoric of honor" maintaining military prestige while resonating with disciplinary norms throughout civil society. Michel Foucault, *Discipline and Punish: The Birth of the Prison*, trans. Alan Sheridan (New York: Vintage, 1979), 135, 153–54.

16 Display was one motive of the officer who ordered the flag raising. The flag in the photo is the second one raised that day on Mount Suribachi. The second flag raising was conducted so that 2nd Battalion could retain the original flag as a souvenir. The order to substitute flags also specified that a bigger flag should be used, and the men raising it were told that it was so everyone on the island could see it. As it happened, the first flag raising produced a large, spontaneous celebration by the troops on land and sea, while the second went largely unnoticed at the time. See Bradley, *Flags of Our Fathers*, 207–9; and the *Heroes of Iwo Jima*, a History Channel documentary originally broadcast on the A&E Television Network on June 17, 2001.

17 *New York Times*, Feb. 28, 1945, 3. It was displayed along with five other photographs of the landing and invasion of Iwo Jima.

18 The importance of the transparency of the image is evident from a controversy that has hounded the photograph from the beginning. Was this a "real" flag raising or a reenactment performed for the camera? Concerned that it might be posed, both *Time* and *Life* initially refused to publish the photograph. *Time* recanted the following week (March 5, 1945), but the photograph did not appear in *Life* until a full month later (March 26, 1945) when it reported that the flag raising had become "one of the most talked about pictures of the war" (17). The claim that the photograph was a reenactment continues to linger in popular lore, though for all of that it doesn't seem to have had any measurable impact on popular reception of the image or its emotional power and resonance. Repetitions of the legend by those who should have known better include John Szarkowski, who calls it a "setup" in his introduction to *From the Picture Press* (New York: Museum of Modern Art, 1973), 4, and Susan Sontag, *Regarding the Pain of Others* (New York: Farrar, Straus, and Giroux, 2003), 56. For a

more detailed account of the controversy see Rosenthal, "Pictures That Will Live Forever"; Tedd Thomey, *Immortal Images: A Personal History of Two Photographers and the Flag Raising at Iwo Jima* (Annapolis: Naval Institute Press, 1996), 168–75; Marling and Wetenhall, *Iwo Jima*, 77–78; and Bradley, *Flags of Our Fathers*, 235–36.

19 Fussell, "Images," 77.

20 Buell, *Moments*, 23.

21 Roeder, *Censored War*, 43–66.

22 Bradley, *Flags of Our Fathers*, 342.

23 See, e.g., *Time*, March 5, 1945, 15; *Life*, March 26, 1945, 17.

24 We are assuming here that "nationalism" is a more descriptive term than the euphemistic "patriotism." See Michael Billing, *Banal Nationalism* (London: Sage, 1995), 55–59.

25 Benedict Anderson, *Imagined Communities: Reflections on the Origins and Spread of Nationalism* (London: Verso, 1983). See also Anthony Giddens, *The Nation-State and Violence* (Berkeley: University of California Press, 1985), esp. 209–21. On the importance of visual media in constituting the imagined community, see Michael J. Shapiro, *Methods and Nations: Cultural Governance and the Indigenous Subject* (New York: Routledge, 2004), esp. 105–204.

26 Thus, this chapter might be one small addition to "a growing body of literature that revisits American nationalism—'the political doctrine that dares not speak its name,' in Michael Lind's apt phrase—as more typical than atypical of how disparate, local communities and social groups imagine themselves part of a national family." Cecilia Elizabeth O'Leary, *To Die For: The Paradox of American Patriotism* (Princeton: Princeton University Press, 1999), 3. "Family" was not originally a part of the Iwo Jima image, but that metaphor is now employed by James Bradley as a back story for the icon on behalf of a conservative politics. See Bradley, *Flags of Our Fathers*. See also our discussion in chapter 8 of the use of the family metaphor by Ronald Reagan and NASA to restore quiescence after the *Challenger* explosion.

27 The locus classicus of this relationship in visual studies is Roland Barthes's example of the photograph on a *Paris Match* cover of "a young Negro in a French uniform [who] is saluting, with his eyes uplifted, probably fixed on a fold of the tricolour." *Mythologies*, trans. Annette Lavers (New York: Hill and Wang, 1972), 116. (The cover can be seen at Daniel Chandler, Semiotics for Beginners, Denotation, Connotation and Myth, http://www.aber.ac.uk/media/Documents/S4B/sem06.html.) In Barthes's explanation, history is converted into a myth that fixes the meaning of the image; thus, the iconic image would be merely a paradigmatic example of the prior order of signification. Note that in Barthes's example the flag doesn't have to be shown, a point in favor of the semiotic explanation, yet one that also demonstrates a degree of interpretive response. That interpretive supplement is not the strong argument against this position, however. As we hope to show, both the design and circulation of iconic images confound the idea that they have fixed meanings determined by a dominant order of signification.

28 Kenneth Burke, *A Grammar of Motives* (Berkeley: University of California Press, 1969), 506. Burke goes on to note that "human relations require actions, which are *dramatizations*," and "the essential medium of drama is the posturing, tonalizing body placed in a material scene" (506–7).

29 Raymond Firth identifies how the rise of nationalism includes the shift from using flags as signs to their incarnation as symbols, in *Symbols: Public and Private* (London: George Allen & Unwin, 1973).

30 Fussell, *Images*, 77.

31 Robert Hariman, *Political Style: The Artistry of Power* (Chicago: University of Chicago Press, 1995), 128–29.

32 See Christina S. Jarvis, *The Male Body at War: American Masculinity during WW II* (DeKalb: Northern Illinois University Press, 2004), 3–4.

33 Hariman, *Political Style*, 131, 132.

34 The extent to which this monumental quality comes from the photographic medium can be discerned easily by comparison with the motion picture film taken of the flag raising at the same time by a camera operator who was standing beside Rosenthal. In the film, the flag goes up quickly and effortlessly; blink and you miss it. The action is too quick and too easy and over before any sense of significance can register. The clip can be seen in the newsreel, United News, Marines Raise Flag Over Iwo Jima, 1945, National Archives and Records Administration, http://video.google.com/videoplay?docid=-634212782694418867&q=39054.

35 On the importance of "vernacular culture" to the development of public memory and especially to U.S. patriotism, see John Bodnar, *Remaking America: Public Memory, Commemoration, and Patriotism in the Twentieth Century* (Princeton: Princeton University Press, 1992), 13–20.

36 Hariman, *Political Style*, 129.

37 Following the battle for Iwo Jima, Admiral Chester A. Nimitz summed up the Marine effort in a communiqué dated March 16, 1945: "Among the Americans who served on Iwo island, uncommon valor was a common virtue." Later it was inscribed on the base of the Marine Corps Memorial, and it appears as the caption to a number of the appropriations of the photographic image. Cited in Marling and Wettenhall, *Iwo Jima*, 1. See also Bradley, *Flags of Our Fathers*, 327; and Hal Buell, *Uncommon Valor, Common Virtue: Iwo Jima and the Photograph That Captured America* (New York: Berkley Caliber Books, 2006).

38 Marling and Wetenhall, *Iwo Jima*, 125.

39 The Ted Williams Museum moved from Hernando, Florida, to Tropicana Field in St. Petersburg, Florida, on April 10, 2006. We do not know if the memorial photograph made the trip.

40 *Texas v. Johnson* 109 S. Ct. 2550 (1989), Chief Justice Rehnquist, dissenting. Goldberg reports that Congressman Ron Marlenee called that decision "'a shot in the back' of the Marines who raised the country's banner over Iwo Jima" (*Power of Photography*, 147). Bush's speech is reported in Marling and Wetenhall, *Iwo Jima*, 215, and Goldberg, *Power of Photography*, 147.

41 The Vietnam era poster with a flower replacing the flag is reproduced in Goldberg, *Power of Photography*, 146. The alternative that substitutes a flag with a peace symbol for the American flag is reprinted in Carol Wells et al., *Decades of Protest: Political Posters from the U.S., Vietnam and Cuba, 1965-1975* (Los Angeles: Center for the Study of Political Graphics, 1996) and is used on the cover of Katherine Kinney, *Friendly Fire: American Images of the Vietnam War* (New York: Oxford, 2000). It is also used regularly at www.alternet.org to identify antiwar stories. The monolith appropriation was the

logo for a now-defunct Web site (http://www.supportthemonolith.org) that lampooned evolutionary progress. It seems that this group was based in Seattle and that the monolith was lifted from the movie 2001: A Space Odyssey.

42 The ad for h.i.s. Men's Jeans appeared in 1990 and is reproduced in Goldberg, Power of Photography, 146.

43 At brumm.com Postcards, http://www.brumm.com/postcardsout/seriesg.html.

44 John Hartley, Popular Reality: Journalism, Modernity, and Popular Culture (London: Arnold, 1996), 217. Hartley's claim exemplifies the anxiety that often arises when commentators realize that icons do not work simply or even primarily by being referential. Note also how the photograph is faulted for lacking propositional statement and truth claims—primary properties of a print culture. Hartley is correct to focus attention on circulation, but his commitment to a referential semiotics leads him to a reading strategy that ignores how familiarity provides a productive means for the (re)invention of public culture. Likewise, his suggestion that the image has "cease[d] to be American" is contradicted in the wake of the events of 9/11. As we demonstrate below, the image was quickly recognized and mimicked as a resource for the reactivation of U.S. public culture in ways that drew upon both its familiarity and its original transcriptions.

45 Marling and Wetenhall, Iwo Jima, 8.

46 Marling and Wetenhall, Iwo Jima, 196. See also 202. The book features a good range of appropriations up to the time of publication (1991), including statuary, editorial cartoons, and artwork.

47 We also note that, notwithstanding intense patriotic identification, the circulation of the Iwo Jima icon confounds explanations that reduce display of national symbols to enactment of primitive social demands. Hence, we disagree with the argument by Carolyn Marvin and David W. Ingle that the American flag activates a unified civic religion that authorizes and even demands blood sacrifice. See Marvin and Ingle, Blood Sacrifice and the Nation: Totem Rituals and the American Flag (Cambridge: Cambridge University Press, 1999), and Carolyn Marvin, "U.S. Nationalism Is a Civil Religion," CRTNET NEWS, no. 6276, September 21, 2001. Such claims ignore the many representations of the flag that do no such thing, including some that intentionally inflect the meaning of American nationalism. Marvin and Ingle's development of Durkheim's social theory requires a corrective that was available in a now neglected work by Raymond Firth, Symbols: Public and Private (London: George Allen & Unwin, 1973). Firth concludes his chapter on "Symbolism of Flags" by noting that "Durkheim and most other commentators have seen the significance of national flags as symbols in serving as rallying points for social solidarity. . . . But a symbol is a double-edged instrument. When as is the case with national flags, it is associated with a structure of power and authority, it becomes an officially defined representation, with the possibility of dissent from the values it is intended to convey. The symbol still stands for the society, or for the controlling power in society, but the 'sentiment' component is diversified . . . This operation of a feed-back principle indicates a complexity in behaviour towards flag symbols which I have not seen examined hitherto in systematic analysis" (367). The significance of this complexity becomes evident once one recognizes that the U.S. flag is a field of multiple projections; such is the nature of abstraction, and how else could it be used both to drape coffins and advertise used cars? Available projections include direct assertions of territorial conquest and

possession, totemic evocations of blood sacrifice, demands for political loyalty to suppress dissent, representations of consensus, tokens of political participation, articulations of civil religion, ornamental signs of civic bonding amid a summer festival, and affirmations of political identity and rights while dissenting. Given the rich intertextuality of the Iwo Jima icon, it is unlikely that only one of these registers is in play, and probable that any of them could be activated by particular audiences. Cf. O'Leary, *To Die For*.

48 For example, *The Illustrated History of the World: Emerging Powers*, vol. 9, ed. J. Roberts (New York: Oxford University Press, 1999). A representative sample of Web sites that feature the photograph include: Iwo Jima and the U. S. Marine Corps (http://members.tripod.com /~vet5/index.html), the Iwo Jima Web site (http://www.iwojima.com), and Art's Iwo Jima Flag History Web Page (http://members.aol.com/iwoart).

49 *World War II: The War Chronicles*, Lou Reda Productions, The History Channel, A&E Television Network, 1995.

50 World War II 2003 Calendar; World War II Library of Congress 2004 Calendar.

51 Richard Holmes, ed., *World War II in Photographs* (London: Carlton Books, 2000). The photographs are from the Imperial War Museum in London.

52 William B. Breuer, *Unexplained Mysteries of World War II* (New York: Wiley, 1998).

53 The question of the photograph's racial ascription is both highlighted and complicated by the two CDs mentioned here, which are by Funkadelic, *One Nation under a Groove*, and Wu-Tang Clan, *Iron Flag*.

54 1stService.org, La Sierra University Church, Riverside, California, August 10, 2001, http://www.1stservice.org/calendar.htm.

55 "Battles for Life," Living, Summer 2000, Lutherans for Life, http://www.lutheransforlife.org/living/2000/summer/battles_4_life.htm.

56 The process described here overlaps partially with Marianne Hirsch's concept of "postmemory," which "most specifically describes the relationship of children of survivors of cultural or collective trauma to the experiences of their parents, experiences that they 'remember' only as the narratives and images with which they grew up, but that are so powerful, so monumental, as to constitute memories in their own right." "Surviving Images: Holocaust Photographs and the Work of Postmemory," in *Visual Culture and the Holocaust*, ed. Barbie Zelizer (New Brunswick: Rutgers University Press, 2001), 218–19. See also Marianne Hirsch, *Family Frames: Photography, Narrative, and Postmemory* (Cambridge: Harvard University Press, 1997).

57 "Allstate's print and television campaign, by Leo Burnett, part of the Bcom3 Group, broke in the Dec. 17 Sports Illustrated and also will appear in *People* and *USA Today*." Jane L. Levere, "Advertisers Try New Games Campaigns," New York Times News Service, WinterSports.com, http://deseretnews.com/oly/view/0,3949,50000391,00.html. The authors' copy is from *Sports Illustrated*.

58 "The Mighty Seventh" bond drive is featured in chapters with that name in Marling and Wetenhall, *Iwo Jima*, and Bradley, *Flag of our Fathers*. Each book also reproduces a photograph of the statue made for a rally in Times Square.

59 The 2006 cinematic reenactment of the flag raising is a near-perfect replication of the iconic image, but for the flag being in color. *Flags of Our Fathers*, Movie, Photo Gallery, Official Photos, http://flagsofourfathers.net/gallery/official-photos/flo16.

60 Beeville.Net, http://www.beeville.net/July4/July4thPictorial.htm.

61 Captioned montage is by Wes Clark and was posted at the Web site of the Western

Suburbs Rugby Football Club, rugbyfootbal.com, in Oct. 2000. Confirmed by personal correspondence with the authors, Feb. 2, 2006.

62 William Fox, "Taste of the Nation," City Link Magazine, http://www.citylinkmagazine.com/culture/eats/craigs.htm.

63 The relationship between representational and performative registers may be exemplified best by one of the more vernacular reproductions: a maze in a cornfield. The full image is visible and perhaps an object of admiration from a distance, while those who enter into the maze have an embodied experience that becomes highly personal. See Andrew Martin, "Maze Craze Aids Farmers Who Have Lost Their Way," *Chicago Tribune*, Oct. 4, 2004, 1; and "What's Wrong with This Picture?' *Smithsonian* 31 (Nov. 2000): 131–38. An aerial photograph of a cornfied maze in Lasalle, Colorodo, is reproduced in Buell, *Uncommon Valor*. Other sites reported include Corinna, Maine, and Temecula, California.

64 Billig, *Banal Nationalism*.

65 For explorations of photographic materiality, see Elizabeth Edwards and Janice Hart, eds., *Photographs Objects Histories: On the Materiality of Images* (New York: Routledge, 2004).

66 Anderson, *Imagined Communities*, 6.

67 Bradley, *Flags of Our Fathers*, 282.

68 On "securing uptake," see James Bohman, *Public Deliberation: Pluralism, Complexity, and Democracy* (Cambridge: MIT Press, 1996), 58–59, 116–18; and J. L. Austin, *How to Do Things with Words*, 2nd ed., ed. J. O. Urmson and Marina Sbisà (Cambridge: Harvard University Press), 101.

69 Kenneth Burke, *A Rhetoric of Motives* (Berkeley: University of California Press, 1969), 50.

70 The phrase "the greatest generation," which has become a common reference to Americans who came of age during the Great Depression and World War II, was made popular by Tom Brokaw, *The Greatest Generation* (New York: Random House, 1998).

71 RockyMountainNews.com, American Patriotism, http://denver.rockymountainnews.com/art/wallpaper/patriotism. Devin Sullivan and Paul Carrol, *A Is for America: An American Alphabet* (Chelseas, MI: Sleeping Bear Press, 2001).

72 Lynne Cheney, *America: A Patriotic Primer* (New York: Simon & Schuster, 2002).

73 Katherine Kinney, *Friendly Fire: American Images of the Vietnam War*, 6–7. As one example, see Edward Keinholz, "The Portable War Memorial," 1968, mixed media installation, in Lucy R. Lippard, *A Different War: Vietnam in Art*, Whatcom Museum of History and Art (Seattle: Real Comet Press, 1990), 39.

74 See *The Simpsons*, "New Kids on the Beach," episode CABF12, originally broadcast Feb. 25, 2001.

75 Doug Marlette, cartoon, *Newsday*, *Washington Post National Weekly Edition*, June 4–10, 2001, 5.

76 David Brion, cartooon, *Freelance Star* [Fredericksburg, Virginia], *Washington Post National Weekly Edition*, May 28–June 3, 2001, 22.

77 See Edwards and Winkler, 301–3; also, Marling and Wetenhall, *Iwo Jima*, 214–17. Examples are not limited to the U.S. media. Recent cartoons from the international press include those by Ricardo of *El Mundo*, Madrid, Spain; Herb, *Dagningen*, Lillehammer, Norway; Heng, *Lianhe Zaobao*, Singapore; Grogan, *Cape Times*, Capetown, South Africa; Hajjaj, *Ad-Dustour*, Amman, Jordan.

78 Steve Bensen, "Ego Jima," *Arizona Republic*, syndicated in the *Sun* [Bremerton, WA], Dec. 7, 2000, C3.

79 Tom Toles, *Washington Post*, Sept. 27, 2005.

80 *The Simpsons*, "Selma's Choice," episode 9F11, originally broadcast Jan. 21, 1993. The literal "consumption" of the flag raising has several precedents. Rosenthal reports that it has been sculpted in ice and in hamburger (62). It is molded in vanilla ice cream and doused with hot fudge in a sexually charged scene in Sy Bartlett's *The Outsiders* (1961), a movie version of the life of Ira Hayes, a Native American and one of the three flag raisers to survive the battle of Iwo Jima. A movie still of the scene—with a somewhat horrified look on the face of Ira Hayes (played by Tony Curtis) as he looks on—is in Marling and Wetenhall, *Iwo Jima*, 185. There is a terrible irony in that Hayes was destroyed by the overconsumption of alcohol, but he still stands for a traditional conception of honor. See, for example, the artwork by Urshel Taylor that substitutes Native American regalia for the Marine uniform to present "The Real Ira Hayes," http://www.artnatam.com/utaylor/n-uto08.html. Taylor, like Hayes, is a member of the Pima tribe and a former Marine. Another work, by Charlene Teters of the Spokane Nation, removes all the figures except for Ira Hayes, and places the image upon a mound of brown rocks. "Mound: To the Heroes," 1999, coverts the triumphalism of victory into the pathos of historical loss. At http://www.antnet.com/magazine_pre2000/reviews/robinson/robinson7-9-10.asp.

81 Homer Simpson represents the consumer, but the producers of this degraded popular culture remain unidentified. The Iwo Jima image has been put to work in this context as well on the cover of the February 2002 issue of *Wired*, which shows the iconic image in silhouette with Disney cartoon characters substituted for the soldiers. The caption announces, "Disney, INVADER/Inside the Ultimate Culture Machine."

82 Sakai, May 13, 2004, Cartoonists and Writers Syndicate, available via a search at http://cartoonweb.com. Related cartoons include "Iraq War Memorial" by Mike Peters, Aug. 29, 2003, which has a single soldier raising a flag at halfmast while an onlooker says, "Rumsfield said we didn't need any more soldiers." On the other side, there is a PhotoShopped image that has the Marines in French ceremonial helmets raising a white flag with the caption, "If French Soldiers Raised the Flag on Iwo Jima."

83 Bradley, *Flags of Our Fathers*.

84 Bradley, 341–42. See also the A&E documentary *Heroes of Iwo Jima*.

85 Buffalogames.com, The Press Room, "Strategy for Success," Oct. 2004, http://www.buffalogames.com/HTML%20pages/Press%20Releases.html.

86 Illustration by Stephen Kroninger, *New York Times*, April 23, 2001, B1. For a similar alteration, see the illustration of the three major network anchormen raising the flag above a story on media coverage of 9/11, *Esquire*, Dec. 2001, 70. The three personalities are given large bodies and oversize heads, they are facing the viewer, and it looks as if they are more likely to be wrestling for the pole than working together.

87 Rick Marin, "Raising A Flag For Generation W.W. II," *New York Times*, April 23, 2001, B1, B8.

88 Kenneth Burke, *Attitudes toward History* (Boston: Beacon Press, 1959), 5, 44.

89 See China Clipper, "Operation Just Return," April 27, 2000, http://www.freerepublic.com/forum/a3908d3c1226f.htm#6. Other commentators have used the Iwo Jim icon as a standard for comparisons between icons, along with other themes we have noted. A Lint Trap cartoon by Matt Wuerker with Terry J. Allen depicts a "Modern

Icon Buying Frenzy" that includes "California Utility Buys Iwo Jima Symbol from Marines to Improve Image," as the workers raise a utility pole. Another by Mike Peters shows three war memorials: Iwo, the Wall, and a big question mark for the "Iraq War Memorial." April 9, 2001, http://www.cartoonistgroup.com/store/add.php ?iid=5914.

90 For review of media response to the attack, see Barbie Zelizer and Stuart Allen, eds., *Journalism after September 11* (New York: Routledge, 2002). Photojournalism is surveyed by Barbie Zelizer, "Photography, Journalism, and Trauma," 48–68.

91 Rick Bragg, "U.S. Binds Wound in Red, White, and Blue," *New York Times*, Sept. 17, 2001, A1, A5.

92 *Record*, Sept. 12, 2001, 1; for alternate versions of the image, see *People Weekly*, Sept. 24, 2001, 136, and http://www.nytimes.com/library/photos/20010914todays-photo.jpg. For Franklin's narrative of how the photograph was taken, see "Getting the Photo of a Lifetime," *Record*, Sept. 13, 2001. Also available at http://www.arlingtoncemetery .net/fireman-01.htm. Note also how the process of imitation traverses a technological change. This is the first iconic photo taken with a digital camera, although its immediate appeal surely was influenced by the fact that the photographer, editors, and the public were already familiar with the Iwo Jima photograph.

93 Jeannine Clegg, "Flag Raising was 'Shot in the Arm,'" *Record*, Sept. 14, 2001, 1. Also available at http://www.arlingtoncemetery.net/fireman-01.htm .

94 See, e.g., *Time*, "The Rescue Continues" Sept. 12, 2001, photo essay, http://www.time .com/time/photoessays/rescue2/index.html. Newsweek, "Special Report: After The Terror—God Bless America," Sept. 24, 2001; and *Time* "Special Report: *Time* for Kids," World Report Edition, vol. 7, no. 2, Sept. 21, 2001; *Life: The Year in Pictures* (n.p.: Time, 2002); *Encyclopedia Britannica: 2001 Year in Review* (New York: Encyclopedia Britannica, 2002); and *People Weekly*, Dec. 31, 2001–Jan. 7, 2002.

95 The *Record* Web site offering to sell the photograph for a donation was at http://www .northjersey.com/index/groundzerospirit.html. That photograph has a full-page description of its origin on the back that includes an explicit comparison to the Iwo Jima image. That Web site has since been replaced by one that details the terms for commercial use of the image (http://www.groundspirit.org). The image displayed there now is stamped "Not for Reproduction," that is, not without payment.

96 Author e-mail communication, New Jersey Media Group Marketing Department, Dec. 13, 2001.

97 For an example of its reenactment at a local Fourth of July celebration, see "Remembering Sept. 11 on America's Birthday," *Herald-Times*, July 5, 2002, 1. Proceeds for the New York Firefighters World Trade Center Commemorative Button were to be dedicated to the Red Cross. The Commemorative Coin was advertised on CNN and in Sunday newspaper magazine supplements such as "American Heroes: Colorized United States Silver Eagle Dollar," *USA Weekend*, Oct. 6–28, 2001, 21.

98 "The Photo No One Will Forget," *USA Today*, Dec. 27, 2001, 1. The reference to Afghanistan probably was taken from an AP report that U.S. Army Rangers had left copies of the photo captioned with the words "Freedom Fighters" after a raid. "Army Rangers Leave Taliban Photos," AP Digital, Oct. 22, 2001.

99 The fourteen awards are listed at About the Photo, Ground Zero Spirit, http://www .groundzerospirit.org/about.html.

100 See "New Fundraising Stamp Honors Heroes of September 11 Unveiled at White House," http://www.usps.com/news/2002/philatelic/sr02_017.htm.

101 *People Weekly*, Sept. 24, 2001, 136. The nominal "echo" is important, for the more recent image is a trace or vestige of the earlier image, as if "a repetition of a sound caused by reflection of sound waves" and thus connected as an index to the sound/image it repeats. *Merriam Webster's Collegiate Dictionary*, 10th ed., s.v. "echo."

102 The comment by Russert was reported by Stephen Olbrys in an e-mail message addressed to the authors, Sept. 25, 2001; the theme was picked up and repeated on a number of Web forums. See, e.g., the comment by "radiogirl" on September 13, http://www.livejournal.com/talkread.bml?itemid=10614558&nc=3. The two photographs have been presented side-by-side on numerous Web sites beginning, we think, at The Boiling Springs Villager, http://www.bsvillager.com/iwojimaflagfire fighters. Other examples include God-Bless-America.org, http://911.wavethemes .net/9-11-franklin.html (see especially the Then and Now posters); When Words Fail Us, at http://www.privilogic.com/wordsfail/; Riders in Recovery, 9/11 Memorial, http://www.ridesinrecovery.com/public/Memorial/Firefighters/FireFighters.htm; and Compass Point Media, http://www.cmpasspointmedia.com/content/philosophy.php.

The doubled-image also appeared as the final frame in a belligerent PowerPoint presentation circulated as an e-mail attachment and cast as a memo from the CEO of the Boeing Corporation to Mr. Osama bin Laden. The two photographs were also paired in an unintentionally ironic articulation of "patriotism" and "commercialism" when they were used on a Newburg, New York, billboard designed to advertise the Blue Moon Strip Club. When confronted by outraged citizens, Blue Moon owner Mike O'Brien noted that his intention was "to honor those who serve us." Kenneth Lovett, "Billboard Blasphemy," *New York Post*, June 18, 2002. A safer bet is the set of two jigsaw puzzles, one of each icon, with the pieces mixed together.

103 Reported in Clegg, "Flag Raising was 'Shot in the Arm.'" Additionally, the two photographs were reenacted side-by-side during the nationally televised broadcast of the opening ceremony for the 2001 baseball World Series on the Fox Network, Oct. 27, 2001.

104 Al Guart, "Flag Men: Don't Call Us Heroes," NYPOST.COM, Sept. 29, 2001. The two photos are compared in a number of other places as well. See Karal Ann Marling, "Salve for a Wounded People," *New York Times*, Oct. 14, 2001, B1, B39; and Marianne Fulton, "Memory of a Flag," Digital Journalist, http://digitaljournalist.org/issue0110/ fulton.htm.

105 This spot was broadcast on The History Channel, A&E Television Network approximately every hour for two weeks beginning on October 8, 2001. It may have had maximum impact during a commercial two-hour documentary rebroadcast of *Heroes of Iwo Jima*. For another version of the original that segues into the newer icon, see "The Spirit of America," a commercial produced by the Foundation for a Better Life as part of its Pass It On campaign, available under TV Spots at http://www.forbetterlife.org.

106 The nine editorial cartoons are by John Deering, *Arkansas Democratic Gazette* [Little Rock, Arkansas], Sept. 13, 2001; Robert Arial, *State* [Columbia, South Carolina], Sept. 12, 3001; Chris Britt, *State Journal-Register* [Springfield, Illinois], Sept. 14, 2001; Bill Day, *Commercial Appeal* [Memphis, Tennessee], Sept. 14, 2001; Marshal Ramsay, *Clarion Ledger* [Jackson, Mississippi], Sept. 14, 2001; Kevin Siers, *Charlotte Observer* [Charlotte, North Carolina], Sept. 14, 2001; Dana Summers, *Orlando Sentinel* [Orlando,

Florida], Sept. 14, 2001; Gary Brookins, *Richmond Times-Dispatch* [Richmond, Virginia], Sept. 16, 2001; Ben Sargent, *Austin-American Statesman* [Austin, Texas], Sept. 18, 2001; and Doug Marlette, Tribune Media Service, Sept. 19, 2001. Each cartoonist maintains a Web site that archives their cartoons. The group of cartoons listed above are also archived at http://cagle.slate.msn.com/news/Firefighters/main.asp. A similar blending of the two images can be found in an artist's rendition of four firefighters raising the flag, in color, superimposed over the original Iwo Jima image rendered in a muted, almost ghostlike grayscale. The accompanying text suggests that the current generation of firefighters is the embodiment of a spectral presence, past and present collapsed as an eternal return of "bravery, and sacrifice [that] proves that, while America's future may once again be uncertain, American resolve is not." This image is available for sale as a poster and on shirts, tote bags, coffee mugs, and magnets at http://www.watermind.com/product.asp?ID=UNC. Other examples include a mural in Queens, New York City, that has male and female first responders raising the flag. Holland Cotter, "Amid the Ashes, Creativity," *New York Times*, Feb. 1, 2002, B31. The blending of the two continues in diverse media. Examples include a collage by Nikki Kern of the Iwo Jima flag-raising with 911 images, at the September 11 Digital Archive, http://www.911da.org/digital_art/details/1814.

107 Examples include the winner of the Huntington Beach annual Christmas Light Display, with an image of two firefighters joining two Marines in raising the flag on Iwo Jima. Bryce Alderdon, "Sign of the Season and Times," *LA Times*, Dec. 20, 2001, 2: 12; *Washington Post National Weekly Edition*, Oct. 8–14, 2001, cover; the *IU Home Page* [Indiana University], vol. 6, no. 3., Oct. 12, 2001, A5; and a newsletter from Indiana State Senator Larry Borst touting his role in passing state antiterrorism measures. Verbal references were also numerous.

108 Calls for Generation X to stand up as the next "Greatest Generation" were prolific throughout the media, including editorials, commentaries, letters to the editor, cartoons, and poems. See, e.g., Robert Kagan, "A Declaration of War," *Washington Post On-Line*, Sept. 11, 2001, http://www.washingtonpost.com/ac2/wp-dyn?pagename =article&node=digest&contentId=A13546-2001Sep11; James Loughrie, "The Worst Brings Out the Best in Americans," *Daily Trojan*, Sept. 13, 2001, 4, 9, Scott Sears, "It's Now Our Turn," letter to the editor, *Dallas Morning News*, Sept. 12, 2001; Julie Ann Ponzi, "'Let's Roll!': Generation X Goes to War," Sept. 2001, Ashbrook Center for Public Affairs, http://www.ashbrook.org/publicat/oped/ponzi/01/genx.html; David Sumner, "It Seems to Us . . . We Are Not Alone," National Association of Amateur Radio, Oct. 8, 2001, http://www.arrl.org/news/features/2001/10/08/2/?nc=1; Joan Murray, "The Greatest Generation: A Poem," broadcast on NPR, http://www.npr.org/news/specials/ americatransformed/essays/010919.murray.html; Suzanne Kahle, "The New Greatest Generation," letter to the editor, *Sacramento Bee*, Oct. 8, 2001; and Marshal Ramsay, *Clarion-Ledger* [Jackson, Mississippi], Sept. 22, 2001. For a cynical view, see Margaret Carlson, "Patriotic Splurging," *Time*, Oct. 15, 2001, 76.

109 Jason Vaillancourt, posting to a Union College Class of 1995 bulletin board, http:// www.union.edu/Alumni/Archive/WTC/display.php?yr=1995.

110 Robb Armstrong, *Jump Start*, Oct. 12, 2001.

111 Goldberg, *Power of Photography*, 143; and Michael Griffin, "The Great War Photographs: Constructing Myths of History and Photojournalism" in *Picturing the Past:*

Media, History, and Photography, ed. Bonnie Brennen and Hanno Hardt (Chicago: University of Chicago Press, 1999), 144.

112 See the cartoons by Robert Arial and Ben Sargant listed above. in note 106.

113 There was extensive coverage of the controversy. See, e.g., Rod Dreher, "The Bravest Speak," *National Review*, Jan. 16, 2002, http://www.nationalreview.com/dreher/dreher011602.shtml.

114 By contrast, Dana Summers inserts the World Trade Center firefighters into the original Iwo Jima pose and adds the words "U.S. Resolve" to the flag, presumably to clarify the sentiment that is not as evident when we cannot see the faces of individuals raising that flag. See fn. 72 above.

115 The appeal to "consumerism" was a distinctive theme of the Bush administration during the weeks following the attack on the World Trade Center and the Pentagon. See, e.g., George W. Bush, "Address to the Joint Session of Congress and the American People," Sept. 20, 2001; "Radio Address of the President to the Nation," Sept. 22, 2001; "Remarks of the President to the Dixie Printing CO., Glen Burrow, MD," Oct. 24, 2001; and "Remarks by the President to Business, Trade and Agriculture Leaders," Oct. 26, 2001. Available at http://www.whitehouse.gov/.

116 Mike Luckovich, *Atlanta Journal-Constitution*, Oct. 5, 2001. Posted at http://cagle.slate.msn.com/news/SHOP-terror/main.asp.

117 Mike Keefe, *Denver Post*, Oct. 4, 2001. Posted at both http://www.intoon.com/archive.php?index=1&searchdate=2001-10 and http://cagle.slate.msn.com/news/SHOP-terror/main.asp.

118 For another use of visual allusions to activate the generational comparison, see the cartoon titled "Civilian Consumption Corps" by R. J. Matson that employs World War II recruitment poster conventions to depict a uniformed woman at a shopping mall doing her national duty—shopping. *Roll Call*, Oct. 8, 2001, http://www.rjmatson.com/frames_R.htm. Print editorials that indicated a similar cynicism include Carlson, "Patriotic Splurging," and Michael Kinsley, "My Agenda for Victory," *Washington Post*, Oct. 16, 2001, A23.

CHAPTER FIVE

1 "Western tradition tends to derogate the role of affect in the public sphere. Being emotional about politics is generally associated with psychological distraction, distortion, extremity, and unreasonableness. Thus, the conventional view is that our capacity for and willingness to engage in reasoned consideration is too often overwhelmed by emotion to the detriment of sound political judgment. As a result, theories of democratic practice proclaim the importance of protecting against the dangers of human passion and political faction by building up institutions, rules, and procedures—all intended to protect us from our emotional selves." George E. Marcus, W. Russell Neuman, and Michael Mackuen, *Affective Intelligence and Political Judgment* (Chicago: University of Chicago Press, 2000), 2. See also George E. Marcus, *The Sentimental Citizen: Emotion in Democratic Politics* (University Park: Pennsylvania State University Press, 2002).

2 Henry Kissinger, *White House Years* (Boston: Little, Brown, 1979), 510. See also Robert Hariman, "Henry Kissinger: Realism's Rational Actor," in *Post-Realism: The Rhetorical*

Turn in International Relations, ed. Francis A. Beer and Robert Hariman (East Lansing: Michigan State University Press, 1996), 35–53.

3 Barbara Koziak, *Retrieving Political Emotion: Thumos, Aristotle, and Gender* (University Park: Pennsylvania State University Press, 2000), 3ff. As Koziak notes (4–5), there are exceptions, most important among them the feminist critique of this paradigm. We also should note that our claim neither denies nor is refuted by the fact that individual scholars are motivated by more than the disinterested pursuit of knowledge. It is important for our argument to emphasize that aversion to emotion is a hallmark of *liberal* political theory. A recent example is Stephen Holmes, *Passions and Constraints* (Cambridge: Harvard University Press, 1995). For an example of political scientists dancing around the problem, see the chapters on "Passion and Politics" in George E. Marcus and Russell L. Hanson, eds., *Reconsidering the Democratic Public* (University Park: Pennsylvania State University Press, 1993), 225–343.

4 Koziak, *Retrieving Political Emotion*. Koziak's critique of liberal theory's valorization of rational self-interest (157–60 and 178) cuts to the core of the matter in respect to many questions of domestic policy, while it can be applied directly to the realist discourse of national interests in international relations. For another critique of the discourse of rational self-interest, see James Arnt Aune, *Selling the Free Market: The Rhetoric of Economic Correctness* (New York: Guilford Press, 2001). We would note that both Aune's critique and his alternative are limited by his rationalism, which leaves him armed only with good reasons while overlooking the structures of feeling that are crucial to valuing and mobilizing labor and "traditional communities" (170).

5 The picture is widely available. See, e.g., Hall Buell, *Moments: The Pulitzer Prize Photographs, A Visual Chronicle of Our Time* (New York: Black Dog and Leventhal Publishers, 1999), 93; Dirck Halstead, "The Picture from Kent State," Digital Journalist, http://digitaljournalist.org/issue0005/filo.htm.

6 Following the news about the Kent State shootings, campuses were convulsed nationwide. "And now the nation, and particularly her students, came fully awake to the horror of both her foreign war and her war at home." Nancy Zaroulis and Gerald Sullivan, *Who Spoke Up? American Protest against the War in Vietnam, 1963–1975* (Garden City, NY: Doubleday, 1984), 320. According to Kissinger, "the very fabric of government was falling apart." *White House Years*, 513.

7 Chronologies are available at William A. Gordon, *Four Dead in Ohio: Was There a Conspiracy at Kent State?* (El Toro, CA: North Ridge Books, 1995); Mike and Kendra's Web site, May 4, 1970, Chronology, http://www.may41970.com/; May 4 Task Force, http://dept.kent.edu/may4/chrono.html. An annotated bibliography with other sources on Kent State is posted at "The Kent State Shootings: An Annotated Bibliography," http://members.aol.com/nrbooks/bibliog.htm. This was not the only fatal shooting that month. On May 14, two students at Jackson State, a small black college, were murdered by police bullets. There had been other shootings previously, including the killing on February 8, 1968, of one college student and two high school students at South Carolina State University, another historically black school, during a civil rights demonstration.

8 Buell, *Moments*, 92, 93. Media use of the photo included the front page of the *New York Times*, May 5, 1970, which can be seen at http://www.nytimes.com/learning/general/onthisday/big/0504.html—and the cover of *Newsweek*, May 18, 1970. The *Newsweek* photo is tightly cropped on the cover and in standard format on the editor's page (3);

the issue is captioned "Nixon's Home Front." The photo received the Pulitzer Prize and is regularly classed with the few others that have become icons of the Vietnam conflict. For example: "You know, my field is photojournalism, and my feeling is that photographs act as symbols. If you really think about the war in Vietnam, there were about five still images that eventually persuaded everybody that what we were doing was wrong. The monk burning himself in Saigon. The police chief in Saigon shooting the Vietcong suspect. The children running down a dirt road having been napalmed and their clothes burned off, and the little girl up front yelling in pain. Her mouth was like a black hole. The photograph of a protest at the Pentagon of a lovely little flower child putting a flower in the muzzle of a soldier's gun. And, of course, the photograph of the student at Kent State, lying dead on the ground, and the girl with her arms up in anguish over the body, crying out. That was a symbol, too. Those pictures made a difference. Millions of people would hold the same image in their minds at the same time. Those things, for millions of Americans, *became* the war. And if there was anything that turned America against the war, it was those images, because symbols are powerful things. Symbols can affect reality." Joan Morrison and Robert K. Morrison, *From Camelot to Kent State: The Sixties Experience in the Words of Those Who Lived It* (New York: Times Books, 1987), 96–97.

9 Linda White, "30 Years On, Kent State Picture Still Haunts," *Baltimore Sun*, May 6, 2000. It frequently is used as the visual "title" and framing device for Kent State stories, Web sites, and so forth: e.g., the cover of Arlene Erlbach, *Kent State, Cornerstones of Freedom* (New York: Children's Press, 1998); the main page of Kent State University, May 4, 1970, http://jmc-reunion2000.freeservers.com/index.html.

10 The other photograph in this class is the picture of "Accidental Napalm" discussed in chapter 6.

11 Put differently, the picture operates iconically to represent the psychological dynamics by which an emotion is constituted. Whether drawing on Aristotle's *Rhetoric* or cognitive neuroscience, emotions can be modeled as combinations of affect and belief that can function to represent complex situations. For a popular exposition of the contemporary literature on brain functioning, see Antonio R. Damasio, *Descartes' Error: Emotion, Reason, and the Human Brain* (New York: Avon Books, 1994).

12 The epistemological status of photorealism has been roundly debated and qualified within the photographic profession and academia, but no one denies that it has been the conventional wisdom of the public. One indication of this framework is that those attempting to discredit the photo did so by declaring that it must have been posed (probably because its composition appeared so artistic). See Buell, *Moments*, 93.

13 For the record, she was neither a student nor a demonstrator, but a fourteen-year-old who had run away from her home in Florida and was watching the protest. The social type of "student demonstrator" displaces these circumstantial details as the iconic photo becomes the primary marker of the event in public memory.

14 Michael Griffin, "The Great War Photographs: Constructing Myths of History and Photojournalism," in *Picturing the Past: Media, History, and Photography*, ed. Bonnie Brennen and Hanno Hardt (Urbana: University of Illinois Press, 1999), 131.

15 We assume this point needs little documentation. See Stephanie Shields, *Speaking from the Heart: Gender and the Social Meaning of Emotion* (Cambridge: Cambridge University Press, 2002). For discussion of the anthropological literature on gender and the emotions, see Catherine A. Lutz and Lila Abu-Lughod, eds., *Language and the Poli-*

tics of Emotion (Cambridge: Cambridge University Press, 1990). For review of the psychological literature, see Leslie R. Brody and Judith A. Hall, "Gender and Emotion," in *Handbook of Emotions*, ed. Michael Lewis and Jeannette M. Haviland (New York: Guilford Press, 1993), 447–60, and "Gender, Emotion and Expression," in *Handbook of Emotions*, ed. Michael Lewis and Jeannette M. Haviland, 2nd ed. (New York: Guilford Press, 2000), 338–49. In rhetorical studies, see Kathleen Hall Jamieson, *Beyond the Double Bind: Women and Leadership* (New York: Oxford, 1995), 91–98, 121–25.

16 Note, for example, the shot selection at political conventions or in advertisements. The exception is at sporting events, where bare-chested, war-painted young men are standard vehicles of exuberance. Sports comprise the primary venue of masculine display in civil society. Yet even here, shots of players' or coaches' wives predominate when a particularly tense or sentimental moment is at hand.

17 Consider, for example, the case of Edmund Muskie, whose presidential campaign was torpedoed by press reports that he had cried in public. As the standards of masculinity began to change in the 1990s there were positive reports of masculine crying, but it should be noted that such crying is typically cast in the sympathetic mode of "feeling the pain" of others or as a function of "touching, poignant things" and not as a sign of inordinate stress or domestic disorder. As *Time* reports, it remains "a source of cultural comedy." See "Annals of Blubbering," *Time*, Oct. 17, 1994 as reported in Tom Lutz, *Crying: The Natural and Cultural History of Tears* (New York: W. W. Norton, 1999), 232. See also Julie Ellison, *Cato's Tears and the Making of Anglo-American Emotion* (Chicago: University of Chicago Press, 1999).

18 On hailing (interpellation) as an ideological operation in public discourse, see Maurice Charland, "Constitutive Rhetoric," *Oxford Encyclopedia of Rhetoric*, ed. Thomas O. Sloane (New York: Oxford University Press, 2001), 616–19; "Constitutive Rhetoric: The Case of the *Peuple Québécois*," *Quarterly Journal of Speech* 73 (1987): 133–50; Louis Althusser, "Ideology and the Ideological State Apparatuses," in *Lenin and Philosophy and Other Essays*, trans. Ben Brewster (New York: Monthly Review Press, 1971).

19 The pole has been airbrushed out of some versions of the photograph, including one published in a May 1995 *Life* magazine retrospective on four photos that "altered the way we thought and felt about ourselves." For comparison of the two photos and excerpts from professional discussion, see Zone|Zero, http://www.zonezero.com/magazine/articles/meyer/06.html.

20 The criteria here come from Jürgen Habermas, *The Structural Transformation of the Public Sphere: An Inquiry into a Category of Bourgeois Society*, trans. Thomas Burger (Cambridge: MIT Press, 1989).

21 As with many dimensions of the iconic photo, this one becomes more evident through comparison with the other photos taken at or near the same time. In this case, the images by Filo and Howard Ruffner often are close-in shots that include a jumble of legs and no clear sense of the surrounding scene, rather than fully embodied citizens standing in what can be seen to be a public space. See, for example, photographs by John Filo in Peter Davies, *The Truth about Kent State: A Challenge to the American Conscience* (New York: Farrar Straus Giroux, 1973); photographs by Howard Ruffner, Digital Journalist, http://digitaljournalist.org/issue0005/hr08.htm and http://digitaljournalist.org/issue0005/hr09.htm; and *Life*, May 15, 1970, 35.

22 Koziak, *Retrieving Political Emotion*, 29. The concept of a political scenario also has been developed by Lance Bennett, "Political Scenarios and the Nature of Politics,"

Philosophy and Rhetoric 8 (1975): 23–42, and *The Political Mind and the Political Environment* (Lexington, MA: Lexington Books, 1975), 51–78. Bennett demonstrates how political judgment can be grounded in a paradigmatic scene constituting a worldview, while Koziak takes the analysis beyond Bennett's cognitive orientation.

23 Some readers may assume that the scene was set in the parking lot where three other students were killed. Jeffrey Miller, the dead student in the iconic photograph, was on a driveway leading into the parking lot. Our thanks to Mike Pacifico for confirming pertinent background information about the events at Kent State in personal correspondence with the authors, June 15, 2006.

24 See also George H. Roeder, Jr., *The Censored War: American Visual Experience during World War Two* (New Haven: Yale University Press, 1993); John Taylor, *Body Horror: Photojournalism, Catastrophe, and War* (New York: New York University Press, 1998); Kevin Robbins, *Into the Image: Culture and Politics in the Field of Vision* (New York: Routledge, 1996); Barbie Zelizer, *Remembering to Forget: Holocaust Memory through the Camera's Eye* (Chicago: University of Chicago Press, 1998); and Barbie Zelizer, ed., *Visual Culture and the Holocaust* (New Brunswick: Rutgers University Press, 2000).

25 Note that this depiction of the girl is entirely an artifact—an effect produced by the composition of this picture in the split second it was taken. She can be seen acting very differently in a reverse angle shot taken a few moments later, while the girl kneeling, Mary Ann Vecchio, is no longer present (Davies, *Truth about Kent State*).

26 See Benjamin R. Barber, *Strong Democracy: Participatory Politics for a New Age* (Berkeley: University of California Press, 1984). If this chapter is successful, it should be more evident *both* that liberal-democratic societies need emotional resources available in the public media if they are to function as strong democracies *and* that the public communication of emotion is caught in the contradiction between autonomy and mutuality that Barber identifies. For additional support for the supposition that this contradiction is not a natural constraint on polity, see Robert H. Frank, *Passions within Reason: The Strategic Role of the Emotions* (New York: W. W. Norton, 1988). The great need for a history of American emotional life is finally being met through Peter Stearns's project on "emotionology." See Peter N. Stearns and Carol Z. Stearns, "Emotionology: Clarifying the History of Emotions and Emotional Standards," *American Historical Review* 90 (1985): 813–36, and Peter N. Stearns and Jan Lewis, eds., *An Emotional History of the United States* (New York: New York University Press, 1988). Although not attentive to visual materials, Andrew Burstein argues that American democracy has been shaped throughout its history by a patriotic emotionalism in *Sentimental Democracy: The Evolution of America's Romantic Self-Image* (New York: Hill and Wang, 1999). For a sense of the depth of alternative traditions, see Shirley Samuels, ed., *The Culture of Sentiment: Race, Gender, and Sentimentality in Nineteenth-Century America* (New York: Oxford University Press, 1992).

27 William Hickey, "KSU Story One-Sided in TV Reports," *Cleveland Plain Dealer*, May 7, 1970, reprinted in Ottavio M. Casale and Louis Paskoff, eds., *The Kent Affair: Documents and Interpretations* (Boston: Houghton Mifflin, 1971), 59–61.

28 There are numerous such examples from the period. We also note that such denunciations of protest often featured its performative aspect. David Brinkley was "too busy acting," for example, and *Newsday* decried the fact that "too many people are playing let's pretend," while the "shoddy drama of violence" could not coexist with "reason." "The Deadly Dramatists," *Newsday*, May 6, 1970, reprinted in *Kent Affair*, 54–55.

29 Nicole Loraux, *The Invention of Athens: The Funeral Oration in the Classical City*, trans. Alan Sheridan (Cambridge: Harvard University Press, 1986); and Jonathan Shay, *Achilles in Vietnam: Combat Trauma and the Undoing of Character* (New York: Simon and Schuster Touchstone, 1994).

30 Davies, *Truth about Kent State*, plate 70. It also can be seen in Lesley Wishchman, "Four Dead in Ohio," *American History Illustrated* (May–June 1990): 32. The only directly political appropriation we know of is a poster with the words "Higher Education, Kent State U., 1970." It is archived at Foothill Technology High School, Mr. Cameron Crouch, Art, Political Art & Protest Art, page 3, http://foothilltech.org/ccrouch/images/image_bank/political_art_webpage/index_3.htm.

31 "Life Cover for 05/15/70," http://www.life.com/Life/covers/1970/cv051570.html. The victim was John Cleary. The photograph was taken by Howard Ruffner. It also can be seen at Eyewitness at Kent State: Photographs by Howard Ruffner, Digital Journalist, http://digitaljournalist.org/issue0005/hr07.htm.

32 The photo does circulate but not as much as the iconic image, nor is it used as often as the definitive representation of the shootings. For a recent example of the icon's use as a historical marker, see the cover of Philip Caputo, *13 Seconds: A Look Back at the Kent State Shootings* (New York: Chamberlain Brothers, 2005). It also is the opening and concluding image in the video documentary distributed as a CD with the book: *Kent State: The Day the War Came Home* (Chamberlain Brothers, Harmony Entertainment, 2005).

33 The cover photo and the iconic image (airbrushed version) are posted together at the top of the main page at Kent State 1970, by Paul E. Haeger, http://www.ecsu.ctstateu.edu/depts/edu/textbooks/kentstate.html.

34 Michael Barton demonstrates how news reporting in the twentieth century has favored more muted forms of emotional display than those featured in the nineteenth century. "Journalistic Gore: Disaster Reporting and Emotional Disclosure in the *New York Times*, 1852–1956," in Stearns and Lewis, eds., *An Emotional History of the United States*, 155–172. We surmise that photojournalism filled the gap created as the print media became more muted emotionally despite the democratic public's continuing need for emotional information and emotional activation. The visual image would function performatively in that context. Or it could be that the shift of emotional performance from verbal text to visual image resulted in the text becoming more muted emotionally to balance the rhetorical power of the visual image and so maintain the sense of order that is built into public culture. This is not a question we can answer through a study of only the iconic photographs. On "cool" as a modern emotional style, see Peter N. Stearns, *American Cool: Constructing a Twentieth-Century Emotional Style* (New York: New York University Press, 1994).

35 A chronology of the judicial aftermath of the shootings is available at the May 4 Collection, Kent State University Libraries and Media Services, Department of Special Collections and Archives, Legal Chronology May 5, 1970–January 4, 1979, http://speccoll.library.kent.edu/4may70/legalchronology.html. No member of the Guard or anyone else was held responsible for the shootings. Civil suits on behalf of the four dead and nine wounded students led to a settlement in 1979 of $675,000. See James A. Michener, *Kent State: What Happened and Why* (New York: Random House, 1971); Davies, *Truth about Kent State*; Joseph Kelner and James Munves, *The Kent State*

Coverup (New York: Harper & Row, 1980); William A. Gordon, *The Fourth of May: Killings and Coverups at Kent State* (Buffalo, N.Y. : Prometheus Books, 1990).

36 Pete Hamill's *Murder at Kent State University*, narrated by Rosko, Flying Dutchman FDS-127, 1970 (thanks for the helping hand from Last Vestige Music Shop, http://www.lastvestige.com). Bitter Passage, Kent State and The Fall of Saigon, http://digitaljournalist.org/issue0005/bpintro.htm.

37 Anonymous, "Avenge," offset lithograph, 1970. A copy can be found in "Guy Lamolinara, "Eyes of the Nation: New Treasury Offers Best of Library's Visual Collection," *Library of Congress Information Bulletin* (Nov. 1977) http://www.loc.gov/loc/lcib/9711/eyes.html. For an example of its use in a contemporary demonstration see the 1970 Timeline, Kent State Massacre, http://www.nyu.edu/library/bobst/collections/exhibits/arch/1970/1970-2.html. It was subsequently employed in a poster produced by the Revolutionary Student Brigade, 1978, archived in the May 4 Collection, Banners and Posters, 1970-, Box 128A, Posters at Kent State University. It is also included on Andy Deck's History of New Media Art in the 20th Century Web site as part of a lecture on "Public Art and Space," http://www.artcontext.org/edu/sva/newMediaArt/lectures/publicArt/poster.html.

38 "The Evening After," annual commemoration, 1988, poster announcing program for 1988 commemoration, http://www.library.kent.edu/exhibits/4may95/exhibit/commemorations/1988.html.

39 In this reading of the photo we are indebted to Elaine Scarry, *The Body in Pain: The Making and Unmaking of the World* (New York: Oxford University Press, 1985).

40 The university response to the tragedy has ranged from outright denial—going so far as to change its name for several years—to grudging denial. Fortunately for public memory, "Kent State Forever Linked with the Vietnam Era," Gary Tuchman, CNN.com, May 4, 2000, http://www.cnn.com/SPECIALS/views/y/2000/04/tuchman.kentstate.may4/index.html. The story is illustrated by the iconic image, which surely is the reason for the university's "problem." (Our lack of sympathy for the institution is easy to justify: It is thriving despite its history, and erasure of its past would be of little benefit to itself but a great loss to public culture.)

41 Mike and Kendra's Web site, History of Prentice Parking Lot Controversy, http://www.may41970.com/prenticelot.htm. Photographs of the markers are at the web link to Prentice Lot Memorial Construction Photos, http://www.may41970.com/prenticelotconstruction.htm.

42 Mike and Kendra's Web site, PRENTICE LOT MEMORIAL DEDICATION SEPTEMBER 8, 1999, http://www.may41970.com/Prentice%20Update%20May%201999/Prentice%20Dedication%20Sept%20,%201999/PreticeLotDedication.htm.

43 Scarry, *Body in Pain*, 52.

44 Ibid., 278–326.

45 We believe that the importance of empathy, and the occasional congruence of norms of civic decorum with deep values of moral life, become evident when viewing a particular parody of the Kent State icon. Different individuals have varied reactions, of course, and we can only report our own while asking the reader to look, act, and reflect accordingly. At the brumm.com Web site, one can obtain many satirical or otherwise transgressive images, including some where the Pillsbury doughboy has been substituted for figures in well-known photographs. Some examples are amus-

ing, others (such as the Iwo Jima alteration) fairly lame, and then there is the Kent State photo: two pudgy, smiling doughboys have been put into the picture, one of them in place of the murdered boy on the ground, and the card is captioned, "The Kent State Bake-off Loser." Postcards You Can Send to Your Internet Friends, Series "G" Cards, http://www.brumm.com/postcardsout/seriesg.html. Sure, it's funny, but it also is, well, awful (precisely the serious reaction mocked by the Web site, www .somethingawful.com), a desecration of the dead that makes one feel as if something inside is being twisted. Other satires don't strike us as having the same harsh effect; these include adding the Verizon man and an alteration that replaces the dead body with a mushed ice cream cone and writes across the photo "MY ICE CREAM!!!!"

46 For a discussion of the importance of J. L. Austin's concept of "uptake" for public deliberation, see James Bohman, *Public Deliberation: Pluralism, Complexity, and Democracy* (Cambridge: MIT Press, 1996), 58.

47 This reaction is enlisted in the service of political commentary in an editorial cartoon by Scott Stantis of the *Birmingham News* on the Elián González case. A citizen is underneath three images—Kent State, the Rodney King beating, and the Elián González seizure by an armed federal agent. The first two cases are decried as state violence, while the third is excused because "the family was asking for it." Elián González Abduction, On the Lighter Side, http://home.att.net/~elian/Humor.html. Empathy for the victims, like justice, must appear consistent if it is to be legitimate.

48 Nick Crossley, "Emotion and Communicative Action: Habermas, Linguistic Philosophy and Existentialism," in *Emotions in Social Life: Critical Themes and Contemporary Issues*, ed. Gillian Bendelow and Simon J. Williams (New York: Routledge, 1998), 16–38.

49 A similar point is made by those who criticize the rationality of public opinion polling and underscore the importance of emotion in public opinion as it affects political identity and social control. See Murray Edelman, *Politics as Symbolic Action: Mass Arousal and Quiescence* (New York: Academic Press, 1971), 53–64; Elisabeth Noelle-Neuman, "Public Opinion and Rationality," in *Public Opinion and the Communication of Consent*, ed. Theodore L. Glasser and Charles T. Salmon (New York; Guilford Press, 1995), 33–54; and Susan Herbst, *Numbered Voices: How Opinion Polling Has Shaped American Politics* (Chicago: University of Chicago Press, 1993), 154–60. As Marcus et al. note, "We might well argue that the conventional normative call for voters to give uniform consideration to each and every issue, each and every candidate for public office, and each and every campaign is naive and perhaps counterproductive. Our results demonstrate that the electorate does apply itself largely as conventionally expected, but that it does so guided by emotional appraisals when circumstances warrant" (*Affective Intelligence*, 124–25). For a study of how the Kent State photo can influence judgments across a range of topics, see D. Domke, D. Perlmutter, and M. Spratt, "The Primes of Our Times?: An Examination of the 'Power' of Visual Images," *Journalism* 3 (Aug. 2002): 131–59.

50 Although labeled a "Western folk psychology" by Geoffrey M. White, this definition is a hallmark of elite discourses as well, including most of the work done within academic psychology. "Emotions Inside Out: The Anthropology of Affect," in Lewis and Haviland, *Handbook of Emotions*, 29; see also "Representing Emotional Meaning: Category, Metaphor, Schema, Discourse," in Lewis and Haviland, *Handbook of Emotions*, 2nd ed., 30–44. For an example of the standard model, see Ross Buck, *The Communication of Emotion* (New York: Guilford Press, 1984).

51 This seemingly radical perspective is grounded firmly in book 2 of Aristotle's *Rhetoric* but receives more fine-grained articulation in contemporary anthropology and sociology: White, "Emotions Inside Out"; Keith Oatley, "Social Construction in Emotions," in Lewis and Haviland, *Handbook of Emotions*, 341–52; and P. N. Johnson-Laird and Keith Oatley, "Cognitive and Social Construction in Emotions," in Lewis and Haviland, *Handbook of Emotions*, 2nd ed., 458–76; Lutz and Abu-Lughod, eds., *Language and the Politics of Emotion*; Catherine A. Lutz, *Unnatural Emotions: Everyday Emotions on a Micronesian Atoll and Their Challenge to Western Theory* (Chicago: University of Chicago Press, 1988); Niko Besnier, "Language and Affect," *Annual Review of Anthropology* 19 (1990): 419–51; and Donald Brenneis, "Performing Passions: Aesthetics and Politics in an Occasionally Egalitarian Community," *American Ethnologist* 14 (1987): 236–50. Margot L. Lyon criticizes a straw man version of the perspective in "Missing Emotion: The Limitations of Cultural Constructionism in the Study of Emotion," *Cultural Anthropology* 10 (1995): 244–63. Our description in this paragraph and subsequently of the social constructivist position is particularly indebted to the essays in the edited volume by Lutz and Abu-Lughod.

52 Hugh Dalziel Duncan, *Communication and Social Order* (New York: Bedminster Press, 1962), 431. Artistic images become particularly important means for establishing collective life. Erwin Panofsky calls such images "cultural equipment." *Meaning in the Visual Arts: Papers in and on Art History* (Garden City, NY: Doubleday, 1955). A democratic culture would be likely to rely on a popular art such as photography for its images.

53 Besnier's definition of emotions as a "multichannel phenomenon" that "floods linguistic form on many different levels of structure in many different ways" is an important observation, and his following methodological precept is at least as important: "More commonly, emotions are alluded to, and the decoding task is a process of 'reading off' complex covert messages" ("Language as Affect," 421, 428). Thus, even with a photo of a blast of affect, the emotional dimension of that communicative act and the communication of emotion regarding the event itself are to be understood only through the more elaborate reconstruction of the sort we have provided. On centrality of emotions to the good life, see Robert C. Solomon, "The Philosophy of Emotions," in Lewis and Haviland, *Handbook of Emotions*, 2nd ed., 3–15. Koziak argues that political emotion—and a regime's emphasis of some emotions rather than others—is a key mediation by which collectivities can flourish more or less successfully.

54 On the shift from individual expression to "affective registers" and related constructs that are similar to our references to the "conventions" or "norms" of "decorum" structuring public representation, see Judith T. Irvine, "Registering Affect: Heteroglossia in the Linguistic Expression of Emotion," in Lutz and Abu-Lughod, *Language and the Politics of Emotion*, 126–61.

55 "In this [social constructivist] perspective, displays of emotions are not uncivilized eruptions coming from deep within individual psyches, but rather amount to sophisticated social discourse that is employed to influence others." David R. Heise and John O'Brien, "Emotion Expression in Groups," Lewis and Haviland, *Handbook of Emotions*, 491.

56 As one small attempt to avoid encouraging these conventions of Western psychology and liberal politics, we have avoided using the individuals' names until this point in the essay.

57 See, e.g., Buell, *Moments*, 93; and "Kent State: 1995 Conferences," Emerson College, http://www.emerson.edu/acadepts/cs/comm/synopsis.html. See also "Images and Icons of May 4, 1970: 'One of the Top 25 Photos of the Century,'" *25 Year Retrospective of Kent State and Jackson State*, Boston, April 23–24, 1995, Center for Ethics in Political and Health Communication, Emerson College, pp. 13–17 and back cover.

58 1995 Restrospective [sic], May4archive.org, http://www.may4archive.org/retrospective 95.shtml. See also May4archive.org, 1995 Retrospective, Mary Ann Vecchio Meets John Filo, http://www.may4archive.org/vecchio_filo.shtml, and the introductory remarks and the interviews with Filo and Vecchio in *25 Year Retrospective of Kent State and Jackson State*.

59 "Mary Ann Vecchio meets John Filo," Emerson College memorial Web site, http://www.emerson.edu/acadepts/cs/comm/filo.html. This site has subsequently been removed and the images have been archived at Kent State University, May 4 Collection, Miscellaneous Photographs, box 109, http://speccoll.library.kent.edu/4may70/box109/109filovec.html.

60 When present, captioning always matters, but it need not be determinative. It seems to us that "anguish" is the most commonly used term with the Kent State icon, and it may be the best single term. So, for example, the photo is captioned "Monday, May 4, 12:27 p.m. Anguish" by James A. Michener, who places it as the last image in his book on the shootings, following a last chapter that gives Mary Ann Vecchio the last word. *Kent State: What Happened and Why*, 355. See also "Images and Icons of May 4, 1970," 13 and 16. "Anguish" is not the only term used in the press, however, and often the photo is reproduced without any specific designation of emotion.

61 For a synopsis of the epistemological problems in the study of emotions, see Daniel L. Rosenberg, "Language in the Discourse of Emotions," in Lutz and Abu-Lughod, *Language and the Politics of Emotion*, 162ff.; and White, "Emotions Inside Out," in Lewis and Haviland, *Handbook of Emotions*, 33–35.

62 This may be part of the reason why Aristotle devoted such attention to cataloging the varieties of emotional response in Athenian society. Note, for example, the attention to the different dispositions of the young, the elderly, and those in the prime of life. *Rhetoric* 2: 12–14.

63 Daniel L. Schacter, *Searching for Memory: The Brain, the Mind, and the Past* (New York: Basic Books, 1996) provides a good discussion of the relationship between memory, emotion, and schematic forms with particular regard to visual phenomena. Ronald de Sousa argues that emotions are essential for rationality because they provide economies in information processing by controlling the salience of perceptions. *The Rationality of Emotion* (Cambridge: MIT Press, 1987), 171–204.

64 Two notable reproductions in this manner are in Buell, *Moments*, 93, and Digital Journalist, http://www.digitaljournalist.org/issue0005/filo.htm.

65 "Kent State Basketball Team Massacred by Ohio National Guard in Repeat of Classic 1970 Matchup," *Onion*, March 16, 2006.

66 Koziak, *Retrieving Political Emotion*, 28.

67 Koziak, *Retrieving Political Emotion*, 29.

68 De Sousa, *Rationality of Emotion*, 301.

69 Eugene Garver, *Aristotle's Rhetoric: An Art of Character* (Chicago: University of Chicago Press, 1994), 135–38.

70 Stjepan G. Mestrovic, *Postemotional Society* (London: Sage, 1997), 2.

71 Robert L. Ivie, *Democracy and America's War on Terror* (Tuscaloosa: University of Alabama Press, 2005).

72 A number of examples are included in Casale and Paskoff, *Kent Affair*. See also Michener, *Kent State*, 434–55, 462–69.

CHAPTER SIX

1 President George H. W. Bush, "Remarks at a Meeting of the American Legislative Exchange Council," March 1, 1991, *Weekly Compilation of Presidential Documents*, vol. 27, no. 9 (March 4, 1991): 233.

2 James Mann, *Rise of the Vulcans: The History of Bush's War Cabinet* (New York: Penguin Books, 2004); Max Boot, *The Savage Wars of Peace: Small Wars and the Rise of American Power* (New York: Basic Books, 2002); and Project for the New American Century, http://www.newamericancentury.org.

3 Michael Hill, "Defining Images: How a Picture Becomes an Icon of War," *Baltimore Sun*, May 9, 2004, C1.

4 Global Women's Strike, "Rape and Other Torture in Iraq," London, May 12, 2004, http://www.globalwomenstrike.net/English/rape_and_other_torture_in_iraq_a.htm. For a similar claim:

> "Photography in war is as old as photography itself. In every conflict since the American Civil War, pictures have told the story and quite often distilled a war into a single image. Robert Capa's *Republican Militiaman at the Moment of Death* from the Spanish Civil War; Joe Rosenthal's Iwo Jima flag from World War II; Nick Ut's napalm girl from Vietnam.
>
> "I was reminded of such pictures when a colleague suggested that the torture scenes from Abu Ghraib prison would change American public opinion. In years to come, when we remember Iraq, those images will define it."

Michael Bowers, "Image Problems—War in the Digital Age" *Sydney Morning Herald Online*, May 15, 2004, available online at http://www.myantiwar.org/view/19034.html. See also Seymour H. Hersh, *Chain of Command: The Road from 9/11 to Abu Ghraib* (New York: HarperCollins, 2004).

5 Impositions and Suppositions, "Iraq Prison Photos: Icons or Just Evidence?" at http://www.newsdesigner.com/archives/cat_iraq_prison_photos.php. This page juxtaposes the photograph of the hooded man standing on a box, his arms stretched out in a Christ-like pose, with the "Accidental Napalm" icon. The accompanying article quotes art historian Frank Cossa who argues that the newer photo cannot be iconic because it isn't "beautiful" and lacks the "detachment" of the professional photographer. The article is a partial transcription of a National Public Radio (NPR) report by Mike Pesca, "Iraqi Abuse Photos and the U.S. Legacy in Mideast," Day to Day, May 10, 2004. The full transcript is available at http://www.npr.org/transcripts.

6 BBC News, "Abuse Pictures," May 10, 2004, discussion with Christopher Hitchens and Robert Thompson, http://news.bbc.co.uk/1/hi/programmes/newsnight/3700989.stm; Pete Hamil, "Iraq: When the Shooting Stopped," *New York Times*, Sept. 25, 2004; Robert Risk, "The Immoral War," *Independent*, May 8, 2004, http://www.counter

currents.org/iraq-fisko80504.htm; Michael Hill, "Defining Images"; and November Coalition, "Iconic Pictures: Photos Change History," http://www.november.org/ abuse/.

7 Gwynne Dyer, "Iconography," *Jordan Times*, May 8, 2004 available at http://www .gwynnedyer.net/articles2004.htm. For another of many examples: "The cynics may be proved right; they usually are. But these are exceptional circumstances. The pictures of abuse, especially the one on our cover of the hooded man wired as if for electrocution, stand an awful chance of becoming iconic images that could haunt America for years to come, just as the famous photograph of a naked girl running during a napalm attack did during the Vietnam war." "Resign, Rumsfeld," *Economist*, May 8, 2004, 11.

8 Two common examples include "A Misplaced Bomb . . . and a Breath of Hell," *Stars and Stripes*, Pacific edition (Tokyo), June 10, 1972; and "Accidental Napalm," *New York Times*, June 9, 1972, 1A.

9 "Pacification's Deadly Price," *Newsweek*, June 19, 1972, 42; "Beat of Life," *Life*, June 23, 1972, 4–5. It is reproduced as well in *Life*, Dec. 29, 1972, 55.

10 Hall Buell, *Moments: The Pulitzer Prize Photographs, A Visual Chronicle of Our Time* (New York: Black Dog and Leventhal, 1999), 102. See also Vicki Goldberg, *The Power of Photography: How Photographs Changed Our Lives* (New York: Abbeville Press, 1991), 241–45. The photo is available at a great many Web sites, often with descriptions similar to Buell's. For example, the promotional copy for the film *Kim's Story: The Road from Vietnam*, directed by Shelley Saywell, First Run/Icarus Films, 1996 notes, "If there was one photograph that captured the nature of the Vietnam War, it was that of a nine-year-old girl running naked down the road, screaming in agony from napalm burns that had eaten into her flesh." Online at http://www.frif.com/cat97/ k-o/kim_phuc.html. See also *Kim Phuc*, a film by Manus vad de Kamp, Icarus Films, 1984, http://www.frif.com/new97/kim_s_sto.html; and From Time to Time, Our Century, Photo Gallery, http://www.nandotimes.com/nt/images/century/photos/ century0256.html.

 For Nick Ut's recollection of the event, see Horst Faas and Marianne Fulton, "The Bigger Picture: Nick Ut Recalls the Events of June 8, 1972," http://www.digitaljournal ist.org/issue0008/ng2.htm. For a chronicle of the girl's life before and after the event, see Denise Chong, *The Girl in the Picture: The Story of Kim Phuc, the Photograph, and the Vietnam War* (New York: Viking Penguin, 1999).

11 Katherine Kinney labels it "one of the most famous" in *Friendly Fire: American Images of the Vietnam War* (New York: Oxford University Press, 2000), 187. Marita Sturken features it as one of three "most iconic images" in *Tangled Memories: The Vietnam War, the AIDS Epidemic, and the Politics of Remembering* (Berkeley: University of California, 1997), 89–94. In 1990 it was used to advertise a special report by Peter Jennings titled "From the Killing Fields," reported in Adam Garfinkle, *Telltale Hearts* (New York: St. Martin's, 1995), 225. In 2001 it was the only image used with a story about Senator Bob Kerrey's involvement in a possible war crime, even though he had *nothing* to do with the bombing of Trang Bang. See "Bob Kerrey's New Vietnam War," *Connection*, April 30, 2001, at http://archives.theconnection.org/archive/2001/04/0430a.shtml. It is also used regularly to mark the immorality of napalm. See "Weapons of Imperialism: Napalm," online at http://www.oz.net/~vvawai/sw/sw31/pgs_03-14/weapons.html; "Incineration: Military Says Goodbye to Napalm," online at http://www.mindfully

.org/Plastic/Napalm-Recycled.htm; and Didi Tang, "Napalm Display Draws Protests," *Columbia Daily Tribune*, May 27, 2001, online at http://archive.columbiatribune. com/2001/may/20010527news007.asp. It has also been referenced in allegations that the U.S. military has used napalm in its assault on Fallujah in the war against Iraq. See Paul Gilfeather, "Fallujah Napalmed: U.S. Uses Banned Weapon . . . but Was Tony Blair Told?" Nov. 28, 2004, Sunday Mirror.co.uk, http://www.sundaymirror.co.uk/ news/news/tm_objectid=14920109%26method=full%26siteid=62484-name_page .html; Alberto Mesquita Filho, "EXTRA! Encontrado NAPALM no Iraque," Espaço Científico Cultural, http://www.ecientificocultural.com/guerra/extra.htm. When the Advertising Standards Authority banned a Sony ad for its PlayStation 2 game "Vietcong: Purple Haze," which employed the quotation "Napalm never smelled so good" (allegedly a "well-known line from the war film *Apocalypse Now*"), the BBC News accompanied the story with the "Accidental Napalm" photograph. BBC News: World Edition, "Vietnam PlayStation Advert Banned," Nov. 24, 2004, http://news.bbc .co.uk/2/hi/uk_news/england/berkshire/4036897.stm.

12 This is a commonly held assumption about the effect of the picture. See Brady Priest, "Three Images: The Effects of Photojournalism on the Protest Movement during the Vietnam War," online at http://www.wellesley.edu/Polisci/wj/Vietnam/ThreeImages/ brady.html. Nick Ut notes, for example, that "[People] tell me, 'Your picture stopped the war' . . . I ask, how could a picture stop a war? But they say, 'Yes! Your picture stopped the war because I didn't join the army because of your picture. It is because of your picture that the war is over.' They even kissed my hand." Quoted in Alisha Rosas, "The Man behind the Camera," *LaVerne* (winter 2001) online at http://www.ulv .edu/comms/lvm/win01/ut.htm. For a more skeptical perspective on the question of influence, see David D. Perlmutter, *Photojournalism and Foreign Policy: Icons of Outrage in International Crises* (Westport, CT: Praeger, 1998), 9. Caroline Brothers makes a stronger claim with less evidence: "These pictures . . . articulated and retrospectively pinpointed shifts in the groundswell of attitudes to the war but were unable to bring about these changes of themselves. . . . images such as these could only surface when the mood of the country was ripe." *War and Photography: A Cultural History* (New York: Routledge, 1977), 203, 204.

13 Senator Robert Kennedy, "Speech on Vietnam, March 2, 1967," U.S. Senate, *Congressional Record*, vol. 113, part 4, 5280 (GPO, 1967). See also Martin Luther King, Jr., "A Time to Break Silence," Riverside Church, New York City, NY, April 4, 1967, in *A Testament of Hope: The Essential Writings of Martin Luther King, Jr.*, ed. James M. Washington (San Francisco: Harper & Row, 1986), 231–44.

14 The images identified here also received Pulitzer prizes: see Buell, *Moments*, 62–67 and 78–81. The *Life* photo essay featuring the iconic picture also includes on the same page a photo of a woman carrying the "fatally charred" body of a small boy. The *Life* photo was taken by David Burnett. A Nick Ut photograph of the same child is in *The Girl in the Picture*, photo insert following p. 190. See also such works as Phillip Jones Griffiths, *Vietnam Inc.* (New York: Macmillan, 1971), and Horst Faas and Tim Page, eds., *Requiem: By the Photographers Who Died in Vietnam and Indochina* (New York: Random House, 1997).

15 "ACCIDENTAL NAPALM ATTACK: South Vietnamese children and soldiers fleeing Trang Bang on Route 1 after a South Vietnamese Skyraider dropped bomb. The girl at center has torn off burning clothes." *New York Times*, June 9, 1972, 1A. Though often

not captioned, later use of this label includes Paul Lester, *Photojournalism: An Ethical Approach* (Hillsdale, NJ: Lawrence Erlbaum, 1991), 51–52.

16 Sturken remarks that "the Vietnam War has been unanimously described as a "television war" (*Tangled Memories*, 89). See also H. Bruce Franklin, *Vietnam and Other American Fantasies* (Amherst: University of Massachusetts Press, 2000), 5–24.; Daniel C. Hallin, *The "Uncensored War": The Media and Vietnam* (New York: Oxford University Press, 1986), esp. 103–13. Those responsible for the war use the observation as an excuse: "The War in Vietnam was the first conflict shown on television and reported by a largely hostile press. The squalor and suffering and confusion inseparable from any war became part of the living experience of Americans; too many ascribed its agony to the defects of their own leaders." Henry Kissinger, *White House Years* (Boston: Little, Brown, 1979), 510.

17 For the critique of photographic realism, see John Tagg, *The Burden of Representation: Essays on Photographies and Histories* (Amherst: University of Massachusetts Press, 1988) and Victor Burgin, *In/Different Spaces: Place and Memory in Visual Culture* (Berkeley: University of California Press, 1996). With respect to war photography in particular see Michael Griffin, "The Great War Photographs: Constructing Myths of History and Photojournalism" in *Picturing the Past: Media, History & Photography*, ed. Bonnie Brennen and Hanno Hardt (Urbana: University of Illinois Press, 1999), 122–57.

18 Gunther Kress and Theo van Leeuwen suggest that the center-margin design implies permanence and is used more often in Asian than in Western composition. *Reading Images: The Grammar of Visual Design* (New York: Routledge, 1996), 203–6.

19 Kress and van Leeuwen, *Reading Images*, 121–30, 143. There is an additional qualification that strengthens the photograph's moral appeal. Because both the girl and the boy have partially closed their eyes, the composition becomes a subtle combination of face-to-face demand with the opposite form of visual address that "offers" the viewed subject for examination. Thus, the viewer is both called to engagement and allowed a more reflective space for thought. The result is a visual form appropriate for activating one's conscience. This direct gaze still "creates a visual form of direct address. . . . the participant's gaze (and the gesture, if present) demands something from the viewer, demands that the viewer enter into some kind of imaginary relation with him or her" (122), but it is muted just enough to call more for empathic engagement rather than confrontation.

20 For discussion of the various norms and negotiations governing photojournalism's portrayal of bodily harm, see John Taylor, *Body Horror: Photojournalism, Catastrophe, and War* (New York: New York University Press, 1998); Susan D. Moeller, *Shooting War: Photography and the American Experience of Combat* (New York: Basic Books, 1989); Kevin Robins, *Into the Image: Culture and Politics in the Field of Vision* (New York: Routledge, 1996), 61–82; and Barbie Zelizer, "The Voice of the Visual in Memory," in *Framing Public Memory*, ed. Kendall R. Phillips (Tuscaloosa: University of Alabama Press, 2003), 157–86. A post–September 11 publication by the American Press Institute devotes a chapter to the question of visual propriety. It correctly claims that "newspapers have not set a new standard since Sept. 11, 2001 for running disturbing photographs" (25). The napalm icon is listed as one of three "'notable examples'" that established the standard for historically significant events (23). What we find most interesting is that the entire report is saturated with color photographs. What once was a tabloid technology is now the dominant mode of self-presentation in

the American Press Institute official report. *Crisis Journalism: A Handbook for Media Response* (Reston, VA: American Press Institute, 2001). A PDF file of the report can be downloaded at http://www.americanpressinstitute.org/articles/publications/crisisjournalism/.

21 This sense of fragmentation must be significant, as it is a feature of each of the iconic photographs from the Vietnam War. After referring directly to the Saigon execution shot, the napalm girl, and a My Lai photo, Kinney observes that "almost without exception, the most-remembered still photographs of the war recall rupture and displacement rather than reconciliation." Judy Lee Kinney, "Gardens of Stone, Platoon, and Hamburger Hill: Ritual and Remembrance," in *Inventing Vietnam: The War in Film and Television*, ed. Michael Anderegg (Philadelphia: Temple University Press), 156.

22 Although the defenders of the U.S. war in Vietnam were wrong from start to finish, there was an inadvertent element of truth in their criticism of the "liberal" mass media. For review of this argument, see Hallin, *The "Uncensored War,"* 3–12.

23 Alan Trachtenberg, *Reading American Photographs* (New York: Hill and Wang, 1989), 74–75.

24 Roland Barthes, "The Rhetoric of the Image," in *Image-Music-Text*, trans. Stephen Heath (New York: Hill and Wang, 1977), 32–52, esp. 37–46.

25 Michael Walzer, *Just and Unjust Wars* (New York: Basic, 1977), 138–43. Note also Fussell's remark on the persistence of scenes of soldiers bathing, "not because soldiers bathe but because there's hardly a better way of projecting poignantly the awful vulnerability of mere naked flesh." Paul Fussell, *The Great War and Modern Memory* (New York: Oxford University Press, 1975), 299.

26 John D. Caputo, *Against Ethics: Contributions to a Poetics of Obligation with Constant Reference to Deconstruction* (Bloomington: Indiana University Press, 1993), 6.

27 For review of this argument, see Francis A. Beer and Robert Hariman, eds., *Post-Realism: The Rhetorical Turn in International Relations* (East Lansing: Michigan State University Press, 1996).

28 Aristotle, *Poetics*, 1453b.

29 This claim recalls the discussion of restored behavior in chapter 2. See Richard Schechner, *Between Theater and Anthropology* (Philadelphia: University of Pennsylvania Press, 1985), 35–116; and Bert O. States, "Performance as Metaphor," *Theater Journal* 48 (1996): 1–26.

30 "Children Fleeing" (2000), Isometric Screenshots for the 20ᵗʰ Century, http://www.whitelead.com/jrh/screenshots.

31 Cf. Susan Sontag, *On Photography* (New York: Dell, 1973), 17–19 and *Regarding the Pain of Others* (New York: Farrar, Straus, and Giroux, 2003), esp. 104–13.

32 The overlapping categories of children and prisoners produce another transcription within the photo, for they are standard categories in just war theory. For summaries of the extensive and quite uniform just war literature, see Francis A. Beer, "Just War," in *World Encyclopedia of Peace*, ed. L. Pauling, E. Laszlo, and J. Y. Yoo (Oxford: Pergamon, 1986); and Terry Nardin and David R. Mapel, eds., *Traditions of International Ethics* (New York: Cambridge University Press, 1992).

33 On the other side, some soldiers feel as though they have been betrayed by the picture—both in that it revealed their habitual and perhaps necessary callousness, and that it did not balance that with images of other, more humanitarian actions. Their argument is strengthened when one considers how it is often cropped: left out of the

image are soldiers whose stance suggests that all could be in danger, and a photographer who is at least as professionally preoccupied as the soldiers on the road. The last omission is the most significant: it erases any sense of journalistic complicity in the war, while it also reduces the photo's reflexivity. We are to reflect on the war but not on how it is photographed. Another available photo, even more damning in this regard, was taken a few seconds later as the children ran past a gaggle of video cameramen and still photographers whose position and behavior parallels that of the soldiers behind them. This photo can be seen at The Vietnam War, "Under Fire," http://www.vietnampix.com/fire9a2.htm.

34 Roland Barthes, *Camera Lucida: Reflections on Photography*, trans. Richard Howard (New York: Hill and Wang, 1981), 97. Judith Lewis Herman, *Trauma and Recovery: The Aftermath of Violence from Domestic Abuse to Political Terror* (New York: Basic Books, 1992); Jonathan Shay, *Achilles in Vietnam: Combat Trauma and the Undoing of Character* (New York: Simon and Schuster Touchstone, 1994). For background on post-traumatic stress disorder with special reference to the Vietnam experience, see *Vietnam Yesterday and Today*, "Post-Traumatic Stress Disorder (PTSD) A Selected Bibliography," at http://servercc.oakton.edu/~wittman/ptsd.htm.

35 Shay, *Achilles in Vietnam*, 3–22.

36 The term is from Fussell, *Great War and Modern Memory*, 36–74.

37 Shay, *Achilles in Vietnam*, 181–93.

38 Julianne H. Newton has discussed the ethical implications of these stories, in *The Burden of Visual Truth: The Role of Photojournalism in Mediating Reality* (Mahwah, New Jersey: Lawrence Erlbaum, 2001), 158–66.

39 See, e.g., Buell, *Moments*, 102–3. Faas and Fulton note, "Nick Ut visits Kim Phuc and her family often in Toronto. 'Kim and I are almost like family, she calls me "uncle" and I talk with her almost every week,' he said." Horst Faas and Marianne Fulton, "Kim Phuc and Nick Ut Meet Again," Digital Journalist, at http://digitaljournalist .org/issue0008/ng5.htm. The story circulates widely across the media, including newspaper, women's magazines, video documentaries, and Web sites. For example: "The Girl in the Picture: 17 Years Later," *Los Angeles Times*, Aug. 20, 1989; Chong, *The Girl in the Picture*, 299–308; Saywell, *Kim's Story: The Road from Vietnam*; and Faas and Fulton, "A Young Girl's Cry for Help in Vietnam and the Photographer who saved her are Honored by the London Science Museum and Queen Elizabeth II," Digital Journalist, at http://digitaljournalist.org/issue0008/ng1.htm.

40 Horst Faas and Marianne Fulton, "Kim Phuc and Nick Ut Meet Again," page 5 of The Survivor Phan Thi Kim Phuc and the Photographer Nick Ut, Digital Journalist, http:// www.digitaljournalist.org/issue0008/ng5.htm. The main page for the story features a composite image of the adult Kim with her child in the right foreground and the young Kim of the iconic image in the left background. http://www.digitaljournalist .org/issue0008/ng_intro.htm

41 Chong, *The Girl in the Picture*, 6.

42 Chong, *The Girl in the Picture*, cover copy. The accompanying text is even less subtle: "The photograph made a victim again of Kim Phuc, by turning her into an icon of wartime suffering." We feel obliged to add that this sentiment is hardly consistent with much of the story as Chong tells it. We see a woman who fears the invasiveness of publicity but also seeks out and enjoys the many benefits it provides, while developing a public life that is itself a form of freedom and that allows her to be more

active, receive more recognition, and do more good than would have been possible otherwise. Chong seems oblivious to this irony, however. None of these qualities can register within the liberal framework of interpretation.

43 "At Long Last, a Conflict Ends for Minister Decades after Napalm Bombing, U.S. Commander, Vietnamese Woman Make Their Peace," *Washington Post*, Feb. 20, 1997, M04. The history of the story suggests that it was not "news" so much as a ritual engagement with the problems of guilt and reconciliation. The February 20, 1997, story is a report on an event that took place on November 11, 1996, and it did not appear until April in Indianapolis or until May in Atlanta. "Pilot Finds Forgiveness— 24 Years after Attack," *Indianapolis Star and News*, April 13, 1997, 1, 2; "Spiritual Heal- ing and Forgiveness: After some 25 years, Vietnam Wounds Assuaged for Pastor," *Atlanta Journal and Constitution*, May 24, 1997, 1F. The story traveled around the world in print and on video, including a CBC television documentary (*Kim's Story: The Road from Vietnam*, directed by Shelley Saywell, 1996), ABC's *Nightline*, A&E's Biography series, etc. The CBC production may be the source for Chong's book: "The picture that moved millions to tears, ultimately made Kim Phuc a victim all over again." See *Kim's Story: The Road from Vietnam*, at http://www.frif.com/cat97/k-o/kim_phuc.html. And isn't there some irony in the film company claiming that "Kim learns that she will always be a public person—and a symbol"? Couldn't they do something to avert this apparently sad fate—say, by not making the film? Or, if that is asking too much, perhaps they could admit to their complicity in the story. Chong provides additional background (359–63), although the book's lack of documentation makes it useless for sorting out questions of fact and credibility.

44 "Vets Challenge Minister's Account of Napalm Attack; VA Man Says He Ordered Strike that Led to Photo," *Washington Post*, Dec. 19, 1997: C05; "Correction" *Washington Post*, Feb. 27, 1997, M03. Plummer, it seems, was no more accurate than the Vietnam- ese pilot who dropped the napalm. See also Ronald N. Timberlake, "Kim Phuc: The Myth of the Girl in the Photo," Nov. 1997, http://www.warbirdforum.com/vphoto.htm. It is interesting to see how Timberlake, rather than limiting his story to the events of 1996, tries to undercut the icon's influence on public opinion. He emphasizes that the picture was an "accurate depiction of about 1/500th of a second of the immediate aftermath of an all-Vietnamese accident in an all-Vietnamese fight in June of 1972." In short, the photo's misrepresentation comes from its fragmentary nature and the fact that the soldiers appear generic. The implication is that Americans did not and would never do such things. See also his essay, "The Shameful Lies," http://www .vietquoc.com/jul24-98.htm. In any case, the story continues to circulate as a narra- tive of forgiveness and redemption, unfazed by the exposé: for example, the Easter sermon by Mark S. Bollwinkel, "The Marys," Los Altos United Methodist Church, April 23, 2000, http://www.laumc.org/worship/sermons_35.html; Dan L. Flanagan, "What About Yes, Don't You Understand," St. Paul's United Methodist Church, Feb. 20, 2000, http://www.asiweb.com/community/churches/stpaulsumc-sermons/ Nor-20-2-00.asp; Cate Terwilliger, "Trial of Fire: Vietnam Icon Focuses on Forgive- ness," *Denver Post*, Feb. 25, 2001; and "John Plummer: Vietnam" in *International Forgiveness Day, August 1, 2004: Selected Forgiveness Stories and Forgiveness Projects*, Hawaii Forgiveness Project, http://www.hawaiiforgivenessproject.org/stories/ Forgiveness-Stories-print.pdf. For another Plummer-like episode, see Chuck Colson's sermon whereby he, too, draws on Kim Phuc to receive forgiveness for his involve-

ment in the war. Chuck Colson and Nancy Pearcey, "Victory over Napalm." *Christianity Today* (March 3, 1997): 96.

45 Kim Phuc's response gets to the heart of the matter: "Whether or not he played a major role or a minor role, the point is I forgive him" (Chong, *Girl in the Picture*, 363). The issue is one of atonement, not of accuracy.

46 Janet Mason, "Caught in Time," *Life*, May 1995, 45; reprinted as "Portrait of Kim Phuc, the 'Napalm Girl,' 23 Years Later," in *Life*, 60th anniversary issue, Oct. 1996, 102. This photo, taken by Joe McNally, won third prize at the 1996 World Press Photo Awards. Another, almost identical photo taken by Anne Bayin, titled "Kim Phuc and Thomas, 1995" is also in circulation. The Bayin photo looks over Kim's bare, scared shoulder as she holds her smooth-skinned baby. As reported in a *Ms.* Moment sidebar, the photograph "is part of a nationwide exhibit entitled 'Moments of Intimacy, Laughter, and Kinship.'" Its placement in *Ms.* magazine is equally clear: "If there is a picture that captures the madness of war, it is the one of nine-year-old Kim Phuc running naked, burned by the napalm that U.S. troops dropped on her Vietnamese village on June 8, 1972. And if there is a picture that captures the power of hope and the joys of renewal, it is the one above." "Ms. Moment: From Hell to Hope," *Ms.*, Oct./Nov. 2001, 20. This photo received an award from M.I.L.K. (Moments of Intimacy, Laughter and Kinship) and became part of a worldwide photographic exhibition that appeared in 2001 in the Vanderbilt Hall, Grand Central Terminal, New York and The Science Museum in London, England; in 2002 at Viaduct Harbour, Auckland, New Zealand; and in 2003 at the Sydney Opera House, Australia. Bayin collaborated with Nick Ut in superimposing the more recent image over the original "accidental napalm" as a poster for *The Kim Foundation*. See Anne Bayin, M.I.L.K., http://www.annebayin.com/milk.htm. A version of the superimposed image is used on the Griffith University Web site (http://www.gu.edu.au/er/campaign/phuc/content01.html) to demonstrate that their graduates not only achieve "financially rewarding careers [as photojournalists] but more importantly, careers that make a mark on society."

47 Chong reports that the scars are a persistent source of discomfort for Kim, but that information is not available in this photo.

48 Note also how the substitution reverses the Christian symbolism implicit in the original image. The little girl's naked arms evoke Christ suffering on the cross, but the image of the "mother and child" goes back down the road from Calvary to Bethlehem.

49 Barbara Ehrenreich, *Blood Rites: Origins and History of the Passions of War* (New York: Henry Holt, 1997), 125. See also Susan Jeffords, *The Remasculinization of America: Gender and the Vietnam War* (Bloomington: Indiana University Press, 1989).

50 Diane Haithman, "Seeing '95 Through Eyes of News Photographers Art: Dark images dominate the 39th international World Press Photo competition, now on view at the Museum of Tolerance," *Los Angeles Times*, Nov. 1, 1996. Ut knows his lines, which sound very similar to John Filo's statement about Mary Anne Vecchio, "I am so happy that she is now happy."

51 Dana Cloud, *Control and Consolation in American Culture and Politics: Rhetorics of Therapy* (Thousand Oaks: Sage, 1998); Peter Ehrenhaus, "Cultural Narratives and the Therapeutic Motif: The Political Containment of Vietnam Veterans," in Dennis K. Mumby, ed., *Narrative and Social Control: Critical Perspectives* (Thousand Oaks: Sage, 1993), 77–96. For a very thoughtful reconsideration of possible relationships between pain, trauma, and political identity, see Lauren Berlant, "The Subject of True Feel-

ing: Pain, Privacy, and Politics," in Jodi Dean, ed., *Cultural Studies & Political Theory* (Ithaca: Cornell University Press, 2000), 42–62.

52 Ehrenhaus, "Critical Narratives," 93–94.

53 Cloud, *Control and Consolation*, 27; Ehrenhaus, "Critical Narratives."

54 The iconic image was the one photograph selected for an art exhibit at the Guernica Culture House in Guernica Spain commemorating the 63rd anniversary of the attack on the city during the Spanish Civil War. See "Exhibit recalls German destruction of Spanish town of Guernica," CNN.com, http://www.cnn.com/2000/STYLE/arts/04/25/guernica.anniversary.ap, April 25, 2000.

55 *Kim's Story: The Road from Vietnam*, http://www.frif.com/new97/kim_s_sto.html. See also Charles Paul Freund, "Vietnam's Most Harrowing Photo: From Guilt to Grace," MSN.com, Nov. 22, 1996, http://slate.msn.com/id/1896/. The narrative is depicted visually by several photocollages: for example, one that superimposes a (composite) mother and (redheaded!) child above the iconic image, and another that places the smiling portrait of an adult Kim in front of her younger self running in what becomes the past.

56 The term comes from Barthes, *Camera Lucida*, 32.

57 Barthes, *Camera Lucida*, 119.

58 Terry Castle notes that photography was the "ultimate ghost-producing technology of the 19th century." "Phantasmagoria: Spectral Technology and the Metaphysics of Modern Reverie," *Critical Inquiry* 15 (fall 1988): 64.

59 Edward M. Chilton, "*Veritatis* Vietnam," at the currently mothballed "breadlosers" Web site, originally accessed Jan. 15, 2000.

60 Jeffrey DeCoster, *Boston Globe*, May 20, 2001, D3.

61 "This shared suffering has given our countries a relationship unlike any other." William Jefferson Clinton, "Remarks at Vietnam National University in Hanoi, Vietnam," Nov. 17, 2000, *Weekly Compilation of Presidential Documents*, vol. 46, no. 36 (Nov. 20, 2000), 2887–91.

62 Quoted in Sturken, *Tangled Memories*, 86.

63 Perlmutter, *Photojournalism and Foreign Policy*, 52.

64 Sturken, *Tangled Memories*, 87.

65 These are the images that appear repeatedly in academic, professional, and public discussions of influential photographs, iconic images, and the coverage of the Vietnam War. For example, these four and the evacuation scene atop the U.S. embassy were used to introduce the Gilder Lehrman Institute of American History teaching module, Major Topics in American History, The Vietnam War, http://www.gilderlehrman.org/teachers/module22/index.html. The images no longer are archived with the module, but the verbal reference remains: "They are among the most searing and painful images of the Vietnam War era. These prize winning photographs helped define the meaning of the war. They also illustrate the immense power of photography to reveal war's brutality." Others are included in some collections, and occasionally one of these four is not mentioned, but there is a strong convergence on these four as the definitive images of the war. We are confident that each of them is the "photographic equivalent of a literary modern classic: an instant archetype." Geoff Dyer, "The picture of a girl ablaze on a London street shocked the world. But haven't we seen it somewhere before?" http://www.tasc.ac.uk/depart/media/staff/ls/Modules/MED1110/Narrative/Dyer.htm. The essay first appeared in the *Observer*,

Feb. 21, 1999. See also Bruce Jackson, "Media and War: Bringing It All Back Home," Keynote Address at Media and War Symposium, University of Buffalo, NY, Nov. 17–18, 2003, online at http://buffaloreport.com/articles/031119.jackson.media.html.

66 Sturken, *Tangled Memories*, 89–94.

67 James Boyd White, *When Words Lose Their Meaning: Constitutions and Reconstitutions of Language, Character, and Community* (Chicago: University of Chicago Press, 1984).

68 Walter Benjamin, "A Short History of Photography," in *Classic Essays on Photography*, ed. Alan Trachtenberg (New Haven: Leete's Island Books, 1980), 203.

69 Barthes, *Camera Lucida*, 96.

70 Elaine Scarry, *The Body in Pain: The Making and Unmaking of the World* (New York: Oxford University Press, 1985), 63.

71 Kinney, *Friendly Fire*, 187.

72 Sturken, *Tangled Memories*, 93.

73 Perlmutter provides an extensive exoneration of the executioner in the Tet photo: "There was much less than meets the eye to have provided fuel for public outrage" *Photojournalism and Foreign Policy*, 47). His standards are misplaced, however, as another statement he uses to support his argument makes clear. The photographer who took the picture, Eddie Adams, is quoted to minimize the photo's documentary value: "'How many times did this happen that we *didn't* see?'" As evidence, it is but one anecdote, but as a performance the photo evokes the deeper knowledge that this behavior has been repeated many times. The performative framing of morally disturbing yet routine behavior produces both public engagement and traumatic memory. It also produces continual contestation of the photos and what they represent. Adams has been a vocal critic of those who read his photo to criticize the Vietnam War. By contrast, Phillip Griffiths has photographed the widow of the executed man holding a Vietnamese newspaper clipping of the photo along with a military medal. She stares into the camera with an expression of long-contained sorrow. The image demonstrates how a visual artist can turn the conventions of "the girl in the picture" and gendered emotionality to the purpose of democratic dissent. Likewise, although still a depiction of an individual, the woman's identity as a wife, the Vietnamese paper, and the medal together create a rhetoric of social types and an alternative history that is decidedly public rather than private. Phillip Jones Griffiths, *Viet Nam at Peace* (London: Trolley, 2005), 74.

74 Note also how the Abu Ghraib photos perpetuate this alignment, despite—indeed, because of—the presence of a female soldier among the tormentors of the Iraqi prisoners. By stripping them, mocking their genitalia, and forcing homosexual acts, the torturers did what they set out to do: the Iraqi men were symbolically emasculated by their treatment. Thus, the torture completed the work of military conquest and occupation. Victimage is again made essentially female: it happens to women or consists of men being reduced to women. Perhaps this is why the napalm girl is the more common Vietnam icon used for comparison, and why "accidental" napalm could have additional resonance regarding many of the Iraqi prisoners, of whom the Red Cross estimated that 90 percent were falsely accused, and for Iraqi citizens more generally.

75 Michael Warner, *Publics and Counterpublics* (New York: Zone Books, 2002), 90 and 74.

76 Warner, *Publics and Counterpublics*, 87. On the importance of uptake for public deliberation, see James Bohman, *Public Deliberation: Pluralism, Complexity, and Democracy*

(Cambridge: MIT Press, 1996), 58–9, 116–18; and J. L. Austin, *How to Do Things with Words*, 2nd ed., ed. J. O. Urmson and Marina Sbisà (Cambridge: Harvard University Press), 101.

77 Warner, *Publics and Counterpublics*, 74.

78 Warner, *Publics and Counterpublics*, 76.

79 Warner, *Publics and Counterpublics*, 75. In actually existing public discourse, exclusionary forms become bonded to the "theoretically" pure public form, as they must to make the latter communicable and effective, and then often come to dominate. Argument about whether the public sphere is necessarily exclusionary or only contingently so turns on this point.

80 Franklin, *Vietnam and Other American Fantasies*, 5–24. This fine essay provides some justification for Perlmutter's claim (*Photojournalism and Foreign Policy*, 54) that the photo could just as easily have been used to promote the war effort as to condemn it. That said, Perlmutter refers to use of the photo in the mainstream public media during the war and for that reason his claim still strikes us as implausible. The popular entertainment media working out of the trauma of losing the war were subject to far fewer constraints. Even so, their use of the photo for dramatic effect depended on its currency and emotional power, just as the ideological realignment of the photo was motivated by its position within cultural memory. See also Lisa M. Skow and George N. Dionisopoulos, "A Struggle to Contextualize Photographic Images: American Print Media and the 'Burning Monk,'" *Communication Quarterly* 45 (1997): 393–409.

81 Jürgen Habermas, *The Structural Transformation of the Public Sphere: An Inquiry into a Category of Bourgeois Society*, trans. Thomas Burger (Cambridge: MIT Press, 1989), 36–37.

82 Tom Toles, Universal Press Syndicate 2, 1994, *Buffalo News*.

83 Jeff Danziger, *Press-Enterprise*, April 5, 1997, A10; Cf. Sriwanichpoom's "This Bloodless War." Kinney discusses the "Just Do It" cartoon in the conclusion of *Friendly Fire* (190–91), although she doesn't attribute the cartoon to Danziger.

84 These include Buell, *Moments*, 102–3; Goldberg, *Power of Photography*, 244; P. Stepan, ed., *Photos That Changed the World: The 20th Century* (Munich: Prestel, 2000) 134–35; M.-M. Robin, ed., *The Photos of the Century: 100 Historic Moments* (Cologne: Evergreen, 1999), 59. It also is one of two photos (the other is Eddie Adam's execution shot) on the war in an award-winning historical text for "young people": Jay Harkin, ed., *All of the People, 1945–1998*, vol. 10 of *History of Us*, 2nd ed. (New York: Oxford University Press, 2001), 132.

85 See Andrew Lam, "Show and Tell," in Barbara Tran, Monique T. D. Truong, and Luu Truong Khoi, eds., *Watermark: Vietnamese American Poetry and Prose* (New York: Asian American Writers' Workshop, 1998), 111–21; Lionel E. Deimel, "Poetry: Phan Thi Kim Phuc at the Vietnam Memorial, Veterans Day, 1996," http://www.deimel.org/poetry/vietnam.htm, Jan. 22, 2001; Allison Durazzi, "Kim Phuc, Found Poem, Veterans Day, 1996," at "Words' Worth" Poetry Readings, Seattle City Council, http://www.ci.seattle.wa.us/council/licata/p_0007a_ad.htm, May 20, 2003; and Bruce Weigl, "Song of Naplam, for My Wife," *The Monkey Wars* (Athens: University of Georgia Press, 1985), n.p. It is also the basis for a program of chamber music composed by Deon Nielsen Price, "Three Faces of Kim, the Napalm Girl, for alto & soprano saxophones & piano," on *Price: To the Children of War*, Cambria Records, 1997.

86 Examples include a poster displayed at an antinapalm "simulation" in 2001, Didi

Tang, *Columbia Missouri Tribune*, May 27, 2001, http://archive.showmenews.com/2001/May/20010527News007.asp; and a placard titled "Lest We Forget" in opposition to the U.S invasion of Iraq, Laura Tiernan, "50,000 Antiwar Protesters March Through Sidney," World Socialist Web site, March 24, 2003, http://www.wsws.org/articles/2003/mar2003/syd-m24.shtml. An editorial cartoon by Kirk Anderson dresses the figures in Iraqi garb and says "Napalm helps us rid the world of morally unacceptable weapons," Aug. 2003, Naplam, http://www.kirktoons.com/august_2003/cartoons.html. The napalm icon is also referred to as the quintessential antiwar image in Fawn Vrazo, "12-Year Old Iraqi Amputee Has Become a Symbol of the War's Effect on Children," *Stars and Stripes*, Dec. 13, 2004. Earlier examples include a poster by Glenn Ruga opposing the 1991 Gulf War: "Stop the Gulf War Now." The poster (which, in a rare departure from convention, features the boy who is screaming) can be seen at the Center for the Study of Political Graphics; http://www.politicalgraphics.org. On the other side of the spectrum, editorial cartoonist Glen McCoy placed the image on John Kerry's T-shirt as the candidate says, "Using a tragedy like 9-11 to score political points! Mr. Bush, have you no shame?!!" *Philadelphia Inquirer*, March 8, 2004. Kim Phuc is the subject of a child's drawing (along with pictures of Césasr Chávez and Sitting Bull) in Caroline Brewer's paean to "hope": *Kara Finds Sunshine on a Rainy Day* (Unchained Spirit Enterprises, 2002) available online at http://www.karafinds sunshine.com/karafindssunshine/wonders.html#article. A very different set of associations is activated by the icon's reproduction in *The People vs. Larry Flynt*, directed by Milos Forman (Columbia Pictures, 1996) where it is alleged that Flynt published the photograph in *Hustler* as part of an article on the "pornography of war." We have been unable to locate the early issues of *Hustler* to confirm the accuracy of this claim.

87 Dennis Draughon, Abu Ghraib 'Nam, May 12, 2004, *Scranton Times*, http://editorial cartoonists.com/cartoon/display.cfm/10557/.

88 J. Burger, "The Influence of Fear in the Eyes of the Child," *Ha'aretz*, Oct. 5, 2000, 2B.

89 We are indebted to Nancy K. Miller for bringing to our attention her careful study of artistic remediation of the image. As a form of personal testimony these works are an important complement to our analysis. See "The Girl in the Photograph: The Vietnam War and the Making of National Memory," *JAC* 24 (2004): 261–90.

90 Lucy R. Lippard, *A Different War: Vietnam in Art*, Whatcom Museum of History and Art (Seattle: Real Comet Press, 1990), 109.

91 Reprinted Lippard, *A Different War: Vietnam in Art*, 107–9.

92 The work is reproduced as part of a discussion of iconic images in Miles Orvell, *American Photography* (New York: Oxford University Press, 2003), 212.

93 Judy Chicago, *Holocaust Project: From Darkness into Light 1985-1993* (New York: Penguin, 1993), 136.

94 Reprinted in *Speechless* (Mariettta, Georgia: Top Shelf Productions, 2001), 35.

95 At http://www.iniva.org/dare/artwork/sriwanichpoom/sriwanichpoom4.html.

96 Winston Wachter Fine Arts Gallery, Seattle, WA, http://www.winstonwachter.com/artists/s_scherman.html; Tony Scherman, http://www.tonyscherman.com/frames/mainframeex.html.

97 Part of an exhibit titled Well They Tell Me of a Party Up in the Sky Waiting for Me to Die, 2001–2002, Air de Paris. A fragment can be seen at http://www.airdeparis.com/artists.htm.

98 At http://www.ewhite.com/gallery/MP/nam.html.

99 Goldberg, *Power of Photography*, chap. 5.

100 John Durham Peters, *Speaking into the Air: A History of the Idea of Communication* (Chicago: University of Chicago, 1999); Barthes, *Camera Lucida*.

101 See Avery F. Gordon, who argues that "to study social life one must study the ghostly aspects of it," and who provides eloquent testimony of what is at stake: "What does it mean for a country to chose blindness as its national pledge of allegiance?" in *Ghostly Matters: Haunting and the Sociological Imagination* (Minneapolis: University of Minnesota Press, 1997), 7, 207.

102 Georg Simmel, "The Stranger," in Kurt Wolff, ed. and trans., *The Sociology of Georg Simmel* (New York: Free Press, 1950), 402–8.

103 Paul Virilio and Sylvère Lotringer, *Pure War*, trans. Mark Polizzotti (New York: Semiotext[e], 1983), 28.

104 James Der Derian, *Antidiplomacy: Spies, Terror, Speed, and War* (Oxford: Blackwell, 1992) and *Virtuous War: Mapping the Military-Industrial-Media-Entertainment Network* (New York: Westview: 2001); Chris Hables Gray, *Post-Modern War: The New Politics of Conflict* (New York: Guilford, 1997).

105 Lester, *Photojournalism: An Ethical Approach*, 120.

106 See, e.g., the testimony in Diane Eicher, "Images: Despite the Barrage of Video Footage, It's Still Photos That Haunt Us," *Denver Post*, September 23, 2001, F1. John Morris makes the claim specifically about the Vietnam icons, including the Nick Ut photo, in "John Morris," in *Photography within the Humanities*, ed. Eugenia Parry Janis and Wendy MacNeil (Danbury, NH: Addison House, 1977), 14–15.

107 Malcolm F. Mallette, "Should These News Pictures Have been Printed?" *Popular Photography* (March 1978): 120. More specifically, "One of the war's most haunting images shows the aftermath of napalm dropped by mistake in June 1972 on the friendly village of Trang Bang." Lorraine Glennon, ed., *The 20th Century: An Illustrated History of Our Lives and Times* (North Dighton, MA: JG Press, 2000), 528. This argument is apt but also can be misleading. Television has been an important vehicle in the circulation of iconic images. As Goldberg remarks of the napalm photo, "Anyone who watched the news that night would have seen the twenty-one-year-old South Vietnamese photographer's image of the little girl. . . . television was disseminating the most telling still images throughout the culture." *Power of Photography*, 242. In addition, because setting still photos over video is a similar distinction to setting print media over visual media, we should recognize that in highlighting one feature of still photography we might be distorting or undervaluing other features of the video flow. The rhetorical technique of dissociation that is at work in these distinctions is identified by Chaim Perelman and L. Olbrechts-Tyteca, *The New Rhetoric: A Treatise on Argumentation*, translated by John Wilkinson and Purcell Weaver (Notre Dame: University of Notre Dame Press, 1969), 411–59.

108 Pierre Nora, "Between Memory and History: Les Lieux de Mémoire," *Representations* 26 (1989): 18.

109 Nora, "Between Memory and History," 24.

110 This emphasis on public memory as a species of collective memory corrects several troublesome assumptions in Nora's theory, particularly the contrast between memory and critical judgment. Critique may be grounded in history, and venerated artifacts will incorporate critical resources differently than historical scholarship, but the simple binary relationship produces serious errors in oversight (on

both sides). The problem is compounded when it is associated with the distinction between verbal and visual media. Although such distinctions may apply at specific historical moments, and although much more could be said about the relationships between history and memory in public discourse, we hope our analysis demonstrates how iconic photographs can both have the aura of a *lieu de mémoire* and direct critical reflection. For discussion of the uses of "memory" in historiography, see Kerwin Lee Klein, "On the Emergence of *Memory* in Historical Discourse," *Representations* 69 (2000): 127–50.

CHAPTER SEVEN

1 Benjamin R. Barber, *Strong Democracy: Participatory Politics for a New Age* (Berkeley: University of California Press, 1984), 3.

2 Craig Calhoun, *Neither Gods nor Emperors: Students and the Struggle for Democracy in China* (Berkeley: University of California Press, 1994); Craig Dietrich, *People's China: a Brief History*, 2nd ed. (New York: Oxford University Press, 1994); George Black and Rogin Munro, *Black Hands of Beijing: Lives of Defiance in China's Democracy Movement* (New York: John Wiley, 1993); Chu-Yuan Cheng, *Behind the Tiananmen Massacre* (Boulder, CO: Westview Press, Inc., 1990); Human Rights in China, *Children of the Dragon: The Story of Tiananmen Square* (New York: Macmillan, 1990); Tony Saich, *The Chinese People's Movement: Perspectives on Spring 1989* (Armonk, NY: M. E. Sharpe, 1990); Associated Press, *China: From the Long March to Tiananmen Square* (New York: Henry Holt, 1990); Scott Simmie and Bob Nixon, *Tiananmen Square* (Seattle: University of Washington Press, 1989); Donald Morrison, ed., *Massacre in Beijing: China's Struggle for Democracy* (New York: Warner, 1989). Chronologies are available in Saich, *The Chinese People's Movement* and *Massacre in Beijing*.

3 See, e.g., *Time*, June 12, 1989, 27. Recent use includes the Virtual Museum of China '89, May 1989 (part 2), China News Digest International, http://museums.cnd.org/China89/8905-2.html; A Peaceful People Movement in Tian'anmen Square 1989, Silicon Valley for Democracy in China, http://www.christusrex.org/www1/svdc/goddess.html; Tiananmen Square Multimedia Exhibit, History Wiz, http://www.historywiz.com/goddess.htm; Melinda Liu, "The Goddess of Democracy," *Media Studies Journal* (winter 1999): 120–21. The statue's demolition is shown in *The Gate of Heavenly Peace*, directed by Carma Hinton and Richard Gordon, Long Bow Group, 1995.

4 Wu Hung reports on the students' decision to not make a literal reproduction of the American model, as had been done in Shanghai, in "Tiananmen Square: A Political History of Monuments," *Representations* 35 (1991): 110. Tsao Tsing-yuan provides a more detailed account of the statue's synthesis of several artistic models, in "The Birth of the Goddess of Democracy," in *Popular Protest and Political Culture in Modern China*, 2nd ed., ed. Jeffrey N. Wasserstrom and Elizabeth J. Perry (Boulder, CO: Westview Press, 1994), 140–47. Thus, the goddess exemplifies one form of the art of rhetoric: skills of appropriation and adaptation, a sophisticated perspective on culture and nationality, and heteronomic modernity (albeit on a Western model).

5 This is not to deny the iconic status of the Goddess. (How could a goddess not be iconic?) The image clearly meets our four criteria for selection, not least in its range of appropriations. These include Web images, book covers, posters, figurines, stat-

ues, an oil painting that then is used within an animated artwork, a T-shirt, and a pendant. There is a difference in degree between the two images, however: for most Western public media and audiences, the man before the tank is the dominant representation of the events in Tiananmen Square. We also believe it is the one that is used to mediate a wider range of issues, perhaps because it also mediates the deeper contradiction within U.S. public culture. A similar comparison can be made with the images of the Statue of Liberty and the firefighters at ground zero following September 11, 2001 (see chapter 4 above). In each case, the statue may be too straightforward a symbol to become a dominant icon. Or it might be antiquated: the statue is an obviously artistic medium, while photography, film, and video are thought to be transparent; it engages in figural representation, contrary to norms of abstraction and realism in modern arts; and it appeals to hope rather than cynicism.

6 It appeared initially on the front page of the *Los Angeles Times*, June 5, 1989. It can be seen online at "Tanks in Tiananmen Square," HistoryWiz, http://www.historywiz .com/tiananmen-mm.htm.

7 It appeared in some newspapers on June 6 (e.g., *Indianapolis Star*, June 6, 1989, A4) and most prominently in *Newsweek*, June 19, 1989, 19. It can be seen online at Photo District News: Twentieth Anniversary, http://pdngallery.com/20years/photojournal ism/04_charlie_cole.html. Cole's description of the photo is at BBC News, "Picture Power: Tiananmen Stand-off," http://news.bbc.co.uk/1/hi/world/asia-pacific/ 4313282.stm.

8 The photo is one from several rolls taken on June 5, 1989 by Stuart Franklin from the balcony of the Beijing hotel on Changan Boulevard overlooking the square. (Cole's photo also was taken from Franklin's balcony.) It appeared most prominently on the cover of *Time*, June 19, 1989 and as part of a two-page spread on the inside of the magazine (10–11). For a full-page color reproduction of this image, see Richard Lacayo and George Russell, *Eyewitness: 150 Years of Photojournalism*, 2nd ed. (New York: Time, 1995), 164. A slightly smaller cropping in black and white is widely available as a poster; it also appears on a T-shirt and a range of other media. An array of five shots from Franklin's roll that show the beginning, middle, and end of the confrontation is in Human Rights in China, *Children of the Dragon*, 189–93. Related images from the Stuart Franklin portfolio can be seen online at www.magnumphotos.com.

9 For discussion of the man's identity, see David D. Perlmutter, *Photojournalism and Foreign Policy: Icons of Outrage in International Crises* (Westport, Conn.: Praeger, 1998), 75–77. Like Perlmutter, we are skeptical of claims that the man is known to be "Wang Weilin" or any other specific individual. The man is often generically identified as a student, but it is more likely that he was a worker. "'My dissident friends and I did our very best to find the man in the photo, but to no avail. . . . If he'd been a student, our networks would have found him." Report of an interview with Wang Dan. Robin, *Photos of the Century*, no. 88. Craig Calhoun identifies him as "a twenty-six-year-old printer" who "apparently was arrested several days later" (*Neither Gods nor Emperors*, 143); he provides no support for either claim. Because the man's actual cultural designation is not legible in the photo, his generic modern dress then keys the dominant frame of reference. On the role of black dress in the ascendancy of modernity, see John Harvey, *Men in Black* (Chicago: University of Chicago Press, 1995). We believe that a similar generalization might apply to the tanks: their only specific marking is the dull red star that is not unlike the red insignia on Soviet tanks or the dull blue and

white star on U.S. tanks, and the Chinese T-59 is a variant on the Soviet T-55, which has been used as well by a number of other countries. Retrofit and gun conversion packages are available from the British companies Oceonics Vehicle Technology and Royal Ordinance Nottingham. See Christopher Foss, *Jane's Main Battle Tanks*, 2nd ed. (United Kingdom: Jane's Publishing Company, 1986), 11–14, 88–94, 163, 185–86. The iconic photo graces a technical display of tank technology at the Federation of American Scientists, Military Analysis Network, Type 80 Specifications, http://www.fas.org/man/dod-101/sys/land/row/type-80.htm.

10 Michael Dutton, ed., *Streetlife China* (Cambridge: Cambridge University Press, 1998), 17. Dutton specifies the symbol as one "of resistance to terror" that captures all that the West abhorred about Chinese Communism. We hope to demonstrate that, as some of our sources attest, a wider range of meanings is available. There is no doubt, however, that the image is valued because it "fits so nicely with the story we [Westerners] expect to see." Richard Gordon, "One Act, Many Meanings," *Media Studies Journal* (winter 1999): 82.

11 Perlmutter, *Photojournalism and Foreign Policy*, 66–71.

12 "Bush Halts Military Sales to China," *Los Angeles Times*, June 5, 1989, 1 and "China Teeters on Edge of Civil War as Rival Forces Mobilize," *Los Angeles Times*, June 6, 1989, 1; "A Drama within a Drama on the Streets of Beijing," *New York Times*, June 6, 1989, 1; "China on the Brink of Civil War," *St. Louis Post-Dispatch*, June 6, 1989, 1; "Unrest Spreads Across China," *Chicago Tribune*, June 6, 1989, 1, and Lewis M. Simons, "One Man's Courage Faces Down a Row of Tanks," *Chicago Tribune*, June 6, 1989, 4; "Tank Face-Off," *Times-Picayune*, June 6, 1989, 1; "Measure of Defiance," *Indianapolis Star*, June 6, 1989, A4; James Barron, "One Man Can Make a Difference: This One Jousted Briefly with Goliath," *New York Times*, June 6, 1989, 15.

13 "Revolt against Communism," *Time*, June 19, 1989; "Reign of Terror," *Newsweek*, June 19, 1989; "History through a Cloudy Lens," *U.S. News and World Report*, June 19, 1989, 18–19.

14 The photo is included in the following visual histories, among others: Lacayo and Russell, *Eyewitness: 150 Years of Photojournalism*, 164; Vicki Goldberg, *The Power of Photography: How Photographs Changed Our Lives* (New York: Abbeville Press, 1991), 251; *Great Images of the Twentieth Century: The Photographs That Define Our Times* (New York: Time Books, 1999), 16; Richard B. Stolley, ed., *Our Century in Pictures* (Boston: Little, Brown, 1999), 375, and *Our Century in Pictures for Young People* (Boston: Little, Brown, 2000), 203; Marie-Monique Robin, *The Photos of the Century: 100 Historic Moments* (Cologne: Evergreen, 1999), no. 88; Peter Stepan, *Photos That Changed the World* (Munich: Prestel, 2000), 162–63; Time, *Great Events of the 20th Century* (New York: Time, 1997), 52. It is used on many Web sites as the only or key visual representation of the protest: e.g., History Wiz, "Tiananmen Square," Tiananmen, April–June 1989, Christus Rex et Redemptor Mundi http://www.christusrex.org/www1/sdc/tiananmen.html; Tiananmen Square Chinese Democracy Movement, 14th Anniversary, June 4 1989, http://www.geocities.com/dredeyedick/tian10.htm; CNN.com, May 28, 1999, "The Lingering Legacy of Tiananmen Square," http://www.cnn.com/WORLD/asiapcf/9905/28/tiananmen.legacy/; and The Freedom Forum, May 26, 1999, "Nearly 10 years on, bloody crackdown at Tiananmen Square stirs vigorous debate," http://www.freedomforum.org/. Other examples include the only image on the English-language main page of ChinaAffairs.Org, http://www.chinaaffairs.org/english/index.html (the

words "freedom," "democracy," "human rights" flash above it, while below are the main links for shopping); and at least nine book covers: *Beijing Spring 1989*, *China at Forty*, *Song of Heaven* (which remediates John Haddock's "Screenshots" rendition of the image, Isometric Screenshots for the 20th Century, http://www.whitelead.com/jrh/screenshots/), *Song of Tiananmen Square*, *Tiananmen Diary*, *Tiananmen Papers*, *Tiananmen 10 Years On*, *1989: The Year the World Changed*, *Human Rights in World Politics*. It is used regularly as a visual caption for stories about protest and/or anniversaries of the event on the World Wide Web. It has been reproduced also as an illustration within a graph of the annual attendance at Tiananmen Square vigils. At Sinomania!, a government site, it is shown as one of three images that may be "the most famous images of China from the Twentieth Century and all three share a bleak and detached view. Pictures have power and the absence of *positive* high-impact images of China is one of the main reasons people today don't understand China." Fact about China: China and Chinese, http://www.sinomania.com/facts_about_china/china_is_land.html. (The main page to this site also offers a "perspective" on "Tiananmen 15 Years Later" that compares the clearing of the square with the U.S. Army's destruction of the squatters' camp of veterans outside of the U.S. Capitol on July 28, 1932—a comparison which we have never seen in the U.S. press—and with the Kent State killings that hyperlink to the John Filo image discussed in chapter 5. See http://www.sinomania.com/CHINANEWS/tiananmen.htm.) The photo also appears in varied vernacular sites, e.g., as the first image of a visual/verbal poem by Johnny Hughes, "Tiananmen Square," 1999–2000, http://www.johnnyhughes.com/tiananmen_square.htm.

15 Perlmutter, *Photojournalism and Foreign Policy*, 66; Gordon, "One Act, Many Meanings," 82.

16 *Time*, "The Unknown Rebel," April 13, 1998, at http://www.time.com/time/time100/leaders/profile/rebel.html. For related hyperbole, the image was used to mark one of the top hundred greatest events of the century, and one of three from the 1980s, at Countdown: Greatest Achievements of the 20th Century, TLC/Discovery.com.

17 Hung, "Tiananmen Square," 104.

18 *Time* magazine coverage reflects this shift. The monument is featured in their first cover story on the demonstrations in the square (May 29, 1989, 37), the Goddess appears in the June 12th issue (27), and the tank photograph is on the cover and as a two-page spread beginning the cover story of the June 19 issue (10–11).

19 Jon Simons, correspondence with the authors, Dec. 10, 2001.

20 Commentators occasionally compare the image to other scenes of democratic revolution. "It is a sister image to the famous photograph of the suppression of the Prague Spring (see page 120), albeit more distanced and less emotional." Stepan, *Photos That Changed the World*, 162.

21 The quoted text is from the narration in *The Gate of Heavenly Peace*. The transcript is available at "The Film," http://tsquare.tv/film/transcript01.html. It also is used in Gordon, "One Act, Many Meanings," 83. The emphasis on the *individual* assertion of liberty is evident in many appropriations of the image: see, for example, the billboard by the Foundation for a Better Life, "Sometimes it's a lone voice," http://www.forbetterlife.org/main.asp?section=billboards&language=eng. See also the prominence given the photo at the Liberty Tree, where it is available on the main page and as a poster, http://www.liberty-tree.org/ltn/tiananmen-square.html. "Our 'politics,'

such as they are, are in the classical liberal tradition of John Locke, Thomas Jefferson, John Adams, and Edmund Burke. We believe in maximizing personal and economic liberties and minimizing the power of the state."

22 Note Stuart Franklin's comment that "'It really isn't a great picture, because I was much too far away.'" Robin, *Photos of the Century*, n.p. The pertinent norm of photojournalism, especially in respect to war or revolution, is that the photographer should be in the middle of the action, a virtual participant, in contrast to the distant or posed compositions of most other professional photography. See Susan D. Moeller, *Shooting War: Photography and the American Combat Experience* (New York: Basic Books, 1989), 9. Perlmutter notes the unusual distance for the Tiananmen icon and concludes that "no icon is immaculately conceived" (*Photojournalism and Foreign Policy*, 80). We also should mention that Franklin's comment displaces another criterion for good photojournalism, which is that the image should be somewhat implausible. See Howard Chapnik, foreword, in Marianne Fulton, *Eyes of Time: Photojournalism in America*, International Museum of Photography at George Eastman House (Boston: Little, Brown, 1988), x–xii. The Tiananmen shot is doubly so: first, the man stands in front of the tank and the tank does not crush him; second, he steps out of private life to perform a heroic act on behalf of the people.

23 It also is consistent with the conventions of newspaper design. The authoritative history of the subject charts transformation of the twentieth-century newspaper through successive stages of design to culminate in the "late modern" phase of the 1980s and 1990s characterized by an "aesthetic of modernism." Kevin G. Barnhurst and John Nerone, *The Form of News: A History* (New York: Guilford, 2001). See also Kevin G. Barnhurst, *Seeing the Newspaper* (New York: St. Martin's, 1994), 174 ff.

24 James C. Scott, *Seeing Like a State: How Certain Schemes to Improve the Human Condition Have Failed* (New Haven: Yale University Press, 1998), 79.

25 Michel Foucault, *Discipline and Punish: The Birth of the Prison*, trans. Alan Sheridan (New York: Vintage, 1979).

26 Robert Hariman, *Political Style: The Artistry of Power* (Chicago: University of Chicago Press, 1995), 36.

27 Hariman, *Political Style*, 36.

28 Note also that the video version of the incident shown in *The Gate of Heavenly Peace* reveals a more complicated political scenario: while the close-in shot leaves a larger, visual field outside the frame, the tank attempts to maneuver around the man, who dodges back and forth to stay in front of it, and then clambers on board to *talk* to the crew through a viewing slit. All this activity appears ad hoc, aesthetically ragged, perhaps impulsive. In this view, historical action is a matter of micropolitical interactions that develop through improvisation and talk among people whose perspectives are likely to reflect their standpoints within the event. Likewise, opinions and actions can be changed by speaking with other citizens. Note also the corresponding shifts in role: instead of the individual opposed to the state, there is a worker talking with a soldier who is a fellow citizen. Instead of forcing a confrontation, the worker is trying to engage the soldier in political dialogue, which had been a strategy of the reform movement. Such alternative narratives are lost to the suppression of speech characteristic of realist doctrine and modernist design.

29 Gunther Kress and Theo van Leeuwen, *Reading Images: The Grammar of Visual Design* (New York: Routledge, 1996), 186–202.

30 Scholars in international relations are accustomed to seeing realism and liberalism defined as opposing theories of world politics. From that perspective, the analysis in this paper then will appear confused or ignorant. To avoid this misunderstanding, it is important to specify the level of analysis: We are not making claims about theoretical arguments in the social sciences. We are examining one instance of how realism and liberalism function as political discourses within public media. When political ideas operate in the "real world" of political actors speaking among themselves and before others to persuade, manipulate, rationalize, and otherwise use speech and other symbolic forms as modes of action, they typically use varied and often seemingly contradictory appeals. They do so because they have to address multiple audiences, represent multiple constituencies, provide flexible responses to contingent events, and so forth. Moreover, these potential contradictions often are managed through incorporation into encompassing norms of representation. So it is that liberalism and realism can be conjoined within a common modernism. We also think that this perspective raises interesting questions about the conduct of international relations theory, such as whether that theory can be so neatly separated from the discourses of world politics, and whether liberalism and realism have more similarities than differences as theoretical projects. There is no doubt that theoretical explanation can provide insight into the operation and failures of political discourse; we believe that the reverse also holds. See also Francis A. Beer and Robert Hariman, eds., *Post-Realism: The Rhetorical Turn in International Relations* (East Lansing: Michigan State University Press, 1996).

31 Criticisms of modernist aesthetics now are legion. In part due to our emphasis on the conventions of modernist visual art, we have been influenced most directly by Scott and by Charles Jencks, *What Is Postmodernism?* 4th ed. (London: Academy Editions, 1996), and *Late-Modern Architecture and Other Essays* (New York: Rizzoli, 1980). See also Brian Wallis, ed., *Art after Modernism: Rethinking Representation* (New York: New Museum of Contemporary Art, 1984).

32 It should be made clear that we are referring to a particular articulation of cultural modernism and not to every painting, sculpture, design, or manifesto bearing the name. Modernism has included powerful critiques of modernity itself, not least through its development of the avant-garde, and one also should acknowledge the Frankfurt school argument that modern art provided a critical moment within modernity precisely because that art was abstract. Fair enough, but these counter-movements pertain far more to high culture than they do to mainstream dissemination of modernism through the design professions and the mass media. The difference becomes more acute as one historicizes: the avant-garde is dead, abstraction's critical function has been neutralized by ubiquity, while late-modern design acquires expanded influence as a political aesthetic when coupled with processes of globalization. The difference is particularly evident in the iconic photo in question: Whatever else modernist aesthetics can do—including the deep explorations of individual subjectivity that have been produced—those variants are not in the picture. There is not one modernism, but the various articulations are not equally manifest in any one case or in the media generally. Using high modernist design to represent citizenship in the news media makes some actions more intelligible and others less so; we attempt to show how that is so.

33 Scott, *Seeing Like a State*, 4.

34 The coverage in *Newsweek* is illustrative. The June 12th cover screams "Bloodbath," and the June 19th cover declares a "Reign of Terror." Both covers and the other photos accompanying the story document the carnage in vivid, emotionally powerful images. The tank photo is captioned, "'A single student standing in front of a tank': Among the indelible images of the upheaval in Tiananmen, a lone demonstrator blocks an armored column on Changan Avenue." It is the last visual record of the confrontation in the streets and followed by portraits of establishment leaders and military police. By contrast with prior images, it is dispassionate, measured, and orderly. This reduction also functions as a transition within the magazine's visual narrative from past to present, from popular protest to official power, from domestic upheaval to global actors.

35 This modernism is also evident in the photo's conformity with the most basic sense of journalistic objectivity: it is a balanced presentation of two sides of a conflict. This norm, which is at the center of the professional standards of print journalism and the standard practice of the mainstream press, is much easier to follow in print than through action photography. Like legibility, it is a norm created by the institutionalization of writing. By contrast, most photos are not balanced portrayals of an event, which is why they can function so well as arguments. Once objectivity is parsed into a range of articulations from myth to one criterion among many, it becomes less of a concern. Critique of its overemphasis includes David T. Z. Mindich, *Just the Facts: How "Objectivity" Came to Define American Journalism* (New York: New York University Press, 1998). On the relationship between writing and norms of rationality and objectivity, see Jack Goody, *The Logic of Writing and the Organization of Society* (Cambridge: Cambridge University Press, 1986).

36 Kress and van Leeuwen, *Reading Images*, 165–71.

37 "Courage on the Avenue of Eternal Peace," by Michael C. O'Neal. It is showcased at Freed Ads, http://www.freedomads.org/live/entries.php?id=75. Reproductions include "Freedom Hero: Tiananmen Square," by Pat Keeton and Jeanne Meyers, http://www.myhero.com/myhero/hero.asp?hero=tiananmenSquare. Interestingly, both sites mistakenly identify the poster with the international human rights organization Amnesty International.

38 O'Neal's wife Patricia remarks, "When I asked him why he did it this way, he replied, 'When I saw the man stand before the tanks during the Tiananmen Square incident, I was moved to honor his bravery. The famous photographs we've all seen blinded me for years as to how to approach this subject. Then it came to me, put the viewer at street level, down there were [sic] the tanks were. This perspective allowed me to suggest the abusive power and danger of the government while being juxtaposed against the heroic scale of what this man did that June day on the Avenue of Eternal Peace.'" Tiananmen Square Demonstrations and Massacre Forum, http://pub5.bravenet.com/forum/395236120/fetch/69690/. Confirmed by Mr. O'Neal in correspondence with the authors.

39 Kress and van Leeuwen, *Reading Images*, 146.

40 Jeffrey N. Wasserstrom, *Student Protests in Twentieth-Century China: The View from Shanghai* (Stanford: Stanford University Press, 1991), 5. See also Esherick and Wasserstrom, "Acting out Democracy: Political Theatre in Modern China," in *Popular Protest and Political Culture in Modern China*, 32–69.

41 The point is accented by a photograph of hundreds of "[protestors] facing lines of troops backed up by tanks at an entrance to Tiananmen Square" that appears in the *New York Times* on June 6, 1989, A14, the same day that the tank photograph was on the front page. Here we have an image of a "democratic" revolution, but of course this photo fades from memory and the public eye. As far as we know it has never been reprinted.

42 The concept of a political scenario comes from Lance Bennett, *The Political Mind and the Political Environment* (Lexington, MA: Lexington Books, 1975), 51–78, and also "Political Scenarios and the Nature of Politics," *Philosophy and Rhetoric* 8 (1975): 23–42. Barbara Koziak relies on the concept, although not Bennett's formulation, in *Retrieving Political Emotion: Thumos, Aristotle, and Gender* (University Park: Pennsylvania State University Press, 2000), 3. Bennett demonstrates how political judgment can depend on a paradigmatic scene constituting a worldview, while Koziak takes the analysis beyond Bennett's cognitive orientation. We discuss Koziak's model briefly in chapter 5. In both cases, an important point is that people don't act on the basis of information but rather on the basis of models of political action. These models are vernacular forms of political theory that simplify, generalize, and otherwise serve as machines for sifting information. Successful models are those that can manage complexity and minimize conflict on behalf of a particular interest, which they do in part by foreclosing on recognition of alternatives. We emphasize how photographs can alternately project or challenge particular scenarios.

43 Likewise, "The 'place' of citizenship is abstracted from the physical forum of collective action and relocated into the individual bodies of private persons. The 'place' of democracy, conversely, is abstracted from those same bodies and delegated to representative government and bureaucracy located elsewhere." John Hartley, *The Politics of Pictures: The Creation of the Public in the Age of Popular Media* (New York: Routledge, 1992), 41. Hartley sees a common transformation being wrought through modernist architecture and modern media.

44 Scott, *Seeing Like a State*, 32.

45 What drops out of this transformation is the recognition of any translation problem between the Western idea of human rights and Chinese political culture. See Xia Yong, "Human Rights and Chinese Tradition," in *Streetlife China*, 23–41. But too much can be made of these differences, and we don't want to disregard the image's inspirational value. "Mickey Spiegel, a China specialist at Human Rights Watch in New York City . . . has hung the photograph in every office she has occupied since 1989." Dana Clavo, "Indelible Images: Profile in Courage," *Smithsonian*, Jan. 2004, 18.

46 Le Corbusier, "Towards a New Architecture," trans. Fredrick Etchells, http://www.cis .vt.edu/modernworld/d/LeCorb.html. Le Corbusier uses both terms ambiguously: "architecture" refers to both the outmoded styles of the past and to the new designs for the modern age; "revolution" refers to both modern architecture's radical break with the past and to the social unrest created by a mismatch between industrialization and a lack of modernist social engineering. By the end of the article, "architecture" has become modern architecture, and "revolution" the masses taking historical change into their own hands to create a "catastrophe." Note also that Bauhaus slogan, "Art and Technology—A New Unity" applies directly to photography as the preferred medium for modernist representation of the social order.

47 Scott, *Seeing Like a State*, 256.

48 Walter Benjamin glimpsed the relationship in his discussion of photographing works of art. "In the final effect, the mechanical methods of reproduction are a technology of miniaturization and help man to a degree of mastery over the works without which they no longer are useful." "A Short History of Photography," in *Classic Essays on Photography*, ed. Alan Trachtenberg (New Haven, CT: Leete's Island Books, 1980), 212.

49 Scott, *Seeing Like a State*, 258.

50 *The Gate of Heavenly Peace*. The Web site maintained by the Long Bow Group on the film summarizes and provides some references regarding discussion of the film, as well as additional information and links regarding the protest and government actions, http://tsquare.tv/.

51 The film's use of the photo is further evidence of its iconic status: it is used to orient the Western viewer to the historical event—"a moment that would come to symbolize the hope and the tragedy of those spring days"—and its appropriation in other media is highlighted. *The Gate of Heavenly Peace—Transcript*. Another example of this "titular" function is provided by the Vanderbilt Television News Archives, which uses the video clip of the confrontation in the introduction to its tapes while newscaster Dan Rather intones that pictures are the essence of the news.

52 This focus on the young masculine body may be a convention of liberal depictions of Chinese democracy. Note, for example, the cover and concluding images in *Children of the Dragon*. First, three young men, two of them bare-chested, and then one, bare-chested and holding up both arms, fists clenched, in a gesture of masculine strength and triumph as he stands on a high railing. (He is supported by another man, although one who is not recognizable in part due to the clothing that is billowing out away from the higher man's torso; both are wearing black in the black and white photo.) There is another reduction as well: from the red flag and Chinese ideograms displayed in the first photo, to one whose culture, like his shirt, has been cast aside to be blown away from him by the winds of change.

53 *The Gate of Heavenly Peace—Transcript*.

54 Contrast this deflection of public mourning with Hung's observation that a vital, grassroots, dissident public emerged in Beijing in 1976 through the experience of grieving together over the death of Zhou Enlai ("Tiananmen Square," 102–4). The public may have required rational-critical debate (occurring in private settings), but it emerged from public mourning mediated by visual arts (the monument in the square, the wreaths and banners placed there, etc.). Such "sentimental" acts may be far more important to democratic life than is acknowledged; if so, their suppression within modernist schemes of representation is incipiently antidemocratic.

55 Associated Press, *China: From the Long March to Tiananmen Square*.

56 Tiananmen Square 1989, New York Times on the Web, Feb. 14, 2006, http://www .nytimes.com/library/world/asia/tsquare-china-index-pix.1.html. The picture of the couple standing beneath the bridge appears in a number of places, including the *New York Times*, June 6, 1989, A16, above two screen shots from the ABC News, one of the lone individual climbing on top of the tank in Tiananmen Square to talk with the driver, and the other of a group of observers shuttling the man off to safety.

57 Anne Norton, *Republic of Signs: Liberal Theory and American Popular Culture* (Chicago: University of Chicago Press, 1993), 1.

58 Kenneth Burke, *A Grammar of Motives* (Berkeley: University of California Press, 1969), xv–xxiii.

59 Hung, "A Political History of Monuments," 90. These squares were very much under the control of the dominant authorities, yet also open to both "official" and "vernacular" articulations. See John Bodnar, *Remaking America: Public Memory, Commemoration, and Patriotism in the Twentieth Century* (Princeton: Princeton University Press, 1992). Hung's article provides a companion piece of sorts to ours. He identifies how "the Square has been and will continue to be a prime visual means of political rhetoric in modern China to address the public and actually to constitute the public itself" (85), and he emphasizes how public emotionality was essential to the emergence of the democracy movement within that space. We identify how a visual image taken to represent the political conflict in the square has become a means for constituting a global public controlled by the absence of emotional display. See also Calhoun, *Neither Gods nor Emperors*, 188; Jonathan Spence, "The Gate and the Square," in Human Rights in China, *Children of the Dragon*, 16–37.

60 China scholars have yet to reach a consensus regarding the existence, nature, and extent of a public culture in China. Discussion of these questions includes the symposium "Public Sphere"/"Civil Society" in China?" in *Modern China* 19 (1993), and Wang Hui and Leo Ou-fan Lee with Michael J. Fischer, "Is the Public Sphere Unspeakable in Chinese? Can Public Spaces (gonggong kongjian) Lead to Public Spheres?" *Public Culture* 6 (1994): 597–605. We believe the problem goes beyond differences between East and West. First, it is difficult to observe Habermas's model in China because it never has existed anywhere strictly on its own terms. Public cultures in the West have developed through and been modulated by oral and visual media, social networks, emotional habits, and other elements of civic association that Habermas doesn't recognize or value. From our perspective, the question to be asked is whether any particular image or text communicates resources that might actually be important for the emergence or development of public media, public opinion, public accountability, public interests, and the like. Where high modernist norms and liberal preoccupations dominate, the prospects are slim.

61 Catherine A. Lutz and Jane L. Collins, *Reading National Geographic* (Chicago: University of Chicago Press, 1993), 125. Other comparisons with the magazine's imperial logic also apply: for example, minimizing the man's Chinese identity aligns him with Americans who see themselves "as no longer in possession of a culture but as holding on to history through their scientific advancements and their power to influence the evolutionary advance of other peoples to democracy and market economies" (108). *Time* claims the same: "The protesters got around official restrictions by communicating with friends abroad via fax; they followed their own progress—unrecorded on Chinese TV—by watching themselves on foreigners' satellite sets in the Beijing Hotel; and in subsequent years they have used the Internet—and their Western training—to claim and disseminate an economic freedom they could not get politically." Iyer, "The Unknown Rebel."

62 This interpretation follows Norton's argument in *Republic of Signs* that liberalism has both enacted itself and reached a limit condition in consumer consumption. Note also Iyer's description in "The Unknown Rebel": "A small, unexceptional figure in slacks and white shirt, carrying what looks to be his shopping." It seems that style is the man, and his style is that of the ordinary consumer.

63 Bruce Plante for the *Chattanooga Times*, reprinted in the *Washington Post National Weekly Edition*, June 5, 2000.

64 Ann Telnaes, National/Syndicated, Dec. 2, 1999, at cagle.slate.msn.com/news/WTO/wto13.asp. This emphasis on global capitalism is also evident in a Lurie cartoon that has an "unemployed American" standing before a row of tanks whose gun barrels are dollar signs; the tanks are labeled "US Jobs Going Abroad." *Washington Post National Weekly Edition*, Feb. 9–15, 2004, 27. The substitution of the United States for China keys a Fritz Behrendt cartoon for the *De Telegraaf* of Amsterdam, Netherlands: Hans Blix of the United Nations stands in front of the tank, which has US on the side and Bush looking out of the turret. Blix's briefcase is on the ground as he leans against the tank, straining futilely to stop the juggernaut of U.S. foreign policy. See also the Bruce MacKinnon cartoon of February 26, 2003, which places a dove of peace on the road before a tank that has "W" (for George W. Bush) on the turret, http://zone.artizans.com/images/previews/MAC703.pvw.jpg. Other examples include at least two (depending on the extent of the allusion) cartoons by Nick Anderson that place Bush in the tank, as well as two by Signe Wilkinson that have the U.S. tank looming ominously over an Iraqi child and a father and child. Archived at http://www.cartoonistgroup.com/.

65 Another example is provided by a Canadian cartoon of a kid with punk hair holding a squeegee and a bucket for washing car windows and standing before a tank commanded by a smiling Mike Harris, the prime minister of Ontario. Bado, *Journal LeDroit*, Ottawa, Canada, May 27, 1999, Artizans, http://zone.artizans.com/product.htm?pid=235. The issue was the banning of squeegees from the streets of the province. The tank may appear American to some viewers, as Harris has been raked for "Americanization" of the province. "The Revolution is over ! Ontario is now just another American State, and The Premier just another U.S. Governor." Harriscide 2001, The Americanization of Ontario, http://members.tripod.com/harriscide/harriscide.htm.

66 Our language here draws directly on Michael J. Sandel, "The Procedural Republic and the Unencumbered Self," *Political Theory* 12 (1984): 81–96, and *Democracy's Discontent: America in Search of a Public Philosophy* (Cambridge: Harvard University Press, 1996). Sandel provides succinct statement of the problem we are addressing: "The global media and markets that shape our lives beckon us to a world beyond boundaries and belonging. But the civic resources we need to master these forces, or at least to contend with them, are still to be found in the places and stories, memories and meanings, incidents and identities, that situate us in the world and give our lives their moral particularity" (349).

67 Geremie R. Barmé, *In the Red: On Contemporary Chinese Culture* (New York: Columbia University Press, 1999), xiv. Stated otherwise, liberalism can develop along more than one track. As Lauren Berlant has argued, one alternative is an "infantile" citizenship in a privatized public sphere that was normalized in the United States during the Reagan-Bush era. *The Queen of America Goes to Washington City* (Durham, NC: Duke University Press, 1997).

68 Strobe Talbott, "Defiance," *Time*, June 19, 1989, 10.

69 The May 29 cover proclaims "China in Turmoil," with a picture of a student shouting (or singing or speaking loudly) as a representative figure of democratic protest. *Time* couples the story with an overblown report of how the demonstration complicated

Gorbachev's scheduled meeting with the regime. As the events develop, *Time* relies more and more on a Cold War narrative of the Communist bloc contending with the values of the West. The June 5 cover proclaims "People Power" and then "Beijing: Defying Dictatorship" and "Moscow: Demanding Democracy" positioned below on each side of a star, out of which a Chinese and Russian demonstrator each thrusts an arm. The story within is that "Two giants of Communism witness a surge of people power" (2). The June 12 cover screams "Massacre in Beijing" over a bloody street scene, but the story is linked with reports on debates over and within the Soviet Union. The narrative peaks with the cover of June 19. By June 26, the story is receding: Kevin Costner ("Smart, Sexy, and on a Roll") is on the cover, which also announces "China's Big Lie." The "Orwellian" (2) label is both accurate and a perfect final touch. The events have been contained within the narrative and familiar roles have been restored on both sides of the East-West divide.

70 *Time*, June 19, 1989, 2.

71 Ibid., 12.

72 See Stepan, *Photos That Changed the World*, 162. The Goddess of Democracy also fits the narrative, particularly the photograph of the statue facing the large picture of Mao in the Square. *Time* apparently didn't have that shot, as it had used a different one on June 12, 1989 (29). That confrontation with Mao is on the cover of *China: From the Long March to Tiananmen Square*.

73 This is an odd list that may appear to be merely an attempt to aggregate different audiences, but there is a logic to it. Sun Yat-sen is the only pre-Communist Chinese reformer well-known in the West, and Churchill is the most famous non-American political leader of a democracy. Einstein is a common reference for modern science and photographs of his face have been widely reproduced in U.S. media. James Joyce is a representative figure of literary modernism—at least for those who frequent chain bookstores. This pantheon of great men exemplifies the political, scientific, and cultural achievements characterizing modernity as a transnational process of global transformation.

74 See O'Neal's poster and also the poster for the Global Petition Campaign for the 10th Anniversary of June 4 Tiananmen (the text alternates in English and ideograms) at Tiananmen Square Chinese Democracy Movement 14th Anniversary–June 4 1989, http://www.geocities.com/dredeyedick/tian10.htm. See also the photo on the main page of Free Tibet for Democracy in China, http://www.grafixnpix.com/buddha.htm. See also Ann Telnaes's cartoon that has the man holding up a sign that says, "Keep Hong Kong Free" before a tank that says "You can trust us." *Washington Post National Weekly Edition*, July 21–27, 2003, 15.

75 Patrick Chappatte, *Tribune de Genève* [Geneva, Switzerland], 1993. See also a later cartoon by the same artist that was published in *L'Hebdo* [Lausanne, Switzerland], Feb. 1997. Chappatte mutates the tank into a wheelchair with treads, driven by an aged Deng. The demonstrator is gone, but the viewer is positioned in his place. The tank still symbolizes the Chinese state, which will not be toppled by popular movements but may succumb to the ills of gerontocracy. Both cartoons are archived at Globe Cartoon, China in Editorial Cartoons, Part 1: Deng's Legacy, http://www.globe cartoon.com/china/timeline.html.

76 Patrick Chappatte, *Le Temps*, July 2001, http://www.globecartoon.com/china/ timeline2.html. There are actually two versions of the cartoon, one of which adds

"Candidate City" under "Beijing 2008"; this version is cataloged at http://www.cagle
.com/politicalcartoons/pccartoons/archives/chappatte.asp?Action=GetImage. More
interesting is the additional caption that is supplied at the globecartoon.com digital
gallery of the artist's China cartoons: "And the winner is . . . *Human Rights?* Beijing
gets the 2008 Olympics." Obviously, the iconic template can be interpreted in regard
to both national self-determination and individual autonomy.

77 The jaded recognition that the image represents a courage that is no longer plausible
is evident in another, highly sophisticated appropriation. On an episode of the televi-
sion show ER a disgruntled patient commandeers a tank and is in the process of driv-
ing it through Chicago to the hospital to blow up one of the doctors. At one point the
targeted doctor is somewhat nervous and suggests to the hospital administrator that
maybe it would be best if he were to leave for the day. The administrator says: "Yeah,
good idea. Why don't you go out on Lake Shore Drive and play Tiananmen Square."
ER, "Forgive and Forget," season 10, episode 176016, NBC network, Feb. 26, 2004. The
icon remains an image of courage, but not one that a sane person would imitate,
and liberals don't display courage except by staying at their jobs.

78 Don Wright, *Palm Beach Post*, reprinted in the *Washington Post National Weekly Edition*,
July 30–Aug. 12, 2001, 28.

79 Cartoon by Ken Hamidi, Face Intel, http://www.faceintel.com. The label is a play on
the advertising slogan, "Intel Inside." Note also how the illustration shifts the point
of view to enhance the viewer's sense of danger.

80 Others use the tank icon to similar effect. These include a digital poster with the
word INFOWAR stamped across it in red. See The Concordat in the Info War, http://
www.nada.kth.se/~asa/InfoWar/infowar.html.

81 "This cartoon was my idea when I was campaigning against Intel, while my case was
going through Supreme Court of California. Probably you are familiar with *Intel* v.
Hamidi. They stopped me from sending informational, educational, and supportive
e-mails to 35,000 Intel employees. Obviously I borrowed the theme from the man
stopping the tank in Tiananmen Square. My idea was to show that Intel in US is
acting as a dictator as Chinese government was doing in China. Cartoon was very
effective and clearly conveyed the message of tyranny and oppression to readers."
Ken Hamidi, correspondence with the authors, Feb. 12, 2006. Face Intel maintains an
archive of articles on the case. On refeudalization, see Jürgen Habermas, *The Struc-
tural Transformation of the Public Sphere: An Inquiry into a Category of Bourgeois Society*,
trans. Thomas Burger (Cambridge: MIT Press, 1989), 142.

82 Lev Grossman and Hannah Beech, "Google Under the Gun," *Time*, February 13, 53–54.

83 "One Search Subject, Two Results: Tiananmen Square," multimedia display for
Joseph Kahn, "So Long, Dalai Lama: Google Adapts to China," *New York Times*, Feb. 12,
2006, http://www.nytimes.com/2006/02/12/weekinreview/12kahn.html?ex=1141448400
&en=6c657b6e5e547f2c&ei=5070.

84 AllPosters.com, Americana, American Moments, http://www.allposters.com/-st/
American-Moments-Posters_c958_s6600_.htm.

85 Video lead-in to the halftime show, 2004 Super Bowl , CBS network, Feb. 1, 2004.

86 Such parodies using Photoshop include a school crossing guard, traffic cop, basket-
ball game, and a large rabbit and large cat each in place of the tank. In another ani-
mated cartoon, the man is replaced with a popular singer wailing at her microphone.
Popular music has become one of the most pervasive modes for defining private

life—it is a key variable used by colleges in matching dormitory roommates—and the substitution is a logical extension of the man's stand for personal liberty. On the other hand, the photo is part of a spoof that shows "a hate figure doing something nice"; the joke comes from the very low probability that the singer would put her life on the line for the common people. Challenge: Hate Figures Doing Nice Things, http://www .b3ta.com/challenge. See also the ubiquitous "Tourist of Death," Image Gallery, File 576 at http://www.touristofdeath.com/. Once again, the presence of an ordinary guy cuts the iconic aura down to size by aggressively reasserting the context of private life as it is constituted by snapshot photography. Even that can be flipped, however: On the August 4, 2004, *The Daily Show with Jon Stewart*, during a discussion of escalating oil prices, "Tiananmen Square guy" was shown standing up to a large SUV. As the tank becomes a symbol of excessive consumption directed by large corporations, the little guy again represents progressive advocacy. But, as in Telnaes's cartoon about the World Trade Organization protest in Seattle, such advocacy is essentially hapless. Perhaps this is why *Daily Show* writers continue to sport with the icon. In *America (the Book)*, for example, they cast the image alongside Mao Zedong, NBA basketball star Yao Ming, and actors Jackie Chan and Chow Yun Fat as "Chinese People Familiar to Average Americans"; on the following page they spoof the man as an "OCD sufferer who only felt comfortable standing in front of large objects." *America (the Book): A Citizen's Guide to Democracy Inaction* (New York: Warner Books, 2004), 190, 192.

87 Cheesy Movies: Tiananmen Square Man, http://www2.eis.net.au/~nujak83/tia.htm (no longer available online).

88 Scott, *Seeing Like a State*, 309–41, and Michel de Certeau, *The Practice of Everyday Life*, trans. Steven Randall (Berkeley: University of California Press, 1984).

89 Dutton, *Streetlife China*, 6–7.

90 *The Simpsons*, "Brother's Little Helper," written by George Meyer and directed by Mark Kirkland, production code AABF22, original airdate on FOX: 3-Oct-1999.

91 There are other examples of this more democratic inflection. An editorial cartoon by Mike Luckovich replaced the man with antiwar protestor Cindy Sheehan, who at the time was leading a vigil outside Bush's ranch during his summer vacation. The lead tank was labeled "Bush & Co." *Atlanta Journal Constitution*, Aug. 14, 2005.

92 "McDonald's Supports U.S. Industry," *Cattle Buyers Weekly*, June 17, 2002.

93 The ad was designed by the Richards Group (Dallas, Texas). Account executive Katie Goodell states, "We actually referred to the spot as 'Tianamen Square' in the agency as it was being concepted" (personal communication with the authors, Jan. 28, 2003). It has been shown subsequently, including at least the 2005 Peach Bowl. Note that the ad's scrupulous attention to iconic detail does not extend as far as the cow, which is a dairy cow and so in no danger of being used for burgers. Presumably a Texas ad agency would know that, and also know that their ads have to rely on commonplaces rather than literal accuracy. By contrast, it is important that the original line of sight has been reproduced faithfully. Unlike those illustrations that shifted the viewer into a stance of participation and endangerment, the ad restores a sense of distance between spectator and political action. That distance serves the comic inflection essential to the ad's success, while habituating consumers to being above the scene of political conflict.

94 Eat Mor Chikin and the Chick-fil-A Cow are registered trademarks of CFA Properties, Inc.

95 By contrast, Chinese political advocacy continues as a story of *collective* protest and largely unreported military crackdowns. "Police statistics show the number of public protests reached nearly 60,000 in 2003, an increase of nearly 15 percent from 2002 and eight times the number a decade ago. Martial law and paramilitary troops are commonly needed to restore order when the police lose control." Joseph Kahn, "China's 'Haves' Stir the 'Have Nots' to Violence," *New York Times*, Dec. 31, 2004, A1. Occasional coverage in U.S. media reveals that "restoring order" includes killing and, notably, also removing the "banners by the people" from village squares. More positively, in at least one incident, "China Admits 'Wrong Action' in Fatal Protest," *Chicago Tribune*, Dec. 12, 2005, 4.

96 See also Calhoun, *Neither Gods nor Heroes*, 189–90.

97 The combination of strong liberalism and weak democracy could result in a global order increasingly less capable of recognizing and learning from the cultures it manages. As Scott has demonstrated, this loss of practical knowledge and adaptive skills can easily lead to extreme degradation of human and natural environments and ultimately to catastrophic collapse of the system. To prevent such outcomes, states and other organizations may need emotional and social resources that can be provided only in local cultures and that are not likely to be legible in modernist representation. More generally, democratic deliberation of any kind requires that citizens have models of civic relationships such as between speaker and audience or between citizens speaking together in a condition of equality, and pertinent political scenarios such as the scenes of public mourning or collective protest. Obviously, the tank photo provides a powerful model of confrontation and courage, yet it also displaces precisely those features that defined the Tiananmen protest as a democratic movement.

98 John Gray makes a similar claim about liberalism: "As the political theory of modernity, liberalism is ill-equipped to address the dilemmas of the postmodern period." He adds, significantly, that "the *liberal problem*—which is that of specifying terms of peaceful coexistence among exponents of rival, and perhaps rationally incommensurable, world-views—is no less pressing than in early modern times." *Liberalism*, 2nd ed. (Minneapolis: University of Minnesota Press, 1995), 85. For the claim that the twenty-first century will increasingly be defined by a new class of political problems, see James A. Marone, *The Democratic Wish: Popular Participation and the Limits of American Government*, rev. ed. (New Haven: Yale University Press, 1998); and F. R. Ankersmit, *Aesthetic Politics: Political Philosophy beyond Fact and Value* (Stanford: Stanford University Press, 1996). Such problems can be defined by their high degree of complexity, low correspondence with established interest groups, and embeddedness in modern civilization; examples include resource depletion, culture depletion, and obsolescence of the human species.

99 Norton, *Republic of Signs*, 3.

CHAPTER EIGHT

1 Franz Kafka, "Leopards in the Temple," *Parables and Paradoxes, in German and English* (New York: Schocken Books, 1958), 93.

2 There is an extensive literature devoted to the problematic of modern risk. See Mary Douglas and Aaron Wildavsky, *Risk and Culture: An Essay on the Selection of Technologi-*

cal and Environmental Dangers (Berkeley: University of California Press, 1983); James Reason, *Human Error* (Cambridge: Cambridge University Press, 1990), *Managing the Risks of Organizational Accidents* (Aldershot: Ashgate, 1997); Charles Perrow, *Normal Accidents: Living with High-Risk Technologies* (Princeton: Princeton University Press, 1999); Cass Sunstein, *Risk and Reason: Safety, Law, and the Environment* (Cambridge: Cambridge University Press, 2002); Lee Clarke, *Worst Cases: Terror and Catastrophe in the Popular Imagination* (Chicago: University of Chicago Press, 2006). See also Diane Vaughan, *The Challenger Launch Decision: Risky Technology, Culture, and Deviance at NASA* (Chicago: University of Chicago Press, 1997).

3 R. Paine, "Danger and the No-Risk Thesis," in *Catastrophe and Culture: The Anthropology of Disaster*, ed. M. Hoffman and A. Oliver-Smith (Sante Fe: School of American Research Press, 2002), 67–90.

4 As Michael Warner has refined that idea, "Disaster is popular because it is a way of making mass subjectivity available" and managing the anxieties about disembodied self-abstraction necessary for the liberal public sphere. "The Mass Public and the Mass Subject," in *Habermas and the Public Sphere*, ed. Craig Calhoun (Cambridge: MIT Press, 1992), 377–401, especially 392–394. Frankly, we think the mass subject thesis only goes so far. For a counterpoint that still avoids romanticizing the public, one can look to Paul Virilio's "accident museum." In place of the carefully controlled "aesthetics of appearance" used to display scientific progress, Virilio celebrates the disaster's exposure of the *"unusual and yet inevitable"* that is usually hidden by modern conventions of representation. The *Challenger* explosion is his central example. "The Accident Museum," in Paul Virilio, *A Landscape of Events*, trans. Julie Rose (Cambridge: MIT Press, 2000), 54–60. Virilio's distinction between "normal" representation of technologies and disaster coverage is supported by Eleanor Singer and Phyllis M. Endreny, *Reporting on Risk: How the Mass Media Portray Accidents, Diseases, Disasters, and Other Hazards* (New York: Sage, 1993): "None of the stories about the space shuttle in our sample mentioned the possibility of harm to the crew. The shuttle was not defined by the media as entailing risk in 1984, prior to the *Challenger* explosion" (49). After the explosion, "this practice underwent significant change" (160).

5 Ann Larabee, *Decade of Disaster* (Champaign: University of Illinois Press, 2000); Susanna M. Hoffman, "The Monster and the Mother: The Symbolism of Disaster," in *Catastrophe and Culture*, 113–42; James R. Chiles, *Inviting Disaster: Lessons from the Edge of Technology* (New York: HarperBusiness, 2001).

6 Scott Adams, *The Dilbert Principle: A Cubicle's-Eye View of Bosses, Meetings, Management Fads and Other Workplace Afflictions*, reprint ed. (New York: HarperBusiness, 1997). It is reproduced at a number of Web sites, usually without attribution.

7 Howard G. Dick and Douglas H. Robinson, *The Golden Age of the Great Passenger Airships: Graf Zeppelin and Hindenburg* (Washington, DC: Smithsonian Press, 1985), 83–102; LZ-129 Hindenderg (n.d.), http://www.ciderpresspottery.com/ZLA/great zeps/german/Hindenburg.html/; John Toland, *The Great Dirigibles: Their Triumphs and Disasters* (New York: Dover Press, 1972), 9–12.

8 "British airship R101 is destroyed in crash and explosion in France: 46 aboard perish, 7 badly injured," *New York Times*, Oct. 5, 1930, 1.

9 *The New York World Telegram* published twenty-one pictures of the explosion, while

the *New York Post* published six pages of pictures. Vicki Goldberg, *The Power of Photography: How Photographs Changed Our Lives* (New York: Abbeville Press, 1991), 192. On the distribution and effect of newsreels see Toland, *Great Dirigibles*, 313, 323, 337.

10 Most of the images were taken by photojournalists working with 4 × 5 sheet film and the then common and relatively slow and bulky Speed Graphic camera, but there were several exceptions that yielded interesting results. Michael L. Carlebach, *American Photojournalism Comes of Age* (Washington, DC: Smithsonian Institution Press, 1997), 158–59, 190–92. Gerard Sheedy, a staff photographer for the *Daily Mirror*, shot a series of photographs with a "miniature" camera and the latest "Kodachrome natural-color film." The images were published in the *New York Sunday Mirror* magazine section with a story that was as much about the new technology of color film as it was about the explosion. "Death of a giant: The exclusive color photo record of the destruction of the Hindenburg," *New York Sunday Mirror*, magazine section, May 23, 1937, 4, 17. These were the only color images of the explosion, but they have been rarely if ever reproduced. Arthur Cofod, Jr., an amateur photographer, used a 35 mm Leica and a single roll of high-speed film to shoot a sequence of nine images that marked the arrival of the *Hindenburg* at Lakehurst, New Jersey, and then the explosion and descent of the dirigible. These pictures were published by *Life*, along with the Shere image. "Amateur Photographs the Hindenburg's Last Loading," *Life*, May 17, 1937, 26–30. They too have rarely been reproduced.

11 "Hindenburg Explodes with 97 Aboard," *Washington Post*, May 7, 1937, 1; "The Hindenburg Makes Her Last Landing at Lakehurst," *Life*, May 17, 1937, 26–27; M.-M. Robin, *The Photos of the Century: 100 Historic Moments* (Cologne: Evergreen. 1999), image no. 022. The *Washington Post* front page can be seen in Goldberg, *Power of Photography*, 193. The *Post* places the iconic shot above the fold, with the image that was on the front page of the *Times* below it.

12 With twenty-two photographers all taking pictures at the same time, there are a number of images that appear to be taken from the same vantage point and all within seconds of one another. As a result, there are several images that are almost identical to the Shere photograph, and they showed up initially in various places, including the *New York Times*, "The Hindenburg on fire in the air and views after crash at Lakehurst," May 8, 1937, 3; the *Chicago Daily Tribune*, "Wirephoto brings spectacular pictures of crash of dirigible Hindenburg in which 35 met death," May 7, 1937, 32; and *Time*, "End of the Hindenburg," May 17, 1937, 4. They continue to show up from time to time. Fairly quickly, however, the Shere photograph was recognized as the primary visual marker of the event, and it appears regularly in histories and historical retrospectives where photographs are employed. Richard B. Stolley, ed., *Life: Our Century in Pictures* (Boston and New York: Little, Brown, n.d.), 138; Richard Lacayo and George Russell, eds., *Eyewitness: 150 Years of Photojournalism* (New York: Time, 1990), 81; Peter Stepan, *Photos That Changed the World* (Munich: Prestel., 2000), 52–53, and on numerous Web sites and a number of book covers. It is also explicitly identified and/or prominently displayed as *the* photograph of the event by historians of photojournalism. See Carlebach, *Photojournalism Comes of Age*, 190; Robin, *Photos of the Century*, 22; and Goldberg, *Power of Photography*, 190–95. In this last context it is interesting to note that while the Shere image never appeared in the pages of the *New York Times*—conventionally regarded as the "paper of record"—it is now sold on the *New York Times* Web site along with other historical photographs and the implication

388

that it was an image that appeared in the paper (*New York Times* store, http://www
.nytstore.com, Photographs, Transportation, Aviation, Hindenburg Explodes).

13 The icon has been parodied in numerous places, including separate episodes of *The
Simpsons:* J. Martin (Writer) and M. Kirkland (Director), "Lisa the Beauty Queen,"
originally broadcast October 15, 1992, and C. O'Brian (writer) and R. Moore (director),
"Marge vs. the Monorail," originally broadcast on January 14, 1993, M. Groening
(creator and producer), *The Simpsons* (New York: Fox Broadcasting Network). See
also Scott Dikkers, *Our Dumb Century: The Onion Presents 100 Years of Headlines from
America's Finest News Source* (New York: Three Rivers Press), 53, and a variety of satiri-
cal Web sites including, of course, www.touristofdeath.com.

14 "The burning Hindenburg and some of its survivors," *New York Times*, May 7, 1937, 20.

15 "Tragedy of the Hindenburg," *New York Times*, May 8, 1937, 18.

16 Robert Hariman, "Allegory and Democratic Public Culture in the Postmodern Era,"
Philosophy and Rhetoric 35 (2002): 267–96.

17 At least one other dirigible photo contrasts the great machine and the little people
below it, but this shot is of a safe landing and the contrast is used to idolize the
machine. This photograph of *R-100* is in *150 Years of Photojournalism* (Cologne: Köne-
mann, 1995), 792. Thus, the same technique of magnification serves either utopian or
dystopian effects, depending on the state of the machine.

18 Kenneth Burke, *A Grammar of Motives* (Berkeley: University of California Press, 1969), 3.

19 *Time*, Feb. 10, 1986, 24.

20 Perrow, *Normal Accidents*, 257.

21 *Time*, Feb. 10, 1986, 23.

22 NASA, photograph S86-38989.

23 Gunther Kress and Theo van Leeuwen, *Reading Images: The Grammar of Visual Design*
(New York: Routledge, 1996), 186–202.

24 The central myth in which the enlightenment values of democracy and progress
were worked out was the "frontier." See J. H. Rushing, "Mythic Evolution of 'The
New Frontier' in Mass Mediated Rhetoric," *Critical Studies in Mass Communication* 3
(1986): 265–96; and J. L. Kauffman, *Selling Outer Space: Kennedy, the Media, and Funding
for Project Apollo, 1961-1963* (Tuscaloosa: University of Alabama Press, 1994). See also
Tom Wolfe, *The Right Stuff* (New York: Farrar, Straus, Giroux, 1979). The continued
development of the frontier myth can be found in commemorative statements by
the director of NASA ("Administrator Goldin Issues Statement on Tenth Anniversary
of Challenger Observance," Jan. 16, 1996), on its Web site at www.hq.nasa.gov/office/
pao/History/administrator.html," as well as in numerous commemorative volumes,
including R. Sullivan, ed., *Man in Space: An Illustrated History from Sputnik to Columbia*
(New York: Time, 2003).

25 David E. Nye comments on the significance of the loss of overwhelming sensory
experience that occurs in the shift from watching an actual launch at Cape Canaveral
to the visual record, even when captured through special equipment designed to pro-
vide a "true life" experience. *American Technological Sublime* (Cambridge: MIT Press,
1994), 245–52.

26 The Kennedy Space Center Web site has displayed the posed portrait of the seven
astronauts superimposed over the *Challenger* taking off, with a flock of birds flying
upward and outward, and above all the colossal ghostlike image of an anonymous
head as if of a god bowed in grief. 51-L (21), John F. Kennedy Space Center, 51-L (21),

2002, Shuttle Mission Archive, http://www.nasa.gov/kscpao/shuttle/missions/51-l/mission-51-l.html.

27 The launch and explosion were broadcast live on NASA Select TV. A single video of both was widely available as an MPEG file at NASA and on numerous websites such as the CNN Video Almanac, The Federation of American Scientists' Space Policy Project, Space Online, and the Online Ethics Center, all of which were linked to NASA. Recently, NASA rendered that link inoperative. Worse yet, the agency divided the video in two so that one can watch *either* the launch (without the explosion) *or* the explosion (without the launch), but need not watch both. The divided videos can be found at NASA History Division Website, http://history.nasa.gov/sts51l.html. Official memory is thus technologically fragmented in a way that further isolates and contains the traumatic moment. For the time being, at least, the launch and explosion remain one in vernacular memory and can be seen at Spaceflight Now: The Challenger Accident, which retains its own copy of the single video at http://spaceflightnow.com/challenger/video/launch_qt.html. 51-L MPEG, John F. Kennedy Space Center, 51-L Shuttle Mission Movie, 1996, http://science.ksc.nasa.gov/shuttle/missions/51-l/movies/movies.html.

28 See Daniel Walker Howe, *The Political Culture of the American Whigs* (Chicago: University of Chicago Press, 1979); John F. Kasson, *Civilizing the Machine: Technology and Republican Values in America, 1776–1900* (New York: Penguin, 1976); and Larry Lambert, "Invoking the Machine: The Rhetorical Appeal to Machine Technology in American Whig Discourse" (Ph.D. diss., Indiana University, 2001).

29 The dirigible was particularly popular in Germany, arguably the most technologically advanced society at the time. "All commentators agreed on one thing: Count Zeppelin and his invention offered the spectator a vision of the technological that transfixed the imagination. . . . The industrialization of European cities, for example, while reflecting control of the nation-state, also acquired a popular dimension, whereby the masses assimilated certain human constructions, from train stations to bridges, as symbols of their communities. In Germany, the zeppelin became the icon of choice. The 'zeppelin spirit' grew out of the majesty, the incredible size of the machine, along with its technological sophistication." Guillaume de Syon, *Zeppelin!: Germany and the Airship, 1900–1939* (Baltimore: John Hopkins University Press, 2001), 4–5. The United States had the dream as well: the Empire State Building included a mooring tower for dirigibles. Winds from the urban canyons proved too dangerous for landings.

30 Walter Benjamin, "The Work of Art in the Age of Mechanical Reproduction," in *Illuminations: Essays and Reflections*, ed. Hannah Arendt, trans. Harry Zohn (New York: Schocken Books, 1969), 217–25. For one example of common usage, see James Day, *The Hindenburg Tragedy* (New York: Bookwright Press, 1989).

31 This rhetorical sophistication is documented by Larabee, *Decade of Disaster*.

32 There is some difference between U.S. and European response to the zeppelins that is consistent with this claim. This is not to deny that other factors also mattered with regard to both the aftermath of the disaster and the eventual disappearance of the airships. U.S. government control of helium, the technological promise of the airplane (a direct competitor with dirigibles), and the lack of a government-industrial complex such as NASA certainly were significant factors. There is no reason to assume that zeppelins would have gone away on their own, however, and so these

other factors provide the background against which the photojournalism could be effective.

33 The French link also includes M. Mooney, *Le Dirigeable "Hindenburg"* (Gallimard, 1974).

34 Examples include R. Conrad Stein, *The Hindenburg Disaster* (Chicago: Children's Press, 1993), James Day, *The Hindenburg Tragedy* (New York: Bookwright Press, 1989), Gina De Angelis, *The Hindenburg* (Philadelphia: Chelsea House, 2000), Victoria Sherrow, *The Hindenburg Disaster: Doomed Airship* (Berkeley Heights, NJ: Enslow Publishers, 2002), among others. These use the Shere image or some very close approximation. It is not the only image used, for example, the *New York Times* image is on the cover of Fran Locher Freiman and Neil Schlager, *Failed Technology: True Stories of Technological Disasters* (New York: ITP, 1995), and given the large number of similar books some variation is to be expected. Disaster sites include Top Twenty Technological Screw-ups of the Twentieth Century, APS (American Physical Society) News Online the Back Page, http://www.aps.org/apsnews/0500/050014.cfm.

35 *Titanic* comparisons include the TV documentary film *Titanic of the Sky: The Hindenburg Disaster*, Vidicom Productions, http://www.vidicom-tv.com/tohiburg.htm, and Web sites such as the Zeppelin Library, The Great Zeppelins, LZ-129, Hindenburg, http://www.ciderpresspottery.com/ZLA/greatzeps/german/Hindenburg.html. The comparison works in reverse as well and also has been extended to include the *Challenger*: for example, the ending of a fable based on the *Titanic*:

> "A lesson learned at the expense of many we shall always keep.
> Boasting never again about the impossibilities of man's creations.
> *Titanic* like the *Hindenburg* and *Challenger* among the reasons.
> To those lost and long departed souls now remembered this day.
> Had you ever envisioned creating history in quite this way?"

Tale of the *Titanic*, http://whiteshadow.com/Blue%20Diamond%20Javas/bdjava6/Titanic.html. The linkage of *Titanic/Hindenburg/Challenger* is a testament of sorts to the media and probably to the visual salience of the successive images. It is extended to 9/11 at Icarus rising: A memorial to the crew of the space shuttle *Challenger* (1999), from http://www.datamanos2.com/icarus_rising.html. Hubris is the theme and modernity's gamble the question, but as each example proves, the attitude one takes can vary greatly.

36 For example, U.S. Centennial of Flight Commission, The Zeppelin, http://www.centennialofflight.gov/essay/Lighter_than_air/zeppelin/LTA8.htm.

37 To give just one example, the Shere photo headlines "The History of Photojournalism" in Kevin Kawamoto's text on Photography and Trauma at the Dart Center for Journalism and Trauma, http://www.dartcenter.org/resources/selfstudy/3_photojournalism/text_01.html.

38 Gibson's Tribute to the Twentieth Century is at http://www.2000guitar.com/building.html. The tableau also includes, to the left of the more well-known figures, a man selling apples, and the set of images stand for the 1930s. Another custom guitar is the Hindenberg by Ed Roman at Global Bass Online, Ed Roman's World Class Guitars, http://www.globalbass.com/archives/nov2000/ed_roman.htm.

39 Maldives 1757-1772 Mysteries of the Universe. The series is for sale at a number of Web sites.

40 *Hindenburg's Fiery Secret*, National Geographic, 2000.

41 The "mystery" regarding the cause of the explosion is a source of a number of media productions and continued discussion on the Web. Puzzle House used to offer a "mystery puzzle" titled "Murder on the Hindenburg." Custom Puzzle Craft also features a puzzle made from the Shere image; it is not for sale but can be seen at http://www.custompuzzlecraft.com/Evolve/puzzle15.html.

42 Chemistry Web Elements Periodic Table: Professional Edition: Hydrogen: key information, http://www.webelements.com/webelements/elements/text/H/key.html. See also "One Man's Crusade to Exonerate Hydrogen for the Hindenburg Disaster," APS News Online, http://www.aps.org/apsnews/0700/070004.cfm. A more direct use of the image has emerged recently in response to development of hydrogen fuel cell technologies for automobiles. Our favorite is the poster that replaces the dirigible with a hydrogen-powered auto, its rear end erupting into the iconic fireball. Online discussions of hydrogen fuel automobiles are replete with references to the *Hindenburg* explosion, sometimes explicitly reviewing the visual image; it seems that the hypodermic effect still has some force. See also the editorial cartoon by Jeff Stahler, *Cincinnati Post*, Jan. 30, 2003, where two guys look at a hydrogen car prototype and one remarks, "We'll call it 'the Hindenburg.'" Reprinted, *New York Times*, March 2, 2003 and available at http://www.cincypost.com/2003/01/30/jeff013003.html

43 Internet Raytracing Competition, IRTC Viewing and Voting (Stills), 1999, http://www.irtc.org/stills/index.html#s1999. At least one other entry in the same year and category (history) also used the same image: DM's Ray Tracing Page, Internet Ray Tracing Competition Entries, http://www.dangermouse.net/povray/history. Both entries use the Shere photo and in each case the compositional alterations ensure that the emotional content will not get in the way of admiring the technological artistry. Spoofs include "Heather and the Hindenburg!" at http://www.ursaluna.com/witch/heather-ev01.htm.

44 The Predominance album liner notes (Loki Foundation label) promise "brooding, dark ambient sonic-scapes." The yellow and orange iris that is named Hindenburg may refer to the German chancellor, but it looks like a fireball.

45 *Wired*, 11, no. 2, Feb. 2003. Similar use of the image is made by Nick Anderson, whose editorial cartoon has the dirigible exploding next to the Washington Monument, which is in place of the mooring tower. The Enron Corporation logo is on the ship, while one of the little congressmen running below says, "It's ok. . . It's just a corporate scandal." *Louisville Courier-Journal*, Jan. 31, 2002, Forum, 6A

46 Dikkers, *Our Dumb Century*.

47 At WAFart.com jpeg art gallery, http://www.wafart.com/pages/Hindenburg_psd.htm.

48 Another, edgier use of the image places it on poster that says "Think Different Think Quality" along with an Apple computer logo. "Think Different" was an Apple ad slogan. The composition is one of a long series of images made by someone who has it in for the Macintosh. See also an image of a Pink Floyd blimp positioned as the *Hindenburg* ablaze; the intent seems to be to criticize the band.

49 A less frequently seen variant says "Oh Shit." It also uses the Shere photograph.

50 The Worlds of Bruce Duncan, http://www.calweb.com/~hatter/painting04.html.

51 Mike McGee and Larry Reid, *Charles Krafft's Villa Delirium* (San Francisco: Grand Central Press, 2002), 26.

52 Promotional copy for Disasterware Delft from Villa Delirium Web site, http://www.antiquesatoz.com/artatoz/krafft/delft.htm.

53 Michael Rogin, *Ronald Reagan The Movie and Other Episodes in Political Demonology* (Berkeley: University of California Press, 1988).

54 "Address to the Nation on the Explosion of the Space Shuttle *Challenger*," Jan. 28, 1986, Ronald Reagan Presidential Library, Public Papers of President Ronald W. Reagan, http://www.reagan.utexas.edu/archives/speeches/1986/12886b.htm. On Reagan's fusion of private and public life, see Lauren Berlant, *The Queen of America Goes to Washington City: Essays on Sex and Citizenship* (Chapel Hill: Duke University Press, 1997). Photojournalism provided Reagan with the perfect medium. As Wendy Kozol has demonstrated, *Life* had schooled the nation to see itself through visual images of domesticity, *Life's America* (Philadelphia: Temple University Press, 1994). Reagan's metaphor was not lost on his supporters. For example, the *Indianapolis Star* editorial was entitled "A Death in the Family," Jan. 29, 1989, 10.

55 Patricia Mellencamp has noted how Christa McAuliffe's presence on the shuttle enhanced this pioneer motif, which then becomes the more effective cover for the technocratic character of the program. "In keeping with the myth of the frontier which has dominated the U.S. space program, MacAuliffe [*sic*] was the adventurous schoolmarm from the Western genre, an Easterner who had won a contest to bring civilization to space via the one-room satellite schoolhouse." *High Anxiety: Catastrophe, Scandal, Age, and Comedy* (Bloomington: Indiana University Press, 1992), 104.

56 Though apt, the metaphor of "infantilization" can be misleading if it suggests a lack of complexity. Consider how Reagan's discourse might also be functioning allegorically. As the full intertext is constructed, its organization replicates the four-fold model of medieval hermeneutics: first, the literal explosion; second, the symbolism of the pioneer myth; third, an ethical imperative to persevere; culminating in the anagogic gesture to "touch the face of God."

57 Berlant, *Queen of America*, 2, 11. Though referring to "reactionary arguments," the observation works as well or better for visual images.

58 Berlant, *Queen of America*, 23.

59 Peter N. Spotts, "Lots in Space," *Christian Science Monitor*, Oct. 9, 2003, http://www.csmonitor.com/2003/1009/p11s02-stss.htm. The main menu for NASA's Hypervelocity Impact Technology Facility is at http://hitf.jsc.nasa.gov/hitfpub/main/index.html.

60 "Remarks at the Memorial Service for the Crew of the Space Shuttle *Challenger* in Houston, Texas," Jan. 31, 1986, Ronald Reagan Presidential Library, Public Papers of President Ronald W. Reagan, http://www.reagan.utexas.edu/archives/speeches/1986/13186a.htm.

61 Discussions of the effect of the televised explosion on children include Lenore Terr, *Too Scared to Cry: Psychic Trauma and Childhood* (New York: Basic Books, 1990); Patricia Mellencamp, "TV Time and Catastrophe, or Beyond the Pleasure Principle of Television," and Mary Ann Doane, "Information, Crisis, Catastrophe," in *Logics of Television: Essays in Cultural Criticism*, ed. Patricia Mellencamp (Bloomington: Indiana University Press, 1990), 240–67, 222–39.

62 Michael D. Cole, *Challenger: America's Space Tragedy* (Berkeley Heights, NJ: Enslow Publishers, 1995). It is the title of chapter 4 in Timothy Levi Biel, *The Challenger* (San Diego: Lucent Books, 1990), which has the iconic image on the second page of the chapter. See also James McCarter, *The Space Shuttle Disaster* (New York: Bookwright Press, 1988), where the iconic image covers two pages under the large caption "malfunction" (6–7). The text provides a minutely technical description of the explosion

and then adds: "The crowd on the grandstand were silent. 'Flight controllers here are looking very carefully at the situation,' said a voice over the loudspeaker. 'Obviously a major malfunction . . .'" (7). This term has developed its own trajectory through popular culture. After the 2004 Super Bowl, Justin Timberlake described the supposedly accidental removal of Janet Jackson's bustier during the halftime show as "a wardrobe malfunction." The choice of terms was weirdly appropriate: the game was played in Houston, home of NASA's Johnson Space Center, on the one-year anniversary of the *Columbia* explosion, and the pregame spectacle had included a commemorative celebration of NASA that included a special song and video by Aerosmith and a USAF flyover. Ralph Blumenthal captures the cultural mix in a lead-in story, "In Houston, Football Mania and a Shuttle Tribute," *New York Times*, Jan. 28, 2004.

63 Cole, *Challenger*, 13, 14. In other words, "the world of space technology is best understood by specialist engineers, rather than politicians or businessmen." McCarter, *The Space Shuttle Disaster*, 27.

64 Cole, *Challenger*, 14.

65 Reagan, "Address to the Nation."

66 Gregory Vogt, *The Space Shuttle* (Brookfield, CT: Millbrook Press, 1991), 82–83.

67 Vogt, *Space Shuttle*, 84.

68 Biel, *Challenger*, 55–56.

69 Biel, *Challenger*, 58. Perhaps this is the place to say again that our account of the discursive structuring of this book and others in the genre is provided only to identify a potent persuasive pattern that operates throughout the society. We are not describing the books' virtues or the good that they do. We would be thrilled, for example, if major newspapers routinely matched Biel's attention to both public controversy and technical detail.

70 The formula is evident even in the most restrained accounts, such as David Shayler, *Shuttle Disaster* (New York: Prentice Hall, 1887). This highly informative children's book concludes with a technical account of the management of the *Challenger* debris and then gives the last word to Reagan, quoting from his January 31 memorial service speech: "'The story of all human progress is one of struggle against all odds'" in which America is the vanguard and the astronauts are "'star voyagers'" (53). Modernity is a gamble, America is the best bet, technology is the means, exploration is the goal, and "'noble sacrifice'" is an unavoidable cost.

71 "A success rate of about 95 percent is more typical of the trade, Dr. Postol said. With two catastrophic failures in 113 flights, for a 98.2 percent success rate, the shuttle program is not looking much different—for sound physical reasons." James Glanz, "Speed Makes Space Flight Very Risky, Experts Say," *New York Times*, Feb. 2, 2003. For another example, and one sympathetic to a particular conception of NASA, see Joseph J. Trento with Susan B. Trento, *Prescription for Disaster: From the Glory of Apollo to the Betrayal of the Shuttle* (New York: Crown Publishers, 1987). Trento nicely summarizes the steep rise in costs (and decline in efficiency) of the program, including this: "The famous Mathematica Study's projected price of $100 to $270 per pound of payload orbited by 1983 was in reality more than $5000 a pound" (237). The classic statement on the risk assessment for the *Challenger* program remains Richard Feynman's appendix to William P. Rogers, et al., *Report of the Presidential Commission on the Space Shuttle Challenger Accident*, 5 vols. (Washington, DC: Government Printing Office, 1986). His statement is reprinted in Richard P. Feynman, *The Pleasure of Finding*

Things Out, ed. Jeffrey Robbins (Cambridge: Perseus / Helix, 1999), 151–69. The Rogers report and Feynman's appendix are available at NASA's History Office Web site, Challenger STS 51-L Accident, http://history.nasa.gov/sts51l.html. For discussion of some of the issues involved in assessing these documents as persuasive texts, see Arthur E. Walzer and Alan Gross, "Positivists, Postmodernists, Aristotelians, and the *Challenger* Disaster," *College English* 16 (1994): 420–33, and Alan G. Gross and Arthur Walzer, "The *Challenger* Disaster and the Revival of Rhetoric in Organizational Life," *Argumentation* 11 (1997): 75–93.

72 Bob Hohler, "As with the *Challenger*, a Nation Is Joined in Grief," *Boston Globe*, Feb. 2, 2003, A24.

73 William J. Broad, "Thousands Watch a Rain of Debris," *New York Times*, Jan. 29, 1986, A1. The statement was by Jess W. Moore, chief administrator of the shuttle program.

74 Todd Halvorson, "'Go Fever' and *Challenger* Lessons: Agency Chooses Safety Over Schedule," Space.com, Jan. 19, 2001, http://www.space.com/missionlaunches/missions/atlantis_rollback_010119.html.

75 Nor is this the only instance. A model fifth grade assignment on the "*Challenger* Disaster" ends on this note: "Secret Question: Do you know who this is? If you know the answer put your name and the answer on a piece of paper and put it in the class raffle box. I will be raffling off prizes on incentive day!!! Good Luck!" "The *Challenger* Disaster," http://cte.jhu.edu/techacademy/fellows/Thomas/webquest/mmtindex .html. Our focus on the discourse structuring this fifth grade lesson plan should not be taken as a criticism of Mila Thomas, the teacher who designed the assignment. If all teachers were as creative and dedicated as Thomas, the world would be a much better place.

76 Eric Rich, "In Christa McAuliffe's town, loss of *Columbia* stirs memories," *Hartford Courant*, Feb. 2, 2003, http://www.chron.com/cs/CDA/story.hts/space/1761541.

77 Coverage of the second explosion produced a near-perfect reprise of the first, both initially and as the institutional errors causing the disaster became public. The February 2, 2003, front page of the *Houston Chronicle* declared "WE MOURN AGAIN NASA inquiry focuses on tile damage Bush vows space program will continue." In brief: Public mourning plus technical explanation plus Presidential reaffirmation of the agency. The media's cybernetic function is also evident in a below-the-fold story that is devoted to public scrutiny of the space program ("Latest loss prompts questions about NASA's future"). Another story, "Post *Challenger* reform gave hope," features the iconic photo and is a puff piece that recounts a completely successful turnaround at NASA. The story ends with the *Discovery* launch and vice-presidential testimony to "our dreams, our future, our grit, determination and courage," as if the agency had been revindicated in advance of the current yet already receding disaster. John Williams, "Post-*Challenger* Reform Gave Hope" *Houston Chronicle*, Feb. 1, 2003, http://www.chron.com/cs/CDA/story.hts/special/columbia/1760866.

78 *Challenger* Learning Center Network, http://www.challenger.org/clc/index.cfm.

79 Kozol, *Life's America*, 51–95.

80 "Christa's Dream Lives On," *Life*, Feb. 1996, http://www.life.com/Life/space/challenger .html

81 CHRISTA, IN HER OWN WORDS, Images and Interviews, Photography by Michael O'Brien and Tobey Sanford, By David Friend, http://www.life.com/Life/space/mcauliffe/mcauliffe01.html. The most thorough personalization of the disaster is a

book by McAuliffe's mother, Grace George Corrigan, *A Journal for Christa: Christa McAuliffe, Teacher in Space* (Lincoln: University of Nebraska Press, 1993). This is the only work that contains no file or news media photos, relying instead on family snapshots. (The one possible exception is the image on the inside front and back covers that shows Christa in a parade.)

82 The Challenger Disaster Ten Years Later, Life.com, http://www.life.com/Life/space/challenger.html. See also Sullivan, *Man in Space*.

83 At http://www.life.com/Life/covers/1996/cv020496.html. The image, with the rose-colored star stream removed, is at Life's Web site: The Challenger Disaster 10 Years Later, http://www.life.com/Life/space/challenger.html. There "Christa's DREAM Lives On," while one link is labeled, "Back Into SPACE America's future." A nearly identical shot is on the cover of Robert T. Hohler, *I Touch the Future . . . : The Story of Christa McAuliffe* (New York: Random House, 1986).

84 We discuss the relationship between icons and ghosts in chapter 6. Although we are less skeptical than many commentators about this relationship, the McAuliffe image does lend support to strong claims. See, for example, Terry Castle, "Phantasmagoria: Spectral Technology and the Metaphysics of Modern Reverie," *Critical Inquiry* 15 (1988): 64.

85 On the connection between representations of "time" and "modernity" and the role that the former plays in claims to legitimacy and accountability, see Carol J. Greenhouse, *A Moment's Notice: Time Politics across Cultures* (Ithaca: Cornell University Press, 1996).

86 Doane, "Information, Crisis, Catastrophe," 230–31. Doane provides an astute account of the relationship between catastrophe and television, and remarks that "catastrophe could be said to be at one level a condensation of all the attributes and aspirations of 'normal' television (immediacy, urgency, presence, discontinuity, the instantaneous, hence forgettable)" (238).

87 Barbie Zelizer, "The Voice of the Visual in Memory," In *Framing Public Memory*, ed. Kendall R. Phillips (Tuscaloosa: University of Alabama Press, 2003), 157–86. Zelizer's work on the about-to-die photos is a direct contribution to the study of visual meaning, one that puts to rest the claim that images cannot articulate syntactical relations. We disagree with her normative claims, however, particularly as they were presented in a lecture at Northwestern University on January 17, 2006. Zelizer faults the photographs for suppressing situational information and communicating a common anguish. Even if these claims are correct, we see no cause for concern: there is no want of that information in the press, while there is need for common emotions, anguish among them. The assumptions that the public always needs more information and less emotion is an article of faith in print journalism but a flawed understanding of public communication. The application of print norms to photojournalism is commonplace even among astute commentators such as Sontag and Zelizer. It also provides solutions for problems that don't exist while missing much of what is sustaining public culture.

88 Cf. Susan D. Moeller, *Compassion Fatigue: How the Media Sell Disease, Famine, War and Death* (New York: Routledge, 1999).

89 Mathew R. Kerbel, *If It Bleeds, It Leads* (New York: Westview Press, 2000). Dan Nimmo and James E. Combs, *Nightly Horrors: Crisis Coverage by Television Network News* (Knoxville: University of Tennessee Press, 1985).

90 Carole Blair and Neil Michel, "Commemorating in the Theme Park Zone: Reading the Astronauts Memorial," in *At the Intersection: Cultural Studies and Rhetorical Studies,* ed. Thomas Rosteck (New York: Guilford Press, 1999), 29–83. Constance Penley provides a succinct discussion of key features of NASA's management of disaster commemoration, in *NASA/TREK: Popular Science and Sex in America* (New York: Verso, 1997).

91 Images of the *Columbia* explosion were fairly consistent across media, including a series of still images taken from video of white smoke cutting across the diagonal from upper right to lower left ("Shuttle Breaks Up," *New York Times,* Feb. 2, 2003, A1) and a photograph by an amateur in Tyler, Texas, that marks debris moving from right to left across a dark blue morning sky ("Streak of Destruction," *Indianapolis Star,* Feb. 2, 2003, 1). In most instances the relatively abstract images were paired with portraits of the seven astronauts.

92 "What Next for NASA?" *Grand Forks Herald,* Feb. 2, 2003, D1.

93 "17 Years Ago in *Time,*" *Time,* 161, Feb. 10, 2003, 24; "The Shuttle's Glory and Tragedy," *Time,* 161, Feb. 10, 2003, 40.

94 John Schwartz, "A Clipper Ship for Its Time," *New York Times,* July 17, 2005, Week in Review, 2. John Schwartz, "As NASA Prepares to Launch Shuttles Again, 70's-Era Technology Is Showing Its Age," *New York Times,* July 25, 2005, A17. On the other hand, NASA's shuttle program continues as if nothing has changed. See John Schwartz, "Minority Report Faults NASA as Compromising Safety," *New York Times,* Aug. 18, 2005, A15.

95 David D. Perlmutter, *Photojournalism and Foreign Policy: Icons of Outrage in International Crises* (Westport, CT: Praeger, 1998), xiii–xvi; Eric Rothenbuhler, *Ritual Communication: From Everyday Conversation to Mediated Ceremony* (Thousand Oaks: Sage, 1998).

96 Amy Harmon, "Reviving Romance with Space, Even as 'Space Age' Fades," *New York Times,* Feb. 4, 2003, F3. For a celebration of twentieth-century America's culture of risk taking, see John H. Lienhard IV, *Inventing Modern: Growing Up with X-Rays, Skyscrapers, and Tailfins* (New York: Oxford University Press, 2003).

97 Icarus rising: A memorial to the crew of the space shuttle *Challenger* (1999), www .datamanos2.com/icarus_rising.html.

98 "Defining the War," *48 Hours* (CBS), ed. Mead Stone, prod. Nancy Krauer, broadcast April 1, 2003; Michael Hill, "Defining Images: How a Picture Becomes an Icon of War," *Baltimore Sun,* May 9, 2004. For a more relaxed discussion among professionals pre– 9/11, see "The Most Influential Photo of All Time?" Photo.net, http://www.photo .net/bboard/q-and-a-fetch-msg?msg_id=001X7G.

CONCLUSION

1 We recognize that this claim is debatable, and we would be happy to be disproved. See Margaret Spratt, *When Police Dogs Attacked: Iconic New Photographs and the Construction of History, Mythology, and Political Discourse* (Ph.D. diss., University of Washington, 2002).

2 "Defining the War," *48 Hours* (CBS), ed. Mead Stone, prod. Nancy Krauer, broadcast April 1, 2003.

3 There has been a steady stream of articles regarding the role of "iconic" photographs in the Iraq war. For example, see Michael Hill, "Defining Images: How a Picture Becomes an Icon of War," *Baltimore Sun,* May 9, 2004; Don Wycliff, "Deadly Face of War,"

Chicago Tribune, May 1, 2003; Lew Wheaton, "Photojournalists Document Iraq War," *Associated Press Photo Managers*, July 2003, http://www.apphotomanagers.org/Iraqwar .html; Ellen Simon, "Digital Photos Change Perception of Iraq War," AP Report in *Red Nova*, May 7, 2004; and John Kifner, "Good as a Gun: When Cameras Define a War," *New York Times*, section 4: 1, 5. Discussion also has focused on the question, "Who delivers the iconic war images—pros or amateurs?" Phototalk, http://talks.blogs.com/ phototalk/2004/05/who_delivers_th.html. For a laughably bad discussion that uses a faux professionalism to deny the Abu Ghraib photos iconic status, see "Analysis: War Photographs and What Makes a Picture Iconic," National Public Radio, May 10, 2004.

4 Mark Bowden, "The Dark Art of Interrogation," *Atlantic Monthly*, Oct. 2003, 51–76. Bowden distinguishes between interrogation and torture and argues that illegality is sufficient to prevent crossing the line.

5 They also demonstrate that critiques of photojournalistic coverage of war can be short-sighted. For example, Barbie Zelizer recently has presented a strong statement of the several ways in which photojournalism can degrade coverage and harm the polity during wartime. The essay should be required reading for journalists and citizens alike, but it also is, ironically, a partial and misleading account. For example, the case depends on emphasizing coverage in the heady days of invasion over long-term coverage of attrition, ignoring images that confound official rhetoric and mobilize dissent, and not acknowledging that verbal press coverage exhibits the same features as those highlighted in the visual images. Journalism needs its watchdogs, but they should not be content to bark at scapegoats. "When War Is Reduced to a Photograph," in *Reporting War: Journalism in Wartime*, ed. Stuart Allan and Barbie Zelizer (New York: Routledge, 2004), 115–35.

6 We could have said, "The Ku Klux Klan hood is inverted, white to black, and removed from the head of the persecutor to be placed on the dark body to be lynched." This description captures a symbolic structure that is more or less salient in the photo depending on the reproduction. In the clearest version, the cowl and body covering are made out of a patterned rug or blanket that has been cut in the middle, and the prisoner is light-skinned. In most reproductions, however, the body is darker and the cowl and body cover are black. This darkening of body and robe has a double effect: it uses race to further objectify the other, and it erases culture and the mutilation of culture.

7 The image of the "Marlboro Marine" is instructive in this regard, as it confirms a number of claims made in this volume, not least the shift from democratic to liberal norms of representation. The photo was widely published in mid-November 2004. The picture is an appealing substitute for the Abu Ghraib photos in public memory, and it is promoted in right-wing newspapers, magazines, Web sites, and blogs as *the* patriotic icon of the war. It also is a triumph of (neo)liberalism. The tightly cropped portrait reduces all questions of democratic legitimacy to the face of a single individual. That face evokes two, intertwined models for imitation: a battle-hardened soldier and the Marlboro Man of advertising fame, that is, thoroughly masculine embodiments of the state (and its monopoly on violence) and the market (and its promotion of addictive consumption). The image is itself a model fragment, eliminating all signs of any larger scene or context and so obliterating any question of the purpose of the war. And why should one ask such questions when there are more pressing concerns? "The Marlboro man was angry: He has a war to fight, and he's running out

of smokes. 'If you want to write something,' he tells an intruding reporter, 'tell Marlboro I'm down to four packs, and I'm here in Fallujah till who knows when. Maybe they can send some. And they can bring down the price a bit.' Those are the unfettered sentiments of Marine Lance Cpl. James Blake Miller, 20." Patrick J. McDonnell, "A Smoke Break Creates Icon of the War; Now Groupies Seek Out the Weary Marine," *Los Angeles Times*, Nov. 13, 2004 http://seattletimes.nwsource.com/html/nationworld/2002089907_marlboro13.html. Yet even this highly conventional story can be turned to prompt more critical reflection. The bad news started to seep to the surface after Miller returned home and was diagnosed with post-traumatic stress disorder. CBS News, The Early Show, "'Marlboro Marine': Home Front Wars," Jan. 3, 2006, http://www.cbsnews.com/stories/2006/01/03/earlyshow/main1174711.shtml. The latest iteration as we go to press both rereads the iconic photo and describes how Miller is becoming critical of the war. David Zucchino, "Iconic Marine Is at Home but Not at Ease; Blake Miller's weary gaze hinted at the psychological pain to come," *Los Angeles Times*, May 19, 2006, A1. Both stories were accompanied by the "image that transformed Miller into a symbol of the Iraq war"; the *Times* may maintain interest in the photo because it was taken by their staff photographer, Louis Sinco. *Times* editorial commentary assumes the importance of iconic imagery: "the image . . . has become the tortured icon of a man at war and what war does to us. In terms of impact, it's the Joe Rosenthal photo of Marines raising the flag on Iwo Jima in World War II and David Douglas Duncan's picture of an infantryman's detached stare in the Korean War. It's the face of combat emerging from the blood and uncertainty of Iraq." Al Martinez, "A Searing Snapshot into the Soul," *Los Angeles Times*, May 29, 2006, E1.

8 See, for example, Richard Cohen, "Baloney, Moore or Less," *Washington Post*, July 1, 2004, A23; Ellen Goodman, "The Left Doesn't Need a Limbaugh," *Washington Post*, July 3, 2004, A27. Bob Somerby provided superb analyses of each column, which are archived at the Daily Howler (http://www.dailyhowler.com), July 2, 6, 7, 8, 9.

9 Paul Messaris, *Visual Literacy: Image, Mind, and Reality* (Boulder: Westview Press, 1994) argues for a strong distinction between verbal and visual communication, while also providing nuanced development of his perspective that belies simplistic claims made by others on behalf of visual meaning. See also James Elkins, *On Pictures and the Words That Fail Them* (Cambridge: Cambridge University Press, 1998) and *Visual Studies: A Skeptical Introduction* (New York: Routledge, 2003) for additional reflection on how visual meaning is learned. The task in any case is to move beyond the truism that images and texts cannot be translated perfectly into one another. The same absolute difference is true of texts in different languages, yet that is not seen as debilitating interpretation nor need it be taken as the guiding principle for hermeneutics.

10 Samuel Ijsseling, *Rhetoric and Philosophy in Conflict: An Historical Survey* (The Hague, Martinus Nijhoff, 1976).

11 Edward Schiappa, *The Beginnings of Rhetorical Theory in Classical Greece* (New Haven: Yale, 1999).

12 W. J. T. Mitchell, *Picture Theory: Essays on Verbal and Visual Representation* (Chicago: University of Chicago Press, 1994), 5.

13 For review of the critical lexicon, see Marita Sturken and Lisa Cartwright, *Practices of Looking: An Introduction to Visual Culture* (New York: Oxford University Press, 2001). Barbie Zelizer, *Taking Journalism Seriously: News and the Academy* (Thousand Oaks: Sage, 2004).

14 Jay David Bolter and Richard Grusin, *Remediation: Understanding New Media* (Cambridge: MIT Press, 1999).

15 Walter Benjamin, "The Work of Art in the Age of Mechanical Reproduction," in *Illuminations: Essays and Reflections*, ed. Hannah Arendt, trans. Harry Zohn (New York: Schocken Books, 1969), 227.

16 We understand the universal audience as a rhetorical fiction, albeit one that is central to the public use of reason in both civic and academic forums. See Chaim Perelman and L. Olbrechts-Tyteca, *The New Rhetoric: A Treatise on Argumentation*, trans. John Wilkinson and Purcell Weaver (Notre Dame: University of Notre Dame Press, 1969), 31–35. See also Michael C. McGee, "In Search of 'the People': A Rhetorical Alternative," *Quarterly Journal of Speech* 61 (1975): 235–49.

17 *The Oxford Encyclopedia of Rhetoric*, ed. Thomas O. Sloane (New York: Oxford University Press, 2001), s.v. "Enthymeme"; Cara A. Finnegan, "The Naturalistic Enthymeme and Visual Argument: Photographic Representation in the 'Skull Controversy,'" *Argumentation and Advocacy* 37 (2001): 133–149.

18 It also should be emphasized that the supposed deficiencies of visual representation are alive and well in verbal form. The Bush administration's false connection between Saddam Hussein and the September 11 attack on the World Trade Center and the Pentagon was largely a verbal accomplishment achieved through repetitive parataxis, that is, persistent mention of the two elements side by side as if there were a connection. Public opinion polls reported that in November 2004 half of the electorate still believed Hussein was behind the attack.

19 Other coverage was not immune to the "clash" fantasy, as Dana Cloud argues in respect to visual coverage of women in Afghanistan. "To Veil the Threat of Terror": Afghan Women and the <clash of civilizations> in the Imagery of the U.S. War on Terrorism," *Quarterly Journal of Speech* 90 (2004): 285–307.

20 Michael Warner, *Publics and Counterpublics* (New York: Zone Books, 2003). Our project exemplifies more than these three categories, including others emphasized by Warner and not least the "poetic world making" capability of public address. We find these so obvious from our perspective that they need not be discussed explicitly.

21 Our sense of focal terms is set out by Michael Calvin McGee, "The "Ideograph": A Link between Rhetoric and Ideology," *Quarterly Journal of Speech* 66 (1980): 1–17; and Celeste Michelle Condit and John Louis Lucaites, *Crafting Equality: America's Anglo-African Word* (Chicago: University of Chicago Press, 1993).

22 Benjamin, "The Work of Art in the Age of Mechanical Reproduction," 242.

23 Kevin G. Barnhurst and John Nerone, "Civic Picturing vs. Realist Photojournalism: The Regime of Illustrated News, 1856–1901," *Design Issues* 16 (2000): 79. This argument is strongest when focused on the period in question, while subsequent development of photojournalism has allowed more complexity and sophistication that can include bringing older sensibilities along with the new. As we have shown in chapter 4 and in other work, civic republican appeals can work through photojournalism and define some political actors. Nonetheless, Barnhurst and Nerone provide an excellent account of one relationship between visual techniques and political style.

INDEX

Berlant, Lauren, 77, 267, 382n67
Berlin, Isaiah, 37
Besnier, Niko, 357n53
betrayal, 120, 181–82, 207
Biel, Timothy Levi, 270
Billig, Michael, 112
Black, Lewis, 336n83
Black Panthers, 61
Blair, Carole, 279
Blitt, Barry, 79
Blix, Hans, 382n64
Blumenthal, Ralph, 394n62
Bodnar, John, 337n91, 341n35
Bohman, James, 344n68
"Bombs Away" (Kuper), 203
Boston Globe, 164, 191
Boston Herald, 164
Boston Red Sox, 105
Bougeureau, William Adolphe, *Charity*,
 57–58
Bourke-White, Margaret, 328n18
Bowden, Mark, 398n4
Bowers, Michael, 359n4
Boy Scouts, 111, 113
Bradley, James, 131, 340n26; *Flags of Our
 Fathers*, 123
Bradley, John, 123
Branham, Robert James, 319n14
Brink, Cornelia, 311n13
Brinkley, David, 147
Britannica, 129
Brokaw, Tom, 125, 344n70
Brothers, Caroline, 361n12
brumm.com, 355n45
Buell, Hal, 98
Bugs Bunny, 77
Burger, Thomas, 317n4
Burgin, Victor, 309n8; on objects within
 ideology, 46
Burke, Kenneth, 323n47, 340n28; on at-
 titudes as incipient actions, 114; on
 dramatic unity, 250; and "frames of
 acceptance," 126
Burke, Martin J., 328n19
Burnett, David, 361n14
burning monk image, 195, 197
Burstein, Andrew, 353n26

Bush, George H. W.: speech on Tiananmen
 Square standoff, 213; support for flag
 desecration amendment, 106; on Viet-
 nam syndrome, 171
Bush, George W., 122, 125, 131–32, 172,
 395n77; 2004 presidential campaign,
 171; administration of, 120, 349n115,
 400n18; ceremony with three firefight-
 ers from ground zero image, 131; in
 "Ego Jima" cartoon, 121; Texas ranch as
 site of protest, 118, 385n91
Butler, Judith, 320n20

Calhoun, Craig, 373n9
Cambodia, U.S. invasion of, 137, 139–40
capitalism, 305
Caputo, John, 178
Cardow, Cam, 335n73
Carlebach, Michael L., 312n26
Cartwright, Lisa, 318n7
Castle, Terry, 367n58
catharsis, 279
CBS, 129
celebrity, as widely recognized stranger,
 204–7
censorship, 236, 294
Chalfen, Richard, 315n38; on snapshot pho-
 tography, 18
Challenger: America's Space Tragedy (Cole),
 269
Challenger, The (Biel), 270
Challenger explosion image, 12, 23, 30, 302;
 discussed, 244–45, 251–55, 264–75,
 276–86
Chan, Jackie, 385n86
Chappatte, Patrick, 383nn75–76; editorial
 cartoons of, 234–35
Charity (Bougeureau), 57–58
Cheney, Lynne, 119
Chicago, Judy, "Im/Balance of Power," 203
Chick-fil-A, 239–41
"Children Fleeing" (Haddock), 180, 181, 203
Chilton, Edward M., 191; "*Veritatis* Viet-
 nam" Web page, 189–90
China, 207, 210, 226, 318n59; culture in, 220;
 democracy in, 241; and globalization,
 209; rise of modern, 214

Made in the USA
Lexington, KY
03 June 2016